American Paintings of the Eighteenth Century

ELLEN G. MILES

with contributions by

Patricia Burda

Cynthia J. Mills

Leslie Kaye Reinhardt

AMERICAN PAINTINGS

of the Eighteenth Century

NORTHERN VIRGINIA COMMUNITY COLLEGE library call number handwritten

THE COLLECTIONS OF THE

NATIONAL GALLERY OF ART

SYSTEMATIC CATALOGUE

National Gallery of Art, Washington

Distributed by Oxford University Press,

New York and Oxford

This publication is made possible by a grant from
THE HENRY LUCE FOUNDATION

The systematic catalogue will include approximately thirty volumes
on the paintings, sculpture, and decorative arts in the collection
of the National Gallery of Art. Published to date are:

Early Netherlandish Painting, John Oliver Hand and Martha Wolff, 1986

Spanish Paintings of the Fifteenth through Nineteenth Centuries, Jonathan Brown
and Richard G. Mann, 1990

British Paintings of the Sixteenth through Nineteenth Centuries, John Hayes, 1992

American Naive Paintings, Deborah Chotner et al, 1992

German Paintings of the Fifteenth through Seventeenth Centuries, John Oliver Hand, 1993

*Western Decorative Arts, Part I: Medieval, Renaissance, and Historicizing Styles including
Metalwork, Enamels, and Ceramics,* Rudolf Distelberger, Alison Luchs,
Philippe Verdier, Timothy H. Wilson, 1993

COVER: John Singleton Copley, *Epes Sargent*, 1959.4.1
FRONTISPIECE: Gilbert Stuart, *Catherine Brass Yates
(Mrs. Richard Yates),* 1940.1.4

Distributed by Oxford University Press,
198 Madison Avenue, New York, New York 10016
Oxford University Press:
Oxford, New York, Toronto, Delhi, Bombay, Calcutta, Madras,
Karachi, Kuala Lumpur, Singapore, Hong Kong, Tokyo, Nairobi,
Dar es Salam, Cape Town, Melbourne, Auckland; and associated
companies in Berlin and Ibadan.
Oxford is a registered trademark of Oxford University Press.

LIBRARY OF CONGRESS CATALOGING-IN-PUBLICATION DATA
Miles, Ellen G., 1941-
American Paintings of the eighteenth century/
Ellen G. Miles with contributions by Patricia Burda,
Cynthia J. Mills, Leslie Kaye Reinhardt.—
(The Collections of the National Gallery of Art:
systematic catalogue)
Includes bibliographical references and index.
 ISBN 0-89468-210-5
 1. Painting, American — Catalogs. 2. Painting. Modern — 18th
century — United States — Catalogs. 3. Painting — Washington (D.C.) —
Catalogs 4. National Gallery of Art (U.S.) — Catalogs I. Miles, Ellen
Gross, 1941- . II. Burda, Patricia. III. Mills, Cynthia J. IV. Reinhardt,
Leslie Kaye. V. Title. VI. Series: National Gallery of Art (U.S.).
Collections of the National Gallery of Art.
ND 207.N28 1995
759. 13' 09' 033074753 — dc20 95-37473
 CIP

CONTENTS

At the time of its fiftieth anniversary in 1991, the National Gallery's collection included nearly fourteen hundred American paintings. This number far exceeds that of any other national school represented in the Gallery. That is perhaps as it should be, but it was not always so. When the National Gallery opened its doors in 1941, only eleven American paintings hung on its walls. Acquisitions since that time have transformed the quantity and especially the quality of the Gallery's collection of American paintings into one of the finest anthologies of our nation's artistic achievements.

Within this splendid collection, the eighteenth century occupies a very special place. Ten of the eleven paintings that represented American art in 1941 were by eighteenth-century artists. (One painting, then believed to be by John Singleton Copley, is now attributed to his British contemporary, Joseph Wright of Derby, and is catalogued with our British works.) Further, the Gallery's eighteenth-century American paintings include some of its greatest treasures—Copley's *Watson and the Shark* and Gilbert Stuart's *The Skater (Portrait of William Grant)*, to name just two—as well as its most renowned national icons—Edward Savage's *The Washington Family* and Stuart's *George Washington (Vaughan portrait)*. Stuart's portraits of the first five presidents of the United States, the so-called Gibbs-Coolidge portraits, are also among the icons, though they came to the Gallery in more recent years. The group of forty-one portraits by Gilbert Stuart forms one of the largest concentrations of works by a single American artist within the Gallery's collections. Others are the special collections of paintings by the Americans George Catlin and Mark Rothko, and photographs by Alfred Stieglitz. The works by Copley, the preeminent American painter of the eighteenth century, are rivaled only by those in collections in his native Boston. The Gallery's paintings span the full range of Copley's remarkable career, from his early portraits painted in colonial America, to the grander portraits and history paintings he later made in England.

This pattern of acquisition reflects the interests of collectors earlier in this century. Most of the eighteenth-century paintings are portraits, both because portraiture was the genre most frequently commissioned in Colonial and Federal America, and because collectors were concerned chiefly with the sitters and their relationship to both family and national history. Andrew W. Mellon had a national portrait gallery in mind as he collected the paintings that he gave to the Gallery. In 1962, with the establishment of the National Portrait Gallery of the Smithsonian Institution, twenty-seven historical portraits were transferred to it, including twenty from the Andrew W. Mellon Collection that had been held in trust by the Gallery.

Like other areas of art history, portraiture is a specialized field of study. It combines the talents and training of the art historian with the sensitivity of the biographer and the painstaking methodology of the genealogist, all of which are required to solve thorny problems of authorship, authenticity, and identification. We are fortunate that Ellen G. Miles, the gifted curator of paintings and sculpture at the National Portrait Gallery of the Smithsonian Institution, agreed to bring to this project her highly developed skills as a scholar of eighteenth-century American portraiture. She has done so with splendid results that put the knowledge and interpretation of our eighteenth-century paintings in a new, revealing, and often surprising light.

Earl A. Powell III
Director

ACKNOWLEDGMENTS

In 1988 the National Gallery of Art invited me to write the volume of the systematic catalogue project on eighteenth-century American paintings. The opportunity to research artists such as Gilbert Stuart, John Singleton Copley, and Benjamin West, and paintings such as *Watson and the Shark* and *The Skater*, was a great attraction. The experience of working with so many talented colleagues, especially Nicolai Cikovsky, Jr., and Franklin Kelly, curators of American and British painting at the Gallery, has been the bonus. Alan Fern, director of the National Portrait Gallery, and Carolyn Kinder Carr, deputy director, made it possible for me to participate in the Gallery's systematic catalogue project as part of my duties as curator of paintings and sculpture at the National Portrait Gallery. Thus began the gradual process of examining the National Gallery's paintings, reviewing the curatorial files, and beginning the research that would lead to new documentation on the provenance and interpretation of more than one hundred works. In much of the research I was assisted by Patricia Burda, Cynthia J. Mills, and Leslie Kaye Reinhardt, who began as research assistants and became colleagues. Their contributions of ideas, hard work, and energy are apparent throughout this book.

At the inception of the project, Suzannah Fabing, former coordinator of the systematic catalogue project, and Paula DeChristofaro and Catherine A. Metzger laid the groundwork that ultimately resulted in this book. I am grateful to the staff in the painting conservation department, headed by Ross Merrill, who steadily examined paintings and prepared the extensive reports that formed the basis for the technical notes published here. Among those who worked on this project, I would especially like to thank Mary Bustin, Carol Christensen, Sarah Fisher, Patricia Goddard, Susanna Pauli Griswold, Ann Hoenigswald, Marie von Möller, Julie Caverne Moreno, Kate Russell, Kay Silberfeld, Michael Swicklik, and Philip Young. In 1993, Elizabeth Walmsley became the conservator for the systematic catalogue. She contributed a keen sense of organization and established new guidelines for presenting conservation information here and in subsequent volumes.

In the department of American and British painting, Deborah Chotner, Charles Brock, and Nancy Anderson made observations that helped further define my research, as did D. Dodge Thompson, curator of exhibitions. Susan Davis, and later Nancy Yeide and Anne Halpern, in the office of curatorial records and files, offered frequent, cheerful assistance in locating gallery records, and Stephanie Belt and Lisa Mariam helped with paintings on loan beyond the walls of the Gallery. Lamia Doumato, Roberta Geier, and Richard Hutton of the library pointed me in the direction of valuable sources. The curatorial files are rich in research notes and documents compiled by previous staff members, particularly the late William P. Campbell, which I have used as the basis for additional inquiries. Lawrence Pamer, a graduate student and volunteer, and Christine Brown, a graduate student and summer fellow, transferred many of these references onto computer discs for my use.

At the National Portrait Gallery, colleagues Margaret Christman, Brandon Fortune, Sidney Hart, Lillian B. Miller, Lou Ockershausen, Wendy Wick Reaves, Robert Gordon Stewart, and David C. Ward helped with questions of research and interpretation. Linda A. Thrift, keeper of the Catalog of American Portraits, and her staff, especially Deborah Sisum, and Cecilia Chin and past and present staff members at the National Museum of American Art/National Portrait Gallery Library, especially Patricia Lynagh, Kimball Clark, and Martin R. Kalfatovic, patiently dealt with a wide range of requests. The staffs of the Inventory of American Painting at the National Museum of American Art and of the Archives of American Art provided assistance with research questions, as did Merl Moore, a generous colleague. Other Smithsonian curators who assisted with specific areas of inquiry are anthropologist William Sturtevant and military historian Donald Kloster. National Portrait Gallery interns Amy Freund, Cathy Gould, LeDée Kidd, Carey Leue, Dina Smith, and Martha Willough-

by helped at various stages, as did Leslie Cook.

Many individuals on the staffs of museums, libraries, newspapers, religious organizations, historical societies, and the archives of cities, states, colleges, universities, and even cemeteries checked records, answered questions, and otherwise assisted our endeavor. Their names appear in the notes of the appropriate catalogue entries. For their outstanding interest and willingness to share information, I would like to thank Georgia Barnhill, Andrew W. Mellon curator of graphic arts, and Thomas Knoles, curator of manuscripts, American Antiquarian Society, Worcester; Judy Throm, Archives of American Art, Washington; Jennifer Abel, registrar's office, Museum of Fine Arts, Boston; Helen Sanger and her staff at the Frick Art Reference Library, New York; James Oldham, Georgetown University Law School, Washington; Burton B. Fredericksen and the staff at the Getty Provenance Index, Malibu; Robin McElheny, Harvard University Archives, Cambridge; Melissa De Medeiros, librarian, M. Knoedler & Co., New York; Virginia H. Smith, reference librarian, Massachusetts Historical Society, Boston; Roger Quarm, curator of pictures, National Maritime Museum, Greenwich, England; John Hayes, former director, and Jacob Simon, curator of eighteenth-century portraits, National Portrait Gallery, London; Brian Allen, Evelyn Newby, and Clare Lloyd-Jacob of the Paul Mellon Centre for British Art and British Studies, London; James Holloway, deputy keeper, Scottish National Portrait Gallery, Edinburgh; Elizabeth R. Fairman, associate curator for rare books, The Yale Center for British Art, New Haven; and Marko Zlatich, historian of military uniforms, Washington. I would also like to thank Marion Mecklenburg, Tom V. Schmitt, and Edwin A. Ahlstrom for sharing their knowledge of painting techniques and the conservation of paintings with me over the years since 1980, when I joined a small informal seminar directed by Marion at the Washington Conservation Studio in Kensington, Maryland. This informal exposure to conservation methods and Ed Ahlstrom's knowledge of painting techniques and pigments used by Gilbert Stuart encouraged my interest in the materials of eighteenth-century painting.

Finally, for their astute comments I would like to thank Allen Staley, professor of art history, Columbia University, and Ian Quimby, both of whom read the entire manuscript, as well as Dorinda Evans, associate professor of art history, Emory University, who read the entries on Gilbert Stuart. With pleasure I thank Frances Smyth, Mary Yakush, and Barclay Gessner of the National Gallery's editors office, and especially the resilient Nancy Eickel, who edited and helped shape this book. I am grateful to Klaus Gemming for his sensitive and elegant sense of typography and design. Sara Sanders-Buell in the department of visual services helped to locate the comparative illustrations and secured permission to reproduce them. These individuals have transformed our research into a book.

Ellen G. Miles

This volume of the series of systematic catalogues that describe the collections of the National Gallery of Art contains entries on paintings by trained artists who were born or worked in the United States in the eighteenth and early nineteenth century and whose earliest work in the collection was painted before 1800. Works by self-taught eighteenth-century American painters are discussed in Deborah Chotner's catalogue of *American Naive Paintings* (Washington, 1992).

Portraits dominate the collection, which is notable particularly for the large number of works by Gilbert Stuart and John Singleton Copley. The forty-one paintings by Stuart cover almost the full span of his long life, from *The Skater (Portrait of William Grant)* of 1782, his most important English painting, to his series of portraits of the first five presidents, completed in the early 1820s. Most of Stuart's paintings are head and shoulder portraits, as is true of most of his work. The large number and broad time frame offer an unusual opportunity to examine his technique as it developed and changed over forty years. We can also arrive at an understanding of the personality of the fabled painter as seen through the eyes of his contemporaries, who left a significant written record of the artist's behavior and manner.

The work of John Singleton Copley can be studied closely as well. The collection begins with his early portrait of Jane Browne (1756), includes two pivotal English pictures, *The Copley Family* (1776/1777) and *Watson and the Shark* (1778), and ends with such late portraits as *Colonel William Fitch and His Sisters Sarah and Ann Fitch* (1801) and *Baron Graham* (1804). The paintings show important changes in Copley's technique and approach to painting, and serve as an historical record rich with public commentary in response to his English work. Benjamin West, Charles Willson Peale, and Ralph Earl are also well represented.

The collection of portraits formed by Thomas B. Clarke in the second and third decades of this century forms the nucleus for the National Gallery's holdings of eighteenth-century American paintings. Of the 107 paintings in this volume, almost half, or 47, were once in Clarke's collec-

tion. In forming this collection Clarke set out to acquire portraits of significant historical figures by prominent artists. After Clarke's death in 1931, the A.W. Mellon Educational and Charitable Trust, Pittsburgh, purchased the collection for the new National Gallery of Art, with the possibility that the works would be transferred to a national portrait gallery, if one was established. Among the paintings in this group that are still in the Gallery's collection are Stuart's portraits of five members of the Yates and Pollock families of New York City and two versions of his first portrait of George Washington, West's portraits of Maria Hamilton Beckford (Mrs. William Beckford) and Elizabeth, Countess of Effingham, John Trumbull's *William Rogers*, and Edward Savage's *Washington Family*. Others, including John Singleton Copley's portrait of Henry Laurens, were transferred to the National Portrait Gallery when it was established.

Because some of the portraits that Clarke acquired came with inflated identifications or provenance, the attributions of a number of the paintings in his collection have since proven false. This volume includes several of these, which are still identified as the work of American artists but have been given new attributions or titles. Among them are John Wollaston's *Gentleman of the Morris Family*, acquired by Clarke as a portrait of Lewis Morris, a signer of the Declaration of Independence; Joseph Blackburn's *A Military Officer*, once thought to represent General John Winslow; and Adolph-Ulrich Wertmüller's *Portrait of a Quaker*, acquired by Clarke as a portrait of General William Shepard by Ralph Earl. Other eighteenth-century paintings that are no longer believed to be American have either been included in John Hayes' catalogue of the Gallery's British collection, entitled *British Paintings of the Sixteenth through Nineteenth Centuries* (Washington, 1992), or will be discussed in the volumes of the Gallery's nineteenth-century American paintings.

A number of significant works have joined the Clarke pictures since the Gallery was founded. Although portraits predominate, thus reflecting the nature of American art in the eighteenth century, the National Gallery of Art now offers a much

greater range of subjects and styles than was true of Clarke's collection. The donors of some of the gifts and bequests were often the descendants of the artists or the sitters. Among the paintings acquired in the early years of the Gallery were Benjamin West's *Battle of La Hogue* and *Colonel Guy Johnson and Karonghyontye (Captain David Hill)* (an early gift of Andrew Mellon that was not in the Clarke Collection), Gilbert Stuart's *The Skater* and portraits of John and Abigail Adams, Ralph Earl's *Daniel Boardman*, and John Singleton Copley's *Epes Sargent, Red Cross Knight*, and *Baron Graham*. In the 1960s the Gallery acquired other major paintings by Copley, including *Watson and the Shark* and *The Copley Family*, as well as Charles Willson Peale's *Benjamin and Eleanor Ridgely Laming*, and John Trumbull's full-length portrait of Patrick Tracy. Twelve paintings in this volume were among the gifts of Edgar William and Bernice Chrysler Garbisch in the 1950s and 1960s. More recently the collection has grown by the inclusion of Peale's *John Beale Bordley*, Stuart's *Eleanor Custis Lewis (Mrs. Lawrence Lewis)* and the Gibbs-Coolidge series of portraits of the first five American presidents, as well as West's *Expulsion of Adam and Eve from Paradise*.

The entries in this catalogue address scholarly and museum audiences that possess either a specific interest in a certain artist's work or have broader interests in American eighteenth-century painting and in patronage and collecting at that time or in more recent years. The purpose of each catalogue entry is to document the painting in regard to its subject, its ownership, and its technique and condition. Each entry is also concerned with the relationship of that work to others by the same or contemporary artists. The overall arrangement of the volume is alphabetical by artist and then chronological by date of work. Following the introductory biography for each painter, as well as the brief bibliography, each entry begins with the title of the work, its medium, dimensions, and the location of signatures or inscriptions. Almost all the paintings have been firmly assigned to identified artists. The exceptions are one which is attributed to Gilbert Stuart, one which is attributed to Adolph-Ulrich Wertmüller, three that are copies of works by Stuart (indicated as "After Gilbert Stuart"), and three that are by unknown artists (the portraits of Matilda Caroline Cruger, Elisha Doane, and Jane Cut-

ler Doane). The following conventions are used for the dates of paintings.

1776	Executed in 1776
c. 1776	Executed in about 1776
1776–1780	Begun in 1776, finished in 1780
1776/1780	Executed sometime between 1776 and 1780
c. 1776/1780	Executed sometime around the period 1776–1780

Dimensions are given in centimeters, height before width (dimensions in inches follow, in parentheses). Signatures and inscriptions have been transcribed in their original spellings, with slashes to indicate line breaks. Any lettering on books, documents, or other objects in the painting, however, is not given in this part of the entry, but instead is discussed in the essay.

Each painting in this volume was examined by a member of the Gallery's painting conservation department, and the findings were discussed. The conservators' examination reports are summarized in the technical notes, which were written by myself and the three contributors and reviewed by Elizabeth Walmsley, conservator for the systematic catalogue. For each examination the painting was unframed. The front, back, and sides were examined in visible light, and the paintings were examined with a stereomicroscope and under ultraviolet light. Most paintings were x-rayed with a Eureka Emerald 125 MT tube, a Continental 0–110 kV control panel, and a Duocon M collimator. Kodak X-OMAT film was used. The results are presented here when they pertain to the interpretation of the work. The x-radiograph composites that are reproduced in this volume were prepared with photographs developed from the film and then assembled into a mosaic. Each painting was also examined with infrared reflectography to reveal underdrawing and compositional changes. Prior to November 1992, a vidicon camera was used for the examination; more recently, a camera with a solid state detector was used. The vidicon camera system consists of a Hamamatsu C/1000–03 camera fitted with either an N2606–10 or N214 lead sulphide tube, a Nikon 55mm macro lens with a Kodak Wratten 87A filter, a C/1000–03 camera controller, and a Tektronics 634 monitor. The infrared reflec-

tograms in this volume were made with a Kodak platinum silicide camera configured to 1.5–2.0 microns and using a Nikon 55mm macro lens. The video signal was collected with a Perceptics Pixelbuffer board and Signal Analytics IP Lab Spectrum software. Each individual image is an average of eight frames. The multiple images were assembled into a composite reflectogram with Adobe Photoshop on a Macintosh Quadra 700 computer. The reflectograms were printed on a Kodak XL7700 dye sublimation printer. Again, only findings essential to the interpretation of the work are discussed here.

Most of the paintings in this volume are similar in construction. Nearly all were executed on single thread, medium-weight fabrics with a plain or twill weave, which are described with the conventional term of canvas and are assumed to be linen, although the fibers were not analyzed. Those on wood supports are on single-member panels without joins. The thickness of each panel is given, as is the type of wood, which was determined by analysis carried out by the National Gallery's scientific research department. The fabric surface is prepared with a ground that is usually white or off-white, which was applied in a smooth layer and fills but does not mask the fabric weave. X-radiographs reveal that the grounds in certain paintings are extremely dense, and this suggests that the ground contains a large percentage of lead white. (Samples were not taken for analysis.) Some canvases were commercially prepared, their proprietary grounds applied before the canvases were stretched. They are occasionally distinguished with a canvas stamp. Some grounds are covered within a restricted area with an imprimatura that was applied as a toner; their location, color, and opacity or transparency are noted.

The paint layer is assumed to be oil. Generally, the paint is applied in thin washes and glazes in the dark backgrounds and the shadows, and a thicker, paste-like paint is used in the flesh tones. The white highlights often show a use of impasto. In general, the faces are brought up to a careful finish, applied in successive layers in a wet-over-dry technique. The clothing and backgrounds are more freely painted. Energy dispersive x-ray fluorescence (XRF) was used to analyze the pigment in two paintings, *Matilda Caroline Cruger* by an unknown American artist,

and *Elizabeth Gray Otis (Mrs. Samuel Alleyne Otis)* by John Singleton Copley.

The condition of the paintings varies. Records of conservation treatment are frequently available in the National Gallery of Art conservation files. In most cases the paintings on fabric have been removed from their original stretchers, have had their original tacking edges removed, and have been lined with a secondary fabric. The presence of a lining canvas is assumed unless noted. At times the files record that the painting was "relined" rather than lined. The technical notes in this volume repeat the phrases as found in the records, without determining whether this means a first or a later lining; this phrase may be merely a casual use of the term, without intending to indicate that an earlier lining was removed during the treatment. Note is made of the exceptional instances in which the original tacking margins or stretchers are found. Presence of the cusping of canvas threads is noted to indicate that the canvas has not been cut down from its original dimensions. The lining of paintings on fabric was usually done with an aqueous adhesive, such as a glue or paste adhesive. The linings of a small percentage of the paintings were accomplished with a wax or wax-resin adhesive. The lining fabric is almost always a plain-weave linen. In a few instances the paintings were looselined (without the use of an adhesive), lined to fiberglass, or marouflaged to a sheet of plywood. These conservation treatments often included removal of discolored varnish layers and old retouching. Damage to the support, such as tears, holes, and patches, may be assumed to have been repaired and retouched. Changes in the condition of the paint are described. A record of later overpaint and retouching was made during the examinations, and photographs with a record of this retouching are in the conservation files of the Gallery. Finally, surface coatings are estimated. None are original. Most paintings have darkened residues of dirt and old varnish caught in the paint texture beneath the overall surface coating. Treatment records and dates of treatments are cited, where known.

The section on *Provenance* gives the name of each known owner. Since many are descendants of the sitters, determining the owner's life dates not only provided a way of verifying the identification of the sitter and, sometimes, the artist but also per-

mitted an interesting chronicle of the changes in ownership. Although the paintings were often acquired with provenances that began with the first probable owner along the genealogical path from the sitter, I have chosen to begin most sections on provenance with the first firmly documented owner. This was done to question the assumed provenances that often complicate the histories of portraits. Dealers' names are provided in parentheses. Close attention was paid to the early twentieth-century dealers who brought about the migration of the paintings from family owners to collectors or to the public arena. In this and later sections, endnotes indicate sources of information, especially for biographical data or for original documents such as wills. Some important information on the provenance of paintings in Clarke's collection is recorded in an annotated copy of *Portraits by Early American Artists of the Seventeenth, Eighteenth and Nineteenth Centuries Collected by Thomas B. Clarke*, the catalogue for the exhibition held at the Philadelphia Museum of Art in 1928, which is in the National Gallery of Art library. This is cited as *Clarke 1928*. The letters NGA in the endnotes indicate that documentation can be found in the Gallery's curatorial file on the object. This is true of research carried out since 1988 for this publication, as well as for the earlier work of Gallery curators. In the section that gives the painting's exhibition history, research into early exhibitions proved especially important for verifying claims for identity of the sitter and artist. In virtually every case the original catalogues or photocopies were checked to verify the loans. If this category is omitted from an entry, no record of an exhibition was found for the painting.

The catalogue essay for each painting addresses the subject of the work, the date, and the artist's style and technique. The biographies of the sitters are given to place them in the same locale as the artist, to indicate possible reasons for the choice of artist, and to explain the portrait's imagery, and not to imply historical or social importance for the sitter, as was often true in the 1920s. Costume de-scriptions are offered to help the reader look closely at the painting or to clarify the date or subject of the portrait. Each entry includes all known contemporary documentation on the sittings as well as comments made in private discussions, letters, or exhibition reviews. The essay also addresses any significant technical findings, preparatory or related studies, replicas, and copies. Finally, the essay seeks to evaluate the painting's place in the study of the artist's work and as part of the broader study of American art, especially portraiture. The list of references concentrates on early documentation and source materials that are essential for the study and interpretation of the work. It omits most discussions of the work in surveys of American painting and does not list every reproduction of the painting. It also does not include references to the sitters if the sources are only for the biographical part of the essay. The authors and titles of references are abbreviated, with the full citation given in the bibliography.

I am author of about three-quarters of the catalogue entries and of all the artists' biographies. Three research assistants—Patricia Burda (PB), Cynthia J. Mills (CJM), and Leslie Kaye Reinhårdt (LKR)—researched and wrote eighteen additional entries under my direction, as indicated by their initials at the end of the entry. The remaining entries, which were drafted by these research assistants, contain additions or changes that I made; in these cases the initials EGM are added to those of the researcher.

These catalogue essays are multi-layered and open-ended. After one series of questions was addressed and perhaps answered, a stream of new questions quickly followed. Writing such entries is, of course, an interpretive process. It is hoped that this catalogue answers some elemental questions, offers interpretations, and provides reliable groundwork for later re-examinations of these important works by eighteenth-century American painters.

Ellen G. Miles

CATALOGUE

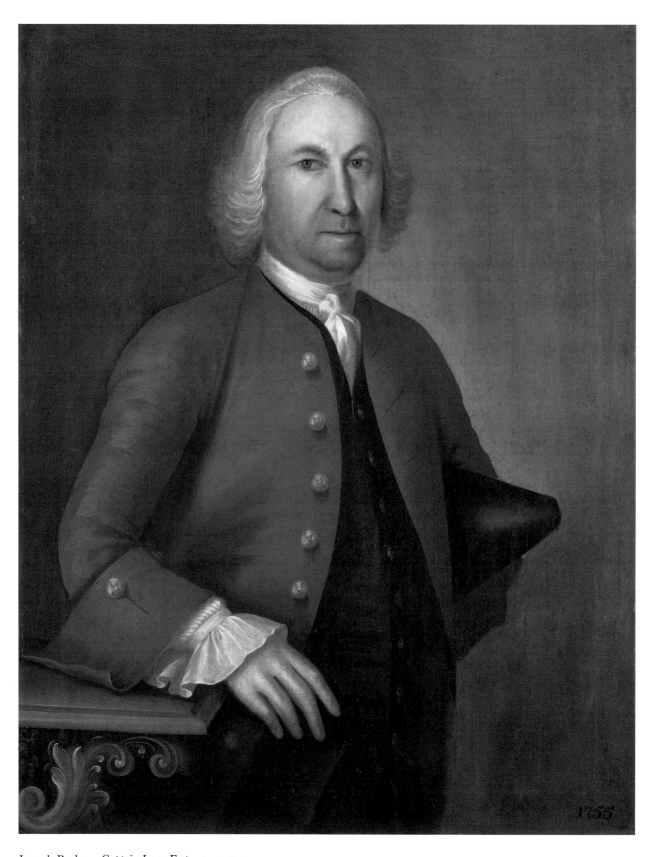

Joseph Badger, *Captain Isaac Foster*, 1957.11.1

Joseph Badger

1708 – 1765

JOSEPH BADGER, the son of a tailor, was born in Charlestown, Massachusetts. In 1731 he married Katharine Felch; they moved about two years later to nearby Boston, where Badger spent his entire painting career. He began as a house painter, glazier, and painter of signs and heraldic devices. His known work numbers around one hundred fifty portraits, the earliest dating from about 1740. Badger was particularly successful in the late 1740s and early 1750s, after the retirement of John Smibert. Some of his compositions show the direct influence of Smibert.

Apparently self-taught, Badger used a very subdued manner. Figures in his portraits are usually posed without dramatic modeling and highlighting. His work, memorable for its soft coloring and delicate treatment of detail, offers a quiet charm unlike that of his contemporaries. In the mid-1750s his conservative style was eclipsed by the work of two younger artists, Joseph Blackburn and John Singleton Copley.

EGM

Bibliography
Park 1918.
Nylander 1972.
Warren 1980: 1044–1045.
Saunders and Miles 1987: 190–191.

1957.11.1 (1488)

Captain Isaac Foster

1755
Oil on bed ticking, 91.7 × 71.2 (36⅛ × 28)
Gift of Edgar William and Bernice Chrysler Garbisch

Inscriptions
Inscribed lower right: 1755
Inscribed on the reverse of the original canvas: Isaac Foster; / Son of Richard; Foster Esqr. / And Parnell His Wife Was Born Janu Ye 3rd, 1703 / 4

Technical Notes: The herringbone twill fabric has two vertical dark stripes, one wider than the other, evenly spaced at 1.5 cm intervals. The vertical pattern ticking has emerged in the portrait itself, especially in the lighter, more thinly painted areas. On the reverse of the fabric, saturation by the wax-resin lining adhesive has obscured the distinction between dark and light values of the stripes. The fabric weave is rather pronounced, as is the cusping along the left and right edges. The original tacking margins are intact. A four-member strainer with butt-ended corners, presumed to be the original and no longer with the painting, was removed and photographed during conservation treatment in 1949–1950. The translucent lining fabric reveals the inscription on the reverse of the original fabric, which, according to x-radiographs, was coated with a transparent material after it was mounted on the strainer.

The ground is gray and is left unpainted for the shadows of the face. The portrait was blocked in with rather opaque layers. The paint is applied thinly, with very low impasto in the whites.

Isolated abrasion is found in the paint layer, and an area of loss above the sitter's right eye has been retouched. Scattered stains and flyspecks appear most prominently in the light tones. A liquid material, possibly wax, was brushed on the back of the painting between the stretcher bars, probably as a moisture barrier. In 1949–1950 the varnish was removed, the painting was lined, and a polyvinyl acetate varnish was applied, which has moderately discolored.

Provenance: Mrs. David Buffum, Walpole, New Hampshire, by 1873;[1] her son Dr. Thomas Bellows Buffum, Walpole, New Hampshire, by 1918;[2] Annie Buffum Williams [Mrs. Nathan W. Williams], Northampton, Massachusetts, 1943.[3] Purchased in Boston before 16 May 1949 by Edgar William and Bernice Chrysler Garbisch.[4]

Exhibited: *The World of Franklin and Jefferson*, The American Revolution Bicentennial Administration, traveling exhibition, 1975–1977, not in cat. *American Naive Paintings from the National Gallery of Art*, Terra Museum of American Art, Evanston, Illinois, 1981–1982, no. 16.

BADGER PAINTED five members of the Isaac Foster family of Charlestown, Massachusetts, in 1755. The four paintings in the Gallery's collection represent Foster, his wife Eleanor Wyer Foster [1957.11.2], and their sons Isaac Foster, Jr. [1957.11.3] and William Foster [1957.11.4]. A fifth portrait (unlocated) depicts their daughter Eleanor Foster, who married Nathaniel Coffin.[5] Before Lawrence Park's study of Badger and his works, the portraits were attributed to John Singleton Copley. They are painted with the subdued coloring and thinly applied paint now recognized as typical of Badger's work. The dates inscribed on the front of each may have been added when the more extensive inscriptions

were written on the reverse, which postdate the death of Foster's son William in 1759 but were apparently done during the lifetimes of the other sitters.

Isaac Foster (1704–1781), the son of Richard and Parnell Winslow Foster, was a successful mariner, having "made near forty voyages to Europe as commander of a vessel," according to his obituary. It further commented that at "the commencement of hostilities between Great Britain and America" he "took an open and active part in the cause of his country, by the destruction of Charlestown, at the memorable battle of Bunker Hill, he was stripped of great part of his hard earned property, and driven from his home."[6] In the portrait Foster's white hair contrasts with his ruddy complexion, which is testimony to his years at sea. The captain wears a taupe coat, black waistcoat, and breeches and rests his right arm on a blue-gray table, while under his left he has tucked his three-cornered hat. His pose, a standard one in British portraiture of the early to mid-eighteenth century, may have been adapted from an engraving. The design of the black, gray and white table, with its leafy bracket, is reminiscent of consoles seen in English engraved portraits, including, for example, John Faber's mezzotint of Thomas Hudson's portrait of Sir John Willes of 1744.[7]

<div align="right">EGM</div>

Notes

1. Perkins 1873, 125; Mrs. Buffum is described as a descendant. Bayley 1915, 108–109, repeats Perkins' information.

2. Park 1918, 14; Historical Records Survey 1942, 8.

3. Letter from Mrs. Williams to the Frick Art Reference Library, 28 November 1943.

4. A treatment report made for the Garbisches by conservators Sheldon and Caroline Keck notes that the Kecks received the painting on 16 May 1949 (NGA). An undated information sheet compiled for the Garbisches states that the painting was acquired in Boston (NGA).

5. The portrait is illustrated in Earle 1903, 1:opp. 280, and in Park 1918, opp. 15. The owner is listed as Mrs. Greely Stevenson Curtis of Boston. The owner is listed in Nylander 1972, 54, as Harriet Curtis, Boston.

6. These statements are quoted from an unidentified newspaper obituary once attached to the back of the painting (NGA).

7. Miles 1976, 2:237, pl. 76.

References

1873 Perkins: 125.
1915 Bayley: 108–109.
1918 Park: 14.
1938 Parker and Wheeler: 253.
1942 Historical Records Survey: 8.
1972 Nylander: 54.

1957.11.2 (1489)

Eleanor Wyer Foster (Mrs. Isaac Foster)

1755
Oil on bed ticking, 91.7 × 71.2 (36 1/8 × 28)
Gift of Edgar William and Bernice Chrysler Garbisch

Inscriptions
Inscribed lower right: 1755
Inscribed on the reverse of the original canvas: Eleanor, Foster; / Onely Daughter of William Wyer Esqr. / And Eleanor His Wife Was Born July Ye 14th, 1714.

Technical Notes: The construction, painting technique, and condition are the same as for the pendant portrait of Captain Isaac Foster [1957.11.1]. The underlying gray-beige tone is visible in the abraded area at the left of the sitter's right shoulder. The sitter's bonnet and the transparent fichu that is part of the dress are painted over a completed head and body. This layering often accounts for what appear as changes, as in the proper right side of her neck.

Although some abrasion exists, particularly in the background, it is isolated, and the areas of actual paint loss are remarkably few. Losses appear in the sitter's left eye, left arm, to the left of her waist, and forehead.

A four-member strainer with butt-ended corners, presumed to be the original and no longer with the painting, was removed and photographed during conservation treatment in 1949–1950. The translucent lining fabric reveals the inscription on the reverse of the original fabric, which, according to x-radiography, was coated with a transparent liquid material, possibly wax, probably as a moisture barrier. The varnish was removed and the painting lined in 1949–1950.

Provenance: Same as 1957.11.1.

Exhibited: *American Primitive Paintings from the Collection of Edgar William and Bernice Chrysler Garbisch*, NGA, 1957, 14, unnumbered. *101 Masterpieces of American Primitive Painting from the Collection of Edgar William and Bernice Chrysler Garbisch*, American Federation of the Arts, traveling exhibition, 1961–1964, no. 12. *National Gallery Loan Exhibition*, Mint Museum of Art, Charlotte, North Carolina, 1967, no. 2.[1] *The World of Franklin and Jefferson*, The American Revolution Bicentennial Administration, New York, traveling exhibition, 1975–1977, not in cat. *American Naive Paintings from the National Gallery of Art*, Terra Museum of American Art, Evanston, Illinois, 1981–1982, no. 17.

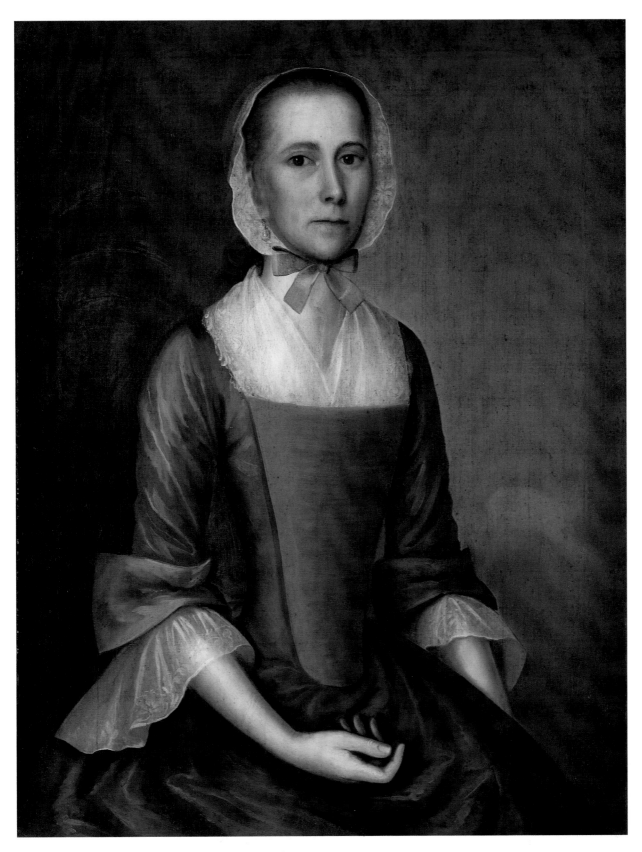

Joseph Badger, *Eleanor Wyer Foster (Mrs. Isaac Foster)*, 1957.11.2

ELEANOR WYER (1714–1798), the daughter of William and Eleanor Wyer of Charlestown, Massachusetts, married Captain Isaac Foster on 24 August 1732. She is shown seated, wearing a gray dress. Her blue eyes, pale pink cheeks, and the blue ribbon under her chin provide subtle color to the subdued image. Embroidery decorates the kerchief tucked into the bodice of her dress, the ruffles on her sleeves, and her cap.

This portrait and the other three by Badger of members of the Foster family are in their original frames—broad black moldings with narrow gilt inner moldings carved in a leafy pattern.[2]

EGM

Notes
1. Mint *Quarterly* 1967, unpaginated.
2. Heydenryk 1963, 96, fig. 86.

References
1873 Perkins: 125.
1915 Bayley: 109.
1918 Park: 14–15.
1938 Parker and Wheeler: 253.
1942 Historical Records Survey: 9.
1963 Heydenryk: 96, fig. 86; 117.
1972 Nylander: 54.

1957.11.3 (1490)

Isaac Foster, Jr.

1755
Oil on canvas, 81.3 × 66.2 (32 × 26 1/6)
Gift of Edgar William and Bernice Chrysler Garbisch

Inscriptions
Inscribed lower right: 1755
Inscribed on the reverse of the original fabric: Isaac; Foster: Son; OF; Isaac: / And; Eleanor; Foster; Was: Born: / August; Ye 18th: 1740

Technical Notes: The support is a medium-weight, plain-weave fabric, its original tacking margins intact. The four-member strainer with butt-ended corners, presumed to be the original and no longer with the painting, was photographed during conservation treatment in 1949–1950. The translucent lining fabric reveals the inscription on the reverse of the original fabric, which, according to x-radiographs, was coated with a transparent liquid material, possibly wax, probably as a moisture barrier.

The ground is a thin red layer, over which a second, thin gray-brown ground runs to within 3.5 cm of the edges. The resulting border was not originally part of the tacking margin: the paint is consistent throughout, cusping appears along all four edges, and the date 1755 is painted in that area.

The paint is thinly applied as an opaque layer, with little glazing and slight impasto only along the contours. Variety in the brushwork occurs rarely; it is used, for example, to define the edge of the waistcoat. The method of painting was to block out large areas of the composition and to fill in the colors sequentially, as can be seen in the sitter's right cuff, where the background was painted up to the edge of the jacket, after which the cuff was painted.

The overall lumpiness of the surface may result from the lining process. Large areas of damage are found to the left of the sitter's chin, on his upper right arm, and in the background to the right of the head. Overall abrasion exposes the reddish ground. The varnish was removed and the painting lined in 1949–1950. The present surface coating is dull but not significantly discolored.

Provenance: Mrs. Philip Peck, Walpole, New Hampshire;[1] Dr. Thomas Bellows Buffum, Walpole, New Hampshire;[2] Annie Buffum Williams [Mrs. Nathan W. Williams], Northampton, Massachusetts, 1943.[3] Purchased before 16 May 1949 by Edgar William and Bernice Chrysler Garbisch.[4]

Exhibited: Georgia Museum of Art, University of Georgia, Athens, on long-term loan, 1972–1974.

BADGER'S PORTRAIT of Isaac Foster, Jr. (1740–1781), shows him with pale skin, pink cheeks, gray eyes, and light brown hair that curls upward over his ears. He wears a gray coat and dark brown waistcoat. Standing with his body turned slightly to the viewer's right, he gestures with his right hand in a genteel pose identical to that of his older brother William. His black three-cornered hat is tucked under his left arm. Dark foliage and a cloudy blue sky appear in the background.

Isaac graduated from Harvard College in 1758.[5] After he studied medicine in Boston with Dr. James Lloyd and in London, he practiced as a physician in Charlestown, Massachusetts. In 1775 he organized a military hospital in Cambridge after the battles of Lexington and Concord. From 1777 to 1780 he established similar hospitals in New York, Connecticut, and Rhode Island as deputy director of military hospitals of the eastern district for the Continental army. Criticized for his management of the hospitals and at odds with his commanders over payments for supplies, he resigned from the army in 1780. After he died the following year, an obituary referred to these difficulties, saying that he had "steadily persevered in the discharge of his duty, choosing rather to hazard [his country's] ingrati-

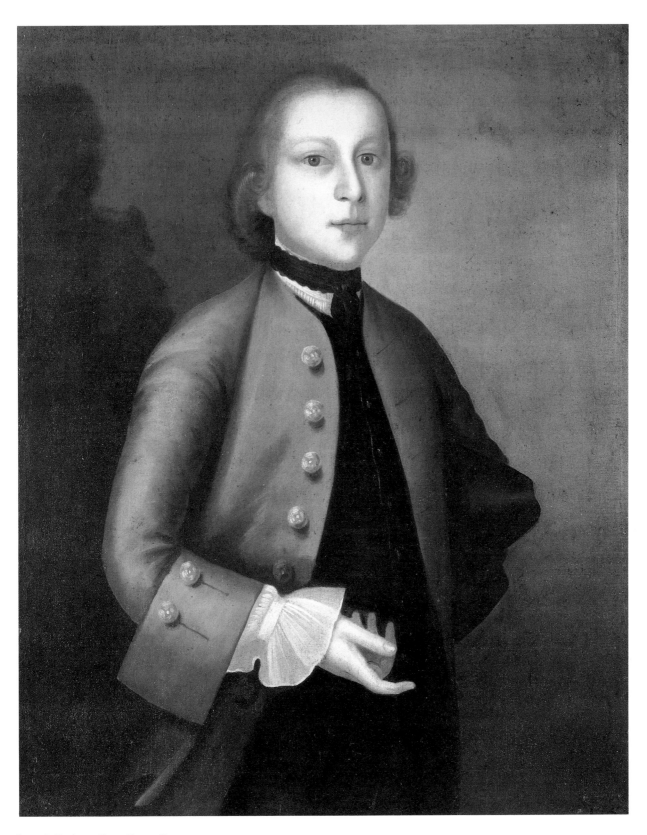

Joseph Badger, *Isaac Foster, Jr.*, 1957.11.3

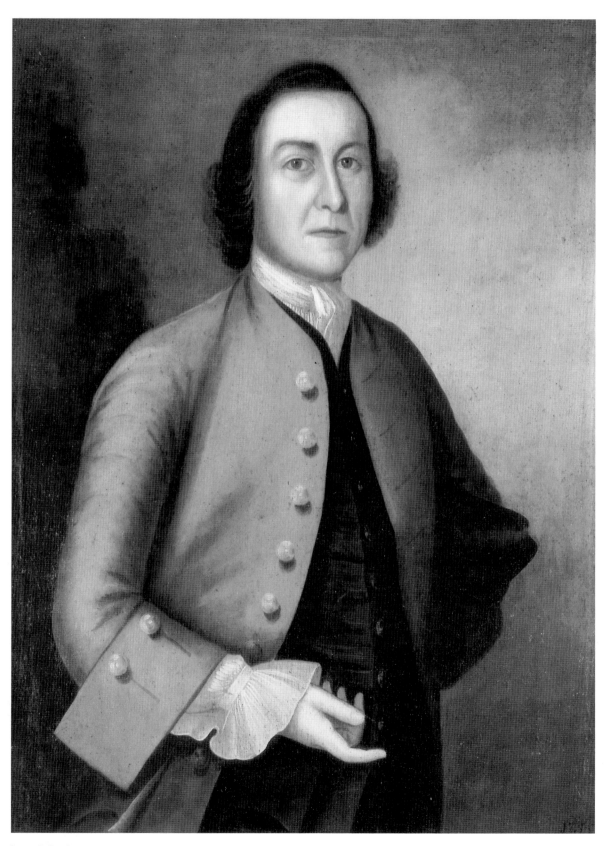

Joseph Badger, *Dr. William Foster*, 1957.11.4

tude, than sacrifice his conscience to views of private interest and emolument."[6]

<div align="right">EGM</div>

Notes
1. Perkins 1873, 125–126, repeated by Bayley 1915, 109.
2. Park 1918, 16; Historical Records Survey 1942, 9.
3. Letter from Mrs. Williams to the Frick Art Reference Library, 28 November 1943.
4. A treatment report made for the Garbisches by conservators Sheldon and Caroline Keck notes that the Kecks received the painting on 16 May 1949 (NGA).
5. For his biography see Shipton 1968, 262–268.
6. This unidentified newspaper obituary, once attached to the back of the painting, is now in the NGA curatorial file.

References

1873	Perkins: 126.
1915	Bayley: 109.
1918	Park: 15.
1938	Parker and Wheeler: 253.
1942	Historical Records Survey: 9.
1968	Shipton: 262–268, repro. between 328 and 329.

1957.11.4 (1491)

Dr. William Foster

1755
Oil on canvas, 90.8 × 71.4 (35 ¾ × 28 ⅛)
Gift of Edgar William and Bernice Chrysler Garbisch

Inscriptions
Inscribed lower right: 1755
Inscribed on the reverse of the original canvas (Figure 1):
William; Foster; / Eldest Son of; Isaac And Eleanor; Foster; / Was; Born; May; Ye 27th, 1733; And Died; / Desember Ye 4th, 1759; Aged; 26; Years And, / Six Months; His Character in The / Advertiser By An Unknown Hand; / Doctor; William; Foster; / Was A young Gentleman Possessed of Every / Virtue That Adorns The Social Life; / Religious, Without Ostentation; / Conscientious Without Affectation; / And Sincere Without Hypocrisy; Was / Universally Beloved By All That Had The / Pleasure of His Acquaintance; / And Whose Death is As Universally Lamented;

Technical Notes: The support is a medium-weight, plain-weave fabric, its original tacking margins intact. The four-member strainer with butt-ended corners, presumed to be the original support and no longer with the painting, was removed and photographed in the 1949–1950 conservation treatment. The translucent lining fabric reveals the inscription on the reverse of the original fabric, which, according to x-radiographs, was coated with a transparent liquid material, possibly wax, probably as a moisture barrier. The ground is a brown-gray layer of medium thickness. The paint is applied thinly with little impasto or glazing, with most of the color applied in an opaque manner. There is little overlapping of areas of color. Instead, the artist blocked out large areas and filled them in sequentially. Only on occasion did he use distinctive brushwork, as when he emphasized the highlights along the edge of the index finger with short, parallel brush strokes.

The fabric weave is pronounced where the paint is thinly applied. The overall lumpiness may result from the lining procedure. Extensive abrasion, particularly in the toned ground, has been inpainted. Dark stains and flyspecks are found overall. The varnish was removed and the painting lined in 1949–1950.

Provenance: Same as 1957.11.3.

Exhibited: Georgia Museum of Art, University of Georgia, Athens, on long-term loan, 1972–1974.

WILLIAM FOSTER (1732–1759), eldest son of Captain and Mrs. Isaac Foster, graduated from Harvard College in 1752 and worked as a physician at a provincial military hospital. When he died at the

Fig. 1. Joseph Badger, *Dr. William Foster*, 1957.11.4, reverse

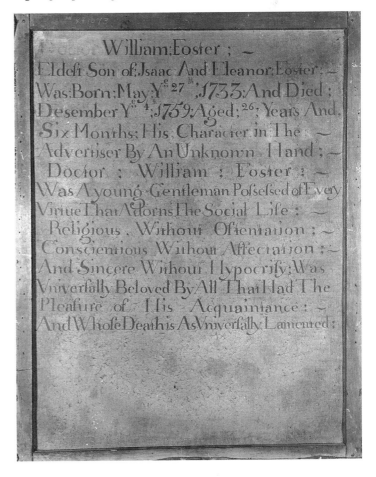

age of twenty-six, his obituary in the *Boston Gazette* (10 December 1759) described him as

A young Gentleman, who, after improving a Genius naturally good, by the best Education the Country affords, was applying himself to the Study and Practice of Physick with indefaticable Assiduity; which gave his Friends the most promising Hopes of his being in a short Time emminently useful to the Public. What was Characteristic of him, was his Honesty, apparent not only in the strictest observance of the Rules of commutative Justice, but also in a very uncommon Sincerity and Openness of Mind.

An obituary in *Green and Russell's Boston Post Boy and Advertiser* for 10 December, which described him as "religious without Ostentation, conscientious without Affectation and sincere without Hypocrisy," is quoted in the inscription on the reverse of the painting.[1]

Badger depicted Dr. Foster standing in a landscape, with a tree to the left and a cloudy sky beyond. The young doctor wears a gray coat with a black waistcoat and breeches. He looks directly at the viewer, his black hair curled upward, his hat tucked under his arm. His pale skin, like that of his younger brother Isaac, contrasts with the ruddy complexion of their father. Also like his brother, he gestures across his body with his right hand; the two poses are identical.

EGM

Notes
1. Both obituaries are quoted in Shipton 1965, 230.

References
1873 Perkins: 125–126.
1915 Bayley: 109.
1918 Park: 16.
1938 Parker and Wheeler: 253.
1942 Historical Records Survey: 9.
1965 Shipton: 230, repro. opp.
1972 Nylander: 55.

Joseph Blackburn

active 1752 – 1777

NOTHING IS KNOWN about English portrait painter Joseph Blackburn prior to his presence on Bermuda in 1752. During an extended stay on the island he painted about twenty-five portraits, including those of members of the Jones, Tucker, and Harvey families. His compositions indicate that he was familiar with the work of the leading London portrait painters of the 1740s. Blackburn's rather dry, precise technique suggests a provincial English training.

After about a year on Bermuda, Blackburn traveled to Newport, Rhode Island, where he painted several members of the Cheseborough family, including Margaret Sylvester Cheseborough (1754, MMA), wife of "King David" Cheseborough, a wealthy Newport merchant. He also painted Mr. and Mrs. John Brown (private collection), whose son-in-law Thomas Vernon introduced Blackburn to James Boutineau of Boston, describing the artist in his letter of 25 November 1754 as "late from the Island of Bermuda a Limner by profession & is allow'd to excell in that sci-

ence, has now spent some months in this place, & behav'd in all respects as becomes a Gentleman, being possess'd with the agreeable qualities of great modesty, good sence & genteel behaviour."[1]

Blackburn's graceful poses, his precise treatment of lace and other clothing details, and his softly colored landscape settings won him numerous commissions in the Boston area during the next five years. He repeated popular English poses: merchants at their desks, military men in uniform, public figures in their robes of office, and women dressed as shepherdesses or in gowns with low-cut bodices decorated with lace, ribbon, jewels, and flowing scarves. He apparently made contact with his sitters through personal recommendation; no newspaper advertisements have been found. Sitters in the Boston area included Isaac Winslow and his family (1755, MFA) and Jeffrey Amherst (1758, Amherst College, Massachusetts). Here his work had an important early influence on John Singleton Copley.

In 1759–1761 Blackburn worked in Ports-

mouth, New Hampshire, where he painted several portraits of the Wentworths, among them *Governor Benning Wentworth* (1760, New Hampshire Historical Society), as well as members of the Warner family (MacPhedris-Warner House, Portsmouth). Portraits of Bostonians that are dated 1760, and a newspaper notice in 1761 regarding an unclaimed letter, suggest that he went back and forth between the two cities. He may also have returned to Rhode Island: a portrait of a member of the Babcock family of Westerly is dated 1761. Blackburn returned to England by January 1764 and painted portraits in the southwestern English counties of Gloucestershire, Herefordshire, and Monmouthshire, as well as in Dublin (*Portrait of a Young Girl Holding a Dublin Lottery Ticket*, 1767, National Gallery of Ireland, Dublin). His last known portrait is of Hugh Jones, agent to the Morgan family of Tregdegar Park, Newport, Monmouthshire (1777, Worcester Art Museum, Massachusetts). About one hundred fifty portraits are signed by or are attributed to him.

EGM

Notes
1. Quoted in Stevens 1967, 101, from the original in the collection of the Newport Historical Society.

Bibliography
Park 1923.
Morgan and Foote 1937.
Baker 1945: 33–47.
Dresser 1966: 41–53.
Stevens 1967: 95–107.
Saunders and Miles 1987: 192–195.

1947.17.25 (933)

A Military Officer

1756
Oil on canvas, 77.5 × 63.6 (30 ½ × 25 ⅛)
Andrew W. Mellon Collection

Inscriptions
Signed and dated lower left on painted spandrel:
 I Blackburn Pinx^t 1756.

Technical Notes: The painting is on a moderate-weight, plain-weave fabric. The right and left tacking margins have been removed. Cusping is visible along all four edges. The top edge is deeply curved, suggesting that the original stretcher was bowed. The paint has been thinly applied on the white ground, with impasto only in the buttons of the uniform. The figure, painted directly on the ground, slightly overlaps the background paint. The face was painted wet-in-wet.

The top and bottom tacking margins have been unfolded and incorporated into the painted surface. There are small losses on the left and right sides. The outline of the sitter's right sleeve and left shoulder have been reinforced. A 1983 examination of the signature with a stereomicroscope indicated that it is original. Residues of old, discolored varnish are present in the weave of the fabric. The present varnish, which appears to be a natural resin, has discolored.

Provenance: (André E. Rueff, Brooklyn, New York); sold 5 January 1924 through (Art House, Inc., New York) to Thomas B. Clarke [1848–1931], New York;[1] his estate; sold as part of the Clarke collection on 29 January 1936, through (M. Knoedler & Co., New York), to The A.W. Mellon Educational and Charitable Trust, Pittsburgh.

Exhibited: Union League Club, March 1924, no. 21, as *General Joshua Winslow*. Philadelphia 1928, unnumbered, as *General Joshua Winslow*.

BOTH the attribution and the identity of the sitter of this portrait have been questioned in the past. Uncertainty about the attribution was based on a misreading of the inscribed date as 1750. Also suspicious was the claim that a missing label for the painting purportedly stated, "This is the first worthy picture I painted since I left my native village of Stonington, Connecticut." Historians of American art had once believed that Blackburn was a native of Connecticut, but this theory is no longer accepted. Therefore, the label, the provenance, and the signature were all open to question.[2] The Blackburn signature and the dates are authentic, however, and the smooth technique, with its lack of strong highlights or shadows, is typical of this artist's style, as are the pose, the detailed treatment of clothing, and the use of a painted oval for a waist-length image.

The sitter cannot be identified. He was once said to be Joshua Winslow of Boston (1727–1801). A contemporary portrait of Winslow by John Singleton Copley (1755, Santa Barbara Museum of Art), however, shows a very different man.[3] In addition, this sitter wears a blue coat with scarlet lapels, while Winslow, an officer in the British army, was depicted by Copley in the regulation British "red coat." No evidence exists to show that the sitter was another member of the Winslow fam-

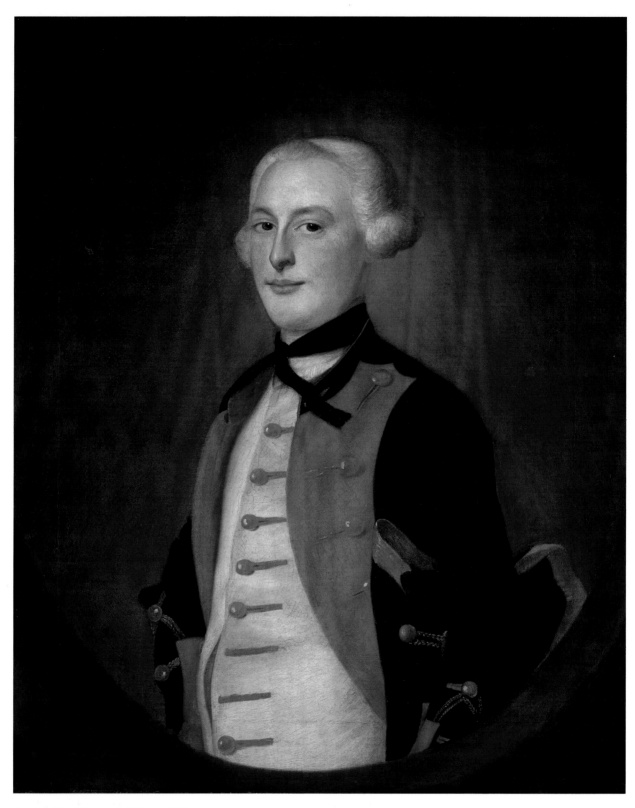

Joseph Blackburn, *A Military Officer*, 1947.17.25

ily, although Blackburn painted a number of Winslows, including General John Winslow (1702–1774) (Pilgrim Society, Plymouth, Massachusetts), Joshua Winslow (1694–1769) (YUAG), and Isaac Winslow (1709–1777) with his family (MFA).[4] Given the uncertainty of the identification, the title was changed in 1965 from *General Joshua Winslow* to *A Military Officer*.

The blue and scarlet coat shows that the sitter was a member of one of the colonial Massachusetts militia regiments or independent companies called into service during the French and Indian War.[5] Both the coat and the buff waistcoat have plain gilt buttons and gold-trimmed button holes. The scarlet facings of the slash cuffs are fastened to the sleeve buttons with gold chains. Apparently the sitter was an officer, as indicated by the gold lace on the three-cornered hat tucked under his left arm, but absence of a commander's sash, a gorget (throat protector), or braid around the edge of the lapel shows that he was not of a high rank. The date of 1756 with the signature suggests that the portrait was painted in the Boston area.

EGM

Notes

1. Letter from André Rueff, 5 January 1924, to Clarence J. Dearden, president of Art House, Inc. (NGA files on the Clarke collection). The name of the seller and the date of purchase are also recorded in an annotated copy of *Clarke* 1928 in the NGA library. According to the provenance provided by Rueff, which lacks documentation, the portrait was given by the sitter to a Colonel Thayer of the British army and later descended in the Adair family, including Esther Latham Adair, Alice Adair, James Adair (d. 1914), and his brother William of Jersey City, from whom Rueff acquired it. Confirmation of this provenance has not been possible. Park 1923, 6, noted that the portrait had come "to light about two years ago." Morgan and Foote 1937, 48, wrote that William Adair, of 34 Grant Avenue, Jersey City, said that he was a descendant of an Adair family of Boston, from whom he inherited the portrait. The only part of the story that can be documented is that William Adair lived at the Grant Avenue address; see *R.L. Polk and Co.'s Jersey City Directory, 1925–1926*.

2. Park 1923, 6, referred to the portrait briefly in his study of Blackburn's work, but he did not include it in the checklist. He wrote Clarke on 7 May 1924 that he believed the painting was by Blackburn, but he was "very uneasy about its history and the date." He added that if the final figure on the date had been a six, not a zero, "I should have included the picture in my list, although still disbelieving in its Stonington origin" (Lawrence Park to Thomas B. Clarke, Clarke files, NGA). The correct date of 1756 was determined later; see Morgan and Foote 1937, 49.

3. Prown 1966, 1:234 and fig. 31; Mead 1981, 50–53 and color pl. 33.

4. These portraits are listed in Park 1923, 61–62, nos. 87 and 88, and Morgan and Foote 1937, 47–48, no. 125, repro.

5. Lawson 1961, 3:196; Haarmann 1980, 58–59. The specific regiment or company has not been identified. Marko Zlatich was very helpful in identifying this uniform.

References

1923 Park: 6.
1929 Bayley: 135 repro., as *General John Winslow*.
1930 Bolton and Binsse, "Blackburn": 92, as *General Joshua Winslow*.
1937 Morgan and Foote: 48–49, no. 126, as *Lieutenant Joshua Winslow II*.
1945 Baker: 41.

Mather Brown

1761 – 1831

A DESCENDANT of the Mather family of Massachusetts, Mather Brown was one of the small number of talented American artists who made their way to Europe during and immediately after the American Revolution to study painting. He went first to Paris and arrived in London in 1781 bearing a letter of introduction to Benjamin West from Benjamin Franklin. Planning to be a miniature painter, Brown entered the school of the Royal Academy of Arts and also worked in West's studio. Soon his ambitions changed to the pursuit of a career as a portrait and history painter.

In 1784–1785 Brown painted portraits of John and Abigail Adams and their daughter Abigail, and in 1786 Thomas Jefferson sat for his portrait. The artist's full-lengths of the Duke of York (1788) and the Prince of Wales (1789) led to his appointment as the duke's official portrait painter. An ob-

server wryly commented on the politics of art: "Mr. West paints for the Court and Mr. Copley for the City. Thus the artists of America are fostered in England, and to complete the wonder, a third American, Mr. Brown of the humblest pretences, is chosen portrait painter to the Duke of York. So much for the Thirteen Stripes — so much for the Duke of York's taste."[1]

Unlike most of the Americans who studied with West, Brown remained in England for the rest of his life. The success of a painting *Raleigh Destroying the Spanish Fleet off Cadiz* (c. 1792, unlocated) led him to found a partnership with painter Daniel Orme for the commercialization of this and other works through exhibition and the sale of engravings. Among the subjects were additional scenes from English history as well as from Shakespeare's plays. Benjamin West's influence on Brown, which remained very strong throughout his career, is evident in Brown's religious and history paintings, including *Lord Howe on the Deck of the "Queen Charlotte"* of 1794 (National Maritime Museum, Greenwich, England). After patronage fell off in the mid-1790s, and Brown failed to be elected to the Royal Academy, he left London for Bath, Bristol, and Liverpool. Eventually he settled in Manchester, returning to London almost two decades later, in 1824, where, even after West's death, he continued to imitate his teacher's style of painting.

EGM

Notes

1. Quoted in Evans 1980, 81, 83, from Whitley 1928, 2:100.

Bibliography

Evans 1980: 74–83, 93–101.
Evans 1982.

1940.1.1 (487)

William Vans Murray

1787
Oil on canvas, 76.2 × 63.7 (30 × 25 1/16)
Andrew W. Mellon Collection

Inscriptions

Signed lower right, in red: M. Brown.

Inscribed faintly, below signature, in white: London / 1787

Technical Notes: The painting is on a primed, plain-weave fabric with fine, loosely woven threads, cusping along all four edges, and a light-colored ground. Paint textures in the face, which is highly finished and where the artist used a wet-in-wet technique, contrast to those in the hair and curtain, where he used a free handling of the brush. The careful planning of the face is shown in the use of reserved areas for the shadows of the eye sockets and in the attention to detail, as in the crow's-feet wrinkles by the right eye, which were later painted out. The wig and curtain were painted with quick, loose strokes. Changes include a shift in the cravat; the black color of the jacket is painted over the lower part of the cravat. Examination of the signature with a stereomicroscope shows it to be original.[1] Examination of the inscription of the city and date below is inconclusive.

Moating of the impasto may be the result of a past lining. Small losses are found on the right temple and cheek, and in the upper right of the painting. The retouching has discolored. In 1967 the varnish was removed and the painting was lined.

Provenance: The sitter's widow Charlotte Hughins Murray, London;[2] gift to Richard Rush [1780–1859], Philadelphia;[3] bequeathed to his son Benjamin Rush [1811–1877], Philadelphia.[4] (Rose M. de Forest [Mrs. Augustus de Forest], New York); purchased 5 November 1921 by Thomas B. Clarke [1848–1931], New York;[5] his estate; sold as part of the Clarke collection on 29 January 1936, through (M. Knoedler & Co., New York), to The A.W. Mellon Educational and Charitable Trust, Pittsburgh.

Exhibited: Union League Club, January 1922, no. 9. Philadelphia 1928, unnumbered.

WILLIAM VANS MURRAY (1760–1803) of Cambridge, Maryland, studied law at the Middle Temple in London from 1784 to 1787.[6] While in England he met John Adams, American envoy to the Court of St. James, and became close friends with his son John Quincy Adams. Murray probably met Mather Brown through the Adamses. Brown painted John and Abigail Adams and their daughter Abigail in 1785 (only the portrait of the younger Abigail Adams survives; National Park Service, Adams National Historic Site, Quincy, Massachusetts).[7] The following year he painted Thomas Jefferson's portrait and made a replica for Adams, and in 1788 he painted Adams again, this time for Jefferson.[8]

As with Brown's other portraits of this period, a noticeable contrast in technique is evident between the face and the body and background. Murray's features are tightly drawn and finely worked, while

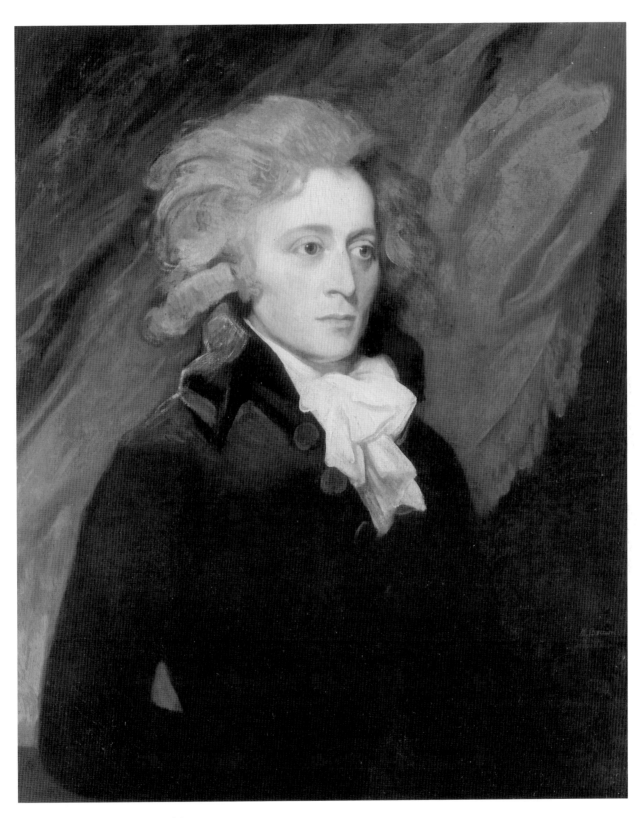

Mather Brown, *William Vans Murray*, 1940.1.1

the hair and curtain are painted with large, sweeping strokes that give a sense of freedom and dash. Typically Brown made preliminary studies of a sitter's face, either on paper or directly on the canvas. The carefully painted features seen here suggest that such an approach was undertaken, although no underdrawing has been detected and no preliminary study is known. A comparison with James Sharples' profile portrait of Murray, probably made in Philadelphia in the mid-1790s (Figure 1), shows the liveliness that Brown's brushwork adds to the likeness.

While in London, Murray married Charlotte Hughins, an Englishwoman. He returned to Maryland in 1787 to practice law, and soon was elected to the state legislature. A few years later he resigned to serve in the United States Congress (1791–1797). Appointed ambassador to the Netherlands at the beginning of John Adams' presidency (1797), Murray was named minister plenipotentiary to France two years later. He and two other commissioners successfully negotiated the Convention of 1800, the

treaty with Napoleon that ended the naval war between the United States and France. Murray retired to his farm in Maryland, where he died at the age of forty-three. John Quincy Adams wrote after Murray's death that his friend had "a strong and genuine relish for the fine arts, a refined and delicate taste for literature, and a persevering and patient fondness for the pursuits of science."9

LKR

Notes

1. The signature was questioned in Rutledge and Lane 1952, 62A, because the same red paint was used on other portraits in the Clarke collection that had been acquired from the same dealer, Rose de Forest.

2. The portrait is not mentioned in Murray's will dated 9 September 1802 (Maryland State Archives; copy, NGA). His wife was his primary heir, receiving land in Cambridge, Maryland, and all personal property not specifically mentioned in the will.

3. A handwritten note once attached to the reverse of the painting documents this gift (NGA; the upper left corner of the note is missing): "... my late Husband William Vans / ... qre belongs to Richard Rush Esqr of / ... near Philadelphia in Pensylvania, U.S. of / ... North America; having been presented to him by me, / Charlotte Murray. / October 15th / 1836. / George Street, / Portman Square / London." Richard Rush's wife Catherine Murray was William Vans Murray's cousin. On Rush see *DAB* 8:231–234.

4. Richard Rush's will, dated December 1854 (Register of Wills, City Hall, Philadelphia; copy, NGA), states: "My household furniture, pictures and other things not already bequeathed, will remain in the house for the use of the daughters with me when I die. The family paintings will belong to Ben, but not be removed while the Sydenham house stands as a homestead." A note by Benjamin Rush, once attached to the reverse of the painting (NGA), states in part: "Came to me under the Will of my Father, 1860." (The handwriting was verified by R.N. Williams, director of the Historical Society of Pennsylvania; see his letter of 25 May 1949, NGA.) For Rush's dates see Leach 1965, 11, and his obituary in the *New York Times*, 6 July 1877, 4.

5. The name of the seller and the date of purchase are recorded in an annotated copy of *Clarke* 1928 in the NGA library.

6. *DAB*, s.v. William Vans Murray.

7. Evans 1982, 42–46, 195.

8. Evans 1982, 52–53.

9. *Port Folio* 7 (January 1804), 5, quoted in the entry on Murray, *DAB* 7:369.

References

1952 Rutledge and Lane: 62A.
1972 Evans: 82, 89, 229.
1981 Williams: 58, repro. 61.
1982 Evans: 73, repro., 220.
1984 Walker: 375, no. 527, color repro.

Fig. 1. James Sharples, *William Vans Murray*, pastel on paper, Baltimore, Maryland Historical Society, Gift of the Rev. William E. Brand

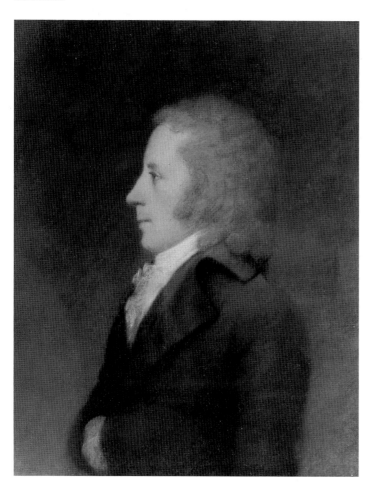

1947.17.28 (936)

Thomas Dawson, Viscount Cremorne

c. 1788
Oil on canvas, 75.2 × 63.3 (29 ⅝ × 27 ⅞)
Andrew W. Mellon Collection

Inscriptions
Signed lower right, in red: M. Brown.

Technical Notes: The support is a medium-weight, plain-weave fabric. Slight cusping on the top and bottom and pronounced cusping on the right side suggest that it is the endpiece of a larger, commercially prepared fabric. On top of the moderately thick white ground the artist used a warm reddish brown layer under the face and body and a gray layer under the curtain. The face and hair are painted with a laborious build-up of pastose layers. In the face the reddish brown layer is used as a middle tone, with carefully placed highlights of white or pale yellow. Additional shading is applied with red and gray paint. In the clothing and background the paint is handled with broader, more fluid strokes. Examination of the signature with a stereomicroscope indicates that it is original.

There are a few losses in the face and hair. There is minor abrasion in the background at the right and in the curtain. A slight flattening of the impasto may be the result of a past lining. Retouching in the jacket has discolored. The varnish is wrinkled and slightly yellowed.

Provenance: Possibly owned by the sitter's widow Philadelphia Hannah Freame, Viscountess Cremorne [1740/1741–1826], London[1] and left to her principal heir Granville Penn [1771–1847], Pennsylvania Castle, Isle of Portland, Dorset, England.[2] Bought with the contents of Pennsylvania Castle by J. Meyrick Head, 1887; sold in his sale (Christie, Manson & Woods, London, 10 July 1916, no. 159); purchased by "Martin";[3] (Robinson & Farr, Philadelphia, 1916); sold 12 February 1917 to Thomas B. Clarke [1848–1931], New York;[4] his estate; sold as part of the Clarke collection on 29 January 1936, through (M. Knoedler & Co., New York), to The A.W. Mellon Educational and Charitable Trust, Pittsburgh.

Exhibited: Union League Club, January 1922, no. 13. Philadelphia 1928, unnumbered. *Early American Portraits on Loan From the National Gallery of Art*, Pack Memorial Public Library, Asheville, North Carolina, 1949, no. 8.

THOMAS DAWSON (1725–1813), son of Dublin banker Richard Dawson and his wife Elizabeth Vesey Dawson, was member of Parliament for County Monaghan (Ireland) from 1749 to 1768. He first married Anne Fermor, daughter of the first Earl of Pomfret. In 1770, after her death, he married Philadelphia Hannah Freame, the grand-daughter of William Penn. That year Dawson was also created Baron Dartrey of Dawson's Grove, in the peerage of Ireland. In 1785 he was made Viscount Cremorne, and in 1797 he became Baron Cremorne of Castle Dawson.[5]

Cremorne was a patron of the arts and a collector of paintings, which he displayed at Cremorne House, his London residence on the Thames.[6] His collection included works by several American artists in London. He owned John Singleton Copley's copy of Correggio's *Holy Family with St. Jerome* (unlocated),[7] and Benjamin West's *Hagar and Ishmael* (1776, MMA).[8] Gilbert Stuart painted his portrait and that of the viscountess (both unlocated); the portrait of Cremorne was exhibited at the Royal Academy of Arts in 1785 as no. 176, "portrait of a nobleman."[9] Cremorne was later included on Stuart's 1795 "List of gentlemen who are to have copies of the Portrait of the President of the United States," as "Lord Viscount Cremorne 1 [copy]"; whether he actually received the painting is unknown.[10]

In Brown's portrait Cremorne, wearing a dark gray coat, is seated in a red chair. Two large books and an inkwell are placed on the table next to him, and a red curtain adds color to the background. According to Dorinda Evans, Brown "apparently attempted here to enrich the flesh tones with more and purer color. . . . Producing a somewhat streaky effect, he added pale yellow ochre, rose madder, and a bluish gray to Cremorne's face with two values of yellow and some light red in the shading under his chin."[11] The clothing and background are broadly rendered.

The attribution of the portrait to Mather Brown has been questioned in the past but is secure. The painting was catalogued as Brown's work at the sale of the J. Meyrick Head collection at Christie's in 1916. The signature was called into question in 1952, at a time when similar inscriptions on a number of paintings from Thomas B. Clarke's collection were regarded with suspicion.[12] Dorinda Evans accepts the signature, however, describing it as in Brown's "usual style."[13] In addition, a recent examination by conservators using a stereomicroscope led them to conclude that it is original.

The painting is assumed to be Brown's life study for his full-length of Cremorne that was exhibited at the Royal Academy of Arts in 1788.[14] The full-length is unlocated today, its appearance known only from the very small image in P. Martini's engraving of J.H. Ramberg's *George III and the Royal*

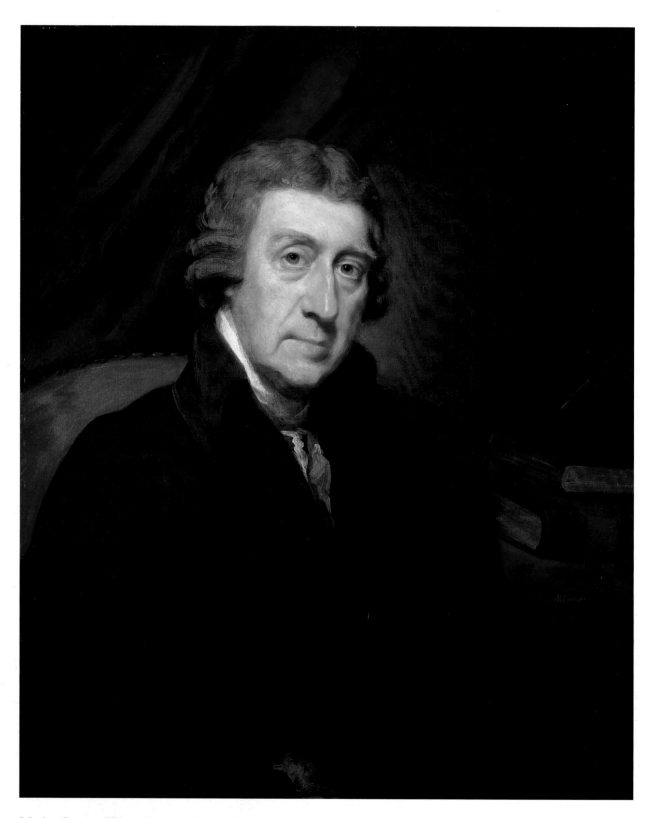

Mather Brown, *Thomas Dawson, Viscount Cremorne*, 1947.17.28

Fig. 1. Mather Brown's portrait of Thomas Dawson, Viscount Cremorne; detail from P. Martini's engraving of J.H. Ramberg, *George III and the Royal Family at the Private View of the Royal Academy Exhibition*, 1788, London, British Museum [photo: Courtesy, The Trustees of the British Museum]

Family at the Private View of the Royal Academy Exhibition (detail, Figure 1). Its catalogue number, "85," is inscribed in the lower left corner. The full-length was well received by critics. The reviewer in the *London Chronicle* for 26–29 April wrote that the "whole length of Lord Cremorne, in all the great requisites of portrait, deserves the highest commendation, and ranks him justly high among the aspiring artists of the day."[15] Another writer commented that the portrait was "in all respects, the best performance we ever witnessed from *Mr. Brown's* pencil. — The figure is well drawn, and painted with great boldness and effect: — The likeness is also very good."[16] The date of about 1788 for the Gallery's portrait is supported by its similarity to the full-length of Cremorne that Thomas Lawrence painted at about that time. It was exhibited at the Royal Academy of Arts in 1789 (Figure 2) with the pendant full-length portrait of Lady Cremorne (Tate Gallery, London).[17] In comparison to these portraits of Cremorne, Stuart's earlier portrait of 1785 is that of a noticeably younger person, whose sharply pointed chin had become jowly by the time he was painted by Brown and Lawrence.[18] The por-

traits of Cremorne and his wife reflect their ambition and social status, as well as their good judgment in supporting the work of young artists. Lawrence's successful portrait of Lady Cremorne led to his introduction to Queen Charlotte, whose portrait he painted in 1789, a fine beginning to a long, successful career.

LKR / EGM

Notes

1. She was the granddaughter of William Penn; see *Pennsylvania Families* 1982, 2:564–565.

2. Pennsylvania Castle was built by Viscountess Cremorne's cousin John Penn (1760–1834) after he became governor of the Isle of Portland in 1805. He left it to his brother Granville Penn; see *Pennsylvania Families* 1982,

Fig. 2. Thomas Lawrence, *Portrait of Thomas Dawson, 1st Viscount Cremorne*, oil on canvas, 1788–1789, New York, Richard L. Feigen & Co.

2:568–569, 625–626, and Wainwright 1963, 393–419. The last family owner of the castle and its contents was Stewart Forbes, a cousin.

3. *Head* 1916, 30, as by Mather Brown. The buyer, noted as "Martin" in the copy of the catalogue at the J. Paul Getty Museum, Malibu, California, may be Sir Alec Martin of Christie's, according to the staff of the Getty Provenance Index. Charles Henry Hart, in a letter of 26 February 1917 to Thomas B. Clarke, identified Martin as "one of the Christie's and often buys pictures that he puts into Farr's hands for sale" (NGA).

4. The name of the seller and the date of purchase are recorded in an annotated copy of *Clarke* 1928 in the NGA library. A letter from Robinson & Farr, Philadelphia, dated 21 February 1917, to Thomas B. Clarke says that the firm owned the painting with "an Englishman" and that they purchased it in London in the summer of 1916 (NGA).

5. Cokayne 1910, 3:527–528; Burke 1934, 714. When Cremorne died without heirs, the title of Baron Cremorne went to a great-nephew.

6. Faulkner 1810, 42: "Lord Cremorne has a good collection of pictures by the Italian and Flemish masters; among which are several pieces by Ferg, some portraits by Vandyke, and the Earl of Arlington and Family, by Netscher." On the house see also Beaver 1892, 155–160.

7. Beaver 1892, 159; Prown 1966, 2:443–444. It was purchased by Copley's son at the sale of the Cremorne collection in 1827.

8. Von Erffa and Staley 1986, 288–289, no. 239; he returned the painting to West by 1802.

9. Graves 1905, 7:296; Park 1926, 254–255, no. 208; Whitley 1932, 78–79. Stuart's portraits, both ovals not showing the sitters' hands, were last recorded in 1937 at the Howard Young Galleries, New York; see Comstock 1937, 215, where the portrait of the viscountess is repro-

duced. Photographs are on file at the Witt Library, Courtauld Institute of Art, London. Charles Merrill Mount identified a painting that he discovered in 1961 as a second version of Stuart's portrait of Cremorne (The Montclair Art Museum, New Jersey), but the face differs from the oval portrait and is instead closer to the later portraits of Cremorne by Brown and Lawrence; Mount 1964, 99, 359; *Montclair* 1989, 178 repro.

10. Stuart 1876, 373.

11. Evans 1982, 78; she added that this use of color may be an indication that Brown reworked the picture over a period of time.

12. Rutledge and Lane 1952, 62A.

13. Evans 1982, 79.

14. Graves 1905, 1:310, no. 85, as Mather Brown, *Portrait of a Nobleman*; Evans 1982, 78. The sitter is identified in "Names of Persons whose Pictures are in the Royal Academy," *London Chronicle*, 26–29 April 1788, 415.

15. Quoted in Evans 1982, 79.

16. Quoted in Evans 1982, 79, from *Press Cuttings* 2:407.

17. Garlick 1989, 174, nos. 219–220, repro. The portraits were sold at Christie's, London, on 15 April 1988, lots 128 and 129.

18. Mount 1964, 137, suggested that Cremorne gave Stuart's paintings to Lawrence to "develop full-length portraits." Michael Levey rejected this suggestion in his essay on Lady Cremorne's portrait in *Lawrence* 1979, 24, no. 1, repro.; I am grateful to Allen Staley for this reference.

References

1917 Hart: 309–314.
1952 Rutledge and Lane: 62A.
1972 Evans: 78, 90–92, 100, 213, no. 43.
1982 Evans: 78–79, repro. 80, 203.

John Singleton Copley

1738 – 1815

BOSTON-BORN John Singleton Copley was the most talented artist in colonial America. He was trained in the arts by his step-father Peter Pelham (c. 1697–1751), an English engraver who immigrated to Massachusetts in 1727 and married Copley's widowed mother in 1748. Copley's artistic talents were extraordinary: he was a bold colorist, and represented faces and fabrics in such a realistic style that the sitters seem alive today. His earliest paintings, dating from the mid-1750s, reveal the influence of English mezzotint portraits as well as the work of local and itinerant artists. As he be-

came experienced with composition, he combined elements of poses and backgrounds to produce his own versions of English portraiture. His ambitions, fed by reading European literature on art, led him to experiment with several media in addition to oil on canvas, notably oil on copper, watercolor on ivory, and pastel. He was well established as a portrait painter by the late 1750s.

Copley's boldest American portraits date from the ten-year period beginning in the mid-1760s. Eager to compare his work with that of contemporaries in England, he sent *Boy with a Squirrel*

(MFA), a portrait of his half-brother Henry Pelham, to London in 1765 to the annual exhibition of the Society of Artists of Great Britain. It was so similar to the work of Joseph Wright of Derby, an English contemporary, that the painting was at first thought to be by Wright. Benjamin West and Joshua Reynolds praised Copley's achievement and advised that a trip to Europe would be beneficial, particularly to his technique, which, with its emphasis on contours and details, was judged to be hard.

With the exception of a six-month painting trip to New York City in 1771, Copley worked in Boston until 1774. At a time of political unrest that would soon culminate in the outbreak of fighting between the British and the colonists, he left for London. He went almost immediately to Italy, where he spent more than a year studying art and painting commissioned copies and portraits. When he returned to London in 1775, he rejoined his wife and three of his children, who had left Boston to escape the hostilities of the American Revolution. By then he had decided to settle permanently in England, for artistic as well as, apparently, for political reasons.

The year 1776 marks the beginning of the English half of Copley's life. In 1777 he exhibited *The Copley Family* as his first work at the Royal Academy of Arts, followed by *Watson and the Shark* in 1778. The success of these paintings brought him the praise of reviewers and earned him full membership in the Academy. His ambition to produce large history paintings of contemporary events, like those by Benjamin West, led him to paint *The Death of the Earl of Chatham* (1779–1781, Tate Gallery, London), *The Death of Major Peirson* (1782–1784, Tate Gallery, London), and *The Siege of Gibraltar* (1783–1791, Guildhall Art Gallery, London). All three works were exhibited independently of the Royal Academy, and all three involved patronage from merchants in the City of London, a fitting source of support for the American painter who had initially found his clientele among the mercantile class of Boston. He also painted portraits in England, many on a much larger scale than his American work. Throughout his English career he retained the ability to depict faces and fabrics with great immediacy, while he learned to compose more complex paintings. The brightness of the colors in his work may be due to his continued practice of using an untinted white or off-white ground.

Copley's American work so epitomizes the colonial era that his shift to an English manner is difficult for many American viewers to accept. This is due to the outstanding quality of his American portraits and to the political significance of his sitters, many of whom were the most famous people of their era, including Paul Revere, John Hancock, Samuel Adams, and Mercy Otis Warren. It is easier to understand his transformation if his move to London is viewed as an indication of his ambitions as a painter. His letters to his half-brother and other family members, written in 1774–1775, reveal the excitement of the discoveries about painting that he made in Europe. Like other artists who began their careers in provincial English cities, Copley was attracted to London because of its sophisticated patronage and its competitive arena. His decision to remain there stemmed primarily from his artistic ambitions.

EGM

Bibliography
Copley-Pelham Letters 1914.
Prown 1966.
Fairbrother 1981: 122–130.
Shank 1984: 130–152.

1942.8.2 (555)

Jane Browne

1756
Oil on canvas 75.6 × 62.6 (29 ³/₄ × 24 ⁵/₈)
Andrew W. Mellon Collection

Inscriptions
Signed lower right on painted spandrel: I.S. Copley. Pinx. 1756
Inscribed on the reverse, in a later hand:[1] Portrait of Jane Browne / afterwards wife of Samuel Livermore / Chief Justice of New Hampshire / Painted in Portsmouth N.H. / 1756 / by J. S. Copley

Technical Notes: The support is a medium-weight, plain-weave fabric. The ground is a thick, gray layer. The paint is applied as a dry to fluid paste with moderate brush stroke texture and low impasto in the highlights. Details of the sitter's features and clothing are applied as opaque strokes with little blending. A pentimento can be seen in the fold of the cape over the sitter's left shoulder.

Fig. 1. John Smith after Sir Godfrey Kneller, *The Lord Churchill's Two Daughters*, mezzotint, c. 1715, Winterthur, Delaware, The Henry Francis du Pont Winterthur Museum [photo: Courtesy, Winterthur Museum]

A slight flattening of the impasto may be the result of a past lining, and there is moderate abrasion in some of the thin, dark shadows. Two retouched areas in the sky, to the left and right of the head, have discolored. Craquelure in the face and bodice of the dress has been retouched. The varnish was removed and the painting lined in 1958.

Provenance: Louisa Bliss Livermore [Mrs. Arthur Livermore, 1790–1871], Holderness and Campton, New Hampshire; bequeathed to her grandson James Lauren Ford [1854–1928], Brookhaven, New York;[2] sold 20 February 1924 to (Art House, Inc., New York);[3] Thomas B. Clarke [1848–1931], New York; his estate; sold as part of the Clarke collection on 29 January 1936, through (M. Knoedler & Co., New York), to The A.W. Mellon Educational and Charitable Trust, Pittsburgh.

Exhibited: *Portraits of Women: Loan Exhibition for the Benefit of St. John's Guild and The Orthopaedic Hospital*, National Academy of Design, New York, 1894, no. 82. Union League Club, March 1924, no. 12. Century Association, 1928, no. 13. Philadelphia 1928, unnumbered. *John Singleton Copley, 1738–1815: Loan Exhibition of Paint-*

ings, *Pastels, Miniatures and Drawings*, MFA, 1938, no. 15. Columbia 1950, no. 2. Atlanta 1951, no. 4. Chattanooga 1952, unnumbered. Mint Museum of Art, Charlotte, North Carolina, 1952, no cat. *Copley*, 1965–1966, no. 7. *First Flowers of Our Wilderness*, University of Arizona Museum of Art, Tucson, 1976, no. 16.

THIS PORTRAIT, one of Copley's earliest works, reveals several influences on the young artist, who was then about eighteen years old. Copley has represented Jane Browne wearing a pale lavender dress trimmed with white lace and ivory-colored bows, with an ivory-colored drape over her shoulder and right arm. The composition—a figure to the waist in a *trompe l'oeil* painted oval—was a standard one in early and mid-eighteenth-century English portraiture. Copley could easily have learned the format from imported English mezzotints or from the work of John Smibert (1688–1751) and Peter Pelham (c. 1697–1751), English artists who settled in Boston in the 1720s. Pelham, an engraver, was Copley's stepfather and first teacher.

For some elements of the pose Copley imitated John Smith's engraving (Figure 1) of Sir Godfrey Kneller's full-length double portrait of sisters Henrietta Churchill, later Duchess of Marlborough, and Anne Churchill, later Countess of Sunderland (1688, Earl Spencer, Althorp, Northampton, England). The drapery that swirls around Jane Browne's shoulders and arms and reappears at her left hip is held in place by a strap that crosses her torso and is attached at her right shoulder with a red jewel, perhaps a garnet. This arrangement of ribbon and drape also appears on Kneller's figure of Henrietta Churchill.[4] The portraits of the two women share other features, notably the curl of hair on the sitter's shoulder and the position of the drapery and buttons on the left sleeve.

Copley's training as an engraver probably led to his preference for sharp contrasts of light and dark.[5] His hard manner of applying paint is evident here, especially in the face of the sitter and in the dress, where the shadow of the ribbon as it crosses the bodice conveys a stiffness not characteristic of soft, silky materials. Some elements of the painting indicate the additional influence of itinerant English artist Joseph Blackburn, who painted portraits in the Boston area from 1755 until 1758. Like Smibert and Pelham, Blackburn often employed the painted oval format. Also typical of Blackburn's work are the light colors and the attention paid to minute details, as seen in Copley's

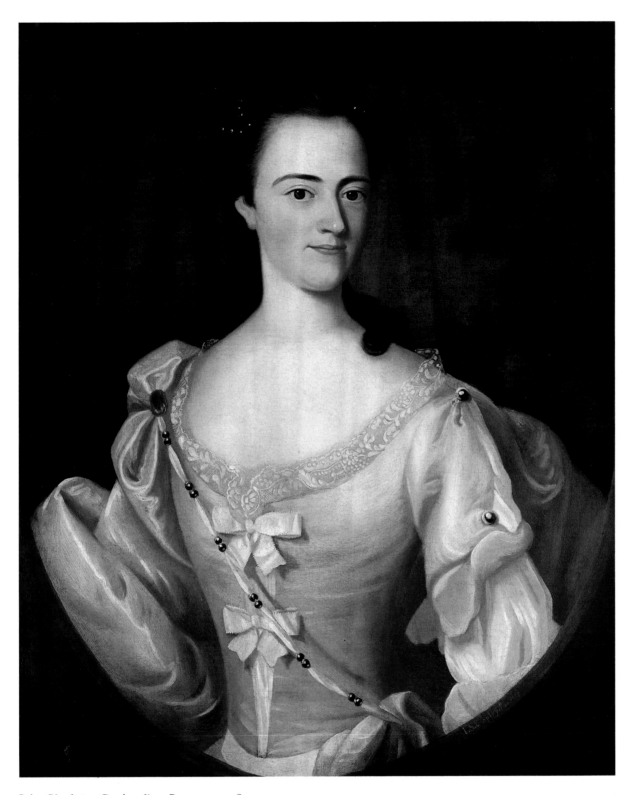

John Singleton Copley, *Jane Browne*, 1942.8.2

rendering of the floral pattern and connecting threads of the white lace, and in the picot edging on the bows of the dress. Copley also imitated the form of Blackburn's signature, using the word "pinx," an abbreviation for *pinxit*, the Latin word for "he painted [it]."[6]

Jane Browne (1734–1802)[7] was the daughter of Anglican minister Arthur Browne and Mary Cox Browne of Portsmouth, New Hampshire, who were painted by Copley in 1757 (Heritage Foundation, Deerfield, Massachusetts).[8] In 1759 she married Samuel Livermore (1732–1803), a lawyer who later served New Hampshire as chief justice of the superior court (1782–1790) and United States senator (1793–1801).[9] He was one of the original grantees of the town of Holderness. In 1921 Jane Browne's great-grandson James Lauren Ford recalled the impression that the painting made on him as a child. "I used to regard that portrait with awe because no matter into what corner of the room I crept, its eyes persistently followed me, a constant reminder of the all-seeing eyes of God. Once, when I had stolen some sugar from the bowl, I was afraid to look it in the face and consumed my plunder in another room."[10] His comment is testimony to the persistent notion of the importance of verisimilitude in portraiture, a belief that the sitter's contemporaries might have shared.[11]

EGM

Notes

1. A photograph of the inscription taken before the painting was lined is in the NGA curatorial file.

2. The portrait probably was inherited by the sitter's son Arthur Livermore (1766–1853), Holderness and Campton, New Hampshire; his widow is the first owner of record. For Livermore's dates see *DAB* 6:304; Mrs. Livermore's dates and the reference to the bequest are in Ford 1921, 7, 10, and Parker and Wheeler 1938, 52. Ford is listed in *Who Was Who* 1:412.

3. Receipt dated 20 February 1924, signed by Margaret Armstrong, a family friend (NGA). Art House, Inc., a fine arts dealership, was founded by Thomas B. Clarke in 1891. Clarke's direct involvement in the purchase is shown by four letters to Clarke from Margaret Armstrong and James Lauren Ford's sister Mary K. Ford, dated 30 January and 2, 9, and 18 February 1924 (NGA). The name of the seller and date of purchase are also recorded in an annotated copy of *Clarke* 1928 in the NGA library.

4. Stewart 1983, 117, no. 476, pl. 30A. Sir Peter Lely used a similar strap to hold drapery in place in his portraits *Anne Hyde, Duchess of York* (c. 1660) and *Louise Renée de Penancoet de Kéroualle, Duchess of Portsmouth and Aubigny* (c. 1671); see Millar 1978, 55, no. 33, repro. and 65, no. 49, repro.

5. Prown 1966, 1:23–24.

6. The most complete listings of Blackburn's work are Park 1923, and Morgan and Foote 1937. For a discussion of Blackburn's influence on Copley see Prown 1966, 1:22–27.

7. The sitter's death date, given correctly in Rogers 1923, 65, has been confirmed by examination of the records of Trinity Church, Holderness, New Hampshire (William Copeley, librarian, New Hampshire Historical Society, Concord, letter of 26 May 1989, NGA).

8. Prown 1966, 1:210–211, figs. 47–48. Jane's sisters Anne and Elizabeth were painted by Blackburn. The portrait of Anne (1758), who married George St. Loe, is owned by the Munson-Williams-Proctor Institute Museum of Art, Utica, New York (Park 1923, 47, cat. 62). Elizabeth's portrait (1761) (Park 1923, 25, cat. 21) is owned by Reynolda House, Winston-Salem, North Carolina. It was painted in Portsmouth, New Hampshire, at the time of her wedding to Major Robert Rogers. Almost two centuries later it was the inspiration for Kenneth Roberts' characterizations of the protagonists of his 1937 novel *Northwest Passage*. The fictional narrator, artist Langdon Towne, wished to paint a portrait of Elizabeth in her orange wool dress. She announced that she much preferred to be painted by Blackburn in her "new gown—it's canary satin—a divine color!" Roberts 1953, 5–21; Lassiter 1971, 6–7, 52.

9. *DAB* 6:308.

10. Ford 1921, 10.

11. Barrell 1986, 24–27, discusses the relationship between rhetoric and illusion according to early eighteenth-century aesthetic theory. Theoretically, the untutored were "more susceptible to the power of illusion."

References

[after 1873] Perkins: 5.
1907 Hodges: xiii, repro. opp. 60.
1915 Bayley: 166.
1921 Ford: 7, 10.
1923 Rogers: repro. opp. 64.
1928 Sherman: 122, repro. 123.
1930 Bolton and Binsse, "Blackburn": 50, repro.
1938 Parker and Wheeler: 51–52, pl. 7.
1939 Morgan, *Copley*: 11.
1943 Burroughs, "Copley": 164, repro. cover.
1953 Roberts: 5–21, fig. 7.
1966 Prown: 1:22–24, 211, and fig. 40.
1981 Williams: repro. 20, 21.
1984 Walker: 387, no. 546, color repro.

1959.4.1 (1533)

Epes Sargent

c. 1760
Oil on canvas, 126.6 × 101.7 (49 7/8 × 40)
Gift of the Avalon Foundation

Technical Notes: The painting is on a fine, tightly wo-

ven, plain-weave fabric. The grayish white ground is of medium thickness. It is toned with a transparent greenish brown imprimatura, which is visible around the contours of the hand. The paint is applied thickly without much blending in the flesh areas, where the uneven surface of the paint corresponds to the wrinkles of the sitter's skin. The background and coat are more thinly painted. A few stains in the upper right corner, perhaps from past mildew damage, have been retouched. There are other minor, scattered retouches, but no major losses. The varnish was removed and the painting lined in 1959.

Provenance: The sitter's great-great-grandson John James Dixwell [1806–1876], Boston;[1] his daughter Caroline Dixwell Clements [Mrs. George Henry Clements, 1856–1931], New York;[2] her daughter Anna Clements Knauth [Mrs. Oswald Whitman Knauth, 1890–1965], New York;[3] her son Arnold Whitman Knauth II [b. 1918], Rockport, Massachusetts; (Milch Galleries, New York), 1958; (Hirschl & Adler Galleries, New York), 1958–1959;[4] by whom sold to the Avalon Foundation.

Exhibited: *Pictures lent to the Sanitary Fair for Exhibition,* Boston Athenaeum, 1863, no. 140.[5] *Paintings and Statuary exhibited for the Benefit of the National Sailors' Fair, at the Athenaeum Gallery,* Boston, 1864, no. 338.[6] *Forty-Seventh Exhibition of Paintings at the Athenaeum Gallery,* Boston, 1871, no. 238.[7] MFA, on long-term loan, 1888–1892.[8] *Retrospective Exhibit of American Painting,* World's Columbian Exposition, Department of Fine Arts, Chicago, 1893, no. 203. *The Hudson-Fulton Celebration; American Paintings, Furniture, Silver and Other Objects of Art,* MMA, 1909, no. 8. *An Exhibition of Colonial Portraits,* MMA, 1911, no. 16. *An Exhibition of Early American Paintings,* Museum of the Brooklyn Institute of Arts and Sciences, New York, 1917, no. 18. *An Exhibition of Paintings by John Singleton Copley,* MMA, 1936–1937, no. 5. *Survey of American Painting,* Department of Fine Arts, Carnegie Institute, Pittsburgh, 1940, no. 62.[9] The Minneapolis Institute of Arts, on long-term loan, 1942–1945.[10] NGA, on long-term loan, 1945–1958.[11] *From Colony to Nation: An Exhibition of American Painting, Silver and Architecture From 1650 to the War of 1812,* The Art Institute of Chicago, 1949, no. 29. *Masterpieces of Art,* Seattle World's Fair, Fine Arts Pavilion, 1962, no. 10. *Four Centuries of American Art,* The Minneapolis Institute of Arts, 1963–1964, unnumbered. *Copley,* 1965–1966, no. 14. Vassar College Art Gallery, Poughkeepsie, New York, 1968, no cat. *The Classical Spirit in American Portraiture,* Bell Gallery, Brown University, Providence, Rhode Island, 1976, no. 3. *American Art: 1750–1800, Towards Independence,* YUAG; The Victoria and Albert Museum, London, 1976, no. 11.

COPLEY'S PORTRAIT of Epes Sargent of Salem, Massachusetts, has long been considered a masterpiece of colonial American painting. A. T. Perkins in 1873 described Sargent as a "vigorous old gentleman . . . in an attitude of repose" and noted that "the late Gilbert Stuart said of the hand represented in this picture, that art could go no further, —

'Prick that hand and blood will spirt out.'"[12] Samuel Isham in 1904 called the painting a "remarkably fine example of Copley's style at a period prior to his departure for England, when some of his most vigorous and characteristic work was produced."[13] Twenty years later Royal Cortissoz proclaimed the "celebrated" painting as a "monumental design painted with power."[14] In 1927 Frank Jewett Mather thought it a "powerful effigy" and "an extraordinary performance."[15] In 1950 Virgil Barker termed it "monumental."[16] Most recently, Jules Prown has described its "spare composition" as "particularly effective."[17] The painting frequently has been included in books and catalogues of American art.

The portrait embodies the characteristics for which Copley's colonial portraits are known: individualistic faces, imaginative compositions, unusual color combinations, and varied brushwork. The portrait shows a man about seventy years old with a thoughtful expression, his face, hands, and wig painted in a heavy impasto to convey wrinkles and rough textures. Even the hairs of his eyebrows are roughened with age. His coat is buttoned tightly across his large chest, giving the impression of solidity and mass. The coat has little texture; its weight is implied in the folds of cloth on the shoulder and sleeves. Its slate gray tonality contrasts with the warm colors of his calloused right hand as it rests against his midriff. The column to the left is painted with ochre, red, and green, all blended with gray. The blue sky is tinted with pink at the horizon. The image is more sympathetic and believable than the earlier *Jane Browne* [1942.8.2].

Copley probably borrowed Sargent's pose from English mezzotints, which reproduced similar portraits by mid-century English painters Thomas Hudson, Joseph Highmore, and Allan Ramsay. He used a similar pose in his contemporary portraits *Thaddeus Burr* (1758–1760, The Saint Louis Art Museum) and *Unknown Subject, Boy called Master Hancock* (1758–1759, Bayou Bend Collection, The Museum of Fine Arts, Houston).[18] John Hill Morgan, the first author to comment on this particular portrait in relation to Copley's practice of borrowing compositional features from engravings, noted that the pillar base was an accessory normally found in "paintings of the classic school."[19] Oskar Hagen suggested that the pose was "closely related to Joseph Highmore's *Gentleman in a Silk Vest* of about 1745 (Huntington Library, Art Collections, and Botanical Gardens, San Marino, California) and

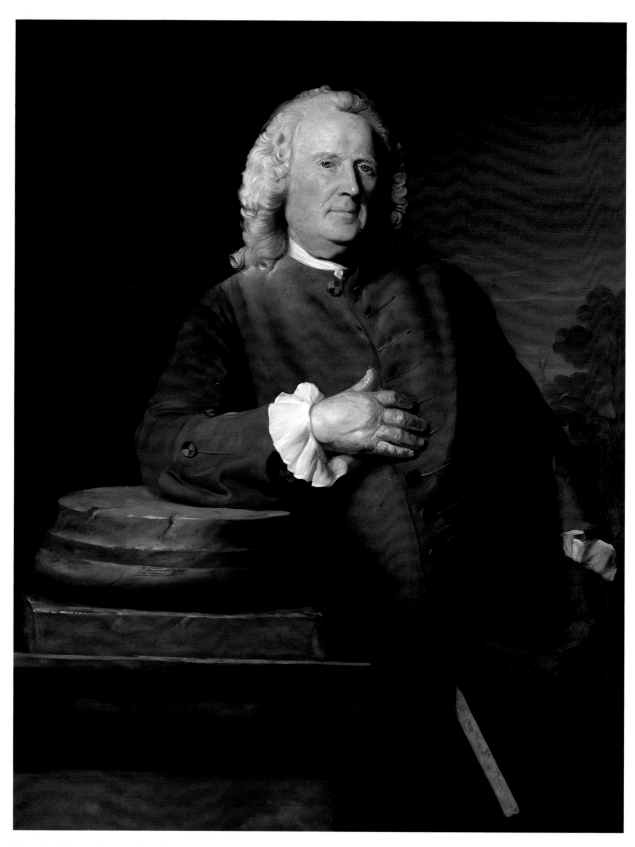

John Singleton Copley, *Epes Sargent*, 1959.4.1

that "Highmore's painting . . . helped Copley to a more advanced idea of voluminosity."[20] No evidence shows, however, that Copley knew this portrait. Michael Quick has suggested there may be a source in the work of Thomas Hudson, but none of the portraits by Hudson that were engraved are identical in pose to this painting.[21] Copley could also have found the pose in an engraving of a classical statue, perhaps Praxiteles' *Leaning Satyr*, which stood in a similar position, resting his arm on a tree stump.[22] Another influence may have been an image of Fortitude, depicted in emblem books with a partial column as its attribute.[23] However, the minute details of the portrait, including the shadow made by Sargent's right thumb against his coat and the powder that has fallen from his wig onto his shoulder, make it likely that Copley was imitating a mezzotint. The painting indicates that Copley had begun to combine elements from different sources in one painting, giving his sitters a characterization appropriate to their ages and presumably their personalities.

Epes Sargent (1690–1762), an ancestor of painters John Singer Sargent (1856–1925) and Henry Sargent (1770–1845), was born in Gloucester, Massachusetts.[24] He attended Harvard College and was, like many of Copley's sitters, a merchant and a Congregationalist. In 1720 he married Esther Maccarty (1701–1743) and was appointed justice of the peace of Essex County, a commission he held six times. After the death of his wife he married Katherine Winthrop Browne in 1744. By 1750 he and his sons owned much of the land in Gloucester. In 1761 he was elected to the Great and General Court, the legislative body of colonial Massachusetts. This portrait may have been painted as a pendant to that of his second wife, who had been portrayed by John Smibert in 1734.[25] Copley also made portraits of several of Sargent's children: Epes Sargent II and his wife; Sarah Sargent and her husband Nathaniel Allen; and Mrs. Daniel Sargent, his daughter-in-law.

EGM

Notes

1. Dixwell, lender to the 1863 Boston Athenaeum exhibition, is the earliest recorded owner of the portrait. It probably descended from the sitter to his son Epes (1721–1779), to his son Epes (1748–1822), to his daughter Esther (Mrs. John Dixwell, 1776–1865), mother of John James Dixwell; see Sargent and Sargent 1923, 10–13.
2. Sargent and Sargent 1923, 14; *Social Register 1932*, 153.

3. Sargent and Sargent 1923, 15; obituary, *New York Times*, 12 April 1965, 35.
4. Information from M.P. Naud, Hirschl & Adler Galleries, in conversation with Mary Ellen Fraser, NGA, 26 July 1988; conservation report from Hirschl & Adler Galleries, 30 March 1959 (NGA).
5. *Sanitary Fair* 1863, 13, cited in Perkins and Gavin 1980, 40, and Yarnall and Gerdts 1986, 1:825.
6. *Sailors' Fair* 1864, 117, cited in Perkins and Gavin 1980, 40, and Yarnall and Gerdts 1986, 1:825.
7. *Forty-Seventh Exhibition* 1871, 10; Perkins and Gavin 1980, 40.
8. A label from the MFA on the reverse of the painting gives October 1888 as the date for Mrs. Clements' loan of the portrait; the loan is confirmed by a letter from the MFA, 28 March 1975 (NGA).
9. Lane 1940, 12, repro. 8.
10. The loan is confirmed by records of The Minneapolis Institute of Arts; see also "Reunion" 1942, 15.
11. This loan, confirmed by NGA records, is referred to by Walker 1951, 15, 42, pl. 2.
12. Perkins 1873, 102.
13. Isham 1904, 39.
14. Cortissoz 1924, 110.
15. Mather 1927, 10.
16. Barker 1950, 83.
17. Prown 1966, 1:33.
18. Prown 1966, 1: figs. 88, 91.
19. Morgan 1937, 117.
20. Hagen 1940, 101.
21. Quick 1981, 19; on Hudson see Miles 1976.
22. *Classical Spirit* 1976, 27.
23. Fleischer 1988, 31.
24. Sargent and Sargent 1923, 6–8; Shipton 1937, 645–646.
25. She was the widow of Samuel Browne, Jr., of Salem, who was the son of the legendary Salem merchant Samuel Browne. The family commissioned twelve portraits from Smibert, the largest group of family portraits by that artist; Saunders 1979, 1:180–181. Her portrait and that of her first husband are owned by the Rhode Island Historical Society, Providence.

References

1867 Tuckerman: 73.
1873 Perkins: 16, 101–102, 105.
1892 MFA: 15, no. 144.
1904 Isham: 5:39 and pl. VII.
1915 Bayley: 214–215.
1924 Sargent and Sargent: 6–8, and frontispiece.
1924 Cortissoz: 110.
1927 Mather: 10, repro.
1930 Bolton and Binsse, "Copley": 118.
1937 Shipton: 645–646, repro. opp. 645.
1937 Morgan: 117.
1938 Parker and Wheeler: 11, 171–172, pl. 21.
1939 Morgan, *Copley*: 12.
1940 Hagen: 101.
1950 Barker: 83.
1966 Prown: 1:33–34, 42, 77, 84, 156–157, 180–181, 190–191, 227–228, and fig. 89.
1967 Prown, "Computer": 27, 30.

1976 Wilmerding: 36–37, pl. 34.
1976 *Classical Spirit*: 27, no. 3.
1981 Quick: 19.
1981 Williams: repro. 13 (detail of face), 21, color repro. 42.
1984 Walker: 386, no. 547, color repro.
1988 Fleischer: 31–32, repro.

1968.1.1 (2341)

Anne Fairchild Bowler (Mrs. Metcalf Bowler)

c. 1763
Oil on canvas, 127.2 × 102.2 (50 × 40)
Gift of Louise Alida Livingston

Technical Notes: The painting is on a medium-weight, plain-weave fabric lined to linen. Cusping is present along the right and lower edges, the two edges that were x-radiographed. The thickly applied ground is off-white. The paint is generally applied in layers, and the flesh tones are intricately built up. Impasto appears in the details of the drapery, lace, and flowers. It appears that the background was blocked in before the figure and the drapery were completed.

There is some abrasion in the drapery at the right edge. Retouching over stains in the background and craquelure in the face are slightly discolored. In 1968 the varnish and a previous lining were removed and the painting was lined. The earlier lining, estimated to be about one hundred years old, was stamped twice with a canvas stamp that appeared to read "[]. L. BECHEY."[1]

Provenance: Susan Louisa Pendleton Bowler [Mrs. Robert Bonner Bowler, d. 1877], Cincinnati, Ohio, and Covington, Kentucky;[2] her daughter Louisa Foote Bowler Livingston [Mrs. John Callendar Livingston, 1861–1933], New York;[3] her daughter Louise Alida Livingston [d. 1967], Oyster Bay, New York.[4]

Exhibited: Possibly *Exhibition of Paintings, Engravings, Drawings, Aquarelles, and Works of Household Art, in the Cincinnati Industrial Exposition*, Cincinnati, 1874, no. 318.[5] MFA, on long-term loan, 1889–1902.[6] *An Exhibition of Paintings by John Singleton Copley*, MMA, 1936–1937, no. 24. *American Portraits by American Painters, 1730–1944*, M. Knoedler & Co., New York, 1944, no. 7. *Old and New England*, RISD, 1945, no. 15. *American Art from American Collections*, MMA, 1963, no. 181. *Copley*, 1965–1966, no. 18.

COPLEY'S MASTERY of the poses and gestures of mid-eighteenth-century English portraiture and his talent with color and the depiction of fabric are readily apparent in this portrait. Mrs. Bowler wears a very fashionable blue satin dress richly trimmed with two rows of lace at the sleeves and lace at the bodice, with a lace cap. According to contemporary inventories, blue was a color preferred by American sitters, whereas brighter colors, such as red, were more popular in Europe.[7] Her distinctive blue sapphire necklace and earrings are unlike the pearls that many women wear in colonial portraits and were probably her own. She holds a garland of multicolored flowers tied along a length of pink ribbon. The careful modeling of the sitter's face and hands, the flowers, and the lace is particularly noteworthy. In the background are a balustrade, a column, a curtain, and a landscape.

Mrs. Bowler's frontal pose and gestures and the background curtain and column are typical of English portraits of the 1740s and 1750s, which in turn were based on earlier works by English portraitists Sir Anthony Van Dyck and Sir Godfrey Kneller. Mid-century examples include Thomas Hudson's portraits *Unknown Woman* (1750, Dulwich College, England) and *Mary Panton, Duchess of Ancaster* (1757, Grimsthorpe Castle, Lincolnshire); Allan Ramsay's portraits *A Lady in a 'Van Dyck' Dress* (1749, private collection) and *Flora MacDonald* (1749, Ashmolean Museum, Oxford, England); and Joshua Reynolds' early portrait *Mrs. Joseph Hamar* (c. 1747, City Museum and Art Gallery, Plymouth, England).[8]

Anne Fairchild (1730–1803) was the daughter of Major and Bathsheba Fairchild of Newport, Rhode Island. In 1750 she married Metcalf Bowler (1726–1789).[9] She may also be the sitter in a portrait that Copley painted around 1758 (Colby College Museum of Art, Waterville, Maine),[10] which shows a woman holding a bird cage, a symbol of the happiness of an engaged or married woman as a "voluntary prisoner" of love.[11] Her husband Metcalf Bowler was an Englishman who became a prominent Newport legislator and judge. He represented Portsmouth in the General Assembly of Rhode Island, serving for nineteen years as Speaker of the House, and he was also a justice of the Superior Court. Their farm in Portsmouth was famous for its gardens and exotic plants. His prominent position in New England hid his role as a spy for the British during the Revolution, a fact that remained secret until this century.[12]

After the war Bowler wrote *A Treatise on Agriculture and Practical Husbandry* (Providence, Rhode Island, 1796), which discusses practical subjects, such as crops and manure. It ends, however, with a discussion of George Washington's retirement "to his

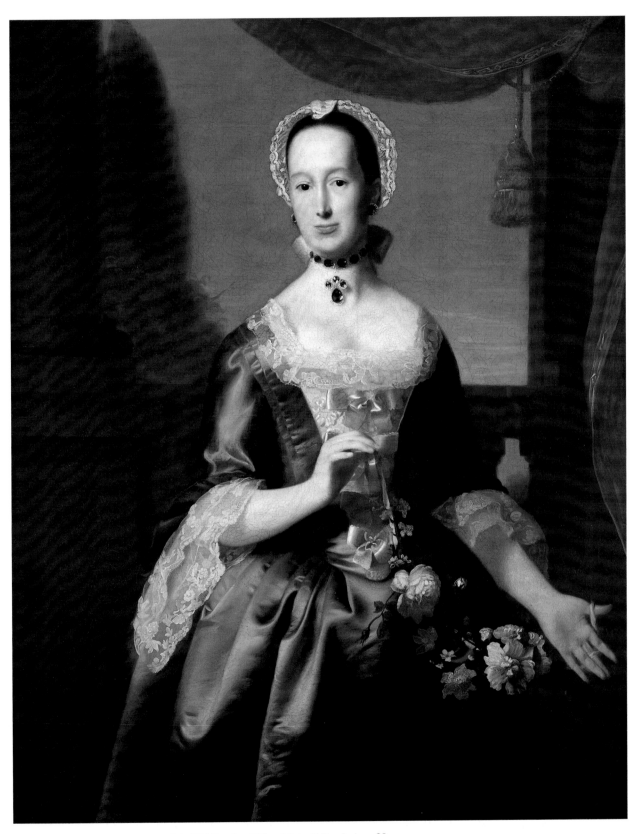

John Singleton Copley, *Anne Fairchild Bowler (Mrs. Metcalf Bowler)*, 1968.1.1

rural seat at Mount Vernon, on the Potowmack, with the blessings of his fellow citizens; and where he still continues to shed his beneficial influence by the promotion of agriculture, and patronage of the arts and sciences." Bowler noted that other great men had done the same: "For it is well known from their own immortal writings, that Cicero, Virgil and Horace, were extremely fond of a country life, and retired to their farms, whenever business would permit them, prefering rural amusement, to the noisy splendor of court."[13] Bowler shared the post-war dreams of other late eighteenth-century Americans.

EGM

Notes

1. A drawing of the stamp by curator William P. Campbell, dated 1/68, is in the NGA conservation file. This would seem to be the stamp of Francis L. Bechet, listed in New York city directories from 1860 to 1866 as a "picture liner and restorer"; see Katlan 1987, 44.

2. Mrs. Bowler probably inherited the portrait from her husband, the sitter's grandson, who was born in Providence, Rhode Island, in 1803 and moved to Cincinnati. They were married in 1842; Bowler 1905, 42. The date of Bowler's death is unknown, but he did predecease his wife (vital statistics file, Cincinnati Historical Society).

3. Bowler 1905, 97; obituary, *New York Times*, 16 August 1933, 17; she is called Louise in some sources.

4. "National Gallery Acquires Its 10th Painting by Copley," *New York Times*, 19 July 1968, 25.

5. This was an unidentified Copley portrait lent by Mrs. R.B. Bowler, Cincinnati; see Yarnall and Gerdts 1986, 1:826. The catalogue commented, "This picture is of especial interest, as the work of one of those distinguished painters, who, like Stuart, Trumbull, and Sully, mark the early history of art in this country" (37).

6. Letter from Jennifer Abel, MFA registrar's office, 14 November 1990 (NGA); MFA 1890, 46. A label on the back of the frame records the date of the loan as 28 May 1889 and gives the lender's maiden name. A second label with a loan date of 1891 gives the lender as Mrs. J.C. Livingston, New York. In 1896 Mrs. Livingston gave her nephew Robert Pendleton Bowler permission to copy the portrait.

7. Nathalie Rothstein, "What Silk Shall I Wear?: Fashion and Choice in Some 18th and Early 19th Century Paintings in the National Gallery of Art," lecture, NGA, 16 September 1990.

8. On these portraits see Miles and Simon 1979, unpaginated, nos. 47 and 58, repro.; Smart 1992, 110, no. 31, pl. 16, and 114, no. 36, pl. 17; and Waterhouse 1973, 50, pl. 2.

9. Bowler 1905, 11–12; Hazard 1915, 392, n. 5. Parker and Wheeler 1938, 42, give her birth date as 1732.

10. Prown 1966, 1:32, 35, 210, and fig. 84. This may be the "Portrait of a Lady" by Copley lent by C.L. Bowler of Providence to the Rhode Island Art Association Exhibition in September 1854 and mentioned in Tucker-

man 1867: "a three-quarter length belongs to the Bowler family" of Providence, Rhode Island. Charles Lee Bowler (1786–1871), a grandson of Mrs. Metcalf Bowler, was the great-grandfather of Charles Fletcher, owner of this portrait in 1938. See *Rhode-Island Art Association 1854*, cited in Yarnall and Gerdts 1986, 1:827; Tuckerman 1867, 73; Bowler 1905, 43; Parker and Wheeler 1938, 43.

11. Fleischer 1988, 28–31, repro.

12. Clark 1930, 101–117.

13. Bowler 1796, 87–88; this publication is referred to in Hazard 1915, 392, n. 5, and was called to my attention by Nancy Stula.

References

1873	Perkins: 38.
1890	MFA: 46.
1892	MFA: 16, no. 147.
1895	MFA: 17, no. 155.
1905	Bowler: 42, repro. opp. 12.
1910	Bayley: 22
1915	Bayley: 64.
1930	Bolton and Binsse, "Copley": 116.
1938	Parker and Wheeler: 42–43, pl. 37.
1966	Prown: 1:38, 103, 156–157, 210, and fig. 119.
1980	Wilmerding: 44, color repro. 45.
1981	Williams: repro. 21, 22.
1984	Walker: 387, no. 549, color repro.
1988	Wilmerding: 52, color repro. 53.

1980.11.1 (2774)

Elizabeth Gray Otis (Mrs. Samuel Alleyne Otis)

c. 1764
Oil on canvas, 78.7 × 69.2 (31 × 27 1/4)
Gift of the Honorable and Mrs. Robert H. Thayer

Technical Notes: The support is a medium-weight, plain-weave fabric. Only the tacking margin on the top edge is present. X-radiography reveals creases and tack holes along the left, right, and bottom sides, which indicate the painting was once on a smaller stretcher. The placement of these creases and holes, together with the lack of cusping on those sides, suggests that the painting was also cropped to a greater extent along these three edges. The ground is a thin, smooth, light gray layer. The paint is applied in opaque layers of thin to average thickness, with a fairly complex system of layers used in the features of the face. The sitter's dress went through two stages of painting, as revealed by pentimenti and x-radiography. In the first, the sleeves were painted white, with a knot of pinkish white fabric at the bodice. In the second, short blue capped sleeves were painted over the upper area of the white sleeves, and a thin scarf was added across the bodice of the dress and behind the figure to the left. Quite thickly applied, semi-transparent glazes were used in the blue dress sleeves and the red sash. The red glaze in the sash has discolored to a murky brown[1] and

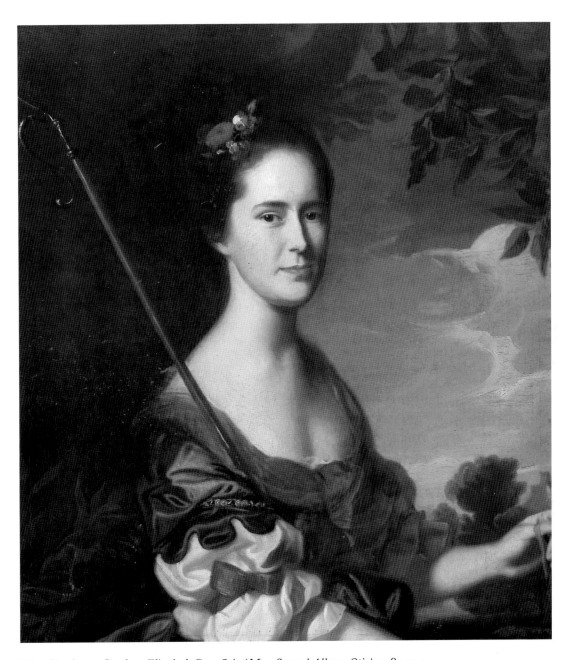

John Singleton Copley, *Elizabeth Gray Otis (Mrs. Samuel Alleyne Otis)*, 1980.11.1

has become transparent, revealing details of the dress and background that it once covered. The left profile line of the sitter's neck was also slightly shifted.

The left hand, right sleeve and arm, and shepherdess' crook were cropped when the painting was cut down. The surface is slightly abraded throughout, and the thinner layers of paint have been damaged. There are a few small retouched losses in the sitter's face and in the lower left corner, as well as long lines of abrasion at the left and right edges. The thickly applied paint of the flesh is penetrated by craquelure. The varnish is not significantly discolored.

Provenance: The sitter's grandson James William Otis [1800–1869], New York;[2] his son William Church Otis [1831–1889], Nahant, Massachusetts;[3] his son Harrison Gray Otis [1856–1915], Nahant, Massachusetts;[4] his son William Alleyne Otis, [b. 1895], Boston.[5] His cousin Robert Helyer Thayer [1901–1984] and Virginia Pratt Thayer [Mrs. Robert Helyer Thayer, d. 1979], Washington.[6]

Exhibited: New York 1853, no. 45.[7] Old State House, Boston, 1892.[8] *Loan Collection of Portraits for the Benefit of the Associated Charities and the North End Union*, Copley Society, Boston, 1896, no. 52. MFA, on long-term loan, 1910–1949.[9] *American Portraits by John Singleton Copley*, Hirschl & Adler Galleries, New York, 1975–1976, no. 14.

ELIZABETH GRAY OTIS (1746–1779) of Boston, Massachusetts, was the youngest child and only daughter of Harrison Gray, who was also painted by Copley [1976.25.1]. The artist depicted her as a shepherdess, copying the composition from Thomas Hudson's portrait of Flora Macdonald (1747, unlocated), engraved by John Faber, Jr. (Figure 1). Macdonald, a Scot, helped Bonnie Prince Charlie, claimant to the English throne, when he escaped in 1746 from the British.[10] Copley reduced Hudson's larger composition by omitting the lower part of Macdonald's figure and by adjusting the position of the sitter's arms. He also left out all references to Bonnie Prince Charlie. Instead of a miniature of the young Pretender, Mrs. Otis holds a blue ribbon, and Copley has substituted a tree in place of Hudson's background view of the prince's escape from Scotland by boat.

The portrait may date from 1764, the year that Elizabeth Gray married Samuel Alleyne Otis (see his portrait by Gilbert Stuart, 1980.11.2). This date would be consistent with the use of shepherdess motifs by Thomas Hudson, Sir Joshua Reynolds, and other English artists for portraits of young women of marrying age.[11] It is also supported by Copley's change in the shape of the dress sleeves to a fashion of the early 1760s. X-radiography (Figure 2) and pentimenti reveal that Copley began by copying the plain white sleeves of Hudson's portrait, but he then superimposed the blue capped sleeves with scalloped edges. The new sleeves appear in several of Copley's other portraits of women of the early 1760s, including Mrs. Daniel Rogers (1762, private collection) and Mrs. Theodore Atkinson (1765, New York Public Library, Lenox Collection).[12] These sleeves are also found in a number of contemporary English portraits by Thomas Hudson, Joseph Wright of Derby, and others.[13] In addition, Copley altered the pinkish white scarf along the edge of the bodice, extending it to float behind her shoulders and changing its color with a red glaze.

Mrs. Otis' portrait, smaller than the standard kit-cat size which measures 91.4 by 71.1 cm (36 by 28 inches), was cut down at some undetermined date on the left and right sides and along the bottom edge. While the minute amount that was taken off

Fig. 1. John Faber, Jr., after Thomas Hudson, *Mrs. Flora Macdonald*, mezzotint, 1747, London, British Museum [photo: Courtesy, The Trustees of the British Museum]

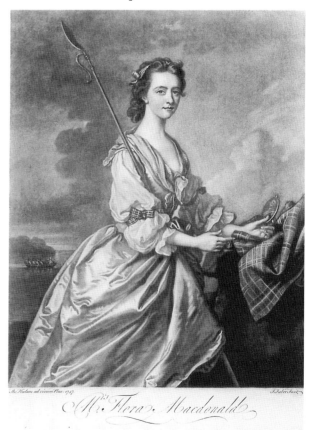

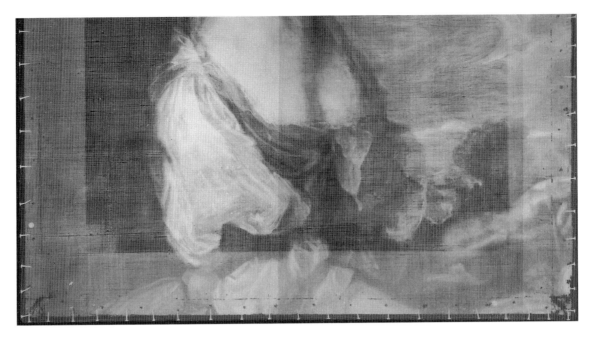

Fig. 2. X-radiograph of the sitter's sleeve in 1980.11.1

the sides probably only eliminated the end of the shepherdess' crook and the tips of her fingers, the approximately 12 cm that apparently was trimmed off the lower edge might have included her right hand. The trimming was done sometime before 1873, when Perkins wrote that the portrait "was cut down many years since."[14] In the early 1760s Copley used the kit-cat format for several portraits of women, including those of Dorothy Murray (1759–1761, Fogg Art Museum, Harvard University, Cambridge, Massachusetts), Mrs. Samuel Quincy (c. 1761, private collection), and Mrs. John Scollay (1763–1764, private collection).[15]

EGM

Notes

1. X-ray flourescence suggests that this glaze is made of pigments employed in the eighteenth century.

2. The presumed provenance is from the sitter to her son Harrison Gray Otis (1765–1848), father of James William Otis, first owner of record (1853); see Otis 1924, 106, 141, 202. This portrait shares its provenance with those of the sitter's father Harrison Gray by Copley [1976.25.1] and husband Samuel Alleyne Otis by Gilbert Stuart [1980.11.2].

3. Perkins 1873, 68; for his dates see Otis 1924, 341.

4. Bowen 1892, 517; Bayley 1915, 123; for his dates see Otis 1924, 495. Records in the MFA registrar's office show that the painting was owned from 1917 to 1926 by Robert H. Gardiner, Robert H. Gardiner, Jr., and William Tudor Gardiner (letter from Jennifer Abel, 14 November 1990, NGA), perhaps as trustees or executors of the estate of Harrison Gray Otis.

5. Parker and Wheeler 1938, 88; for his birth date see Otis 1924, 608.

6. Otis 1924, 496; Thayer was the son of Harrison Gray Otis' sister Violet Otis Thayer. The painting was delivered to Thayer on 22 June 1949 by the MFA on the authority of William A. Otis. Thayer is in Who's Who 1974, 3056, and NYT Bio Service 15:143. Mrs. Thayer's date of death is in the NGA curatorial file. A copy was painted for the donors by Adrian Lamb in 1976.

7. Washington Exhibition 1853, 8, lent by J.W. Otis. The exhibition is misdated 1 May 1854 by Yarnall and Gerdts 1986, 1:828. For confirmation of the 1853 date see Cowdrey 1953, 1:283.

8. Bowen 1892, 517; this and other Otis family portraits were on deposit in the rooms of the Bostonian Society at the Old State House, Boston.

9. Records of the MFA registrar's office (letter from Jennifer Abel, 14 November 1990, NGA).

10. Miles 1976, 2:135–136, no. 126, repro.; Miles and Simon 1979, cat. no. 32, repro.

11. For Reynolds' use of this motif see Nicholas Penny, "An Ambitious Man: The Career and the Achievement of Sir Joshua Reynolds," in Penny 1986, 27, 29, and 221, cat. 54, Anne Dashwood (MMA).

12. Prown 1966, 1:figs. 100 and 162.

13. Ribeiro 1984, 174 and pls. 73–75.

14. Perkins 1873, 91, described Mrs. Otis as "holding a crook and a lamb by a blue ribbon," which seems to be an error. While the portrait is reminiscent of Copley's larger Ann Tyng (1756, MFA), which includes a lamb,

there is no indication that the painting once included a lamb.

15. Prown 1966, 1:figs. 96, 97, and 106.

References
1873 Perkins: 91.
1892 Bowen: 517, repro. opp. 172.
1915 Bayley: 190.
1924 Otis: 106, repro. 108.
1930 Bolton and Binsse, "Copley": 118, owner listed as Robert H. Gardiner.
1938 Parker and Wheeler: 147–148, pl. 52.
1966 Prown: 1:40, 45, 111, 160–161, 225, and fig. 137.
1969 Morison: 6, 22–33, repro. 26.
1981 Williams: color repro. 1, 22.

1976.25.1 (2691)

Harrison Gray

c. 1767
Oil on canvas, 76.5 × 64 (30 1/4 × 25 3/16)
Gift of the Honorable and Mrs. Robert H. Thayer

Technical Notes: The painting was executed on a medium-weight, plain-weave fabric. The lining canvas and stretcher extend beyond the original paint surface by 0.5 cm on each side. The off-white ground is visible through parts of the thinly applied contours of the figure as well as parts of the coat and the background. The paint is applied thinly except in the flesh areas. The edges of the face were reworked after the wig and collar were painted, resulting in sudden transitions, especially between the forehead and wig. The forefinger of the sitter's right hand has been shortened, and the top left edge of the coat by the cravat has been reworked.

There is a tear in the upper right; two small losses are near the sitter's right eye and two are in the left portion of the wig, and small scratches are in the area of the quill and right hand. A slight flattening of the impasto highlights on the buttons may be the result of a past lining.

Provenance: The sitter's great-grandson James William Otis [1800–1869], New York;[1] his son William Church Otis [1831–1889], Nahant, Massachusetts;[2] his son Harrison Gray Otis [1856–1915], Nahant, Massachusetts;[3] his son William Alleyne Otis [b. 1895], Boston;[4] his cousin Robert Helyer Thayer [1901–1984] and Virginia Pratt Thayer [Mrs. Robert Helyer Thayer, d. 1979], Washington.[5]

Exhibited: New York 1853, no. 41.[6] *Loan Collection of Portraits for the Benefit of the Associated Charities and the North End Union,* Copley Society, Boston, 1896, no. 53. MFA, on long-term loan, 1910–1949.[7] *Loan Exhibition of One Hundred Colonial Portraits,* MFA, 1930, 39. *Fifty-Three Early American Portraits,* MFA, 1935, no cat.[8] *American Portraits by John Singleton Copley,* Hirschl & Adler Galleries, New York, 1975–1976, no. 32.

COPLEY'S waist-length portrait of Boston merchant Harrison Gray (1711–1794) shows him looking directly at the viewer with a steady gaze and a slight smile. He wears a plum-colored suit with gold buttons and gold braid, and a wig of the type worn by members of the learned professions.[9] He is seated on a Chippendale-style side chair, his right arm hooked over the crest rail. Gray holds a quill pen and a folded sheet of paper, references to his role as treasurer and receiver-general for the Province of Massachusetts Bay, a position that he held from 1753 until the eve of the American Revolution. In the background are a green curtain and the slight suggestion of a column base.

In the sitter's expression, the positioning of the head, and the type and treatment of the wig, this portrait is similar to Copley's image of Martin Howard (Social Law Library, Boston), painted in 1767.[10] Careful highlighting on the white paper and quill pen and in the buttons strengthens the portrait's secondary details. Gray's face, thickly painted in broad strokes, appears almost to be a caricature of authority. A viewer looking at the painting in 1910 described Gray as "cold, incorruptible, and stately,"[11] an interpretation undoubtedly biased by knowledge of Gray's Loyalist stance during the Revolution. Initially opposed to the use of violence by either side, he remained loyal to the British, publishing his political views in a pamphlet titled *The Two Congresses Cut Up* (1775). He fled Boston in 1776 with other Loyalists and spent the rest of his life in England.[12]

EGM

Notes
1. The probable sequence of ownership was from the sitter to his daughter Elizabeth Gray Otis to her son Harrison Gray Otis (1765–1848), father of James William Otis, first owner of record; see Otis 1924, 106, 141, 202. This portrait shares its provenance with Copley's *Elizabeth Gray Otis (Mrs. Samuel Alleyne Otis)* [1980.11.1] and Gilbert Stuart's *Samuel Alleyne Otis* [1980.11.2].

2. Perkins 1873, 68; for his dates see Otis 1924, 341.

3. Bayley 1915, 123; for his dates see Otis 1924, 495. Records in the MFA registrar's office show that the painting was owned from 1917 to 1926 by Robert H. Gardiner, Robert H. Gardiner, Jr., and William Tudor Gardiner (letter from Jennifer Abel, 14 November 1990, NGA), perhaps as trustees or executors of the estate of Harrison Gray Otis.

4. Parker and Wheeler 1938, 88; for his birth date see Otis 1924, 608.

5. Otis 1924, 496. Thayer's mother, Violet Otis Thayer, was Harrison Gray Otis' sister. The painting was delivered to Thayer by the Museum of Fine Arts on the authority of William A. Otis on 22 June 1949. For Thayer's

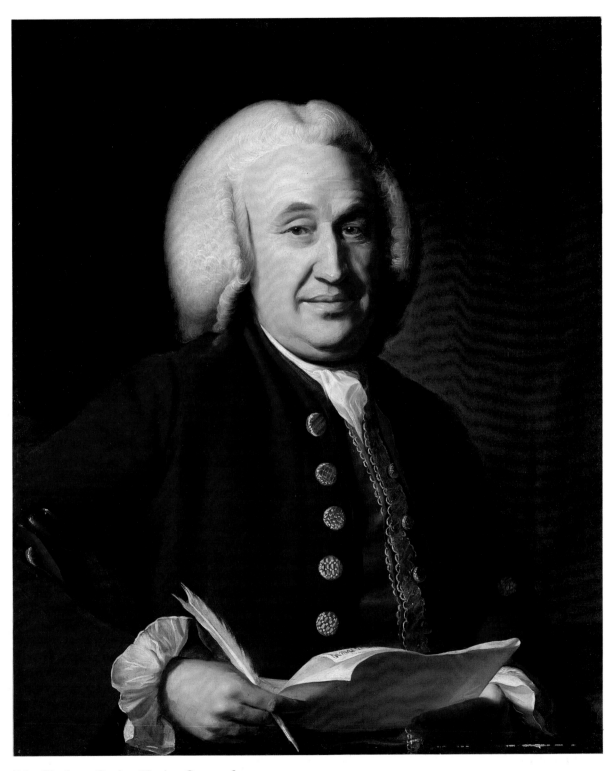

John Singleton Copley, *Harrison Gray*, 1976.25.1

dates see *Who's Who* 1974, 3056, and *NYT Bio Service* 15:143. The date of Mrs. Thayer's death is in the NGA curatorial file. Adrian Lamb painted a copy of this portrait in 1976 for the donors.

6. *Washington Exhibition* 1853, 8, lent by J.W. Otis. The exhibition is misdated 1 May 1854 by Yarnall and Gerdts 1986, 1:827. For confirmation of the 1853 date see Cowdrey 1953, 1:283.

7. Addison 1910, 5; Addison 1924, 5; MFA 1932, unpaginated, repro., lent by William A. Otis, 1926; Parker and Wheeler 1938, 87–88; records of the MFA registrar's office (letter from Jennifer Abel, 14 November 1990; NGA).

8. Typewritten list of the exhibition, Frick Art Reference Library.

9. Cunnington and Cunnington 1972, 243–244.

10. Prown 1966, 1:56, fig. 192.

11. Addison 1910, 5.

12. Jones 1930, 151–152; Prown 1966, 2:261, note; Morison 1969, 6, 17–30.

References

1873 Perkins: 68.
1910 Bayley: 43.
1910 Addison: 5.
1915 Bayley: 123.
1930 Jones: 151–152, repro. opp. 146.
1930 Bolton and Binsse, "Copley": 116.
1932 MFA: unpaginated, repro.
1938 Parker and Wheeler: 87–88, pl. 65.
1966 Prown: 1:56–57, 106, 160–161, 216 and fig. 195; 2:261, note.
1969 Morison: 6, 17–30, repro. 20.
1975 Hirschl & Adler: no. 32, color repro.
1981 Williams: 22, repro.

1965.6.1 (1944)

Eleazer Tyng

1772
Oil on canvas, 126.5 × 100.2 (49 3/4 × 40 1/8)
Gift of the Avalon Foundation

Inscriptions
Signed and dated lower left: John Singleton Copley / pinx. 1772. Boston.—

Technical Notes: The painting is on a fine, plain-weave fabric. The reverse of the lining is coated with aluminum paint. The ground is off-white. The paint is applied in a medium paste, but with thin glazes in the dark areas and low impasto in the white highlights. For the most part the paint was worked wet-in-wet. X-radiography shows dense modeling in the face.

A band of retouched losses across the horizontal center of the painting suggests that it was once folded. There is no retouching in the face, but there is scattered re-touching in the background. The outlines of the figure and the chair have been strengthened. The varnish is even and has not yellowed markedly.

Provenance: For sale by unidentified owner, Boston, 1841.[1] Copley Amory [1841–1879];[2] his son Copley Amory [1866–1960], Washington;[3] his wife Mary Forbes Russell Amory [1870–1961], Washington, in 1929; their son Copley Amory, Jr. [1890–1964], Cambridge, Massachusetts, in 1944;[4] bequeathed to his nephew Walter Amory [b. 1924], Wellesley Hills, Massachusetts;[5] from whom it was purchased by the Avalon Foundation.

Exhibited: Boston Athenaeum, 1841, no. 59.[6] *Loan Collection of Portraits for the Benefit of the Associated Charities and the North End Union*, Copley Society, Boston, 1896, no. 59. MFA, on long-term loan, 1910–1924.[7] American Wing, MMA, 1924.[8] *Exhibition of Early American Paintings, Miniatures and Silver Assembled by the Washington Loan Exhibition Committee*, NGA, SI, 1925–1926, no. 11. *John Singleton Copley, 1738–1815, Loan Exhibition of Paintings, Pastels, Miniatures and Drawings*, MFA, 1938, no. 74. Fogg Art Museum, Harvard University, Cambridge, Massachusetts, 1944.[9] *Copley*, 1965–1966, no. 53.

THIS PORTRAIT of octogenarian Eleazer Tyng (1690–1782) is one of a number of sympathetic, masterful images of older men that Copley painted in the early 1770s. Tyng, a graduate of Harvard College, was a landowner in what is now Tyngsborough, New Hampshire, and served as a magistrate, a colonel in the militia, and a justice of the peace.[10] His expression suggests that he managed these positions with shrewd judgment. Tyng, in a dark gray suit and black stockings, is seated in a green Windsor armchair that faces to the left. Turning his body, he looks directly at the viewer, his shoulders hunched forward, his hands resting on one arm of the chair. Copley used a similar pose for his portraits of John Erving (c. 1774, Smith College Museum of Art, Northampton, Massachusetts) and Congregational minister Thomas Cary (1773, MFA).[11] Here, the structural and decorative divisions of the wall behind Tyng create lines and shadows that focus attention on his face, which is set against the upper, dark green section of the wall. The placement makes the sitter appear small in stature, his head somewhat large for his body.

The portrait is particularly memorable for its representation of Tyng's face and hands. A comparison with Copley's earlier portrait of seventy-year-old Epes Sargent [1959.4.1] reveals notable changes in the artist's technique. In Sargent's portrait Copley used thick layers of pigment in the face and hands. Here, a more liquid paint enabled the

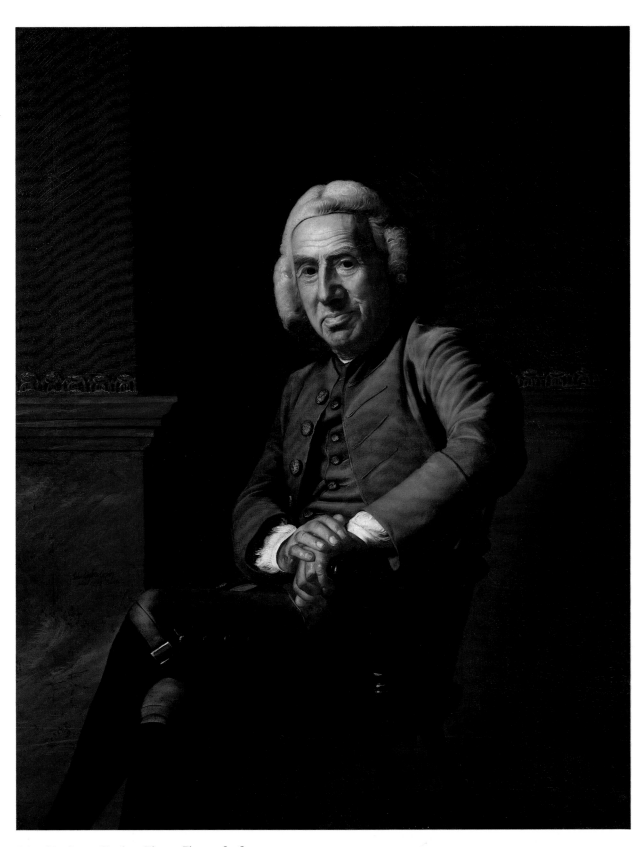

John Singleton Copley, *Eleazer Tyng*, 1965.6.1

artist to delineate the details more precisely. Tyng's watery blue eyes and moist lower lip are minutely described, as are the prickly white hairs of his eyebrows and chin, and the knuckles and nails of his fingers. While both portraits stand out as very successful images, the contrast between the details indicates the refinements that Copley made in his work in the intervening decade.

EGM

Notes

1. When the painting was exhibited at the Boston Athenaeum, it was catalogued as "Mr. E. Tyng. For sale"; Perkins and Gavin 1980, 40, no. 59. The seller could have been a distant relative for whom the portrait had no personal value. Of Tyng's five children only his daughter Sarah Tyng Winslow outlived him. After she died in 1791 without children, the sitter had no direct descendants; see Anthony 1956, 24–28, 51.

2. Copley Amory, the artist's great-grandson, probably purchased or was given the portrait, since there was no family connection between the Amorys and the Tyngs; see Linzee 1917, 2:766, 781–782. Amory's ownership was first recorded in 1873.

3. On Amory see Linzee 1917, 795, and his obituary, *New York Times*, 18 April 1960, 29.

4. The birth dates of Mary Forbes Russell Amory and Copley Amory, Jr., are found in Linzee 1917, 795–796. Their death dates were provided to the author by Walter Amory, 19 November 1990. Ethel C. Amory (Mrs. Copley Amory, Jr.) documented Copley Amory's gift of the portrait to Mary Amory and her gift to Copley Amory, Jr. (letter 1 May 1965, NGA).

5. Walter Amory to author, 19 November 1990 (NGA).

6. Perkins and Gavin 1980, 40.

7. Bayley 1910, 244, who notes that the portrait "hangs in the Museum of Fine Arts, Boston"; Addison 1910, 5; Addison 1924, 5.

8. According to information provided to the Frick Art Reference Library by the Metropolitan Museum of Art, Copley Amory lent the portrait for the opening of the American wing on 11 November 1924.

9. Fogg Art Museum, "Portraits in Current Exhibition," typescript, 19 December 1944, Frick Art Reference Library.

10. Shipton 1937, 651–653, which mentions that the portrait was then unlocated; Tyng's niece Ann Tyng was one of Copley's earliest sitters (1756, MFA); Prown 1966, 1:22.

11. Prown 1966, 1:212–213 and figs. 319, 324.

References
1873 Perkins: 19, III.
1910 Bayley: 99–100.
1910 Addison: 5.
1915 Bayley: 244.
1924 Addison: 5.
1930 Bolton and Binsse, "Copley": 118.
1937 Shipton: 651–653.

1938 Parker and Wheeler: 190, pl. III.
1966 Prown: 1:85, 88, 92, 115, 194, 231, and fig. 317.
1981 Williams: 22, repro. 23, 28.
1984 Walker: 386, no. 548, color repro.

1978.79.1 (2756)

Adam Babcock

c. 1774
Oil on canvas, 117 × 91.7 (46 $^{1}/_{16}$ × 36 $^{1}/_{8}$)
Gift of Henry A. and Caroline C. Murray

Technical Notes: The painting is on a medium-weight, plain-weave fabric, and cusping is present along all four edges. The ground is white. The colors are applied evenly, except for those mixed with white, which tend to be thicker. Virtually no glazes were used.

Damages in the fabric have been repaired with five small canvas inserts, four of which are in the area of the body. Areas of paint loss are scattered across the entire painting. There is extensive retouching, notably in the sitter's face, hands, shirt, and jacket. The retouching is discolored. The thickly applied varnish is discolored also.

Provenance: The sitter's great-grandson Edwin A. Blake [1847–1928];[1] sold 1916 to (Macbeth Gallery, New York);[2] purchased 1917 by Alice Greenwood Chapman [1853–1935], Milwaukee;[3] repurchased by (Macbeth Gallery, New York) and sold 25 February 1919 to Arthur Meeker [1866–1946], Chicago.[4] Fannie Morris Babcock Murray [Mrs. Henry Alexander Murray, 1858–1940], New York;[5] her son Dr. Henry A. Murray [1893–1988], Cambridge, Massachusetts.[6]

Exhibited: *An Exhibition of Early American Paintings*, Museum of the Brooklyn Institute of Arts and Sciences, New York, 1917, no. 8.

ADAM BABCOCK (1740–1817), the son of Dr. Joshua and Hannah Babcock of Westerly, Rhode Island, was a merchant and ship owner in New Haven, Connecticut. An ardent patriot during the American Revolution, he outfitted a privateer for American use and supplied the army with rice and woolen cloth. He may have moved to Calcutta, India, after the war before he settled in Boston.[7]

Wearing a three-piece brown suit with gold buttons, Babcock is seated in an upholstered chair at a table covered with a dark cloth. He holds a folded paper in his left hand, a pen in his right. Although no evidence places Babcock in Boston in 1774, the portrait, like that of Mrs. Babcock [1985.20.1], is believed to be among the last portraits that Copley painted before leaving for England that June. A vir-

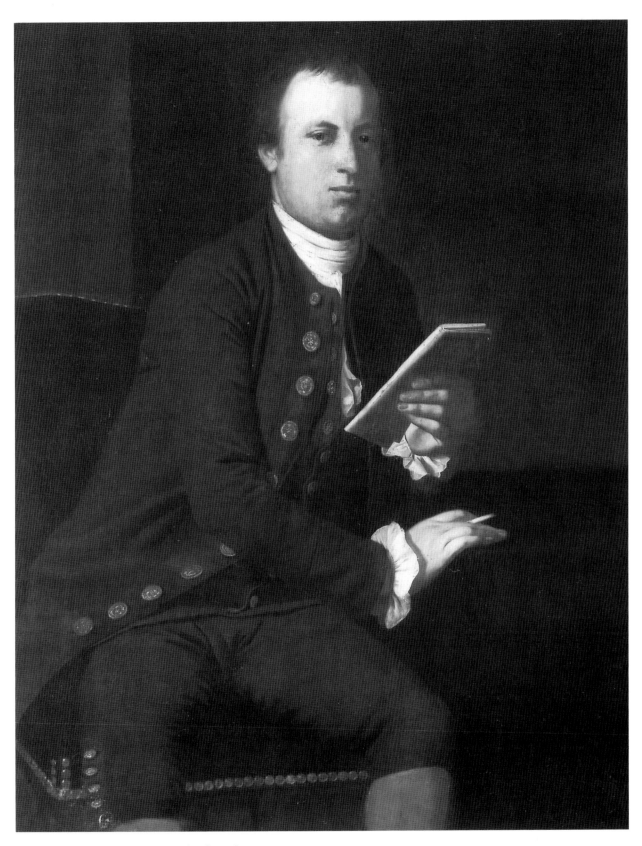

John Singleton Copley, *Adam Babcock*, 1978.79.1

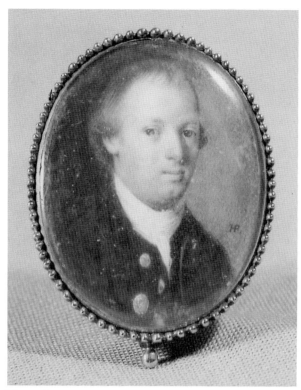

Fig. 1. Henry Pelham, *Adam Babcock*, watercolor on ivory, c. 1774, Washington, Louisa B. Parker, on loan to the Diplomatic Reception Rooms, United States Department of State

tually identical miniature of Babcock by Henry Pelham, Copley's half-brother, is probably a copy (Figure 1), perhaps made on Pelham's visit to New Haven in November and December 1774.[8] Copley's portrait was also the model for Ralph Earl's portrait of Henry Daggett (unlocated), painted in New Haven in 1774–1775.[9] Because the portrait later suffered considerable damage and was extensively retouched, it no longer is a good example of Copley's late colonial style.

Babcock and his family often commissioned portraits. His father, mother, elder brother Henry, and sister Hannah were painted by Joseph Blackburn between 1756 and 1761.[10] Hannah's husband John Bours was painted by Copley around 1760 (Worcester Art Museum, Massachusetts).[11] Babcock later had his portrait painted by Gilbert Stuart (c. 1806–1810, MFA).

<div align="right">EGM</div>

Notes

1. Babcock 1903, 219; Updike 1907, 2:v; on Blake see *Methodist Episcopal Church* 1928, 665–667.

2. Macbeth Gallery Papers, AAA, correspondence with Arthur Meeker, 16 January 1919.

3. Macbeth Gallery Papers, AAA, correspondence with Miss Chapman, 14 January to 19 June 1917. Miss Chapman made a first payment on the portrait and that of Mrs. Babcock [1985.20.1] in January 1917, but by June she had changed her mind about the purchase. She wrote on 7 June, "I am too overcome by the outcome of the war to be indulging in such luxuries... I have just given an ambulance to the Wisconsin Ambulance Co." On Miss Chapman, a Milwaukee art patron and collector, see the *Milwaukee Journal*, 27 April 1935 (obituary) and 12 May 1935.

4. Meeker, vice-president of Armour & Co. and a collector of American art, is listed in *Who Was Who* 2:367. His obituary is in the *New York Times*, 6 February 1946, 23. Although he offered to sell the portraits back to Macbeth in June 1925, there is no record in the Macbeth Gallery papers that they were repurchased (Macbeth Gallery Papers, AAA, Correspondence).

5. Babcock 1903, 520; obituary, *New York Times*, 3 June 1940, 15; Mrs. Murray was a descendant of the sitter's brother Henry Babcock. According to Parker and Wheeler 1938, 30, she acquired the portrait around 1930.

6. On Murray see Turner 1987, 560–561; obituary, *New York Times*, 24 June 1988, reprinted in *NYT Bio Service* 19:746. Adrian Lamb painted a copy of this portrait in 1979 for the Murrays.

7. Parker and Wheeler 1938, 29–30.

8. Kornhauser 1991, 11, fig. 5.

9. Kornhauser 1991, 104, 106, repro.

10. Park 1923, 17–19, nos. 9–12. That of Dr. Babcock is owned by the Museum of Fine Arts, Boston, and that of Hannah Bours by the Worcester Art Museum. The other two are unlocated.

11. Prown 1966, 1:208.

References

1903 Babcock: 67–68, repro. opp. 68.
1907 Updike: 2:v, repro. opp. 52.
1910 Bayley: 23.
1915 Bayley: 48.
1930 Bolton and Binsse, "Copley": 116.
1938 Parker and Wheeler: 29–30, pl. 120.
1966 Prown: 1:92, 156–157, 208, and fig. 333.
1991 Kornhauser: 10–11, 104 repro., 106.

1985.20.1 (2679)

Abigail Smith Babcock (Mrs. Adam Babcock)

c. 1774
Oil on canvas, 116.8 × 90.8 (46 × 35 ¾)
Gift of Mrs. Robert Low Bacon

Technical Notes: The support is a plain-weave fabric that appears to be the same as that used for the companion portrait of Adam Babcock [1978.79.1]. Cusping is vis-

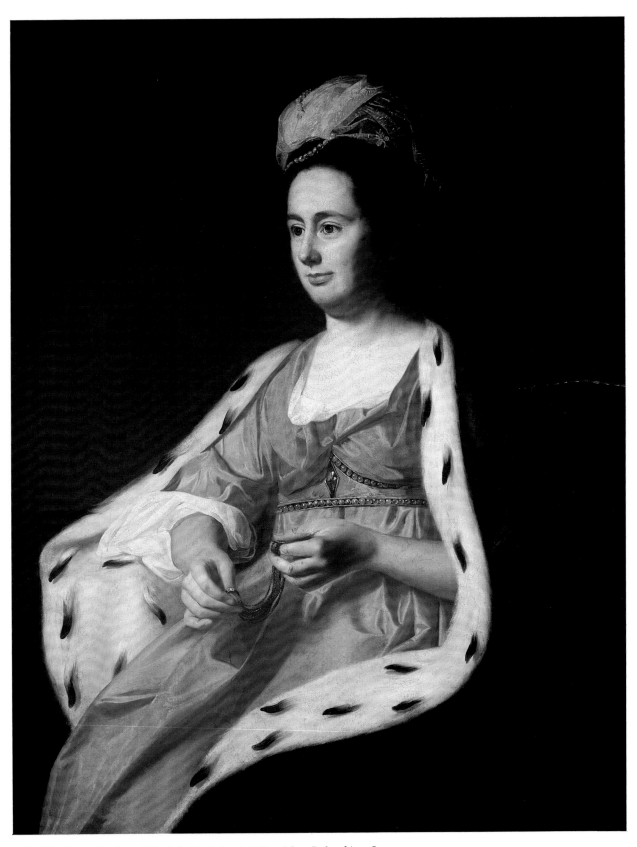

John Singleton Copley, *Abigail Smith Babcock (Mrs. Adam Babcock)*, 1985.20.1

ible on the top and sides, but not along the lower edge. The paint is applied with varying consistencies, ranging from thin and fluid to a thick paste, to create impasto in the jewels of the sitter's necklace and belt and in the pearls of the turban. X-radiography reveals that the necklace and the lower edge of the belt were painted over already developed folds in the dress and that the upper edge of the belt was slightly lowered.

Two canvas inserts to the left of the sitter's head are visible in x-radiography. Paint losses are present throughout, and there is cupped craquelure. There are, however, few losses in the sitter's face, arms, and hand, except for damage in the shadowed area of her head. Retouching and varnish have discolored.

Provenance: The sitter's great-grandson Edwin A. Blake [1847–1928];[1] sold 1916 to (Macbeth Gallery, New York);[2] purchased 1917 by Alice Greenwood Chapman [1853–1935], Milwaukee;[3] repurchased by (Macbeth Gallery, New York) and sold 25 February 1919 to Arthur Meeker [1866–1946], Chicago.[4] Fannie Morris Babcock Murray [Mrs. Henry Alexander Murray, 1858–1940], New York;[5] her daughter Virginia Murray Bacon [Mrs. Robert Low Bacon, 1890–1980], Washington.[6]

Exhibited: *An Exhibition of Early American Paintings,* Museum of the Brooklyn Institute of Arts and Sciences, New York, 1917, no. 9. *Copley, Stuart, West in America & England,* MFA, 1976, no. 15. *Ralph Earl: The Face of the Young Republic,* NPG; Wadsworth Atheneum, Hartford; Amon Carter Museum, Fort Worth, 1991–1992, no. 3.[7]

IN THIS PORTRAIT, one of Copley's most attractive, Mrs. Babcock wears a deep rose-colored dress with a gold belt trimmed with pearls. A blue cape with an ermine lining is draped over her shoulders, and pearls decorate the white muslin scarf in her dark hair. Seated on a blue sofa, she gazes off to the viewer's left, lost in thought. As she readies the gold clasp of a garnet bracelet, she weaves its delicate strands between her fingers.

Abigail Smith (1744–1777) married Adam Babcock in New Haven around 1764.[8] This portrait and that of her husband are believed to be among the last works that Copley painted in America; the artist left Boston for London on 10 June 1774. This dating is based on a reference to Mrs. Babcock made by Joshua Wentworth of Portsmouth, New Hampshire, in his letter of 7 April 1775 to Henry Pelham, Copley's half-brother. In response to a bill from Pelham for Copley's portrait of Mrs. Wentworth, he wrote,

Mr. Copely, on my determination, of hav'g those portraits taken, Engag'd with me no other's shou'd impeed the execcution of them. After Mrs Wentworth had set many days, and myself one, he agreed and finish'd a Portrait for a Mrs Babcock, wch exceedingly disapointed my

Intentions, and my business cal'g me hither, was oblig'd to leave Boston, without a finish of either Portrait.[9]

(The portraits of the Wentworths are unlocated today.)

Mrs. Babcock's dress, with its wide, jeweled belt and loosely fitted bodice, is a variant of a style that imitated classical Greek and contemporary Turkish dresses.[10] In its most popular form, the dress was made of white satin, although crimson or blue satin were also used. The design often incorporated a cross-over bodice and a sash at the waist. Sleeves were either long and fitted to the wrist, or short and flowing loosely to the elbow. A cape, often in blue and lined or trimmed with ermine, and a gauze-like turban were characteristic accessories.[11] Copley employed elements of this costume in a number of portraits. The ermine trim, worn over a draped dress, first appeared in his portrait of Elizabeth Ross (1766–1767, MFA), based on the figure of Lady Amabel Yorke in Joshua Reynolds' double portrait *The Ladies Amabel and Mary Jemima Yorke* (1761, Cleveland Museum of Art).[12] The combination of ermine-trimmed cape and draped dress appeared in the portraits of Mrs. William Turner (1767), Mrs. Joseph Green (c. 1767), Mrs. Joseph Barrell (c. 1771), and Mrs. Jeremiah Lee (1769).[13] A variation without the cape, worn with a wide, jeweled belt, is seen in the portraits of Mrs. Joseph Hooper (1770–1771), Mrs. Roger Morris (1771), and, most appropriately, Mrs. Thomas Gage (1771), the American-born granddaughter of an English merchant who had lived in Turkey.[14] Often these women also wear turbans decorated with pearls. In England aristocratic women wore such dresses for masquerades. The dresses were also considered appropriate for portraits, especially from the 1750s through the 1770s. Joshua Reynolds discussed the use of such dresses in a letter written in 1770 to Sir Charles Bunbury about the completion of a portrait of Polly Kennedy.

As to the dress, I should be glad it might be left undetermined till I return from my fortnight's tour. When I return I will try different dresses. The Eastern dresses are very rich, and have one sort of dignity: but 'tis a mock dignity in comparison of the simplicity of the antique.[15]

It is not known whether American sitters owned such dresses and are therefore depicted in actual costumes, or if Copley used the designs as Reynolds did, to give the sitters a "sort of dignity."

If this portrait was painted in 1774 and not earlier (most of Copley's portraits showing oriental-style

dresses date from the years 1766 to 1771), it must have been sent to New Haven soon after it was completed. There it was imitated by the young Connecticut painter Ralph Earl for his portrait of Elizabeth Prescott Daggett (1774–1775, Stowe-Day Foundation, Hartford). Mrs. Daggett, in an ermine-lined cape, wears a simplified version of Mrs. Babcock's dress.[16]

EGM

Notes

1. Babcock 1903, 219; Updike 1907, 2:v; on Blake see *Methodist Episcopal Church* 1928, 665–667. The painting shares most of its history with the portrait of Adam Babcock [1978.79.1].
2. Macbeth Gallery Papers, AAA, correspondence with Arthur Meeker, 16 January 1919.
3. Macbeth Gallery Papers, AAA, correspondence with Miss Chapman, 14 January to 19 June 1917. Miss Chapman made a first payment on the portrait and its pendant of Mr. Babcock in January 1917, but she changed her mind about the purchase. On Miss Chapman, a Milwaukee art patron and collector, see the *Milwaukee Journal*, 27 April 1935 (obituary) and 12 May 1935.
4. Meeker, vice-president of Armour & Co. and a collector of American art, is listed in *Who Was Who* 2:367; his obituary is in the *New York Times*, 6 February 1946, 23. This painting and eight other American portraits in his collection were illustrated in an article by Van Horn 1921, 22–30; the painting is discussed on 22 and reproduced on 29. Although he offered to sell the portraits back to Macbeth in June 1925, there is no record in the Macbeth Gallery papers that they were repurchased (Macbeth Gallery Papers, AAA, Correspondence).
5. Babcock 1903, 520; obituary, *New York Times*, 3 June 1940, 15; Mrs. Murray was a descendant of the sitter's brother Henry Babcock. According to Parker and Wheeler 1938, 30, she acquired the portrait around 1930.
6. Babcock 1903, 520; obituary, *New York Times*, 26 February 1980, reprinted in *NYT Bio Service* 11:161. Adrian Lamb painted a copy of this portrait in 1979.
7. This portrait was exhibited only in Washington.
8. Babcock 1903, 67.
9. *Copley-Pelham Letters*, 313.
10. Aileen Ribeiro, "Costume Notes," in Kornhauser 1991, 108.
11. Ribeiro 1984, 233–245.
12. Prown 1966, 1:54, and fig. 175; Penny 1986, 202–203, cat. 39.
13. Prown 1966, 1: figs. 212, 216, 233, and 258.
14. Prown 1966, 1: figs. 278, 296, 284; Saunders and Miles 1987, 241–243, cat. 77.
15. Ribeiro 1984, 242, quoting Leslie and Taylor 1865, 1:398.
16. Kornhauser 1991, 106–108, no. 4, repro.

References

1903 Babcock: 67–68, repro. opp. 80.
1907 Updike: 2:v, repro. opp. 58.
1910 Bayley: 23.

1914 *Copley-Pelham Letters*: 313.
1915 Bayley: 48.
1930 Bolton and Binsse, "Copley": 116.
1938 Parker and Wheeler: 31, pl. 120.
1966 Prown: 1:92, 156–157, 208, and fig. 334.
1969 Miller: repro. 154.
1991 Kornhauser: 10–11, 104–108, no. 3, repro.

1991.141.1

Sketch for The Copley Family

1776
Oil on canvas en grisaille, 39.5 × 34 (15 ½ × 13 ⅜)
Gift of Richard T. York in Honor of the 50th Anniversary of the National Gallery of Art

Technical Notes: The painting is on a medium-weight, plain-weave fabric with a moderately thick off-white ground. The fabric has been cut into an oval, lined, and restretched onto a rectangular stretcher. One indication that the design was originally larger is found in the compositional lines, which extend to the edge of the original fabric. In addition, there is no cusping in the original support, which suggests substantial trimming of the edges. The medium is liquid, possibly ink, worked up with washes of brown paint and highlighted with a dilute white paint. The paint has a narrow aperture craquelure, very slightly cupped, which has been retouched. Small paint losses along the cut edge have also been retouched.

Provenance: The artist's grandson John Singleton Copley Greene [1810–1872], Brookline, Massachusetts;[1] his daughter Mary Amory Greene [1860–d. by 1938], Boston;[2] her sister-in-law Rosalind Huidekoper Greene [Mrs. Henry Copley Greene, d. 1975], Cambridge, Massachusetts;[3] her daughter Joy Singleton Copley Greene Sweet [Mrs. Gordon Sweet], Mount Carmel, Connecticut;[4] (Hirschl & Adler Galleries, New York, 1978); Jo Ann and Julian Ganz, Jr., Los Angeles; (Hirschl & Adler Galleries, New York); (Richard York, New York).

Exhibited: MFA, on long-term loan, 1894–1932, 1933–1964, 1965–1972.[5] *John Singleton Copley, 1738–1815, Loan Exhibition of Paintings, Pastels, Miniatures and Drawings,* MFA, 1938, no. 24. *Centennial Loan Exhibition, Drawings & Watercolors from Alumnae and Their Families,* Vassar College Art Gallery, Poughkeepsie, New York, and Wildenstein & Co., Inc., New York, 1961, no. 68. YUAG, on long-term loan, 1972–1978.[6] *An American Perspective: Nineteenth-Century Art from the Collection of Jo Ann & Julian Ganz, Jr.,* NGA; Amon Carter Museum, Fort Worth; Los Angeles County Museum of Art, 1981–1982, unnumbered, repro. *Adventure and Inspiration: American Artists in Other Lands,* Hirschl & Adler Galleries, New York, 1988, no. 5.

IN THIS OIL SKETCH for *The Copley Family* [1961. 7.1], done on a smaller scale than the finished work, Copley focused on the central figures in the family portrait: the artist's wife Susanna, their son John Singleton Copley, Jr., and daughter Mary Copley. The unpainted area and the outline of the figure of Elizabeth on the left indicate that the sketch was made after Copley established the overall composition of the larger painting. The canvas is now cut into an oval. There is no evidence that it once represented the entire composition.

This is Copley's earliest known preliminary oil sketch. Such studies were not part of his colonial American training or practice, when he instead drew or painted the poses and faces directly on the canvas. He commented on the question of posing figures when he wrote to Henry Pelham in 1774 after arriving in London.

I find the practice of Painting or rather the means by which composition is attained easyer than I thought it had been. the sketches are made from the life, and not only from figures singly, but often from groups. This you remember was [a subject we] have often talked of, and by this a great difficulty is removed that lay on my mind.[7]

From this time on and throughout his English career, Copley continued to make preparatory studies, most of them on paper. His use of outlines, as seen here, is the process that he described to Henry Pelham when he wrote about composing his painting of the *Ascension*. "When I had got my Sketch in the above [final] state I determined to put it in Colours, so that if I should paint it I should have nothing to alter. so I covourd my Drawing [with] squares and [took] a Canvis of a Kitcat sise, and Drew all the outline."[8]

The grouping of the figures of Mrs. Copley and two of her children suggests the influence of Italian sixteenth-century images of the Holy Family (see *The Copley Family*). Copley used similar poses for his group portrait *Sir William Pepperrell and his Family*, painted the following year (North Carolina Museum of Art, Raleigh). The similarity of the two paintings extends even to the individual features; Mrs. Copley is thought to have posed for the image of the deceased Mrs. Pepperrell.[9] For the Pepperrell family portrait Copley made five chalk studies, which, like the Gallery's study for *The Copley Family*, are evidence of the new challenges that the artist met when he turned from single or double portraits to larger compositions.

EGM

Notes

1. Perkins 1873, 48, who describes Greene as "the late John Singleton Copley Greene, Longwood." The inclusion of the name of Greene's home in Brookline, Massachusetts, distinguishes him from his son, John Singleton Copley Greene, Jr., who died the same year. Greene was the son of Elizabeth Clarke Copley, the artist's daughter, and Gardiner Greene; see *Greene Family* 1901, 83–86, and Clarke 1903, 432, 580.

2. Bolton and Binsse, "Copley," 1930, 116; an old label now attached to the backing board reads: "COPLEY J. S., LORD LYNDHURST AND HIS MOTHER Lent by Miss Mary Amory Greene." Her birth date is given in *Greene Family* 1901, 84, and Clarke 1903, 432.

3. Mrs. Greene was the lender of the portrait to exhibitions held in 1938 and 1961. Her husband Henry Copley Greene [1871–1951] was a half-brother of Mary Amory Greene; they were the children of John Singleton Copley Greene, Jr.; *Greene Family* 1901, 84, and Clarke 1903, 432, 687. Mrs. Greene is mentioned in her husband's entries in *Who's Who* 1948, 970, and *Who Was Who/Authors* 1976, 1:619.

4. She is mentioned in her father's entry in *Who's Who* 1948, 970. According to Hirschl & Adler 1979, no. 3, she owned the sketch from 1966 to 1978.

5. Bayley 1915, 102; Hirschl & Adler 1988, 16. The loan dates were confirmed by Jennifer Abel, MFA registrar's office, 14 January 1992 (NGA).

6. Hirschl & Adler 1988, 16, confirmed by letter from Elizabeth Marsh, YUAG, 10 February 1992 (NGA).

7. Copley to Pelham, 15 July 1774, in *Copley-Pelham Letters*, 226.

8. Copley to Pelham, 14 March 1775, in *Copley-Pelham Letters*, 298.

9. Rutledge 1957, 201; Prown 1966, 2:265; Lovell 1991, 30–42.

References

1873 Perkins: 48.
1910 Bayley: 109.
1915 Bayley: 85, 102.
1930 Bolton and Binsse, "Copley": 116.
1957 Rutledge: 201 and fig. 4.
1966 Prown: 2:262–263, 415 and fig. 345.
1979 Hirschl & Adler: no. 3 [unpaginated], color repro. frontispiece.
1980 Troyen: 66–67.
1981 Wilmerding, Ayres, and Powell: 9, 44, 90, 124, repro. fig. 8.
1988 Hirschl & Adler: 16, no. 5 repro.
1990 York Gallery: unpaginated, repro.

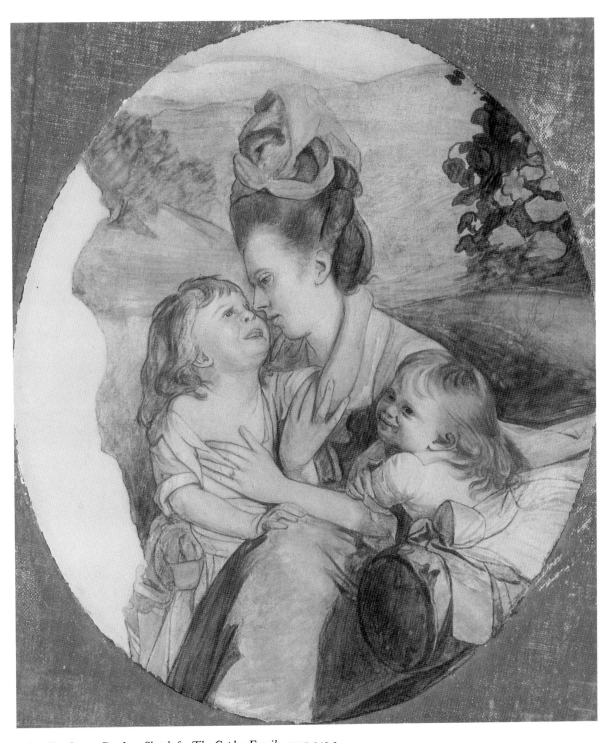

John Singleton Copley, *Sketch for The Copley Family*, 1991.141.1

1961.7.1 (1650)

The Copley Family

1776/1777
Oil on canvas, 184.1 × 229.2 (72 ¹/₂ × 90 ¹/₄)
Andrew W. Mellon Fund

Technical Notes: The tacking margins of the original, moderately fine weight, plain-weave fabric were trimmed at the top and sides, but only partially at the bottom, where the remainder was flattened. There are two lining fabrics. The more recent one, visible from the reverse, is a medium-weight, twill-weave fabric. The older one, sandwiched between this lining and the original fabric, is perhaps a double layer of a finer, plain-weave fabric.[1] The present stretcher is larger on all sides than the original dimensions of the painting, which were 180.8 by 227.2 cm.

The moderately thick ground is white and probably covered the tacking margins. Infrared reflectography reveals no underdrawing, although the forms are blocked in with very careful placement, suggesting that Copley was working from earlier studies. The paint is applied with a broader range of techniques—ranging from dry and wet pastes to thin, dry, and fluid glazes—than observed in Copley's earlier style. There is high, globular impasto in the highlights of the face, cap, jewelry, rugs, and decorative borders. The youthful quality of the children's skin is differentiated from that of the artist's father-in-law by a smooth blending of tones. The decorative sashes and bows of the children's costumes were painted over the underlying folds of cloth. There are extensive pentimenti in these sashes and bows on either side of the child in the center, notably in the standing girl's left sleeve cuff, in the drapery in that area, and in her brother's ribbon, to the right.

In addition to a tear to the left of the father's head, there are vertical central and diagonal corner stretcher creases. The paint surface has extensive vertical fabric weave texture and traction crackle in some of the darks. There are scattered small holes but no major losses. There are, however, areas of severe local abrasion, generally in the less important areas, including Mrs. Copley's hair and hair-covering, the peripheral areas above her head, the greens of the landscape, and the browns of the foliage. There is also some abrasion in the clothing of the sitters.

Only some of the craquelure and abrasion has been retouched. The varnish was removed in 1962. The present varnish is unevenly discolored and grayed.

Provenance: The artist; his son John Singleton Copley, Jr., Lord Lyndhurst [1772–1863], London; his sale (Christie, Manson & Woods, London, 5 March 1864, no. 91); bought by "Clarke" for the artist's granddaughter Martha Babcock Greene Amory [Mrs. Charles Amory, 1812–1880], Boston;[2] her husband Charles Amory [1808–1898], Boston;[3] their son Edward Linzee Amory [1844–1911], New York;[4] his nephew Copley Amory [1866–1960], Washington,[5] to his descendants Copley Amory, Jr. [1890–1964], Cambridge, Massachusetts,[6]

Henry Russell Amory [1892–1962], Santa Barbara, California, Katharine Amory Smith [b. 1908], Washington, Walter Amory [b. 1924], Duxbury, Massachusetts, and Elizabeth Cole Amory [b. 1955], Princeton, New Jersey.[7]

Exhibited: Royal Academy of Arts, London, 1777, no. 61. International Exhibition, London, 1862, no. 51.[8] Boston Athenaeum, 1873, no. 144. Boston Athenaeum, 1874, no. 130.[9] MFA, on long-term loan, 1888–1916, 1921–1925.[10] *John Singleton Copley, 1738–1815, Loan Exhibition of Paintings, Pastels, Miniatures and Drawings*, MFA, 1938, no. 22. NGA, on long-term loan, 1941–1951.[11] *Copley*, 1965–1966, no. 61. *American Self-Portraits 1670–1973*, NPG, 1974, no. 6. *La Pintura de Los Estados Unidos de Museos de la Ciudad de Washington*, Museo del Palacio de Bellas Artes, Mexico City, 1980–1981, no. 1.

AMONG Copley's most memorable images is this group portrait, which celebrates the artist's reunion in London in October 1775 with his wife Susanna (1745–1836) and their children Elizabeth (1770–1866), Mary (1773–1868), and John Singleton Copley, Jr. (1772–1863). Copley was separated from his family for about a year and a half in 1774–1775, after he left Boston to study in Europe. His wife and children moved to London in May 1775. They were joined at the end of the year by the artist's father-in-law Richard Clarke (1711–1795), a wealthy Boston merchant.[12] Susanna (1776–1785), the youngest child in the painting, was born the following 20 October in London. *The Copley Family* is one of the artist's first English pictures and his first large group portrait. Painted during the early years of the American Revolution, the portrait expresses Copley's pride at being reunited with his family in such troubled times at the beginning of a new phase of his career.

While in Europe in 1774–1775, Copley frequently expressed his longing to rejoin his family, either in Boston or in England. On 15 September 1774 he wrote his wife from France, "If you knew how great my desires were to be with you, you would not think it necessary to say one word to hasten that happy time; I am sure I shall think that an hour of happiness that brings us together beyand any I shall enjoy till it arrives."[13] On 8 October he questioned whether they would remain in Boston or live in London. "As soon as possible you shall know what my prospects are in England, and then you will be able to determine whether it is best for you to go there or for me to return to America."[14] In December, as turmoil in America increased, he expressed concern over his family's well-being. "When I reflect on the condition Boston may be in, I tremble

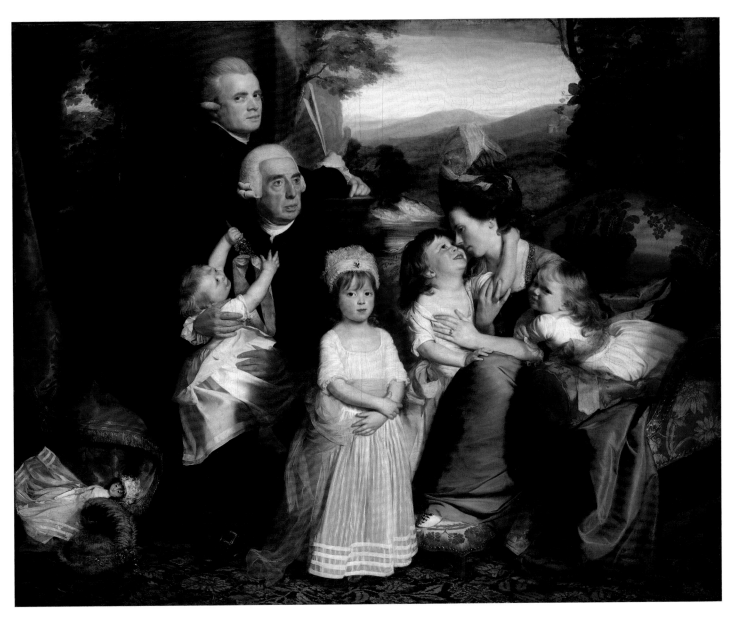

John Singleton Copley, *The Copley Family*, 1961.7.1

for you all; in a state of confusion and bloodshed no one is safe, and I greatly fear the dispute will end in the most fatal and dreadful consequences . . . if general confusion is inevitable, I hope it will not take place till you are in England."[15] From Parma the following June he wrote,

By the time this reaches you, if it please God to give me life and health, I shall be very near England; when there, I shall think of myself at home. You cannot more ardently wish to meet me than I do for the happy moment that will again bless me with the possession of so endearing a wife and children. Be not too anxious, for the time will soon arrive.[16]

Copley, dressed in a blue brocade robe and wearing a wig, stands in the background on the far left. He leans on a plinth and holds two large sheets of paper that are presumably drawings (no lines or marks are visible). His father-in-law, seated in front of him, holds young Susanna on his lap. Elizabeth, the oldest child, wearing a white dress with striped skirt and a pink sash, stands solemnly in the foreground. Susanna Copley, the artist's wife, in blue, is seated on the right on a rose-colored sofa. She has her arms around John Singleton Copley, Jr., who is dressed in a yellow frock of the type worn by young girls and boys alike. His sister Mary, in a white dress with a gold sash, plays on the sofa next to her mother. In the left foreground are a boy's brown hat with a blue feather and a doll dressed in imitation of Elizabeth, in a white dress and hat. Their clothing is very fashionable for 1776, although Mrs. Copley's hair is not quite as elaborate as the style worn by her English contemporaries.[17] A rose and green floral carpet and a rose-colored curtain on the left define the interior. Behind Copley and on the right are pillars, which mark the transition to the outdoor space. Behind the drawings that Copley holds can be seen the outline of a large urn, decorated with standing and seated figures that appear to be wearing classical drapery or robes. The distant landscape includes trees, a stream, and hills on which stands a small, church-like, two-story building.

Copley began the painting by 1 April 1776 when Samuel Curwen, a Massachusetts Loyalist living in London, visited Richard Clarke and the Copleys in their house at 12 Leicester Square, where they had moved in January 1776 and where they lived until 1783.

Passing through Leicester Square I called in at Mr. Copely's to see Mr. Clarke and the family, who kindly pressed my staying to tea, and in the meantime was amused by seeing his performances in painting. He was then at work on a family piece containing himself, Mr. Clarke, his wife and 4 Children, of all of Whom I observed a very striking likeness; at Tea was present Mr. West, a Philadelphian, a most Masterly hand in the Historic painting; author of the well known, and applauded piece now in print, called West's death of Wolfe; and taken from his painting.[18]

At this time, however, only three children were with the Copleys in London. The fourth child in the painting was apparently intended to be Clarke Copley, born in Boston in January 1775 and left with relatives when the family sailed to London. Copley learned that Clarke was left in America when he received Susanna's letter in July 1775 in Italy, saying that she was in London with three of the children. "My thoughts are constantly with you and our children. You tell me you brought *three*, but you do not say which you left behind; I suppose it was the youngest, he being too delicate to bring."[19] Clarke died in Boston in January 1776. It is thought that Copley began the group portrait before he learned of his son's death, and he retained the figure of the infant because he knew that his wife was expecting another child.[20]

This group portrait combines the best qualities of Copley's American work with features that reveal the influence of paintings he had seen since his arrival in Europe. Hallmarks of Copley's earlier style include the realism of the facial features, particularly of Richard Clarke and the children, and the skillful representation of fabrics. Also reminiscent of his American works is the artist's pose, which was modified from one used in 1768 for his portrait of John Amory (MFA). The pose was derived from Thomas Hudson's portrait of English landscape painter Samuel Scott (1731–1733, Tate Gallery, London), who leans against the back of a chair and holds a group of drawings.[21] Copley's pose is also similar to the earlier American self-portrait of John Smibert (1688–1751), seen on the far left in Smibert's painting of *The Bermuda Group* (1729–1731, YUAG). Copley undoubtedly knew this painting from visits to Smibert's Boston studio; its contents were accessible long after Smibert's death.

New with *The Copley Family* is a greater variety of brushwork, which ranges from dry and wet pastes to thin, dry, and fluid glazes. Also new is Copley's success in uniting a large number of figures in one composition. Examination of the painting with infrared reflectography indicates that the placement of the forms was done very carefully and without changes, evidence that Copley was working from

studies such as that of his wife and two children (see 1991.141.1). The organization of the painting is along several diagonals that cascade from upper left to lower right. The diagonal composition and the Italianate background, with its gently sloping hills (unlike the topography of Boston or London) and small church-like building, are reminiscent of *The Madonna di San Gerolamo* (1523, Galeria Nazionale, Parma), a popular work by the sixteenth-century Italian artist Correggio. Copley had copied this painting for an English patron during his last two months in Italy (the location of his copy is unknown).[22] (For a contemporary copy of the Correggio see Matthew Pratt's *Madonna of St. Jerome*, 1944.17.1). Other Italian paintings of madonnas with children that may have influenced Copley include Raphael's *Madonna della Sedia* in the collection of the Grand Duke of Tuscany (Figure 1).[23] Copley wrote his wife on 26 October 1774, "At the grand duke's gallery there is a wonderful collection of pictures, statues, bas-reliefs, and gems. At the palace there is a great collection of paintings also, of the best the arts have ever produced: in this the sweet picture of the Virgin with Jesus, by Raphael, delighted me very much, — I mean the one that hung over our chimney."[24] He discussed the painting again on 14 March 1775 with his half-brother Henry Pelham, suggesting that Pelham look at John Smibert's copy (now unlocated).[25] It is also possible that while he was in Florence, Copley saw Raphael's *Niccolini-Cowper Madonna* (NGA), acquired at about this time by George, 3rd Earl Cowper, a friend of the Grand Duke of Tuscany. English artists who wished to copy pictures in the duke's collection applied to Cowper to arrange permission.[26] Although Copley followed this procedure in June 1775 to request permission to copy the *Madonna della Sedia* for Ralph Izard and for his wife (he decided eventually not to make these copies), he does not mention the newly acquired Madonna.[27] Copley also saw an unidentified Madonna and Child by Guido Reni in Rome; he tried but was not able to get permission to copy it.[28] In addition, he came upon a *Holy Family* by Raphael in the collection of the King of Naples in January 1775.[29]

The influence of these paintings on Copley is particularly noticeable in Mrs. Copley's pose. At the same time that the group portrait was being painted, Mrs. Copley was apparently her husband's model for the figure of the Madonna in a *Nativity* (Figure 2). Her features, seen in profile in the group portrait, are very similar to those of the Madonna.[30]

Fig. 1. Raphael, *Madonna della Sedia*, oil on wood panel, c. 1513–1514, Florence, Galleria Pitti [photo: Scala/Art Resource, New York]

Jules Prown has suggested that Copley's use of an allusion to the Madonna in his group portrait shows the influence of Benjamin West, who used a madonna-like pose for the image of his wife in *The West Family* (1772, Yale Center for British Art, Paul Mellon Collection, New Haven). "This conflation of a family picture and a *Nativity* including his own wife and child in Copley's oeuvre . . . at the moment when he first arrived in England, admiring and emulating West, suggests that Copley's artistic imagination was particularly stimulated by West's family picture."[31] West chose similar poses for other family groups, notably for the figure of Mary Izard in *Arthur Middleton, His Wife Mary Izard, and Their Son Henry Middleton* (1771–1772, Collection of Dr. Henry Middleton Drinker) and for that of Mrs. West in *Mrs. West with Raphael West*, of which there were four versions, including one of about 1773 (Yale Center for British Art, Paul Mellon Collection, New Haven).[32] Also, West modeled his double portrait *Mrs. West with Raphael West* on Raphael's *Madonna della Sedia*, which he had seen in Florence in 1761–1762.[33] Prown notes about *The West Family* that "an intimate family scene is informed not only with the larger theme of the Ages of Man but the specifically Christian themes of the Holy Family and of the Nativity, of birth as the immanent manifestation of the Divine in the affairs of men."[34] Margaretta Lovell

offers a similar interpretation, suggesting that these artists incorporated religious images "into a context of modern domestic life" and have "appropriated for their wives—in their role as mother—the supreme example of female virtue."[35]

Copley's letter to Henry Pelham of 14 March 1775 suggests that he saw the issue differently, as one regarding the use of familiar models for thematic paintings. He told Pelham about the practice of using live models for images in such works.

By making use of a Model for the heads you will naturally vary your faces agreable to your Models, and though I would not make the heads like the model, that is, not such a likeness as I would make in a portrait, yet should they be like to the greatest degree I should not think it a matter to be objected to.... Chusing such Models as are most agreable to the several carracters you mean to paint, you will procure that variety in your Works that is so much admired in the first Works of Art.[36]

Perhaps in his view it was his wife's experience with motherhood that informed the pose of the Madonna in his *Nativity*.

Two baroque family group portraits painted in England in the early seventeenth century—Peter Paul Rubens' *Deborah Kip, Wife of Sir Balthasar Gerbier, and Her Children* (1630, NGA) and Anthony Van Dyck's *The Five Eldest Children of Charles I* (1637, Collection of Her Majesty Queen Elizabeth II)—as well as Joshua Reynolds' recent portrait of Lady Cockburn and her three sons (1773, National Gallery of Art, London) may also have influenced the concept and composition of *The Copley Family*. The baroque group portraits were well known to mid-eighteenth-century English artists and connoisseurs and, like Copley's picture, depict family groups, with children, in indoor-outdoor settings. Frederick Prince of Wales acquired *Balthasar Gerbier and Family*, a seventeenth-century copy of Rubens' composition (Figure 3), in 1749. This painting, a wider version of Rubens' portrait that includes Gerbier, was then attributed to Van Dyck but is now unattributed.[37] George III purchased Van Dyck's group of Charles I's children (Figure 4) from a private collection in 1765.[38] Copley might have seen these works in London in July 1774, when with West he visited "the queen's palace, where I beheld the finest collection of paintings I have seen, and, I believe, the finest in England."[39] Rubens' original

Fig. 2. John Singleton Copley, *The Nativity*, oil on canvas, 1776–1777, Boston, Museum of Fine Arts, Ernest Wadsworth Longfellow Fund [photo: Courtesy, Museum of Fine Arts, Boston]

Fig. 3. Unknown artist after Peter Paul Rubens, *Balthasar Gerbier and Family*, oil on canvas, c. 1635, London, Royal Collection [reproduced by gracious permission of Her Majesty Queen Elizabeth II]

Fig. 4. Anthony Van Dyck, *The Five Eldest Children of Charles I*, oil on canvas, 1637, London, Royal Collection [reproduced by gracious permission of Her Majesty Queen Elizabeth II]

(NGA) was also in England at the time, in a private collection. These paintings may also have been known to Copley through reproductive engravings. Reynolds' portrait of Lady Cockburn and her three sons was exhibited at the Royal Academy of Arts in the spring of 1774, before Copley's arrival from Boston. Like Copley's painting, Reynolds' work is a depiction of motherhood that incorporates references to earlier works of art, in this case to images of Charity. If Copley had been able to see this painting, perhaps when he visited Reynolds' studio on 15 July 1774, it may have influenced his grouping of Mrs. Copley and her children.[40]

Copley sent *The Copley Family* to the spring exhibition of the Royal Academy of Arts in 1777. Its only review appeared in both the *London Packet, or New Lloyd's Evening Post* for April 25–28 and the *Morning Chronicle, and London Advertiser* for April 26. The reviewer was critical of Copley's control of light and shade.

Mr. Copley, from the size of his family piece, is likely to be as much the subject of observation in the rooms as any artist who has exhibited; as his picture (No. 61) has, in some of its parts, great merit, it is a pity that the whole effect should be destroyed from a want of proper proportion of light and shade. Several of the figures, particularly that of the lady and old gentleman, are well painted. The face of the infant in the lap also has great merit; but the arm round the mother's neck appears to be rather unnaturally turned, and extravagantly long. The figure of the gentleman, leaning behind with some plans in his hand, seems also to be oddly placed, and not properly one of the family. Add to this the settee, the carpet, and the prospect through the window, are all so glaring, that the effect of the figures is greatly destroyed; and, after regarding the picture for some time, it is difficult for a beholder to guess which object the painter meant to make his main subject. The *portrait of a gentleman*, in the little room fronting the door, is also in part liable to the same objection, the background is not sufficiently kept under.[41]

This aspect of technique—balancing the elements of a painting to retain the focus on the central figures—had concerned Copley since his arrival in England. He wrote Henry Pelham from London on 17 August 1774 with advice based on pictures that he had recently seen.

Be carefull as you go towards the bottom of your Canvis to mannage your objects that they do not take the eye. Scumble them down so that when you Vew the Picture the Center shall predominate. I think in Diana's figure in your Room you have an Example, observe her leggs how they seem to run out of observation, from her head and breast Downwards how gradualy her figure seems to lose it self.[42]

Copley had not learned this aspect of painting in America, where his primary examples of European art were engravings.

After the Academy exhibition Copley hung the painting in his exhibition room, where Samuel Curwen saw it when he visited on 19 December 1780. "We departed for Mr. R. C[larke's] home in Leister square. Found him at home, after some time invited into picture room, wherein were 2 Exhibition pictures, Brooke Watsons wonderful deliverance from a great shark . . . , the other picture Copeley's own family containing 6 persons, himself, wife, 3 children and Mr. Clarke his father in law."[43] When the family moved to 24 George Street, London, in 1783, "It was placed by his own hand, in the position it retained for nearly a century, over the fireplace in the dining-room in George Street," according to the artist's granddaughter Martha Amory.[44] In 1789, when the painting was to be engraved by Robert Thew (1758–1802), Copley made a small oil (Figure 5), which represents the entire composition and is the same size as the engraving. The small painting was in Thew's possession at his death.[45] The plate was left unfinished (Figure 6, proof print, NGA).[46] Mrs. Copley sent the oil to her daughter Elizabeth Greene in Boston on 31 August 1804.

We have sent . . . the sketch of the family picture, the print remains in the state in which Mr. Thew left it at his death . . . should it ever be thought worth wile to finish the plate, you must only let the sketch again cross the Atlantic in the meantime we shall be happy in the pleasure it affords you, and the rest of our dear Friends; it contains the best likeness of my departed and dearly valued Father.[47]

The oil copy and print differ from the large painting in details of Mrs. Copley's dress and hair, in the details of the sofa, the left foreground and background, and in the dress of Mary, the girl on the sofa.

The Copley Family was well known in nineteenth-century England. Allan Cunningham remarked that it had a natural look and "some very fine colouring," and it was reviewed with praise when it was exhibited at the International Exhibition in London in 1862.[48] The artist's granddaughter Martha Amory purchased the painting from the estate of her uncle John Singleton Copley, Jr., Lord Lyndhurst, in 1864 and brought it to Boston. In 1872 it was rescued from the great Boston fire of 9–10 November, "having been transported by hand with great difficulty, on account of its size, and

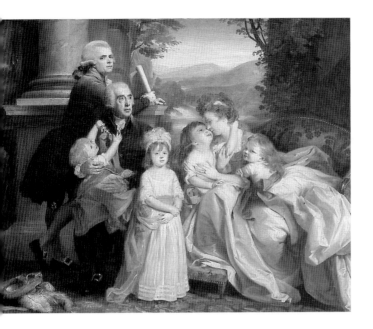

Fig. 5. John Singleton Copley, *The Copley Family*, oil on canvas, 1789, Boston, Museum of Fine Arts, Henry H. and Zoë Oliver Sherman Fund and Gift of Daniel and Robert Amory [photo: Courtesy, Museum of Fine Arts, Boston]

Fig. 6. Robert Thew after John Singleton Copley, *The Copley Family* (unfinished), stipple engraving, Washington, National Gallery of Art, Gift of Mr. Copley Amory, Jr., 1961.11.1

placed under the care of a gentleman who kindly offered to harbor it during that calamitous night."[49] Since that time it has frequently been on view in museums and has become familiar to an American public as one of Copley's most endearing paintings.

<div align="right">EGM</div>

Notes

1. The painting was conserved in London after the 1864 Lyndhurst sale, according to the essay on John Singleton Copley in *DNB* 4:1105.

2. The annotated copy of Christie's *Catalogue of the Very Valuable Collection of Pictures, of the Rt. Hon. Lord Lyndhurst, deceased* at the Boston Athenaeum indicates that "Clarke" was the purchaser, as does the *Art-Journal*, London, 1 April 1864, 120. The initials *BA* that are entered next to the lot number indicate that it was purchased for Martha Babcock Amory. Redford 1888, 2:20, thought the painting was bought in, but James Hughes Anderdon, who was at the sale, noted in his copy of the catalogue (Royal Academy of Arts) that there was a round of applause after the painting was auctioned (Prown 1966, 2:404). News of the sale appeared in the (Boston) *Daily Advertiser*, 19 March 1864. For Mrs. Amory's dates see Linzee 1917, 2:766.

3. For Charles Amory's dates see Linzee 1917, 2:766; he placed the painting on loan at the Museum of Fine Arts, Boston.

4. Edward Linzee Amory continued the loan of the painting to the Museum of Fine Arts from 1898; his dates are in Linzee 1917, 2:766.

5. For Copley Amory's dates see Linzee 1917, 2:795, and the *New York Times*, 18 April 1960, 29 (obituary).

6. The birth date of Copley Amory, Jr., is in Linzee 1917, 2:796; his death date was provided to the author by Walter Amory on 19 November 1990.

7. Birth and death dates are from Linzee 1917, 2:796, or have been provided by family members.

8. Graves 1913, 1:206, no. 51, "Family Portraits," lent by Lord Lyndhurst. The review in the *Times*, 1 May 1862, 11, described the painting as "the group of Copley portraits (51) in which the painter has represented his father, in the background himself, and his wife and children on the right." Mrs. Amory was wrong when she wrote that the exhibition was in Manchester.

9. Perkins and Gavin 1980, 41; Yarnall and Gerdts 1986, 825, list the second exhibition under "Museum of Fine Arts, Boston," on whose behalf it was held.

10. Cook 1888, 160; MFA 1890, 46; MFA 1892, 15, no. 140; MFA 1895, 17, no. 150; *MFA Bulletin* 1903, 18; *MFA Handbook* 1906, 102; Addison 1924, 6–7; letter from Diana Hallowell, MFA, 15 August 1961 (NGA).

11. Gallery records; see also Walker and James 1943, 22 and pl. 11, and Walker 1951, 16, 42, pl. 5.

12. *Curwen* 1972, 1:102, entry for Friday, 29 December 1775: "W. Cabot... brought account of Mr. Richard Clarke's arrival from Boston, the vessell had a short passage of 21 days."

13. *Copley-Pelham Letters*, 256.

14. Amory 1882, 33.

15. Amory 1882, 40, letter from Rome dated 4 December 1774.

16. Amory 1881, 55, letter of 12 June 1775.

17. Nathalie Rothstein, "What Silk Shall I Wear?:

Fashion and Choice in Some 18th and Early 19th Century Paintings in the National Gallery of Art," lecture, NGA, 16 September 1990.

18. *Curwen* 1972, 1:132.

19. Amory 1882, 63.

20. Prown 1966, 2:262.

21. Prown 1966, 1:figs. 220–221; Copley knew the portrait from the mezzotint by John Faber, Jr.

22. Prown 1966, 2:253–254, 443.

23. Brown 1983, 23; on the painting see Dussler 1971, 36 and pl. 84. For a discussion of the Grand Duke's collection and its popularity among the English in Italy see Millar 1967, especially 6–7, 10, 18.

24. Copley to his wife, quoted in Amory 1882, 38, and partially quoted in Prown 1966, 2:248.

25. *Copley-Pelham Letters*, 304; he also mentioned the painting to his mother on 25 June 1775; *Copley-Pelham Letters*, 331.

26. On the history of this painting see Shapley 1979, 1:389–391, and Millar 1967, 27. The exact date of Cowper's acquisition is not known.

27. Letter to Susanna Copley, 9 June 1775, in Amory 1882, 53.

28. *Copley-Pelham Letters*, 331, to his mother, 25 June 1775.

29. Letter to his sister, 28 January 1775; Prown 1966, 2:251, quoting Amory 1882, 44. Perhaps this was Raphael's *Madonna del Divin' Amore* (c. 1518, Museo Nazionale, Naples), which was in the Palazzo de Giardino, Naples, Capodimonte by 1680; see Dussler 1971, 49 and pl. 104.

30. Prown 1966, 2:263–264 and figs. 347–349.

31. Prown 1986, 281.

32. Von Erffa and Staley 1986, 530–532, no. 661, repro.; 461–462, no. 546, repro.; 457–459, nos. 535–538, repros.

33. Brown 1983, 17–18; Von Erffa and Staley 1986, 458.

34. Prown 1986, 278.

35. Lovell 1987, 259–260.

36. *Copley-Pelham Letters*, 304.

37. On Rubens' painting and its versions and engravings, and the history of their ownership see Stechow 1973, 6–22, and Whitfield 1973, 23–31.

38. Millar 1963, 1:99; 2:pl. 74.

39. Letter to his wife dated 21 July 1774, in Amory 1882, 28.

40. The author is grateful to Allen Staley for the suggestion that Reynolds' portrait was a possible influence on Copley's family group. On the painting see Wind, "Charity," 1938, 322–330; Davies 1959, 84–85; Penny 1986, 259–260, no. 88; it is reproduced in Waterhouse 1973, unpaginated, pl. 70. For Copley's visit to Reynolds' studio see *Copley-Pelham Letters*, 226.

41. The *Portrait of a Gentleman* has not been identified; see Prown 1966, 2:387.

42. *Copley-Pelham Letters*, 240–241.

43. *Curwen* 1972, 2:701.

44. Amory 1882, 79.

45. Prown 1966, 2:263, 415 and fig. 346; Troyen 1980, 66–67, no. 12, repro.

46. Prown 1966, 2:414. The proof print at the National Gallery of Art [1961.11.1], the gift of Copley Amory, Jr.,

is inscribed on the plate "J. S. Copley R.A. pinx / London Publish'd Novr 25 1789 as the Act directs / Rt. Thew Sc." The image measures approximately 51 by 62 cm.

47. Quoted in Amory 1882, 80, misdated; the original is on deposit at the Massachusetts Historical Society, Boston.

48. "The Pictures at the International Exhibition — No. I." *Times* (London) (1 May), 11.

49. Amory 1882, 80.

References

1777 "Exhibition of the Royal Academy." *London Packet, or New Lloyd's Evening Post*, 25–28 April: 1.

1777 "Exhibition of the Royal Academy." *Morning Chronicle, and London Advertiser*, 26 April: 2.

1832 Cunningham: 5:178–179.

1867 Tuckerman: 79.

1873 Perkins: 20–21, 48–49, 134.

1882 Amory: 12, 23, 77–80, 106–107, 240, 262–263, 438.

1888 Cook: 3:159, repro., 160.

1890 MFA: 46.

1892 MFA: 15, no. 140.

1895 MFA: 17, no. 150

1903 *MFA Bulletin*: 18

1905 Isham: 37–38, repro. 35.

1906 *MFA Handbook*: 102, repro.

1910 Bayley: 35.

1915 Bayley: 35–36, 79, 101–102.

1924 Addison: 6–7

1930 Bolton and Binsse, "Copley": 116.

1938 Parker and Wheeler: 8–9.

1966 Prown: 1:61, 2:262–263, 373n, 387, 403–404, 414–415, and fig. 344.

1972 *Curwen*: 1:132, 2:701.

1980 Wilmerding: 46, color repro. 47.

1981 Williams: 24, 30, color repro. 44–45.

1984 Walker: 384, no. 545, color repro.

1986 Prown: 281, 286 n. 32, repro. 279.

1987 Lovell: 256, repro., 259.

1988 Wilmerding: 54, color repro. 55.

1963.6.1 (1904)

Watson and the Shark

1778
Oil on canvas, 182.1 × 229.7 (71 3/4 × 90 1/2)
Ferdinand Lammot Belin Fund

Inscriptions
Signed center left, inside boat: JSCopley. P. 1778—

Technical Notes: The support is a twill canvas primed with a white ground. A small section of the original, unprimed tacking edge, with its original tack holes, was flattened during the lining process and can be seen along the lower border. Infrared reflectography shows that the design was blocked out in a painted outline and was sub-

sequently refined. (X-radiography reveals little because a thick white paint was applied to the back of the lining canvas after restretching.) Figures, painted wet-in-wet within the predetermined compositional framework, have thin transparent shadows; the flesh is worked in opaque colors. Pentimenti show that contours of Watson's right arm, the right arm of the old man in the boat, and the back of the man in the left side of the boat were reduced during the final stages of painting. In addition, the hands reaching towards Watson and the sail in the top left corner were substantially shifted. The sea and sky were added after the figures were introduced, and occasionally the figures and sea are blended. The sea and shark are painted in thin washes, with crests of waves added in impasto.

There are three vertical cracks in the sky. The generally thin paint layer is abraded, especially in the sky. There is minor retouching in some of the figures, including Watson's right arm and in the boat's rudder, the waters around the shark, and the landscape around the heads of the seated man dressed in red and white stripes and of the standing figure of the black sailor. Most of the ship's rigging in the background has been strengthened. The previous varnish was removed in 1963.

Provenance: Brook Watson [1735–1807], London and East Sheen, Surrey; bequeathed to Christ's Hospital, London.[1]

Exhibited: Royal Academy of Arts, London, 1778, no. 65. *Art Treasures of the United Kingdom*, Manchester, 1857, unnumbered.[2] *American Painting From the Eighteenth Century to the Present Day*, Tate Gallery, London, 1946, no. 49. *The First Hundred Years of the Royal Academy, 1796–1868*, Royal Academy of Arts, London, 1951–1952, no. 420. *Copley*, 1965–1966, no. 68a (shown only in Washington). *Royal Academy of Arts Bicentenary Exhibition, 1768–1968*, Royal Academy of Arts, London, 1968–1969, no. 505. *Bilder aus der Neuen Welt, Amerikanische Malerei des 18. und 19. Jahrhunderts*, Orangerie des Schlosses Charlottenburg, Berlin; Kunsthaus, Zurich, 1988–1989, no. 7. *Facing History: The Black Image in American Art, 1710–1940*, CGA; The Brooklyn Museum, New York, 1990, unnumbered. *John Singleton Copley's Watson and the Shark*, The Detroit Institute of Arts; NGA; MFA, 1992–1993, no cat.[3]

Watson and the Shark depicts the dramatic rescue of fourteen-year-old Brook Watson from a shark that attacked him while he was swimming in the harbor of Havana, Cuba, in 1749. Copley painted the episode almost thirty years later and exhibited the picture at the Royal Academy of Arts in 1778 to much acclaim.[4] Since then *Watson and the Shark* has been recognized as an important contribution to the development of English history painting. It has been described as an early Romantic image of a man pitted against the forces of nature. Recent writers have demonstrated that the artist followed contemporary English art theory in borrowing images

from works by other artists. They have noted the theme of rescue from the sea, particularly as an allegory for Christian concepts of resurrection and salvation. And they have suggested that the painting contains hidden commentary on the politics of the era of the American Revolution and on the institution of slavery. These interpretations, which often ascribe to Copley a particularly American viewpoint, rightly credit the artist for his skill and invention but do not credit Brook Watson with a role in the making of the painting. Although no documentation exists in the form of an invoice, letter, or diary entry, it is very likely that Watson commissioned the work, and it is important to understand the subject from his viewpoint, a perspective that reiterates the theme of salvation.

Who was Watson? Born in Plymouth, England, in 1735, he was orphaned and sent to Boston, Massachusetts, to be cared for by a relative named Levens, who was a merchant with ships that traded in the West Indies.[5] In 1749, one of Levens' ships, with the fourteen-year-old Watson on the crew, docked in the harbor at Havana. While some of the sailors waited to take the captain ashore, Watson went swimming. A shark attacked, tearing off his right leg below the knee before he could be rescued by fellow sailors. According to an early biographer, the accident "obliged him to quit the profession of his choice, and he turned his mind to the acquiring of instruction, adapted to mercantile pursuits."[6] He returned to Boston and took a job on a schooner whose captain was a supplier of provisions to the British army at Fort Lawrence, Nova Scotia. Watson settled in Canada, learned to walk with a wooden leg, and became a merchant. In 1759 he moved to London, where he continued his mercantile career.

Watson and Copley met through relatives of the artist's wife Susanna. Her uncle Joshua Winslow had employed Watson at Fort Lawrence in 1755, when Winslow was commissary to Robert Monckton's troops.[7] In the early 1770s her father Richard Clarke was head of one of the Massachusetts firms that received the tea shipped to Boston by the British East India Company. During the summer of 1773, Watson and her brother Jonathan Clarke in London coordinated plans to ship the tea.[8] This was the tea that was dumped into the harbor during the Boston tea party that December, in protest of British taxes. Copley contacted Jonathan Clarke after his arrival in England in July 1774, writing his half-brother Henry Pelham on 11 July,

Sunday Even'g I arrived at the New England Coffee House. and soon found Brother Clarke, who is very well....July 15th. I have been to see my friend Mr. West...on Wednesday he introduced me and Brother Clarke to Sr. Josha. Renolds's....I am sorry Brother Clarke and I are so distant from each other, but he is in the City and I at the Coart End of the Town, about two Miles....I am within a few Doors from Mr. West's, but shall see Mr. Clarke every Day.[9]

Copley wrote his half-brother on 5 August that "you cannot Immagine how much it adds to my pleasure having Brother Clarke here; he is so used to the place that I am already allmost innectated into all the manners and Customs of the City."[10] Perhaps the artist met Brook Watson during this two-month stay in London. He mentioned to Pelham on 17 August: "To Morrow I have an invitation to breakfast with Sr. Joshua Reynolds ..., Dine with a Mr. Watson, etc., etc.."[11]

Copley's and Watson's paths could not have crossed again until 1776. Copley returned to London from Italy in October 1775, by which time Watson was in Canada, where his merchant activities hid his Loyalist political sympathies.[12] He returned to England in early January 1776, accompanying American prisoner Ethan Allen, who wrote that he

was put under the power of an English Merchant from London, whose name was Brook Watson: a man of malicious and cruel disposition, and who was probably excited, in the exercise of his malevolence, by a junto of tories who sailed with him to England;...All the ship's crew...behaved toward the prisoners with that spirit of bitterness, which is the peculiar characteristic of tories, when they have the friends of America in their power.[13]

Watson returned to Canada in the spring of 1776 with Jonathan Clarke.[14] Further details of his activities in 1776–1777 are unknown.

Copley probably began *Watson and the Shark* sometime in 1777, completing it in time for the spring exhibition of 1778 at the Royal Academy. On 17 April 1778, while *Watson and the Shark* was on exhibition, the *Morning Chronicle, and London Advertiser* published a letter that fully described the shark attack of 1749. The description, which must have been Watson's, explains the precise actions of the sailors, the bloody flesh of the boy's leg, the harbor setting, and the activities of the figures on the ship in the left background. It is undoubtedly the story that Watson told Copley about the event. It clarifies the main theme of the painting: rescue and salvation.

Brook Watson, Esq., merchant, now resident in the city of London, being at the Havannah, when a youth, in a

merchant ship, amusing himself one day by swimming about it, whilst it lay at anchor, and being at the distance of about two hundred yards from it, the men in the boat, who were waiting for the Captain to go on shore, were struck with horror on perceiving a shark making towards him as his devoted prey. The monster was already too near him for the youth to be timely apprized of his danger; and the sailors had the afflicting sight of seeing him seized and precipitated down the flood with his voracious assailant, before they could put off to attempt his deliverance. They however hastened towards the place where they had disappeared, in anxious expectation of seeing the body rise. In about two minutes they discovered the body rise at about a hundred yards distance, but ere they could reach him, he was a second time seized by the shark, and again sunk from their sight. The sailors now took the precaution to place a man in the bow of the boat, provided with a hook to strike the fish, should it appear within reach, and repeat its attempt at seizing the body. In less than two minutes they discovered the youth on the surface of the water, and the monster still in eager pursuit of him; and at the very instant he was about to be seized the third time, the shark was struck with the boat hook, and driven from his prey. This is the moment the ingenious artist has selected for the distressing scene, and has given the affecting incident the most animated representation the powers of the pencil can bestow. Suffice it to say, in regard to the singular fate of Mr. Watson, the shark seized him both times by the right leg; in the first attack, all the flesh was stripped off the bone from the calf downwards; in the second, the foot was divided from the leg by the ancle. By the skill of the surgeon, and the aid of a good habit of body, after suffering an amputation of the limb a little below the knee, the youth who was thus wonderfully and literally saved from the jaws of death, received a perfect cure in about three months.

Although earlier writers have assumed that Copley painted *Watson and the Shark* on his own, it was more likely a commission, as Watson's later ownership of the painting suggests. As patron, Watson would have chosen the theme of the painting, that of individual salvation achieved by triumph over adversity.[15] The theme would have appealed to Copley at the beginning of a new career in England and is one that is central to numerous religious autobiographies and autobiographical journals written in seventeenth- and eighteenth-century England and America. Early models of this genre include *Grace Abounding to the Chief of Sinners* (1666), which was the autobiography of John Bunyan, author of *The Pilgrim's Progress* (1678), and the journal of Quaker leader George Fox (1694).[16] The recounting of a physical or emotional trial and a subsequent change of direction in life is central to these works, as it was to the equally influential fictional model of salvation, Daniel Defoe's *The Life and*

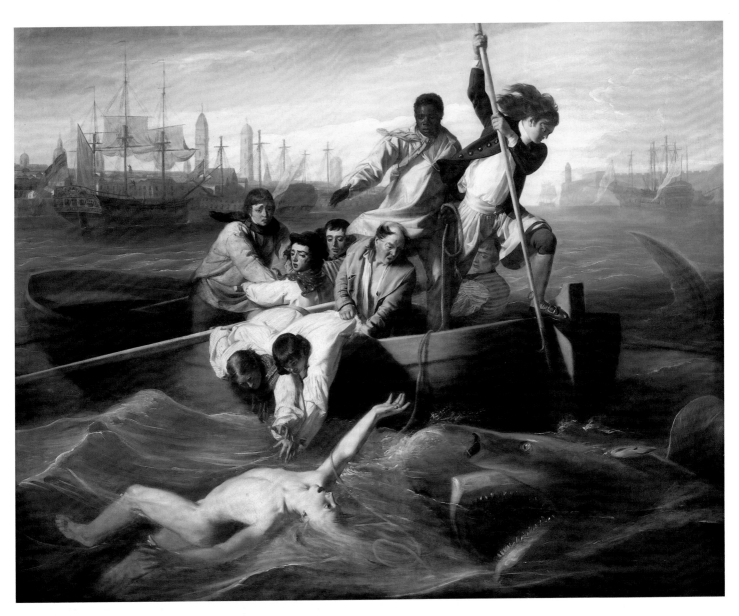

John Singleton Copley, *Watson and the Shark*, 1963.6.1

Strange Surprizing Adventures of Robinson Crusoe (1719). The practice of writing personal stories of salvation and religious conversion continued throughout the eighteenth century. Watson, after the trauma of the event, considered his life a triumph over adversity. Not only was he a successful merchant in Canada and London, but four years after *Watson and the Shark* was painted, he served as commissary general to Guy Carleton in New York, where he was assigned the task of finding transportation to Canada for Loyalists who flocked to the British army for protection. In politics he was allied with the merchants in the City of London, who in 1784 elected him to Parliament, where for the next decade he actively supported William Pitt, son of the first Earl of Chatham. Watson became a director of the Bank of England, was Lord Mayor of London in 1796–1797, and served as chairman of the Corporation of Lloyds of London from 1796 to 1806.[17] He was made a baronet in 1803, the year that Robert Dighton, Jr., depicted him in a satirical engraving that clearly shows his wooden leg.[18] That year he bequeathed *Watson and the Shark* to Christ's Hospital, London, the Royal Hospital established in 1553 for the care and education of orphans.[19] In his will he stated that he hoped "the said worthy Governors . . . will allow it to be hung up in the Hall of their Hospital as holding out a most usefull Lesson to Youth."[20] The label that forms part of the frame alludes to the theme of the painting, that Watson's life shows "that a high sense of integrity and rectitude with a firm reliance on an over ruling providence united to activity and exertion are the sources of public and private virtue and the road to honours and respect."

In his pictorialization of this event Copley was influenced by Benjamin West, whose history painting *The Death of General Wolfe* (1770, National Gallery of Canada, Ottawa) caused artists and patrons to rethink the depiction of contemporary events. Copley first saw this painting in the summer of 1774, writing his half-brother Henry Pelham in Boston on 15 July, "I have seen Mr. West's Death of General Wolf, which is sufficient of itself to Immortalize the Author of it."[21] At the time that Copley was painting *Watson and the Shark*, West was probably at work on his painting *The Battle of La Hogue* [1959.8.1], which depicts a similar theme of rescue at sea, although on a grander scale.[22] Copley's debt to West particularly appears in the representation of the event in terms of the emotions of terror and awe, elements of response that Edmund Burke in-

cluded in his definition of the sublime in his *Philosophical Enquiry into the Origin of Our Ideas of the Sublime and Beautiful* (1757). West had recently begun to depict subjects with this psychologically powerful aesthetic in mind, notably his *Saul and the Witch of Endor* of 1777 (Wadsworth Atheneum, Hartford). Burke's treatise "legitimized and popularized the evocation of terror and related responses as a goal of a work of art, and led a generation of artists to an obsession with awe, horror, and terror."[23]

While planning the composition of *Watson and the Shark*, Copley borrowed motifs from works by West and other artists. For the setting of the harbor, which he had never seen, he relied on an engraved view, probably the recent engraving by Peter Canot of *A View of the Entrance of the Harbour of the Havanna taken from within the Wrecks*, based on a drawing by Elias Durnford and published by Thomas Jeffreys in London in 1764. (Copley's pictorial or other sources for the shark, which resembles a tiger shark, a species found in Havana harbor, are unknown.)[24] For the composition Copley turned to images of men in boats by late Renaissance and baroque painters Raphael and Peter Paul Rubens, especially their images *The Miraculous Draft of the Fishes* and *Jonah and the Whale*, both of which are appropriate sources for the theme of salvation.[25] In Christian iconography the Old Testament narrative of Jonah was seen as a presage of the New Testament story of the resurrection of Christ, since both events involved the number three: Jonah was in the whale for three days, and Christ rose from the dead on the third day. Watson, according to his own narrative, was rescued as he came to the surface a third time. Rubens' composition of *Jonah and the Whale*, which was engraved by Philippe Joseph Tassaert, was one of the lower panels of the altarpiece that he painted in 1618–1619 in the Church of Notre Dame for the Fishermen's Guild of Mechelen (Malines), Belgium. The central image of the altarpiece is *The Miraculous Draft of the Fishes*. The scene is described in the New Testament: arriving at the Sea of Galilee, Jesus instructed four fishermen to let their nets out again after an unsuccessful night of fishing. After they pulled in large numbers of fish, Jesus called them to be his disciples as "fishers of men." Copley owned an example of Schelte à Bolswert's engraving of this subject, although it is not known when he acquired it. A more stately, less dramatic image of the same subject is Raphael's *Miraculous Draught of the Fishes* (Collection of Her Majesty Queen Elizabeth II), one of the Renaissance mas-

Fig. 1. John Singleton Copley, *Harpooner and Oarsman*, black and white chalk on green-gray paper, The Detroit Institute of Arts, City of Detroit Purchase [photo: copyright The Detroit Institute of Arts]

Fig. 3. John Singleton Copley, *Two Oarsmen*, black and white chalk on green-gray paper, The Detroit Institute of Arts, City of Detroit Purchase [photo: copyright The Detroit Institute of Arts]

Fig. 2. John Singleton Copley, *Head of Figure on the Far Left*, black and white chalk on green-gray paper, The Detroit Institute of Arts, City of Detroit Purchase [photo: copyright The Detroit Institute of Arts]

ter's large preparatory drawings, or cartoons, which Copley might have seen, since it was then owned by George III. Or, again, he may have relied on an engraving, such as that by Nicholas Dorigny. The figure in the bow of the boat is similar in pose to images of St. Michael overcoming the dragon, including those by Raphael (1518, Louvre, Paris) and more recently by Benjamin West, who painted the theme in 1776 (Trinity College, Cambridge, England) and 1777 (James Ricau).[26] And the figure of Watson bears striking similarities to that of the child in Raphael's *Transfiguration* (The Vatican, Pinacoteca), which Copley told his wife was "allowed to be the greatest picture in the world." He also commented on the painting in letters to Henry Pelham from Italy, when he was working on his *Ascension* (1775, MFA).[27] The use of these images underscores the interpretation that Watson and Copley saw the painting of *Watson and the Shark* as a modern tale of salvation.[28]

Four drawings for details of *Watson and the Shark* (The Detroit Institute of Arts) indicate that Copley reversed the composition as he designed the painting. *Harpooner and Oarsman* (Figure 1) shows the man with the boat hook on the left. *Head of Figure on the Far Left* (Figure 2) and *Two Oarsmen* (Figure 3) depict individual sailors. *Rescue Group (Eight Men)*

Fig. 4. John Singleton Copley, *Rescue Group (Eight Men)*, black and white chalk, squared and numbered in red chalk, on green-gray paper, The Detroit Institute of Arts, City of Detroit Purchase [photo: copyright The Detroit Institute of Arts]

(Figure 4) delineates the group in the boat and is squared for transfer, a process that involved drawing a grid of equidistant lines on the image to be copied, as a way to permit the artist to transfer the details into another work. Copley drew a similar grid on a preparatory drawing for *The Ascension* (MMA). A fifth drawing, *Head of Brook Watson* (Figure 5), appears from its pattern of outline and shading to be based on a sculpture. The planes of light and shadow are those of a smooth, hard surface. The drawing closely resembles the figure of the younger boy in the classical Greek statue of Laocoon and his sons. Copley admired the sculpture and acquired a cast of it in Rome in 1775, writing to his wife about his purchase of this and other casts, "I shall possess all I would recommend an artist to study; for it is not the number that he studies, but a thorough understanding of the best and the principles of art, which can alone make him great."[29]

Recent examination of the painting with infrared reflectography reveals Copley's underdrawing and thus his changes as he sought to personalize the emotional reactions of the rescuers. Although the underdrawing agrees in general with the

Fig. 5. John Singleton Copley, *Head of Brook Watson*, black and white chalk on gray-blue paper, Boston, Museum of Fine Arts, Gift of Thomas Inglis [photo: Courtesy, Museum of Fine Arts, Boston]

finished work, some details differ, confirming that the Gallery's painting was based directly on Copley's study *Rescue Group (Eight Men)* (Figure 4). Underneath the central older sailor is a younger man who is positioned about a half head higher in the composition (Figure 6). In the figure of the sailor who reaches from the boat on the far left, his right arm and elbow were initially higher in relationship to the oar (Figure 7). The scarf and coattails of the standing sailor on the far left were also repositioned. The scarf is now above his shoulder, and in both the drawing and the infrared image, the scarf blows across his upper arm, and his coattail flaps farther behind him (Figure 8). Some of the changes from the drawing to the painting show that Copley varied the appearances of the sailors, making one an older man and, in the example of the black sailor, changing the race of another. (The process of the latter change is not recorded in the underdrawing, however.)

Copley also gave the figures a range of emotional responses to the event. The expressions he used appear to be based on the work of French academic painter Charles LeBrun, whose depictions of the human figure in narrative contexts were much admired by eighteenth-century painters. Examples of LeBrun's representations of emotional expressions were available in English in translation from the *Conférence de M. Le Brun sur l'expression générale et Particulière* (Paris, 1698), including John Williams' *A Method to learn to Design the Passions* (London, 1734).[30] They were also reproduced as illustrations for drawing manuals. The introductory essay of *The Compleat Drawing-Master: containing many curious specimens . . . neatly Engraved on Copper-Plates, after the Designs of the greatest masters*, cites LeBrun: "The Eyebrow, according to Mr. Le Brun, is the principal seat of Expression, and where the Passions make themselves most known." At the same time the writer pointed out that Roger de Piles was quoted as saying that "the head . . . contributes more to the Expression of the Passions, than all the other Parts of the Body put together. These separately can only share some few Passions, but the Head expresses them all."[31] While Copley's sailors do not exactly duplicate the various passions as illustrated in book plates, some of the images are very close and help explain the artist's intentions in the painting. One of the images in this manual—of a man with lowered brow, directed glance, and an open mouth, labeled "Attention" (Figure 9)—closely resembles the face of the man with the boat hook at the prow

of the boat. Another, of a man with knit eyebrows, his eyeballs set low in the sockets, and the corners of his mouth turned downward, labeled "Horrour" (Figure 10), is similar to the figure of the sailor on the far left. A profile of "Compassion" (Figure 11) is somewhat like the face of the black sailor. "Terrour or Fright" (Figure 12) might be the older sailor, and "Simple Bodily Pain" is, not surprisingly, very like Watson (Figure 13).[32] These alterations and borrowings from other artists' works occurred at a time when Copley was painting compositions that were more complex than the single-figure portraits of his New England years. The first of these had been *The Ascension*, painted when he was in Italy. On his return to London, he painted *The Nativity* (1776, MFA), *The Copley Family* (1776–1777, NGA), and *Sir William Pepperell and His Family* (1778, North Carolina Museum of Art, Raleigh). All of these have Christian themes, either as overt subject matter or by allusion, since the two family groups derive elements of their compositions from paintings of the Holy Family.[33]

Watson and the Shark was exhibited at the Royal Academy of Arts in 1778 as "A boy attacked by a shark, and rescued by some seamen in a boat; founded on a fact which happened in the harbour of the Havannah." It became known as "A Youth Rescued from a Shark," the title of Valentine Green's mezzotint (Figure 14), published on 31 May 1779.[34] The legend of the engraving, in English (and repeated in French), reads:

This Representation is founded on the following Fact: a Youth bathing in the Harbour of the Havannah, was twice seized by a Shark, from which, (though with the Loss of the Flesh & Foot, torn from the Right Leg), He disentangled himself, & was, by the assistance of a Boat's Crew, sav'd from the Jaws of the voracious Animal: for in the Moment it was attempting to seize its prey (a third Time), a Sailor with a Boat Hook drove it from its Pursuit.

The mezzotint was "Engraved from the Original Picture in the Possession of Brook Watson Esq. to whom this Plate is most respectfully Inscribed by his most Obliged & obedient Servt. V: Green."

Contemporary reviews of the exhibition are helpful in understanding some aspects of the work. (The reviews are fully quoted in the appendix.)[35] They make it clear that to viewers the varied poses and attitudes of the figures expressed reactions to the full horror of the event. One reviewer wrote that

the Drawing of the Figures is correct and firm; their various Actions, and every one of their Features, such as the

Terror of the Situation requires, and they are expressed in so excellent and masterly a Manner, and the Whole is so well coloured, that we heartily congratulate our Countrymen on a Genius, who bids fair to rival the great Masters of the ancient Italian Schools. . . . The Boatswain, an elderly Man, has catched one of [Watson's] Arms in the Noose of a Rope, and he pulls it clear with Prudence and Caution. Two sailors, brave Fellows, Horror bristling their Hairs, and the Eagerness of a compassionate good Heart for the poor Sufferer in their Faces, lean overboard.[36]

Another, in the *Public Advertiser*, also called attention to the emotions of the men in the boat.

This is a very extraordinary Production. . . . The Story is clearly told, and it scarce leaves any Thing for the *Amateur* to wish, or for the *Critic* to amend. The judicious Choice of the Characters, employed to rescue the Youth from the *Jaws of Death*; the Eagerness and the Concern so strongly marked in every Countenance; such Propriety in the different Actions and Attitudes of each, all concur to render it a very uncommon Production of Art, and a most interesting Scene to every feeling Bosom.[37]

A brief comment in the *General Evening Post* for 28–30 April said that "the passion of terror is well expressed in the different characters." The critic in the *Morning Chronicle, and London Advertiser* of 25 April commented, "The figures of the men in the boat, with the expression in each of their countenances, cannot be too much praised. . . . The Black's face is a fine index of concern and horror. The same feelings are also very forcibly impressed on the looks of the sailors." One reviewer summarized the reactions, saying that the painting "may fairly be estimated among the first performances of this exhibition. The softness of the colouring, the animation which is displayed in the countenances of the sailors, the efforts of the drowning boy, and the frightened appearance of the man assaulting the shark, constitute altogether a degree of excellence that reflect the highest honour on the composer."[38]

Criticism centered on the depiction of the shark, boat, the setting, and the proportions of the composition. The reviewer in the *Morning Chronicle, and London Advertiser* of 25 April who praised the painting as "one of the most striking pictures in the Great Room" also said it was

one of those frequent proofs we meet with of great abilities joined to little judgment. . . . The shark is neither like any thing "in Heaven above, or on Earth beneath, or in the Waters under the Earth." . . . The sea should be of a foam with the lashing of the shark's tail, and the boat, as almost every man leans on one side, in order to save the

boy, ought to lie nearly gunnel to, whereas the waves are as placid as those of the Thames when there's little or no wind, and the boat as steady as if it was in that sort of safe sea which is occasionally exhibited on the stage of Sadler's-Wells.

The reviewer for the *General Advertiser, and Morning Intelligencer* for 27 April cited other inaccuracies in the action and setting, but concluded that "the piece is very fine. He has improved upon the horror of the shark, by leaving it unfinished, and we think he studied narrowly the human mind in this circumstance. No certain and known danger can so powerfully arouse us, as when uncertain and unlimited. He gives the mind an idea, and leaves it to conceive its extent."

The criticisms and concerns of the reviewers prompted "A Young Painter" to write to the editor of the *General Advertiser, and Morning Intelligencer* (19 May).

I Should be glad to receive Information from any of your correspondents, if there was ever a compleat painter, at least in Britain. I was led into this thought from the different criticisms on the present Exhibition; the most severe of which is that on *the boy attacked by a shark*, on which I heard a gentleman hold forth in the room, for half an hour. The men, he said, were not rowing the boat the right way to approach the body; that the sailors were imperfect, in having their fingers *open* to make a grasp, and the old man in holding by a shirt that hung loose; that the boy was too large, being equal to the boatmen; that he was drawn as if dead, though *they* had lately examined him before their house, &c. &c. &c. An objection was started by another gentleman, that the boat had two men leaning over her side, without heeling half a streak. This is true. To obviate these objections in future, I would propose that a drawing of every historical piece should first be submitted to the public inspection, as many errors might strike an observer, which the painter may have entirely overlooked.[39]

The black man has recently received much attention for the role he plays in the rescue. Interpretations of the painting suggest that the seaman represents the artist's attitude toward the issue of freedom, for slaves from their masters as well as for American colonists from the political control of England.[40] Although these theories seem overly forced and complex, the man's racial identity and prominent position are clearly purposeful to the painting's subject. This is shown by Copley's change in the figure from the preliminary drawing *Rescue Group (Eight Men)*, in which this sailor was not black. Although blacks often appear in eighteenth-century English paintings, they are usually relegated to secondary roles, and very few images give

Fig. 6. Infrared reflectogram revealing
younger man underneath older sailor
[1.5–2.0 microns (μm)]

Fig. 7. Infrared reflectogram composite showing changes
to the sailor reaching from the boat on the far left
[1.5–2.0 microns (μm)]

Fig. 8. Infrared reflectogram composite showing changes
to the scarf and coattails of the standing sailor on the far left
[1.5–2.0 microns (μm)]

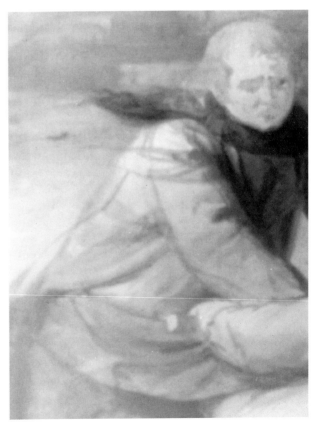

Fig. 9. "Attention" Fig. 10. "Horrour" Fig. 11. "Compassion"

Fig. 12. "Terrour or Fright" Fig. 13. "Simple Bodily Pain"

Figs. 9–13. After Charles LeBrun, engravings, from *The Compleat Drawing-Master*
(London, 1763), New Haven, Yale Center for British Art, Paul Mellon Collection
[photos: Richard Caspole]

them the prominence seen in *Watson and the Shark*. Reviewers disagreed about his role in the painting. One wrote that "the Black's face is a fine index of concern and horror,"[41] while another was more critical.

We must suppose, that at that instant of time, no horror in beholding the object would prevent seamen from acting to his rescue. It would not be unnatural to place a woman in the attitude of the *black*; but he, instead of being terrified, ought, in our opinion, to be busy. He has thrown a rope over to the boy. It is held, unsailorlike, between the second and third finger of his left hand and he makes no use of it.[42]

A third gave him a purpose while implying both cowardice and intelligence: "An idle Black, prompted by the connate Fear of his Country for that ravenous Fish, leans backward to keep the Gunnel of this Side of the Boat above Water."[43] The editor added a comment about this in the next issue.

Our correspondent has desired us . . . to rectify an Inadvertency which his Candour acknowledges to have been guilty of, in respect to the Boatswain and the Black, in Mr. Copley's excellent historical Composition, the one being rather tenderly concerned for the two Sailors, who lean overboard, and vociferous to his Crew; and the idle Black holding the Rope loose, which the Boatswain seems to have flung over one of the Sufferer's Arms.[44]

The reviews reveal the prejudices of the viewers and suggest that the role of the black was to present another of the various types of responses to the event.

Questions have been raised about the model for this figure. Was he a member of Copley's household? At the time that Copley painted *Watson and the Shark*, approximately fifteen thousand blacks resided in England, brought there at a time when slavery was legal in the British empire. They lived on the fringes of society as servants, vendors, seamen, craftsmen, and entertainers.[45] Copley painted a very sympathetic portrait of the same man (Figure 15). When it was sold in 1864 after the death of the artist's son, it was described as "Head of a Favourite Negro. Very fine. Introduced in the picture of 'The Boy saved from the Shark.' "[46] There is no documentation that Copley had a black servant or slave.

Copley painted an exact replica of *Watson and the Shark* for himself (MFA),[47] which closely follows the details of the first version but shows signs of being a copy in the tightening of the composition, with the figures in the boat being smaller relative to the boy and the shark, the bow of the boat foreshortened, and the shark sharper in outline. Also the painting

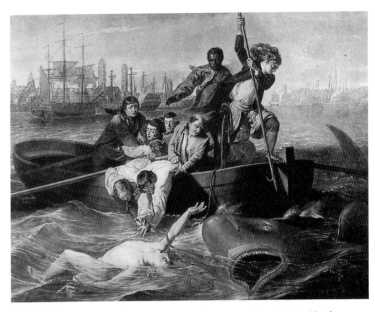

Fig. 14. Valentine Green after John Singleton Copley, *A Youth Rescued From a Shark*, mezzotint, 1779, St. John, New Brunswick, Canada, The New Brunswick Museum, Webster Canadiana Collection

has greater contrasts of light and dark. It was probably this version that Samuel Curwen saw in the artist's exhibition room in 1780 when he visited on 19 December. "We departed for Mr. R. C[larke's] home in Leister square. Found him at home, after some time invited into picture room, wherein were 2 Exhibition pictures, Brooke Watsons wonderful deliverance from a great shark who had twice seized him and possessed one leg which he had bit off, the other picture Copeley's own family. . . ."[48] Valentine Green's mezzotint seems closer in detail to the Boston version, suggesting that despite its legend, it was derived from Copley's replica. Later Copley painted a smaller third version that is vertical in format (The Detroit Institute of Arts), inscribed "Painted by J. S. Copley R. A. London 1782."[49] The purpose of the small oil is unknown. The figures in the boat are the same size as the figures in the drawing *Rescue Group (Eight Men)*. The vertical orientation of the small oil and of another painting of the same size that has been attributed to Copley but appears to be a copy (Bayou Bend Collection, Museum of Fine Arts, Houston) may be the result of a comment made by the reviewer in the *St. James's Chronicle; or, British Evening-Post* for 25–28 April.

There is one Thing which in our Opinion lessens the Effect of the whole. The horizontal Line being taken too

Fig. 15. John Singleton Copley, *Head of a Negro*, oil on canvas, c. 1778, The Detroit Institute of Arts, Founders Society Purchase, Gibbs-Williams Fund [photo: copyright The Detroit Institute of Arts]

high, makes it somewhat heavy, and brings the Hulks of the Ships, and the Batteries of Fort Moro, almost in Contact with the upper Part of the Canvass: But we remember that a very fine Picture of Nicholas Poussin, in the Gallery of the Landgrave of Hesse, representing the Murther of Pompey in the Harbour of Alexandria, is subject to the same Reproach, and we are very apt to believe in both Pictures, it arose from Circumstances which it was not in the Power of either of the Artists to avoid; they would have done it very easily if they had been allowed to give their Canvass a greater height.

Watson and the Shark established Copley's reputation in England. Already an associate of the Royal Academy of Arts, he was elected to full membership in February 1779. Three years later, in December 1782, he submitted *The Tribute Money* (Royal Academy of Arts, London) as his diploma piece and was formally recommended to George III by the governing council. (Perhaps the date on the small Detroit version of *Watson and the Shark* is a reference to this event.) The commission of *Watson and the Shark*

also marked the beginning of a successful partnership between Copley and the merchants in the City of London that embittered some rivals. A writer in the *Public Advertiser* for 1 May 1783 alluded to this. "The late accidental Vogue of Copley has arisen much more from a lucky Selection of Subject, than from any ascendant Skill in the Manner of treating it. — The instances are, the Death of Chatham, the Shark, &c. &c."[50] Six years later an unidentified English rival commented, "Mr. West paints for the Court and Mr. Copley for the City. Thus the artists of America are fostered in England, and to complete the wonder, a third American, Mr. Brown of the humblest pretenses, is chosen portrait painter to the Duke of York. So much for the Thirteen Stripes — so much for the Duke of York's taste."[51]

In 1805 Watson commissioned a second painting whose subject underscores his view of the rescue from the shark as a turning point in his life. *Brook Watson and the Cattle Incident at Chignecto in April, 1755* (New Brunswick Museum, St. John) depicts an event that took place in Nova Scotia, Canada, when Watson proved his bravery despite his wooden leg. He swam across the Missiguash River to retrieve a herd of cattle that had crossed into the French enemy's territory. He rescued sixty of the cattle needed by the British garrison at the fort as a source of food. A French officer who could have killed or imprisoned Watson took pity as the young man struggled in the mud of the river bank with his wooden leg and allowed him to return to the British fort by boat. The painting is based on a sketch taken of the site in 1755 and was commissioned from a "Mr. Callander," probably Scottish landscape painter Adam Callander (active 1780–1811). Watson inscribed his account of the event on the reverse of the painting, and later attached these verses.[52]

> Did not the Energetick mind have powers
> To wing her flights beyond the present hours.
> Her boundless sphere were narrowed to a span,
> And life a thing not worthy of a man.
> Snatch from his daring-ness the Glorious Prize,
> And what remains to prompt him to be wise?
> Bound his aspiring wishes by the grave,
> And what shall prompt him to be good or brave?
> [signed] CAREY

Many early nineteenth century writers on British and American art praised the painting. John Neal wrote in 1824 that it showed Copley's "decided and vigorous talent for historical composition." Samuel Knapp (1829) listed it among his "celebrated works," and it was singled out by Francis Lieber

(1830) and Allan Cunningham (1832) in early biographies of the artist. American painter William Dunlap had been one of its earliest admirers, when, as an aspiring young painter from New York, he arrived in London in 1784 with his own copy of *Watson and the Shark*, made from the mezzotint, to demonstrate his skill. By 1834, however, when he published his history of American art, Dunlap had become critical of Copley's English patrons. "Copley was, when removed to England, no longer an American painter in feeling; and his choice of subjects for historical composition, was decided by the circumstances of the time, or by employers."[53] Dunlap introduced what has become a concern of later writers, namely, Watson's Tory allegiance and, especially, his opposition to the abolition of slavery (1789–1792). The historian described Watson as "an American adventurer from one of the New-England provinces," who "is memorable as arrayed with our enemies in opposition to our independence, and with the enemies of God and man in opposition to the abolitionists of the slave-trade in the English house of commons." He pointed out that Watson was a British spy on the eve of the Revolution and that when he was a member of Parliament, his "argument in support of the trade in human flesh was that it would injure the market for the refuse-fish of the English fisheries to abolish it — these refuse-fish being purchased by the West India planters for their slaves. To immortalize such a man was the pencil of Copley employed."[54] Since then, Watson's politics have been the concern of many writers, including Samuel Isham, who wrote in 1905 that "in spite of his later elevation as Lord Mayor of London and Baronet of the United Kingdom, there are those whose sympathy is with the shark."[55]

Watson and the Shark has represented a number of themes to twentieth-century historians, including that of Copley as a proto-romantic, depicting man's struggle with natural forces, and that of Copley's important contribution to the development of English history painting. Several writers in the 1930s and 1940s developed the idea that the painting presaged works by nineteenth-century French Romantic painters. Charles Cunningham wrote in 1938 that Copley's painting "to some extent anticipates Géricault's *Raft of the Medusa* by nearly fifty years."[56] James Thrall Soby and Dorothy Miller agreed. "In emotional pitch and journalistic appeal, *Watson and the Shark* foretells by forty-four years the epoch-making *Raft of the Medusa* . . . and

leads to Winslow Homer's *Gulf Stream*, painted more than a hundred years later."[57] Many later writers have expanded on these suggestions, while some recent historians have proposed political interpretations: that the painting represents Copley's ambivalent attitudes toward the American war for independence, and that the painting has hidden and conflicted messages about the abolition of slavery. It is the idea of redemption and salvation, however, that seems to have been on Watson's mind when he willed his version of the painting to Christ's Hospital. This, as Hugh Honour recently wrote, is an indication "that he regarded it as a kind of Protestant ex-voto with wide implications — the record of a calamity narrowly escaped and of disabilities successfully overcome either through the working of Divine Providence or as a result of human courage and solidarity, with some intimation, it might even be suggested, of the brotherhood of man."[58] Copley's success brought him to the attention of other City of London merchants, notably John Boydell, who played an important role in the making of Copley's next narrative painting, *The Death of the Earl of Chatham* (Tate Gallery, London; see the Gallery's oil sketch, 1747.15.1).

EGM

Notes

1. Watson's will, dated 12 August 1803, states: "I give and bequeath my Picture painted by Mr. Copley which represents the accident by which I lost my Leg in the Harbour of the Havannah in the Year One Thousand Seven Hundred and Forty Nine to the Governors of Christs Hospital to be delivered to them immediately after the Decease of my Wife Helen Watson or before if she shall think proper so to do hoping the said worthy Governors will receive the same as a testimony of the high estimation in which I hold that most Excellent Charity and that they will allow it to be hung up in the Hall of their Hospital as holding out a most usefull Lesson to Youth" (Public Record Office, London; photocopy, NGA). The school's committee of almoners voted on 28 September 1819 to accept the painting and place it in the great hall (minutes of a meeting of the Board of Almoners, Christ's Hospital, 28 September 1819; extract, NGA). The hospital was founded in London in 1553 and was moved to Horsham, Essex, in 1902; *Enc. Brit.* 6:295–296.

2. *Manchester* 1857, 82, no number; Graves 1913, 1:206.

3. The National Gallery of Art produced a sixteen-page brochure for the exhibition, with the painting reproduced on the cover; the text by Ellen Miles was based on the research for this catalogue.

4. Prown 1966, 2:459–461, lists all known oil versions of this painting, as well as drawings, prints, and copies.

5. For biographies of Watson see Betham 1805, 540–542; "Watson" 1807, 987–988; Webster 1924; and Namier and Brooke, 3:611–612.

6. Betham 1805, 540.

7. Boime 1989, 25 n. 15, citing Webster 1936, 11, 18.

8. Abrams 1979, 267.

9. *Copley-Pelham Letters*, 225–227. Before Copley went to England, Clarke sent him advice from Benjamin West about the trip (letter dated 20 December 1772, *Copley-Pelham Letters*, 190–193). West's letter of 6 January 1773 to Copley mentions Clarke (*Copley-Pelham Letters*, 194–197). Another tie to the merchant community was through Susanna Copley's sister Hannah, wife of London merchant Henry Bromfield, who had supplied Copley with painting materials in 1771 (*Copley-Pelham Letters*, 115–116, 140–141), forwarded Copley's letter of 15 July 1775 from Parma to Henry Pelham, and gave Susanna Copley and her children a place to stay before Copley's return to London (*Copley-Pelham Letters*, 359, 371).

10. *Copley-Pelham Letters*, 237.

11. *Copley-Pelham Letters*, 239.

12. Letters from Watson in Montreal dated 16 October 1775 to Benjamin Faneuil and 19 October 1775 to John Butler were intercepted by American general Richard Montgomery; see *Naval Documents* 2:468–469, 512–513; 3:67.

13. Allen 1838, 44.

14. Richard Clarke to Isaac Winslow, 4 May 1776, Boston Public Library (copy, NGA).

15. Roger Stein and Irma Jaffe have focused on the importance of the painting's Christian theme of deliverance and salvation. Stein 1976, 105–110, points out that many early American religious writers wrote about deliverance from the terrors of the sea. Jaffe 1977, 15–18, stresses the importance of resurrection and salvation to Copley's "religio-cultural mentality."

16. Morris 1966, 89–168. Wilson 1989, 33–34, discusses Bunyan's *Pilgrim's Progress* as a model for Benjamin Franklin's autobiography, begun in 1771 in England and published in 1790 after his death.

17. The similarities between some aspects of Watson's life and elements of William Hogarth's series of engravings titled *Industry and Idleness* (1747) are striking. Hogarth's industrious apprentice was rewarded for his hard work by election as Lord Mayor of London. By contrast, Tom Idle, who forfeited his apprenticeship as a weaver by his poor behavior, was sent to sea as a common sailor; see Paulsen 1975, 58–78.

18. Watson's wooden leg, the focus of lampooning by his political enemies, remained an essential characteristic of his *persona* after his death. In 1841 Edward Everett published a fictional tale of two American visitors to London in 1769 who quizzed Watson about how he lost his leg, to which he replied that it was bitten off, without explaining the circumstances (Everett 1841, 228–248).

19. *Enc. Brit.* 6:295–296.

20. Public Record Office, London; copy, NGA.

21. *Copley-Pelham Papers*, 225–227, 237, 239.

22. This observation was made by Allen Staley; letter to the author, 7 May 1993.

23. Staley, in Von Erffa and Staley 1986, 78–79; the painting, no. 275, is catalogued on 311–312 and reproduced in color, 83.

24. *Sharks* 1986, 132; John Prescott, director of the New England Aquarium, suggested to the authors of *Sharks* 1986 that Copley's shark is "a combination of fea-tures of various sharks, with two kinds of teeth and imaginary lips."

25. Jaffe 1977, 20–25. Discussions with Charles Brock, exhibitions assistant, Department of American and British painting, NGA, helped focus my attention on the relevance of the story of Jonah to Watson's rescue.

26. *Raffael* 1905, 127; Von Erffa and Staley 1986, nos. 406–407, 394–395, repro.; Williams 1981, 30. I am indebted to Bill Williams and Allen Staley for these observations.

27. On Copley's comments on works by other artists that impressed him in Italy see Prown 1966, 2:250, 252, 255; Bill Williams pointed out the similarity of Watson to the epileptic child; see Williams 1981, 30.

28. Busch 1992, 42, carries the parallel with images of Saint Michael further, noting that Michael's expulsion of Lucifer from heaven "theologically . . . marks the beginning of the history of salvation," and that Michael was also present at the Last Judgment, "the end of the history of salvation."

29. Quoted in Prown 1966, 2:253; the cast broke during shipment to London, but other casts would have been available. Kemp 1980, 647, has suggested that the figure of Watson was modeled on the drowning nude figure at the lower left of the woodcut of Titian's *Submersion of Pharoah's Army in the Red Sea* (1549). The pose is very similar, suggesting instead a common source; see Rosand and Muraro 1976, 70–73, cat. no. 4, repro. 82–83 (detail).

30. Reprinted by the Augustan Reprint Society, with an introduction by Alan T. McKenzie (Los Angeles, 1980), a publication of the William Andrews Clark Memorial Library, University of California, Los Angeles.

31. *Compleat Drawing-Master* 1766, 16. The illustrations reproduced here are from the 1763 edition. I am grateful to Elisabeth R. Fairman, associate curator for Rare Books, Yale Center for British Art, for her assistance in locating images of LeBrun's "passions." I recognized their relevance to *Watson and the Shark* after reading Patricia Burnham's discussion of the reuse of the image of "Veneration" by John Trumbull in his *Woman Taken in Adultery* (YUAG), in Cooper 1982, 197–198, no. 135.

32. Busch 1992, 46, 48–52, arrived at the same realization about Copley's borrowings from LeBrun, identifying the sailor on the left as modeled on the image of "Dread," and the older sailor as based on "Astonishment with Fright." He identified the sailor holding the boat hook with LeBrun's image of "Contempt" and the sailor seen between the first man's legs with the image of "Sadness." He notes that West had also borrowed from Le Brun, apparently basing a figure in his *Death of Wolfe* on the image of "Compassion."

33. For a discussion of this imagery see the entry on *The Copley Family* [1961.7.1]. In his interpretation of the painting as a theme of salvation, Busch 1992, 51, 56, concludes that, while Copley perhaps revived a traditional use of such images in a religious context, contemporary artists in England had begun to question the value of such religious imagery.

34. Smith 1883, 2:596, no. 152, with an incorrect publication date of 1 May 1779.

35. Although many writers have quoted from the reviews, the text of only one (*St. James's Chronicle; or, British Evening-Post*, 25–28 April) has been fully published, in

Cairns and Walker 1966, 2:396. For copies of these reviews I would like to thank Mrs. Clare Lloyd-Jacob, The Paul Mellon Centre for Studies in British Art, London, who is compiling an index of newspaper reviews of English art exhibitions to 1800.

36. *St. James's Chronicle; or, British Evening-Post*, 25–28 April 1778.

37. *Public Advertiser*, 28 April 1778.

38. *Morning Post, and Daily Advertiser*, 25 April 1778.

39. Quoted in Prown 1966, 2:267 n. 17.

40. See Boime 1989, 18–47; Boime 1990, 20–36; and McElroy 1990, ix, 6.

41. *Morning Chronicle, and London Advertiser*, 25 April 1778.

42. *General Advertiser, and Morning Intelligencer*, 27 April 1778.

43. *St. James's Chronicle; or, British Evening-Post*, 25–28 April 1778.

44. *St. James's Chronicle; or, British Evening-Post*, 28–30 April 1778.

45. Fryer 1984, 67–77.

46. *Detroit* 1991, 62–64, repro., essay by Richard H. Saunders.

47. Prown 1966, 2:460, and fig. 372; MFA 1969, 1:80–81; 2: fig. 73; and Stebbins, Troyen, and Fairbrother 1983, 210–211. The replica is signed in the same manner and location as the first version. The painting's subsequent popularity is indicated by smaller copies: a reverse painting on glass (S.W. 1934, 52) and a version on metal (Parnassus Gallery 1955, 24).

48. *Curwen* 1972, 2:701.

49. Prown 1966, 2:460 and fig. 373; *Detroit* 1991, 68–70, repro., essay by Richard H. Saunders. Examination of this painting at the National Gallery with infrared reflectography in the spring of 1993 confirmed that it is a replica, since it has none of the changes found in a study.

50. Quoted in Prown 1966, 2:298, from a review of Copley's portrait *William Murray, Earl of Mansfield*.

51. Quoted by Evans 1980, 81, from Whitley 1968, 2:100. The writer is referring to Copley's commission from the Corporation of London for *The Siege of Gibraltar* (1783–1791).

52. Webster 1924, 7–8, repro. opp. 7; Webster 1939, 324–325. On Callander see Waterhouse 1981, 68.

53. Dunlap 1834, 117.

54. Dunlap 1834, 117–118. Dunlap says that he saw *Watson and the Shark* on exhibition in London when he arrived. This may have been Copley's version, on exhibition in his painting room.

55. Isham 1905, 26.

56. Cunningham 1938, 12.

57. Soby and Miller 1943, 9.

58. Honour 1989, 39, 41.

References

1778 "Royal Academy, 1778." *Morning Chronicle, and London Advertiser*, 25 April: 2.

1778 "The Painter's Mirrour; Royal Academy Exhibition, 1778." *Morning Post, and Daily Advertiser* (London), 25 April: 2.

1778 "Royal Academy Exhibition." *St. James's Chronicle; or, British Evening-Post*, 25–28 April: 4.

1778 "Exhibition of the Royal Academy." *General Advertiser, and Morning Intelligencer*, 27 April: 4.

1778 "Royal Academy Exhibition." *St. James's Chronicle; or, British Evening-Post*, 28–30 April: 4.

1778 "Royal Academy Exhibition." *Public Advertiser*, 28 April: 2.

1778 A Lover of the Fine Arts. "A Short View of the Articles of the Exhibition of the Royal Academy, Pall Mall." *General Evening Post*, 28–30 April: 4.

1778 A Young Painter. [Letter to the Editor.] *General Advertiser, and Morning Intelligencer*, 19 May: 2.

1796 Pasquin: 136–137.

1824 Neal: 26–27.

1829 Knapp: 191.

1830 *Enc. Amer.*: 3:520.

1832 Cunningham: 5:177–178.

1834 Dunlap: 1:106, 116–118, 120, 127.

1834 Trollope: 353.

1841 Everett: 228–248.

1847 Tuckerman: 25–26.

1867 Tuckerman: 78–79.

1873 Perkins: 20–21, 128.

[after 1873] Perkins: 9.

1882 Amory: 70–75.

1905 Isham: 26, 38.

1915 Bayley: 253–254.

1924 Webster.

1937 Allan: 67–68.

1938 Cunningham: 12–13.

1938 Wind, "History Painting": 119.

1943 Mayor: 107.

1943 Soby and Miller: 9.

1947 Richardson: 213–218, fig. 3.

1953 *Christ's Hospital*: repro. opp. 280.

1953 Waterhouse: 160, 203, pl. 172.

1956 Richardson: 94, 316.

1966 Prown: 2:267–274, 298, 387, 459–461, and fig. 371.

1974 Gerdts: detail repro. 33, 38.

1975 Paulson: 202–203 repro.

1975 Stein: 18, 20, 112, color repro. opp. 32, pl. 1.

1976 Stein: 85–130, repro. 88.

1977 Jaffe: 15–25, repro.

1979 Abrams: 265–276.

1980 Kemp: 647.

1980 Wilmerding: 48, color repro. 49.

1981 Williams: 30–31, repro. 32–33, color repro. 46.

1984 Walker 388, no. 552, color repro.

1986 *Sharks*: 132–135.

1987 Wilmerding: 33–35, color repro. 32.

1988 Wilmerding: 56, color repro. 57.

1989 Honour: 37–41, figs. 6–7.

1989 Boime: 18–47, color repro. fig. 1.

1990 Boime: 20–36, color repro. after xvi.

1992 Busch: 34–59.

1993 Miles: 162–171, repro.

APPENDIX:

Reviews in London Newspapers, April 1778

The Morning Chronicle, and London Advertiser, 25 April.

One of the most striking pictures in the Great Room is a painting by Mr. COPLEY, of *a boy attacked by a shark, and rescued by some seamen in a boat.* This piece is one of those frequent proofs we meet with of great abilities joined to little judgment. The figures of the men in the boat, with the expression in each of their countenances, cannot be too much praised, and at the same time the other parts of the picture cannot be too severely reprehended. The Black's face is a fine index of concern and horror. The same feelings are also very forcibly impressed on the looks of the sailors; but the shark is neither like any thing "in Heaven above, on the Earth beneath, or in the Waters under the Earth," and exclusive of its want of resemblance to what it is designed to represent, it is destitute of that spirit and eagerness which a voracious fish must necessarily express when so near its prey as the picture shews it. Add to this: the sea should be of a foam with the lashing of the shark's tail, and the boat, as almost every man leans on one side, in order to save the boy, ought to lie nearly gunnel to, whereas the waves are as placid as those of the Thames when there's little or no wind, and the boat as steady as if it was in that sort of safe sea which is occasionally exhibited on the stage of Sadler's-Wells.

The Morning Post, and Daily Advertiser, 25 April.

A Boy attacked by a Shark . . . , may fairly be estimated among the first performances of this exhibition. The softness of the colouring, the animation which is displayed in the countenances of the sailors, the efforts of the drowning boy, and the frightened appearance of the man assaulting the shark, constitute altogether a degree of excellence that reflect the highest honour on the composer.

The St. James's Chronicle; or, British Evening-Post, 25–28 April.

Genius and Love . . . have been very friendly to Mr. John Singleton Copley, in his Representation, No. 65, of some Seamen, saving a Lad from the Attacks of a Shark. The Drawing of the Figures is correct and firm; their various Actions, and every one of their Features, such as the Terror of the Situation requires, and they are expressed in so excellent and masterly a Manner, and the Whole is so well coloured, that we heartily congratulate our Countrymen on a Genius, who bids fair to rival the great Masters of the ancient Italian Schools. The beautiful Boy, just disintangled from the ravenous bloody Monster, which had tore away one of his Legs, cries for that Assistance, which every one of the honest Tars hurries to give without Loss of Time. The Boatswain, an elderly Man, has catched one of his Arms in the Noose of a Rope, and he pulls it clear with Prudence and Caution. Two Sailors, brave Fellows, Horror bristling their Hairs, and the Eagerness of a compassionate good Heart for the poor Sufferer in their Faces, lean over-board, and stretch their Hands to help him in so dangerous a Manner, that the Beholder must tremble for Fear of their falling overboard, and their becoming a Prey of a young Shark, that flies against them, swift as lightning, with open Snout, and inexpressible Greediness in his flaming Eye; the same Moment that a fine young Sailor, standing at the Helm, strikes at him with a lifted Boat-Hook. An idle Black, prompted by the connate Fear of his Country for that ravenous Fish, leans backward to keep the Gunnel of this Side of the Boat above Water; herein he is assisted by two Rowers on the other Side, who, less engaged in the more noble Part of the other Actors, have of course their Compassion and Curiosity stronger expressed in their Features. The whole makes an excellent Group, by the Dampness of the hazy hot Climate, well parted from the Background, in which some English Men of War, and the Moro Castle at the Havannah, serve to determine the glorious Time, and the Place where our Tars so nobly exerted themselves. There is one Thing which in our Opinion lessens the Effect of the whole. The horizontal Line being taken too high, makes it somewhat heavy, and brings the Hulks of the Ships, and the Batteries of Fort Moro, almost in Contact with the upper Part of the Canvass: But we remember that a very fine Picture of Nicholas Poussin, in the Gallery of the Landgrave of Hesse, representing the Murther of Pompey in the Harbour of Alexandria, is subject to the same Reproach, and we are very apt to believe in both Pictures, it arose from Circumstances which it was not in the Power of either of the Artists to avoid; they would have done it very easily if they had been allowed to give their Canvass a greater height.

70 AMERICAN PAINTINGS

The General Advertiser, and Morning Intelligencer,
27 April.

A boy attacked by a shark . . ., by John Singleton Copley, deserves particularly to be praised. Its *whole* is very fine, though there are some inaccuracies in its *parts.* The *story* is well told. The point of time is, when the shark is darting upon him a third time, two men are in the act of catching him, a third is striking the shark. So far the design is perfect. But we must suppose, that at that instant of time, no horror in beholding the object would prevent seamen from acting to his rescue. It would not be unnatural to place a woman in the attitude of the *black*; but he, instead of being terrified, ought, in our opinion, to be busy. He has thrown a rope over to the boy. It is held, unsailorlike, between the second and third finger of his left hand and he makes no use of it. There is not a blast of wind stirring. The colours and sails of the distant ships, as well as the waves of the present sea, are unruffled; and yet, to add to the expression, the hair of the sailor, who is darting at the shark, is blown to a great degree. Notwithstanding these inaccuracies, and they are merely so, the piece is very fine. He has improved upon the horror of the shark, by leaving it unfinished, and we think he studied narrowly the human mind in this circumstance. No certain and known danger can so powerfully arouse us, as when uncertain and unlimited. He gives the mind an idea, and leaves it to conceive its extent.

The St. James's Chronicle; or, British Evening Post,
28–30 April.

Our correspondent has desired us . . . to rectify an Inadvertency which his Candour acknowledges to have been guilty of, in respect to the Boatswain and the Black, in Mr. Copley's excellent historical Composition, the one being rather tenderly concerned for the two Sailors, who lean overboard, and vociferous to his Crew; and the idle Black holding the Rope loose, which the Boatswain seems to have flung over one of the Sufferer's Arms. To this we add, that Mr. Copley is a native of America, and that he has sent some excellent Portraits to the former Exhibitions, before he had been improved by any academical Education in Europe.

The Public Advertiser, 28 April.

This is a very extraordinary Production. The Subject is undoubtedly of such a Nature, that it is extremely difficult to treat it properly: yet it must be confessed that Mr. Copley has succeeded beyond the most sanguine Expectations: — This Picture is extremely well conceived in all its Parts, and appears to be the Result of mature Reflection. In short, it is a perfect Picture of its Kind. The Artist seems to have compassed every Thing he intended; the Story is clearly told, and it scarce leaves any Thing for the *Amateur* to wish, or for the *Critic* to amend. The judicious Choice of the Characters, employed to rescue the Youth from the *Jaws of Death*; the Eagerness and the Concern so strongly marked in every Countenance; such Propriety in the different Actions and Attitudes of each, all concur to render it a very uncommon Production of Art, and a most interesting Scene to every feeling Bosom.

The General Evening Post, 28–30 April.

The passion of terror is well expressed in the different characters. The boat, however, does not seem sufficiently agitated by the water, in consequence of such a disaster, and the head of the fish is made out in a very obscure manner.

1947.15.1 (907)

The Death of the Earl of Chatham

1779
Oil on canvas, 52.7 × 64.2 (20 ½ × 25 ¼)
Gift of Mrs. Gordon Dexter

Inscriptions
Signed lower right in dark brown paint:
 JSCopley / 1779

Technical Notes: The painting is on a medium-weight, plain-weave fabric. The thin white ground has fine horizontal striations from a brushed application. A penciled grid was applied to the ground layer in the lower half of the painting, in squares measuring approximately 1.8 cm. The paint, applied over the grid, is a semi-translucent monochrome brown wash, highlighted with white. To make the paint more opaque, white is also added to the transparent brown in the walls and the shaft of light. The contours of the figures are drawn with fluid, brushy lines of semi-transparent dark brown paint. Compositional changes are found in the area of the oculus and the canopy, where a curtain appears to have been painted out.

The weave texture of the canvas was probably enhanced by the lining process. The most textured areas of paint were flattened. The thinly applied paint is abraded throughout. Some vertical lines of particularly severe abrasion and loss occur in the central and lower regions.

Small losses throughout have been retouched. The varnish was removed in 1939.[1]

Provenance: Possibly (Christie, Manson & Woods, London, 23 May 1865, no. 130, bought in).[2] (Henry Graves & Co., London).[3] The artist's great-granddaughter Susan Greene Amory Dexter [Mrs. Franklin Gordon Dexter, 1840–1924], Boston;[4] her son Gordon Dexter [1864–1937], Boston;[5] his widow Isabella Hunnewell Dexter [c. 1871–1968], Boston.[6]

Exhibited: *A Salute to William Pitt; An Exhibition of Art and Letters Honoring the First Earl of Chatham*, Chatham College, Pittsburgh, 1958–1959, no. 8. *Copley*, 1965–1966, no. 71. *American Painting of the Revolutionary Period*, The Baltimore Museum of Art, 1976, no. 31.[7] *The Eye of Thomas Jefferson*, NGA, 1976, no. 66. *The Age of Queen Charlotte 1744–1818*, Mint Museum of Art, Charlotte, North Carolina, 1968, no. 3. *Zeichen der Freiheit; Das Bild der Republik in der Kunst des 16. bis 20. Jahrhunderts*, Bernisches Historisches Museum und Kunstmuseum, Bern, Switzerland, 1991, no. 318.

WILLIAM PITT (1708–1778) became a hero to many colonial Americans when, as a member of Parliament, he opposed the Stamp Act of 1765. After he became Earl of Chatham, he continued to urge that the British government adopt a conciliatory approach toward America. Copley wrote his wife from Rome on 4 December 1774,

> It is suggested that Lord Chatham is coming into the administration; if so, the dispute will end speedily in favor of the Americans. But I suspect this will not be the case; it does not look likely that the measures carried on with so much vigilance and seemingly with so determined a resolution to humble the provinces will be relinquished.[8]

Although Chatham spoke in favor of ending the war, he believed that independence for America was not in line with England's economic interests. On 7 April 1778, in poor health and supported by crutches, he attended a session of the House of Lords to hear the Duke of Richmond speak in favor of the withdrawal of British troops from the colonies. Chatham voiced his opposition to Richmond's views, but when he rose to rebut his opponent's response, he fell backwards in a faint and was carried from the chamber. He died a month later.

Copley's monumental painting *The Death of the Earl of Chatham* (Figure 1) shows the moment immediately after Chatham's collapse. The artist began work on the painting within a year of the earl's death and completed it by 1781.[9] Incorporating life portraits into an image of a recent historical event,

Fig. 1. John Singleton Copley, *The Death of the Earl of Chatham*, oil on canvas, 1781, London, Tate Gallery

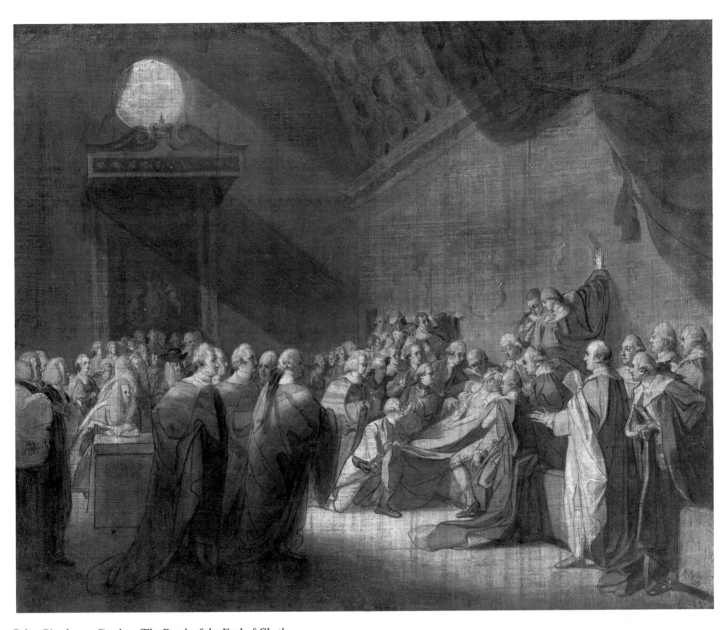

John Singleton Copley, *The Death of the Earl of Chatham*, 1947.15.1

he took Benjamin West's concept of contemporary history painting in a new direction, one that would later occupy other artists who depicted subjects from the history of the American Revolution, notably Robert Edge Pine and John Trumbull. Copley's composition is indebted to Benjamin West. Early drawings for the composition, including the one in the Gallery's collections (Figure 2), are very similar to West's *Death of the Earl of Chatham* (Figure 3), which West began at about the same time Copley initiated his composition.[10] West, however, did not finish his until the mid-1780s, deciding to let Copley take the lead, as Horace Walpole noted in 1785. "Mr. West made a small Sketch of the death of Lord Chatham, much better expressed & disposed than Copley's. It has none but the principal person's present; Copley's almost the whole peerage, of whom seldom so many are there at once, & in Copley's most are meer spectators. . . . West wd not finish it not to interfere with his friend Copley."[11]

Copley prepared three oil sketches for the painting. Two (Tate Gallery, London) show less detail than that of the Gallery and are clearly preliminary to it.[12] In the Gallery's sketch a grid drawn in pencil on the lower half of the canvas enabled Copley to transfer details from the earlier sketches, and its presence indicates that the painting is late in the sequence of preparatory studies. Copley painted the figures on top of the grid, modeling them with a monochrome brown wash highlighted with white. The placement of the figures is very similar to the final work, in which one person was added in the group above Chatham. In the Gallery's sketch most of the faces have been completed, their individualized features easily recognizable. The study contains some elements of the composition that were omitted in the final painting, including the circular window over the throne through which a beam of sunlight emphasizes the figure of the dying earl, and the large drape in the upper right corner. Certain elements indicate it to be a transitional work. The canopy differs from that in earlier versions, and yet it resembles the one seen in a detailed drawing for the final composition (Munson-Williams-Proctor Institute Museum of Art, Utica, New York), and the Duke of Richmond, in the right corner, gestures with his left hand in a horizontal position. Earlier studies show his arm in a lowered position, while in the finished painting his arm is raised.

The oil sketch may have been completed by June 1779, when print seller and publisher John Boydell,

Fig. 2. John Singleton Copley, *Study for The Death of the Earl of Chatham*, 1779, Washington, National Gallery of Art, John Davis Hatch Collection; Andrew W. Mellon Fund and Avalon Fund, 1980.4.2

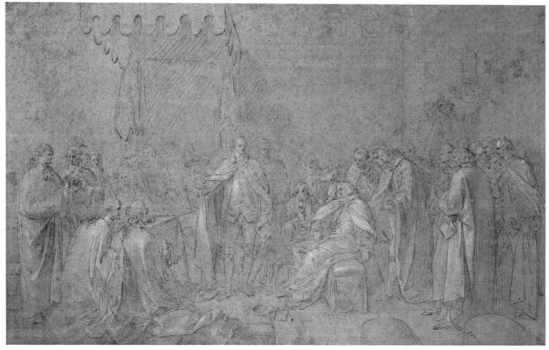

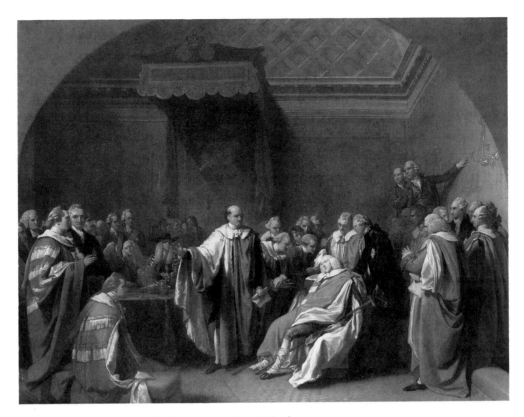

Fig. 3. Benjamin West, *The Death of the Earl of Chatham*,
oil on canvas, c. 1778–1786, Fort Worth, Kimbell Art Museum

without mention of Copley, sought to convince the London Common Council to commission a painting, rather than a statue, as a tribute to Chatham. Boydell had grown wealthy from the profits of the sale of the engraving of Benjamin West's history painting *The Death of General Wolfe*, in which he owned a third interest. He had the same arrangement in mind with Copley's *Death of Chatham*.[13] A pamphlet that he published in June commented that in England there was more encouragement for statuary than for history painting, which "does not meet with the Patronage it deserves and is rather neglected in this Country."[14] The Gallery's painting could be the one that was submitted to the Court of Common Council in December 1779. Sculptors Nicholas Read and John Bacon also submitted proposals for the commission. The *St. James's Chronicle* (16–18 December 1779) described Copley's submission as "a Sketch in Colours, representing Lord C in the unfortunate moment when he was apprised of his Dissolution in the House of Lords, attended by his Sons and the Minority Lords. The Duke of Richmond is a principal Figure in the Groupe, which comprises fifty-six different Figures, all exe-

cuted in a masterly manner."[15] Perhaps the phrase "a Sketch in Colours" is meant to distinguish an oil sketch from one in watercolor or chalk.

When Bacon was chosen for the commission, Copley completed the painting at his own expense. He put it on display in 1781 in the large exhibition space in Spring Gardens, Charing Cross that was owned by the Society of Artists of Great Britain.[16] In May and June, during the first six weeks of the exhibition, almost twenty thousand people paid admission to see the painting. Copley, the first to arrange such a display of a single painting and to charge admission, was said to have made 5,000 pounds. A brochure published for the exhibition, *Description of Mr. Copley's Picture Of the Death of the late Earl of Chatham, Now Exhibiting at the Great Room, Spring-Gardens* (London, 1781), explained the scene, identified the sitters, and announced the proposal to publish the engraving, for which subscribers could contact Copley or Boydell. Copley's success secured his reputation in Britain and embittered some rivals. A writer in the *Public Advertiser* for 1 May 1783 noted, "The late accidental Vogue of Copley has arisen much more from a lucky Selection of Sub-

ject, than from any ascendant Skill in the Manner of treating it. — The instances are, the Death of Chatham, the Shark, &c. &c."[17] Boydell and Copley then went on to a new partnership with the painting of *The Death of Major Peirson*, which Boydell commissioned in 1783.

EGM

Notes

1. The present lining predates the varnish removal, done at the Fogg Art Museum, Cambridge, Massachusetts, in 1939; Richard D. Buck examination notes, Fogg Art Museum (copy, NGA).

2. *Chiefly Modern Pictures* 1865, 9; Graves 1918, 1:149. According to Christie's records, the consignor was W. Bettle, 195, Bishopsgate, London; Jeremy Rex-Parkes, archivist, letter dated 2 August 1991 (NGA). The uncertainty that this is the Washington sketch stems from confusion surrounding the provenance of Copley's three oil sketches of this subject. Prown 1966, 2:438, stated that lot 130 was purchased by James Anderdon; in fact he bought his two sketches (Tate Gallery, London) at the H. Scott Trimmer sale (Christie's, 17 March 1860, lot 31) and the Lyndhurst sale (Christie's, 5 March 1864, lot 70). Bayley 1910, 34, erroneously claimed that the National Gallery's sketch was from the Lyndhurst sale.

3. The printed label of the firm of Henry Graves & Co., 6, Pall Mall, London, is attached to the stretcher. It is inscribed with the number *765*. Graves (1806–1892) was a dealer and print publisher in London from 1852; see Lugt 1921, 195, 561, and *Supplément* 1956, 160; *DNB* 22 (supplement), 771–772. His ownership of the painting is not documented elsewhere. He was probably also the buyer of Copley's *Baron Graham* [1942.4.1] at auction in 1878 in London, which he apparently sold to the artist's granddaughter Martha Babcock Amory.

4. Bayley 1910, 34; Mrs. Dexter's birth date is in Linzee 1917, 2:781–782; her death date is in *New England Register* 1925, 325.

5. Dexter is listed in *Who Was Who* 1:320.

6. Mrs. Dexter died at the age of ninety-seven in New York City; obituary, *New York Times*, 16 December 1968, 47.

7. See *Maryland Heritage* 1976, 74, repro.

8. Quoted in Amory 1882, 40–41.

9. Prown 1966, 2:275–291, and fig. 392.

10. Von Erffa and Staley 1986, 65 (repro.), 218, no. 104. The drawing is illustrated in Prown 1966, 2:pl. 399; Wilmerding 1980, 21; and Williams 1981, 26–27.

11. Horace Walpole's "Book of Materials," 113, Lewis-Walpole Library, Farmington, Connecticut, as quoted by Prown 1966, 2:280–281. The passage is also quoted in Kraemer 1975, 14–15, no. 20, pl. 10, which discusses and reproduces one of West's drawings of the subject.

12. The two sketches are illustrated in Prown 1966, 2:figs. 402–403.

13. Bruntjen 1985, 205–206, discusses Boydell and Copley's business arrangement for this painting, which included a share of profits from the sale of the engraving, completed in 1791 by Francesco Bartolozzi.

14. Boydell 1779, 3, quoted in Bruntjen 1985, 205.

15. Quoted in Prown 1966, 2:278.

16. The Society of Artists used this "Great Room" for its annual exhibitions from 1761 until 1772, when it moved to a new location in the Strand; see Edwards 1808, xxvi, xxxvii; Graves 1907, 305, 321, 326. The room was apparently available as a place for artists to exhibit their work, as English painter Robert Edge Pine did the following year; see Stewart 1979, 16.

17. Quoted in Prown 1966, 2:298, from a review of Copley's portrait of *William Murray, Earl of Mansfield*. Copley's success impressed American artist John Trumbull, who later noted that the Royal Academy's income from exhibitions, about 3,000 pounds per year, gave Copley the idea of exhibiting *The Death of Chatham*; see Dickson 1973, 5.

References

1910 Bayley: 34.
1915 Bayley: 76.
1966 Prown: 2:275–291, 437–439, fig. 404.
1981 Williams: 31, color repro. 47.
1984 Walker: 390, no. 553, color repro.

1942.4.2 (551)

The Red Cross Knight

1793
Oil on canvas, 213.5 × 273 (84 × 107 ½)
Gift of Mrs. Gordon Dexter

Technical Notes: The painting is on a twill canvas which has a thick white lead ground. Regularly spaced small holes along the top and lower edges may once have held the painting in a frame. The forms were generally painted from dark to light. The paint is generally thinnest in the dark colors, with the most impasto found in the highlights. The shadows on the knight are done with a thick paint whose traction crackle suggests that a bituminous pigment was used. Some adjustments were made during execution. X-radiography reveals that the eyes of Faith, in the center, seem to look both at the knight and upward. Slight changes in Hope's waistline are visible with infrared reflectography.

The paint is abraded to the right of Hope's head, on the balustrade, and in the knight's plume. Vertical cracks and deformations show that the painting was once tightly rolled. Moating around the impasto may be due to a past lining. The craquelure and areas of the figures have been retouched. Residues of darkened varnish are visible beneath the overall thick, yellowed varnish.

Provenance: The artist; his son John Singleton Copley, Jr., Lord Lyndhurst [1772–1863], London; his sale (Christie, Manson & Woods, London, 5 March 1864, no. 86); bought by "Clarke" for the artist's granddaughter Martha Babcock Greene Amory [Mrs. Charles Amory, 1812–1880] and her husband Charles Amory [1808–

1898], Boston;[1] purchased in 1872 by their daughter Susan Greene Amory Dexter [1840–1924] and son-in-law Franklin Gordon Dexter [1824–1903], Boston;[2] their son Gordon Dexter [1864–1937], Boston;[3] his widow Isabella Hunnewell Dexter [c. 1871–1968].[4]

Exhibited: Royal Academy of Arts, London, 1793, no. 75, as *Portraits in the characters of the Red Cross knight, Fidelia and Speranza.* Boston Athenaeum, 1871–1873.[5] *Copley*, 1965–1966, no. 90.

The Red Cross Knight is an allegorical portrayal of the artist's children Elizabeth, Mary, and John Singleton Copley, Jr., as characters in a scene from Book I, canto 10 of Edmund Spenser's *Faerie Queene* (1596).[6] The knight, beguiled by Duessa (Falsehood) and weakened by suffering and remorse, is brought by Una (Truth) to the House of Holiness, which was the home of the wise Dame Caelia and her three daughters. John, Jr. (1772–1863) is the Red Cross Knight who symbolizes Christian virtue. He is described in Book I, canto 1 (stanzas 1–2):

> A Gentle Knight was pricking on the plaine,
> Y cladd in mighty armes and silver shielde . . .
> But on his brest a bloudie Crosse he bore,
> The deare remembrance of his dying Lord,
> For whose sweete sake that glorious badge he wore,
> And dead as living ever him ador'd.
> Upon his shield the like was also scor'd.

Dame Caelia comments that it is strange to see a knight "that hither turnes his steps. So few there bee, / That chose the narrow path, or seeke the right." On his arrival the knight is greeted by her "most sober, chast, and wise" daughters Fidelia (Faith) and Speranza (Hope). Copley's eldest daughter Elizabeth (1770–1866) is Faith, in the center of the painting.

> . . . The eldest, that *Fidelia* hight,
> Like sunny beames that threw from her Christall face,
> That could have dazd the rash beholders sight,
> And round about her head did shine like heavens light.
> She was araied all in lilly white,
> And in her right hand bore a cup of gold,
> With wine and water fild up to the hight,
> In which a Serpent did himselfe enfold,
> That horrour made to all, that did behold;
> But she no whitt did chaunge her constant mood:
> And in her other hand she fast did hold
> A booke, that was both signd and seald with blood,
> Wherein darke things were writ, hard to be understood.
> (canto 10, stanzas 12–13)

Copley's younger daughter Mary (1773–1868) as Hope, stands on the right.

> Her younger sister, that *Speranza* hight,
> Was clad in blew, that her beseemed well;
> Not all so chearefull seemed she of sight,
> As was her sister: whether dread did dwell,
> Or anguish in her hart, is hard to tell:
> Upon her arme a silver anchor lay,
> Whereon she leaned ever, as befell;
> And ever up to heaven, as she did pray,
> Her stedfast eyes were bent, ne swarved other way.
> (canto 10, stanza 14)

The three young figures stand on a terrace in front of a balustrade. The red cape billows over the left arm of the knight in his armor as he raises his silver shield. The sisters wear dresses of a late eighteenth-century design in the colors described by Spenser. To the right are seen a column and a red curtain. The distant landscape includes a pink-tinted blue sky.

As the sisters see Una, "then to the knight, with shamefast modestie / They turn themselves, at Unaes meeke request, / And him salute with well beseeming glee; / Who faire them quites, as him beseemed best, / And goodly gan discourse of many a noble gest" (canto 10, stanza 15). Fidelia reads from her book "Of God, of grace, of Justice, of free will." The knight, who grieves "with remembrance of his wicked wayes," is comforted by Speranza, who "taught him how to take assured hold / Upon her silver anchor" (canto 10, stanzas 19, 21, 22).[7]

In both subject and technique this painting is strikingly different from most of Copley's work. It is a unique literary image, painted in a style very different from Copley's highly finished manner. Brush strokes are softer, the figures are lit by a suffused light, and the craquelure in the dark shadows of the knight's figure suggests that Copley used bituminous paint to achieve a richness not obtainable with his more customary thinly painted shadows. Comparison with the grisaille oil study (Figure 1)[8] verifies that the overall composition was established in the sketch, although Copley made some changes in the final work.[9] In the study Speranza appears to be looking at the knight, while in the painting she looks upward. The swirl of drapery around Fidelia and the anchor in Speranza's arm were repositioned. The dog seen in the lower left in the sketch, next to the knight, was omitted, and the left and center backgrounds were changed, from a wall to trees on the left, and from mountains to trees in the center. By painting a poetic allegory

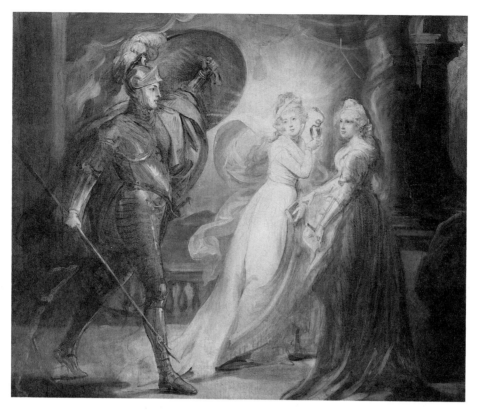

Fig. 1. John Singleton Copley, *Study for The Red Cross Knight*, oil on canvas, c. 1793, New Haven, Yale Center for British Art, Paul Mellon Collection

and experimenting with suffused lighting and broken surfaces, Copley produced a work reminiscent of Sir Joshua Reynolds and Henry Fuseli, his contemporaries.

The *Fairie Queene* was a new source of thematic material for Copley, although it had been used by English painters from about 1770.[10] Thomas Daniell had exhibited *The Red Cross Knight and Una* in 1780 at the Royal Academy of Arts, and John Graham had exhibited a painting there of *Una* in 1783.[11] New also for Copley was the combination of portraits with a literary subject, which had already been achieved with success by his contemporaries, notably West and Reynolds.[12] The female characters in the *Fairie Queene* had proved especially popular for portraits, including West's *Una and the Lion (Mary Hall in the Character of Una)* (1771, Wadsworth Atheneum, Hartford) and Reynolds' *The Character of Spenser's Una (Miss Mary Beauclerc)*, exhibited at the Royal Academy in 1780 (Fogg Art Museum, Harvard University, Cambridge, Massachusetts). George Stubbs painted *Isabella Saltonstall as Una* in 1782 (Fitzwilliam Museum, Cambridge, England),

and Maria Cosway took a subject from Book III for her portrait *The Duchess of Devonshire as Cynthia* (1784, Chatsworth, Derbyshire, England).[13]

Copley's motivations for choosing this subject and technique may have been linked to his return as a participant in the Royal Academy of Art's annual exhibition in 1793 and perhaps to his rivalry with Benjamin West. Copley had hoped to be elected president of the Academy in 1792 after the death of Reynolds, but the Academy had chosen West. As a member of the exhibition committee in 1793, Copley was able to position *Portraits in the characters of the Red Cross knight, Fidelia and Speranza* in one of the four central spaces in the Academy's Great Room. Paintings by West and Thomas Lawrence occupied the other three spaces. *The Red Cross Knight* was not only the first work Copley had exhibited at the Academy since 1786, but it was also the first of his thematic paintings exhibited there since *Watson and the Shark* in 1778 (see 1963.6.1). From 1780 to 1786 he had showed only portraits at the Academy, presenting his large dramatic works at other London exhibition sites. He exhibited *The Death of the Earl of*

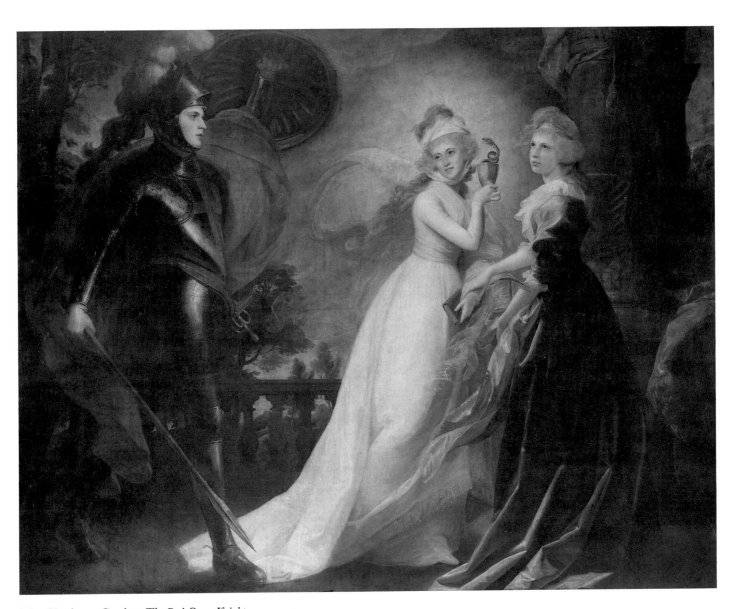

John Singleton Copley, *The Red Cross Knight*, 1942.4.2

Chatham in 1781 in a large room that belonged to the Society of Artists, *The Death of Major Peirson* in 1784 at number 28 Haymarket, and the large *Siege of Gibraltar*, a commission from the Corporation of the City of London, in 1791 in a tent in Green Park. West had painted *Fidelia and Speranza* in 1776 (Timken Art Gallery, San Diego), which was exhibited at the Royal Academy of Art in 1777 at the same time as *The Copley Family* [1961.7.1]. West's painting, a smaller and more static vertical composition, depicts the two sisters before their meeting with the knight.[14] Dressed in classical robes, they stand on steps under a portico. Una and the knight can be seen on horseback in the distant left. A third impetus for Copley's choice of subject may have been Thomas Macklin's plans for a Poet's Gallery of paintings, for which Macklin published a prospectus in 1787. The gallery was to feature paintings of themes from the work of several English poets, including Spenser, Alexander Pope, Thomas Gray, and James Thomson. Two of the earliest works painted for the gallery were taken from the *Fairie Queene*: *The Dream of Prince Arthur* by Henry Fuseli (1788) and *The Freeing of Amoret* by John Opie (1790).[15]

Reviews of the exhibition of 1793 identified *The Red Cross Knight* as a subject from Spenser[16] and mentioned that the figures were portraits.[17] The *Public Advertiser* noted, "Mr. Copley has an allegorical, historical, and portraitical picture from Spenser's Fairy Queen, in which are the Red-cross Knight and sundry other eminent personages appended to the allegory, which being portraits, are in modern dresses."[18] Two writers thought his interpretation of the theme was not successful. One wrote:

This, it seems, is a Family Picture, which represents the Son and Daughters of the Artist who painted it. The figures are so very light and airy, that if the wind of Heaven were to visit them a little too roughly, it would blow them all away. We should certainly have mentioned it as a great impropriety in the *Red-Cross Knight* that he does not look at the Ladies — if we did not recollect that they are his Sisters.[19]

Another said that "Copley's picture of the *Red-Cross Knight* from Spencer, accosting *Fidelia* and *Speranza*, recalls the pleasing images of *fairy* and *chivalric* history, but does not much assist the readiest promptings of any imagination upon the subject."[20]

Personal friends of the Copley children were more enthusiastic. "M. Sword" wrote one of the Copley sisters, "I have a great curiosity to see the Picture wherein your Portrait & those of your Brother and sister are introduced."[21] John Quincy Adams described the painting in glowing verse that was probably written when he visited the family in 1794 or again in 1795–1796. On 27 October 1794, on his way to Holland as the newly appointed American ambassador, Adams noted in his diary that he had visited the Copleys. He seemed infatuated with Elizabeth, whom he described as "handsome, if not beautiful, and is very pleasing in her manners." The young man added, "There is something so fascinating in the women I meet with in this country, that it is well for me I am obliged immediately to leave it."[22] He returned to London in 1795–1796, when Copley painted his portrait as a gift from the artist's wife to Adams' mother Abigail Adams (1796, MFA).[23] About *The Red Cross Knight* he wrote:

On Copley's canvas, just and true,
Our Spenser's happy thought is given,
As some clear mirror brings to view,
More bright, the radiant bow of heaven.

Yet here to rob the poet's store
(And let the muse the crime disclose)
T'is but to gild the golden ore,
And add new fragrance to the rose.

Small need have those to win the eye
To shine in fiction's colors drest,
Or thou to raise thy rival's sigh,
To snatch the poet's glowing vest.

With forms less fair thy pencil's power
Might woo oblivion from her throne,
And these, enriched by nature's dower,
Would charm were art and thee unknown.[24]

The painting remained in the collections of the artist and his son until it was acquired in 1864 for the artist's American descendants.

EGM

Notes

1. "Clarke" is listed as the purchaser in the annotated copy of Christie's *Catalogue of the Very Valuable Collection of Pictures, of the Rt. Hon. Lord Lyndhurst, deceased,* owned by the Boston Athenaeum, and by Graves 1918, 1:149; see also Prown 1966, 2:400, 403. News of the sale appeared in the (Boston) *Daily Advertiser*, 19 March 1864. The initials *CA* in the Athenaeum catalogue, noted next to the lot number, indicate that it was purchased for Charles Amory. For the Amorys' dates see Linzee 1917, 2:766.

2. Amory 1882, 104; Bayley 1910, 85. Charles Amory wrote Franklin Gordon Dexter on 31 January 1872, "As regards the Red X Knight, we originally bought it to keep, but on buying the Family Picture, thought it putting too much money, for our means, into two pictures and determined to dispose of the first . . . to confess the truth to

you we neither of us like the idea of selling to our children" (NGA). Dexter's 1894 "Memorandum about some of my pictures in 55 Beacon St." (NGA) states, "The Red Cross Knight by Copley was bought in England by Mr. Charles Amory who sold it to me. The figures are those of Copley's children. The Knight became in later life Lord High Chancellor Lyndhurst — the woman in white became the wife of Gardiner Greene and consequently the mother of Gordon's grandmother Amory — and the one in blue lived and died Miss Copley. Both were long lived. I have seen both since Gordon was born. Miss Copley I saw in London. I bought the picture when I moved to 55 Beacon St. Mr. Charles Amory's note to me gives some more particulars." The price is added later in pencil: "$1500." For Dexter's dates see Dexter 1904, 197; Mrs. Dexter's birth date is in Linzee 1917, 2:781–782; her death date is in *New England Register* 1925, 325.

3. Bayley, 1915, 206; Bolton and Binsse, "Copley," 1930, 116; Dexter is listed in *Who Was Who* 1:320.

4. Richardson 1942, 267; Mrs. Dexter died in New York City at the age of ninety-seven (obituary, *New York Times*, 16 December 1968, 47).

5. The painting is listed in five exhibition catalogues for these years; see Swan 1940, 108–109, and Perkins and Gavin 1980, 41, 288–289. The lender was Charles Amory in 1871 and 1872, and Franklin Gordon Dexter in 1873.

6. The quotes used here are from the edition of *The Fairie Queene* in Smith and Selincourt 1912, 4, 51–52.

7. The three Copley children also appear in *The Copley Family* [1961.7.1]. According to Amory 1882, 104, the painting was "engraved by Dunkarton, as it would seem from some remarks in the family letters, at a later date." No other evidence of an engraving has been found.

8. Oil on canvas, 43.2 by 53.3 cm [17 by 21 inches]; Prown 1966, 2:445 and fig. 593; Cormack 1985, 68, 69 repro.

9. An examination with infrared reflectography did not reveal any signs of a squaring-off system often used to transfer the image.

10. Bradley 1980, 32, 37.

11. Bradley 1980, 49; she includes a list of works (48–51), with subjects from the *Fairie Queene*, that were exhibited at the Royal Academy from 1769 to 1900.

12. Bradley 1980, 41.

13. Bradley 1980, 41–42, and figs. 15, 19–21.

14. Von Erffa and Staley 1986, 279–280, no.222, repro.

15. Bradley 1980, 38–40 and figs. 10a, 10b, 11. The project is also discussed in Hammelmann 1975, 34–35.

16. "The Royal Academy," *True Briton*, 29 April 1793, 2, included Copley's "subject from Spenser" in a list of the principal features of the exhibition.

17. "Royal Academy. A Review of the Exhibition, 1793. No. II," *London Recorder, or Sunday Gazette*, 5 May 1793, 4; "Royal Academy. Names of the Persons whom the Portraits represent," *Public Advertiser*, 2 May 1793, 4, described this painting as representing "Mr. Copley's Son and Daughter."

18. "Royal Academy," *Public Advertiser*, 30 April 1793, 2; "Royal Academy," *London Chronicle*, 27–30 April 1793, 412, similarly called the painting "an allegorical, historical, poetical, and portraitical picture from *Spenser's Fairy Queen*."

19. "Royal Academy," *True Briton*, 1 May 1793, 3.

20. "The Twenty-Fifth Exhibition of the Royal Academy," *Morning Herald*, 30 April 1793, 2; in "Exhibition of Pictures," *Times*, 30 April 1793, 4, was the comment, "*Copley*'s red cross Knight, from Spencer's Fairy Queen, is a fine composition, but with this fault, that the horses are *out of drawing*, and consequently *out of nature*. They are in the old style — on the *grand pas*, without any motion to the shoulders." This comment is puzzling, since there are no horses in the painting.

21. M. Sword, undated letter to Miss Copley, in the Rare Books and Manuscripts Division, Boston Public Library (Ch. J. 5.71; copy, NGA). The writer says that she is living with her sister in Scotland and mentions Mrs. Sword, her mother-in-law.

22. Adams 1874, 1:54–55.

23. Prown 1966, 2:412; Oliver 1970, 37–41.

24. Quoted by Amory 1882, 454–455; no manuscript or printed copy of the poem has been located.

References
1793 "Royal Academy," *London Chronicle*, 27–30 April: 412.
1793 "The Royal Academy," *True Briton*, 29 April: 2.
1793 "The Twenty–Fifth Exhibition of the Royal Academy," *Morning Herald*, 30 April: 2.
1793 "Royal Academy," *Public Advertiser*, 30 April: 2.
1793 "Exhibition of Pictures," *Times*, 30 April: 4.
1793 "Royal Academy," *True Briton*, 1 May: 3.
1793 "Royal Academy. Names of the Persons whom the Portraits represent," *Public Advertiser*, 2 May: 4.
1793 "Royal Academy. A Review of the Exhibition, 1793. No. II," *London Recorder, or Sunday Gazette*, 5 May: 4.
1867 Tuckerman: 79.
1873 Perkins: 83, 98–99, 133.
1882 Amory: 75, 104, 453–455.
1910 Bayley: 85.
1915 Bayley: 32, 35–36, 170, 205–206.
1930 Bolton and Binsse, "Copley": 116.
1942 Richardson: 267–268.
1956 Richardson: 143.
1966 Prown: 2:342, 388, 403, 445 and fig. 592.
1980 Bradley: 42.
1981 Williams: 31, repro. 28–29.
1984 Walker: 390, no. 554, color repro.

1960.4.1 (1550)

Colonel William Fitch and His Sisters Sarah and Ann Fitch

1800/1801
Oil on canvas, 257.8 × 340.4 (101 ½ × 134)
Gift of Eleanor Lothrop, Gordon Abbott, and Katharine A. Batchelder

Technical Notes: The support consists of three pieces of fabric sewn together: a large piece of coarsely woven fabric measuring about 246 by 304 cm, to which two nar-

row strips have been added, one about 10 cm wide along the top, and the second, about 36 cm wide, on the right. The paint is applied smoothly on a whitish ground. For the most part the colors are placed next to each other and do not overlap. Glazes are rarely used. There is moderate impasto in some of the highlights. Pentimenti and infrared examination reveal compositional changes in the lapels of Colonel Fitch's uniform coat, as well as in the area around the coattails, left knee, left hand, and boots. In addition, infrared reflectography reveals underdrawing in the left hand of the sister on the left, and in the colonel's right hand, left foot, and sword hilt, as well as detailed underdrawing of the urn at the left.

Vertical craquelure, visible throughout, was perhaps caused when the painting was rolled for shipment from London to Boston soon after it was painted. The exaggeration of the seams connecting the three original pieces of fabric, and a slight flattening of the impasto, may be the result of a previous lining. There is minor retouching in the paint, especially in Ann Fitch's hair, in the area of the horse's rear legs and tail, and in the landscape.

Provenance: Dr. James Lloyd [1728–1810], Boston, or his son James Lloyd [1769–1831], Boston;[1] John Borland [1792–1876], Boston, nephew of James Lloyd;[2] his sons John Nelson Borland [1828–1890] and M. Woolsey Borland [1824–1909], who bought his brother's share;[3] his granddaughter Katharine Tiffany Abbott [Mrs. Gordon Abbott, 1872–1948], Boston; her children Katharine Abbott Batchelder [Mrs. George L. Batchelder, 1899–1977], Beverly, Massachusetts, Gordon Abbott [1904–1973], Manchester, Massachusetts, and Eleanor Abbott Lothrop [Mrs. Francis Bacon Lothrop, 1900–1992], Boston.[4]

Exhibited: Royal Academy of Arts, London, 1801, no. 21, as *Portraits of the late Col. Fitch and the Misses Fitches.* Boston Athenaeum, 1829, no. 47.[5] MFA, on long-term loan, 1898–1907.[6] Fogg Art Museum, Harvard University, Cambridge, Massachusetts, on long-term loan, 1944–1960.[7]

Colonel William Fitch and His Sisters Sarah and Ann Fitch, which depicts Sarah (1763–1851), Ann (1759–1839), and William Fitch (1756–1795),[8] is Copley's largest surviving group portrait.[9] It was painted in 1800–1801 as a memorial to Colonel Fitch, who was killed in action in Jamaica in September 1795. The portrait, on the scale of a history painting, is both heroic and sentimental. Fitch is seen with his sisters before his departure from England at the command of his new regiment, the 83rd Regiment of Foot.[10] The scene is thus a literal and figurative farewell. The sisters, who are saying goodbye before Fitch's departure for battle in 1795, are also offering a permanent farewell. In the drama of the painting, they are unaware of his fate.

The Fitches were born in Massachusetts and immigrated with their parents to England at the beginning of the American Revolution. Sarah, on the left, married Leonard Vassall, also an expatriate, in October 1801, less than a year after the portrait was finished. Ann, in the center, never married. Copley's granddaughter described the two women many years later.

These ladies belonged to the class known as refugees,—persons who had seen more prosperous times under the colonial government; handsome, showy women, fond of company and gayety, but with scanty means of gratifying their taste. They delighted in going to London when their brother, at the head of his regiment, was stationed there. As they walked through the brilliant streets of the metropolis, attended by his servant, they attracted all eyes by their style and beauty. To Mrs. Copley's hospitable invitations they would gayly answer, "We should indeed be delighted to accept, but alas! our scanty wardrobe hardly allows us to join your company." They were sure, however, to appear fresh and elegant.[11]

The Fitches were close friends of many Loyalists in England, including Margaret Shippen Arnold and Benedict Arnold, who named their youngest son after William Fitch. Ann and Sarah Fitch served as trustees of the estate of Benedict Arnold, and Ann Fitch was an executor of Mrs. Arnold's will.[12]

Fitch wears a British army uniform with a scarlet coat, buff-colored breeches, and black boots. The coat is in the style of the 1790s, with lapels that could be worn open or closed, and a standing collar.[13] The collar and facings, at the lapels and cuffs, are yellow. The epaulettes, the trim on the buttonholes, the coat buttons, and belt plate on the white sword belt are silver. At his waist Fitch wears a rose-colored sash, denoting a commanding officer. He holds a cocked hat with silver trim and a walking stick in his right hand. His gloved left hand, resting on the saddle of his chestnut horse, holds his second glove. The two sisters stand to the left and slightly behind their brother. Sarah, in white, reaches her right hand toward that of her brother. Her white dress may indicate her approaching marriage in October 1801. White dresses and white head coverings were customary for bridal wear from the mid-eighteenth century.[14] With her left hand she holds her white veil away from her face with a gesture that may refer to a woman's "chaste marital state."[15] Ann, in the center, is dressed in black and carries a green parasol. She places her left hand on her brother's arm. Her black dress, which contrasts dramatically with Sarah's white gown and the colonel's uniform, reminds viewers that the sitters' parents had died within the year, Samuel Fitch in October 1799 and Elizabeth Lloyd Fitch in February 1800.[16] The

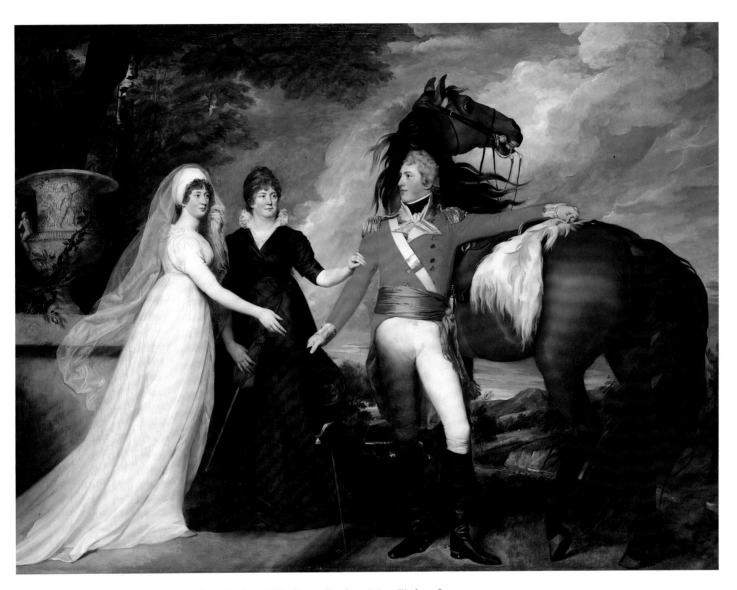

John Singleton Copley, *Colonel William Fitch and His Sisters Sarah and Ann Fitch*, 1960.4.1

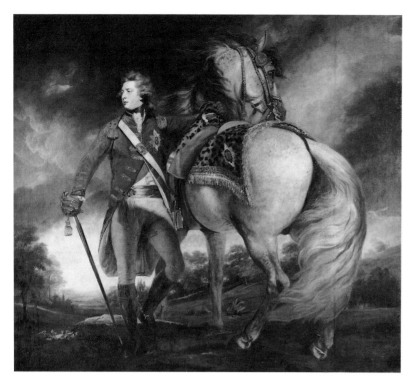

Fig. 1. Joshua Reynolds, *George, Prince of Wales*, oil on canvas, c. 1784, collection of Lord Brocket, Brocket Hall, England [photo: Reeve Photography]

figures stand on a terrace before a low wall. An urn, trees, and climbing pink roses complete the left side of the composition. On the urn the small figure of a cherub cuts a bunch of grapes from a vine, perhaps an emblem of Fitch's death. A yellow and pink sunset sky, deep blue hills, and a small stream with a waterfall complete the background.

Copley's many years of experience as a painter are evident in this work. He combined a military image, a family group, and a memorial portrait in one large canvas. For the composition of the man and his horse Copley imitated Sir Joshua Reynolds' large portrait *George, Prince of Wales*, exhibited at the Royal Academy of Arts in 1784 (Figure 1).[17] In both paintings a man in uniform stands with his body facing forward, his head turned to the viewer's left, his right hand on a walking stick and his left arm stretched outward, resting on the horse's saddle. And in both paintings the figures are seen against landscapes with a low horizon, the expansive sky filled with clouds. Copley seems to have based the portrait of the deceased colonel on Sir Thomas Lawrence's full-length pastel of 1784 (The Royal Irish Rangers, Belfast),[18] which shows Fitch standing with his body turned to the viewer's left, his face almost in full profile. Copley made a study in oil of the horse on the scale of the pastel (Figure 2).[19] To the grouping of Fitch and his horse he added the figures of the two sisters. In imitating Lawrence's

portrait, he attempted to update the military uniform, which predated Fitch's promotion to lieutenant colonel in 1793 and thus was in an earlier style, its colors indicating his earlier regiment and rank. Copley first designed the coat with the lapels in an open position, perhaps an influence from Lawrence's portrait, but he later changed it to its closed position. Pentimenti of the earlier positions of the open coat and buttons are visible on the surface of the painting. Infrared examination revealed Copley's initial drawing of the open coat and the numerous buttons (Figure 3). Despite these adjustments the artist apparently did not represent Fitch's regimental colors and other details correctly. The silver buttons, epaulettes, and buttonhole trim are incorrect for the 83rd Regiment, which would have worn gold trim and gold epaulettes. The shoulder belt plate should have been a gilt, oval plate, rather than a silver, rectangular one.[20]

Details surrounding the commission of *Colonel Fitch and his Sisters* are unknown. On 20 December 1800 the artist's wife Susanna Copley wrote their daughter Betsy Greene, who had recently married and moved from London to Boston, that Copley "has been combating the unfavorable season for finishing the Misses Fitch's heads, which he accomplished two days since, to their and his own satisfaction; they have stayed in town till now for that purpose. They have taken a house thirty miles from

London for one year, to which they set out this day. They are very agreeable; the more I know them, the more I esteem them."[21] On 3 March 1801 she wrote her daughter again, telling her that "the Fitch picture is now in hand, finishing for the Exhibition. The paragraph in your letter occasioned me a little fun with these ladies; they are in the long list of those friends who are very frequently inquiring after you, and who desire kind remembrances to yourself and Mr. Greene."[22] By the time of her letter of 6 April, the painting was on view in the annual exhibition at the Royal Academy of Arts. "The Fitch picture is the one that at present engages attention; if I dare to give an opinion before the connoisseurs, I should say that it was very fine."[23] A reviewer in the *Oracle, and The Daily Advertiser* for 7 May supported her opinion. "One of the finest groups of family portraits we have seen. Col. Fitch is a graceful manly figure, with an engaging and animated countenance. He is taking leave of his sisters, and about to mount his horse. Fraternal affection is finely expressed in the countenances." Other notices ranged from a mere comment in the *Morning Herald* for 27 April, "Copley — large picture of Family Portraits," to a longer review in the 1 May issue of the same paper.

The fate of the Colonel attaches to this piece a degree of interest which it would otherwise have failed to produce. The figures, however, are all well drawn and the colouring is natural and chaste. The ladies' drapery is particularly fine; but their countenances indicate too much a *presentiment* of their brother's fate, which at the time they cannot be supposed to have foreseen.

The review in the *St. James's Chronicle* for 7–9 May was less favorable. "This picture is well conceived; but the figures are stiff and ill drawn, and the wooden horse is abominable." Another reviewer commented in general on the number of portraits in the exhibition. "One of the most obvious defects is the great preponderance of portraits. As subjects, however, which most engage the labour and study of our artists, and for which they are best paid, it is amongst them we find the most merit."[24]

Sometime after the exhibition at the Academy closed, the painting was shipped to the Lloyd family in Boston. Dr. James Lloyd was the maternal uncle of the Fitch siblings. In an undated letter to her daughter, Mrs. Copley gave instructions about how to care for the painting once it arrived.

Miss Fitch sent her picture to Mr. Lloyd. It went from this [word missing] in very good order; should it, by being shut up, or by the dampness of the sea, contract a fog,

Fig. 2. John Singleton Copley, *Study of a Horse*, oil on canvas, c. 1800, Robert H. Ellsworth Private Collection [photo: Shin Hada, 1993]

Fig. 3. Infrared reflectogram composite showing the initial drawing of Colonel Fitch's coat [1.5–2.0 microns (μm)]

it will only be necessary to have it well rubbed with a warm, soft handkerchief, which will restore the varnish. I mention this, as perhaps they may be at a loss, and apply to you for information.[25]

In Boston the painting would serve as a memorial to the Fitch family, separated permanently from their American relatives by war and political loyalties.

EGM

Notes

1. The artist's descendants believed that the portrait was painted for the Fitches' maternal uncle, Dr. James Lloyd, a prominent Boston surgeon (Amory 1882, 195; Bayley 1915, 104; and Prown 1966, 2:419). The donors also believed this (letter from Katharine Abbott Batchelder, 27 February 1974, NGA). Earlier owners, however, believed it was painted for Lloyd's son, who later served as United States senator from Massachusetts. When M. Woolsey Borland placed the painting on loan at the Museum of Fine Arts, Boston, in 1898, for example, he wrote that it was "sent to my grand-uncle Senator James Lloyd in Boston" (letter of 19 December 1898, MFA archives). Dr. Lloyd is listed in *DAB* 6:333; for his descendants see Barck 1927, 2:889, 895, 899.

2. Letter from Katharine Abbott Batchelder, 27 February 1974 (NGA).

3. Letter from Katharine Abbott Batchelder, 27 February 1974 (NGA). M. Woolsey Borland's death date is found in the *Social Register 1911*, 165.

4. The birth dates of Mrs. Abbott and her daughters are found in Tiffany 1901?, 37; Mrs. Lothrop's death is listed in "Deaths 1993," an appendix to *Social Register 1993*, 21. Other dates were obtained in conversations with Gordon Abbott III in 1988.

5. Perkins and Gavin 1980, 39, with the title *Col. W. Fitch, Taking Leave of His Sisters, Before Embarking With His Regiment for Actual Service*, lent by J. Lloyd.

6. According to the files of the MFA registrar, the painting was placed on loan on 19 December 1898 by Woolsey Borland and was returned to him on 21 November 1907. According to Bailey 1915, 104, the painting was "exhibited in the Boston Museum of Fine Arts for many years."

7. Lent by Mrs. Abbott on 17 April 1944, the painting remained there until 1960. It was on exhibit during part, but not all, of the loan period.

8. Information on the Fitches can be found in Calder 1921, 28; Barck 1927, 2:888; Taylor 1931, 31–41, and 74–75 (Appendix IV); *DAB* 3:426–427 (Samuel Fitch); and Rickword 1951, 112–115. Tuckerman 1867, 72, erroneously identified the painting as of General Vassall with his daughters. Perkins 1873, 54, identifed the sitters correctly.

9. Only *The Knatchbull Family*, which Copley painted at the same time, was larger. It has since been cut down, and only three sections survive (owned in 1966 by Lord Brabourne, Mersham le Hatch, Ashford, Kent; see Prown 1966, 2:424).

10. For the history of the regiment, raised in Dublin in 1793 by Fitch, see Chichester and Burges-Short 1900, 779–781.

11. Amory 1882, 196.

12. Taylor 1931, 26, 33.

13. Letter from Mrs. S.K. Hopkins, National Army Museum, London, 29 June 1989 (NGA). Additional assistance in identifying the uniform came from Donald Kloster, curator, Division of Armed Forces, National Museum of American History, SI.

14. Cunnington and Lucas 1972, 60–62. Miss Fitch's dress, hat, and veil are very similar to those worn by Julia, Viscountess Dudley and Ward, in her full-length portrait by Copley, which had been painted the previous year and exhibited at the Royal Academy of Arts in 1800 (Earl of Dudley, Great Westwood, King's Langley, Herts.); Prown 1966, 2:418. This was not a wedding dress, however; the Viscountess had been married since 1780.

15. Anthony Van Dyck used the same gesture for a portrait of Lady Elizabeth Thimbelby, whose veil is around her shoulders, in his double portrait *Lady Elizabeth Thimbelby and Dorothy, Viscountess Andover* (c. 1637, National Gallery of Art, London). The portrait appears to celebrate the wedding of Dorothy Savage to the Viscount Andover. The gesture was used "in antiquity to indicate a woman's chaste marital state"; see Filipczak 1990, 64, 65 fig. 7, 68 n. 45.

16. Jones 1930, 134–135. According to Taylor 1931, 32–33, Samuel and William Fitch left no wills. Their letters of administration (Public Record Office, London) give only the values of their estates. If either man left his heirs money for a portrait, this is not documented. For a discussion of mourning dress see Cunnington and Lucas 1972, 145, 147, 244–245.

17. The portrait, which measures 239 by 260 cm [94 by 102 3/8 inches], is illustrated in Waterhouse 1973, pl. 104, and is discussed in Penny 1986, 38, fig. 22.

18. Garlick 1964, 261; it measures 58.4 by 42.6 cm [23 by 16 3/4 inches]. The pastel is described as being inscribed on the backing: "To be kept from the Dampe & from the Sun LAWRENCE 1784" (NGA). Since the pastel was later owned by Sarah Fitch Vassall, it probably belonged to the family at the time Copley painted the group portrait. See Rickword 1951, 112–115, repro., and Phipps 1930 (original unlocated; incomplete photocopy, NGA). The portrait is also illustrated in Taylor 1931, opp. 36.

19. The oil sketch of the horse, with its reins tied to a tree trunk, is signed and dated, lower right "J S Copley / 1801"; Prown 1966, 2:420; oil on canvas, 76.5 by 63.8 cm (30 1/8 by 25 1/8 inches).

20. Letter from Mrs. S.K. Hopkins, National Army Museum, London, 29 June 1989 (NGA).

21. Amory 1882, 193; the original letter is on deposit at the Massachusetts Historical Society, Boston.

22. Amory 1882, 202; the original letter is on deposit at the Massachusetts Historical Society, Boston.

23. Amory 1882, 203; the original letter is on deposit at the Massachusetts Historical Society, Boston.

24. "Royal Academy," *Morning Post and Gazetteer*, 27 April 1801, 3.

25. Amory 1882, quoted on 195–196; there appears to be a word missing, either in the original letter or in the transcription. The original letter has not been located.

References

1801 "Royal Academy," *Morning Herald*, 27 April: 3.
1801 "Royal Academy, III," *Morning Herald*, 1 May: 2.
1801 "Royal Exhibition. Number VI," *Oracle, and The Daily Advertiser*, 7 May: 3.
1801 "Exhibition of Paintings, &c. At the Royal Academy, Somerset-Place," *St. James's Chronicle: or, British Evening-Post*, 7–9 May: 4.
1867 Tuckerman: 72.
1873 Perkins: 54.
1882 Amory: 193, 195–196, 202–203.
1905 Graves: 2:159.
1915 Bayley: 104.
1966 Prown: 2:362, 388, 419–420 and fig. 635.
1981 Williams: 31, repro. 34.
1984 Walker: 390, no. 556, color repro.

1942.4.1 (550)

Baron Graham

1804
Oil on canvas, 144.8 × 118.8 (57 × 46 3/4)
Gift of Mrs. Gordon Dexter

Inscriptions
Signed on base of column: JSCopley. R.A. pinx

Technical Notes: The original support, a heavy-weight, twill-weave fabric with its original tacking margins, has been lined to a thin particle board with a fabric interleaf and then mounted on a heavy stretcher. The thin ground is white. The paint was applied in a range of techniques to imitate the varying textures being represented: thin, dry washes in the left background; fluid, quite high impasto in the highlights of the chair; and glazes in the crimson drapery. The flesh tones show rather sharply juxtaposed planes of color, and reddish outlines and reflections in the hands.

An irregular line of loss is in the white fur, and dots of discolored retouching are in the red drapery over the chest and cape, and in the sitter's right arm and left thigh. The crimson drapery has faded noticeably. The painting was varnished in 1946; the varnish has yellowed slightly.

Provenance: Bequeathed by the sitter Robert Graham [1744–1836], to Sir George Henry Smyth [1784–1852], 6th baronet, Berechurch Hall, Colchester, Essex;[1] Smyth's grandson and heir Thomas George Graham White [d. 1878], Wethersfield Manor and Berechurch Hall, Colchester, Essex; (his estate sale, Christie, Manson & Woods, London, 23 March 1878, no. 25) to "Graves."[2] The artist's granddaughter Martha Babcock Greene Amory [Mrs. Charles Amory, 1812–1880], Boston;[3] her husband Charles Amory [1808–1898], Boston;[4] their daughter Susan Greene Amory Dexter [Mrs. Franklin Gordon Dexter, 1840–1924], Boston;[5] her son Gordon Dexter [1864–1937], Boston;[6] his widow Isabella Hunnewell Dexter [c. 1871–1968].[7]

Exhibited: Royal Academy of Arts, London, 1804, no. 21. *Copley*, 1965–1966, no. 102. *From El Greco to Pollock: Early and Late Works by European and American Artists*, The Baltimore Museum of Art, 1968, no. 22.

AS A LATE WORK, this portrait of Sir Robert Graham demonstrates Copley's lifelong talent with color and texture. The sitter, the son of a Middlesex schoolmaster, graduated from Trinity College, Cambridge, England, and studied law at the Inner Temple, London. In 1793 he was appointed attorney general to the Prince of Wales and a King's Counsel. Graham was made a judge of the Court of the Exchequer in 1799, the appointment from which his title of baron derives. He was knighted in 1800.[8]

Copley has depicted Graham in his scarlet judicial robe, with its ermine cuffs and an ermine cape, seated in a chair upholstered in rose-colored brocade, next to a table draped with a rose-colored cloth. On the table is a letter addressed to "Mr: Baron Graham London." In the background are a masonry column and a green curtain. The crimson and rose-reds that dominate the portrait vie for attention with the brilliant white of the lush ermine cape and cuffs. Copley's use of a variety of brush strokes for the differing textures, and his range of techniques, from thin washes and glazes over opaque underpainting to high impasto, produced dramatic results. The color contrasts and the seated pose and formal setting result in an image of judicial authority. The painting reflects Copley's familiarity with the tradition of British official portraiture. It is similar to his earlier full-lengths *William Murray, 1st Earl of Mansfield* (1783, National Portrait Gallery, London) and *Henry Addington, 1st Viscount Sidmouth as Speaker of the House* (1797–1798, The Saint Louis Art Museum).[9] According to art historian Edgar P. Richardson, the painting shows that "Copley had mastered the rich, fluent, decorative qualities of London painting. It demonstrates also that he could paint an official portrait, an image of the authority and self-assurance of a man of high rank and great affairs, no less effectively than one of a quiet New Englander."[10]

Baron Graham apparently commissioned this, his only portrait, in memory of his friend Sir Robert Smyth, 5th baronet (1744–1802), who was member of Parliament for Colchester, Essex, from 1780 to 1790 before he moved to France. There Smyth be-

came an ally of the American revolutionary Thomas Paine and endorsed the political views of the leaders of the French Revolution.[11] When he died in Paris in 1802, Smyth named Graham as one of his executors, bequeathing him five hundred pounds

as a token of my regard and friendship for him and in consideration of the trouble he may have in the Execution of this my will whose opinion and advice in all Matters of Importance respecting my family and property it is my earnest wish my said dear wife will take being from our long acquaintance perfectly persuaded of his honor, worth and integrity.[12]

He also appointed Graham as trustee for his young son George Henry Smyth (1784–1852). Many years later, in 1836, Graham bequeathed the portrait to young Smyth when he named him an executor of his own will: "I do hereby by this Codicil give the picture of myself by Mr. Copley to my friend Sir Henry Smyth of Berechurch Executor."[13] The painting, which became part of the family portrait collection at Berechurch Hall, was inherited in 1852 by Smyth's grandson Thomas Graham White, who was also Baron Graham's godson.[14]

Graham may have chosen Copley to paint his portrait because of the artist's son John Singleton Copley, Jr., who, like the baron, was a graduate of Trinity College, Cambridge. One of the artist's early biographers wrote in the 1870s that Graham was an intimate friend of the young Copley and that "on that account, perhaps, Copley painted his portrait with uncommon care."[15] Young Copley rode the court circuit with Judge Graham in 1803, when he was a law student in London. His mother Susanna Copley wrote to his sister Betsy Greene in Boston on 1 March 1803.

The Templer has left us to accompany Judge Graham as Marshal on the Circuit; he will be absent five weeks. We feel rather solatary without his company at dinner, but it is a pleasant excursion for him and not without some profit. The two Circuits are something above a Hundred per Year. I dont know if he will continue it or not.[16]

He rode circuit with the judge again that summer, informing his sister on 28 July that "I am at present upon the circuit with Judge Graham and shall return to town, after completing a tour through Devonsh[ire], Cornwall, and Somerset, in about three weeks."[17] He told her of their visit to Wilton,

the seat of Lord Pembroke where I had the opportunity of seeing the celebrated picture of the Pembroke family [by Sir Anthony Van Dyck]. I was most extremely delighted with the production, which is certainly one of the finest works of art, in that style, which the world con-

tains. My father, who has never seen it, will almost be disposed to envy me the opporty. which the circuit has afforded. His Knatchbull family is a picture of the same character.[18]

It was presumably this professional association that led to the choice of Copley for the portrait commission.

When Copley exhibited Graham's portrait at the Royal Academy of Arts in the spring of 1804, reviews were mixed. The portrait was judged by some a "strong likeness"[19] that possessed "a very uncommon degree of merit."[20] One writer called it a "striking and animated likeness. The attitude of the Baron is perfectly easy and natural."[21] Both the *Morning Herald* and the *Daily Advertiser, Oracle, and True Briton* for 30 April listed the painting among the principal portraits in the exhibition.[22] One writer, however, criticized the work. "This is a good painting but a very indifferent likeness. The Baron has more of the milk of human kindness in his visage than the Painter is pleased to allow him."[23] Another noted that "Mr. Copley, though there are some who admire his very peculiar talent, will not be considered, in general, as having added to his fame. He has a number of portraits, not so fortunate, we think as he has been heretofore."[24] Because it is the only portrait of Graham, the painting is judged today not for its strength or weakness as a likeness but as a masterful achievement of Copley's later years.

EGM

Notes

1. Robert Graham's will, dated 12 May, 19 September, and 25 October 1833 and 21 September 1836, was proved on 15 October 1836 (Public Record Office, London; copy, NGA).

2. *White* 1878, 6. "Graves" is listed as the purchaser in the annotated copy of the catalogue at Christie's (copy, NGA) and by Graves 1918, 1:149. He may be London dealer Henry Graves (1806–1892) who bought Copley's *Death of the Earl of Chatham* [1947.15.1]. Perkins 1873, 129, listed the portrait among the paintings by Copley in England, but he did not give the owner's name.

3. Amory 1882, 239, note (published after Mrs. Amory's death in 1880). For her dates see Linzee 1917, 2:766.

4. Perkins [after 1873], 18–19; his dates are found in Linzee 1917, 2:766.

5. Bayley 1910, 43; Bayley 1915, 122; her birth date is in Linzee 1917, 2:781–782; her death date is in *New England Register* 1925, 325.

6. Bolton and Binsse, "Copley," 1930, 116; Dexter's dates are in *Who Was Who* 1:320.

7. Mrs. Dexter died at the age of ninety-seven in New York City (obituary, *New York Times*, 16 December 1968, 47).

John Singleton Copley, *Baron Graham*, 1942.4.1

8. "Graham" 1837, 653; *DNB* 8:358.

9. Prown 1966, 2:297–298 and fig. 429, 352 and fig. 614.

10. Richardson 1968, 41.

11. "Smyth Family" 1915, 178–190.

12. Will of Sir Robert Smyth, dated 14 March 1797 and proved 26 June 1802 (Public Record Office, London; copy, NGA).

13. This codicil of Graham's will is dated 21 September 1836; the portrait is also referred to in the section of the will dated 12 May 1833, in which he appointed Smyth an executor: "I appoint Sir George Henry Smyth of Berechurch Essex to whom I [?can only] give my portrait by Copley."

14. On the portrait collection see "Mr. T. Graham White's Collection," *Times* (London), 23 March 1878, quoted in Redford 1888, 1:281–282. Graham bequeathed a silver tureen and a pair of silver candlesticks to his godson.

15. Perkins [after 1873], 18.

16. The letter, quoted in Amory 1882, 239, is on deposit at the Massachusetts Historical Society, Boston.

17. Quoted in Amory 1882, 244; his mother had written Betsy on 29 June (quoted in Amory 1882, 241–242) that "your brother will in a short time repeat his jaunt with Judge Graham upon the circuit. I feel happy that he will have so good an opportunity to leaving London in the warm season but he will write to you previous to that excursion." The letters are on deposit at the Massachusetts Historical Society, Boston.

18. Quoted in Amory 1882, 244.

19. "Royal Academy," *Times*, 28 April 1804, 2.

20. "Royal Academy," *Morning Post*, 28 April 1804, 3.

21. "Royal Academy," *St. James's Chronicle: Or, British Evening-Post*, 12–15 May 1804, 4.

22. "Royal Academy Dinner," *Morning Herald*, 30 April 1804, 3; "Royal Academy," *Daily Advertiser, Oracle, and True Briton*, 30 April 1804, 3, which praised the artist: "Mr. Copley's contribution to the general display reflects honour on his industry and talents."

23. "Royal Academy. Exhibition, No. I," *Daily Advertiser, Oracle, and True Briton*, 5 May 1804, 3.

24. "Royal Academy," *Morning Chronicle*, 30 April 1804, 3.

References

1804 "Royal Academy," *Morning Post*, 28 April: 3.

1804 "Royal Academy," *Times*, 28 April: 2.

1804 "Royal Academy," *Daily Advertiser, Oracle, and True Briton*, 30 April: 3.

1804 "Royal Academy Dinner," *Morning Herald*, 30 April: 3.

1804 "Royal Academy," *Morning Chronicle*, 30 April: 3.

1804 "Royal Academy. Exhibition, No. I," *Daily Advertiser, Oracle, and True Briton*, 5 May: 3.

1804 "Royal Academy." *St. James's Chronicle: Or, British Evening-Post*, 12–15 May: 4.

1832 Cunningham: 5:184.

1873 Perkins: 18–19, 129.

[after 1873] Perkins: 18–19.

1882 Amory: 239, 241–242, 244.

1910 Bayley: 43.

1915 Bayley: 33, 122.

1930 Bolton and Binsse, "Copley": 116.

1966 Prown: 2:373–374, 388, 421, and fig. 653.

1968 Richardson: 41.

1981 Williams: 31, repro. 35.

1984 Walker: 390, no. 555, color repro.

Ralph Earl

1751 – 1801

RALPH EARL created many memorable portraits that convey the prosperity and optimism of his affluent sitters. A New Englander born in Worcester County, Massachusetts, Earl was the son of a farmer. He learned the trade of painting portraits by observing the work of others. Both he and his younger brother James (1761–1796) became painters. In 1774 he married his cousin Sarah Gates and settled in New Haven, where he painted portraits for three years. His early work includes the imposing full-length of Connecticut patriot *Roger Sherman* (c. 1775–1776, YUAG). During these years an important influence was John Singleton Copley's work, especially his portraits *Adam Babcock* [1978.79.1] and *Mrs. Adam Babcock* [1985.20.1].

A Loyalist, Earl fled Connecticut during the American Revolution to escape certain imprisonment as a spy. Abandoning his family, he disguised himself as the servant of British army captain John Money and in the spring of 1778 accompanied Money to England. He settled in Money's hometown of Norwich, where he painted his first English portraits. By 1783 Earl was in London, a student of Benjamin West. Four of his portraits were included in annual exhibitions of the

Royal Academy of Arts (1783–1785). His approximately two dozen English portraits indicate that he successfully adopted the cosmopolitan London manner.

Earl returned to the United States in 1785 with a second wife, Ann Whiteside. The announcement of his return that appeared in newspapers in Hartford, Connecticut, and Worcester, Massachusetts, described him as "a very capital Portrait Painter . . . scholar of Copley, West and Sir Joshua Reynolds."[1] In New York City in September 1786 Earl was sentenced to prison because of nonpayment of personal debts. While in jail he was supported by the Society for the Relief of Distressed Debtors. The Society's members sent their families and friends to have their portraits painted. Other sitters were members of the recently formed Society of the Cincinnati.

Released from prison in January 1788, Earl returned to Connecticut. His patron, Dr. Mason Fitch Cogswell, a founding member of the Society for the Relief of Distressed Debtors, gave the artist introductions to his many friends, acquaintances, and even his patients, describing Earl as a "mighty plain, peaceable man."[2] Earl found enthusiastic patronage for his portraits among the social leaders of western and central Connecticut. His sitters during the next decade included the Boardmans and Taylors of New Milford, the Wolcotts of Litchfield, and the Ellsworths of Hartford. They are portrayed in richly detailed domestic settings or in front of landscapes of the towns in which they lived, and they seem to share a sanguine outlook on life in the new republic. For the next decade Earl successfully translated his English experience into a new Connecticut style characterized by deep, rich colors that were rarely modified with glazes, in contrast to the English manner. Portrait commissions also took him to Long Island, New York City, and toward the end of his career, western Massachusetts and southern Vermont. He often painted on coarsely woven large canvases that give his work a rough finish. The scale of his portraits and their rich colors and detailing exerted an impact on local artists, including Joseph Steward of Hartford, who imitated Earl's new Connecticut manner with great success.

An accomplished landscape painter, Earl frequently included landscape backgrounds in his portraits, and at times he was commissioned to paint views of his patrons' houses. In the late 1790s he painted a panorama of Niagara Falls (unlocated). At age fifty he died of alcoholism, the disease that had plagued him since his confinement in the New York debtors' prison.

EGM

Notes
1. Quoted in Kornhauser 1991, 34.
2. Letter from Dr. Mason Fitch Cogswell to Rev. James Cogswell, dated 15 July 1791, quoted in Kornhauser 1991, 41.

Bibliography
Evans 1980: 60–66.
Kornhauser 1988.
Kornhauser 1991.

1965.15.8 (1957)

Dr. David Rogers

1788
Oil on canvas, 86.6 × 73.5 (34 1/8 × 28 15/16)
Gift of Edgar William and Bernice Chrysler Garbisch

Inscriptions
Signed and dated lower left, in red: R. Earl / Pinxt / 1788

Technical Notes: The painting is executed on a rough, coarsely woven, plain-weave fabric. According to treatment records, the painting was originally secured to a strainer. Stretcher creases indicate that the painting has been trimmed by 0.63 cm on the right edge. The fabric was primed with a white ground of uneven thickness, which suggests that it was applied by the artist. The paint was applied smoothly in single, moderately thin layers, with few areas of overlap. X-radiographs show that areas for the eyes were left in reserve. On the bottom edge of the sitter's coat a red underlayer is allowed to show through the brush strokes of brown paint, giving a rich tone to the shadow cast by the chair. There is some use of glazes in the sitter's clothing.

The paint is severely abraded, particularly in the background. There are also losses to the paint layer, particularly in the upper left quadrant, the upper and lower right corners, and in the sitter's cheek, chin, neck, and left eye. The enhancement of the canvas weave may be the result of past lining. Traction crackle is evident over the entire painting. In 1963 the varnish was removed and the painting was lined. The present surface coating is glossy and slightly discolored.

Provenance: By descent from the sitter to Annie Munro West [1858–1919], Macon, Georgia; bequest to her nephew Addison Tinsley West [1897–1985], Orlando, Florida;[1] by whom sold 21 February 1963 to (Hirschl & Adler Galleries, New York); from whom purchased 15

March 1963 by Edgar William and Mrs. Bernice Chrysler Garbisch.[2]

Exhibited: *Men and Women: Dressing the Part*, National Museum of American History, SI, 1989–1991, not in cat. *Ralph Earl: The Face of the Young Republic*, NPG; Wadsworth Atheneum, Hartford; Amon Carter Museum, Fort Worth, 1991–1992, no. 23.

DR. DAVID ROGERS (1748–1829) and his wife Martha Tennent Rogers (see 1965.15.9), of Greenfield Hill, were among Earl's first sitters when the artist returned to Connecticut in 1788. Rogers was trained as a doctor by his father, Dr. Uriah Rogers of Norwalk, and was licensed to practice medicine in New York City. He undoubtedly met Earl through Dr. Mason Fitch Cogswell, with whom Rogers had served as an army surgeon in Connecticut during the Revolution. Later, in 1792, Rogers and Cogswell were founders of the Connecticut Medical Society.[3]

In the portrait Rogers wears a brown wool coat with large metal buttons, a yellowish vest perhaps made of nankeen (a cotton fabric), and dark breeches. His gray eyes and dark brows convey an inviting yet pensive personality. His powdered hair is casually arranged, and powder has dusted the coat collar. According to costume historian Aileen Ribeiro, "It was quite acceptable for the loose powder to be shown on the coat collar."[4] He is seated in a red upholstered armchair. The green curtain behind him is pulled back to reveal numerous books bound in green and red, with gold lettering, on red shelves. Earl's palette of broadly applied bright colors is characteristic of his Connecticut work. The greens and reds are balanced with buff and brown to create a warm, attractive image.[5]

Rogers' erudition is indicated by the book that he holds, his index finger between its pages. The titles of the books on the shelves indicate his professional, political, and religious views. On the shelf immediately above his arm are several medical reference books, the authors' names prominently marked on the spines. Four of the five volumes are numbered as if in a series: "SYDENHAM," "SMELLIE 1," "BOERHAAVE 2," "CULLEN 3," and "CULLEN 4." Thomas Sydenham (1624–1689), an English physician, was considered the founder of modern clinical medicine. Dutch physician Hermann Boerhaave (1668–1738) was one of the most influential early eighteenth-century medical teachers. William Smellie (1697–1763), a Scottish physician, was known for his expertise in obstetrics and midwifery, and his fellow Scot, William Cullen (1710–1790), lectured on the classification and diagnosis of disease. The writings of these four physicians were frequently found in the libraries of American doctors of the colonial and revolutionary era.[6]

On the upper shelf are books that reflect Rogers' religious and political beliefs: "LOCKE 2," "EDWARDS'S HIST: OF REDEMTION," and "CONQUEST OF CANAAN BY DWIGHT." The theories of statehood expressed by English philosopher John Locke (1632–1704) were central to the principles on which the new American republic was founded. Connecticut Congregationalist Jonathan Edwards (1703–1758) expressed his views on redemption and good works in sermons, many of which were posthumously published as the *History of the Works of Redemption* (Edinburgh, 1774). *Conquest of Canaan*, an epic poem published in 1785 by Timothy Dwight (1752–1817), a Connecticut Congregationalist minister, alluded to contemporary events and characters within a biblical framework. Dwight, a friend of the artist, was the grandson of Jonathan Edwards. He was the minister at the Congregational Church in Greenfield Hill and later served as president of Yale College.

EGM

Notes
1. De Beixedon 1921, repro. opp., with owner's name; information from Addison West's daughter Elizabeth H. Reed, Orlando, Florida, 1991.
2. Letter from Hirschl & Adler Galleries, 17 May 1991 (NGA).
3. De Beixedon 1921, 5–6; Jacobus 1932, 2:790; Barker 1942, 9; Kornhauser 1991, 142.
4. Costume note in Kornhauser 1991, 142, nos. 23, 24.
5. Robert R.G. Munro-Erwin of New York, a descendant of the sitter, commissioned a copy, which was painted in Madrid in 1929 by English artist Nelly Harvey. It was last recorded in 1934 (Frick Art Reference Library).
6. Harvey 1942, 179.

References
1921 De Beixedon: repro. opp. 2.
1988 Kornhauser: 121–122, 314–315.
1991 Kornhauser: 142–143, 145, color repro.

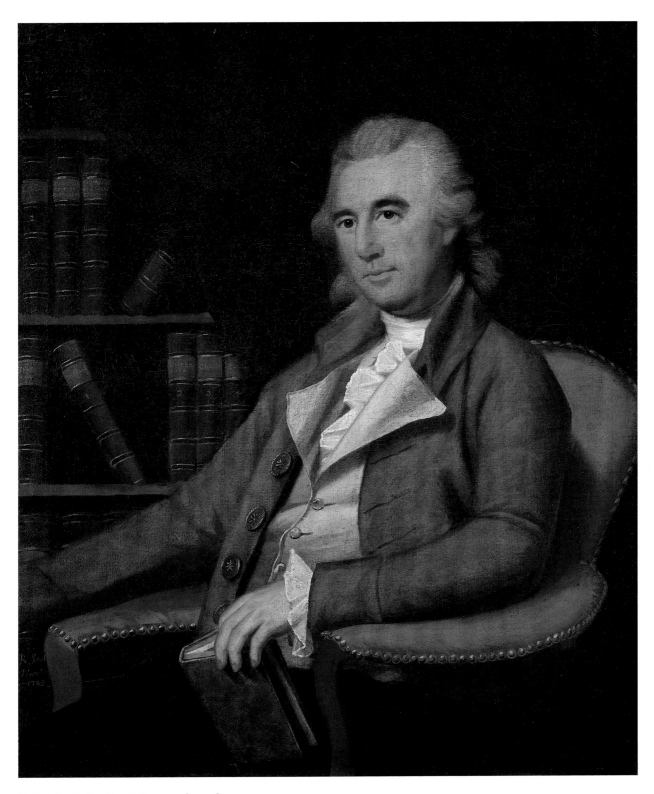

Ralph Earl, *Dr. David Rogers*, 1965.15.8

1965.15.9 (1958)

*Martha Tennent Rogers
(Mrs. David Rogers) and Her Son,
probably Samuel Henry Rogers*

1788
Oil on canvas, 86.4 × 73.3 (34 × 28 ⁷⁄₈)
Gift of Edgar William and Bernice Chrysler Garbisch

Inscriptions: Signed and dated lower left, in yellow:
R. Earl / 1788

Technical Notes: The painting is on a rough, coarsely woven, plain-weave fabric. Treatment records indicate that the painting was originally secured to a strainer. Earlier measurements indicate that the painting has been cut down by one centimeter in each dimension. The thick white ground was applied by the artist.

The paint has been applied directly, without complex layering or glazing. Layering occurs only where elements of the composition overlap: the blue sash is painted on top of the child's dress, and edges of the landscape are painted on top of the sky. A considerable amount of visible brushwork is found in the child's costume and hair, in the patterning of the mother's shawl, and in the trees. Impasto is present in the highlights. Damages have occurred to the area of the lower left and in the woman's upper arm. Another such loss is in the lace cap. There are other small losses of paint and ground throughout the painting. The woman's left hand is badly damaged, and the chair and the child's dress and sash are in poor condition. The paint is severely abraded. Moating of the impasto may be the result of a past lining. The varnish was removed and the painting lined in 1963. Discolored varnish residues remain beneath the present varnish, which is only slightly discolored but excessively glossy.

Provenance: By descent from the sitter to Frank Bartow West [1869–1942], Macon, Georgia; to his son Addison Tinsley West [1897–1985], Orlando, Florida;[1] by whom sold 21 February 1963 to (Hirschl & Adler Galleries, New York); from whom purchased 15 March 1963 by Edgar William and Bernice Chrysler Garbisch.[2]

Exhibited: *American Primitive Paintings from the Collection of Edgar William and Bernice Chrysler Garbisch*, Museum of Arts and Crafts, Inc., Columbus, Georgia, 1968–1969, no. 2. *Men and Women: Dressing the Part*, National Museum of American History, SI, 1989–1991, not in cat. *Ralph Earl: The Face of the Young Republic*, NPG; Wadsworth Atheneum, Hartford; Amon Carter Museum, Fort Worth, 1991–1992, no. 24.

MARTHA TENNENT (1751–1813) was the daughter of Rev. Charles and Martha Tennent of Buckingham, Maryland. She married David Rogers in 1772. Their twelve children were baptised in Greenfield

Hill, where her brother William served for a time as minister.[3] In the portrait she wears a brown dress with long sleeves, and over her shoulders is a large white muslin kerchief. A few curls of her dark brown hair show modestly beneath her white cap, which is tied with a blue bow. According to costume historian Aileen Ribeiro, the indoor cap was "*de rigueur* in England and America for middle-class married women, particularly in households with strong Protestant beliefs."[4] Mrs. Rogers is seated in a red upholstered armchair identical to that in her husband's portrait. The extended arms of the chair seem to have been exaggerated for effect. As Elizabeth Kornhauser has noted, the chair is "a variation on the form seen in Earl's English and New York portraits . . . more suited to a gentleman's study or library, as in David Rogers's portrait, than to the outdoors."[5] Behind and to the right of Mrs. Rogers appear a meadow and trees.

On her lap she holds a child wearing a pink frock with a large blue sash. The child's ash-blond hair is cut with straight bangs and shoulder-length curls. Identified in the past as a daughter (unnamed), this child is undoubtedly a boy, probably Samuel Henry Rogers, who was born on 25 May 1786, two years before the portrait was painted. Like his two older brothers named Samuel, born in 1782 and 1784, he did not survive childhood. Another son born in 1796 was also named Samuel Henry.[6] Boys often wore the same loose-fitting frock as girls until they were three or four years old. The lack of "aprons and white indoor caps" was a subtle feature that distinguished them from girls.[7]

EGM

Notes

1. De Beixedon 1921, repro. opp. 106, with the name of the owner; information from Addison West's daughter Elizabeth H. Reed, Orlando, Florida, 1991.
2. Letter from Hirschl & Adler Galleries, 17 May 1991 (NGA).
3. De Beixedon 1921, 5–6, 9–10, 107; Jacobus 1932, 2:790–791; Kornhauser 1991, 142.
4. Costume notes by Aileen Ribeiro in Kornhauser 1991, 142–143.
5. Kornhauser 1991, 142.
6. On the Rogers' children see De Beixedon 1921, 5–6, 9–10 (who erroneously identifies the child as Gilbert, who was born in 1790, in the illustration of the painting opp. 106), and Jacobus 1932, 2:791. The Rogers had two daughters, Martha and Susan or Susanna, born in 1774 and 1778, respectively. Jacobus lists a third daughter, Julia Ann, born in 1794; De Beixedon lists a boy named "Julian."
7. Cunnington and Cunnington 1972, 409, 415 fig.

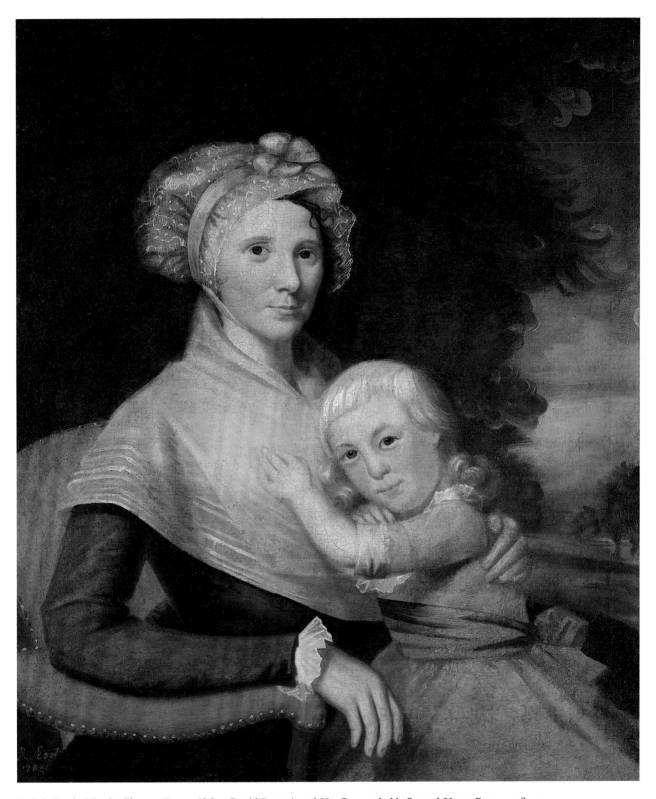

Ralph Earl, *Martha Tennent Rogers (Mrs. David Rogers) and Her Son, probably Samuel Henry Rogers*, 1965.15.9

156. Deborah Chotner first noted in conversation with me that the child might be a boy rather than a girl, judging from the style of hair, especially the blunt bangs.

References
1921 De Beixedon: repro. opp. 106.
1988 Kornhauser: 121–122, 314–315.
1991 Kornhauser: 142–143, 144 color repro.

1948.8.1 (1026)

Daniel Boardman

1789
Oil on canvas, 207.4 × 140.4 (81 $^{11}/_{16}$ × 55 $^{1}/_{4}$)
Gift of Mrs. W. Murray Crane

Inscriptions
Signed and dated lower left, in red: R. Earl Pinxt 1789—

Technical Notes: The painting is executed on two pieces of heavy weight, very coarsely woven, plain-weave fabric that have been joined by a vertical seam 45.6 cm from the left edge. The fabric, with its great number of large canvas slubs, imparts a pronounced texture to the paint.

The ground is a fairly thick red-brown layer. It appears that the artist painted the basic tones of the sky, the landscape background, and the large trees prior to the figure. X-radiography shows that the mountains in the landscape continue beneath Boardman's torso. The details and much of the modeling and shading of the background, however, were not painted until after the figure. The paint is thickly applied and well blended, with high impasto in the highlights of the figure and in the foliage of the large tree. A minor contour change can be detected in the sitter's upper right sleeve.

Sparsely scattered small losses occur throughout the work. Retouching was done along the seam. The varnish layer is heavy and glossy. The painting received minor conservation treatment in 1979.

Provenance: The sitter's grandson Rev. William S. Boardman [b. 1838], New York.[1] The sitter's great-grandniece Josephine Porter Boardman Crane [Mrs. Winthrop Murray Crane, 1873–1972], New York and Woods Hole, Massachusetts.[2]

Exhibited: *Exhibition of Connecticut Portraits by Ralph Earl, 1751–1801*, Gallery of Fine Arts, Yale University, New Haven, 1935, no. 15. *Masterpieces of Art*, World's Fair, New York, 1940, no. 172. *American Portraits by American Painters, 1730–1944*, M. Knoedler & Co., New York, 1944, no. 9. *Ralph Earl, 1751–1801*, Whitney Museum of American Art, New York; Worcester Art Museum, 1945–1946, no. 14. *American Painting from the Eighteenth Century to the Present Day*, Tate Gallery, London, 1946, no. 76. *Ralph Earl: The Face of the Young Republic*, NPG; Wadsworth Atheneum, Hartford; Amon Carter Museum, Fort Worth, 1991–1992, no. 28.

THIS PORTRAIT of Daniel Boardman (1757–1833) is one of Earl's most memorable Connecticut full-lengths. Behind Boardman stretches a landscape that includes, in the distance, his hometown of New Milford, on the Housatonic River. The sitter was a grandson of the Reverend Daniel Boardman, "the first minister of the town," whom he was said to resemble strongly. His father Sherman Boardman was a deacon in the Congregational Church. Daniel Boardman attended Yale College, where he earned a Bachelor of Arts and a Master of Arts degree. From 1782 to 1793 he was in business with his younger brother Elijah, who had opened a dry goods store in New Milford. A captain in the local militia, Boardman also represented the town in the State Assembly in May 1790 and October 1792.[3] In the portrait Boardman stands in a cross-legged pose and rests his right hand on an elegant walking stick with an ivory head.[4] He wears a blue coat, a white silk double-breasted waistcoat trimmed with gold braid, a white ruffled shirt, a white linen cravat, buff breeches, and white stockings, all befitting a young, prosperous dry goods merchant. At his waist Boardman wears a watchfob with two seals, and he holds an expensive hat made of black beaver. Earl painted a full-length of Boardman's brother Elijah at the same time. In contrast to the landscape setting of this portrait, Elijah Boardman (MMA) is shown in his dry goods store, with bolts of cloth and books shelved behind him. The family apparently was pleased with the portraits, for the Boardmans commissioned seven additional pictures from Earl that year and in 1796.[5]

Daniel Boardman continued to manage the store after the brothers dissolved their partnership in 1793. Two years later he moved to New York, where he became a partner with Henry Hunt in a wholesale dry goods business. He married Hetty Moore in 1797. On 24 January 1799 he asked Elijah to send him the portrait. "Mrs. Boardman is frequently solliciting me to send for my Portrait. You will therefore tell Sims [?] or some Carpenter to make a Case for it & screw it in fast that it will not chafe the gilding send it the first Sleighing by One of your Carful Teamsters to Newfish direct them to be carful of it & order your Coaster [?] to bring it also to me with Care and charge me the expenses." Eager for the portrait, Boardman wrote again on 21 February: "I wish my portrait forwarded when opportunity presents."[6]

The composition of Earl's *Daniel Boardman* falls squarely in the tradition of eighteenth-century

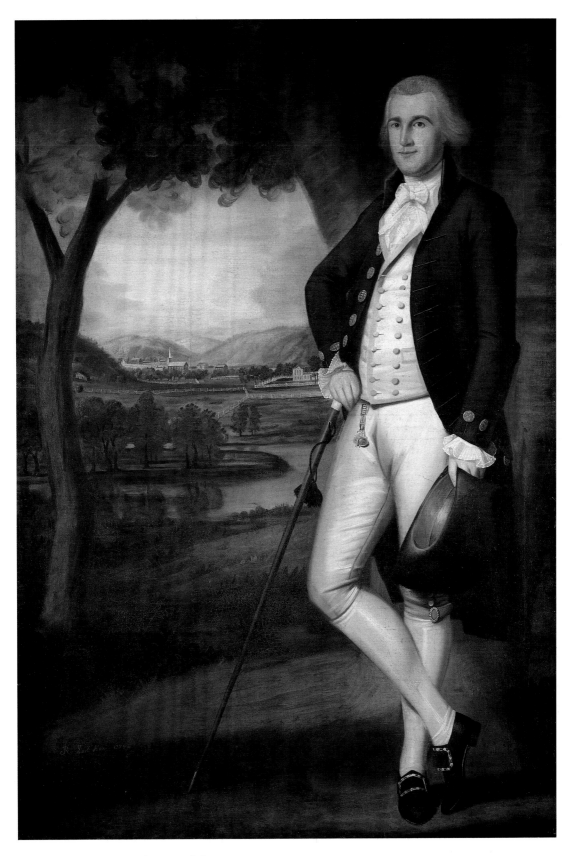

Ralph Earl, *Daniel Boardman*, 1948.8.1

British full-length portraits. The cross-legged stance had been popular in English painting since the 1740s. A similar image, although not with this exact pose, is Thomas Gainsborough's *Sir Benjamin Truman* (early 1770s, Messrs. Truman, Hanbury & Co., London), which shows the English brewer standing in the countryside, holding a cane and a hat with the maker's name visible on the lining.[7] When Earl was in England in 1783–1784 he had portrayed General Gabriel Christie (William Rockhill Nelson Gallery of Art, Kansas City) and a *Hunter with Gun and Two Dogs* (Worcester Art Museum) in similar full-lengths.[8]

The background of New Milford includes the second Congregational Church, built in 1754 and torn down in 1833, which stood in the middle of the long narrow green at the center of the village. The mansion that is depicted is puzzling. Although the architecture seems distinctive, local historians have found no record of such a building.[9] The post-and-rail and diamond-construction fences in the landscape suggest agricultural activity, although no animals or people are visible.

Earl's technique in the portrait is broad, without complex layers and glazes, although he may have used some glazed shadows in the face. The brushwork is opaque and completely covers the red-brown ground that was laid over the rough-textured canvas. Earl's seemingly literal truth lies more in descriptive details, however, than in representation of personality. While Boardman's fashionable costume is painted button by button and his powdered hair is carefully rendered in short stippled strokes, his individual character may have eluded the painter. Boardman appears a confident merchant who might welcome visitors, yet later descriptions spoke of a "rather distant and formal manner" that "did not encourage familiarity." His Yale biography concludes, "His reputation was not that of a generous man."[10]

CJM / EGM

Notes

1. The portrait was presumably inherited by the sitter's son Frederic William Henry Boardman [1804–1882], New York City and New Hamburg, New York, and then by his son William S. Boardman. On these relationships see Goldthwaite 1895, 331–332, 408.

2. Mrs. Crane, the great-granddaughter of Elijah Boardman, the sitter's brother, owned the portrait by 1935, when she lent it to the exhibition at Yale University. Carl Boardman Cobb recalled that Mrs. Crane, his great-aunt, said she bought the painting from another

member of the family (telephone interview, 8 January 1990). For Mrs. Crane's dates see Goldthwaite 1895, 545, and *NCAB* 57:720.

3. For Boardman's biography see Kornhauser 1991, 152; Schroeder 1849, 397–399; Dexter 1907, 181–182.

4. Descendant Carl Boardman Cobb owns an identical walking stick, engraved "E. Boardman, 1785," which is believed to have belonged to Boardman's brother Elijah (letter from Cobb, 24 April 1958, NGA). Boardman's clothing is described in detail by Aileen Ribeiro in Kornhauser 1991, 152.

5. These include portraits of their sister Esther (private collection) and brother Homer (Colby College Museum of Art, Waterford, Maine), as well as sister-in-law Amaryllis Boardman (private collection), their parents Sarah and Sherman Boardman (New Milford Historical Society, Connecticut), and Mrs. Elijah Boardman and son (Huntington Library, Art Collections, and Botanical Gardens, San Marino, California). Earl also painted a view of Elijah Boardman's home; see Kornhauser 1991, 157–158, 212–217.

6. Boardman's letters are in the collection of Carl Boardman Cobb of Aurora, Ohio, a descendant (copies, NGA), and are quoted in part in Kornhauser 1991, 152.

7. Hayes 1975, 216–217, no. 79, pl. 76.

8. Kornhauser 1988, 71–72, 274; the portrait of Christie was at one time attributed to Gainsborough.

9. President Malcolm P. Hunt and members of the board of the New Milford Historical Society studied details of the portrait and identified the church. "The consensus is that the scene is as viewed from the west side of the Housatonic River looking in a northeasterly direction toward the town." However, "the perspective here [of the church] is not strictly correct, because the church is seen as viewed from the southeast, not the southwest" (letter from Hunt, 19 November 1989, NGA).

10. Schroeder 1849, 399; Dexter 1907, 181.

References

1895 Goldthwaite: 331.
1907 Dexter: 4:182.
1934 Sherman: 83, 88, repro. facing 81.
1939 Sherman: 177, no. 33.
1946 Goodrich: 5, repro. 2 (detail).
1960 Sawitzky and Sawitzky: 27, repro. (detail), 26, fig. 18.
1967 Goodrich: 9–10, 58, fig. 24.
1980 Wilmerding: 60, color repro. 61.
1984 Walker: 394, no. 560, color repro.
1988 Kornhauser: 129–130, 258.
1991 Kornhauser: 45, 47, 73–76, 152, 153 (color), 154.

1947.17.42 (950)

Thomas Earle

1800
Oil on canvas, 95.5 × 86.1 (37⅝ × 33⅞)
Andrew W. Mellon Collection

Inscriptions
Signed and dated lower left, in red, reinforced with pink:
 R. Earle Pinxᵗ 1800

Technical Notes: The support is a medium-weight, plain-weave fabric. The painting has its original tacking edges. Many of the horizontal threads of the original fabric are more prominent than the vertical threads, creating a "striped" texture. The dark ground varies in tonality from a dark brown, found under warm colors such as the red curtain, to a dark gray, found under cooler colors. The paint is applied in different consistencies ranging from thick impasto to transparent glazes. The green in the landscape has a coarse texture, as if mixed with sand. X-radiographs make evident the artist's broad, sketchy brush strokes throughout the painting. They also reveal two changes: a large tree on top of the hill at the right was covered, and the house was once slightly lower.

There are extensive losses and abrasion, along with much retouching. The signature consists of a pink layer over an abraded red layer; the pink lettering appears to be a later reinforcement. The varnish is thick and discolored.

Provenance: From the sitter to his daughter Electa Earle Nye [Mrs. Luther Nye, 1778–1847], New Braintree, Massachusetts; her daughter Melinda Earle Nye Chandler [Mrs. Marcus Chandler, d. 1887], Springfield, Massachusetts; her daughter Harriet M. Chandler Schoepf, Springfield, Massachusetts; purchased by (Edward Francis Coffin, Worcester, Massachusetts); sold to the Worcester Art Museum in 1916.[1] Acquired 1921 by exchange with the Worcester Art Museum by (Ehrich Galleries, New York); repurchased by (Edward Francis Coffin); sold on 16 March 1923 to Thomas B. Clarke [1848–1931], New York;[2] his estate; sold as part of the Clarke collection on 29 January 1936, through (M. Knoedler & Co., New York), to The A.W. Mellon Educational and Charitable Trust, Pittsburgh.

Exhibited: *Exhibition of Portraits by Early American Portrait Painters*, Union League Club, February 1924, no. 12. Philadelphia 1928, unnumbered. Georgia Museum of Art, University of Georgia, Athens, on long-term loan, 1972–1974. *Ralph Earl: The Face of the Young Republic*, NPG; Wadsworth Atheneum, Hartford; Amon Carter Museum, Fort Worth, 1991–1992, no. 65.

RALPH EARL painted this portrait of his cousin Thomas Earle (1737–1819) when he visited his native Leicester, Massachusetts, in 1800, for the first time in twenty-five years. It was the artist's only recorded return to the hometown that he had left in the tumultuous years before the Revolution.[3] His cousin had become a "famous gunsmith . . . who is supposed to equal any workman in the United States, in that branch of business."[4] His ability had been recognized since the beginning of the American Revolution, when George Washington admired "a gun of exquisite workmanship" that Earle made in 1773. Washington ordered one for himself.

Mr. Earle, having completed it, loaded and primed it, and placed it under water, all but the muzzle, during a night; and, taking it out in the morning, discharged it as if it had just been loaded. He carried it to New York, where the army then lay, and delivered it personally to Gen. Washington; having travelled the distance on foot, and carried it upon his shoulder.[5]

Earle spelled his name with an *e* at the end. According to family tradition, Washington had noticed that the gunsmith had inscribed his name on the weapon as "Thomas Earl" and proposed that he democratize the spelling of his name. "Mr. Earle, your name is not correctly spelled," Washington declared. "E-a-r-l is a title of nobility; you should add an e to it."[6]

Earle, dressed in black and with powdered hair, appears youthful for a man in his sixties. He is seated in a red upholstered chair in front of a reddish brown curtain. His right hand rests on a map of Asia with the words "Shanghai" and "Tartary" clearly imprinted on it. A pair of silver spectacles slightly magnify his gray eyes. The background scene includes his large, red-roofed house in the center of the landscape, as well as his gunsmith shop, which is the low, peaked-roof building at the left edge of the painting, immediately above his hand. The trees along the road in front of the house are sycamores that Earle is said to have planted on the day of the battle of Lexington.[7] The map, an unusual attribute for the sitter, could refer to gunpowder, which was introduced in China as early as the ninth century. Other portraits in which the artist used maps or globes include those of his second wife Ann Whiteside Earl (1784, Mead Art Museum, Amherst College), Sherman Boardman (1796, New Milford Historical Society, Connecticut), and Noah Smith (1798, The Art Institute of Chicago). In his similarly posed portrait, Sherman Boardman holds a pair of spectacles in one hand and points with the other to a map of Hungary. Boardman, a farmer and state legislator, was known for his "thirst for knowledge" and "attainments in geography."[8]

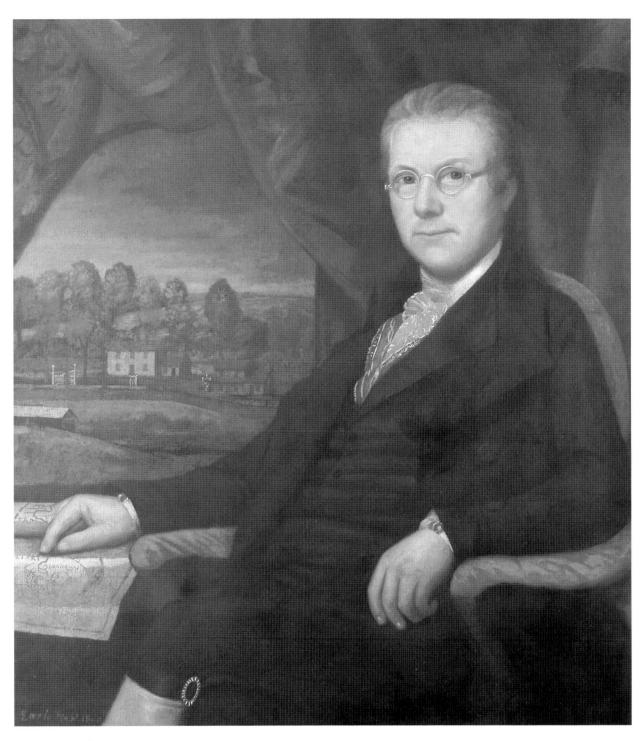

Ralph Earl, *Thomas Earle*, 1947.17.42

Stylistically, the portrait is consistent with Earl's other late works. The artist has continued to use the compositional formulas of his earlier portraits, with the landscape background as a major feature. The sitter's large torso and head seem out of scale with the rest of his figure, and perhaps result from the artist's attempt to include a nearly full-length seated figure on a canvas that was unusually small for such a composition. Numerous losses throughout the painting have been extensively retouched, leading some, who thought it an earlier work, to question the signature and date. The signature itself has also presented problems. The final *e* and the pink paint are not typical of the signatures found on other paintings by Earl. Examination with a stereomicroscope, however, shows that the present signature appears to be a modern reinforcement of the original one in red paint, which is badly abraded.

CJM

Notes

1. "Portrait by Earl" 1917, 10; Edward Francis Coffin to Thomas B. Clarke, letter dated 10 March 1923 (typed copy, NGA); Louisa Dresser, Worcester Art Museum, 19 December 1951, to Anna Wells Rutledge (NGA). Coffin initially hoped to sell the painting through the Macbeth Gallery in New York, for which he would have paid the gallery a commission. Correspondence with Robert Macbeth between 2 June and 20 October 1916 shows that Coffin sent the painting to the gallery in the fall. After the two men could not agree on a price, it was apparently returned. By then, according to Dresser, the director of the Worcester Art Museum had seen the painting. Their correspondence discusses the condition of the portrait and its conservation. Coffin also wrote Macbeth (29 June 1916) that the painting had been reframed but that he had kept the original frame in case the purchaser was someone "of antiquarian leanings" and the original was "preferred to a modern, though more appropriate manner of framing." The letters, damaged by fire and not completely legible, are found in the General Correspondence files, Macbeth Gallery Papers, AAA.

2. Dresser to Rutledge, 19 December 1951 (NGA); Historical Records Survey 1939, 1:132. The name of the seller and date of purchase are recorded in an annotated copy of *Clarke* 1928 in the NGA library.

3. Kornhauser 1988, 235–236.

4. Whitney 1793, 108.

5. Washburn 1860, 361.

6. Earle 1888, 57.

7. Washburn 1860, 361. The house burned in 1873, according to Earle 1888, 57.

8. Schroeder 1849, 395. Kornhauser 1988, 261–262.

References

1888	Earle: 57–58, repro. 56.
1917	"Portrait by Earl": 7, 9, repro. 10.
1936	"Clarke Collection Sold": repro. 6.
1939	Sherman: 163, 168, 174 no. 1; 165 repro.
1967	Goodrich: 42–43, fig. 16.
1988	Kornhauser: 235–236, 243 n. 33, 286.
1991	Kornhauser: 232–233 (color).

Robert Feke

c. 1707 – c. 1751

ROBERT FEKE was the second son of Robert Feke, a Baptist minister and blacksmith in Oyster Bay, New York. The artist's birth and death dates have never been determined but are deduced from references to him and his family in contemporary documents. He worked as a surveyor in Oyster Bay from 1725 to 1730 and then, it is believed, learned the techniques of painting in New York City. His earliest documented portrait is the ambitious group *The Isaac Royall Family* (1741, Harvard University Law School, Cambridge, Massachusetts), which may have been painted in Rhode Island. The following year Feke married Eleanor Cozzens, daughter of Newport's most prominent tailor Leonard Cozzens. They settled in Newport, where he painted portraits for the next four years. Dr. Alexander Hamilton of Annapolis, who visited his studio in 1744, described Feke as "the most extraordinary genius I ever knew, for he does pictures tollerably well by the force of genius, having never had any teaching." He wrote that Feke was a man with "exactly the phizz of a painter, having a long pale face, sharp nose, large eyes with which he looked upon you stedfastly, long curled black hair, a delicate white hand, and long fingers."[1] This description closely matches the image in the self-portrait that Feke painted at about this time (MFA).

In 1746 Feke went to Philadelphia to paint portraits, probably at the suggestion of John Wallace,

who had moved there from Newport. Two years later he made a similar painting trip to Boston, where he painted some of his best-known work, including portraits of members of the Bowdoin family and a full-length of Samuel Waldo (Bowdoin College Museum of Art, Brunswick, Maine). His work rapidly became more accomplished, his steady improvement particularly noticeable in his bold decorative renderings of the fabrics of his sitters' clothes. On a second trip to Philadelphia in 1749–1750, Feke received a number of commissions for portraits from members of the Philadelphia Dancing Assembly, which had been established by Wallace and others the previous year. Feke's promising career ended abruptly. The last record of the artist is his attendance at his brother-in-law's wedding in Newport on 26 August 1751. Although he may have gone to Barbados, where members of the Feke family lived, no record of his activity or death has been found there.

EGM

Notes
1. Bridenbaugh 1948, 102.

Bibliography
Foote 1930.
Bridenbaugh 1948: 102.
Mooz 1970.
Mooz 1971: 180–216.
Saunders and Miles 1987: 165–169.

1966.13.2 (2318)

Captain Alexander Graydon

c. 1746
Oil on canvas, 101.2 × 81 (40 × 32)
Gift of Edgar William and Bernice Chrysler Garbisch

Technical Notes: The support is a plain-weave linen fabric with a pronounced texture. Its original tacking margins are intact. The ground is a moderately thick, evenly applied neutral brown layer. The paint is applied in multiple smooth layers, mainly as a paste but with some fluid highlights. X-radiography shows that the artist blocked out a large area for the wig, then narrowed it on the sitter's left side. The main body of the coat is underpainted with a reddish brown layer, while the sleeve cuff and background shadow in the lower right corner are painted directly on the ground layer. There is a pentimento in the sitter's right sleeve cuff.

The painting's visual condition is poor because of severe abrasion to the paint layer, which reveals the canvas threads. There is a hole 5 by 1.5 cm in the sitter's right sleeve cuff, and several small paint losses are located to the right of the sitter's right hand and in the upper right corner. The abraded flesh tones, especially in the sitter's right hand, have been retouched. Craquelure in the white cuffs and face have been retouched. The shadows of his wig and inside his left arm have been reinforced. The varnish was removed and the painting lined in 1956.

Provenance: Alexander Graydon [d. 1761], Bristol, Pennsylvania, the subject of the portrait;[1] his wife Rachel Marks Graydon [d. 1807], Philadelphia;[2] their son Alexander Graydon, Jr. [1752–1818], Philadelphia;[3] his brother William Graydon [1759–1840], Harrisburg, Pennsylvania;[4] his son Henry Murray Graydon [d. 1900], Harrisburg, Pennsylvania;[5] his daughter Julia Graydon [d. 1954], Harrisburg, Pennsylvania;[6] sale of her estate, 28 October 1954, at her Harrisburg residence, bought by (Edgar H. Sittig, Shawnee-on-Delaware, Pennsylvania);[7] sold 8 November 1954 to Edgar William and Bernice Chrysler Garbisch.

THE UNDERSTATED GRACE of this image is typical of the portraits that Feke made on his first trip to Philadelphia in 1746, which are more thickly painted and less dramatic than the vivid representations that he would create on his return three years later. Feke depicted Captain Graydon, a Philadelphia merchant, wearing a long black waistcoat and a gray coat with a red lining. He wears a wig and holds his black three-cornered hat under his left arm. Graydon's right hand is tucked into his waistcoat, while his left is posed in a graceful gesture at his side. Below his left hand is the gilt handle of his sword. In the distance, beyond the brown wall behind him, are a hilly landscape and a light blue sky with clouds. Graydon's portrait has extensive surface abrasion; the repainting altered the modeling of the face to emphasize its mask-like contours.

The portrait is very similar in composition to Feke's signed and dated 1746 portrait of Tench Francis (MMA) and his unsigned portrait of Benjamin Franklin (c. 1746, Harvard University, Cambridge, Massachusetts), which were also painted in Philadelphia. Francis' pose is identical to Graydon's but with his gestures reversed—his nearer, left hand is tucked in his waistcoat—while Franklin, turned to the viewer's right, is posed in a mirror image to Graydon.[8] The dimensions of Graydon's portrait are notable. While it is smaller than most of Feke's portraits, including those of Francis and Franklin, which are in the standard English size called a "half-length" (127 by 101.5 cm [50 by 40 inches]), it is larger than the kit-cat format (91.5 by 71 cm [36 by 28 inches]), the next smaller standard size for

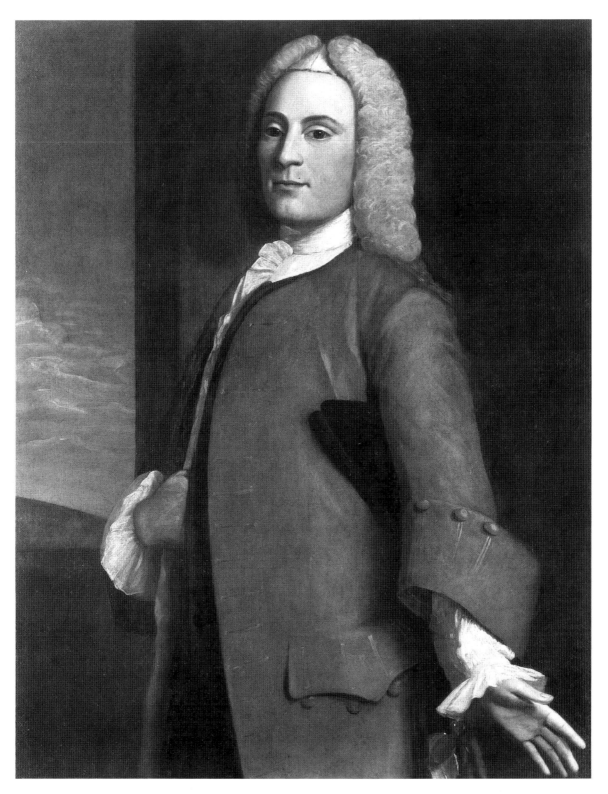

Robert Feke, *Captain Alexander Graydon*, 1966.13.2

portraits. Feke's only other portraits in this unusual size—*Phineas Bond* (Philadelphia Museum of Art) and *Mrs. James Tilghman* (Goldsborough Family Collection)—were also Philadelphia works.[9] Since portrait prices were calculated in proportion to the size of the canvas and the amount of figure shown, this may indicate a demand in Philadelphia for less expensive images.

Graydon, born in Longford, Ireland, around 1708, was educated to be an Anglican minister. After coming to the American colonies in 1730, he instead became a merchant. His son wrote that "among his qualities was that of a singularly clear and harmonious voice, which he frequently exercised in reading aloud" as a member of a conversation and reading club in Philadelphia.[10] He was a successful businessman and around 1760 built a house in Bristol, Pennsylvania,

on a favourite spot, sufficiently elevated to overlook the adjacent district for some miles around . . . together with an extensive intervening tract of meadow ground, stretching to the shore of the Delaware, whose bright expanse was also subjected to the eye. He had long been improving the site before he began to build; had planted it with the best fruits in every kind, and had given to it the style of embellishment, both with respect to the disposition of the grounds, and the trees, which was at that time

in fashion. But this residence, at once so cherished and delightful, he was permitted to enjoy not quite a year.[11]

Graydon died in March 1761.

EGM

Notes
1. For his biography see Graydon 1846, 18–19, 33–35. Much of this information is also in Graydon 1822 and Graydon 1828.
2. For her biography see Graydon 1846, 20, 409.
3. *DAB* 4, part 1:524–525.
4. *Appleton's* 1898, 2:732; Sharpe 1909, 20–21.
5. Sharpe 1909, 24–25, comments that he died "a few years ago" and does not mention his daughters.
6. Her sister Alice Graydon (d. 1948), Harrisburg, Pennsylvania, may have been joint owner of the portrait.
7. Letter from Edgar Sittig to William P. Campbell, 27 August 1971 (NGA).
8. On Francis' portrait see Gardner and Feld 1965, 7–8, repro., and Mooz 1971, 188, fig. 3; on Franklin's portrait see Sellers 1962, 24–32, 281, repro. pl. 1.
9. Mooz 1970, 219, 234. For an explanation of these sizes and their derivation see Saunders and Miles 1987, 61–62.
10. Graydon 1846, 34, note.
11. Graydon 1846, 33.

References
1970 Mooz: 80–81, 227.
1971 Mooz: 203, 204 repro.
1981 Williams: 15, repro. 16.

John Greenwood

1727 – 1792

BORN IN BOSTON, John Greenwood began his artistic career in 1742 as an apprentice to Thomas Johnston (c. 1708–1767), who taught him to engrave bookplates and heraldic devices. By 1747 he began painting portraits. The approximately fifty paintings that he made in the Boston area during the next five years represent formally posed sitters in attitudes and settings reminiscent of the work of the English painter John Smibert (1688–1751), who had settled in Boston in 1729. The colors that Greenwood used suggest that he also knew the work of Robert Feke. His most ambitious painting is his six-figure group portrait *The Greenwood-Lee Family* (c. 1747, MFA), which includes a self-portrait. Greenwood's American work is witty, enter-

taining, and naive. His engraving of Jersey Nanny, a nurse (1748), and his humorous tavern sign lampooning the judges of the Massachusetts Supreme Court (1749) reveal the comical side of his personality.

Greenwood left Boston in 1752 for the Dutch colony of Surinam, in South America, where he painted 115 portraits of residents and of the New England sea captains who visited the port. Although he recorded these in a memorandum book (NYHS), none of his work from these years is located today with the exception of *Sea Captains Carousing at Surinam* (c. 1758, The Saint Louis Art Museum), which reveals in its satirical content the direct influence of William Hogarth's engrav-

ing *A Midnight Modern Conversation*. In 1758 Green-wood went to Amsterdam, where he worked as a portrait painter and engraver for five years and also became an auctioneer and dealer. In the 1760s he settled in London, where he joined the Society of Artists of Great Britain and participated in the members' annual exhibitions from 1764 to 1776. In 1770, realizing that he would not return to America, he commissioned John Singleton Copley to paint a portrait of his mother, Mrs. Humphrey Devereux (National Gallery of Art, Wellington, New Zealand). The painting is one of Copley's most sympathetic portraits. Greenwood became a successful dealer and auctioneer and spent the rest of his life in London.

EGM

Bibliography

Greenwood 1934: 57–67.
Burroughs, *Greenwood*, 1943.
Saunders and Miles 1987: 170–175.

1961.4.1 (1600)

Elizabeth Fulford Welshman

1749
Oil on canvas, 91.4 × 71.1 (36 × 28)
Gift of Edgar William and Bernice Chrysler Garbisch

Inscriptions
Signed and dated center left: J. Greenwood pinx: / 1749.

Technical Notes: The support is a coarse, loose, and irregularly woven plain-weave fabric with cusping on all four edges. The thin but highly textured yellowish white ground was applied in a sweeping motion with a large knife or spatula that created ridges. The paint was applied with a moderately fluid consistency in thin layers with little glazing or overlap. Very little brushwork is evident, with the exception of the white ruffles and the flesh areas, where the paint is slightly thicker. The distant landscape was applied in thin washes.

A few tack holes and tacking folds in the picture plane show that at one time the painting was on a smaller stretcher. Both paint and ground suffered signficant damage and loss along the 5–7.5 cm perimeter of the painting when it was attached to the smaller stretcher. There is general abrasion in the paint layer. The varnish was removed and the painting lined in 1955. The present varnish is moderately discolored.

Provenance: (Victor Spark, New York, New York); sold 18 December 1948 to Edgar William and Bernice Chrysler Garbisch.[1]

Exhibited: *American Colonial Portraits, 1700–1776*, NPG, 1987–1988, no. 46.

THIS PORTRAIT IS characteristic of John Greenwood's early work in the derivation of the composition from an English mezzotint and his predilection for using images as emblems, as well as in its overall similarity to the work of American painter Robert Feke. The sitter wears a blue dress with white ruffles on the sleeves and the bodice; a rose-colored drape covers her shoulders and left arm. She holds a pearl necklace that falls from one hand to the other. A brown rocky ledge, a tree, and a distant landscape are behind her. The forms of the portrait are distinctly drawn in bright colors. The lack of tonal glazes suggests that Greenwood had no training in the subtleties of painting in oil.

The composition is very similar to that of English artist William Wyssing's portrait of Princess Anne,

Fig. 1. Isaac Beckett after William Wyssing, *Her Highness The Princess Anne*, mezzotint, c. 1683, Winterthur, Delaware, The Henry Francis du Pont Winterthur Museum, Gift of Mrs. Waldron P. Belknap [photo: Courtesy, Winterthur Museum]

engraved by Isaac Beckett around 1683 (Figure 1), which shows the princess holding a similar string of pearls.[2] Most of the pose is in reverse of the mezzotint. Robert Feke used this engraving in 1748 for his portrait of Mrs. James Bowdoin II (Figure 2).[3] Feke's painting was clearly one source of Greenwood's composition; the two portraits share a number of features that are not found in the engraving. Mrs. Bowdoin and Mrs. Welshman wear dresses of a style popular in the 1740s, with low-cut, tight bodices and flared sleeves, unlike Princess Anne, and their hair is styled in the so-called Dutch coiffure of their era. Each is posed with her body turned slightly to the viewer's right, her head turned to the left, her left arm raised and her right in her lap, the opposite of the pose in the engraving. Also, the two American works have a rounded hill and a peaked mountain in the background, and the coloring of the two portraits is similar. However, Mrs. Welshman, like Princess Anne, holds a string of pearls, while Mrs. Bowdoin holds a basket of roses. This indicates Greenwood's familiarity with the engraving as well as with Feke's painting.

Greenwood's portrait is unique in one respect: he included the rays of a rising or setting sun in the right background. The meaning of this emblem is obscured by a lack of information about the sitter, who is identified only as Elizabeth Fulford Welshman, the widow of a Massachusetts mariner named William Welshman who died at sea in 1772.[4] Presumably her husband was Captain William Welshman, Senior, whose death "on his Passage from Nevis to London" is recorded in the *Massachusetts Gazette: and the Boston Weekly News-Letter* for 20 August 1772.[5] The sun is probably an emblem of mortality. An emblem book published in London in 1755, *Emblems for the Improvement and Entertainment of Youth* combines an image of a setting sun with the phrase "Not without Regret: The Light of Heaven has almost finished his daily Course, and hastens to the Goal" as an emblem of "Blessings, little prized while possessed, but highly esteemed the very Instant they are preparing for Flight, bitterly regretted when once they are gone, to be seen no more."[6] Similar setting or rising suns (this is unclear from the images) were engraved on late eighteenth-century New England gravestones as symbols of death and the resurrection of the soul.[7] They continued to be used with this meaning in the early decades of the nineteenth century. A few days before Mary Fish Silliman Dickinson died in New Haven, Connecticut, in 1818, her grandson wrote, "It would be a matter of no surprise to us if she should drop away at any time. Her sun, to appearance, is already down, & is now only throwing a beam of light upon her horizon."[8] A more distinctly Christian reference was recorded at the death of Mrs. Benjamin Tappan of Northampton, Massachusetts, in 1826, when the Reverend Mark Tucker observed, "As her life was an exemplification of the holiness of the gospel, her death was a confirmation of the preciousness of its hopes. I saw her die. It was the triumph of faith—the cloudless setting of an evening sun. Her confidence in God was unshaken."[9]

Images of rising or setting suns are very rare in eighteenth- and early nineteenth-century American portraits. Among the few is the image of a shining sun that John Singleton Copley included in the background of his portrait of Elkanah Watson, painted in London in 1782 (Princeton University Art Museum, New Jersey). This sun appears to be a prophetic emblem of the future of the United States. Copley also added an American flag on the ship in the back-

Fig. 2. Robert Feke, *Mrs. James Bowdoin II*, oil on canvas, 1748, Brunswick, Maine, Bowdoin College Museum of Art, Bequest of Sarah Bowdoin Dearborn

John Greenwood, *Elizabeth Fulford Welshman*, 1961.4.1

ground of the portrait, after he and Watson witnessed George III's announcement of American independence in the House of Lords.[10] Charles Willson Peale in 1789 used an image of a rising sun to indicate the bright future of America in decorations at Gray's Ferry, near Philadelphia, that marked the route of president-elect George Washington.[11] In 1818 he included a setting sun in the background of a portrait of his son Rembrandt Peale (NPG). He intended the painting to be a *"Profitick Picture,"* writing Rembrandt that there was a dark, thick wood on one side of the background, and on the other, "in the horizon a brig[h]theng up, emblematical that the evening of your days will be brighter than on former times."[12]

Greenwood's use of such emblems is unusual in Boston portraits in the late 1740s. It may stem from his apprenticeship to Boston engraver and heraldic designer Thomas Johnston, when Greenwood probably became familiar with heraldic devices and emblem books, including John Guillum's *Display of Heraldry* (London, 1610). This book went through many editions and was a popular reference work for American engravers. Guillum, however, described the sun as a fountain of light and heat, and not as an image of death or the resurrection of the soul.[13] Greenwood's predilection for using images in combination with words is clearly expressed in his 1748 mezzotint engraving *Jersey Nanny*, in which the portrait of a plump, working-class woman is accompanied with verses urging viewers to recognize their kinship with her.[14]

EGM

Notes

1. Greenwood 1934, 58, and Burroughs, *Greenwood*, 1943, 72, both list the portrait as of Elizabeth Fulford Welshman, but they do not give the location or owners' names. The sale is listed in an entry dated 18 December in Spark's 1948 ledger: "John Greenwood-comm [commission] 300—" (Victor Spark Papers, AAA). He confirmed the sale in a letter to William Campbell, 7 May 1971 (NGA). The Garbishes later recorded that the painting was found in Maryland; this information probably came from Victor Spark but does not appear in his records.

2. Smith 1883, 1:20–21, no. 2; Belknap 1959, pl. 20 between 330 and 331. The mezzotint source was first pointed out by Alfred Frankenstein in his letter of 4 March 1957 (NGA).

3. Sadik 1966, 49–52, repro. The engraving was used again in 1753 by the young John Singleton Copley for his portrait of Mrs. Joseph Mann (MFA); see Prown 1966, 1:fig. 20.

4. Greenwood 1934, 58, and Burroughs, *Greenwood*, 1943, 72. Because Greenwood erroneously recorded that the portrait of Elizabeth Fulford Welshman was signed and dated "J. Greenwood, Boston, 1749" (instead of "J. Greenwood pinx: 1749"), NGA curator William Campbell questioned whether the Gallery's portrait was the one listed and changed the painting's title to *Mrs. Welshman*. The full title has been restored because it seems likely that Greenwood misrecorded the signature and that this is the portrait he listed.

5. Two years later, on 14 July 1774, the same paper recorded the death of a different Captain William Welshman "at London." These are the only two deaths of anyone named Welshman that are listed in the *Index of Obituaries* 1968.

6. *Emblems* 1755, 104 and pl. 52, no. 5, opposite.

7. Forbes 1927, 123; Gillon 1967, pls. 147–149; Tashjian 1974, 48–50.

8. Her son Benjamin Silliman recorded the remark as an annotation to her "Reminiscences and Journal," Silliman Family Papers, Yale University, New Haven, Connecticut; quoted in Buel and Buel 1984, 281.

9. Quoted in *Tappan* 1834, 42; for her portrait by Gilbert Stuart see 1970.34.3.

10. Prown 1966, 2:293.

11. Lawson 1992, 468 and n. 38.

12. Letter of 9–10 August 1818, quoted in Sellers 1952, 168, no. 666, and in Miller 1983, 3:597–598.

13. See, for example, Guillum 1724, 90.

14. Saunders and Miles 1987, 170–171, repro.

References

1934 Greenwood: 58.
1943 Burroughs, *Greenwood*: 72.
1981 Williams: 18, repro. 19.
1987 Saunders and Miles: 172–173, no. 46, repro.

John Johnston

1751/1752 – 1818

JOHN JOHNSTON was the son of engraver and decorative painter Thomas Johnston (c. 1708–1767) of Boston. Of four sons who became painters, John was the most talented. Trained first by his father, he was apprenticed to coach and heraldic painter John Gore after his father's death. In 1773 he joined his brother-in-law Daniel Rea, Jr., in the painting firm of Johnston and Rea, a continuation of his father's business. Account books of the firm (Baker Library, Harvard University Business School, Cambridge, Massachusetts) indicate that much of Johnston's work involved decorating clock faces, furniture, fire buckets, coaches, and other utilitarian objects. Johnston served in the Continental army during the Revolution, was severely wounded at the battle of Long Island in 1776, and was imprisoned by the British for about a year. On his return to Boston, he continued the partnership with Daniel Rea until 1787, when he established himself as a portrait painter.

Johnston was one of the few portrait painters working in Boston in the years after John Singleton Copley's departure in 1774 and before Gilbert Stuart's arrival in 1805. His compositions belong to the well-established tradition of Massachusetts colonial portraiture. He and Danish artist Christian Gullagher (1759–1826), who worked in Boston from 1789 to 1796, were mentioned as "the two best portrait painters of this metropolis" in a contemporary Boston newspaper.[1] By 1795 Johnston was renting the painting studio of colonial artist John Smibert (1688–1751), where he acquired Smibert's most important painting, *The Bermuda Group* (1729, YUAG). He is listed as a portrait painter in Boston city directories through 1808, the year he sold Smibert's painting to Isaac Lathrop of Plymouth, Massachusetts, who gave it to Yale University. Johnston died on 28 June 1818, age sixty-six, according to his obituary in the *Boston Daily Advertiser* for 29 June.[2]

EGM

Notes
1. Sadik 1976, 21.
2. Coburn 1933, 136.

Bibliography
1932 Coburn: 27–36.
1933 Coburn: 132–138.
1943 Swan: 210–212.
1966 Sadik: 108–110.
1976 Sadik: 21.
1980 Troyen: 70–71.

1947.17.65 (973)

John Peck

c. 1795
Oil on canvas, 63.5 × 47.9 (25 × 18 ⁷⁄₈)
Andrew W. Mellon Collection

Technical Notes: The support is a very loosely woven, plain-weave fabric. The ground is light in color. Thin paint is applied in a direct manner, without complex layering or glazing. The modeling of the sitter is heavy and simple, and the edges of the fabrics are depicted with angular brush strokes. There is a vertical rectangular loss in the upper right, to the right of the sitter's brow, which has two tears associated with it, and a smaller rectangular damage a third of the way down the right side. There are smaller losses in the top left quadrant and in the lower right. Some of the traction cracks in the darker areas, the red draperies, and the face have been retouched. Extensive traction cracks in the lower half of the painting create a bubbly effect in the paint. The bottom edge is heavily retouched and the varnish is discolored.

Provenance: Gift of the sitter's brother-in-law Edward Stow [c. 1768–1845], Boston, 1836 / 1838, to his daughter Caroline Adelaide Stow Hyatt [Mrs. George Hyatt, 1807–1893], Ithaca, New York;[1] her niece Ann Broadhurst Phillips, Boston; her niece Adelaide Phillips Walton, Oakland, New Jersey, 1920;[2] (André E. Rueff, Brooklyn); sold in 1921 to Thomas B. Clarke [1848–1931], New York;[3] his estate; sold as part of the Clarke collection on 29 January 1936, through (M. Knoedler & Co., New York), to The A.W. Mellon Educational and Charitable Trust, Pittsburgh.

Exhibited: Union League Club, March 1922, no. 3. Philadelphia 1928, unnumbered.

JOHN PECK of Boston was the son of Robert Maynard Peck and Sarah Brewer Peck, who were married in 1769. After Robert Peck died, John, his two brothers, and his sister became wards of William Bryant, who later married their mother. Peck was

appointed guardian of his younger siblings in July 1790. His sister Nancy Brewer Peck married Edward Stow in 1793 (see his portrait by Gilbert Stuart, 1942.8.23).[4] Nothing more is known of the sitter. He could be the John Peck listed in John West's *Boston Directory* (Boston, 1796) as a broker at 33 Marlborough Street.[5]

Peck wears a white shirt, a cravat tied in a bow, and a black coat with a high collar of the style that was in fashion in the mid-1790s. The warm tones in his reddish blond hair and brown eyes are complemented by the red curtain in the background. Peck's face is smoothly painted, with no strong contrasts, a technique typical of the artist's work. Thin brush strokes highlight or shade the features. Delicate squiggles define his hair and highlight the collar of the waistcoat visible inside his coat collar. His cravat and the curtain are more broadly treated. Similarly painted portraits by Johnston include oils in this format of Samuel Thwing (1804, Society for the Preservation of New England Antiquities, Lyman House, Waltham, Massachusetts) and Samuel Bass (c. 1810, Lyman Allen Museum, New London, Connecticut),[6] as well as larger paintings of Judge David Sewall (1790, Bowdoin College Museum of Art, Brunswick, Maine) and *Man in a Gray Coat* of about 1788 (MFA).[7] Johnston also made portraits in pastel.

The delicate shading and highlighting of the face, and the looser handling of the hair, cravat, and highlights on the coat and curtain suggest the influence of two painters on Johnston's technique. One was Ralph Earl, who painted a portrait of Johnston's wife, Martha Spear Johnston (Anderson House, Washington) during his brief visit to Boston in 1785, shortly after he returned from London.[8] The second was Danish artist Christian Gullagher, who enlivened his paintings with touches of zig-zag brushwork.

<div align="right">EGM</div>

Notes

1. Certified typed copy of a memorandum signed by Edward Stow and dated Boston, 22 February 1836, provided by Adelaide Phillips Walton on 31 October 1921 (NGA) (she owned the original, which is now unlocated). According to the memorandum, Stow also gave his daughter Gilbert Stuart's portrait of her mother, Ann Brewer Peck Stow (Jordan-Volpe Gallery, New York) and a miniature of himself (YUAG). The year 1836 on the certified copy may be an error. A transcript of the same memorandum (YUAG) gives the year as 1838, which agrees with the date of a second memorandum, by which Stow gave his portrait by Gilbert Stuart to his daughter Louisa Matilda Stow (see 1942.8.23).

2. Mrs. Walton provided this provenance in her notarized statement of 3 October 1921 (NGA). Lawrence Park made a drawing of the portrait that summer, when it was in Mrs. Walton's collection (letter to Thomas B. Clarke, 15 October 1921; NGA).

3. The name of the seller and the date of purchase are recorded in an annotated copy of *Clarke* 1928 in the NGA library. Lawrence Park understood that Clarke bought the portrait "for the Brook" (letter, 13 January 1922; NGA).

4. Lawrence Park provided Clarke with biographical information on Peck (letter, 23 November 1921; NGA). The information is repeated in Sherman 1922, 260, who described Peck as a shipbuilder, confusing him with a different John Peck who was from Plymouth, Massachusetts, and built ships in 1776 and 1789, when the sitter was less than twenty years old.

5. This is the only listing for a John Peck in city directories up to 1810. Robert M. Peck, the sitter's brother, is listed in West's *Boston Directory* for 1803 as a hatter at 57 Marlborough Street.

6. These and other works by Johnston are listed in the Inventory of American Painting, NMAA, and the Catalog of American Portraits, NPG.

7. Sadik 1966, 110–112, repro.; Troyen 1980, 70–71, no. 14, repro.

8. *Kornhauser* 1991, 135–136, no. 20 (color).

References

1922 Sherman: 259–260, repro. opp. 260.
1932 Sherman: 69, pl. 30A opp. 120.
1933 Coburn: 137, no. 32.
1952 Rutledge and Lane: 129.

John Johnston, *John Peck*, 1947.17.65

Charles Willson Peale

1741 – 1827

OF THE THREE most talented painters born in the British colonies of North America—Charles Willson Peale, Benjamin West, and John Singleton Copley—only Peale lived in America after the Revolution. Born in Maryland and trained as a saddler, he became a painter in the 1760s by studying the work of other artists, especially John Hesselius (1728–1778) and Copley, whom he met in Boston in 1765. Several merchants and lawyers, including John Beale Bordley, financed a two-year trip to London (1767–1769), where Peale studied with West. On his return he became a portrait painter in Maryland, Virginia, and Philadelphia, where he moved with his family in 1776. His early style is characterized by graceful poses, subtle coloring, and meticulous attention to detail. Professing to paint only "by mear immatation of what is before me,"[1] Peale in fact had steeped himself in English painting theory and practice when he was in London, and he corresponded with West for many years after his return.

During and after the Revolution, Peale combined his artistic career with Whig politics. He served with the Pennsylvania militia against the British, carrying his miniature case to paint portraits of fellow officers. In 1779 the Supreme Executive Council of Pennsylvania commissioned him to paint the first official portrait of George Washington, a full-length that commemorated the victories at Princeton and Trenton (PAFA). Peale's idea of a Gallery of Great Men led him next to paint a series of head and shoulder "museum" portraits of the heroes of the war and the new republic; the first were completed by 1782. Peale was a friend of the intellectual and political leaders of the day and painted portraits of Thomas Jefferson, David Rittenhouse, the Marquis de Lafayette, and Benjamin Franklin (Independence National Historical Park, Philadelphia), to name only a few of his illustrious sitters. He trained his brother James, his nephew Charles Peale Polk, and his sons Raphaelle, Rembrandt, and Rubens Peale to be painters, and he was a founder of the Columbianum, the first American artists' society, which held its only public exhibition in Philadelphia in 1795.

By that time Peale had opened a museum of natural history. Although he continued to paint portraits, he turned the business of miniature painting over to James Peale so he could increasingly concentrate on his museum. Its collections, which he moved to Independence Hall in 1802, were primarily scientific and included the mastodon bones that he exhumed from a bog in upstate New York in 1801. He helped found The Pennsylvania Academy of the Fine Arts in 1805 but painted fewer and fewer portraits, primarily of close friends and family. One of his last works was his full-length self-portrait, *The Artist in his Museum* (1822, PAFA). He wrote his son Rembrandt on 23 July 1822 that he intended this painting to be "a lasting ornament to my art as a painter, but also that the design should be expressive that I bring forth into public view the beauties of nature and art, the rise and progress of the Museum."[2]

Peale's diaries and letters reveal his lifelong energy and curiosity. His painting style combined close observation, invention, and a personal interest in his sitters' lives. His role as a painter and teacher was equal to his interests in natural science and invention. His Whig political views placed him at the center of the formation of the new American republic, a role unlike that played by his contemporaries Benjamin West and John Singleton Copley.

EGM

Notes
1. Letter to John Beale Bordley, November 1772; Miller 1983, 1:126–127.
2. Richardson, Hindle, and Miller 1983, 104.

Bibliography
Richardson, Hindle, and Miller 1983.
Miller 1983.

1984.2.1

John Beale Bordley

1770
Oil on canvas, 200.8 × 147.4 (79 1/16 × 58 1/32)
Gift of The Barra Foundation, Inc.

Inscriptions
Signed along top right corner of rock in right fore-ground:[1] Peale / land / 70

Technical Notes: The painting is on a moderate-weight, twill-weave canvas. The ground is an off-white color. The paint is applied in a fairly thin manner with a wet-in-wet technique. The figure was worked first, and then the background.

The painting is badly abraded. There are two sets of vertical fold lines, accompanied by paint loss. The painting was probably reduced in size at one time and tacked to a smaller stretcher. Additional fold lines occur horizontally through the sitter's forehead, at the sitter's waist, through the sitter's knees and ankles, and diagonally near the statue on the right, suggesting that the painting was once rolled. Heavy overpainting is found in all these areas, as well as in the sky behind the sitter's head and in his clothing.

The original signature, in black paint, is abraded and has been reinforced. The varnish was removed in 1973; the present varnish is thick and slightly discolored.

Provenance: The sitter's half-brother Edmund Jenings [1731–1819], London. L. LeRoy Highbaugh, Sr. [1889–1965], and L. LeRoy Highbaugh, Jr. [b. 1928], Louisville, Kentucky; gift of Mr. and Mrs. LeRoy Highbaugh, Jr., to The Stetson University, Deland and St. Petersburg, Florida, 1973.[2] (Kennedy Galleries, New York, 1973);[3] purchased by The Barra Foundation, Inc., 1974.[4]

Exhibited: The Stetson University College of Law, Deland and St. Petersburg, Florida, on long-term loan, c. 1960–1973. *Art in Florida Public Collections*, John and Mable Ringling Museum of Art, Sarasota, Florida, 1962, as *Portrait of a Lawyer* by Joseph Badger.[5] *Inaugural Exhibition*, Museum of Fine Arts, St. Petersburg, Florida, 1965, no. 3, as *Portrait of an Unidentified Lawyer* by Charles Willson Peale. *Philadelphia Painting and Printing to 1776*, PAFA, 1971, no. 24. NGA, on long-term loan, 1974–1984.[6] *Charles Willson Peale and His World*, NPG; Amon Carter Museum, Fort Worth; MMA, 1982–1983, no. 5.

JOHN BEALE BORDLEY (1727–1804), Peale's life-long friend and benefactor, was a Maryland lawyer who sought in the years preceding the Revolution to manage his 1,600-acre island estate as a model of American economic self-sufficiency.[7] Bordley may have advised Peale on the imagery of this full-length allegorical portrait, which carries a clear message: the colonies will not tolerate British injus-

tice. In its choice of symbols, the picture expresses the shared values and republican (Whig) political sympathies of Bordley, Peale, and Edmund Jenings, Jr., Bordley's half-brother in London, to whom Peale and Bordley sent the portrait in 1771.

John Beale Bordley was the son of Thomas Bordley, attorney general of colonial Maryland, who died before his son's birth. Bordley's mother Ariana Vanderheyden Bordley then married Edmund Jenings and moved to England, where their son Edmund Jenings, Jr. (1731–1819), Bordley's half-brother, was born. Bordley remained in Maryland, where he became a student of Peale's schoolmaster father and then studied law with his elder brother Stephen Bordley. In 1753 John Beale Bordley became clerk of Baltimore County, resigning from that position because of the Stamp Act. In 1766 he was named a judge of the Maryland Provincial Court and the following year a judge of the Admiralty Court. He was also a member of the Maryland Governor's Council.

Bordley gradually withdrew from public life after his wife inherited part of Wye Island, in the Chesapeake River near Maryland's Eastern Shore. He moved there with his family in 1770, determined to become a self-sufficient patriot farmer and develop a model plantation. He believed that America needed to establish economic independence from England. While he, like most colonists, had long imported many luxuries from Britain, he now substituted homemade beer for London ale and porter, and grew wheat instead of tobacco, the staple of Anglo-American commerce. His farm included its own carpenter and blacksmith shops, as well as looms and spinning wheels that he supplied with his own fleeces, hemp, flax, and cotton.[8]

In this portrait Peale used imagery similar to that in his full-length of William Pitt (1768, Westmoreland County Museum, Montross, Virginia), a commission arranged by Bordley's half-brother Edmund Jenings when the artist was in London. In that portrait Peale depicted Pitt, a key defender in Parliament of American resistance to the Stamp Act, holding a copy of the Magna Carta and pointing to a statue of British liberty to illustrate the justice of the colonies' claims under the British constitution. Peale used Bordley's clothing as well as other symbols to convey a similar pictorial message. Bordley wears a homespun brown cloth coat and waistcoat, perhaps made of wool or cloth from his farm, and his hair is naturally dressed. His appearance is simple in comparison with some of Peale's

other sitters, who wear elegant brocade coats with brass buttons and wigs or powdered hair. In the background graze the sheep from which Bordley produced his wool in an effort to reduce dependence on British textiles, a major export to the colonies. This juxtaposition would have pleased Jenings, who was proud of wearing garments made of American wool in London. In 1768 Jenings wrote his Virginia friend Richard Henry Lee, for whom the portrait of Pitt was painted, "Your brother has given me some cloth made in your Family I wear it on all occasions to show the Politicians of this Country that the sheep of America have wool not hair on their backs, They can hardly believe their eyes."⁹

Bordley shared this view, writing, apparently to Jenings, "We expect to fall off more and more from using your goods; we are already actually the best people, using our old clothes and preparing new of our own manufacture; they will be coarse, but if we add just resentment to necessity, may not a sheepskin make a luxurious jubilee coat?"¹⁰

Bordley, like Pitt, gestures toward a statue of a woman carrying a staff topped by a Phrygian cap, the emblem of liberty. Here the figure carries the scales of Justice in her right hand, and a cornucopia rests at her feet.¹¹ The inscription on the pedestal reads "LEX ANGLI," indicating that the statue personifies English law and the fruits of its justice. Above the inscription can now be read the overpainted word "Com̃on" [common], indicating that Peale first intended the inscription to read "Common Law." He may have changed the phrase to Latin in consultation with Bordley. On the ground to the left is a document inscribed "Imperial Civil / Law — Sum̃ary / proceeding." The paper, which, according to historian Sidney Hart, "was probably intended to symbolize the arbitrary proceedings by which the new customs duties after 1763 were collected," is ripped into two as a rejection of its contents.¹² Bordley rests his left arm on an open book placed on a large rock that serves as a natural lectern. The text on the book reads "Nolumus Leges Angliae mutari," which can be translated, "We are unwilling that the laws of England be changed." This legal phrase became widely known after it was used by King Charles I of England in his *Answer to the Nineteen Propositions* (1642), which endorsed the concept of a government in which the monarch shared power with the two houses of Parliament. The phrase came to be used to refer to dangers involved in any alteration of the English constitution. John Dickinson repeated it in 1774 in his *Essay on the*

Constitutional Power of Great Britain Over the Colonies, arguing that it would be wrong for the colonies to accept a change in laws that provided justice for British subjects throughout the empire.¹³

Peale carefully painted a Jimson weed growing in front of the statue's pedestal. The weed was a natural hallucinogen with a distinctive thorn apple and trumpet-shaped flower. Its inclusion was intended to bring home the artist's point that Britain would regret its conduct toward the colonies. The weed, *Datura stramonium*, especially its seeds, has narcotic properties that were used by the Algonquins and other native Americans as a medicine. The plant became associated with British tyranny and irrationality through an anecdote repeated by Robert Beverly in his *History and Present State of Virginia* (1705). According to Beverly, British soldiers sent to Jamestown in 1676 to quell Bacon's Rebellion became insane after eating the plant in a "boil'd salad." They

turn'd natural Fools upon it for several Days: One would blow up a Feather in the Air; another wou'd dart Straws at it with much Fury; and another stark naked was sitting up in a Corner, like a Monkey, grinning and making Mows at them.... In this frantic condition they were confined lest they should in their Folly destroy themselves....

They returned to their senses at the end of eleven days.¹⁴ Next to the Jimson weed Peale painted red clover, which Bordley recommended planting when rotating fields in preparation for growing wheat. A dandelion also appears in the foreground.¹⁵ A tree to the right bears peaches, one of Bordley's successful experiments at Wye Island.

Although blue sky is seen at the upper right and the sheep graze on a sunny pasture, a darker scene is played out to the left of Bordley, where in the distance a man is seen with a pack animal loaded with sacks. He can be identified as a British soldier by his red coat, with lapels and cuffs of a lighter color, and by his red breeches, black stock, and black cocked hat.¹⁶ He appears to carry a musket. Smoke billows from the top of a conical structure behind him. Peale apparently used a similar image a decade later, in 1782, in the transparent painting (unlocated) that he displayed to celebrate the birthday of French king Louis XVI, an ally of the colonies during the American Revolution. According to the description in the *Pennsylvania Packet* (Philadelphia) for 29 August 1782, the transparency included "as a contrast to the Temple of Independence, an ass heavy laden with plunder, driven with the point of

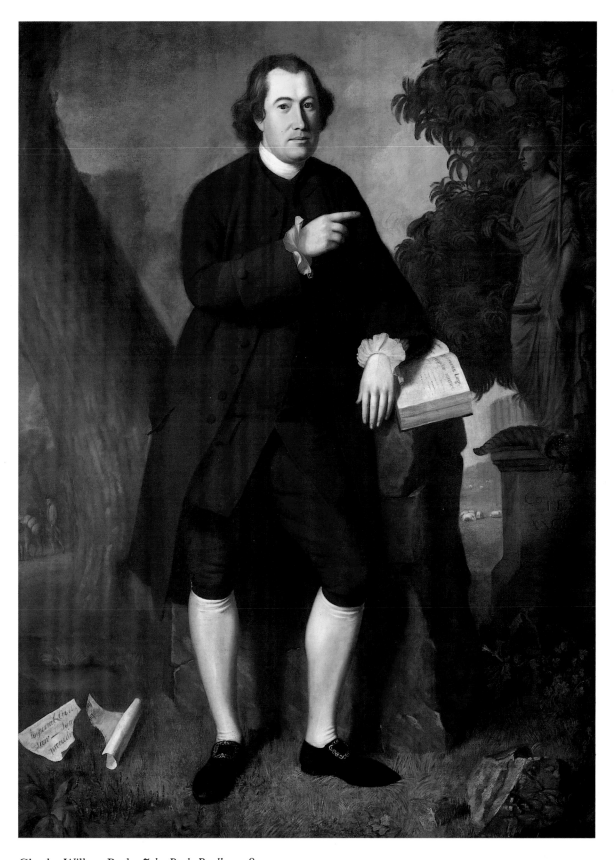

Charles Willson Peale, *John Beale Bordley*, 1984.2.1

a fixed bayonet by a British soldier . . . in the background a miserable log hut and a female in tears, beholding her property taken away; over the whole was inscribed, DEPENDENCE."[17] The image as used in the portrait of Bordley might refer to the Maryland controversy in 1770 over renewal of the tobacco inspection law and to general discontent over the fees paid to colonial officials.[18]

The portrait is included on Peale's list of portraits for 1770–1772: "Mr. Bordly whole lenth 22.1–0."[19] It is generally believed that the painting was commissioned by Jenings, since it was sent to him in London at the same time as the portraits of Mr. and Mrs. Charles Carroll of Carrollton, Maryland, and of John Dickinson. Peale referred to all these in his letter to Jenings of 20 April 1771 when he wrote that Jenings would receive two packing cases shipped in care of Charles Carroll, the barrister. The smaller one contained portraits of Mr. and Mrs. Charles Carroll of Carrollton and a painting of "Mrs. Peale and Child," which appears to have been a gift from Peale. In describing the portraits he indicated that Jenings had asked for American views in the backgrounds. He commented that "in Mrs. Carrolls is my Idea of the Blossoms of the Dog wood. The pieces are so small that I cou'd not give you any views <of> without spoiling the effects of the Portraits. in my other pieces I promise to obey you, in Mr. Dickensons I have the falls of [the] Schulkill river." Peale continues:

The other packing [case] containing a whole length of Mr. Bordly I suppose needs no description. I will only mention a weed with a white flower and burr that contains the seed. this Weed vulgerly call'd gemsen <instead of> for James-Town (Virginia) where they were found in abundance on the first settling of that place. I have heard of Children Eating a few seeds and in a few hours after was raveing Mad. it acts in the most violent, manner and causes Death.[20]

Dickinson and Carroll, like Bordley, were supporters of the American cause. Dickinson (1732–1808) was the author of *Letters From a Farmer in Pennsylvania*, a protest against the Townshend Acts, and Carroll (1737–1832) became a Revolutionary leader and signer of the Declaration of Independence.[21]

Peale's letter of 18 March 1771 to Bordley suggests, however, that the portrait may instead have been Bordley's gift to Jenings. Peale, who apparently began work on the portrait when he traveled to Wye Island in the fall of 1770,[22] seems to have completed it on a return visit that month. He wrote Bordley, "I have some thoughts of paying you a Visit in

a few Days to put your paints in order and do any thing you may think necessary to your Portrait. Perhaps you would like to send it or some other peice to Mr. Jenning[s] by the opportunity of Mr. Joshua Johnson."[23] Apparently this opportunity was missed, for on 5 April he wrote Bordley again.

Mr. Carroll is expected to leave this about friday next, on his Voyage to England, if you please to role up your portrait in any manner, and send here, with the pieces of the Box, that I may put it up properly this is supposeing your Vessel to be here before the middle of the week.[24]

If the portrait was a gift, it could have been part of an exchange that originated in 1767. Before Peale went to London that year he noted in his "Memorandoms for England" that he was to "Begg the Favour of taking Mr——Jennings Picture in Miniature <or as a Large Piece> to hang up to be complymented to Mr. Bordely." This portrait, if it was painted, is unlocated.[25]

Peale also wrote to Benjamin West, on 20 April, sending the letter with Carroll.

At the time you receive this letter I expect Mr. Jennings will have several of my Pieces, and I must beg a line soon from you of your candid opinion of <these pieces> them. Pray do not be tender in speaking the faults. I am used to hear them and have learnt much patience in that way. but from you, who I have the Honor to <have been> be a Pupil of, it will be kind to till me how I might have done better.[26]

The paintings arrived safely. Jenings wrote to Peale on 10 August.

I thank you for the Pictures of Mr and Mrs Carrol your Familys & Mr. Bordley & His son. I look in them as Evidences of the Progress you have made and of your Esteem for me . . . I intend to send the Pictures to our Friend Mr West for his Examination and Approbation too."[27]

The history of the painting is unknown from that time until about 1960, when the portrait was lent to The Stetson University College of Law by L. LeRoy Highbaugh and his son, of Louisville, Kentucky, who had found it in an abandoned house in Louisville.

CJM / EGM

Notes

1. When the painting was cleaned, the signature was recorded as "C. Peale, Maryland, 1770" and, later, as "C. Peale Pinx. / maryland / 1770"; Sellers, *Patron and Populace*, 1969, 55. Traces of the word "Peale" can still be seen with a stereomicroscope, although the paint of the original lettering is severely abraded. Only the letter *l*, however, can be clearly read on the second line, followed by the very faint letters *and*. There is no trace of the first

two numbers of the date, and the number *70* has been heavily reinforced. Examination of the painting at the Gallery in 1984 found a small *n* before "Peale," but it is no longer visible.

2. Bruce Jacob, dean of The Stetson University College of Law, stated in a telephone interview on 14 August 1989 that L. LeRoy Highbaugh, Sr., found the portrait in a house in Louisville and donated it to the law college in the late 1950s or early 1960s. Jacob said he learned this from the late Ollie Edmunds, president of the university at the time. According to the document titled "Gift From L. LeRoy Highbaugh Jr., Dorothy L. Highbaugh to John B. Stetson University" (NGA), the transfer of ownership took place in 1973.

3. Letter from Russell E. Burke III, senior vice president, Kennedy Galleries, New York, 29 March 1984 (NGA).

4. Letter from Gail H. Fahrner, program officer, The Barra Foundation, Inc., 19 March 1984 (NGA).

5. News clippings, dated 23–24 May 1962, in the files of the Ringling Museum reproduce the painting as *Portrait of a Lawyer* by Joseph Badger. Curatorial files suggest there was an exhibition catalogue, but no copy has been located.

6. Gustafson 1984, 1052, repro.

7. On Bordley see Gibson 1865, 65–159; *DAB* 1:460–461; and Fischer 1962, 327–342.

8. Gibson 1865, 97–98. Bordley's notes on his agrarian scheme, written in the winter of 1769, were first published in 1776 in Philadelphia as *Necessaries: Best Product of Land; Best Staple of Commerce*. The text was reprinted in Bordley 1801; see Miller 1983, 1:167, n. 105, and Hart 1985, 210. Bordley also wrote *A Summary View of the Courses of Crops, in the Husbandry of England and Maryland* (1784).

9. Letter from Jenings, 7 November 1768, to Lee, Virginia Historical Society, Richmond.

10. Quote in Gibson 1865, 85, undated.

11. A possible source is Giovanni Battista Cipriani's image of British liberty, invented in England in the 1760s for Thomas Hollis; see Sommer 1976, 40–49. According to Miller ("Harmony and Purpose," 1983, 178), Cipriani could also be a source for the cornucopia and the use of "massed clouds contrasting with blue skies as forecasts of the storm ahead and the eventual emergence of peace." Above the cornucopia can be seen what appears to be an uncompleted fluted column. The pink of the column extends underneath the cornucopia but cannot be detected below this point in the composition (conservation report, NGA).

12. Hart 1985, 210.

13. Hart 1985, 211–213.

14. Beverly 1705, 2:24. Also see Safford 1922, 557–558. Joseph Ewan of the Missouri Botanical Garden helpfully discussed the plant's possible origins in a letter dated 23 August 1989, citing Ewan 1970, 248.

15. Bordley 1801, 86. The dandelion, Jimson weed, and red clover were identified by Peter M. Mazzeo, a botanist at the U.S. National Arboretum, and Dr. F.G. Meyer, his colleague. The leafy plants at the extreme lower left and lower right are too stylized to be identified, although the second plant at the lower left, with a small blue flower, may have been intended to represent chicory.

16. Marko Zlatich, a historian of military uniforms, has identified the figure as that of a British soldier in a regimental uniform.

17. The similarity of the two images was pointed out by Miller in "Harmony and Purpose," 1983, 185, who followed Sellers' description of the Bordley vignette as that of a man driving a pack animal loaded with wool. The description of the transparency in the *Pennsylvania Packet* is in Miller 1983, 1:370–371. For an explanation of Peale's transparent paintings, which were lit from behind for dramatic effect, see Miller 1983, 1:364 n. 9.

18. This controversy is discussed in Cox 1976, 142, and in Semmes 1945, xxvii–xxix.

19. Miller 1983, 1:631.

20. Miller 1983, 1:96.

21. For a recent analysis of Dickinson's portrait see Lawson 1992, 455–486.

22. Peale wrote John Cadwalader from Annapolis on 7 September 1770 that he intended to go to Wye Island; Miller 1983, 1:82–83.

23. Miller 1983, 1:88. Peale noted that the visit had to be short since he needed to finish the portrait of Mr. Carroll.

24. Miller 1983, 1:92–93.

25. Miller 1983, 1:51 n. 12.

26. Miller 1983, 1:95.

27. Miller 1983, 1:103. Some have taken the reference to pictures of "Mr Bordley & His son" as a description of a double portrait. Others thought it might refer to a separate portrait of a son of Bordley that Peale had not mentioned. No picture of either description is known today. Sellers thought that, because the full-length of Bordley was found in the United States in the 1950s, it was never sent to Jenings in England; the correspondence strongly indicates, however, that Jenings did receive the painting.

References

1952 Sellers: 36–37, no. 61 (unlocated).
1969 Sellers, "Jimson Weed": 20–25, repro., cover.
1969 Sellers, *Peale*: 81–86, fig. 22.
1969 Sellers, *Patron and Populace*: 55–56, cat. SP8, fig. 2.
1983 Miller: 1:88, 92–98, 103, 631–632.
1983 Miller, "Harmony and Purpose": 177–179, 185.
1983 Richardson: 38, 40, 43, 244, 39, pl. 5.
1985 Hart: 203–213, fig. 2; reprinted in Miller and Ward 1991: 145–165, fig. 5.
1992 Lawson: 460, 462 (fig. 4), 463, 484–485.

1942.8.9 (562)

John Philip de Haas

1772
Oil on canvas, 127 × 101.6 (50 × 40)
Andrew W. Mellon Collection

Inscriptions
Signed lower right: C.W. Peale pinx[t]: 1772
Inscribed on the reverse:[1] I.P. de HAAS Æ 37 / Chas W.
 Peale PINX — 1772

Technical Notes: The support is a heavy, plain-weave fabric primed with a thin white ground. Paint is applied in a wet-in-wet technique. The flesh tones are smoothly blended, ranging from gray-green shadows to a pink flush. Dabs of impasto highlight the sword hilt, chair nails, and shirt ruffles. A flattening of the impasto may be the result of past lining. The paint surface has multiple scattered losses that have been retouched without being filled, thus creating an unnatural, pitted texture. The varnish was removed and the painting lined in 1945 / 1946. The varnish is significantly discolored.

Provenance: Sold in or before 1858 by the artist's niece Margaretta Angelica Peale [1795–1882] to the artist's granddaughter Mary Jane Peale [1827–1902];[2] bequeathed to her sister-in-law Louisa Harriet Hubley Peale [Mrs. Edward Burd Peale, b. 1839];[3] her daughter Anna Frances Peale Carrier [Mrs. Frederick Carrier, 1860–1924]; sold on 5 December 1922 to Thomas B. Clarke [1848–1931], New York;[4] his estate; sold as part of the Clarke collection on 29 January 1936, through (M. Knoedler & Co., New York), to The A.W. Mellon Educational and Charitable Trust, Pittsburgh.

Exhibited: Union League Club, January 1923, no. 18. *A Loan Exhibition of the Earliest Known Portraits of Americans Painted in This Country by Painters of the Seventeenth and Eighteenth Centuries*, Century Association, New York, 1925, no. 16. Philadelphia 1928, unnumbered. *Paintings and Sculpture from the Mellon Collection*, NGA, 1949, no. 562. Columbia 1950, no. 9. Atlanta 1951, no. 8. Chattanooga 1952, unnumbered. Mint Museum of Art, Charlotte, North Carolina, 1952, no cat. Randolph-Macon Woman's College, Lynchburg, Virginia, 1952–1953, no cat. *The Peale Heritage, 1763–1963*, The Washington County Museum of Fine Arts, Hagerstown, Maryland, 1963, no. 4. *La Pintura de los Estados Unidos de Museos de la Ciudad de Washington*, Museo del Palacio de Bellas Artes, Mexico City, 1980–1981, no. 3. *Charles Willson Peale and His World*, NPG; Amon Carter Museum, Fort Worth; MMA, 1982–1983, no. 15.

JOHN PHILIP DE HAAS (c. 1735–1786) was born in Holland and immigrated to America with his parents, who settled in Lebanon Township, Pennsylvania. He had a long, successful military career that began with his commission as an ensign in the first battalion, Pennsylvania regiment, in 1758. Promoted to captain in 1760, he served under Colonel Henry Bouquet on an expedition to relieve Fort Pitt in the summer of 1763 and took part in the battle of Bushy Run that August. He was promoted to major in June 1764 and put in command of Fort Henry, one of the colony's frontier forts. From 1765 to 1779 de Haas lived in Lebanon, Pennsylvania, where he worked in the iron industry and served as a justice of the peace. When the American Revolution began, he became a colonel of the First Pennsylvania Battalion. He was promoted to the rank of brigadier-general in 1777 but for unknown reasons resigned his commission at the end of that year. Two years later he moved to Philadelphia, where he died in 1786.[5]

Peale painted de Haas' portrait in Philadelphia in 1772 on a painting trip from Maryland, when he was "making a Tryal how far the Arts will be favoured in this City."[6] That November he wrote that he was uncertain about whether to settle there, but "not for want of Bussiness. I have my hands full. And I believe would allways find a Sufficiency between this and New York.... I am now refusing business (contrary to Mr. Cadwa[la]ders advice) in order to get these out of hand that I may return."[7] De Haas, in his thirties, wears a brown suit with a silk-lined jacket, white silk hose, and a white shirt trimmed with lace.[8] He is seated on a chair with a red upholstered seat, next to a window. The sunlight makes diagonal patterns on the brown shutter. His right elbow rests on a table, pushing the green tablecloth into folds. On the table are three books and a sheaf of papers. Only the letters "FAR" and "LET" on the spine of the thinnest book are legible. The sitter's easy pose and the portrait's warm coloring and careful descriptions of detail, notably in the highlighting on the sword and the nails on the chair, and the white lace shirt ruffle and cuffs, are typical of Peale's work at this time.

The portrait includes references to de Haas' military career. A gilt-framed picture hanging on the wall behind him appears to depict a battle, with figures of men and horses, and a bright red spot of rifle fire or flame. The image undoubtedly represents one of the battles in which de Haas participated during the French and Indian War, perhaps that of Bushy Run. For his services in the war de Haas received extensive land grants along a branch of the Susquehanna River in Pennsylvania; he eventually owned over two thousand acres. As if to allude again to his military achievements, de Haas rests his

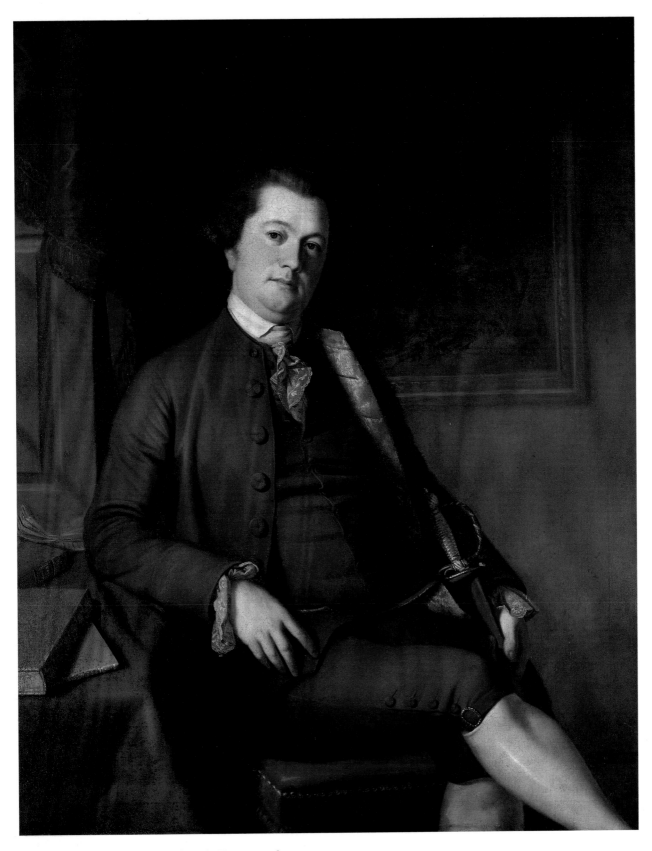

Charles Willson Peale, *John Philip de Haas*, 1942.8.9

left hand on a sheathed sword. Peale has carefully delineated the blue and white military sword knot and the gold wire wrapped around its handle.[9]

In 1858, Peale's son Rubens Peale restored the painting for his daughter Mary Jane Peale, noting in his diary on 2 February that he "painted a part of the morning in repairing the old portrait of General DeHas for Mary and then I sat to her for my portrait which she began in 1855." Two days later he wrote, "In the morning I finished repairing the portrait of Gen Haas, painted by my father in the year 1772."[10] He wrote his son Charles that he "repaired the old painting by my father [of] Gen. De Haas, dated 1772 and have made it look quite well and in a little while I will varnish it."[11]

LKR / EGM

Notes

1. This inscription, covered by the lining canvas, was recorded in 1922 by Beers Brothers, a New York City firm of restorers; see their correspondence with Art House, Inc., New York, 11 December 1922 (NGA). When the painting was relined at the National Gallery of Art in 1945/1946, conservators made a transcription of the inscription (NGA).

2. Mary Jane Peale, in her "List of Pictures I Own, 1884," noted, "43 Gen De Haas one of Washington's Generals — by Chas W. Peale. This I bought from Margaretta Peale" (Peale-Sellers Collection, American Philosophical Society, Philadelphia). It is not known how Margaretta Peale obtained the painting; family lore held that it was found in a Philadelphia attic (notes, William Campbell, 1957; NGA). The painting could be one of the "Pictures" left by de Haas to his wife Eleanor Bingham de Haas in his will, dated 21 February 1786. The inventory of the contents of his house, dated 13 July 1786, listed in the front parlor a "Mahogany Desk, Tea Table, Dining Table, 6 Chairs, 5 pictures &c." (Hess 1916, 121, 124).

3. The picture is listed in the codicil to her will dated 6 September 1901: "To Louisa wife of my brother Edward Gen de Haas if not sold painted by my grandfather" (will, proved 29 May 1903, Register of Wills, Pottsville, Pennsylvania; photocopy, NGA).

4. The name of the seller and the date of purchase are recorded in an annotated copy of *Clarke* 1928 in the NGA library. The painting was apparently purchased through Art House, Inc. (see n. 1). Mrs. Carrier stated in an interview with Wilfred Jordan, curator at Independence Hall, Philadelphia, on 3 October 1917 that the "portrait had been in the possession of her immediate family since painted by Charles Wilson Peale.... She has known the portrait intimately for fifty-two years, it having formerly belonged to her mother" (Wilfred Jordan, "Notes of an Interview Under Date of October 3rd, 1917, with Mrs. Carrier, 406 S. 16th St., Philada.," typescript; copy, NGA).

5. Stauffer 1878, 345–347; Hess 1916, 69–124; *DAB* 3 (part 1):199–200; Boatner 1966, 325.

6. Peale to John Beale Bordley, 29 July 1771, in Miller 1983, 1:123–124.

7. Peale to John Beale Bordley, November 1772, in Miller 1983, 1:126–127.

8. De Haas is described by Warwick, Pitz, and Wyckoff 1965, 213 and fig. 33, as "the very epitome of the well dressed man shortly before the Revolution."

9. Marko Zlatich, a historian of military uniforms, pointed out the military nature of the sword and sword knot to the authors.

10. Rubens Peale, Diary 1, "Journal of Woodland Farm," 22 October 1855–22 April 1858, AAA; in Miller 1980, fiche VIIB/5D6.

11. Undated letter, Mills Collection, American Philosophical Society, Philadelphia; in Miller 1980, fiche VIIA/10D9.

References

1923 Sherman: 334–335, 329 repro.
1952 Sellers: 63–64, no. 193; fig. 36.
1983 Miller: 1:124 n. 1.
1983 Richardson, Hindle, and Miller: 50, fig. 15; 245.

1966.10.1 (2313)

Benjamin and Eleanor Ridgely Laming

1788
Oil on canvas, 106 × 152.5 (42 × 60)
Gift of Morris Schapiro

Technical Notes: The painting is on a medium-weight, plain-weave fabric lined to a medium-weight fabric with a thick white paper as an interleaf. The ground appears to be white. The paint is applied in a thick, opaque manner, with low impasto in most areas. Dark areas are built up in a series of glazes. X-radiography shows that the handkerchief in Laming's lap was repositioned. Also, although Laming's fully painted legs and torso, and the vertical folds of the handkerchief are visible under x-radiography, the telescope is not. The lack of a reserve for the telescope and the repositioning of the handkerchief suggest that the telescope was a later addition or at least was painted after the other elements were finished (see Figure 1).

The paint layer is abraded, especially in the sky. Pinpoint losses are found throughout. In 1988 the varnish was removed and the painting was revarnished.

Provenance: Mary Ridgely Palmer [Mrs. Henry Clay Palmer, 1852–1932], Baltimore.[1] Luke Vincent Lockwood [1872–1951] and his wife Alice Gardner Burnell Lockwood [1874/1875–1954], Greenwich, Connecticut, by 1926;[2] their sale (Parke-Bernet Galleries, New York, 13–15 May 1954, no. 455).[3] Morris Schapiro [1882/1883–1969], Baltimore, Maryland.[4]

Exhibited: *Loan Exhibition of Eighteenth and Early Nineteenth Century Furniture & Glass ... Portraits by Stuart, Peale*

and Others for the Benefit of The National Council of Girl Scouts, Inc., American Art Galleries, New York, 1929, no. 834. *Paintings by the Peale Family*, Cincinnati Art Museum, 1954, no. 19. *J. Hall Pleasants, A Memorial Exhibition*, The Baltimore Museum of Art, 1958–1959, p. 12. *American Painters of the South*, CGA, 1960, no. 21. MMA, 1965.[5] *The Peale Family: Three Generations of American Artists*, The Detroit Institute of Arts; Munson-Williams-Proctor Institute Museum of Art, Utica, New York, 1967, no. 37.

THIS DOUBLE PORTRAIT depicts Eleanor Ridgely (c. 1760–1829), a member of a prominent Maryland family, and her husband Benjamin Laming (c. 1750–1792), a prosperous Baltimore merchant who was born in the West Indies.[6] Peale painted the portrait in September and October 1788 at the Lamings' country estate, one and a half miles north of Baltimore. The couple is seated on a rise in the ground. Their poses, gestures, and expressions convey an intensely personal mood. Laming, dressed in a green coat, an embroidered white waistcoat, a white shirt and tie, and buff breeches, leans toward his wife, his body almost horizontal. He looks adoringly at her. His position, with his head slightly lower than that of his wife, is unusual for a double portrait. The wife's figure was traditionally positioned at the same level as, or slightly lower than, her husband's. His pose seems aggressive, an impression reinforced by the strong horizontal line of the telescope in his lap, which points directly at his wife's abdomen. Mrs. Laming, in contrast, gazes dreamily into the foreground. Her softly draped white dress, its blue sash decorated with gold threads and a gold fringe, differs from dresses worn by the older women that Peale painted at this time and by matronly women in portraits by other American artists. Their dresses, which are frequently of printed or patterned material, have long tight sleeves and low bodices that are often modestly covered.[7] Mrs. Laming's brown hair, entwined with pearls, flows loosely over her shoulders. Small bright pink flowers decorate the bodice of her dress. In her left hand she holds three ripe peaches in her lap. She shows her affection for her husband by resting her right forearm on his left arm. Her right hand is almost entwined with his left, as the sprigs of purple clover in her hand rest in midair.[8] Next to Laming is a green parrot with blue around its eye and on its wing, and a red patch behind the wing. This parrot is a mosaic of characteristics of several species of the genus *Amazona*, native to Central and South America.[9] In the distance is a view of Baltimore harbor at Fell's Point. While the painting has been admired for its characterizations and its use of serpentine curves, the intense emotional content has received the most comment. The portrait has been seen as an image of "conjugal felicity."[10] Its sexual imagery of the telescope and the peaches has been read as "anatomical analogues" indicating the late eighteenth-century "popularity of love matches and a new acceptability of public demonstrations of private affection."[11]

The painting is documented by the detailed entries that Peale made in his diary.[12] On 31 August, three days after his arrival in Baltimore on a painting trip, Peale went to Mr. Laming's country seat for breakfast with Daniel Bowley, a merchant and state senator who had provided Peale with a room in a building on Water Street.[13] He spent part of the next day "in preparing a Canvis for Mr. Lamings family picture." He did not begin the commission, however, until 16 September, when, unable to find Laming at his store in the city, he "took a walk to his country seat about 1½ mile. I staid here to lodge." The next day he "staid to breakfast being engaged to bring my Colours & canvis to begin the Portraits of Mr & Mrs Laming tomorrow morning." On 18 September he went back to the Lamings' estate, where he "found Mr. Lamings family at Dinner I sketched out the design —." He worked on the portrait for the next eighteen days at their country estate, occasionally returning to the city. "Mrs. Laming sat" on 19 September. The next day "Mr. Laming satt in the Morn:g company of sundry Gentlemen to dinner the picture thought very like, yet I am determined in my own mind, [to] paint over & place the head in another direction, because by so doing I hope to improve the picture."[14] On 22 September, "I paint again the likeness of Mr. Lamming I find as I expected the picture improved—Mrs. Laming also sat—." The following day he "painted Mr Lamings drapery." Returning to town two days later "to clean myself," he returned to their estate and "then painted the background which was [a] view of part of Baltimore Town—."

The dates for the next entries are confused, as Peale explains in his entry of 1 October. Noting that he had been "very bussey at this picture of this family," he added, "I find at many moments that I would use to make my memorandoms <*a repunction*> an unwillingness to write before a family, least I should give a suspicion that I am making remarks on the transactions of a family where I am treated with the greatest politeness. — this repunction [compunction] I have experien[c]ed at other times

in other families." During the previous three days, "Mr Laming sat for his face 2d sitting and yet ment for a finishing — company coming interrupt us considerably, & with difficulty I compleat the likeness. however it is esteemed good." The next day, "Mrs. Laming sat for her hands." On 30 September "<*Mr Laming sat*> I had to grind so[me] white paint. . . . I paint flowers in Mrs. Lamings bosom – the tucker and other parts of her drapery in the afternoon at the finishing of Mr. Lamings drapery. but have not time to compleat it—."

On 1 October he "painted the ruffles of Mr Laming, Mrs. Laming satt what I call a sitting for consideration, & I have been so fortunate as very much to improve her portrait – after dinner painted a handkerchief in Mr. Lamings lap. &c—."[15]

The next day he "painted the back ground, a parriot [parrot] and flowers in Mrs. Lammings hand &c and returned to Baltimore Town in the Evening—." On 3 October he "made what haste I could to Mr. Lamings country seat, with the hopes that I should get him to set for the compleating his portrait. but I was too late, he had gone to Town. I then wrote him a note requesting him to sett in the afternoon. I then with my Machine made a per[s]pective drawing <*with my*> Mr Laming could not be found, and of consequence does not comply with my request." On 4 October "Mr. Laming satt this morning & I made some improvements yet it is not what I wish." The next day he again "walked out to Mr Lamings and got him to set and made the portrait much better, worked on a small portrait of him painted in London, also on the miniature which I pain[t]ed 2 or 3 yrs. ago—."

With the sittings completed, Peale finished the painting in the city. On 8 October he "got of Mr Laming eighteen Dollars & one half Dollar." Almost three weeks later, on 27 October, he "wrote notes to Mr Laming & Mr Saml. Sterret to acquaint them that I should finish My pictures in about 3 days & requesting the necessary [money] in that time as I should then set out for Philada." On 2 November he "worked on Mr. Lamings Miniature," and the next day noted that he "Recd of Mr Laming £28.1.3 in full for his & Ladys picture—."[16]

Peale expressed the painting's themes of romantic love and country pleasures by characterizing the Lamings as Rinaldo and Armida, central figures in the epic poem *Gerusalemme Liberata* (Jerusalem Liberated) by Torquato Tasso (1544–1595), published in 1581. The poem describes the events of the first Crusade, including the reconquest of Jerusalem in 1099. The first complete English translation of the poem was published in 1600. It remained popular in England through the seventeenth century and enjoyed a revival in the mid-eighteenth century because of Tasso's romantic, non-classical subject matter and language.[17] New translations included

Fig. 1. X-radiograph composite of 1966.10.1

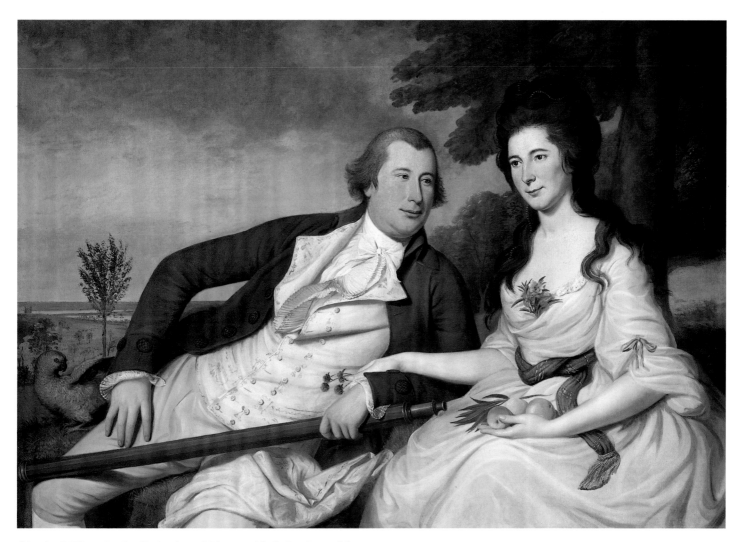

Charles Willson Peale, *Benjamin and Eleanor Ridgely Laming*, 1966.10.1

John Hoole's *Jerusalem Delivered: An Heroic Poem* (London, 1763).[18] Peale illustrated the passage given in Book Sixteen, lines 1–194, which tells of Rinaldo as he languishes far from battle in Armida's enchanted garden. According to Rensselaer Lee, "The passage in the sixteenth canto which describes the beauty of the garden and the langorous passion of the lovers, is one of the most famous in Italian literature."[19] Peale's interpretation relies on the poem and draws on his apparent familiarity with paintings, prints, and drawings of the subject by seventeenth- and eighteenth-century artists, including Benjamin West and Angelica Kauffmann, two artists much admired by Peale.[20]

Passages in the poem inspired the landscape setting and the positions of the figures. Two of Rinaldo's knights seek him out in the gardens of Armida's palace. They see Rinaldo reclining against a seated Armida, his head lower than hers: "Armida on a flow'ry bed; / Her wanton lap sustain'd the hero's head" [125–126]. This pose characterizes all images of the scene, from its earliest example: Agostino Carracci's engraving for the first illustrated edition of the poem (Genoa, 1590).[21] A parrot in the garden talks of love and sets the emotional tone. The bird, a central figure in the story, first appeared in Annibale Carracci's *Rinaldo and Armida* of around 1601, believed to be the earliest extant painting of the subject (Pinacoteca Nazionale, Capodimonte, Naples).[22] The parrot speaks:

> Behold how lovely blooms the vernal rose
> When scarce the leaves her early bud disclose:
> When half inwrapt, and half to view reveal'd,
> She gives new pleasure from her charms conceal'd.
> But when she shows her bosom wide display'd,
> How soon her sweets exhale, her beauties fade!
> No more she seems the flow'r so lately lov'd,
> By virgins cherish'd, and by youths approv'd.
> So, swiftly fleeting with the transient day,
> Passes the flow'r of mortal life away!
> In vain the spring returns, the spring no more
> Can waning youth to former prime restore:
> Then crop the morning rose, the time improve,
> And, while to love 'tis giv'n, indulge in love!
> [98–112]

Mrs. Laming's loosely flowing dress, her long hair, and her dreamlike state are based on the poem's description of Armida.

> Her op'ning veil her iv'ry bosom show'd;
> Loose to the fanning breeze her tresses flow'd;
> A languor seem'd diffus'd o'er all her frame,
> And ev'ry feature glow'd with am'rous flame.

> The pearly moisture on her beauteous face
> Improv'd the blush, and heighten'd ev'ry grace:
> Her wand'ring eyes confess'd a pleasing fire,
> And shot the trembling beams of soft desire.
> Now, fondly hanging o'er, with head declin'd,
> Close to his cheek her lovely cheek she join'd:
> [127–136]

Laming's lustful gaze is also the poet's invention: "While o'er her charms he taught his looks to rove, / And drank, with eager thirst, new draughts of love" [137–138].

Other details of Armida's clothing and hair are described in the epic. As the knights watched, she "bound her flowing hair" and "Her veil compos'd, with roses sweet she dress'd / The native lilies of her fragrant breast." The spells that she cast on Rinaldo were confined in the sash, or "girdle," that she wore around her waist: "But o'er the rest her wond'rous cestus shin'd, / Whose mystic round her tender waist confin'd. / Here, unembody'd forms th'enchantress mix'd, / By potent spells, and in a girdle fix'd." Mrs. Laming's unusual clothing is, appropriately, an example of the Turkish or oriental-style masquerade dress that appears frequently in English portraits from the 1760s to the 1780s. The dress, made of a plain white fabric, was styled with a cross-over bodice and worn with a fringed sash. Sitters often wore clusters of pearls in their hair. The style of dress, according to historian Aileen Ribeiro, "could most easily be utilised by the artist for many kinds of costume—oriental, romantic, classical."[23]

During the day the two lovers would separate. As Armida "review'd / Her magic labours, and her spells renew'd" [187–188], Rinaldo would wander in the garden. "But when the silent glooms of friendly night / to mutual bliss th'enamour'd pair invite; / Beneath one roof, amid the bow'rs they lay, / And lov'd, entrac'd, the fleeting hours away"[191–194]. When Rinaldo sees his fellow knights, "his breast rekindles with a martial fire." One of them holds up his shield so that Rinaldo could see his appearance reflected.

> To this he turn'd; in this at once survey'd
> His own resemblance full to view display'd:
> His sweeping robes he saw, his flowing hair
> With odours breathing, his luxuriant air:
> His sword, the only mark of warlike pride,
> Estrang'd from fight, hung idly at his side;
> And, wreath'd with flow'rs, seem'd worn for
> empty show;
> No dreadful weapon 'gainst a valiant foe.
> [213–220]

The passage ends as the "Christian knight," awakened from his trance, is ashamed of his appearance and behavior while "All Europe arms, And Asia's kingdoms catch the loud alarms" [227–228]. He leaves the garden in haste, with Armida pursuing him. (The couple is reconciled at the end of the poem.)

Although Peale closely followed many elements of the poem, he omitted or reinterpreted others. Most paintings, including Domenichino's *Rinaldo and Armida* (c. 1620, Musée du Louvre, Paris),[24] show either Rinaldo or Armida holding the mirror in which Armida admires her image, as Rinaldo sees his reflection in her eyes, "One proud to rule, one prouder to obey." This is the only central element of their interaction that Peale omitted. Also he depicted Laming in an upright position, more appropriate for a portrait, rather than with his head in Armida's lap. And Rinaldo's sword has been transformed into a telescope. In addition Peale selected a specific setting at their country estate, with the view of Fell's Point beyond. Such views are often found in the background of portraits. Here, however, the view plays an emblematic role, representing the world outside the garden. According to art historian Rensselaer Lee, the garden scene from *Gerusalemme Liberata* was popular not only for its "intrinsic beauty and human interest," but also because it had behind it "a long tradition of pastoral art and literature extending back into antiquity, with its images of the country, its implications of escape from the weary, complex life of cities, and its haunting references to the Golden Age when an idly happy life prevailed."[25] The Laming estate provided such an escape for its owners, as Peale observed in his autobiography.

In several directions round the City of Baltimore, are country seats, some of them small, but they serve for a retreat from the bustle of business, and many in walking distance, this of Mr. Lamings was one of that kind, it afforded a fine view towards Felspoint and its grounds were cultivated with much taste. Thus the wives of merchants resided in healthy situations, and prepaired the comforts necessary to refresh their weary husbands.[26]

Peale probably knew the theme of Rinaldo and Armida from paintings by Benjamin West and Angelica Kauffmann. West's *Rinaldo and Armida* of 1766 (Figure 2) shows Rinaldo leaning against the seated Armida, their right arms intertwined, in a fashion similar to that of the Lamings.[27] As in the painting by Annibale Carracci, Rinaldo's sword lies by his side. Although West's painting may not have

Fig. 2. Benjamin West, *Rinaldo and Armida*, oil on canvas, 1766, Rutgers, The State University of New Jersey, Jane Voorhees Zimmerli Art Museum, Gift of Willet L. Eccles [photo: F.J. Higgins, Highland Park, New Jersey]

been in his studio when Peale arrived in London in 1767, West probably still owned the monochrome oil study.[28] Kauffmann's images of Rinaldo and Armida date from the years after Peale had returned to America, but he could have known the earliest, made in 1771 (Yale Center for British Art, New Haven, Connecticut), through one of the engravings made of it (Figure 3).[29]

Fig. 3. James Hogg after Angelica Kauffmann, *Rinaldo and Armida*, engraving, 1784, Vienna, Graphische Sammlung Albertina

Except for Peale's use of the theme here, the earliest known American depiction of Rinaldo and Armida in the garden is a crudely painted Maryland overmantle by William Clarke, copied in 1793 from Philip Dawe's mezzotint of Richard Cosway's *Rinaldo and Armida*.[30] That Tasso's poem was already popular in Maryland is indicated by the name of one of Peale's sitters, Rinaldo Johnson (1754/1755–1811), an attorney who had served in the Maryland House of Delegates. He may have been the immediate inspiration for the Laming portrait. In September 1788, when Peale was to begin work on the Laming portrait, he was commissioned by Rinaldo Johnson to paint a miniature of him and two small oils of his parents, Thomas and Anne Johnson.[31] Peale went to "Pleasant Grove," the elder Johnson's home, on 7 September and stayed until the fifteenth. On 14 September he saw "all Mr. Johnsons children collected their number 10. 4 Girls & 6 Boys all grown up allmost to men & women — it was a pleasing sight to see them placed at the dinner Table in the order they were born. Mr Johnson aged 77 yrs. & Mrs. Johnson 52 yrs. — this family have generally contrived to meet togather on[c]e a year — and seem to be very happy in much brotherly Love —."[32] Returning to Baltimore, Peale continued to work on Rinaldo's miniature and to improve the coloring. Two days later, on 18 September, he went to the Lamings' estate to begin their portrait. It was on his arrival that he "found Mr. Lamings family at dinner" and "sketched out the design," apparently with Rinaldo Johnson and his family's happiness in mind. While painting the Laming portrait Peale continued to work on the miniature of Rinaldo Johnson, which he finished at the end of September. Thus Peale transferred the garden of Rinaldo and Armida to a Maryland country estate.

> Art shew'd her utmost pow'r; but art conceal'd,
> With greater charms the pleas'd attention held.
> It seem'd as nature play'd a sportive part,
> And strove to mock the mimic works of art!
>
> [69–72]

LKR / EGM

Notes

1. The portrait is not listed in Mr. Laming's will; he left his property, unitemized, to his wife (will, proved 14 December 1792, Maryland State Archives, Will Book 5, 68–69; copy, NGA). Nor is it in Mrs. Laming's will or inventory (will, proved 24 October 1829, Maryland State Archives, Will Book 13, 294–297; copy, NGA; inventory,

22 April 1831, Maryland State Archives, Will Book 39, 361–374; copy, NGA). It probably came to Mrs. Palmer, the great-granddaughter of Mrs. Laming's brother John Ridgely (d. 1814), through Ridgely's son Edward (1791–1852), who was Mrs. Laming's heir. Genealogical information on the Lamings was provided by Lynne Hastings of the Hampton National Historic Site, Towson, Maryland, and in Papenfuse 1979, 2:681–691. On Mrs. Palmer see Powell 1925, 4:717, and her obituary in the *New York Times*, 18 March 1932, 21.

2. Mrs. Lockwood informed the Frick Art Reference Library of their ownership of the portrait on 18 March 1926 (letter from Helen Sanger, 24 August 1990; NGA). For the Lockwoods' dates see the entry on Luke Vincent Lockwood in *Who Was Who* 3:526, and Mrs. Lockwood's obituary in the *New York Times*, 6 March 1954. The Lockwoods were collectors of American art and probably bought the painting from Mrs. Palmer.

3. *Lockwood* 1954, 128, repro. 129.

4. Schapiro's obituary in the *New York Times*, 4 May 1969, identified him as the founder of the Boston Metals Company, Baltimore, and owner of the Laurel Race Course.

5. When the painting was on loan at the Metropolitan Museum of Art, Stuart Feld described it as "probably Peale's most successful double portrait" (Feld 1965, 280).

6. Eleanor Ridgely was the daughter of John Ridgely (c. 1723–1771) of "Ridgely's Delight," Baltimore County. She married Benjamin Laming on 13 January 1784. After his death she married James Dall (d. 1808) in 1803. See Sellers 1952, 119–120; *Maryland Journal*, 22 May 1792, 2 (Benjamin Laming's obituary); *Federal Gazette*, 19 February 1803; Papenfuse 1979, 2:688–689; Miller 1983, 1:529 n. 166 and 533 n. 184.

7. For examples of late eighteenth-century women's clothing see Cunnington and Cunnington 1972, 266–294; for Peale's portraits of older women see *Mr. and Mrs. James Gittings and Granddaughter* (1791, The Peale Museum, Baltimore) and *The Robert Goldsborough Family* (1789, private collection). Peale's portraits of younger women, such as *Elizabeth Maxwell Swan* (1788, The Baltimore Museum of Art), depict dresses similar to that of Mrs. Laming.

8. The flowers and fruit in the portrait were identified by Dan H. Nicolson, Department of Botany, National Museum of Natural History, SI. The flowers in the bodice of her dress are *Impatiens balsamina L.*, or garden balsam; the clover is *Trifolium pratense L.*, and the peaches are *Prunus persica L.* (memorandum, 23 August 1990, NGA).

9. The identification was made in August 1990 by Dr. Gary Graves, ornithologist, National Museum of Natural History, SI, a specialist in tropical American birds. Some details, including the proportions, the color of the beak, and the presence of the red spot behind the wing, are not correct for this species.

10. Sellers 1952, 120; he saw the composition as the creative solution to the problem posed by having to place "a large man with a small woman without permitting his figure to dominate hers." The sitters' relative sizes, however, are unknown except from the portrait.

11. Lovell 1987, 247. Jules Prown first called attention to this imagery in his 1981 lecture "Charles Willson Peale in London," published in 1991; see Prown 1991, 44. Cikovsky 1988, 68 n. 15, comments that the expandable telescope "is, particularly given Mr. Laming's more lustful than merely affectionate gaze, something more than an image of 'conjugal felicity'—or at any rate, a special condition of it."

12. Miller 1983, 1:529, 533–543, from Diary 7, 30 May–3 November 1788. Quoted material is reproduced as published, with editorial corrections in square brackets and Peale's crossouts in italics within angled brackets.

13. Peale already knew Laming, having painted his miniature two or three years earlier, perhaps in the winter of 1785–1786; Sellers 1952, 120, no. 454. The portrait is not located today.

14. It is not possible to determine the previous position of Laming's head from the x-radiographs (see Figure 1), although the area above and to the left of its present position is somewhat murky, suggesting an area of change. The clean shapes of Mrs. Laming's head indicate Peale's usual modeling techniques.

15. When Peale added the telescope, he repositioned the handkerchief so that it draped horizontally across Laming's thigh. It is not clear from the diary entries when Peale did this. Examination of the x-radiograph composite (Figure 1) indicates that the telescope was added after Laming's torso and legs were fully painted.

16. Peale listed the painting in the "Amount of Pictures painted in Baltimore from 30 of Aug.t to the 3d of Nov.r 1788" in his diary for 4 November–8 December 1788 (Diary 8): "Mr. & Mrs. Laming in one piece 5 feet by 3 feet 6 Inches – 35 [pounds]"; Miller 1983, 636. On the back of page 34 of his diary for 12 December 1788–29 April 1789 (Diary 9) is a notation on "The Size of Pictures to be framed," which includes "Mr Laming picture 3 feet 7 1/4 by 5 feet 1 1/4 wide." See Miller 1980, fiche IIB/10. Sellers 1952, 120, noted that this diary entry shows that Peale provided the frame, "probably the work of his brother James."

17. Praz 1958, 308–347; Brand 1965; and Lea and Gang 1981, 25–34

18. His translation, quoted here from an illustrated edition published in London by J. Johnson in 1797, went through eleven editions between 1763 and 1811. The first American edition, based on the eighth edition, was published in 1810 in Newburyport, Massachusetts, and Exeter, New Hampshire.

19. Lee 1967, 53.

20. Depictions of Rinaldo and Armida are discussed in Lee 1967, 48–56, where, on page 53, the scene has been described as "the all-popular subject from Tasso among the Italian and French painters for more than two centuries." The subject is also discussed in Waterhouse 1946, 146–162.

21. The engravings were made after drawings by Bernardo Castello; see Bohlin 1979, 272–273.

22. This may be the earliest surviving painting of any subject from Tasso; see Posner 1971, 2:58, cat. 132[S]. The painting was included in the exhibition Torquato Tasso 1985, 255–259, no. 74.

23. Ribeiro 1984, 244. The same type of dress can be found in portraits by Joshua Reynolds, Francis Cotes, and Benjamin West, among others; Ribeiro 1984, 241–244.

24. Spear 1982, 1:221, no. 68; 2:pl. 234; and Torquato Tasso 1985, 264–265, no. 77. It was probably painted for the Duke of Mantua.

25. Lee 1967, 48, described "Rinaldo's enchantment in the Fortunate Isles . . ., famous for its languorous voluptuousness," and the story of the princess Erminia as a shepherdess.

26. This passage in his autobiography discusses a visit with his wife in the month of June 1791; it begins, "20th. our friend Mrs. Curtis going from home, they take a walk to Mr. Lamings 1-1/2 miles out of town, the family was not at home, and they return proposing to go to Fell's point to dine, but passing through Major Yate's lane, they mett him on horseback, after the usual salutations, he invited them to his house, were they dined, and Mrs. Laming having returned and hearing that Mr. and Mrs. Peale was at Major Yates's, sent a request that they come there, and after dinner Mrs. Yates went with them." Peale ends the passage with a long discussion of the negative aspects of owning a country house, including the expense and the temptation for their owners to ignore business. Peale, "Autobiography," Horace Wells Sellers typescript; Miller 1980, fiche IIC/16F4-5, 164–166.

27. Von Erffa and Staley 1986, 282–283, cat. 226, repro. The painting is signed and dated B. West 1766, Retouched 1790. It was sold following the death of the original owner, Peter Delmé, at which time West retouched it. Jules Prown noted the general influence of West on Peale's "love-infused portraits painted in America," culminating in the "almost erotically explicit double portrait" of the Lamings; Prown 1991, 44.

28. Von Erffa and Staley 1986, 283–284, cat. 227, repro., collection of Nicolas M. Eustathiou. It had descended in the family of Raphael West. Benjamin West made other paintings on the theme of Rinaldo and Armida—in 1773, 1780–1796, and 1797 (Von Erffa and Staley 1986, 284, cat. 228–230). Peale probably did not know these; they were painted after he returned to America and were never engraved.

29. Kauffmann's three paintings of Rinaldo and Armida were exhibited at the Royal Academy of Arts in 1772, 1775, and 1776 (Graves 1905, 4:299–300). The earliest, at Yale, was illustrated in Truth to Nature 1968, unpaginated, no. 26. Three prints after the painting are listed and illustrated in Kauffmann 1979: Kauffmann's aquatint of 1780, done in reverse, 32, no. 30, repro. 33; James Hogg's engraving of 1784, also in reverse, 60, no. 114, repro. 61; and W. Dickinson's mezzotint, 1790, 58, no. 113, repro. 59. Hogg's engraving is also included in Kauffmann 1968, 84, no. 91f, repro. 272.

30. Fowble 1969, 49–58. The signed and dated painting, on American pine, was painted for a house near Centreville, Maryland. Clarke worked in Maryland, Delaware, and Pennsylvania in the 1780s and 1790s. On Cosway see Daniell 1890, 49, dated 1780. A drawing by Cosway is owned by the Albertina in Vienna; see Kauffmann 1968, 108, no. 182, fig. 273.

31. Sellers 1952, 112–114, nos. 422, 425–426; Miller 1983, 1:532–533, 536. The portraits of the elder Johnsons

are at the Hammond-Harwood House, Annapolis, Maryland. That of Rinaldo Johnson is in a private collection. On Rinaldo Johnson see Papenfuse 1979, 2:493–495.

32. Miller 1983, 1:533.

References
1952 Sellers: 119–120, no. 453 and fig. 184.
1969 Sellers: 231, fig. 51.
1977 Andrus: 118–121, fig. 42.
1980 Wilmerding: 13, 56–57, color repro.
1980 Miller: fiche IIB/10; IIC/164–165.
1982 Hallam: 1075–1076 and 1078, fig. 7.
1983 Miller: 1:529, 533–543, 636.
1984 Walker: 375, no. 525, color repro.
1987 Lovell: 247, 251, repro. 253, fig. 10.
1988 Cikovsky: 68, n. 15.
1991 Prown: 44.

Robert Edge Pine

c. 1730 – 1788

ENGLISH PORTRAITIST Robert Edge Pine spent the last four years of his life in the United States, where he was one of the first artists to paint history paintings of the events of the American Revolution. Born in London, Pine was the son of engraver John Pine. His birth date is unknown, and nothing has been learned about his training as a painter. In 1760 he won first prize from the Society for the Encouragement of Arts, Manufacture and Commerce for his *Surrender of Calais to Richard III* (unlocated). He exhibited regularly at the Society of Artists and the Free Society of Artists from 1763 until 1772, when he moved to Bath. Sympathetic with the American cause, he painted an allegory titled *America* (1778, engraved 1781, destroyed by fire 1803), in which he showed a suffering "America" visited by Liberty, Concord, Plenty, and Peace. Two patrons with American ties were George William Fairfax, a close friend and neighbor of George Washington, and Samuel Vaughan, a London merchant who was a friend of Benjamin Franklin.

After the American Revolution, Pine decided to go to the United States. In April 1784 he asked Samuel Vaughan's son John about "the present state of the country, with respect to the disposition and ability of its inhabitants for giving encouragement to Painting, either at Portraits or in perpetuating to Posterity the many glorious Acts which honours the name of an American."[1] On 23 August, Fairfax sent George Washington a print of Pine's *America* and recommended Pine to Washington and his friends "as true a Son of Liberty as any Man can be."[2] After he arrived in Philadel-

phia, Pine obtained permission to use a room in the State House (Independence Hall) as an exhibition space and painting room for his projected series of paintings of the events of the Revolution. Only one painting, *Congress Voting Independence*, was completed (destroyed 1803; copied in oil and engraved by Edward Savage).

While in the United States, Pine also painted portraits. His technique was unusual. According to Rembrandt Peale, "His custom was, on small, thin pieces of canvas, to paint the heads of his sitters, making on paper pencil sketches of their figures, so that on his return home, having pasted his heads upon larger canvases, he and his two daughters could rapidly finish them."[3] In some cases, rather than gluing the small head to the larger canvas, he would fit it into a space in the larger fabric that was especially cut to match its dimensions. Twenty-two American portraits with this piecing technique are known.

After Pine's death in November 1788, the paintings in his studio were purchased by wax modeler Daniel Bowen, who, beginning in 1792, exhibited them in Philadelphia, New York, and Boston. Nearly all of the paintings were destroyed by fire in 1803, when they were on display in Bowen's museum in Boston. This left only two family groups and about forty individual portraits as examples of Pine's American work.

EGM

Notes
1. Letter from Pine to John Vaughan, dated 29 April 1784, Historical Society of Pennsylvania, quoted in Stewart 1979, 20.

2. George Washington Papers, LC, quoted in Stewart 1979, 19.

3. Rembrandt Peale, 1865, quoted in Stewart 1979, 29.

Bibliography
Stewart 1979.

1947.17.89 (997)

General William Smallwood

1785 / 1788
Oil on canvas, 73.8 × 61.1 (29 ¹/₁₆ × 24 ¹/₁₆)
Andrew W. Mellon Collection

Technical Notes: The head and neck area of the portrait are painted on a small rectangular piece of plain-weave fabric approximately 36.5 by 33.9 cm. After it was painted it was attached to a larger plain-weave fabric, on which the sitter's torso was then painted. The larger fabric measures approximately 65.5 by 56 cm and is estimated to be contemporary with the smaller one. The smaller piece has cusping along all four edges and has numerous slubs. The larger piece, which is slightly heavier and of a more regular weave, also has cusping on all four edges. The portrait was enlarged again at a much later date, when two strips of fabric were added at the right edge and along the bottom. The width of the right strip is 6 cm and the bottom strip 8.3 cm. Finally the entire painting was lined.

A thin white ground is applied to the smallest fabric section. It is difficult to observe a ground layer on the larger canvas. The paint is applied in exceedingly thin layers on the face and more thickly on the upper torso. The hair and the ruffle of the shirt are laid on in a dry, finely textured paint. The braid, buttons, and medal are applied with low impasto. The paint layer is severely abraded and damaged throughout, particularly in the face, which has been retouched. The hair is abraded and overpainted. The background, coat, and medal have been heavily overpainted as well. A tear in the fabric support on the right-hand side has been repaired and heavily overpainted. Discrete losses and abrasion are found on the torso, while the gold braided epaulettes and white ruffle are intact. The varnish is moderately discolored.

Provenance: The sitter's nephew William Truman Stoddert [1759–1793]; his son John Truman Stoddert [1790–1870], Charles County, Maryland; his daughter Elizabeth Stoddert Bowie [Mrs. Robert Bowie, Jr., 1826–c. 1905], Charles County and Baltimore, Maryland;[1] sold 1892 to James A. Conner [d. 1921], Baltimore;[2] bequeathed to George D. Hall, Seattle, Washington.[3] J. Bannister Hall; purchased 1922 by Thomas B. Clarke [1848–1931], New York;[4] his estate; sold as part of the Clarke collection on 29 January 1936, through (M. Knoedler & Co., New York), to The A.W. Mellon Educational and Charitable Trust, Pittsburgh.

Exhibited: Union League Club, January 1923, no. 4. Philadelphia 1928, unnumbered. *A Loan Exhibition of Portraits of Soldiers and Sailors in American Wars*, Duveen Galleries, New York, 1945, no. 10. Hagerstown 1955, no cat.[5] Smallwood Foundation, Inc., La Plata, Maryland, 1958. Daughters of the American Revolution, Washington, April 1960. National Museum of American History, SI, on long-term loan, 1965–1989. *Robert Edge Pine: A British Portrait Painter in America, 1784–1788*, NPG, 1979–1980, no. 61.

WILLIAM SMALLWOOD (1732–1792) of Charles County, Maryland, began his military career during the French and Indian War. During the American Revolution he commanded the First Maryland Regiment, which fought in New York, Maryland, and South Carolina. He was appointed major-general in September 1780 when headquartered in South Carolina, and after the battle of Camden he was made a division commander. Smallwood's dislike for "foreigners," however, hampered his military career, and when he refused to serve under Baron von Steuben he was sent back to Maryland to raise supplies and reinforcements. After the Revolution, he served as governor of Maryland from 1785 to 1788.[6]

Pine's portrait shows Smallwood in his general's uniform, blue with buff collar, facings, and waistcoat. The portrait was completed sometime before June 1788, when Pine asked Charles Willson Peale to add the insignia of the Society of the Cincinnati to the lapel.[7] Smallwood was a founding member of the Society of the Cincinnati in 1783 and served as president of the Maryland chapter.[8] Peale noted in his diary on 2 June,

Mr. Pine called on me and after making many apoligies requests me to paint the Eagle in a portrait which he had made for Govenor Smallwood, I agree to do it. his reason for requesting it was that his paints &c was gone to Baltimore Town.... I am requested to meet the Governor & Mr. Pine at Mr Richmonds room at 4 o'clock. Mr. Pine does not meet us, perhaps had not information in time.[9]

As well as adding epaulettes to another portrait by Pine, of David Harris, Peale fulfilled similar requests to add badges to two of his own paintings.[10] General Smallwood also wanted Peale to work on the portrait, but for a different reason: he was dissatisfied with Pine's efforts.[11] Peale noted in his diary that "Genl. Smallwood finds a great <deal> many faults with his Portrait, the likeness not good, the Colour of the facings not buff the hump on the his back, and bad Epaulet &c. I told him that I had seen worse portraits of Mr. Pine's painting."[12] Peale

noted on 23 June, "After Breakfast Genl Small-wood sat for the finishing of his Minia: painted by my Brother, afterwards I painted the Drapery, in part, of his picture painted by Mr. Pine."[13] The next day,

> Govr. Smallwood also satt for the painting of the lapels & Epaulets I am obliged to alter the hair on the foretop, he wants me to make further alterations, I find him very difficult to please, this picture I consider among the best of Mr. Pines works, he has laboured to please and has given the mouth and cheeks an affected smile that has done Injury to the portrait. I have been obliged to make the figure as beautifully formed as possible, and now scarcely have satisfied him. I finished the Epaulets & Eagle, and work on the miniature which now is almost what he wants.[14]

Although the painting is now badly abraded and overpainted, the epaulettes and eagle are distinguishable from the rest of the painting as the work of a different painter.

Artistic rivalry may have made this a difficult situation for Peale, who later wrote that Pine had an undeservedly high reputation. He noted in his diary on 7 August 1791 in reference to miniaturist Jean Pierre Henri Elouis (1755–1840), "I wish to know if this Gentleman so cried up, will do better than Mr. Pine, whose reputation was equally cryed up."[15] Although Peale probably handled the Smallwood situation diplomatically, a certain testiness emerged when he wrote about Pine many years later in his autobiography. There Peale suggested that Pine's painting showed a lack of close observation of detail.

> Mr. Pine had not accustomed himself to paint the manutia of his draperies from nature, this might have been thought too laborious for a man of genius. This was the case with his portrait of General Smallwood, for on delivery of it the General being a judge of Epulets and other parts of military dress, he refused to pay the last price untill Mr. Pine finished the drapery in a better manner, therefore Mr. Pine requested his friend Peale to mend the drapery for him, this being done he was paid for the picture.[16]

The image of Smallwood is a side view, unusual for single-figure portraits. The method Pine used for making the portrait is also uncommon. As revealed by x-radiography (Figure 1), he completed the face on a small piece of canvas and then attached it to a larger canvas. Pine used this method for many portraits, recording the likeness on a painting trip and completing the portrait later in his Philadelphia studio. Circumstances suggest that he planned to include Smallwood's portrait in one of his history paintings. Perhaps he designed the pose to conform to the larger composition, as he did with portraits included in his *Congress Voting Independence* (destroyed 1803).[17] The painting in this case would have been *George Washington Resigning His Commission to Congress*, which Pine left unfinished at his death.[18] Pine collected images for this painting when he visited Maryland in 1785, as John Beale Bordley wrote to Peale on 8 July: "I hear how that Pine painted as he passed on the Western Shore: but I suspect it was only the Likenesses of the Persons present on the Surrender of the General's Commission."[19] A notice in a London newspaper at this time also commented on Pine's plans.

> Mr. Pine, the Historical Painter, was also at Annapolis in the beginning of last June — The object of his visit to the United States, is to do honour to the Americans. — The subject of his picture, which is highly interesting, is, Gen. Washington in the act of surrendering his commission as Commander in Chief of the American army; and Congress in the act of accepting a resignation, which reduced him to the rank of a private citizen.[20]

Washington, like the Roman general Cincinnatus, surrendered his position at the head of a victorious army to return to life as a farmer. Smallwood was

Fig. 1. X-radiograph composite showing the piecing of the canvas, 1947.17.89

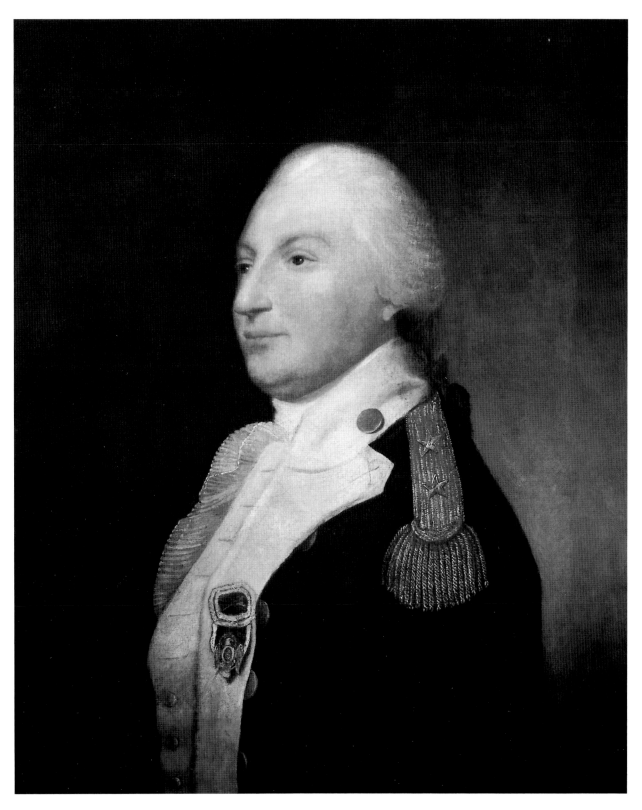

Robert Edge Pine, *General William Smallwood*, 1947.17.89

present when this occurred, at the meeting of the Continental Congress in Annapolis on 23 December 1783.[21] Therefore it is likely that Pine painted General Smallwood on his trip to Maryland in 1785 and returned to Maryland with the portrait in 1788, at which time Peale made his changes.

<div align="right">LKR / EGM</div>

Notes

1. After the death of her children, Mrs. Bowie moved to Baltimore, where she lived with her grandson Robert William Bowie Stoddert. She provided the provenance for the portrait in a statement given to Thomas G. Hull, Notary Public, Baltimore, on 15 April 1905 (copy, NGA). She also stated that the sitter had commissioned the portrait for his mother, but this is unlikely since Mrs. Smallwood died in 1784. For biographical information on these owners see Bowie 1899, 204-206; *Who Was Who*, historical volume, 580 (John Truman Stoddert); and Papenfuse 1979, 2:741 (William Smallwood). William Truman Stoddert's dates were provided by the Society of the Cincinnati, Washington; he was a founding member (Metcalf 1938, 299).

2. A copy of the bill of sale dated 30 November 1892 was given to Thomas B. Clarke in 1922 (NGA).

3. Conner, who died on 29 May 1921, named his deceased wife's nephew George D. Hall as his heir (will filed with the Register of Wills, Baltimore, Maryland); the inventory of Conner's estate included a "Family Oil Portrait" valued at $5 and a "Lot of Pictures" valued at $25. Hall, of Seattle, Washington, is listed as a former owner of the painting in *Portraits of Soldiers* 1945, 40.

4. The name of the seller and the date of purchase are recorded in an annotated copy of *Clarke* 1928 in the NGA library. J. Bannister Hall, Jr., is listed as a lawyer in a 1922 Baltimore city directory; his relationship to George D. Hall is unknown.

5. Washington County Museum of Fine Arts newsletter, October 1955, unpaginated.

6. Papenfuse 1979, 2:741; *DAB* 9 (part 1):225-226.

7. The design of the Cincinnati emblem was conceived by Pierre L'Enfant and shows an eagle with wings outspread, holding a central medallion in which three Roman senators present a sword to Cincinnatus. On the reverse Fame crowns Cincinnatus with a wreath. L'Enfant was commissioned to have the medals made in France and returned to the United States with them in 1784. Later medals were made by American jewelers. Hume 1933, 749-759.

8. Metcalf 1938, viii, 22, 288.

9. Miller 1983, 1:495.

10. For the additions Peale made to Pine's portrait of Harris see Stewart 1979, 59. He added badges to his portraits of Otho Holland Williams and Samuel Smith on 4 November 1788; Miller 1983, 1:494, 545.

11. Peale had painted Smallwood's portrait around 1782 for his museum; Sellers 1952, 195, no. 798.

12. Miller 1983, 1:495-496.

13. Miller 1983, 1:504.

14. Miller 1983, 1:504-505. Although Peale disliked the task of improving Pine's paintings, he did so if it would please a client. In October 1788 Peale was asked to make "alterations" to Pine's portrait of William Smith and his grandson Carvil Hall. He recorded in his diary that "this I am prevail'd on to do by Mr. Smith & his family which however disagreable, I could not well refuse, as I wish to make my services in this family acceptable." See Miller 1983, 1:540, 545.

15. Miller 1980, fiche IIB/12, 29.

16. Peale, "Autobiography," typescript by Horace Wells Sellers, Miller 1980, fiche IIC/15:105.

17. Stewart 1979, 29, 100, no. 90.

18. Stewart 1979, 28, 101, no. 91 (unlocated).

19. Miller 1983, 1:433.

20. Clipping from an unidentified London newspaper, in *Press Clippings* 1:260. The clipping is inscribed "1785."

21. John Trumbull's *Resignation of General Washington, December 23, 1783* (1822–1824, United States Capitol, Washington) also includes Smallwood; see Jaffe 1975, 252, 323, figs. 177, 178; Cooper 1982, 88–90, no. 31, repro.

References

1952 Sellers: 12, 195, no. 800.
1979 Stewart: 59, 82–83, no. 61, repro.
1983 Miller: 1:495–496, 504–505.

Charles Peale Polk

1767 – 1822

BORN IN MARYLAND, Charles Peale Polk was the nephew of painter Charles Willson Peale, who raised him in Philadelphia after the deaths of his parents Robert Polk and Elizabeth Digby Peale. His painting career was heavily dependent on his uncle's example. Although Polk first advertised as a portraitist while on a painting trip to Baltimore and Richmond in 1785, his earliest known work was done in Philadelphia in the period 1785–1790. These paintings show the clear influence of his uncle in both composition and color, and include copies of works by Peale.

After moving to Baltimore in 1791, Polk had considerable success as a portrait painter for about five years. The more than thirty-five portraits that he made during this period constitute his largest group of works. He supplemented his income by opening a drawing school in 1793 and 1794, and by starting a dry goods business in 1795. Polk left Baltimore the following year to settle in Frederick County, Maryland. From there he traveled throughout the surrounding Maryland and Virginia countryside to paint portraits, including the majestic images of members of the Madison and Hite families of the Shenandoah valley. In composition his portraits from these years continued to imitate his uncle's work. Their bright colors and lack of subtle shading, however, as well as their great attention to detail, offer a heightened, literal realism.

After Thomas Jefferson's election to the presidency in 1800, Polk sought appointment to a federal post in Washington. His persistence led to a position as a clerk in the Treasury Department. The family moved to Washington, where they lived for almost twenty years. During these decades Polk painted an occasional portrait and for a few years also made small profile portraits in *verre églomisé*. Polk moved from Washington to Richmond County, Virginia, two years before his death at age fifty-five.

EGM

Bibliography
Simmons 1981.

1953.5.32 (1236)

Anna Maria Cumpston

c. 1790
Oil on canvas, 147.0 × 95.6 (57 7/8 × 37 5/8)
Gift of Edgar William and Bernice Chrysler Garbisch

Inscriptions
Signed center right, on pedestal: C. Polk

Technical Notes: The support is a medium-weight, plain-weave fabric. The thin ground is off-white. The paint is applied in a fairly thin manner, with areas of low impasto in the white decorations on the dress. The technique is wet-in-wet, with details added in the face and skirt after the paint dried. Pentimenti are visible in the

waistline and in the sash around the waist, which was repositioned slightly upward.

A slight flattening of the impasto may have occurred as a result of a past lining. Scattered areas of retouching throughout, as well as two larger areas of retouching on the pedestal to the sitter's right, have discolored. The varnish is moderately discolored.

Provenance: Probably by descent from the sitter to her daughter Emily Williams Cooper [Mrs. Colin Campbell Cooper], Philadelphia; probably her son Colin Campbell Cooper [1856–1937], Philadelphia, or his sister Emily or his brothers Samuel M. and Ned Cooper; (Victor Spark, New York, 1944); sold 1948 to Edgar William and Bernice Chrysler Garbisch.[1]

Exhibited: *American Primitive Paintings from the Collection of Edgar William and Bernice Chrysler Garbisch*, Columbus Museum of Arts and Crafts, Georgia, 1968–1969, no. 10. *Charles Peale Polk 1767–1822: A Limner and His Likenesses*, CGA; Abby Aldrich Rockefeller Folk Art Center, Williamsburg, Virginia; Dayton Art Institute, Ohio; Hunter Museum of Art, Chattanooga, 1981–1982, no. 10.

THIS PORTRAIT of Anna Maria Cumpston is Charles Peale Polk's only full-length and one of his earliest known works. The sitter was the only child of Civel and Thomas Cumpston of Philadelphia; her father was a merchant and shopkeeper.[2] She wears a pale pink dress made of two layers of fabric. The top one of white muslin or lawn is embroidered or printed with small flowers; the lower one is of a bright pink material. A rose pink sash and red shoes provide bright accents. Holding a pink rose in her right hand, she leans on a stone pedestal on which a stem of rosebuds lies next to an urn on which is a climbing rose. Behind her is a field with a large shade tree. The portrait can be dated to about 1790 by the style of her dress—a type worn by young American girls in the 1780s and 1790s—and by the apparent age of the sitter: Miss Cumpston may be about twelve to fourteen years old. Her birth date is not recorded, but it presumably occurred sometime after her parents' marriage on 17 July 1776 at Christ Church, Philadelphia.[3]

This striking image is similar in pose and symbolism to several eighteenth-century American portraits of young women, including *Deborah Hall* by William Williams (1766, The Brooklyn Museum, New York) and *Catherine Beekman* by John Durand (1766, NYHS). It is particularly close to New York artist John MacKay's 1791 portrait of Catherine Brower (NGA), who holds a rose and stands next to a pedestal on which an urn is filled with flowers.[4] Roses were often included in eighteenth-

century portraits to symbolize the transitory beauty of youth. The relationship of youth and roses was described most memorably in 1648 by English poet Robert Herrick: "Gather ye rosebuds while ye may. Old time is still a-flying; And this same flower that smiles today, Tomorrow will be dying."[5] William Williams' portrait of Deborah Hall includes a rose tree, a fountain, a vine, and a neoclassical frieze that refer to the youth, beauty, and marriageability of the sitter.

Roses in combination with an urn could point to the death of a specific person. In *Emblems for the Improvement and Entertainment of Youth* (London, 1755), cropped rosebuds signify "untimely, yet happy Fate.... An Infant cut off in its Innocency ... not having experienced ... Life's uncertain Maze," and a nosegay of roses alludes to "the Decay of all terrestrial Things" in contrast to the glories of heavenly wonders, which never decay.[6] If this is true, whose death is implied? The portrait is not a posthumous one, for the sitter lived to marry James Williams in 1807 and to raise a family. It cannot be her father's; he lived until 1820. His portrait was painted in a miniature in 1797 by James Peale, Polk's uncle (Worcester Art Museum, Massachusetts).[7] It could, however, be a reference to Miss Cumpston's mother, about whom nothing is known. The urn stands out more prominently here than it does in Polk's only other painting to include such a feature—his portrait of his wife Ruth Ellison Polk, painted at about this time (unlocated). In that painting the background and urn were probably added by Charles Willson Peale, who noted in his diary on 6 July 1791, "All the afternoon I work on a picture of Mrs. Polk which was begun by my Nephew."[8] Peale used similar urns as part of the garden setting for his earlier portraits of Mrs. John O'Donnell (1787, The Chrysler Museum, Norfolk, Virginia), Mrs. Jonathan Dickinson Sergeant (1789, Historical Society of Pennsylvania, Philadelphia), and Mrs. Maskell Ewing (c. 1788, private collection).[9] Whatever the explanation, this early, ambitious portrait possesses an enchanting tenderness that typifies many portraits of women by members of the Peale family.

EGM

Notes

1. A photograph of the painting in the Edgar Preston Richardson Papers, AAA, is inscribed "Victor Spark 1944." Spark described the previous owners of the painting as the sitter's direct descendants (letter of 4 March 1948, NGA). Later he wrote that he bought the painting "in Philadelphia from a family with which Colin Campbell Cooper must have been closely connected as the house was filled with his works. I believe that the family's name was Cooper also" (letter of 18 October 1983, NGA). Spark's papers, AAA, offer no information on the history of this painting. For information on Cooper and his relatives see Hansen 1981, unpaginated, and an obituary in the *New York Times*, 7 November 1937, sec. 2, 9.

2. Thomas Cumpston is listed in Philadelphia city directories for 1785 through 1819; his obituary appears in *Poulson's American Daily Advertiser*, 19 July 1829; his will, giving details of his family, is on microfilm at the Historical Society of Pennsylvania (biographical information courtesy of Susan Strickler, curator of American art, Worcester Art Museum, Massachusetts, letters of 21 December 1982 and 3 August 1983 to Linda Simmons, curator, CGA; and 13 December 1983 to Deborah Chotner; copies, NGA).

3. Information provided by Susan Strickler from the *Record of Pennsylvania Marriages Prior to 1810* 1:63 (letter to Linda Simmons, 3 August 1983; copy, NGA).

4. The similarity of these and other portraits of young women is discussed in Schloss 1972, 41, no. 23, and in Chotner 1992, 247. Williams' portrait is analyzed in greater detail in Saunders and Miles 1987, 225, no. 68, repro.

5. From "To the Virgins, to Make Much of Time," quoted in Lacy 1990, 213.

6. *Emblems* 1755, 90, 118.

7. On this miniature and one of Anna Maria's husband by Benjamin Trott see Schwarz and Son 1982, unpaginated, nos. 5 and 13, repro. These portraits were once owned by the same descendants who owned the portrait of Anna Maria Cumpston.

8. Simmons 1981, 42, no. 56, repro.

9. On these portraits see Sellers 1952, 75, 152, 193, and figs. 185–187, and 513, 515, 564.

References

1981 Simmons: 25–26, no. 10, repro.

1947.13.1 (1943)

General Washington at Princeton

c. 1790
Oil on canvas, 91.3 × 70.3 (35 $^{15}/_{16}$ × 27 $^{11}/_{16}$)
Gift of William C. Freeman

Inscriptions

Inscribed on the modern plywood backing, in black paint, in a later hand: N° 32 Cs. Polk Painter.[1]

Technical Notes: The painting is on a medium-weight, plain-weave fabric marouflaged to a fairly rough piece of plywood approximately 0.7 cm thick, which is stained brown on the reverse. The smooth, thinly applied white ground does not hide the weave texture of the fabric support. The paint is applied in opaque, rich, and yet moderately thin paste layers in a wet-in-wet

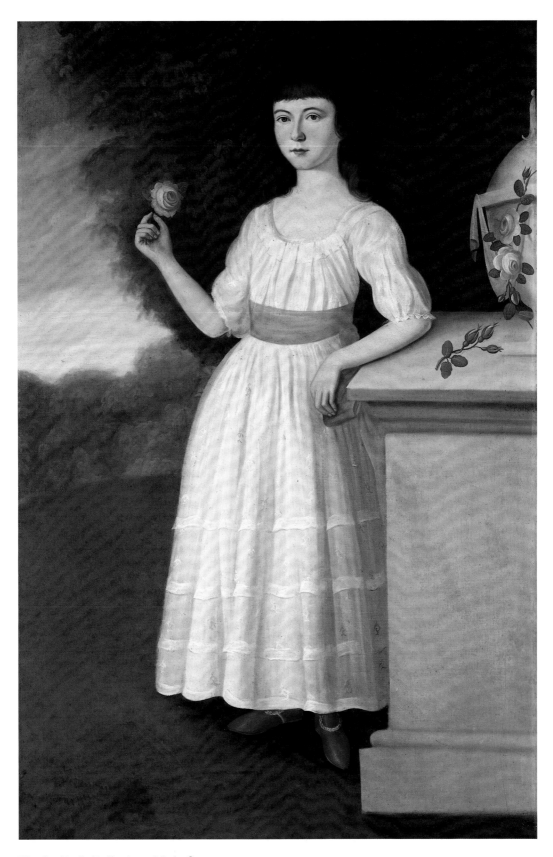

Charles Peale Polk, *Anna Maria Cumpston*, 1953.5.32

technique. Details of the features were added in a wet-over-dry technique. A prominent brushed texture is seen, particularly in the sky; the strokes do not follow specific forms. Low impasto is evident in some details and highlights.

There may be overpainting in the blue jacket. The thin, highly glossy layer of varnish is estimated to be a natural resin, perhaps combined with synthetic resin.

Provenance: Margaret Freeman Buckingham [1857–1946], Lebanon, Pennsylvania; her nephew William Coleman Freeman [1881–1955], Lebanon, Pennsylvania.[2]

Exhibited: Woodlawn Plantation, Alexandria, Virginia, 1952, no cat. Randolph-Macon Woman's College, Lynchburg, Virginia, 1952–1953, no cat. Woodlawn Plantation, Alexandria, Virginia, 1956, no cat. National Museum of American History, SI, on long-term loan, 1965–1993. *Charles Peale Polk 1767–1822: A Limner and His Likenesses*, CGA, 1981, no.38.

WHEN POLK WROTE George Washington on 6 August 1790 requesting a life sitting, he had already painted fifty portraits of the president. Describing himself in the third person, he told Washington, "He has in the Course of the last year Executed Fifty Portraits tho his advantages were not what he wished. But Imagines if your Excellency's Leisure and Inclination will permit he shall hereafter be capable of Exhibiting more Just and Finished performances."[3] This portrait and similar images that show Washington in a three-quarter pose are now referred to as the "Princeton type" to distinguish them from other images of Washington by Polk. This type depicts Washington in his blue and buff army uniform as commander of the American Revolutionary army. While dark, stormy clouds threaten overhead, in the distance is a blue sky with pink clouds, emblematic of the bright prospects of the new republic after the war.

To create the image without a sitting, Polk copied the head and shoulders from his uncle Charles Willson Peale's life portrait of 1787 (PAFA) and enlarged the composition on a kit-cat portrait canvas to show Washington's hands, which hold a sword and a three-cornered hat. Polk, a young and inexperienced painter, may have copied the entire pose from a composite portrait of Washington that his uncle James Peale had painted at about this time (The New York Public Library).[4] In place of James Peale's more accomplished backgrounds, however, Polk depicted scenes whose small scale exaggerates the figure. The views—of an army encampment and Nassau Hall, Princeton College—

vary in the placement or number of tents, soldiers, and buildings. For the detail of Nassau Hall, which is not included in every painting, Polk again turned to Charles Willson Peale's work, copying the background from the full-length portrait of Washington that Peale had painted in 1779 (PAFA).[5] Its inclusion alludes to the critical victories gained by Washington's army in New Jersey at the beginning of the war.

Polk apparently numbered each version of the portrait; inscriptions on eight examples include numbers that range from "30" to "57."[6] The inscription on the Gallery's painting, which presumably was copied onto the wood backing from the back of the original canvas, reads: Nº 32 Cˢ. Polk Painter. The low number suggests that this was painted before Polk wrote to Washington in 1790. As one of many replicas, the portrait is stiff and flat, in striking comparison to the artist's sensitively modeled portrait of Anna Maria Cumpston [1953.5.32], painted at about the same time. In a few examples, including this one, the design of the flag on the encampment's flagpole consists of a field of blue with a circle of thirteen stars, and a small rectangle of red and white stripes in the upper corner. Since the flag's design is similar to the one used by the first city troop of Philadelphia,[7] it may indicate that the portrait was painted for a member of the troop. Polk apparently never enjoyed the opportunity to paint Washington's portrait from life. Instead he continued to paint versions of the portrait for at least three more years.

EGM

Notes

1. The inscription is apparently a record of Polk's signature on the back of the original canvas, copied when the canvas was attached to the plywood. It is of the type found on other examples of Polk's portraits of Washington, with a different number.

2. Freeman's dates are in *NCAB* 1965, 193.

3. George Washington Papers, LC, quoted in Simmons 1981, 4–5.

4. For a discussion of Polk's reliance on the work of Charles Willson and James Peale see Morgan and Fielding 1931, 131–138, and Simmons 1981, 4–5 and 18 n. 36. On Peale's portrait of Washington see Sellers 1952, 237–238, no. 939, fig. 371.

5. Sellers 1952, 225–228, no. 904, fig. 357

6. Simmons 1981, 28–36, nos. 16–40, with illustrations.

7. Simmons 1981, 28.

References

1931 Morgan and Fielding: 131–138.
1981 Simmons: 4–5, 35, no. 38. repro.

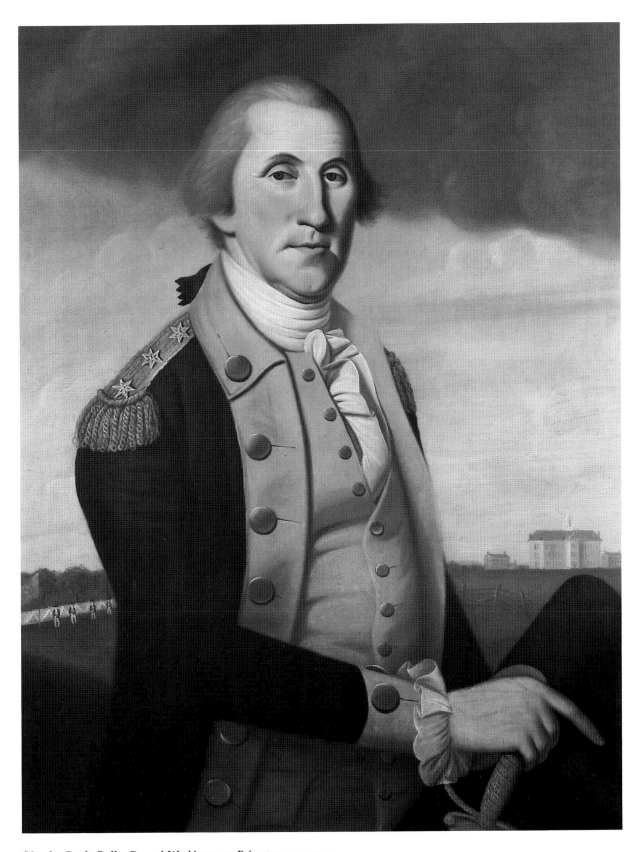

Charles Peale Polk, *General Washington at Princeton*, 1947.13.1

Matthew Pratt

1734 – 1805

PHILADELPHIA PAINTER Matthew Pratt served an apprenticeship with his uncle James Claypoole, a "Limner and Painter in general," from 1749 to 1755.[1] He then opened a similar business which he interrupted in 1757 with a brief speculative trading voyage to Jamaica. When he returned to Philadelphia he "began to practice Portrait painting" and "met with great encouragement, having full employ, and much to my satisfaction; making money fast, with the approbation of every employer." He married Elizabeth Moore in 1760 and had two sons. His earliest known work is a portrait of his wife (c. 1760, private collection).

In June 1764, Pratt escorted his cousin Elizabeth Shewell to London for her marriage to Benjamin West. He remained in London as West's pupil and colleague, the first of numerous Americans to benefit from that artist's generosity. "Mr. Benjn West had a very elegant house, completely fitted up, to accomodate a very large family, and where he followed his occupation, in great repute, as a Historical & Portrait painter. And where he kindly accomodated me with Rooms, and rendered me every good & kind office he could bestow on me, as if I was his Father, friend and brother." During his two and a half years with West, Pratt painted his best-known work, *The American School* (1765, MMA), a depiction of the American painter giving instruction to pupils in his London studio. He also made portraits of West and his wife (PAFA), as well as copies of paintings by West and other artists. He then went to Bristol, where for the next eighteen months he "practiced to much advantage in my professional line." Pratt returned to Philadelphia in March 1768 to "full employ" as a portrait painter. He made a brief trip to Carlingford, Ireland, in March 1770 on behalf of his wife to claim an inheritance, at which time he painted a small number of portraits in Dublin and in Liverpool.

Pratt was most successful as a painter in the years immediately before the American Revolution. Charles Willson Peale later remembered that at this time Pratt painted a full-length of John Dickinson and had "a considerable number of portraits on hand."[2] He worked in New York City in 1771–1772, where his commissions included a full-length of Governor Cadwalader Colden (New York Chamber of Commerce). There he met John Singleton Copley and praised his portrait of Mrs. Thomas Gage (1771, Timken Art Gallery, San Diego). Pratt's self-effacing appraisal was recounted by Copley. "Mr. Pratt says of it, It will be flesh and Blood these 200 years to come, that every Part and line in it is Butifull, that I must get my Ideas from Heaven, that he cannot Paint etc, etc."[3] Pratt next worked in Williamsburg, Virginia, where he advertised in the *Virginia Gazette* (4 March 1773) that he was "Lately from England and Ireland But last from New York."[4]

Pratt's career was less successful after the Revolution. As a partner in the firm of Pratt, Rutter & Co., which offered "Portrait and ornamental painting,"[5] he returned to the functional brand of painting for which Claypoole had in part trained him. He was remembered by the next generation for his unusual signs, including one of "The representation of the Constitution of 1788." His work is difficult to characterize; few paintings are documented or firmly attributed.[6] *The American School* and other paintings from his London years, including his self-portrait (NPG), show the influence of West's teaching in their composition, coloring, and technique. Later portraits, including the double portrait *Cadwalader Colden and Warren de Lancey* (c. 1772, MMA) and those of *James Balfour and his Son* and *Mary Balfour* (Virginia Historical Society, Richmond), show that this style softened under the influence of other English and American painters.

EGM

Notes

1. Matthew Pratt, "Autobiographical Notes," in Sawitzky 1942, 18. The manuscript was transcribed by Charles Henry Hart before it was destroyed in a fire. Most of the transcription is published in Sawitzky 1942, 17–22. All quotes are from these autobiographical notes, unless indicated.

2. Charles Willson Peale to Rembrandt Peale, 28 October 1812, in Miller 1980, fiche IIA/51G2.

3. John Singleton Copley to Henry Pelham, 6 November 1771, *Copley-Pelham Letters*, 174.

4. This and other advertisements are quoted in Sawitzky 1942, 29–31.

5. *Aurora*, Philadelphia, 15 February 1796, quoted in Sawitzky 1942, 31.

6. Sawitzky's checklist of Pratt's work (Sawitzky 1942, 33–80) contains many incorrect attributions.

Bibliography

Evans 1980: 24–31.
Saunders and Miles 1987: 265–268.
Sawitzky 1942.

1944.17.1 (777)

Madonna of Saint Jerome

1764/1766
Oil on canvas, 77.7 × 59.8 (30 ⁵/₈ × 23 ⁹/₁₆)
Gift of Clarence Van Dyke Tiers

Technical Notes: The painting is executed on a plain-weave fabric. Cusping is present along all edges except the top. A moisture barrier, probably a lead-based paint, was once brushed between the stretcher bars, and remnants are apparent in x-radiographs. The ground is white. The image was painted according to a pre-determined plan, applied wet-in-wet within boundaries and then glazed. A small *L*-shaped tear is located in the lower center to the right of St. Jerome's right foot. Flattening of the impasto may be the result of a past lining. The eyes of the child and the angels have been strengthened. The varnish was removed and the painting lined in 1945–1947. The present varnish is moderately discolored.

Provenance: The artist's descendants, to his granddaughter Maria Fennell [d. 1880], Philadelphia;[1] bequeathed to her niece Rosalie Vallance Tiers Jackson [Mrs. Charles P. Jackson, 1852–1944];[2] to her nephew Clarence Van Dyke Tiers [1869–1959] of Oakmont, Pennsylvania and Daytona Beach, Florida, in 1915.

Exhibited: The King's Arms Tavern ("Mrs. Vobe's"), Williamsburg, Virginia, 1773. Perhaps *First Annual Exhibition of the Society of Artists of the United States*, Philadelphia, 1811, no. 323, as *Holy Family*.[3] Perhaps *Seventeenth Annual Exhibition of the Pennsylvania Academy of the Fine Arts*, Philadelphia, 1828, no. 316, as *Holy Family* after Correggio.[4] Immaculate Heart Retreat House, Spokane, Washington, 1969. *The Eye of Thomas Jefferson*, NGA, 1976, no. 17. *Benjamin West and His American Students*, NPG; PAFA, 1980–1981, unnumbered.

WHEN PRATT WAS STUDYING with Benjamin West in London, he made this copy of West's copy of Correggio's *Madonna di San Gerolamo*.[5] In Correggio's composition (Figure 1), a seated Madonna holds the infant Jesus. Mary Magdalene, kneeling on the right, rests her head against the baby. Saint Jerome, on the left, is shown holding a large book, the pages

of which are turned by an angel. West, who painted his version in Parma in 1762–1763, commented in 1802 on the importance of the original to his own education, saying that he had "formed himself upon it."[6] The painting, which was widely celebrated in the eighteenth century, was also copied by John Singleton Copley and John Trumbull. Copley, whose copy (unlocated) was painted as a commission in 1775, praised Correggio's rich, clear colors in a letter to his half-brother Henry Pelham. "I find the Picture I am now Copying so remarkably rich in the tints and Clear at the same time, that I am convinced Corregio must have use'd Varnish or somthing of that sort in his Colours."[7] Trumbull's copy (Figure 2) was painted from West's version in 1780–1781. Trumbull referred to Correggio's original as "universally regarded as one of the three most perfect works of art in existence."[8]

Pratt's copy, once removed from the original, bears characteristics of works by Correggio as well as by West. The copy retains the composition and coloring of Correggio's original. The Madonna appears in a red robe with a blue drape; Mary Magdalene in white, yellow, and lavendar; and Saint Jerome in a blue robe. At the same time the precise handling of small areas, such as the features of the angel, the hands of Mary Magdalene, and Jesus' feet, reveals West's strong influence. The careful process of copying is apparent in the brush strokes, which were applied with equal attention to forms and to the spaces between them. Some details of the original, especially in the shadowed areas of the drapery and in the background, do not appear in the copy. These probably were not in West's copy; they are also absent from Trumbull's version.

As West indicated, the copying process was a method of learning for young artists. In his *Madonna*, Pratt displays the same attention to clarity of form as in his painting *The American School* (1765, MMA), his well-known conversation piece of students gathered in West's London studio. Both works are more precisely rendered than many of Pratt's later portraits. Like his *Self-Portrait* (NPG), also painted in London, *Madonna of Saint Jerome* reveals Pratt's high level of accomplishment under West's direction.

Pratt brought *Madonna of Saint Jerome* with him when he returned to the American colonies, exhibiting it with other paintings in Williamsburg, Virginia, in 1773 at "Mrs. VOBE's, near the Capitol." His advertisement in the *Virginia Gazette* for 4 March listed the painting first among the works on

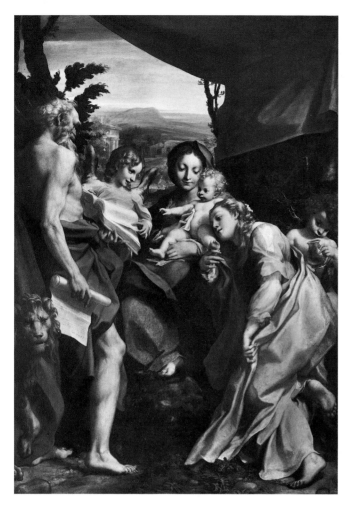

Fig. 1. Antonio Allegri da Correggio, *Madonna di San Gerolamo*, oil on wood panel, 1523, Parma, Italy, Galeria Nazionale [photo: Alinari-Scala, New York]

Fig. 2. John Trumbull, *Copy of Correggio's Picture Called St. Jerome at Parma*, oil on canvas, 1780–1781, New Haven, Yale University Art Gallery

exhibition: "A very good Copy of *Correggio's* ST. JEROME, esteemed to be one of the best Pictures in *Italy*, and ranks next to RAPHAEL'S TRANSFIGU-RATION."[9] Pratt also exhibited a Holy Family, a Venus and Cupid after West, a copy of "*Guido's* JUPITER and EUROPA," a "very fine Fruit Piece," and "a few Copies of some of Mr. *West's* best Portraits." Jane Vobe's tavern was popular with Virginia's political leaders. Thomas Jefferson was in Williamsburg at the time of the artist's exhibition and could have seen the painting, which, according to William Campbell in 1976, was one of the "first copies after the Old Masters recorded as having been in Virginia."[10] Pratt offered the paintings for sale in notices in the *Virginia Gazette* on 11 and 18 March.[11] A number of the paintings, includ-

ing *Madonna*, did not find buyers and were later owned by the artist's descendants.

This painting may be the "scripture piece" mentioned by artist and historian William Dunlap in 1834 as being among the paintings by Pratt that were "praised by competent judges."[12] Dunlap commented that in this group, which included *William Henry Cavendish Bentinck, 3rd Duke of Portland* [1942.13.2] and *The American School*, "the colouring and effect are highly creditable to the infant arts of our country."

EGM

Notes

1. The painting's presumed provenance is from the artist to his daughter Mary (Mrs. William Fennell,

Matthew Pratt, *Madonna of Saint Jerome*, 1944.17.1

1771–1849). Her three daughters were Maria and Susan, who never married, and Anna Matilda, who married Arundius Tiers (Sawitzky 1942, 27).

2. In her will, dated 4 September 1879 (Register of Wills, Philadelphia), Maria Fennell left most of her estate to Rosalie Tiers. She provided that her niece inherit "my share of the pictures and household furniture, which I own jointly with my sister Susan Fennell." The portrait is not mentioned specifically.

3. Rutledge 1955, 175. Pratt, however, exhibited a now unlocated "Holy Family" in Williamsburg in 1773, which could also be this painting.

4. Rutledge 1955, 175.

5. The present title of Pratt's copy is a literal translation of the Italian title of Correggio's work. Sawitzky (1942) gave Pratt's copy the title *Madonna and St. Jerome*. After the National Gallery's acquisition of the painting in 1944, the titles used were *Madonna and Child with the Magdalene and St. Jerome (after Correggio)* and *Madonna and Child (after Correggio)*. For Correggio's original see Ricci 1930, 171–172; the painting, on a wood panel 205 by 141 cm, was commissioned in 1523.

6. See Von Erffa and Staley 1986, 442, no. 505. West began the copy in Parma in 1762 and completed it in 1763. The painting remained in his studio until his death, when it was sold by his sons.

7. On his copy see Prown 1966, 2:253–254, 443–444; Copley's letter of 25 June 1775 is in *Copley-Pelham Letters*, 338.

8. Von Erffa and Staley 1986, 442, who quote Sizer 1953, 62. Cooper 1982, 194–195, offers a different version of the assessment ("one of the three finest paintings in existence") from Trumbull 1832, 17. Trumbull's copy (80 by 60 cm [31 ½ by 23 ⅝ inches]) is the same size as Pratt's and is remarkably similar in all compositional details; see Cooper 1982, 194–195, no. 133, and Jaffe 1975, 326.

9. Sawitzky 1942, 29.

10. *Eye of Jefferson* 1976, 14–15, no. 17.

11. See Sawitzky 1942, 29–30.

12. Dunlap 1834, 1:101.

References

1834 Dunlap: 1:101.
1942 Sawitzky: 9, 29–30, 57–58, pl. 3.
1955 Rutledge: 175.
1983 Razzetti: 3 repro.

1942.13.2 (697)

William Henry Cavendish Bentinck, 3rd Duke of Portland

c. 1774
Oil on canvas, 76.3 × 63.2 (30 1/16 × 25 1/16)
Gift of Clarence Van Dyke Tiers

Technical Notes: The painting is on a medium-weight, plain-weave fabric. The white ground is applied in a smooth layer, with an opaque gray layer in the area of the face. In general the paint is applied in smooth, highly opaque layers. The paint is quite thick in the highlighted areas of the face and hand, while thin red-brown glazes are found in the shadows. Highlights and details of the lace of the shirt and cuff are done in a thick paste paint with low impasto. A thin, opaque paste, dragged across the surface in fine striations, depicts the powdered wig and the fallen powder on the sitter's shoulder. Brown and red glazes are used for the background architecture, the drape, and the brocade fabric on the chair. The brown paint, possibly containing bitumen, that was used on the background column has contracted, leaving small islands.

The paint layer has minimal abrasion. Some retouching is found over the two tears in the lower right quadrant, along the top and left edges, and over small losses throughout and over long, linear cracks in the background. In 1943 the varnish was removed and the painting was lined. The present varnish appears to be slightly toned.

Provenance: Same as 1944.17.1.

Exhibited: *Seventeenth Annual Exhibition of the Pennsylvania Academy of the Fine Arts*, Philadelphia, 1828, no. 98.[1] *Loan Exhibition of Historical Portraits*, PAFA, 1887–1888.[2] Chattanooga 1952, unnumbered. Mint Museum Art, Charlotte, North Carolina, 1952, no cat. Georgia Museum of Art, University of Georgia, Athens, on long-term loan, 1972–1974.

WILLIAM HENRY CAVENDISH BENTINCK (1738–1809) succeeded his father as Duke of Portland in 1762. He was made a member of the Privy Council when the Marquis of Rockingham formed his first cabinet in 1765.[3] The portrait has been considered Pratt's work throughout its documented history. It was exhibited at The Pennsylvania Academy of the Fine Arts in 1828 as by Pratt and was cited in 1834 by William Dunlap as one of the artist's paintings "praised by competent judges."[4]

The date and circumstances surrounding the portrait are unknown. Henry Tuckerman, writing in 1867, thought that Pratt painted it when he was in England from 1764 to 1768. The composition, however, is virtually identical to the 1774 portrait of the duke by Benjamin West, as it appears in the artist's full-length double portrait of Portland with his brother Lord Edward Bentinck (private collection).[5] It is therefore probably derived from John Raphael Smith's mezzotint engraving of that portrait, published in London that year (Figure 1).[6] There is no evidence that Pratt made any trips to England after 1770.[7]

In Pratt's copy the duke's clothing was changed from peer's robes to a blue-gray coat and waistcoat,

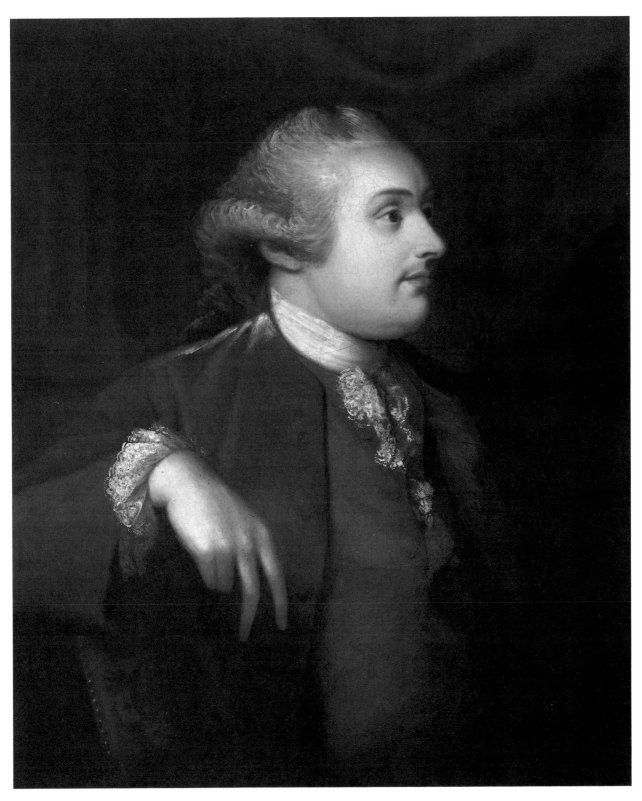

Matthew Pratt, *William Henry Cavendish Bentinck, 3rd Duke of Portland*, 1942.13.2

Fig. 1. John Raphael Smith after Benjamin West, *William Henry Cavendish Bentinck, Duke of Portland, and Lord Edward Bentinck*, mezzotint, 1774, London, National Portrait Gallery [photo: National Portrait Gallery, London]

and his right arm and body were repositioned slightly. In the eighteenth-century English practice of portraiture, reduced copies often show such modifications. The chair and curtain are red, the column brown. The modeling of light and shadow of the head closely imitates the mezzotint. While the portrait's technique is not unlike that of Pratt, espe-

cially in the use of a dry brush in the white highlights, the use of glazes in the background and red for the shadows of the hand and face are not typical. Also the modeling of the flesh lacks the subtlety seen in Pratt's *Self-Portrait* (NPG), painted in London in the 1760s. Pratt's flesh colors after his return to America have been characterized as "more delicate and muted than West's," and the effect much softer.[8] Perhaps the hardness seen here can be attributed to the copying process, especially when it was done from a print.

Pratt's motivation in making the copy would probably have been curiosity about West's recent work rather than the desire to own a portrait of the duke. The artist advertised such copies for exhibition and sale in Williamsburg, Virginia, in 1773: "A few Copies of some of Mr. West's best Portraits, to be seen with the above every Day from ten o'Clock till five" (*Virginia Gazette*, 4 March 1773).

EGM

Notes

1. Rutledge 1955, 175.
2. Although the portrait is not listed in the catalogue, a label from the exhibition is attached to the stretcher. It identifies the lender as R.V. Tiers Jackson.
3. Portland later served as Lord-Lieutenant of Ireland (1782–1783), Prime Minister (1783, 1807–1809), and Home Secretary (1794–1801); *DNB* 4:302–304.
4. Dunlap 1834, 1:101.
5. Von Erffa and Staley 1986, 544–545, no. 683, repro.
6. Smith 1883, 3:1297, no. 138; O'Donoghue 1906, 3:500. The mezzotint was published on 24 November 1774.
7. The only record of a reduced replica of West's portrait is the one requested in June 1774 by a man named James Moray, who asked the duke for permission for "Mr. West to paint me a quarter length from the picture he has done for you." Nothing further is known of the replica, which may never have been painted; see Von Erffa and Staley 1986, 545.
8. Evans 1980, 30.

References

1834 Dunlap: 1:101, repro. in 1969 reprint, 1:pl. 24.
1867 Tuckerman: 48.
1931 Bolton and Binsse, "Pratt": 50, as "Portland, Duchess. Mentioned by Dunlap."
1942 Sawitzky: 10–11, 59–60, pl. 9.
1955 Rutledge: 175.

Edward Savage

1761 – 1817

A SELF-TAUGHT PAINTER and engraver, Edward Savage became proprietor of a paintings gallery and natural history museum in New York and Boston. Although his artistic abilities improved, his talent never equaled his ambition. Born in Princeton, Massachusetts, Savage began his painting career in the mid-1780s by making commissioned copies of portraits by John Singleton Copley, as well as a full-length of Abraham Whipple (United States Naval Academy, Annapolis, Maryland). He painted portraits of George and Martha Washington in New York in 1789–1790 (see *The Washington Family* [1940.1.2]) and then traveled to London in 1791, where he published prints of his portraits of George Washington and Henry Knox and came into contact with Benjamin West. He returned to Massachusetts in 1794, continued to paint portraits, and exhibited his work in Boston at his "Columbian Exhibition of Pictures and Prints."[1] He married Sarah Seaver of Boston in November.

In 1795 Savage moved to Philadelphia, where from July he exhibited his panorama of London. The following February he opened the Columbian Gallery, "a large collection of ancient and modern Paintings and Prints."[2] In addition to working successfully as a painter and engraver in Philadelphia until 1801, Savage exhibited his panorama in New York City (1797) and Charleston, South Carolina (1798). Although his painting and engraving techniques had improved in England, he relied considerably on the assistance of his apprentice John Wesley Jarvis (1780–1840) and English engraver David Edwin (1776–1841). Later they and others claimed that their talents added significantly to the quality of Savage's work in these years.

Savage settled in New York in 1801, where he reopened the Columbian Gallery. He is listed in New York city directories through 1810 as a "historical painter and museum proprietor." On view in the gallery were his paintings of *The Washington Family*, *Liberty*, *Columbus's First Landing in the New World* ("the size of life"), and his copy of West's *Cupid Stung by a Bee*, among other works. Engravings of "The Washington Family, Liberty, Columbus, Etna, Vesuvius, a large whole length

of Washington . . . and many other Prints published by E. Savage" were offered for sale.[3] In 1802, after he acquired the collection of "Natural History and Curiosities" of the American Museum, which had been founded by the Tammany Society in 1791, he opened the newly combined institution under the name Columbian Gallery of Painting and City Museum. The natural history exhibits were "arranged, agreeably to the ideas of Sir Hans Sloane, and with the addition of a number of paintings, and other interesting articles, will form a complete source of amusement for every class, particularly the amateurs of Arts and Sciences."[4] Over the next two years he added a number of exhibits, including a large painting of the mastodon skeleton that Charles Willson Peale unearthed in 1801. He and Peale also exchanged natural history specimens. Savage continued to work on his own scenes of American historical events, including an eight by eleven foot painting of the signing of the Declaration of Independence. Charles Bird King (1785–1862) and Ethan Allen Greenwood (1779–1856) were among his students in this period.

In the summers of 1806 and 1807 Savage made extended sketching trips throughout New England and the middle Atlantic states. His drawings of waterfalls (Worcester Art Museum, Massachusetts, and the Rush Rhees Library, University of Rochester, New York) may have been intended for a planned series of engraved landscape views. By this time his wife and children had moved back to Princeton, Massachusetts. Savage, too, returned to Massachusetts permanently, probably in 1810, the year he also painted portraits briefly in Baltimore.[5] In 1812 he opened the New-York Museum in Boylston Hall, Boston, where it was still located when he died at his farm in Princeton five years later.

EGM

Notes

1. *Massachusetts Mercury* (Boston), 27 May 1794, courtesy of Peter Benes, Concord, Massachusetts.
2. *Gazette of the United States* (Philadelphia), 20 February 1796, quoted in Prime 1929, 2:33.
3. *Mercantile Advertiser* (New York), 19 November 1801,

2, and 20 April 1802, 2; the advertisement also appeared on 14 and 16 November 1801 and 18, 22, 24 April 1802.

4. *Daily Advertiser*, 10 June 1802.

5. *American, and Commercial Daily Advertiser*, 19 March 1810.

Bibliography
Dunlap 1834: 1:321, 2:75–76.
Blake 1915: 1:294–297, 2:260–261.
Dickson 1949: 35–57.
Dresser 1952: 155–212.
Gottesman 1954: 18.
Gottesman 1959: 288–305.
Gottesman 1965: 25–26, 29–37.
Miller 1983: 2:113–114, 744, 913, 932, 934.

1940.1.2 (488)

The Washington Family

1789–1796
Oil on canvas, 213.6 × 284.2 (84 3/4 × 111 7/8)
Andrew W. Mellon Collection

Technical Notes: The support is a coarse, heavyweight, twill-weave fabric with only a few fragments of the original tacking margins. It is lined to an aluminum honeycomb panel with a fabric interleaf. The smoothly applied white ground is moderately thick but allows the fabric texture to be seen. The paint is applied wet-in-wet, ranging from fluid pastes to thinner scumbles and some glazing. Pentimenti reveal that the curtain once extended further across the background, the floor tiles were aligned differently, and the lower edge of the map was repositioned. Slight changes are also apparent in Washington's uniform.

The paint has darkened in many areas, including Washington's right hand, the boy's left hand, and parts of the sky. There are generalized paint losses, especially in the upper left quadrant, which includes the curtain and pillar. The entire paint surface has been abraded, most noticeably in the dark passages and in the face of the black servant, the trees, and Mrs. Washington's skirt.[1] Extensive flaking and blistering along the bottom edge suggest water or fire damage. Extensive traction crackle is present in every color area. A vertical crackle pattern may be the result of rolling the painting. There is a vertical tear in the lower left. The varnish was removed and the painting relined in 1984.[2]

Provenance: The artist;[3] purchased from his estate, 14 November 1820, by Ethan Allen Greenwood [1779–1856], Boston;[4] sold 1839 to Moses Kimball [1809–1895], Boston, with the contents of the New England Museum and Gallery of Fine Arts;[5] sold December 1891 to (Samuel P. Avery, Jr., New York);[6] sold 1892 to William Frederick Havemeyer [1850–1913], New York.[7] National Democratic Club, New York;[8] sold 15 December 1922 to (Art House, Inc., New York);[9] Thomas B. Clarke

[1848–1931], New York; his estate; sold as part of the Clarke collection on 29 January 1936, through (M. Knoedler & Co., New York), to The A.W. Mellon Educational and Charitable Trust, Pittsburgh.

Exhibited: Columbian Gallery, Philadelphia, 1796.[10] Columbian Gallery, at the Pantheon, Greenwich Street, New York, 1801–1802, no. 48.[11] Probably exhibited at the Columbian Gallery, New York, until 1810.[12] New-York Museum, Boston, 1812–1817.[13] New-England Museum and Gallery of Fine Arts, 1818–1840.[14] Boston Museum and Gallery of Fine Arts, 1841–1891.[15] *Exhibition of the Important Oil Painting [of] Washington and His Family By Edwin Savage, of Princeton, Mass. Born 1761. Died 1817.* Avery Galleries, New York, 1892. Union League Club, February 1924, no. 1. MMA, on loan, 1924–1925.[16] Philadelphia 1928, unnumbered. *Virginia Historical Portraiture*, Virginia House, Richmond, 1929.[17] *George Washington Bicentennial Historical Loan Exhibition of Portraits of George Washington and his Associates*, CGA, 1932, no. 17. *Life in America*, MMA, 1939, no. 39. NGA 1950, unnumbered.

EDWARD SAVAGE'S PAINTING *The Washington Family* depicts George and Martha Washington, her grandchildren Eleanor Parke Custis and George Washington Parke Custis (adopted by the Washingtons after the death of their father John Parke Custis), and an unidentified black servant. Savage worked on this ambitious group portrait and several related images during the seven-year period from 1789 to 1796. He began the large painting before going to London in 1791, continued to work on it in England, and completed it after he returned to the United States in 1794. He exhibited the finished portrait for the first time in Philadelphia in 1796. Two years later he published an engraving. The picture was always intended for public view. In this unique interpretation of Washington in his combined civic, military, and familial roles, a contemporary artist made an important attempt to capture and idealize the likeness of the first president.

Savage apparently conceived the idea of the painting when he went to New York City, the first capital of the United States, in the winter of 1789–1790 to paint a portrait of Washington as a gift for Harvard College (Figure 1). Joseph Willard, the president of Harvard, arranged for the sittings when he wrote to Washington on 7 November 1789.

When you were in the Philosophy Chamber of the University in this place, you may perhaps remember that I expressed my wishes, that your Portrait might, some time or other, adorn that Room. Since that, Mr. Savage, the Bearer of this, who is a Painter and is going to New York, has called on me, and of his own accord, has politely and

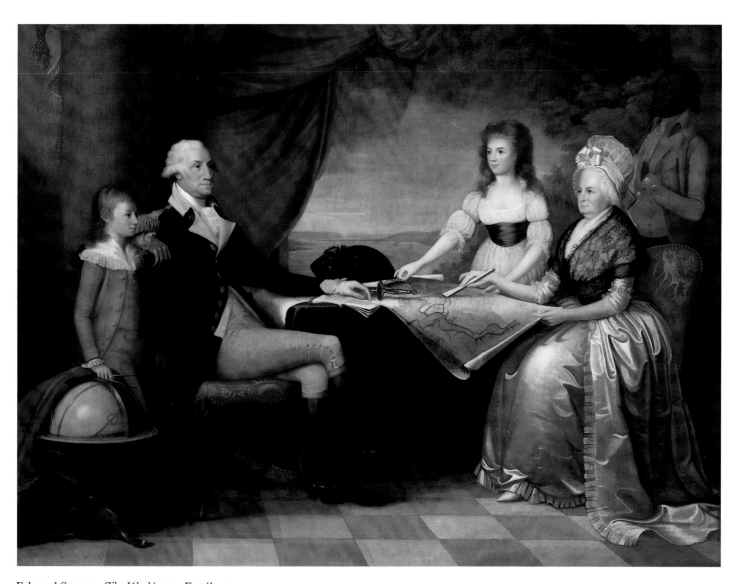

Edward Savage, *The Washington Family*, 1940.1.2

Fig. 1. Edward Savage, *George Washington*, oil on canvas, 1789–1790, Cambridge, Massachusetts, The Harvard University Portrait Collection, Harvard University Art Museums, Gift of Edward Savage to Harvard College, 1791

Fig. 2. Edward Savage, *Martha Washington*, oil on canvas, 1790, Quincy, Massachusetts, Adams National Historic Site [photo: David Bohl]

generously offered to take your Portrait for the University, if you will be so kind as to sit.[18]

Washington sat for the portrait on 21 and 28 December 1789 and 6 January 1790, and again on 6 April 1790 so that Savage could paint a replica for John Adams (Adams National Historic Site, Quincy, Massachusetts).[19] For Adams, Savage also painted a portrait of Martha Washington (Figure 2).[20]

The Harvard commission led to several ambitious projects that involved Washington's image, including this group portrait. The only comments that Savage made about the painting appear in a letter he wrote to Washington almost a decade later, on 3 June 1798. Discussing the engraving he had made of the painting, he explained,

The Likenesses of the young people are not much like what they are at present. The Copper plate was begun and half finished from the Likenesses which I painted in New York in the year 1789. I Could not make the alter-

ations in the Copper to make it like the Painting which I finished in Philadelphia in the year 1796. The portrait of your Self and Mrs. Washingtons are generally thought to be likenesses.[21]

Before painting the large portrait, Savage painted a small oil (private collection).[22] Not surprisingly for a painting completed over a number of years, a comparison of the study with the final painting shows some differences, although the overall composition remained very much the same. Both show Washington seated on the left, with young Custis standing beside him. Washington rests his right arm on the boy's shoulder, while his left hand is on the table at the center of the painting. Martha Washington sits opposite the president, with Nelly Custis standing to her right. Together they hold a large unrolled map of the city of Washington. The setting of the portrait includes a view of the Potomac River framed by columns and a red curtain. In the study there are only four figures; the servant

who stands on the right side of the finished painting is missing.

The images of the president and his wife in the study are very similar to those in the individual portraits that Savage had painted in 1789–1790. Washington has the same elongated oval head as seen in the Harvard portrait, with powdered hair combed smoothly upward and backward in a single tight curl above the ears. His nose is long and slightly bulbous at the end; his chin is fleshy. Only his uniform is changed: the coat is partly buttoned. Martha Washington also appears similar to her single portrait, although her hair has been reduced slightly from the halolike round shape, and she looks toward Washington rather than at the viewer. In addition, the portrait of George Washington Parke Custis in the study closely corresponds to an engraving of Custis by Savage, which is inscribed "E. Savage Pinxt. 1790" (Figure 3).[23] No additional images of Eleanor Parke Custis by Savage are known.

Savage began the large painting by duplicating the portraits in the study. Recent examination of the painting with infrared reflectography reveals that under the present forms are images that agree

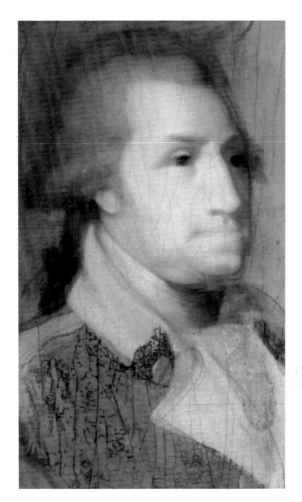

Fig. 4. Infrared reflectogram of the head of George Washington [1.5–2.0 microns (μm)]

Fig. 3. Edward Savage, *George Washington Parke Custis*, engraving, 1790, Worcester, Massachusetts, Worcester Art Museum

with those in the study and with the portraits Savage made in 1789–1790. The outline of the earlier image of Washington can be detected outside and above the lines that delineate his portrait on the surface (Figure 4). That earlier image exactly duplicates the taller outline and oval shape of Washington's head as seen in the Harvard portrait. The earlier image of Custis, positioned to the left of the final image and turned toward the viewer (Figure 5), agrees with the engraving of 1790. By contrast, his final image is more of a profile. (This similarity suggests that the engraving of 1790 may be based on the earlier image in the group portrait.) The earlier, less-visible image of Eleanor (Figure 6), to the right of her present image, shows that she was originally shorter and stood nearer her grandmother, as in the study. Other indications that the large painting was once very similar to the study appear through x-radiography, which reveals that the

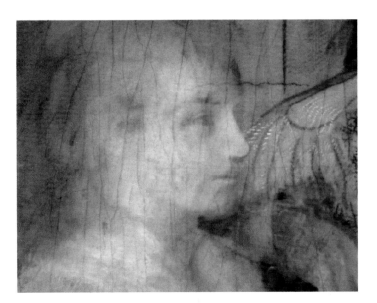

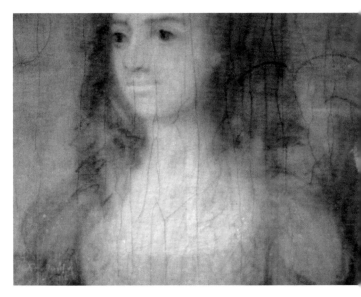

Fig. 5. Infrared reflectogram of the head of
George Washington Parke Custis [1.5–2.0 microns (μm)]

Fig. 6. Infrared reflectogram of the head of
Eleanor Parke Custis [1.5–2.0 microns (μm)]

drapery in the finished painting once extended across the background, as in the study. Pentimenti of the swags can also be seen on the surface of the present composition.

The group portrait is a very ambitious painting, both in subject and in scale. For a model for the group Savage might have turned to an earlier, colonial group portrait that was still on view in Boston. John Smibert's *Bermuda Group* (YUAG), the most famous group portrait in Boston at the time, was painted in 1729–1731 to commemorate Bishop George Berkeley's plans to establish a missionary college in North America. It was still on exhibition in Smibert's Boston studio in the 1790s, many years after the artist's death. Although the figures in Smibert's *Bermuda Group* are not full-lengths like those in Savage's painting, its comparable commemorative subject matter and size (176.5 by 236 cm [69½ by 93 inches]) makes it a very likely influence on the aspiring young Edward Savage. Other similarities include its colors—muted reds, browns, greens, and blues—the setting with columns, and the distant landscape.

In 1791 Savage made a trip to London, where he apparently intended to engrave some of his paintings; his first work there was the publication on 7 December 1791 of an engraving of his own portrait of Henry Knox.[24] Soon afterwards, on 7 February 1792, he published a stipple engraving of the Harvard portrait of Washington (Figure 7), which ex-

Fig. 7. Edward Savage, *George Washington*, stipple engraving, 1792, Washington, The National Portrait Gallery, Smithsonian Institution

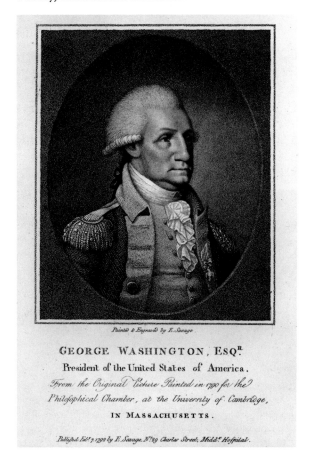

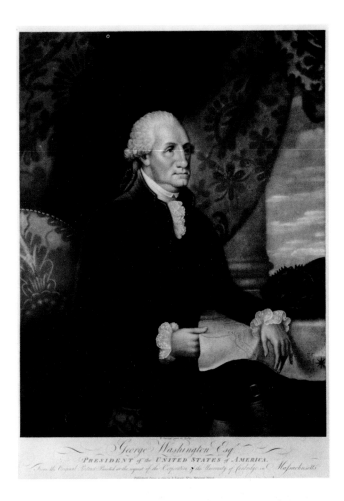

actly duplicates that painting.[25] Over a year later, on 25 June 1793, still in London, he published another engraving of Washington, this time in mezzotint, a medium he had not tried previously (Figure 8).[26] Although the inscription on the engraving says that it is "from the Original Portrait painted at the request of the Corporation of the University of Cambridge in Massachusetts," it is not the same composition, and the portrait itself has been changed. Instead it is identical to an oil painting on wood panel of Washington that Savage signed and dated 1793 (Figure 9).[27] The new image bears some striking similarities to the group portrait. The composition shows Washington seated in a brocade-upholstered chair at a table, his left arm resting on a plan of the city of Washington on which the words "EASTERN BRANCH" mark one boundary of the city, the river now called the Anacostia.[28] His hat is on the table, and behind him are a column and a large curtain. It is his image that has undergone the greatest change. He wears a black suit instead of a uniform, his hair is now softer and curlier, and the top of his head is less oval. Savage sent an example of this print and one of Benjamin Franklin to Washington on 6 October 1793. His comments suggest that Washington might have known the painting.

I have taken the Liberty to send two prints, the one Done from the Portrait I first Sketched in black Velvet, Labours under Some Disadvantages, as the Likeness never was quite finished. I hope it will meet with the Approbation of yourself and Mrs. Washington, as it is the first I Ever published in that method of Engraving.... I have the pleasure to inform you that Both of these prints are approved of by the artists, particularly Mr. West.[29]

Savage apparently also had taken the group portrait to London, perhaps planning to complete it and publish an engraving. There, he altered Washington's appearance, probably at the time that he produced the two engravings of the president. Also he added the figure of the black servant. According to Charles Cotesworth Pinckney, writing a century

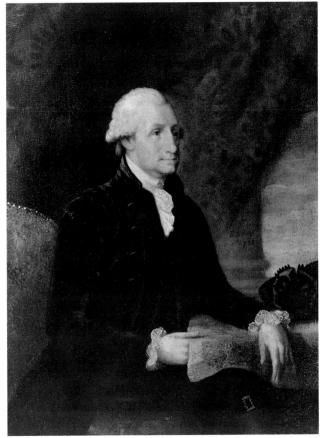

later in 1895, the model for the figure was John Riley, a freeman who was the personal valet of Thomas Pinckney, the American ambassador to the Court of St. James, London, from 1792 to 1796. Pinckney wrote that "as the painter [Savage] who was then engaged on the Washington family picture had no black model at hand, he borrowed John Riley from the American ambassador to pose as one of Washington's servants, and thus contribute the requisite local coloring to the home of a Virginia planter."[30] This identification confirms that Savage worked on the painting in London, since Thomas Pinckney did not return to South Carolina until September 1796, and thus was not in Philadelphia during the time that Savage completed the painting there.

The identity of the figure of the black servant is not given in the caption of Savage's engraving of 1798, which names only four people: "The Washington Family. George Washington his Lady and her two Grandchildren by the name of Custis." He was identified many years later as William Lee, a slave at Mount Vernon. There is no portrait of Lee that might confirm this identification.[31] Lee, a favorite of Washington's, had served with him during the Revolution, but by 1790 he was badly crippled. Washington, in his will written 9 July 1790, gave Lee

immediate freedom; or if he should prefer it (on account of the accidents which have befallen him, and which have rendered him incapable of walking or of any active employment) to remain in the situation he now is, it shall be optional in him to do so. In either case however, I shall allow him an annuity of thirty dollars during his natural life, which shall be independent of the victuals & cloaths he has been accustomed to receive; if he chuses the last alternative; but in full with his freedom, if he prefers the first; — & this I give him as a testimony of my sense of his attachment to me, and for his faithful services during the Revolutionary War.[32]

Charles Willson Peale visited with Lee at Mount Vernon in 1804, describing him as Washington's "faithfull attendant through the war." He found him "making shoes, he was now a cripple & in an extraordinary manner — both of his knee pans was moved from their places — was some Inches higher up — These accidents happened to him by falls at different Periods . . . by sliping on stones & being a heavy man the fall was severe."[33] The identity of the figure of the servant is complicated by the recent discovery, through examination with infrared reflectography, of a second, shorter figure underneath the tall one. The shorter, younger black man,

Fig. 10. Infrared reflectogram of the figure of the servant [1.5–2.0 microns (μm)]

who also faces left, can be clearly seen (Figure 10). The position of his head is visible because of his curly hair. The lower position of his coat collar is revealed with infrared reflectography as well as by the pentimenti visible on the painting's surface. The uniform collar of the taller man was added when the figure was changed and covers the lower half of his head. It seems possible that perhaps the figure underneath is Riley, and the second one, on top, is meant to be Lee, which may not be a life portrait. (Lee was apparently living at Mount Vernon during the 1790s.)

After Savage returned to the United States in 1794, he continued to work on the large version of the family group. He needed to alter the figures of the two children, who had grown considerably since 1789. To do this he went to Philadelphia, the new capital of the United States.[34] This is undoubtedly when he changed the earlier full-faced image of George Washington Parke Custis to a profile, and modified Eleanor's shorter figure to that of a taller, more mature young woman. (Because Nelly was not in Philadelphia with her grandparents in the fall of 1795, Savage must have painted her that spring or

summer.)[35] The final painting shows George Custis in a rose-colored suit, Washington in his uniform from the Revolutionary army, Eleanor in a white dress with a blue sash, Martha in a gray silk dress with a black kerchief, and the servant on the right in a grey coat with dark breeches and a red vest. On the table is a map of Washington that appears to be the official engraving of Pierre L'Enfant's plan for the new capital, published by James Thackara and John Vallance, Philadelphia engravers, in 1792.[36]

Edward Savage placed the finished painting on view in his Columbian Gallery in Philadelphia on 22 February 1796, Washington's birthday. It has been on public view for most of its two-hundred year existence.[37] Although the Columbian Gallery included paintings and prints by other artists, it featured the portrait of "the President and Family, the full size of life." Savage completed the engraving in 1798 and published it that March (Figure 11). A small oil, the same size as the original study, may have been used to prepare the engraving (Figure 12). Like the earlier study, it has the same dimensions as the copperplate.[38] Savage planned to distribute the engraving widely, listing Robert Wilkinson, London, as co-publisher. As was the practice in the London print trade, Savage repeated the English caption in French. The *Pennsylvania Gazette* carried an announcement of the engraving's forthcoming publication on 3 March 1798 and printed a second notice on 21 March.[39] The (New York) *Time-Piece* also announced its publication, on 16 May: "Washington Family. This print, executed by E. Savage, of Philadelphia, is now ready for delivery to subscribers at No. 66 Nassau Street."[40] The engraving was also advertised in the (Boston) *Columbian Centinel* on 8 August 1798.

THE FINE ARTS. A number of plates of the elegant picture of the *Washington* Family, are expected to arrive from *Philadelphia* in all *September*, one of which is now in town. The execution is wholly American; and MR. SAVAGE, the Painter and Engraver, is intitled to the gratitude and patronage of his fellow-citizens for his talents, patriotism and assiduity. This plate is worthy to adorn the parlours of every house in the U. States. — It represents our late beloved PRESIDENT, his amiable Lady, and her two Grand-children, seated in the piazza of the General's residence at *Mount Vernon*, which has a 30-miles view of the river Powtomac. The likenesses are correct, and impressive — the drapery exact — and the engraving throughout masterly.[41]

After George Washington ordered four framed copies, Savage wrote him on 3 June to explain the appearance of the figures. He also told Washington,

living in retirement at Mount Vernon, about the popularity of the print.

Agreeable to Col. Biddle's order I Delivered four of the best impressions of your Family Print. They are Chose out of the first that was printed. Perhaps you may think that [they] are two Dark, but they will Change lighter after hanging two or three months. The frames are good Sound work. I have Varnished all the Gilded parts which will Stand the weather and bare washing with a wet Cloth without injury. The Likenesses of the young people are not much like what they are at present. The Copper plate was begun and half finished from the Likenesses which I painted in New York in the year 1789. I Could not make the alterations in the Copper to make it like the Painting which I finished in Philadelphia in the year 1796. The portrait of your Self and Mrs. Washingtons are generally thought to be likenesses; as soon as I got one of the prints Ready to be seen I advertised in two of the papers that a Subscription would be open for about twenty Days. Within that time there was three hundred and thirty one Subscribers to the print and about one hundred who had subscribed previously, all of them the most respectable people in the city. In consequence of its Success and being generally approved of I have continued the Subscription. There is every probability at present of its producing me at least ten thousand Dollars in one twelve month. As soon as I have one printed in Colours I shall take the Liberty to sent it to Mrs. Washington for her acceptance. I think she will like it better than a plain print.[42]

Savage later presented Mrs. Washington with an example printed in color.[43]

Perhaps because the print was so successful, Savage's ability as a printmaker became a subject of debate among nineteenth-century American artists. It was suggested that Savage was able to finish the engraving only after he hired English engraver David Edwin, who had arrived in Philadelphia in December 1797. William Dunlap commented in 1834 that Savage had relied heavily on Edwin as well as on painter John Wesley Jarvis, who was Savage's apprentice at the time. "He published the 'Washington Family,' engraved by Edwin, who made it tolerable, and perhaps Jarvis helped. Jarvis has said, 'I assisted in engraving it — I printed it, and carried it about for sale.'"[44] Philadelphia engraver John Sartain agreed, saying, according to Mantle Fielding, that "Savage drew the outlines on the copper, but Edwin did a large part of the engraving."[45] Dunlap also recorded that Savage brought an unnamed engraver from London before he hired Edwin, and that the engraver worked on the plate for *The Washington Family*.[46] Savage, in his eagerness to sell the prints, was also made to look foolish in another of Jarvis' tales. During the yellow

fever epidemic of 1798, Savage insisted on taking *The Washington Family* to Burlington, New Jersey, so that he could continue to prepare frames for the engravings. They made the trip from Philadelphia by boat, and Edwin recounted to Sartain that Savage "refused to allow the canvas to be taken off from is [*sic*] stretcher. In consequence it required some nice engineering to keep the upright canvas edgewise to the eye of the wind."[47]

Savage moved his museum and the painting to New York, where he placed it in his Columbian Gallery at the Pantheon. He described it in the published catalogue of the gallery in terms that stressed Washington's military leadership, his presidency, and plans for the capital city, to which the federal government moved in 1800.

The General is seated by a table, drest in his uniform, which represents his military Character; his left arm rests on papers which are suitable to represent his Presidentship; Mrs. Washington sets at the other end of the table, holding the Plan of the Federal City, pointing with her fan to the grand avenue; Miss Custis stands by her side assisting in showing the Plan; George Washington Custis stands by the Gen.—his right hand resting on a Globe: the back ground is composed of two large Columns with Architect; a large curtain partly drawn up, under which appears a view of thirty miles down the Potowmac River, from Mount Vernon.[48]

One of a series of reviews of the paintings at the museum, in the November 1802 *New York Morning Chronicle*, repeated Savage's description and added some observations.

In the General appears the serene commanding aspect of a venerable man, whose presence alone calms the tempest, and calls to our remembrance the beautiful picture drawn by Virgil. — "Tum pietate gravem ac meritis si forte virum quem conspexere – silent – et arectis auribus adstant." We cannot sufficiently admire the drapery of Mrs. Washington; it is inexpressibly graceful—the small folds arise by the gentle gradation of an imperceptible curve from the grand and bold parts of the drapery, and are again dissolved in *these* parts with a noble liberty. In the whole reigns harmony, correctness, and beauty.[49]

When Savage moved his museum to Boston at the end of the decade, the painting was placed on public view there.

The popularity of the painting in the nineteenth century is indicated by the number of existing copies, including those by unidentified artists at The Pennsylvania Academy of the Fine Arts and the Chicago Historical Society, and one that Henry Inman painted in 1844 for James Cathcart Johnston of Edenton, North Carolina, as a gift for Mrs.

Henry Clay (Ashland, Lexington, Kentucky).[50] Rembrandt Peale in 1858 commented on the popularity of the painting in his lecture on portraits of Washington. Like other comments about Savage, this one mixes truth with exaggeration.

Mr. *Savage*, an Engraver, with the view of getting up a popular Furniture Print, painted his Picture of the *Washington Family*, and published a large *Mezzotint* of it, which is known all over the United States — no engraving ever having had a more extensive sale. *Savage* had but little reputation as a Painter, as this engraving may testify. For the head of Washington, it was said, he had one [crossed out] 2 sittings from the life.[51]

The painting was also reproduced in newly issued prints, including a mezzotint by John Sartain and several lithographs by Currier and Ives. These lithographs often changed the composition to fit the sentiments of the time. *Washington at Home* (1867), for example, shows the family in an interior, with a print of Mount Vernon on the wall behind them.[52] Despite these later interpretations, the painting itself is a marriage of formal baroque group portraits of a commemorative nature with the more informal style of family groups that was becoming popular in America in the late eighteenth century. Its scale and subject place it in the category of a history painting, rather than a genre scene. Savage's ambition and the painting's role in his development from provincial painter to museum proprietor contribute to its importance; it clearly is his masterpiece.

EGM

Notes

1. In 1892 the painting was given "a good scrubbing with soap and water and solvent," according to "An Old Portrait of the Washington Family," *New York Sun*, 31 December 1892 (clipping in *Savage's Painting of Washington and Family*, an album of letters and clippings compiled around 1893; NGA library). For a description of the album see *Kindred Spirits* 1992, 40–42, no. 285. The condition of the painting is mentioned in a letter dated 28 January 1936 from C.H. Messmore, vice president, M. Knoedler & Co., New York, to Andrew W. Mellon, at the time that the Clarke collection, which included this painting, was purchased by the Mellon Trust. "There are three or four pictures which require attention namely the Washington Family by Savage which should be relined. This has been done some time previous to 1892 but the restorer who did the work made a clumsy job of it and for posterity it should be entirely done over." National Gallery of Art Archives, Record Group 12, Records of The A.W. Mellon Educational and Charitable Trust.

2. During this treatment several reconstructions were removed because they were not original to the painting, notably an elaborate base on the pillar at the left and many folds in Mrs. Washington's skirt.

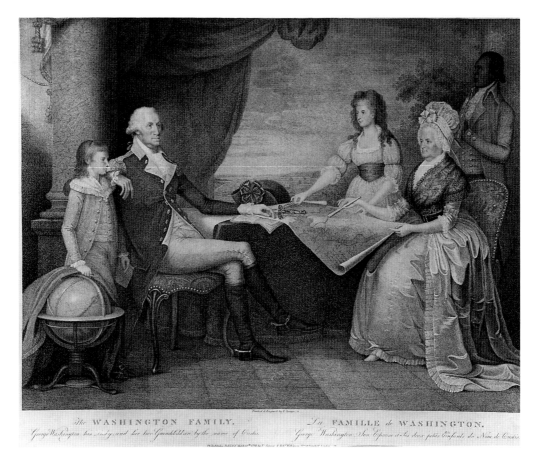

Fig. 11. Edward Savage and David Edwin, *The Washington Family*, stipple engraving, 1798, Washington, The National Portrait Gallery, Smithsonian Institution

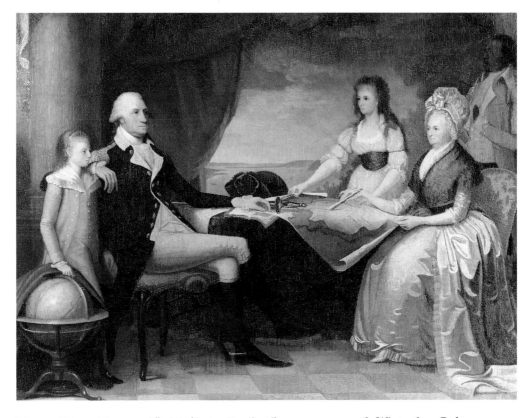

Fig. 12. Edward Savage, *The Washington Family*, oil on canvas, c. 1798, Winterthur, Delaware, The Henry Francis du Pont Winterthur Museum [photo: Courtesy, Winterthur Museum]

3. Ethan Allen Greenwood, John R. Penniman, and William M.S. Doyle, "Inventory of the estate of Edward Savage, late of Princeton in the County of Worcester deceased, lying and being in Boston in the County of Suffolk," 12 September 1817, no. 51 (with his paintings of Christopher Columbus and Liberty). This inventory of the contents of Savage's museum in Boston is filed with the inventory of his property in Princeton and his administrator's accounts at the Worcester County Probate Court, Worcester, Massachusetts (photocopy, NGA, courtesy of Georgia Barnhill, Andrew W. Mellon Curator of Graphic Arts, AAS), series A, case 52130; see Dresser 1952, 157–158, n. 5, and Barnhill 1993, 97.

4. Bill of sale signed by Savage's son Edward Savage, Jr. (1795–1858), Boston, administrator of his father's estate; Ethan Allen Greenwood Papers, AAS (photocopy, NGA, courtesy of Georgia Barnhill). The price of $1,000 was for "One Marble Statue of the Venus de Medicis and the large Painting of the Washington Family." On Greenwood see Barnhill 1993, 91–178.

5. Watkins 1917, 127–128; according to Ryan 1915, 1–2, Moses Kimball (1809–1895) bought a large part of the collection of the New England museum when he was "about thirty" and opened the new Boston Museum and Gallery of Fine Arts in 1841. A draft of a document written by Greenwood in 1839, which would have transferred ownership of the museum to Robert Gould Shaw and the Reverend Edward T. Taylor, is in the Ethan Allen Greenwood Papers, AAS, quoted in Barnhill 1993, 101. This transfer did not take place.

6. Letter from Moses Kimball to Samuel P. Avery, Jr., 28 December 1891, confirming the sale, in *Savage's Painting of Washington and Family* (album, NGA library). Kimball said that the painting, which he owned for more than fifty years, came to him "in the collection of the New England Museum that I purchased." Also in the album is a letter of 23 November 1892 from Charles H. Savage, the artist's grandson, to Avery, giving the history of the painting.

7. "An Old Portrait of the Washington Family," *New York Sun*, 31 December 1892 (in *Savage's Painting of Washington and Family*, album, NGA library) recounted the painting's history. "From this dismal seclusion [in the Boston Museum] the old painting was recovered by Mr. Samuel P. Avery, Jr., about a year ago, and after a good scrubbing with soap and water and solvent it was brought to this city. Mr. William F. Havemeyer has recently bought it to add to his extensive Museum of Washingtoniana." Havemeyer owned the painting by 3 January 1893, when collector Thomas B. Clarke wrote to Charles Henry Hart asking whether it would be an appropriate loan for the exhibition of retrospective art they were planning for the World's Columbian Exposition; they were on the advisory committee (New York Public Library, Papers of the Columbian Exposition, AAA); ultimately the painting was not included in the 1893 exhibition. Havemeyer's dates are in *Who Was Who* 1:535.

8. Hart 1905, 10.

9. The name of the seller and the date of purchase are recorded in an annotated copy of *Clarke* 1928 in the NGA library. The receipt for payment by Art House, Inc., dated 15 December 1922, is signed on behalf of the National Democratic Club by F. Newlin Price (NGA).

10. *Gazette of the United States* (Philadelphia), 20 February 1796, quoted in Prime 1929, 2:33.

11. *Mercantile Advertiser* (New York), 19 November 1801, 2, quoted in Gottesman 1965, 25, no. 57. The same notice also appeared on 14 and 16 November and on 18, 20, 22, and 24 April 1802. A copy of the printed catalogue of the gallery, titled *Columbian Gallery. At the Pantheon, No. 80, Greenwich-Street, near the Battery* (New York, 1802), is at the New-York Historical Society, bound with *Catalogue of the Pictures, &c. in the Shakspeare* [sic] *Gallery. No. 11, Park, New York: 1802*. A modern typed copy, cited by Yarnall and Gerdts 1986, 3121, no. 79367, is at The Ryerson Library, The Art Institute of Chicago. Gottesman 1959, 288–305, discusses a review of the exhibition by "An Admirer of the Polite Arts," which appeared in the (New York) *Morning Chronicle* on 18 November 1802.

12. Savage is listed in New York city directories from 1802 to 1810. From 1801 to 1804 he was at the Pantheon, 80 Greenwich Street, as a "historical painter"; in 1805–1806 he was listed at 166 Greenwich Street as a "historical painter," and from 1807 to 1819 he was listed as a "historical painter & museum proprietor."

13. Watkins 1917, 124, comments that Edward Savage opened the New York Museum in Boylston Hall, over Boylston Market, in 1812. The artist's grandson Charles H. Savage referred to the museum as the New York Museum in his letter to Samuel P. Avery, Jr., 23 November 1892; the letter, quoted in Avery Galleries 1892, 9, is in *Savage's Painting of Washington and Family* (album, NGA library). The New York Museum is listed in the *Boston Directory* for 1813 and 1816, "over Boylston Market." An inventory of the contents was made at Savage's death; see n. 3 above, Greenwood, Penniman, and Doyle, "Inventory," 1817.

14. "Guide and Abstract of the New-England Museum at No. 76 Court Street, Boston," Ethan Allen Greenwood Papers, c. 1822, 1, AAS; see also Yarnall and Gerdts 1986, 3123, no. 79407. The proprietors of the "New England Museum and Gallery of Fine Arts" purchased the entire contents of Savage's museum, except for the Washington Family and a marble statue of the "Venus De Medicis," from Savage's son on 17 April 1818; bill of sale, Ethan Allen Greenwood Papers, AAS. Although Greenwood did not purchase *The Washington Family* until 1820, he moved the painting with the rest of the contents of the New York Museum to a new location in New-England Hall, 76 Court Street. He "renailed and stretched" the painting on 14 May (1818) and, according to Ethan Allen Greenwood's "New England Museum," an undated manuscript in the Ethan Allen Greenwood Papers, AAS, the museum opened on 4 July 1818. The New-England Museum was first listed in the *Boston Directory* in 1826, at 76 Court Street. The collection was broken up in 1840 after it was sold; see Watkins 1917, 127–128, and Barnhill 1993, 96, 135–138, 154.

15. Catalogues of the museum published in 1841, 1842, 1844, and 1847 indicate that the painting was on view (see References); Avery 1892, 4, said that it hung over the main entrance in the Boston Museum on Tremont Street "for over fifty years," and Johnston 1882, 46, more specifically wrote that it hung over the entrance to the theater.

16. *BMMA* 1924, 252; Halsey and Tower 1925, frontispiece (pl. I).

17. Weddell 1930, frontispiece (color), 16–17 (repro. of exhibition installation).

18. George Washington Papers, Manuscript Division, LC; photocopy, NGA, courtesy of Dorothy Twohig, editor of The Papers of George Washington, University of Virginia, Charlottesville.

19. Jackson and Twohig 1979, 5:509, 511; 6:2, 57; Dresser 1959, 191–196, nos. 20–21, repro.

20. Dresser 1959, 197, no. 22, repro.

21. George Washington Papers, Manuscript Division, LC; photocopy, NGA, courtesy of Dorothy Twohig.

22. Dresser 1952, 199–202, no. 24, 47 by 61 cm (18 ½ by 24 inches), repro. According to the Frick Art Reference Library, the painting was owned for a number of years by Clarence Dillon, Far Hills, New Jersey, who purchased it at the sale of the Herbert Lawton Collection at the American Art Association, Anderson Galleries, New York, 3 April 1937, no. 346.

23. Dresser 1952, 201, no. 24a, repro.

24. Dresser 1952, 177–179, no. 12, repro. (painting).

25. Wick 1982, 40, 104–105, no. 31, repro.

26. Wick 1982, 40, 106–107, no. 33, repro. The mezzotint is signed "E. Savage pinx. et sculp."

27. Morgan and Fielding 1931, 181, no. 4; Dresser 1952, 197–199, no. 23, repro.; Naeve 1976, 13–15.

28. On this mezzotint and plans of the city see Reps 1991, 20–39. Reps does not identify the plan, except that it is "one of the engraved plans used to advertise the city's existence." The first of these to be published was by Boston engraver Samuel Hill in 1792; see Reps 1991, 34–37.

29. George Washington Papers, LC; photocopy, NGA, courtesy of Dorothy Twohig; partially quoted by Hart 1905, 8; Dresser 1952, 198; and Naeve 1976, 15.

30. Pinckney 1895, 232; see also Honour 1989, 47 and 311 n. 70.

31. John Sartain to Samuel P. Avery, 12 May 1892; in Savage's Painting of Washington and Family (album, NGA library). This identification is repeated in Kaplan 1973, 33. A portrait by Charles Willson Peale at the Historical Society of Pennsylvania, Philadelphia, once identified as of William Lee is now identified as of Mamout Yarrow; see Sellers 1952, 254, no. 1007, fig. 330; Honour 1989, 323 n. 303.

32. Prussing 1927, 45.

33. Miller 1983, 2:696.

34. Some authors, including Eisen 1932, 2:462, wrote that Washington sat again for Savage at this time. This appears to be a misunderstanding of Rembrandt Peale's comment that "for the head of Washington, it was said, he had one [crossed out] 2 sittings from the life" (Peale 1858, 15), a reference to the sittings for the Harvard portrait.

35. Nelly Custis' letters to Elizabeth Bordley in the fall and winter of 1795 indicate that she was with her mother in Virginia rather than with her grandparents; see especially her letters of 13 and 19 October 1795 in Brady 1991, 19–23. For a later portrait of her by Gilbert Stuart see 1974.108.1.

36. The plan is discussed and reproduced in Reps 1991, 38–39.

37. Dickson 1973, 4, says that it was apparently "the first such work to be executed for commercial exhibition in America" and that Savage painted it after he "had lately seen that done with notable success in London." This influence is less certain now that infrared examination shows that Savage began the painting before going to London.

38. Richardson 1986, 76–77, no. 40 (color repro.); the painting, which measures 45 by 61 cm (18 by 24 inches), was owned previously by descendants of the artist.

39. Hart 1905, 11; Wick 1982, 124.

40. Quoted in "Odd History of a Famous Painting," Mail and Express (New York), 31 December 1892; newspaper clipping in Savage's Painting of Washington and Family (album, NGA library).

41. Columbian Centinel, 8 August 1798, 3.

42. George Washington Papers, LC; photocopy, NGA, courtesy of Dorothy Twohig. The letter was quoted by Hart 1905, 9–10; Dresser 1952, 204; and Wick 1982, 122–123. Clement Biddle had told Washington about the engraving on 11 March 1798, and Washington asked Biddle to buy four good examples for him (letter of 19 March 1798; Fitzpatrick 1941, 36). The invoice dated 14 May 1798 for $73 is endorsed "Rec'd payment Edward Savage" (in Savage's Painting of Washington and Family, album, NGA library).

43. Savage's letter to Washington, 17 June 1799, sending the print (Hart 1905, 10–11) and Washington's letter of thanks, 30 June 1799 (Fitzpatrick 1941, 37) are in the George Washington Papers, LC; photocopy, NGA, courtesy of Dorothy Twohig.

44. Dunlap 1834, 321; on Jarvis' apprenticeship and Savage's reliance on Edwin see also Hart 1905, 13–15, and Dickson 1949, 39–52.

45. Fielding 1924, 199.

46. Dickson 1949, 46 n. 34, from William Dunlap's Diary 3, 706.

47. John Sartain to Samuel P. Avery, 12 May 1892, in Savage's Painting of Washington and Family (album, NGA library); see also Fielding 1924, 199.

48. Columbian Gallery 1802, 3–4 (see n. 11).

49. Morning Chronicle, 18 November 1802, 3; see Gottesman 1959, 300.

50. Gerdts 1987, 52, fig. 7. Ethan Allen Greenwood noted an embroidered copy made in Boston in 1816; see Barnhill 1993, 127.

51. Peale 1858, 15. Peale added and crossed out a final phrase: "but I doubt it, as it is a gross Caricature."

52. Currier & Ives 1984, 2:726, no. 7050; for other versions see 727, nos. 7063–7067.

References

1796 Gazette of the United States. Philadelphia. 20 February.

1801 Mercantile Advertiser. New York. 19 November: 2.

1802 Columbian Gallery. At the Pantheon, No. 80, Greenwich-Street, near the Battery. New York: 3–4, no. 48.

1802 Mercantile Advertiser. New York. 20 April: 2.

1802 Commercial Advertiser. New York. 14 June: 4.

1802 An Admirer of the Polite Arts. "Review of Exhibition of Paintings." Morning Chronicle. New York. 18 November: 3.

1834 Dunlap: 1:321.

1841 Boston Museum: 3, no. 6.

1842 *Boston Museum*: 3, no. 6.
1844 *Boston Museum*: 3, no. 6.
1847 *Boston Museum*: 14, no. 184.
1858 Peale: 15.
1882 Johnston: 46–47, engraving repro. opp. 46.
1892 Avery Galleries.
c. 1893 *Savage's Painting of Washington and Family*. Album of letters and newspaper clippings. NGA library.
1897 Hart, "Washington": 299.
1905 Hart: 8–11.
1924 Fielding: 197–200, engraving repro. opp. 193.
1931 Morgan and Fielding: 178–179, 183–186, no. 8, repro.
1932 Eisen: 2:457–458, 461–465, pls. 99 and 153 (detail).
1949 Dickson: 38, 45–50, 54.
1952 Dresser: 199–204, no. 25, repro.
1959 Gottesman: 300, 301 (repro.), 304–305, no. 48.
1973 Kaplan: 33.
1973 Dickson: 4, 7–8, fig. 3.
1981 Williams: 54–55 color repro., 67, 72.
1982 Wick: 43, 122–124.
1984 Walker: 383, no. 539, color repro.
1988 Wilmerding: frontispiece, 9.
1989 Honour: 46–48, repro. fig. 13; 311.
1993 Barnhill: 91–178.

Fig. 1. Infrared reflectogram composite of 1960.3.1 [1.2–2.0 microns (μm)]

1960.3.1 (1552)

George Washington

c. 1796
Oil on canvas, 76.1 × 63.3 (30 × 24 ⅞)
Gift of Henry Prather Fletcher

Technical Notes: The moderately heavy twill-weave support has pronounced cusping along the top edge. The white ground fills the fabric but does not disguise the weave. Infrared reflectography reveals brush-applied black underdrawing that delineates the face and wig, including the contours of the hair, ear, features, chin, and the upper edge of the collar. The drawing has the character of a freehand copy of an existing model.

The oil paint is thin and is applied flatly and smoothly in contained areas. The definition of the features was completed in the paint layer, although the underdrawing is used as part of the shadow below the chin. The colors of the face adjoin or overlap but do not blend, while the brushwork in the coat and background is applied wet-in-wet, and the colors are blended liberally. The basic folds of the collar and cravat were sketched in, with daubs of white and black added on top.

The weave enhancement may be the result of a past lining. The rather thin paint layer is slightly abraded in the flesh tones. Small, contained in-painting is in the thinned areas, and a few minor areas of shading in the coat are reinforced. The overall varnish is thick and glossy.

Provenance: Sophia Dwight Foster Burnside [Mrs. Samuel MacGregor Burnside, b. 1787], Worcester, Massachusetts; her daughter Harriet Pamela Foster Burnside [1827–1903], Worcester, Massachusetts; bequeathed to Roger Sherman Baldwin Foster [1857–1924], New York;[1] his widow Laura Pugh Moxley Foster Fitch;[2] (Fridenberg Galleries, New York, 1929);[3] (Russell W. Thorpe, Flushing, New York);[4] acquired 1929 by Francis Patrick Garvan [1875–1937], New York;[5] his estate; (M. Knoedler & Co., New York); sold 24 January 1947 to Henry Prather Fletcher [1873–1959], Newport, Rhode Island.[6]

Exhibited: *Loan Exhibition of Eighteenth and Early Nineteenth Century Furniture and Glass ... Portraits by Stuart, Peale and Others. For the benefit of the National Council of Girl Scouts, Inc.*, American Art Galleries, New York, 1929, no. 839. *An Exhibition in Honor of the Bicentenary of the Birth of George Washington*, The Grolier Club, New York, 1931–1932, no cat.[7] Washington Bicentennial Exhibition, YUAG, 1932, no cat.[8] Homewood, The Johns Hopkins University, Baltimore, on long-term loan, 1932–1946.[9] *Loan Exhibition of Portraits of George Washington*, Scott & Fowles, Inc., New York, 1947, unnumbered.[10] *Celebration of the 40th Anniversary of NATO*, NATO Headquarters, Brussels, Belgium, 1989, no cat.

SAVAGE'S BUST PORTRAIT shows Washington wearing a black coat and waistcoat and a white shirt

Edward Savage, *George Washington*, 1960.3.1

with a lace-edged ruffle; his hair is powdered. Except for touches in the eyebrows and hair, the surface is very even. The portrait is carefully painted and has all the hallmarks of a copy from another two-dimensional image. The face is virtually the same as that in Savage's portrait of Washington in *The Washington Family* [1940.1.2]. Infrared reflectography (Figure 1) reveals underdrawing in black paint for the face and head that is similar to the underdrawing in the family portrait. The painting is difficult to date but appears roughly contemporary with *The Washington Family*. This may be one of the two portraits of Washington that he exhibited at his Columbian Gallery in New York in 1802.[11] The painting's provenance in a prominent family in Worcester County, Massachusetts, suggests that it might have come from the artist's estate.[12] A similar portrait of Washington is owned by the Yale University Art Gallery, and another, known as the Stedman bust, was on the art market in New York in 1987.[13]

EGM

Notes

1. The early provenance is in Morgan and Fielding 1931, 182, no. 6. According to Knoedler, "SOPHIA R.F. BURNSIDE" is written on the reverse of the original canvas; see letter and provenance sheet from Elizabeth Clare, M. Knoedler & Co., 17 March 1960 (NGA). Harriet Burnside left most of her estate to the children of her cousin Dwight Foster, among them Roger Foster; will, dated 10 July 1899 (copy, NGA). On the Fosters see Pierce 1899, 222.

2. Fitch provided the provenance in a letter to Harry MacNeill Bland of Fridenberg Galleries, 10 April 1929 (typed copy, NGA, provided by Elizabeth Clare, M. Knoedler & Co., 17 March 1960).

3. Information provided by the Frick Art Reference Library, based on a letter from Harry MacNeill Bland, Fridenberg Galleries, New York, 24 March 1930.

4. Information from the Frick Art Reference Library, based on a letter from Russell W. Thorpe, 13 February 1942.

5. For his dates see *Who Was Who* 1:442; Mrs. Garvan lent the painting to the American Art Galleries exhibition in September 1929.

6. Letters from Elizabeth Clare, M. Knoedler & Co., 22 March 1960 and 1 April 1960 (NGA). Fletcher is listed in *Who Was Who* 3:288.

7. The loan was confirmed by Nancy Houghton, staff assistant, The Grolier Club; letter, 15 March 1993 (NGA).

8. The loan was confirmed by Josephine Setze, YUAG; letter, 29 March 1960 (NGA).

9. This loan was confirmed by F. Stewart Macaulay, The Johns Hopkins University, Baltimore; letter, 23 March 1960 (NGA).

10. "Reviews" 1947, 43 repro.

11. Yarnall and Gerdts 1986, 3121 no. 79375, "Last Original Portrait Ever Painted of George Washington" (no. 119) and 3122 no. 79389, "A Portrait of George Washington" (no. 143). Unfortunately the reviewer of the exhibition for the *Morning Chronicle* only reviewed the first ninety-nine pictures and did not provide a description of either portrait; see *The Washington Family* [1940.1.2].

12. Sophia Burnside, the earliest recorded owner, was the daughter of Dwight Foster (1757–1823), congressman and senator from Massachusetts and chief justice of the court of common pleas of Worcester county from 1801 to 1811; see his entry in *NCAB* 2:6–7.

13. Morgan and Fielding 1931, 182, discuss the painting now at Yale (no. 5), which was purchased around 1897 from Eleanor Parke Custis Lewis' grandson H.L.D. Lewis by Luther Kountze of Morristown, New Jersey. The Stedman bust is discussed in Eisen 1932, 2:461; see also "Savage Sold" 1941, 30 repro., and the Berry-Hill advertisement in *Antiques* 131, no. 2 (February 1987), 320–321 repro.

References

1931 Morgan and Fielding: 182, no. 6, repro. opp.
1932 Eisen: 2:461–462, pl. 98.

Gilbert Stuart

1755 – 1828

GILBERT STUART, the pre-eminent portraitist of Federal America, combined a talent for recording likeness with an ability to capture a sitter's personality or character through his choice of pose, color and style of clothing, and setting. He introduced to America the loose, brushy style used by many of the leading artists of late eighteenth-century London. Lawyers, politicans, diplomats—all had their likenesses recorded by Stuart. His sitters included many prominent Americans, among

them the first five presidents, their advisors, families, and admirers. He is known especially for his portraits of George Washington.

Born in North Kingstown, Rhode Island, Stuart was baptized with his name spelled "Stewart." His father, an immigrant Scot, built and operated a snuff mill, which contributed to the artist's lifelong addiction to snuff. He grew up in the trading city of Newport, where itinerant Scottish portraitist Cosmo Alexander (1724–1772) gave him his earliest training in painting. In 1771 Stuart accompanied Alexander to Scotland, but he returned home after Alexander died the following year. Three years later, on the eve of the American Revolution, he went to London, where he worked for five years (1777–1782) as an assistant to Benjamin West. Stuart began exhibiting work at the Royal Academy of Arts in 1777, at first using the name Gilbert Charles Stuart. The success of *The Skater* [1950.18.1] in 1782 enabled him to establish his own business as a portrait painter. In 1786 he married Charlotte Coates, and the following year they went to Dublin, where Stuart painted portraits for over five years.

Stuart returned to the United States in 1793, planning to paint a portrait of George Washington that would establish his reputation in America. After about a year in New York City, he moved to Philadelphia, then the capital of the United States, expressly to paint the president. Washington sat for Stuart in the winter or early spring of 1795 (see *Stuart's Portraits of George Washington* below). Martha Washington commissioned a second portrait, and Mrs. William Bingham a third. Stuart's success led immediately to many commissions, including those for replicas of his second portrait of Washington, now known as the "Athenaeum" portrait. Politically prominent and wealthy sitters sought his skills. In December 1803 Stuart moved again, this time to Washington, the new national capital, where he painted portraits of the Madisons, Thomas Jefferson, the Thorntons, and others from Jefferson's administration. In the summer of 1805 Stuart settled permanently in Boston, where for the next two decades he continued to paint the politically and socially prominent.

Never adept at painting large compositions, Stuart produced primarily waist-length portraits. He painted over a thousand portraits during his long career, excluding his many copies of the images of George Washington. Younger American artists, including Thomas Sully, Rembrandt Peale, and John Vanderlyn, sought his advice and imitated his work. Among his students were his children Charles Gilbert (1787–1813) and Jane (1812–1888). In 1816 another pupil, Kentucky painter Matthew Harris Jouett (1787–1827), jotted down "Notes Taken by M. H. Jouett while in Boston from Conversations on painting with Gilbert Stuart Esqr,"[1] which today constitute one of the most lively and enlightening descriptions of an early American portrait painter at work.

As a young artist Stuart employed a tightly controlled technique imitative of Cosmo Alexander and other painters working in New England. When he studied in England he imitated Benjamin West's technique and gradually adopted the looser style of Joshua Reynolds and George Romney. Thus his technique changed from one that is characterized by an evenly painted surface to one that relied on energetic brush strokes, impasto touches of highlighting, thin shadows, and subtle variations of color for its representation of the warmth of flesh and the softness of fabric. Even after his return to America, Stuart preferred English twill canvases, and from 1800 used wood panels that were scored with parallel grooves to imitate twill's rough surface. Both the twill canvases and the grooved panels enabled him to apply paint so that it left an uneven mark. One indication of his lasting popularity is the number of copies that other artists made of his portraits. In addition, his sitters, fascinated by his personality and talent, recorded lengthy descriptions of their sittings, leaving an unusually rich written record about an American portraitist.

Stuart's Portraits of George Washington

According to Irish painter John Dowling Herbert, Stuart's ambition when he left Dublin in 1793 was to paint the first president of the United States: "I expect to make a fortune by Washington."[2] Stuart went to Philadelphia in the late autumn of 1794 with a letter of introduction to Washington from Chief Justice John Jay.[3] The sitting or sittings took place that winter or, according to the artist's daughter Jane Stuart, "towards the Spring of

1795."[4] On 20 April 1795 Stuart compiled "A list of gentlemen who are to have copies of the Portrait of the President of the United States," which provides the names of thirty-two people who commissioned replicas.[5]

Stuart's success led immediately to two additional commissions for portraits of Washington. The first was from Martha Washington, and the portrait became known during Stuart's lifetime as the "Mount Vernon Portrait." It is now known as the "Athenaeum" portrait because it was acquired by the Boston Athenaeum after Stuart's death (1796, jointly owned by NPG and MFA).[6] The second commission was for a life-size full-length, a gift from Mrs. William Bingham to the Marquis of Lansdowne. This portrait is referred to today as the "Lansdowne" portrait (1796, The Earl of Rosebery, on loan to NPG).[7]

Stuart, however, never gave Mrs. Washington the original portrait of her husband, as promised. Preferring it to the one he had painted in 1795, he abandoned the earlier type after making about a dozen replicas, including the "Vaughan" portrait [1942.8.27] and the "Vaughan-Sinclair" portrait [1940.1.6]. The artist explained the fate of the first painting in 1823, when he wrote that the Lansdowne full-length was "the only original painting I ever made of Washington except one I own myself [the Athenaeum portrait]. I painted a third, but rubbed it out."[8] He made numerous replicas of the "Athenaeum" portrait throughout his life. Two are in the Gallery's collection: one painted when Stuart was in Washington in 1803–1805 [1954.9.2], and one painted in Boston in 1821, as part of the series of five presidential portraits that Stuart painted for George Gibbs [1979.5.1].[9] Stuart also used this portrait as a model for larger three-quarter and full-length paintings of Washington.

EGM

Notes

1. Morgan, *Stuart*, 1939, 80–93.
2. Herbert 1836, quoted in Whitley 1932, 85.
3. Quoted in Mount 1964, 184. For recent discussions of Stuart's portraits of Washington, with illustrations, see Richardson 1967, 25–30, and McLanathan 1986, 78–96.
4. Stuart 1876, 369.
5. Stuart 1876, 373; Morgan and Fielding 1931, 227.
6. Prime 1929, 2:34, quotes Stuart's advertisement announcing plans for an engraving of the "Mount Vernon Portrait" in the *Aurora* on 12 June 1800.

7. The terms Athenaeum and Lansdowne were used by Mason in 1879, 87–91, and by Hart 1879, 220–221.
8. Scottish Record Office, Edinburgh; see Eisen 1932, 1:59, pl. V, and Morgan and Fielding 1931, 358–359.
9. See Morgan and Fielding 1931, 223–224, 228–247, 273–311, for the most complete presentation of the documentation on the Athenaeum portrait and the differences in the various replicas.

Bibliography
Stuart 1876: 367–374.
Park 1926.
Morgan and Fielding 1931: 211–361.
Eisen 1932: vol. 1.
Whitley 1932.
Morgan, *Stuart*, 1939.
Mount 1964.
Stuart 1967.
DeLorme 1979: 339–360.
Evans 1980: 52–59.
McLanathan 1986.
Crean 1990.
Evans 1993: 123–137.

1950.18.1 (1051)

The Skater (Portrait of William Grant)

1782
Oil on canvas, 244.5 × 147.4 (96 1/4 × 58)
Andrew W. Mellon Collection

Technical Notes: The support is a finely woven twill fabric. The top and bottom tacking edges have been unfolded and add about 6 cm to the painting's height. The lateral tacking margins have been cropped, but cusping remains along these edges. The thin white ground extends to cover the tacking margins, suggesting that the canvas was pre-primed. Much of the preliminary drawing, done loosely with paint and brush, is visible on the surface, having been incorporated into the painting. The paint is thinly applied, except in the sitter's upper body, face, and collar, and in the sky around his head, where the paint is thicker and its handling more controlled. Many pentimenti are evident, including changes in the figure's hat, shoulders, tail of the coat on the viewer's right, and the sitter's right leg.

Abrasion is found in the ice at the sitter's feet. Crackle is more pronounced near the head, where the paint is thicker, and is especially pronounced to the right of the skater's thigh. There are pinpoint losses throughout. The painting was lined prior to 1950.

Provenance: William Grant [d. 1821], Congalton, Scotland, and Cheltenham, England; his son William Grant [d. 1827], Congalton, Scotland, and London; his daughter Elizabeth Grant [Mrs. Charles Pelham-Clinton, d. 1899];[1] her son Charles Stapleton Pelham-Clinton [1857–1911], Moor Park, Stroud, Gloucestershire;[2]

his widow Elizabeth Pelham-Clinton [d. 1946], London and Holmes Green, Buckinghamshire; her niece and adopted daughter Georgiana Elizabeth May Pelham-Clinton [Mrs. John Stuart Bordewich, b. 1913], London.

Exhibited: Royal Academy of Arts, London, 1782, no. 190, as *Portrait of a gentleman skating. Exhibition of Works by the Old Masters, and by Deceased Masters of the British School,* Royal Academy of Arts, London, 1878, no. 128, as *Portrait of W. Grant, Esq., of Congalton, Skating in St. James's Park,* attributed to Thomas Gainsborough.[3] *American Painting from the Eighteenth Century to the Present Day,* Tate Gallery, London, 1946, no. 206. *Style, Truth and the Portrait,* The Cleveland Museum of Art, Ohio, 1963, no. 38. *Gilbert Stuart,* NGA; RISD, 1967, no. 8. *American Art: 1750–1800, Towards Independence,* YUAG; The Victoria and Albert Museum, London, 1976, no. 44. *American Portraiture in the Grand Manner: 1720–1920,* Los Angeles County Museum of Art; NGA, 1981–1982, no. 21.

IN 1782 Gilbert Stuart, a young painter in London, was "suddenly lifted into fame by the exhibition of a single picture,"[4] his full-length of William Grant called *Portrait of a Gentleman Skating.* (The painting was given its present title of *The Skater* in 1946.) Stuart devised the theme after an outing on the Serpentine river in Hyde Park with Grant, a young Scottish lawyer, who had come for a sitting for a full-length portrait. According to American artist William Dunlap, who heard the story from miniaturist Charles Fraser,

Stuart said that he felt great diffidence in undertaking a whole length; but that there must be a beginning, and a day was accordingly appointed for Mr. Grant to sit. On entering the artist's room, he regretted the appointment, on account of the excessive coldness of the weather, and observed to Stuart, that the day was better suited for skating than sitting for one's portrait. To this the painter assented, and they both sallied out to their morning's amusement. Stuart said that early practice had made him very expert in skating. His celerity and activity accordingly attracted crowds on the Serpentine river — which was the scene of their sport. His companion, although a well-made and graceful man, was not as active as himself; and there being a crack in the ice, which made it dangerous to continue their amusement, he told Mr. Grant to hold the skirt of his coat, and follow him off the field. They returned to Mr. Stuart's rooms, where it occurred to him to paint Mr. Grant in the attitude of skating, with the appendage of a winter scene, in the back ground.[5]

The setting for the portrait is the Serpentine, a popular skating spot in London that was created when Kensington Gardens was landscaped during the reign of George II.[6] Grant is dressed completely in black, from his hat and the fur-lined lapels of his coat to his breeches, stockings, and shoes. Behind him to the right two skaters sit at the edge of the ice, putting on their skates, while two other men stand under a tree. In the left background two skaters perform the Salutation, also known as the Serpentine Greeting, while others watch.[7] The painting offers a balance of black, gray, and off-white, with slight touches of red on the clothing of the background figures. Stuart's pupil Matthew Harris Jouett later described the portrait as a "fine contrast of Grant in full black to the snow & grey chilly background."[8] The young lawyer William Grant (d. 1821) was the son of Ludovick Grant of Edinburgh.[9] Why he chose Stuart to paint his portrait is not known; perhaps he was a friend or a distant relative of Stuart's early London patron Alexander Grant, also a Scot.[10] Moderately wealthy, Grant was fond of portraits. George Romney painted him in 1781 and again in 1787, and in 1794 he painted "Mrs. Grant," perhaps Grant's wife Dorothea Dalrymple, whom he married that year. Grant's children were painted by John Opie (LaSalle University Art Museum, Philadelphia).[11] At his death in 1821, Grant left his heirs a large estate called Congalton, in Scotland, as well as stock in the Bank of England and the Royal Bank of Scotland.

The portrait, Stuart's first full-length, showed his ability to invent new compositions within the tradition of English portraiture, in which standing cross-legged poses had been popular for men's portraits since the 1740s. Its success made it possible for Stuart to move from West's studio into one of his own. Comparisons between the two American artists by contemporaries were inevitable. When Giuseppi Baretti, an Italian-born lexicographer, author, and friend of Sir Joshua Reynolds, saw the painting at West's before its exhibition at the Royal Academy of Arts, he commented, according to Dunlap, "What a charming picture! Who but the great West could have painted such a one!" Later, seeing Stuart at work on the painting, he exclaimed, "What, young man, does Mr. West permit you to touch his pictures?" Stuart replied that it was his own painting. Baretti is supposed to have said, "Why, it is almost as good as Mr. West can paint."[12] The close association of the two men's work is revealed by an undated chalk drawing by West titled *Skateing* (Figure 1). West, like Stuart, enjoyed a reputation as a good skater, and in this chalk drawing depicted skaters and spectators on the ice at the Serpentine. A skater in the center foreground turns toward the man behind him, who lies

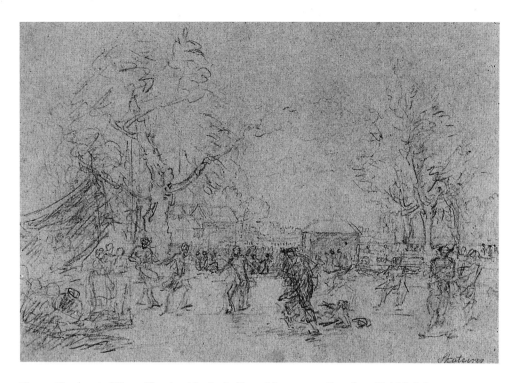

Fig. 1. Benjamin West, *Skateing*, black chalk on blue paper, London, British Museum
[photo: Courtesy, The Trustees of the British Museum]

on the ice after a fall. To the left, two figures who perform the Serpentine Greeting are virtually identical to the two skaters in the background of Stuart's portrait of Grant. To the right is a small figure whose pose seems similar to Grant's; the figure is very sketchy.

A reviewer noted Stuart's relationship to Benjamin West when Stuart exhibited the painting with three others at the Royal Academy of Arts in 1782.

Mr. Stuart is in Partnership with Mr. West; where it is not uncommon for Wits to divert themselves with Applications for Things they do not immediately want; because they are told by Mr. West that Mr. Stuart is the only Portrait Painter in the World; and by Mr. Stuart that no Man has any Pretensions in History Painting but Mr. West. After such Authority what can we say of Mr. Stuart's Painting.[13]

The portrait enchanted visitors who attended the Academy's exhibition. Horace Walpole, author of *Anecdotes of Painting in England* (1762–1771), the first history of British art, wrote "very good" next to the entry for the portrait in his copy of the catalogue.[14] Stuart overheard the Duke of Rutland on opening day, urging Sir Joshua Reynolds, "I wish you would go to the exhibition with me, for there is a

portrait there which you must see, every body is enchanted with it." When Sir Joshua asked who painted it, the Duke replied, "A young man by the name of Stuart."[15] Visitors and reviewers praised the portrait's unusual pose and Stuart's ability with likeness. Sir John Cullum commented on the novelty of the theme in his letter of 1 May 1782 to Frederick Hervey, Bishop of Derry and Earl of Bristol. "One would have thought that almost every attitude of a single Figure had long been exhausted in this land of portrait painting but one is now exhibited which I recollect not before — it is that of Skating. There is a noble portrait large as life thus exhibited and which produces the most powerful effect."[16] A reviewer for the *Morning Chronicle, and London Advertiser* commented on 30 April that "Stuart and Opie, whose merits were not so generally known, have proved themselves able artists" and praised Stuart for his "striking likenesses."[17] Stuart's ability to capture a likeness was borne out by Charles Fraser's later comment to artist William Dunlap that the picture attracted so much comment that Stuart was "afraid to go to the academy to meet the looks and answer the inquiries of the multitude. Mr. Grant went one day to the exhibition, dressed as his portrait represented him; the

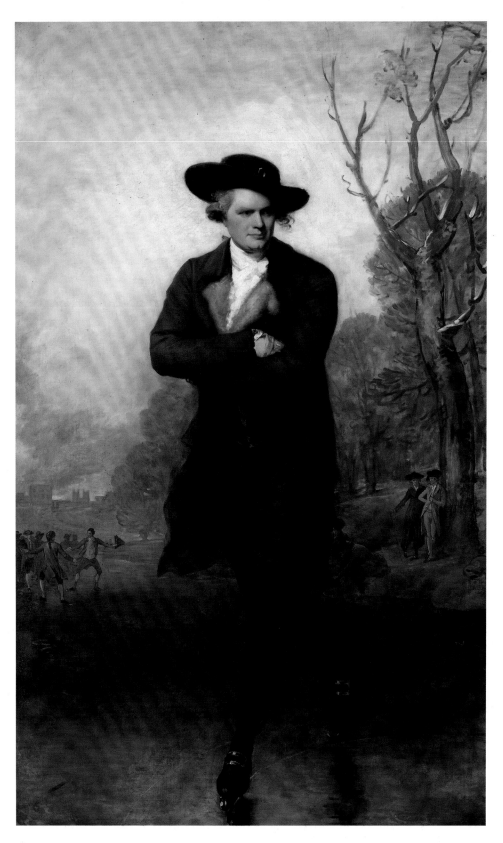

Gilbert Stuart, *The Skater (Portrait of William Grant)*, 1950.18.1

original was immediately recognized, when the crowd followed him so closely that he was compelled to make his retreat, for every one was exclaiming, 'There he is, there is the gentleman.'"[18]

Opinion was divided on the technique of the painting. One reviewer said that "Mr. Stuart seldom fails of a Likeness; but wants Freedom of Pencil, and Elegance of Taste."[19] However, the author of a letter in the *Morning Chronicle, and London Advertiser* noted, "Mr. Stuart . . . may be said to be an acquisition to the public; his Gentleman scating, No. 190, is reposed, animated and well drawn."[20] And a critic in the *London Courant* commented on the portrait as Stuart's first attempt at a full-length. "If we have been informed aright this is the gentleman's first essay in this branch of the art; at all events it does honour to his pencil, from the novelty of the design and the neatness of the execution."[21] A commentator in 1795 wrote about Stuart's early difficulty with a portrait of this size.

It is now some years since Stuart the portrait painter . . . painted a portrait of a Mr. Grant in the action of skating; this portrait was given in so spirited an attitude and with so appropriate a character that when it was exhibited, it established the fame of the artist, of whom his brethren had before that time said he made a tolerable likeness of a face, but as to the figure he could not get below the fifth button.[22]

The combination of the full-length portrait with the act of skating was indeed a novel theme. Stuart appropriately portrayed Grant as a figure skater, the version of the sport popular in England, which emphasized graceful and refined movements, instead of as a Scottish speed skater, which encouraged skill, speed, and competition. Grant wears skates designed for the "small pivots and graceful maneuvers which were essential to the art of figure skating."[23] Robert Jones, in his influential *Treatise on Skating* (London, 1772), recommended a similar crossed-arm pose as "a proper attitude for genteel rolling" (Figure 2).[24] Matthew Harris Jouett in 1816 quoted Stuart on "the importance of keeping the figure in its circle of motion," giving the example of "his famous skaiting picture of Grant as contrasted with Buckminster Preble who turns his body one way his neck another and his eyes another. . . ."[25]

The painting is unlike other images of skaters, which belong to the tradition of sporting scenes. They include Irish painter Robert Healy's *Tom Conolly and his Friends Skating* (1768, private collection, Ireland), Sir Henry Raeburn's *The Reverend Robert Walker Skating on Duddingston Loch* (c. 1784,

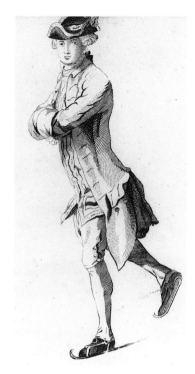

Fig. 2. Illustration of a skater from Robert Jones, *A Treatise on Skating*, 1772 (as reprinted in the 1818 edition) [photo: World Figure Skating Museum]

National Gallery of Scotland, Edinburgh), Thomas Rowlandson's watercolor *Skaters on the Serpentine* of 1784 (National Museum of Wales, Cardiff), and a view by Julius Caesar Ibbetson engraved in 1787 as *Winter Amusement; A View in Hyde Park from the Moated House*.[26] Philippe Jacques de Loutherbourg's *A Winter Morning, with a Party Skating* of 1776 is particularly close to Stuart's and West's images in that it shows skating figures similar to those who perform the Serpentine Greeting. And like de Loutherbourg's scene, Benjamin West's undated drawing *Skateing* focuses its action on the popular Serpentine river. In the background is a structure similar to the Cheesecake House, a refreshment lodge that is also seen in the images by Rowlandson and Ibbetson. De Loutherbourg's scene, which includes portraits of the artist and his wife, the artist's partner V.M. Picot and others, was the best known of the various images of skaters made before or at the time that Stuart painted his portrait of Grant. It was reproduced by Matthew Boulton's picture manufactory in Birmingham, England, between 1776 and 1780 by an unusual reproductive process that replicated paintings with their original coloring. In the mid-

Fig. 3. Gilbert Stuart, *Portrait of the Artist*, oil on canvas, c. 1786, New York, The Metropolitan Museum of Art, Fletcher Fund, 1926

developed in verse many years earlier by the English poet James Thomson in his poem "Winter" in *The Seasons* (1730). "Winter" itself could be the theme, rather than "melancholy." As Jules Prown has pointed out, "The skater evokes an allegorical image of Winter as one of the Four Seasons."[29] Lines from Thomson's "Winter" form the caption for a late eighteenth-century English mezzotint titled "Winter," which shows three warmly dressed figures walking near the Serpentine, where skaters can be seen in the background. "While every work of man is laid at rest," they "swoop on sounding skates a thousand different ways" and the "land is madden'd all to joy" ("Winter," verses 761, 769, 771).[30] The allusion to the mood of the season indicates that Stuart had absorbed the highly sophisticated London practice of borrowing from literary works for the subject matter of portraits.

Stuart was also absorbing lessons on technique. The portrait is a masterpiece of the late eighteenth-century British style of portraiture, which focuses on the figure, particularly the face, by painting the background with less detail. X-radiography (Figure 4) shows that Stuart, when painting Grant's

Fig. 4. X-radiograph detail of 1950.18.1

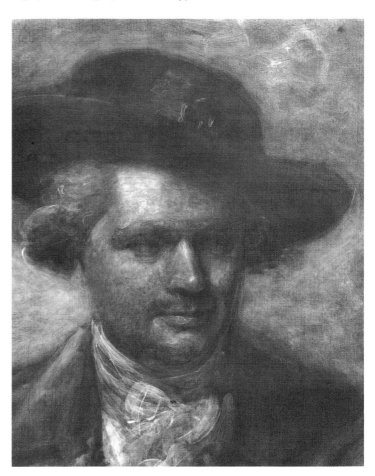

1780s a cloth merchant and amateur painter named Joseph Booth revived the idea of reproducing the painting by using a "polygraph process." Numerous color reproductions of de Loutherbourg's *Winter Morning* survive.[27]

Art historian William Pressly has proposed an interpretation of *The Skater* as expressing the theme of melancholy. To Pressly, the "recently revived tradition of the melancholy hero" explains the somber coloration of the painting, the darkly shaded eyes of the skater, and the use of a crossed-arm pose. In this view the painting becomes a self-portrait of Stuart's own tendency toward melancholy. The snowy setting is appropriate in this theory, since winter was traditionally associated with melancholia.[28] One might even suggest that Stuart included himself as the man on the right who stands under a tree. The physiognomy of this spectator, with his long nose and angular chin, closely resembles Stuart's self-portrait of around 1786 (Figure 3). Whether the association of the mood and the season necessarily points to melancholy as the subject of the painting is uncertain, even though the connection of the two was well known at the time and had been

face, had not yet developed the fully calligraphic brushwork for which he is known in his later paintings. Here he shaped the eyes, nose, mouth, and shadow of the nose by drawing the features with the brush. Later he would not follow the outline of the individual features as closely. Stuart also used more white pigment in the transitional flesh tones than he would in later works. X-radiography suggests, not surprisingly, that Stuart painted the background after completing the figure; the brushstrokes of the clouds mark the outer edges of the hat, face, and shoulders, which were already blocked out and painted. In addition, close examination of the painting reveals changes, or pentimenti, in the hat, shoulders, tail of the coat, and sitter's right leg, indicating that Stuart did indeed struggle with the challenge inherent in a full-length, a size he rarely agreed to use again in his long career.

EGM

Notes

1. The wills of William Grant and his son (Scottish Record Office, Edinburgh) do not mention the portrait. Burke 1956, 1611, lists Mrs. Pelham-Clinton, the first owner of record, as her father's only surviving child at the time of her marriage in 1848. Her husband was the second son of Henry Pelham-Clinton, 4th Duke of Newcastle.

2. According to a file note by William P. Campbell (NGA), a label from the 1878 exhibition at the Royal Academy of Arts is attached to the stretcher and documents this owner and address; see Burke 1956, 1611, for the dates of this and later owners.

3. Royal Academy 1878, unpaginated; Graves 1913, 1:383, 3:1275; Graves 1905, 7:296. For a discussion of the attribution of the portrait in 1878 to Gainsborough, and the Grant family's research to determine Stuart's authorship, see Whitley 1932, 33–36.

4. Quincy 1883, 84, who does not identify the picture.

5. Dunlap 1834, 1:183; Fraser heard the story from Stuart. John Galt had by then published his story about Benjamin West as a skater; see Galt 1820, 2:26–31. Galt told how, when West was a young artist in London in the 1760s, his skating skills had brought him to the attention of the English aristocracy. Allen Staley kindly pointed out the similarity of the two anecdotes.

6. Hayes 1990, 64.

7. Button 1973, 354.

8. Jouett 1816, in Morgan, *Stuart*, 1939, 87; since Jouett never saw the portrait, his description must be a quotation from Stuart.

9. *Faculty of Advocates* 1944, 90, courtesy of Dr. Louise Yeoman, Scottish Record Office, Edinburgh.

10. Alexander Grant is mentioned in Stuart 1877, 642; see also *Stuart* 1967, 14.

11. Ward and Roberts 1904, 2:63–64. The earlier portrait of Grant by Romney was sold by Georgiana Bordewich, former owner of *The Skater*, at Christie's on 22 March 1974 (lot 96) and bought by Leger Galleries; see Leger Galleries 1975, unpaginated, no. 5. Mrs. Bordewich also sold a portrait said to be of Grant by Thomas Hudson (lot 94), 127 by 101.6 cm (50 by 40 inches), and the portrait of his four eldest children, attributed to Opie (lot 95). The portrait of Mrs. Grant remained in Romney's studio and was sold at Romney's sale in 1807.

12. Dunlap 1834, 1:183; Jouett referred to Baretti's "mistaking it for Wests best production" when he recorded Stuart's comments about painting in 1816; see Jouett 1816, in Morgan, *Stuart*, 1939, 87.

13. "Postscript. Account of the Exhibition of Paintings, &c. at the Royal Academy," *St. James's Chronicle, or British Evening Post*, 2–4 May 1782, 4.

14. Whitley 1932, 32.

15. Dunlap 1834, 1:184.

16. Quoted in Whitley 1932, 33, and Pressly 1986, 44, from Childe-Pemberton 1925, 1:284.

17. "Royal Academy, 1782. Fourteenth Exhibition," *Morning Chronicle, and London Advertiser*, 30 April 1782, 3.

18. Dunlap 1834, 1:184.

19. "Postscript. Account of the Exhibition of Paintings, &c. at the Royal Academy," *St. James's Chronicle, or British Evening Post*, 2–4 May 1782, 4.

20. The letter from the correspondent, identified as "Candid," was published in the *Morning Chronicle, and London Advertiser* on 9 May 1782, 2.

21. Quoted in Whitley 1932, 33, from an unidentified issue.

22. Quoted in Whitley 1932, 33, from an unidentified source.

23. Pearson 1987, 59.

24. Pressly 1986, 48; Pearson 1987, 60, 62, fig. 8.

25. Jouett 1816, in Morgan, *Stuart*, 1939, 86.

26. For three of these paintings see Hayes 1990, 64–66, no. 19, color repro.; and Pearson 1987, 57 fig. 2 and 61 fig. 7.

27. *de Loutherbourg* 1973, unpaginated, cat. no. 22. Allen Staley kindly pointed out the significance of this image for Stuart's and West's works.

28. Pressly 1986, 42–51.

29. Prown 1969, 48.

30. Quoted in Button 1973, 355, fig. 4.

References

1782 "Royal Academy, 1782. Fourteenth Exhibition." *Morning Chronicle, and London Advertiser*. 30 April: 3.

1782 "Postscript. Account of the Exhibition of Paintings, &c. at the Royal Academy." *St. James's Chronicle, or British Evening Post*. 2–4 May 1782: 4.

1782 "Candid." Letter to the Editor. *Morning Chronicle, and London Advertiser*. 9 May: 2.

1816 Jouett: 86, 87.

1834 Dunlap: 1:183–184.

1846 Lester: 126.

1877 Stuart: 642.

1878 "The Old Masters at the Royal Academy." *Saturday Review* 45, no. 1159 (12 January): 50.

1878 "The Old Masters at Burlington House. Second Notice." *Illustrated London News* 72, no. 2012 (19 January): 66.

1878 "The Old Masters at Burlington House.

Third Notice." *Illustrated London News* 72, no. 2013 (26 January): 91.

1879	Mason: 187–190.
1880	MFA: 41, no. 268.
1883	Quincy: 84.
1926	Park: 34, 358–359, no. 343, repro.
1928	Whitley: 2:395–396.
1932	Whitley: 15, 31–36.
1961	Oswald: 268–270, repro.
1964	Mount: 69–74.
1969	Prown: 47–48.
1973	Button: 351–362, color cover repro.
1980	Evans: 55, 57–58, repro. 59.
1980	Wilmerding: 50, color repro. 51.
1981	Waterson: 872 repro.
1981	Williams: color repro. 49, 62, repro. 63.
1984	Walker: 376, no. 531, color repro.
1986	Pressly: 42–51, fig.1.
1986	McLanathan: color repro. 36, 37, 45–47.
1987	Pearson: 55–70, fig. 1.
1988	Wilmerding: 58–59, color repro.
1990	Crean: 55–62.

1954.1.10 (1194)

Sir John Dick

1783
Oil on canvas, 91.8 × 71.4 (36 ⅛ × 28 ⅛)
Andrew W. Mellon Collection

Inscriptions
Inscribed in a later hand, upper right: Sir John Dick of Braid, Bar^t / Knight of S^t Anne of Russia. / Born 1719 — Died 1804. / by Gilbert Stuart 1782.

Technical Notes: The support is a medium-weight, plain-weave linen.[1] Cusping is present on all edges. The ground is an opaque, moderately thick white layer, with a horizontal texture indicating its application with a brush. The opaque, fluid colors are blended wet-in-wet in the face and in the lower layers of the coat. Details are worked up in a linear fashion. The pen and paper were added over the completed lower portion of the painting, and the decoration and braid were added over the completed body color of the coat. The white sleeve ruffles lie over portions of the jacket sleeve, while the flesh tones of the hands lie on white ground. A rectangular form under the thumb and part of the quill is visible with both x-radiography and infrared reflectography. The paint is flat and smooth, with the exception of the impasto used for the ruffles and jacket decoration. The inscription at the upper right is not original.

Losses of paint and ground are found primarily at the edges. Considerable abrasion has been retouched. The vest, paper, right hand, and areas in the upper right corner, under the sitter's chin, under the lower lip, under the sitter's right eye, and under his right cheek have been retouched and the shadows of the jacket have been glazed. Moating of the impasto may be the result of a past lining.

Heavy residues of a discolored varnish are found on the jacket and in the canvas weave. The varnish has grayed slightly. The painting was lined in 1948.

Provenance: Painted for Sir Alexander Dick, 3rd Baronet [1703–1785], Prestonfield, Scotland;[2] by descent to his great-grandson Sir Robert Keith Alexander Dick-Cunyngham, 9th Baronet [1836–1897], Prestonfield, Scotland; his son William Stewart Dick-Cunyngham, 10th Baronet [1871–1922], Prestonfield, Scotland; (T.H. Robinson, London, 1921); (M. Knoedler & Co., New York); from whom purchased 14 October 1921 by Thomas B. Clarke [1848–1931], New York;[3] his estate; sold as part of the Clarke collection on 29 January 1936, through (M. Knoedler & Co., New York), to The A.W. Mellon Educational and Charitable Trust, Pittsburgh.

Exhibited: *Scottish National Portraits*, Edinburgh, 1884, no. 456.[4] Union League Club, January 1922, no. 4. Philadelphia 1928, unnumbered. *American Painting*, Art Resources Traveler (Artmobile), Illinois, 1967–1968. *Selected American Paintings from the National Gallery of Art*, University of Tennessee at Chattanooga, 1974. Utah Museum of Fine Arts, University of Utah, Salt Lake City, 1976.

SCOTTISH MERCHANT Sir John Dick (1719–1804) was British Consul at Leghorn, Italy, from 1754 to 1776.[5] He became 6th baronet of Braid, Scotland, in 1768.[6] The *Gazzetta Toscana* for 24 August 1776 quoted architect Robert Adam's description of Sir John as "a clever little man . . . with a glib tongue, quick conception and good understanding, esteemed by all for his hospitality, genteel spirits and sweet behavior."[7] Sir John befriended many English-speaking artists in Italy during his years there, including American painters Benjamin West and Henry Benbridge.[8] After he returned to London, Sir John was auditor and comptroller of the army and lived at Mount Clare, Roehampton, Surrey. According to his obituary in the *Gentleman's Magazine*, "He is said to have died worth upwards of 70,000 pounds."[9]

Sir John Dick, seated at a table, wears a double-breasted blue coat, a white waistcoat, a white shirt with ruffles at the neck and sleeves, and a powdered wig. The blue coat, with its paired gold buttons and gilt-laced buttonholes with tassels, may be an unofficial consular uniform. On the coat he wears the star of the order of St. Anne, in which he was knighted in 1774 by Catherine the Great of Russia. Across his chest is the yellow-edged red ribbon of the same order. He wears the badge of a baronet of Nova Scotia on an orange-red ribbon around his neck.[10] Looking off to the left, he holds a letter and a quill pen; other documents lie on the table.

Gilbert Stuart painted Sir John Dick's portrait

in London in 1783 at the request of Sir John's kinsman, the Scottish physician Sir Alexander Dick (1703–1785), a friend of painter Allan Ramsay and the host of Dr. Samuel Johnson during his tour of the Hebrides with James Boswell.[11] Sir John answered Sir Alexander's request for a portrait on 19 January 1783.

I have only to add that I am vastly flattered at your obliging wishes to honour my Portrate with a Place in your house. Mr. Naesmith when here had not time to do it as he had engaged in Painting a whole Family in the City. If you will be so obliging as to send me the size you wish it to be, I will have it done by one of our Artists here.[12]

After the portrait was sent to Scotland, Sir John wrote on 14 December 1783,

I am glad to hear that the Picture has reached you, you are very good in honouring it with a Place in your Great Room, amongst the rest of the fine Collection you have of the Family Pictures; the Painter's Name is Charles Stuart, an American, was some time at Edinburgh, where he did several Pictures, since that he has studied under Mr. West, and is, I think, one of the best Portrait Painters here.[13]

Fig. 1. X-radiograph of 1954.1.10

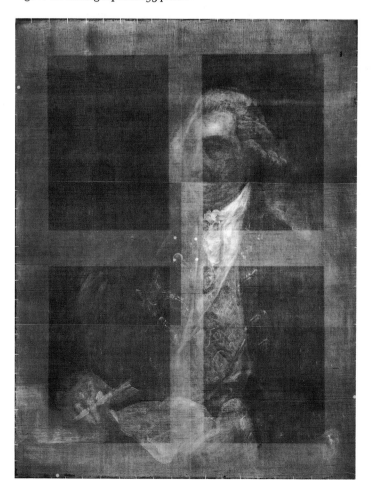

The correspondence makes it clear that the portrait was painted in 1783, not in 1782 as inscribed on the painting.

As is true for his portrait of William Grant, *The Skater*, of 1782 [1950.18.1], the praise for Stuart's work and the emphasis on his Scottish connections are significant indications of the artist's early reputation and source of patronage. In this portrait, one of his earliest after he established his own studio in London, the loose handling of the coat, waistcoat, shirt and shirt ruffle, and the curls of the wig are typical of his early work and are similar to his almost contemporary portrait of Sir Joshua Reynolds [1942.8.21]. X-radiography (Figure 1) reveals that Sir John's face is more smoothly painted than would later be characteristic of Stuart. Other parts of the painting suggest uncertainty and change. The buttons and buttonholes on the coat, and the arm of the chair under his left elbow, are awkwardly placed. The pen and paper were added to an already completed composition, as seen in x-radiographs, and the addition of the pen may explain the uncharacteristic bend in its shaft.

Members of the Sinclair family, descendants of the sitter's cousins, owned a reduced replica or copy of this painting until 1958 (unlocated), which lacked the sitter's right hand, the table, and the documents.[14]

EGM

Notes

1. A stencil on the reverse of the canvas was recorded in 1948, when the tacking edges were trimmed and the picture lined, but the note recording the stencil has been lost.

2. On the baronets of Prestonfield see Smith 1898, 126–136, and Burke 1939, 710–712.

3. M. Knoedler & Co. purchased a joint share in the portrait from T.H. Robinson, London, in June 1921 and sold the painting to Clarke in October, according to Knoedler librarian Melissa De Medeiros (letter, 5 June 1992; NGA). The name of the seller and the date of purchase are recorded in an annotated copy of *Clarke* 1928 in the NGA library.

4. *Scottish Portraits* 1884, unpaginated. The lender was Sir R.K.A. Dick-Cunyngham. A partial label attached to the reverse of the painting confirms this loan.

5. On Dick see a note dated 2 December 1804 in "Dick" 1804, 1175, which states that Dick died "in his 85th year"; Cokayne 1900, 2:449; Morgan, *Stuart*, 1939, 13; and Millar 1967, 28. Johann Zoffany included Dick on the far left of his painting of the Tribuna of the Uffizi, Florence (1772–1777, Collection of Her Majesty Queen Elizabeth II). According to the files of the National Portrait Gallery of Scotland and *Scottish Portraits* 1884, unpaginated, no. 456, Dick was born in 1719; Millar gives

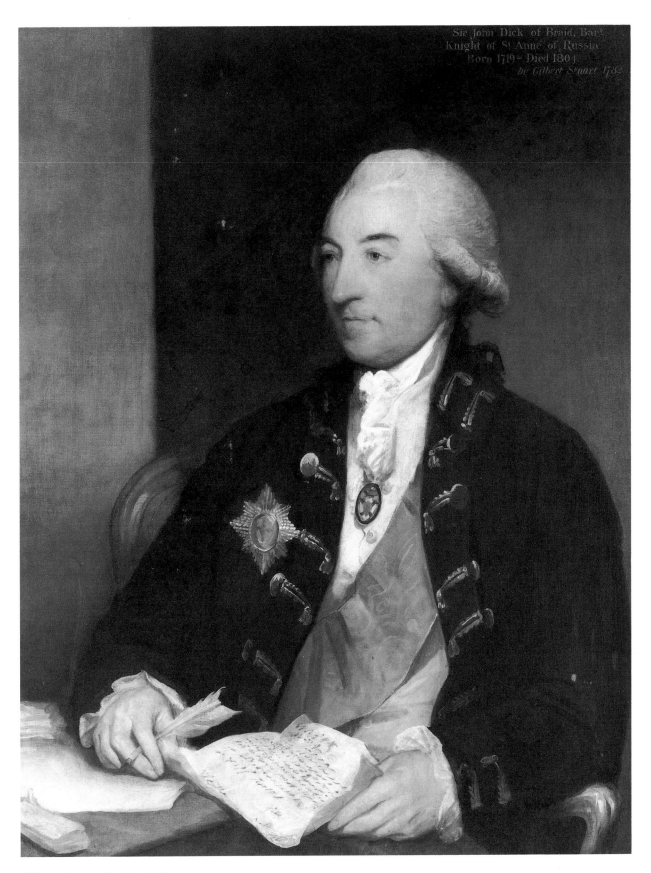

Gilbert Stuart, *Sir John Dick*, 1954.1.10

his birth date as 1720. Park 1926, 287–288, no. 246, confused the sitter with Sir John Dick (1767–1812), who became 6th baronet of Prestonfield in 1808.

6. Smith 1898, 64–65.

7. Quoted in Millar 1967, 28, n. 1.

8. Dick provided hospitality to West in 1760 and arranged for the shipment of Benbridge's portrait of Corsican general Pascal Paoli to James Boswell in London in 1768; see Galt 1816, 124; Stewart 1971, 45.

9. "Dick" 1804, 1175. According to Playfair's *Baronetage*, quoted in Cokayne 1900, 2:449, his nearest relatives at Prestonfield "would have succeeded to a large fortune, but Sir John was induced in his old age to leave almost the whole to a stranger and three of that stranger's friends."

10. Werlich 1974, 368–370; Fox-Davies 1904, 392. Dick wears the same orders in Zoffany's *Tribuna*; they are identified in Millar 1967, 28 and after 48, in the key to the painting. The order of St. Anne was founded in Germany in 1735 by Duke Frederick of Schleswig-Holstein in memory of his wife Anna Petrovna, daughter of Peter the Great. Their son, later Peter III of Russia, began conferring the order on Russians in 1742.

11. *DNB* 5:919.

12. Forbes 1897, 308. Alexander Nasmyth (1758–1840) was a Scottish painter of conversation pictures and landscapes; Waterhouse 1981, 254.

13. Forbes 1897, 316, quoted in Whitley 1932, 11, and in Morgan, *Stuart*, 1939, 13. Stuart occasionally used Charles as a middle name; see Morgan, *Stuart*, 1939, 14.

14. This portrait, which measured about the same size (89 by 69 cm) was sold by Lord Sinclair at Dowell's Ltd., Edinburgh, on 18 April 1958, lot 163, as an unidentified gentleman, attributed to David Martin. The portrait was sold at Christie's, London, on 6 November 1959, lot 110, and on 24 November 1972, lot 114. It was at the Old Hall Gallery Ltd., Rye, Sussex, in 1972–1973. According to Smith 1898, 41, Jean, the cousin of Sir John Dick's father, married Adam Sinclair, 7th laird of Brew; also, his grandmother was a Sinclair.

References

1897	Forbes: 308, 316.
1898	Smith: 126–136.
1913	Strickland: 2:414.
1914	Fielding: 321, no. 43.
1922	Sherman: 143–144.
1926	Park: 287–288, no. 246, repro.
1932	Whitley: 10–11.
1939	Morgan: 13.
1986	McLanathan: 50 color repro., 51.

1942.8.21 (574)

Sir Joshua Reynolds

1784
Oil on canvas, 91.6 × 76.4 (36 $^{1}/_{16}$ × 30 $^{1}/_{16}$)
Andrew W. Mellon Collection

Technical Notes: The primary support is a medium-weight, plain-weave fabric with a vertical seam 4.5 cm from the left side. A second, almost identical fabric is stretched beneath this support. Both the added strip and the lining appear to be original to the painting, as only one set of tack holes is found in the fabric, which has its original tacking margins. The four-member mortise-and-tenon, keyed stretcher also appears to be original. The thin, grayish white ground extends over the edges of the fabric, indicating that the canvas was prepared before stretching. The ground color contributes generally to the tonality in the more thinly painted passages in the hair, scroll, and column. In the more thickly painted coat, face, and hands, the ground is visible around the eyes and in the sitter's left hand.

A mild, retouched abrasion is in the more thinly painted passages, with an untouched area of abrasion in the sitter's left hand. Heavy retouching is evident in the areas of abrasion in the jacket. The varnish is a somewhat discolored, thick, and uneven glossy layer of natural resin.

Provenance: Commissioned by John Boydell [1719–1804], London; probably inherited by his nephew and business partner Josiah Boydell [1752–1817], London. Possibly sold by an unidentified consignor at (Greenwood & Co., London, 3 April 1806, no. 49) and (Greenwood & Co., London, 21 May 1807, no. 40), purchaser not recorded.[1] Murrough O'Brien, 5th Earl of Inchiquin and 1st Marquis of Thomond [d. 1808];[2] by descent to his nephew James O'Brien, 7th Earl of Inchiquin and 3rd Marquis of Thomond [1769–1855], Bath.[3] (T.H. Robinson, London, and M. Knoedler & Co., New York), October 1919; sold 11 December 1919 to Thomas B. Clarke [1848–1931], New York;[4] his estate; sold as part of the Clarke collection on 29 January 1936, through (M. Knoedler & Co., New York), to The A.W. Mellon Educational and Charitable Trust, Pittsburgh.

Exhibited: John Boydell's Gallery, London, 1786. Possibly at Boydell's Shakespeare Gallery, London 1792–1802. Union League Club, January 1922, no. 1. Philadelphia 1928, unnumbered. Richmond 1944–1945, no. 1. *Gilbert Stuart*, NGA; RISD; PAFA, 1967, no. 12.

GILBERT STUART painted this portrait of sixty-one-year-old Sir Joshua Reynolds (1723–1792), the celebrated English painter and president of the Royal Academy of Arts, in July 1784. It is one of fifteen portraits of painters and engravers commissioned from Stuart by John Boydell, the London

print publisher, of the men associated with his commercial success. In addition to Reynolds, Stuart painted portraits of John Singleton Copley (National Portrait Gallery, London), Benjamin West (National Portrait Gallery, London), Ozias Humphrey (Wadsworth Atheneum, Hartford), William Miller, and Richard Paton, and engravers James Heath (Wadsworth Atheneum, Hartford), William Woollett (Tate Gallery, London), John Hall (National Portrait Gallery, London), Johann Gottlieb Facius, Georg Sigmund Facius, John Browne, and Richard Earlom, as well as Boydell and his nephew and partner Josiah Boydell.[5] He completed the portraits of Copley, Heath, and Josiah Boydell by 3 April 1784, when Robert Adam, the Scottish architect, designed an elaborate frame that positioned the portraits as a group above Copley's history painting *The Death of Major Peirson* (1782–1784, Tate Gallery, London).[6] Boydell had commissioned the *Death of Peirson* and had employed Heath as its engraver. He exhibited these paintings at 28 Haymarket, London, before moving them to the gallery in his print shop at 90 Cheapside.[7] On 12 June, Robert Adam designed a second grouping of a number of circular, oval, and rectangular frames on one wall, perhaps for the display of some of Stuart's fifteen portraits with other, horizontal works.[8]

Reynolds sat for his portrait that July. He listed the sittings in his pocket diary: on 23 July, "9½ Mr. Stewart" (fractions indicate the half-hour), and on 28 and 30 July, also at half past nine.[9] A month later, on 27 August, "Mr. Stewart" had a final appointment at nine o'clock.[10] The result shows Reynolds in a black suit, white shirt, and powdered gray wig. His cheeks are ruddy and his wig frizzy, in a natural style. Seated in an upholstered chair, Reynolds rests his hands in his lap as he holds a gold snuffbox in his left hand. Between the thumb and index finger of his right hand he takes a pinch of snuff. On a red-draped table beside him are rolled sheets of paper; a column and a red curtain fill the background.[11] Stuart's technique, with its loose, dry brushwork, is similar to that in his full-length of *The Skater (Portrait of William Grant* of 1782 [1950. 18.1] and his portrait of Sir John Dick of 1783 [1954.1.10], English works that mark the artist's transition from the more evenly painted colonial American manner to his later fully calligraphic style. This transitional quality can be seen in his modeling of Reynolds' face (Figure 1), where hatched brushwork defines the features, the shadows, and the wig, while a more

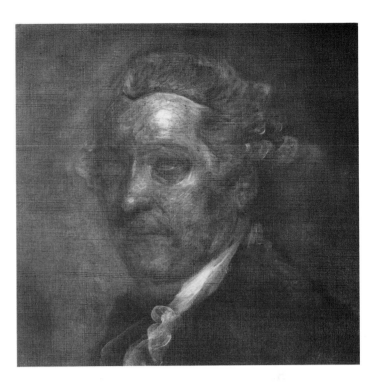

Fig. 1. X-radiograph detail of 1942.8.21

thickly applied paint layer depicts the skin. The looser brushwork was undoubtedly a conscious imitation of Reynolds' own technique.

In this portrait, Reynolds appears slightly older than in his self-portrait in academic robes with the bust of Michelangelo (c. 1780, Royal Academy of Arts, London). Instead, he more closely resembles his self-portrait of about 1789 (Royal Collection, London).[12] Despite this similarity, Sir Joshua remarked about Stuart's painting, according to American painter Charles Fraser, that "if that was like him, he did not know his own appearance."[13] As Susan Rather indicates in her close reading of the portrait, Reynolds no doubt was referring to the characterization. As she aptly points out, the two men, one a young artist and the other the most admired British portrait painter of the time, shared the habit of taking snuff. She suggests that Reynolds might have though the gesture of taking snuff was inappropriate for his portrait. Through this response to the portrait, however, she interprets Stuart as satirizing Reynolds "by coded references to his deafness and irascibility, while overtly presenting the Royal Academy president in a manner that Reynolds, in his public addresses on art, condemned."[14] The gesture of pinching snuff might, on

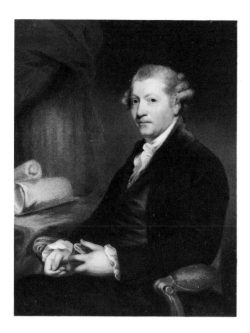

Fig. 2. Charles Bestland after Gilbert Stuart, *Sir Joshua Reynolds*, oil on copper, undated, Oxford, England, Ashmolean Museum

the other hand, be seen as an early example of Stuart's exceptional gift of interpreting personality through the choice of a characteristic pose, in this case, one with which he was very familiar.

Stuart's series of artists' portraits was completed by the fall of 1786, when it was exhibited at Boydell's gallery at 90 Cheapside. Among the many visitors who saw the portraits there was Sophie de la Roche, a young traveler to London who noted in her journal on 28 September 1786 that Boydell's second floor exhibition room was "devoted to works by native artists, and contains portraits of famous English painters, especially engravers."[15] "Fabius" wrote a more detailed description for the 14 November issue of the *Morning Post, and Daily Advertiser*. "The inner room is now furnishing wholly with modern paintings — around it on the top are portraits of the most eminent English artists, whose works have been purchased, and engraved from by the Alderman, or of engravers, whom he hath at different times employed to engrave for him — They are strong likenesses, and by Stuart." A writer for the London *Monthly Magazine; or British Register* later wrote about the group of portraits when remarking on the generally commonplace appearance of the artists of his time in their portraits, compared to the distinguished air of Van Dyck's portraits of seventeenth-century painters.

Very different are the portraits of the painters of the present day. A large number of them sat to Gilbert Stuart the American, who painted them for Alderman Boydell; they were afterwards shown at his gallery. They were all strong resemblances, but a set of more uninteresting, vapid countenances it is not easy to imagine; neither dignity, elevation nor grace appear in any of them; and had not the catalogue given their names they might have passed for a company of cheesemongers or grocers. The late President of the Royal Academy [Reynolds] was depicted with a wig that was as tight and close as a hackney coachman's caxon, and in the act of taking a pinch of snuff. The present President [West] and many others were delineated as smug upon the mart as so many mercers or haberdashers of small wares, all of which originated in the bad taste of the sitters.[16]

The commission for this series of artists' portraits predates by two years Boydell's announcement in December 1786 of plans for a collection of paintings by English artists on subjects from Shakespeare. He intended to commission the series and to offer two sizes of engravings for public subscription. By the time the Shakespeare Gallery opened at 52 Pall Mall in 1789, thirty-four of the paintings were completed.[17] Boydell moved Stuart's portrait of Reynolds there by 1792, when Samuel Felton, the author of *Testimonials to the Genius and Memory of Sir Joshua Reynolds* (London, 1792), listed a number of portraits and self-portraits of Reynolds, including one "in Mr. Boydell's Shakespeare Gallery, among those of the other painters who are now engaged in painting scenes for Mr. Boydell's edition of that poet." Felton declared the Boydell portrait "undoubtedly the best painted Head of Sir Joshua," thinking it was a self-portrait.[18] That he was referring to Stuart's portrait is confirmed by an engraving of it by Johann and Georg Facius that Boydell published in 1802. Crediting Stuart as the painter, it is inscribed "From the Original Picture in the Shakespeare Gallery."[19] The Shakespeare Gallery project went bankrupt in 1804, and Boydell offered the collection for sale by lottery to raise funds to repay extensive loans. His *Plan of the Shakespeare Lottery* lists sixty-two prizes, the last being the entire contents of the Shakespeare Gallery. The lottery was held on 28 January 1805.[20] None of Stuart's portraits was included, however. The most likely scenario is that they remained at the print gallery at 90 Cheapside, which became the property of Boydell's nephew Josiah after Boydell's death in 1804.[21] In 1825 Henry Graves acquired the holdings of the Boydell firm when he, Francis Graham Moon, and J. Boys purchased the company's stock and leasehold and

Gilbert Stuart, *Sir Joshua Reynolds*, 1942.8.21

changed the firm's name to Moon, Boys and Graves.²² Three of the Stuart portraits—those of John Hall and Benjamin West (National Portrait Gallery, London) and James Heath (Wadsworth Atheneum, Hartford)—can be traced to Henry Graves and Company, the successor firm of Moon, Boys and Graves.²³

Charles Bestland (b. 1764?) copied the portrait in miniature (Figure 2).²⁴

EGM

Notes

1. Fredericksen 2:951, as "Stuart, *An Original Portrait of Sir Joshua Reynolds*," consigned by "a gentleman," and as "G. Stuart, *A Portrait of Sir Joshua Reynolds*." Only the second price is recorded, with some question, as three pounds, six pence. Since this is a very small price for a full-size portrait, perhaps these sales are instead for the "Small head, Sir Joshua Reynolds, sketch" attributed to Stuart that was sold at Christie's on 5 February 1818 by a Mr. Rising, with a small head of the Marquis of Lansdowne, also attributed to Stuart. The pair went for five guineas. (Information courtesy of the Getty Provenance Index, 7 April 1992.)

2. Stuart 1877, 644, recorded that "Lord Inchiquin" paid 250 guineas for her father's portrait of Reynolds. It has been assumed that this was the 5th earl, whose wife was Mary Palmer [d. 1820], Reynolds' niece and heiress. On the Earls of Inchiquin see Burke 1967, 1325–1330.

3. According to Knoedler's records (letter from Melissa De Medeiros, librarian, 5 June 1992; NGA), the portrait was from the estate of James O'Brien, the 3rd and last Marquis of Thomond, and "the present Lord Inchiquin is unable to say when the picture left the family." Beechey 1855, 300, records the portrait and reproduces an engraving of it as his frontispiece, but he does not record any owner after Boydell.

4. Knoedler purchased a joint share from T.H. Robinson in October 1919 and sold the painting to Clarke in December. The name of the seller and the date of purchase are recorded in an annotated copy of *Clarke* 1928 in the NGA library.

5. Whitley 1932, 55, lists the portraits without giving his source. It may have been the catalogue to which the anonymous author in *Monthly Magazine* 1804 referred; no copy has been located. On the portrait of West see Walker 1985, 1:543–544; 2:pl. 1352. A portrait at the Holburne of Menstrie Museum, Bath, has been identified as that of Josiah Boydell, but the identity is open to some question. Many of the portraits are unlocated today.

6. Harris 1990, 93, and fig. 1 (Sir John Soane's Museum, London); this reference courtesy of Jacob Simon, National Portrait Gallery, London.

7. Prown 1966, 2:307.

8. Harris 1990, 94 and fig. 3, dated 12 June 1784 (Sir John Soane's Museum).

9. Reynolds' pocket ledger for 1784, Royal Academy of Arts, London. The entries are also cited in Leslie and Taylor 1865, 2:468, and in Whitley 1932, 46.

10. Mount 1959, 223, proposed without documenta-tion that the August appointment was for Stuart to finish a copy of one of Reynolds' self-portraits (the attribution of the copy to Stuart is Mount's). Stuart has also been credited, without apparent documentation, with the copy of a Reynolds self-portrait that was exhibited at the Maryland Historical Society in 1853 and is now in the Charles J.M. Eaton Collection, Peabody Institute, Baltimore. See *Peabody Institute* 1949, 19; Yarnall and Gerdts 1986, 3418.

11. Stuart widened the canvas of the portrait from the standard kit-cat proportions of 91.4 by 71 cm (36 by 28 inches) by adding a 5-cm (2-inch) strip of canvas on the left, which did not change the composition appreciably. It may have been done in keeping with its setting in Boy-dell's gallery.

12. Penny 1986, 287–288, no. 116, repro., and 320–322, no. 149, repro.

13. Dunlap 1834, 1:184, quoting Fraser, who added that the remark "was certainly not made in the spirit of his usual courtesy."

14. Rather 1993, 63–65.

15. Her description of Boydell's shop is quoted in Bruntjen 1985, 28–29, from *Sophie in London* (London, 1933), 237–239.

16. *Monthly Magazine* 1804, 595, quoted by Rather 1993, 63.

17. Friedman 1976, 3, 71–73.

18. Felton 1792, 67; Whitley 1932, 47.

19. See Park 1926, 642; an example of the engraving is in the NGA curatorial file. Another engraving by E. Scriven is listed in O'Donoghue 1906, 3 (1912):564.

20. For an example of the *Plan*, published in London on 5 April 1804, see the scrapbook collection of *Press Cuttings* 3:815–818. William Tassie, a gem engraver, won the lot that included the Shakespeare paintings, which he sold at Christie's, 17–20 May 1805. The catalogue is discussed in Fredericksen 1:52; the paintings are indexed under Boydell's name and listed by the name of each artist.

21. Boydell also acquired Copley's *Death of Major Peirson*, which he sold at Christie's on 8 March 1806, lot 98; it was bought in and sold to Copley; Prown 1966, 2:440, and Fredericksen 2:264.

22. Bruntjen 1985, 242–243; on the history of this firm see also Graves 1897, 143–148 (the author was the son of Henry Graves), and the entry on Henry Graves (1806–1892) in *DNB* 22 (supplement), 771–772.

23. Information on the provenance of these portraits is courtesy of Jacob Simon, Keeper of 18th Century Portraits, National Portrait Gallery, London, and Elizabeth Mankin Kornhauser, curator of American Art, Wadsworth Atheneum, Hartford.

24. Foskett 1972, 1:163.

References

1786 "Fabius." "The Arts. No. II. Alderman Boy-dell's Gallery." *Morning Post, and Daily Advertiser*. 14 November: 2.

1792 Felton: 67.

1804 *Monthly Magazine*: 595.

1834 Dunlap: 1:184, 219.

1855 Beechey: 1:300, and frontispiece engraving by E. Scriven.

1865 Leslie and Taylor: 2:468.
1877 Stuart: 644.
1879 Mason: 248.
1880 MFA: 52, no. 508.
1913 Strickland: 2:416.
1922 Sherman: 139 repro., 143–144.
1926 Park: 641–642, no. 702, repro.
1932 Whitley: 46–47, 55–56.
1959 Mount: 220, 223.
1964 Mount: 90, 362.
1981 Williams: 62, color repro. 50.
1984 Walker: 378, no. 534, color repro.
1985 Bruntjen: 28–29, 36, 58, 63.
1986 McLanathan: 51, color repro. 54.
1990 Harris: 93–96 and figs. 1–3.
1993 Rather: 61–84.

1942.8.28 (581)

Luke White

c. 1787
Oil on canvas, 76.2 × 63.5 (30 × 25)
Andrew W. Mellon Collection

Technical Notes: The support is a fine-weight, plain-weave fabric. The white ground layer does not mask the fabric weave. The paint is applied in smooth, thin, semi-opaque layers. The face is modeled in broad, assured strokes. A thicker paint is applied in fluid, loose strokes in a wet-in-wet technique in details of the costume, such as the white shirt ruffle, and in the flesh tones of the face and hands. A thin layer of orange-brown glaze is used on the waistcoat, directly over the white paint of the shirt. The same glaze is applied in the background. The faint impression of a painted oval compositional format can be seen when the painting is examined in strong light.

Small blisters, possibly caused by excessive heat during lining, are seen on some thickly applied areas of paint, such as the sitter's face. Some abrasion is found in these blisters. Slight flattening of the highlights may be the result of a past lining. Only a few feathery strokes of overpaint are observed in the left background. The varnish is moderately yellowed.

Provenance: The sitter's daughter Matilda White [1799–1883], Killakee, County Dublin, Ireland, who married Hugh Hamon, 4th Baron Massy; their son John Thomas William Hamon, 6th Baron Massy [1835–1915], Killakee, County Dublin, Ireland;[1] sale of his estate at Killakee by (J.H. North & Co., Dublin, 16 February 1916, no. 622); bought by T.K. Laidlaw, Castleknock, Ireland;[2] (T.H. Robinson, London); (M. Knoedler & Co., New York, October 1919);[3] purchased 11 December 1919 by Thomas B. Clarke [1848–1931], New York;[4] his estate; sold as part of the Clarke collection on 29 January 1936, through (M. Knoedler & Co., New York), to The A.W. Mellon Educational and Charitable Trust, Pittsburgh.

Exhibited: Union League Club, January 1922, no. 16. Philadelphia 1928, unnumbered. *Survey of American Painting*, Department of Fine Arts, Carnegie Institute, Pittsburgh, 1940, no. 59. Richmond 1944–1945, no. 3. Columbia 1950, no. 10. Atlanta 1951, no. 11. Chattanooga 1952, unnumbered. Mint Museum of Art, Charlotte, North Carolina, 1952, no cat. Randolph-Macon Woman's College, Lynchburg, Virginia, 1952–1953, no cat.[5]

LUKE WHITE was one of Stuart's first sitters in Dublin after the artist moved there from London in the fall of 1787.[6] According to an anecdote recounted by Irish portrait painter John Dowling Herbert, Stuart had been in the city "about a month" and had painted only three pictures when a Dr. Hill came to his studio and asked to see some of his work. The doctor thought the first painting he was shown was a self-portrait. "No. It is Luke White," Stuart said, correcting him. "So it is," the doctor conceded — "and very like indeed; but the contour is not very different from your's." The visitor made the same mistake about the next picture placed before him and declared as he departed that his vision required some "revision."[7]

White (1740–1824), of Killakee and Woodlands,

Fig. 1. Gilbert Stuart, *John Philip Kemble*, oil on canvas, c. 1785–1787, London, National Portrait Gallery

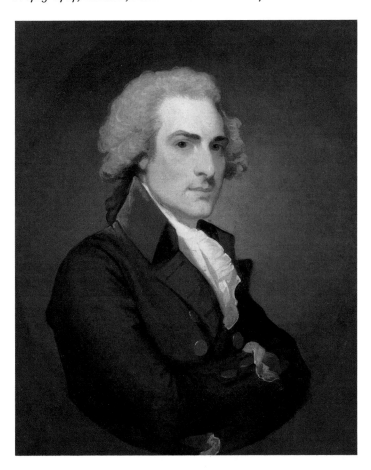

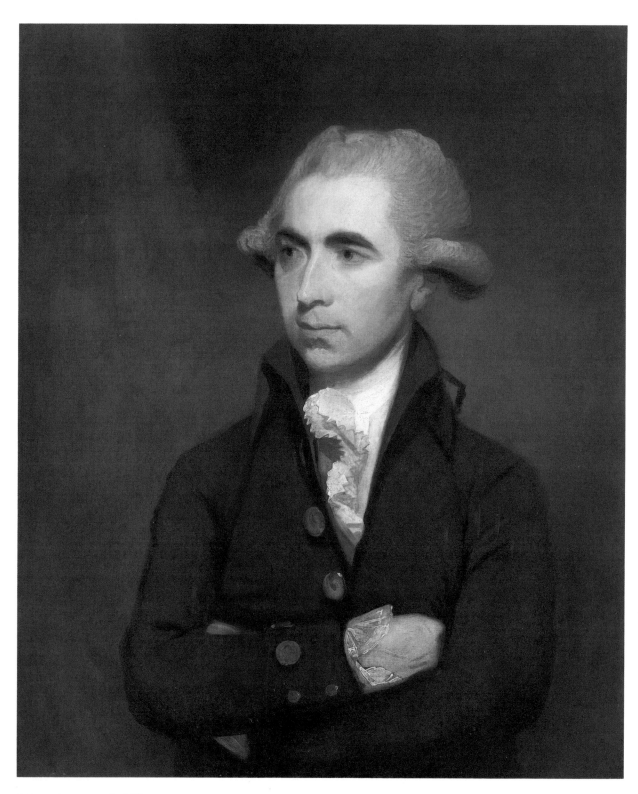

Gilbert Stuart, *Luke White*, 1942.8.28

in County Dublin, became high sheriff of County Longford in 1806 and served as a member of Parliament for Leitrim from 1818 to 1824.[8] The painting shows him in a blue coat with narrow sleeves, a high collar and gold buttons, and a yellow waistcoat. He stands in front of a brown wall, with red-brown drapery to the left. His powdered hair is dressed with side curls and a queue, with the ribbon glimpsed near his collar. The sitter's averted gaze, and his crossed-arm pose reminiscent of Stuart's portrait of *The Skater* [1950.18.1], give White a thoughtful appearance. Stuart also painted a portrait of White's wife Elizabeth de la Maziere with their son.[9]

The portrait's technique is enlivened with impasto highlights on the sitter's forehead, nose and upper lip, and hair. The crinkled edges of the white shirt ruffle contrast with the dark outlines of the sitter's body. Contours and folds of the blue coat are loosely painted with fluid brush strokes in blue-black paint. The portrait was originally composed in a painted oval, with the corners left incomplete, which would have given it an appearance similar to Stuart's English portrait of actor John Philip Kemble (Figure 1). The change to a rectangular format, including the positioning of the sitter's left hand and coat, is poorly executed.[10]

CJM / EGM

Notes

1. For the family genealogy see Burke 1967, 1672.

2. The date of the sale appears in a cablegram from North & Co. in Dublin, dated 9 February 1916, to Charles Henry Hart in New York (typed copy, NGA) and in a letter to Hart from Laidlaw, Castleknock, Ireland, dated 5 March 1916 (Charles Henry Hart Papers, AAA). No catalogue for the sale has been located.

3. Letter, 29 April 1989, from Melissa De Medeiros, librarian, M. Knoedler & Co. (NGA).

4. The name of the seller and the date of purchase are recorded in an annotated copy of *Clarke* 1928 in the NGA library.

5. Campbell 1953, 7.

6. Stuart arrived in Dublin in October 1787; Crean 1990, 101–102.

7. Herbert 1836, 235–236. Herbert did not witness the incident but said it was described to him by Stuart.

8. Park 1926, 807, and Watson 1969, 40. Mount 1964, 123, described White as "the print-seller in Castle Street." The only Luke White listed in *Wilson's Dublin Directory* for the years 1787–1789 is "Luke White. Bookseller. 86 Dame Street." There is no evidence this is the same Luke White.

9. According to Strickler 1979, 105, the painting was "most recently in the collection of David R. Russell, Dallas." It may be the "interesting unfinished sketch" of Mrs. White and child, "undoubtedly painted by Gilbert Stuart," that T.K. Laidlaw saw at the home of Lord Annaly, a descendant of Luke White, in 1916. He told Hart that Lord Annaly asked permission to have a copy of *Luke White* to hang beside it; Laidlaw to Hart, 11 July 1916 (Charles Henry Hart Papers, AAA). Laidlaw had purchased a different portrait of Mrs. White and her son at the 1916 auction of Baron Massy's estate; Laidlaw to Hart, 5 March 1916 (AAA). This double portrait (Toledo Museum of Art) is now considered a copy after Stuart, although Park 1926, 808–809, no. 904, considered it to be the original.

10. The painting was restored in London in 1916, according to T.K. Laidlaw, who commented after the cleaning, "I was much surprised to find that his coat, which seemed to be black, is really a beautiful blue colour." Laidlaw to Charles Henry Hart, 11 July 1916, AAA.

References

1836 Herbert: 235–236.
1926 Park: 806–807, no. 902, repro.
1964 Mount: 123, 363.
1969 Watson: 40, 47 repro.
1981 Williams: 62, repro. 63.
1986 McLanathan: repro. 64.
1990 Crean: 227, 266–267, 405 no. 84.

1942.8.16 (569)

Dr. William Hartigan (?)

c. 1793
Oil on canvas, 76.2 × 63.5 (30 × 25)
Andrew W. Mellon Collection

Technical Notes: The original medium-weight, plain-weave fabric has been cut in the shape of an oval, inset into a rectangular canvas, and lined to a second rectangular fabric. Cusping on the left, bottom, and (faintly) right sides of the oval suggests that it was cut down from a rectangle. The thin, white ground, which contributes to the overall tonality of the painting, is faintly visible through the thinly painted face, hair, and background. Infrared reflectography reveals underpainted brush strokes in the hair. The white cravat is formed with thick, broad, pastose strokes. The paint of the black coat is slightly thicker than the adjacent areas, and its collar is painted with loose, low-textured strokes with gray highlights. Infrared reflectography reveals on the left side a tall, unidentified object with a rounded top that has been painted out.

Marked abrasion is found in the face and hair, with retouching in the facial features. The background area on the oval canvas has been heavily overpainted. A cross-shaped tear, measuring approximately 5 cm in each direction, is located to the left of the sitter's face. A smaller area of damage has been repaired on the bottom of his coat. The varnish is discolored.

Provenance: Acquired from descendants of the sitter by Charles Loring Elliott [1812–1868], New York, by 1846;

Abraham M. Cozzens, New York, by 1856; sale of his estate (Clinton Hall Art Galleries, New York, 22 May 1868, no. 23),[1] purchased by Jonathan Sturges [1802–1874], New York and Mill Place, Connecticut;[2] his widow Mary P. Sturges; their son Henry C. Sturges [1846–1922], New York and Fairfield, Connecticut;[3] bought 1 April 1921 by Thomas B. Clarke [1848–1931], New York;[4] his estate; sold as part of the Clarke collection on 29 January 1936, through (M. Knoedler & Co., New York), to The A.W. Mellon Educational and Charitable Trust, Pittsburgh.

Exhibited: Union League Club, January 1922, no. 2. Philadelphia 1928, unnumbered. Richmond 1944–1945, no. 4. Hagerstown 1955, no cat.

THE INCOMPLETE HISTORY of this portrait involves many uncertainties: an unclear provenance, undated copies by unknown artists, undocumented family traditions, and published comments that are confused about the identification of the sitter. The attribution to Stuart, however, appears sound. The portrait was first recorded as the property of American artist Charles Loring Elliott in New York City. His friend Thomas Thorpe described it as "a delicately finished head by G. Stuart," which Elliott had acquired by 1846; the sitter was not identified.[5] By 1856, when the portrait was touted as one of the "attractions of the collection" of Abraham M. Cozzens, the subject was identified as "Dr. Houghton" of Dublin.[6] Cozzens, a New York merchant and an officer of the American Art Union from 1840 to 1851, had purchased the portrait from Elliott.[7]

The portrait is featured in a story about Elliott that was told by both Henry Tuckerman and Thomas Thorpe. To Tuckerman, the tale exemplified "the artist-life in America, the spirit in which difficulties are surmounted, and the happy accidents that favor its true votaries." Tuckerman reported that the portrait had surfaced in upstate New York in the collection of a young English painter. It had been a gift from the son of the physician who had treated Stuart's injured and infected arm after a coach accident. After the English painter died, his widow gave the portrait to Elliott as payment for a family portrait that he had painted. "The offering of gratitude became the model and the impulse whereby a farmer's son on the banks of the Mohawk rose to the highest skill and eminence." However, "a wealthy trader in Syracuse, desirous of the *éclat* of a connoisseur, was resolved to possess the cherished portrait." When the young Elliott was unable to repay a debt, the trader bought his notes, intending to use them to acquire

the portrait. Elliott made a copy of the portrait that was "so good . . . that the most practised eye alone could detect the counterfeit." When his possessions were attached for nonpayment of the debts, the copy was sold to the trader, who soon found out about the substitution and sued Elliott. The case, according to Tuckerman, went to the "Supreme Court." Elliott eventually was able to keep the portrait, but he did have to pay court costs.[8]

Thorpe's version of the tale was that Elliott owned the portrait when he was living in New York City in 1846. On one occasion, when he owed fifty dollars, a "boyhood friend" paid the debt and then asked for the portrait as payment. When Elliott refused, a constable came to seize the painting. But Elliott had made a copy, which he aged "by scratching it on the back with the point of a pin." The constable took the copy. "That's it," he said, "the old gentleman with the powdered hair, looking for all the world like George Washington." The "friend" sold the painting and then found out that he had been tricked. By then the legal papers had been returned to Elliott, the claim marked "satisfied."[9]

The suggestion that the sitter was Dr. William Hartigan (c. 1756–1812), member of the Royal College of Surgeons, Dublin, and professor of anatomy at Trinity College, was made in 1914.[10] Collector and dealer Charles Henry Hart had begun his search for the painting in 1881, when he wrote, "By the bye, where is the head formerly owned by Elliott, the portrait painter."[11] Lucie Lull Oliver, a descendant of Hartigan, told Hart the story of the accident and identified the doctor who cared for Stuart as Dr. Hartigan.[12] After Hart's death, Thomas B. Clarke continued the search for portraits of Hartigan and his wife. Dealer Stanley Sedgwick wrote Clarke on 25 March 1919 from London, "I shall no doubt find Dr. William Hartigan and his wife in due course and shall undoubtedly be able to trace the other pictures to which you refer in your memorandum."[13] The misidentified painting was eventually located in the Sturges collection and was acquired by Clarke in 1921.

Two copies of the portrait are known, but neither seems to be by Elliott. The first, unattributed and undated (Figure 1), is paired with a copy of Stuart's portrait of Richard Yates (see 1942.8.29). Each of these paintings measures 61 by 46.7 cm (24 by 18 ⅜ inches) and is painted on a scored mahogany panel of the type used by Stuart. Elliott's copy would not be paired with a portrait of

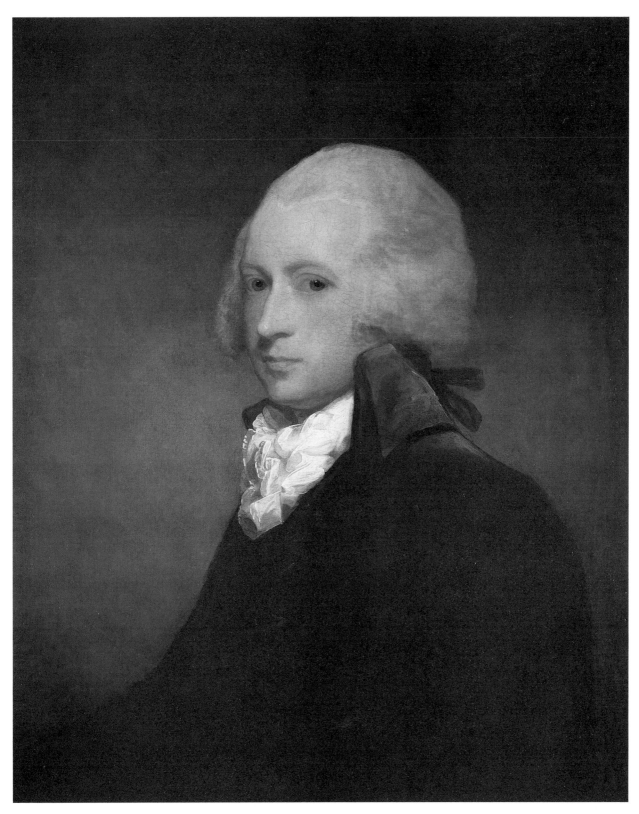

Gilbert Stuart, *Dr. William Hartigan (?)*, 1942.8.16

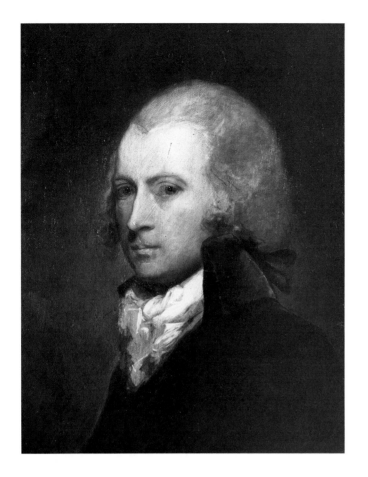

Fig. 1. Unknown artist, *Dr. William Hartigan*, oil on wood panel, collection of Clifford A. Kaye, Brookline, Massachusetts, 1965

Richard Yates. The pairing, however, supports the identification of the sitter as Hartigan, who was related to Yates through the Pollock family. Hartigan's second wife was Anne Elizabeth Pollock, a sister of George Pollock.[14] The other copy (Figure 2) has been attributed to two early nineteenth-century painters who resided in New York City: John Paradise (1783–1834) and "Parisen," the family name of several early nineteenth-century German-American artists, including Julian, Philip, William, and Otto.[15] The style of this copy does not resemble Elliott's known early work. By 1846 this copy was erroneously identified as a portrait of James Madison and thus does not provide any evidence of the original identification of the sitter.

It seems wise to retain the identification of Dr. Hartigan until another, perhaps more sound one can be proposed. For example, the portrait could represent one of George Pollock's brothers, painted in New York rather than in Dublin. The loosely woven canvas (with a thread count of 13 by 13) is similar to the canvases that Stuart used for the Yates portraits and unlike the very fine (22 by 22) thread count of *Luke White*, painted earlier in Dublin (1942.8.28).[16] But this identification does not explain why Tuckerman in 1867 said that the portrait was of the surgeon who saved Stuart's arm. Until more answers are provided, this portrait's origins remain mysterious.

EGM

Notes

1. Thorpe 1868, 7; *Crayon* 1856, 123; *Cozzens* 1868, 7, no. 23, as "Dr. Houghton, of Dublin." According to the auction catalogue, Elliott "obtained it direct from the family for whom Mr. Stuart painted it."

2. Park 1926, 386; on Sturges see *NCAB* 3:350.

3. In his will (according to the *New York Times*, 17 December 1874, 3), Jonathan Sturges left all books, pictures, and works of art in his city residence to his wife Mary P. Sturges. On Henry Sturges see *New York Times*, 18 February 1922, 13 (obituary).

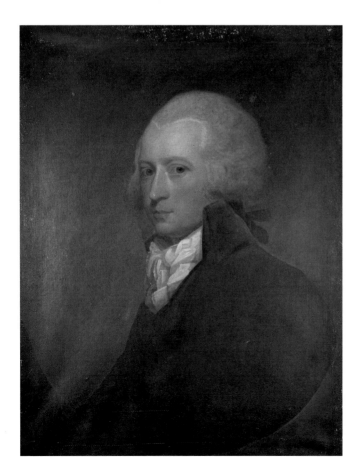

Fig. 2. John Paradise, *Dr. William Hartigan, Irish Surgeon*, oil on canvas, undated, The Archives of the Peabody Institute of the Johns Hopkins University, Charles M. Eaton Collection, on extended loan to The Baltimore Museum of Art [photo: The Baltimore Museum of Art]

4. The name of the seller and the date of purchase are recorded in an annotated copy of *Clarke* 1928 in the NGA library.

5. Thorpe 1868, 7.

6. *Crayon* 1856, 123.

7. On Cozzens see Cowdrey 1953, 2:105, 306, and Parry 1988, 280, 345.

8. Tuckerman 1867, 303–305. Tuckerman mentioned the portrait three times: as "Dr. Houghton, of Dublin" with an attribution to Rembrandt Peale (62), as the portrait of an Edinburgh physician owned by Elliott, and as Stuart's portrait of Dr. Houghton in Cozzens' collection (623). Cozzens also owned work by Henry Inman, Emmanuel Leutze, John Frederick Kensett, Thomas Cole, and Daniel Huntington.

9. Thorpe 1868, 7; Bolton 1942, 60, 64, mentions the story. He did not locate the copy (see his "Checklist," 85–96).

10. On Hartigan see Park 1926, 385, and *Wilson's Dublin Directory* for the years 1785–1790, which list him as a member of the court of assistants of the Royal College of Surgeons.

11. Hart 1880, 487, in a review of the exhibition of works by Stuart at the Museum of Fine Arts, Boston.

12. See her letter of 11 August 1914 (NGA).

13. Sedgwick to Clarke, 25 March 1919 (NGA).

14. Some portraits of Mrs. Hartigan are attributed to Stuart, although the portrait of her in the Gallery's collections [1942.8.15], once attributed to Stuart, is now identified as the work of Swedish portrait painter Carl Fredrik von Breda; see Park 1926, 899; Hayes 1992, 24–27.

15. *Peabody Institute* 1949, 16; the portrait, from the Charles M. Eaton Collection, is an oil on canvas measuring 76.8 by 61.6 cm (30 ¼ by 24 ¼ inches). Information provided by archivist Elizabeth Schaaf from the research notes of Anna Wells Rutledge indicates that the portrait was offered for sale in New York in 1846 as a portrait of President James Madison by Parisen; it was sold from the estate of Louis E. Smith, Baltimore, on 3–5 May 1876 as "Portrait, President Madison" (*Smith* 1876, 6, no. 137).

16. Mount 1964, 345–346, was the first to suggest that this portrait was from Stuart's New York period, 1793–1794.

References

1856	*Crayon*: 123.
1867	Tuckerman: 62, 303–305, 623.
1868	Thorpe: 7.
1879	Mason: 43–45, 201, as Dr. Houghton.
1880	MFA: 43, no. 310.
1880	Hart: 487.
1926	Park: 385–386, 900, repro.
1929	Lee: 25.
1964	Mount: 152, 167, 169, 345–346, 369.

1942.8.18 (571)

George Pollock

1793/1794
Oil on canvas, 92.2 × 72.1 ($36^{5}/_{16}$ × $28^{3}/_{8}$)
Andrew W. Mellon Collection

Technical Notes: The painting was executed on a medium-weight, plain-weave fabric that is identical to the fabric used for the portrait of Mrs. George Pollock [1942.8.19] but differs from that used for the portraits of three members of the Yates family, which were painted at about the same time (see below). The weave texture is quite prominent in the painting. Slight cusping can be seen at the edges on the top, bottom, and left sides. A thin gray ground is visible where the surface layers are thinnest, particularly in the areas of the face and hands. The paint is generally applied in thin, semi-opaque layers, with slightly thicker paint on the flesh tones and highlights. Facial features are blended wet-in-wet. Glazes are employed in the shadows of the hands. Brown glazes and thin layers used for the eye sockets also define the contours of the nose and lips. The white paint of the shirt ruffle is thicker and more fluid, as are highlights of the inkstand and buttons. A combination of red glazes and thin, opaque red paint mixed with white makes up the red color of the drapery. Opaque green stripes highlight the semi-translucent paint of the jacket, and the same green color defines the right edge of the jacket near the sitter's neck.

The paint surface is finely abraded overall where thinly applied, and in some areas the threads of the fabric support are exposed. The varnish was removed and the painting lined in 1964. The varnish is uneven, with small cracks.

Provenance: The sitter's son Carlile Pollock [1791–1845], New Orleans; his daughter Marie Louise Pollock Chiapella [1828–1902]; possibly to her son Henry Chiapella [1849–c. 1908]; his daughter Louise Chiapella Formento, New Orleans; sold to Isaac Monroe Cline [1861–1955], New Orleans, between 1915 and 1917;[1] purchased 16 January 1918 by Thomas B. Clarke [1848–1931], New York;[2] his estate; sold as part of the Clarke collection on 29 January 1936, through (M. Knoedler & Co., New York), to The A.W. Mellon Educational and Charitable Trust, Pittsburgh.

Exhibited: Union League Club, February 1922, no. 6. Philadelphia 1928, unnumbered. Richmond 1944–1945, no. 9. Columbia 1950, no. 13. Atlanta 1951, no. 13. Birmingham Museum of Art, Alabama, 1951. Chattanooga 1952, unnumbered. Mint Museum of Art, Charlotte, North Carolina, 1952, no cat. Randolph-Macon Woman's College, Lynchburg, Virginia, 1952–1953, no cat.[3]

WHEN STUART RETURNED to the United States from Ireland in 1793, he quickly established a close relationship with Irish emigré George Pol-

lock (1762–1820) and his brothers Hugh and Carlile, who were importers and shipping underwriters in New York City. Stuart may have painted their brother-in-law in Ireland (see *Dr. William Hartigan (?)*, 1942.8.16). He gave Hugh Pollock an introduction to his uncle Joseph Anthony in Philadelphia, writing Anthony on 2 November 1794 that, although introductions to men of business could be troublesome, "To their House I am indebted for more civilities than to the world beside."[4] Perhaps it was Stuart's acquaintance with Pollock that led to the commission for the portraits of Pollock, his wife, and his wife's parents Mr. and Mrs. Richard Yates, as well as of Lawrence Reid Yates. The portraits, mentioned in 1834 by William Dunlap as among the many fine works of the artist's New York period, demonstrate Stuart's technical virtuosity, gained in his years in England and Ireland, and the directness of his depictions of American sitters in the Federal era.

George Pollock, the son of John Pollock of Newry, Ireland, apparently arrived in New York sometime between 1780 and 1786. He married Catherine Yates [1942.8.19] in 1787 after the death of his first wife.[5] Ten years later he became a junior partner in the import firm of his father-in-law Richard Yates [1942.8.29]. "Yates (R.) & G. Pollock's Counting House" was listed in New York city directories through 1799. He also was a partner as a merchant with his brother Hugh Pollock. His country house, called "Monte Alta," stood on the present-day site of Grant's Tomb.

Between 1797 and 1801, Pollock's business was devastated when a number of his ships were lost in the undeclared American naval war with France. One of the most debilitating losses occurred in 1798 when the French privateer *La Vigilante* seized the *Leeds Packet*, a 220-ton ship owned by Hugh Pollock & Co. loaded with rice, cotton, skins, and lumber on a voyage from Charleston to London.[6] George Pollock moved his family to New Orleans in 1803 to begin rebuilding his fortune. There he became a justice of the peace for Orleans Parish and president of the Chamber of Commerce.[7]

The portrait of Pollock is an example of Stuart's energetic New York style. Pollock, with ruddy cheeks, thick lips, and pale brown eyes, is seated in a red leather armchair, his hands folded in his lap. His brown coat with its subtle green striping contrasts with his white waistcoat, shirt ruffle, and powdered hair tied in a queue, which present him as a

man of prosperity, and also a man of business. As in the portrait of his father-in-law Richard Yates, Pollock is seen with an inkstand on a nearby table. A package of letters tied with a pink ribbon adds to the red color of the tablecloth. The painting, on a kit-cat canvas, measures 91.4 by 71 cm (36 by 28 inches).

Based on technical examinations, the five Yates-Pollock portraits by Stuart in the Gallery's collection appear to be the artist's originals. Their provenance suggests that they were taken to New Orleans by George and Catherine Pollock in 1803. If this is the case, William Dunlap's reference to the portraits in 1834 was based on memory. The question of originality arises because second versions exist of four of the five paintings, which are not all necessarily by the same artist. The second version of the portrait of Mrs. Yates (MFA) was purchased in 1896 from the sitter's descendant Emma G. Lull of Washington and is now considered an early copy by an unknown painter.[8] The second portrait of Lawrence Reid Yates (The Huntington Library, Art Collections, and Botanical Gardens, San Marino, California), attributed to Stuart, and its pendant of Matilda Caroline Cruger [1942.8.13] were cited specifically by Henry Tuckerman after he praised Stuart's "admirable likenesses of the Pollock and Yates families" in 1867.[9] Miss Cruger's portrait, however, is no longer considered Stuart's work. The second version of the portrait of Richard Yates, a recent acquisition of The Fine Arts Museums of San Francisco, the gift of Mr. and Mrs. John D. Rockefeller 3rd, is now attributed to an unidentified artist after Stuart, c. 1800. A small second version of George Pollock's portrait (74.9 by 62.2 cm [29½ by 24½ inches]), with differences in the design of the coat, was sold at Sotheby's in London on 12 November 1980, lot 30.

CJM / EGM

Notes

1. The provenance is the same as the Yates portraits [1940.1.4, 1940.1.5, and 1942.8.29], except for the date of Cline's purchase. Cline bought this portrait and that of Mrs. George Pollock [1942.8.19] after 19 April 1915, when he wrote Charles Henry Hart in Philadelphia that he only owned three portraits of members of the Yates and Pollock families. He owned them by 12 December 1917, when he wrote New York dealer Robert Macbeth that he owned the five Gilbert Stuart portraits of members of the Pollock and Yates families that were mentioned by Dunlap (General Correspondence, Macbeth Gallery Papers, AAA).

2. The name of the seller and the date of purchase are

Gilbert Stuart, *George Pollock*, 1942.8.18

recorded in an annotated copy of *Clarke* 1928 in the NGA library. Clarke sent Clarence J. Dearden of Art House, Inc., to New Orleans to negotiate the purchase of the portraits; Dearden confirmed the purchase in a telegram to Clarke, 16 January 1918 (NGA for *Mrs. Richard Yates*, 1940.1.4).

3. Campbell 1953, 7.

4. Photostat of an unlocated letter from Stuart to Anthony dated 2 November 1794; Massachusetts Historical Society, Boston. The original was once owned by Thomas B. Clarke, according to Park 1926, 105–106. In 1795, Hugh Pollock married Stuart's cousin, Martha Anthony. Carlile Pollock's name is sometimes spelled Carlisle.

5. Pollock married Catherine Yates on 17 March 1787 at Trinity Church in New York City. His brother Carlile married her sister Sophia in 1792; letter from the office of the Corporation of Trinity Church, New York, 9 June 1915, to Charles X. Harris, West Hoboken, New Jersey (NGA).

6. Pollock's descendants received appropriations from Congress after filing claims for losses under an 1885 law providing for compensation. See Records of French Spoilation Cases, United States Court of Claims, Record Group 123, United States National Archives, Washington.

7. New Orleans city directory, 1807; Hayden 1883, 47–48; will of George Pollock dated 2 September 1819, New Orleans (copy, NGA).

8. MFA 1969, 1:261.

9. Tuckerman 1867, 109.

References

1834 Dunlap: 1:230.
1867 Tuckerman: 109.
1926 Park: 605, no. 648, repro.
1964 Mount: 167, 169, 373.
1986 McLanathan: 79, repro. 78.

1942.8.19 (572)

Catherine Yates Pollock (Mrs. George Pollock)

1793/1794
Oil on canvas, 91.6 × 71.8 (36 1/16 × 28 1/4)
Andrew W. Mellon Collection

Technical Notes: The painting was executed on a medium-weight, plain-weave fabric that is identical to the fabric used for the portrait of George Pollock [1942.8.18]. Cusping is found along the right and top edges; none is present on the left and lower edges. When the painting was on its original stretcher, the tack holes may have been positioned on the picture plane rather than on a folded tacking margin, since no crease is apparent in the ground or paint structure. A thin, gray ground layer is applied overall. A light-colored brown-beige layer is applied in the area under the face and extends outward over the gray ground. The paint is applied in rich, opaque layers into which thin, semi-transparent glazes and textured brushwork have been incorporated. Moderately high impasto is in some details, especially in the highlights of the pearls and fabric tacks on the chair. The paint of the flesh is applied wet-in-wet. The base tones are blended, and details of the lips, nose, and eyes are added in liquid strokes but are not blended in. The rosy pink paint of the cheeks is probably applied over the flesh tones after the paint dried. A similar technique is used in the hands. The gray ground imparts a tonality to the left sleeve and to the green background, while the gray tonality of the shadow under the sitter's chin is made by adding gray to the surface paint.

The paint suffers from mild abrasion overall, and in the thinly painted areas this reveals the gray ground. No major discrete damages are noted. The few areas of overpaint are most notable in the background. The varnish was removed and the painting lined in 1964.

Provenance: Same as 1942.8.18.

Exhibited: Union League Club, February 1922, no. 4. Philadelphia 1928, unnumbered. Golden Gate International Exposition, *Historical American Paintings*, San Francisco, 1939, no. 22. Richmond 1944–1945, no. 10. *Early American Portraits and Silver*, J.B. Speed Memorial Museum, Louisville, Kentucky, 1947, no cat.[1] Columbia 1950, no. 12. Atlanta 1951, no. 12. Birmingham Museum of Art, Alabama, 1951. Chattanooga 1952, unnumbered. Mint Museum of Art, Charlotte, North Carolina, 1952, no cat. Randolph-Macon Woman's College, Lynchburg, Virginia, 1952–1953, no cat.[2] Kentucky 1970, unnumbered.

CATHERINE YATES POLLOCK (d. 1805) is posed with her body turned forward, her dark brown eyes directed away from the viewer, in sharp contrast to the penetrating gaze that marks Stuart's portrait of her mother, Mrs. Richard Yates [1940.1.4]. Like her merchant husband George Pollock [1942.8.18], Catherine Pollock may have been in her early thirties when Stuart painted her portrait.[3] She is well dressed, in a youthful style in the fashion of the 1790s. Her dress, with its low neckline filled with a fine gauze fichu and its raised waistline, appears to be made of a filmy white dotted material and is accentuated by a blue sash. Mrs. Pollock's brown hair is curled in ringlets and pulled into a flat chignon that is fastened at the back of her head. The elaborate coiffure includes pearls and blue bows.[4] She wears two strings of pearls around her neck and prominently displays a wedding band on her left hand. A silver basket with a white cloth rests on a table next to her. Seated in a red armchair very similar to the one in her husband's portrait, Mrs. Pollock poses before a green background, with gray paneling to one side.

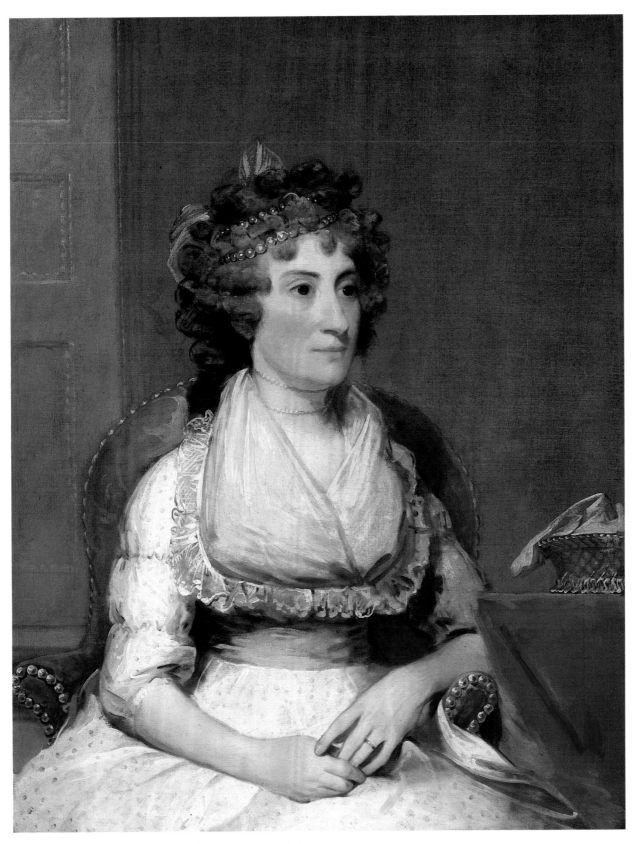

Gilbert Stuart, *Catherine Yates Pollock (Mrs. George Pollock)*, 1942.8.19

The portraits of Catherine and George Pollock are larger than Stuart's images of her parents, Mr. and Mrs. Richard Yates, and their size and kit-cat format allowed the painter to include more of the figure. The painting's technique is exemplary of Stuart's New York style, with a specificity of detail, such as the dots of the fabric or the highlights of the silver basket, combined with fluid, generalizing brushwork, notably in the fichu and the hair. The warm imprimatura under the area of the face is an unusual technical element. William Sawitzky hailed this painting as an example of Stuart's technique, observing that every detail displayed the "completely self-assured, easy grace, which was Stuart's distinctive gift," yet the details "remained in complete subjection to the quiet dignity of the painting as a whole."[5]

CJM

Notes

1. *Speed Bulletin* 1947, unpaginated.
2. Campbell 1953, 7.
3. Her birth date is unknown. She was buried in New Orleans on 15 October 1805; letter from the archivist of St. Louis Cathedral, New Orleans, 23 July 1918, to Charles X. Harris, New York (NGA).
4. Warwick, Pitz, and Wyckoff 1965, 2:pl. 92b.
5. Sawitzky 1933, 91–92.

References

1834 Dunlap: 1:196.
1867 Tuckerman: 109.
1926 Park: 606, no. 649, repro.
1933 Sawitzky: 91–92.
1964 Mount: 169, 373.

1940.1.5 (491)

Lawrence Reid Yates

1793/1794
Oil on canvas, 76.2 × 63.5 (30 × 25)
Andrew W. Mellon Collection

Technical Notes: The painting is on a medium-weight, plain-weave fabric that is very similar to the fabric used for the portraits of Richard Yates [1942.8.29] and Mrs. Richard Yates [1940.1.4] but differs from the canvas used for the portraits of the Pollocks [1942.8.18 and 1942.8.19]. A light gray ground of medium thickness has been applied overall and contributes to the surface tonality in areas such as the face, where it can be seen through thin paint layers. The surface paint is applied in fluid layers, primarily in a wet-in-wet technique. There is little impasto, although the white highlights of the cravat are tex-

tured. The highlights on the buttons are only slightly raised. A thin, dark brown layer of paint is observed below the surface paint at the edges of the hands and hair.

The paint is abraded throughout wherever it is most thinly applied, but only scattered, feathery retouching is apparent. Small damages are located in the upper right corner and over an area of abrasion at the tip of the sitter's coat lapel, where the overpaint is significantly discolored. The varnish is discolored.

Provenance: Same as 1940.1.4.

Exhibited: Union League Club, February 1922, no. 18. Philadelphia 1928, unnumbered. Richmond 1944–1945, no. 8. *The Arts of the Young Republic*, The William Hayes Ackland Memorial Art Center, Chapel Hill, North Carolina, 1968, no. 72.

STUART DEPICTED Lawrence Yates as a stylishly dressed young man seated in a Windsor armchair. Yates wears a gray coat with a wide triangular lapel and a broad buff collar; his hair is powdered.[1] The background wall is gray-green. Like Richard Yates, he has a long aquiline nose. He turns a dreamy gaze to the spectator, and his pose is one of studied inaction and refinement. His arms, exaggerated in length, form a triangle. His left elbow is thrust beyond the arm of the chair and his wrist is turned inward. The quiet image suggests an introspective character. The artist, in painting the elaborately tied cravat, displayed the technical brilliance that won him popularity in Federal America.

Lawrence Yates (d. 1796) was the junior partner in the New York import firm run by Richard Yates. New York city directories list them as partners from 1792 to 1796. His family relationship to Richard Yates (see 1942.8.29) is uncertain, although he is generally assumed to be his younger brother.[2] Like Richard Yates, Lawrence was English, as indicated by his membership in the St. George's Society in New York, to which he was admitted in 1786.[3] In 1795 he married nineteen-year-old Matilda Caroline Cruger, whose portrait by an unidentified artist is part of this series of family portraits [1942.8.13]. The couple had one daughter, Caroline Matilda (1796–1866), who was born the year of Lawrence's death.[4]

A second version of this portrait (Figure 1) was inherited by Caroline Matilda's step-daughter Maria Taylor Hunt, who also inherited the portrait of Yates' wife Matilda Caroline Cruger. Purchased by Charles Henry Hart in 1916 from Mrs. Hunt's nephew James Taylor Van Rensselaer, the second version was sold from Hart's estate in 1918 to

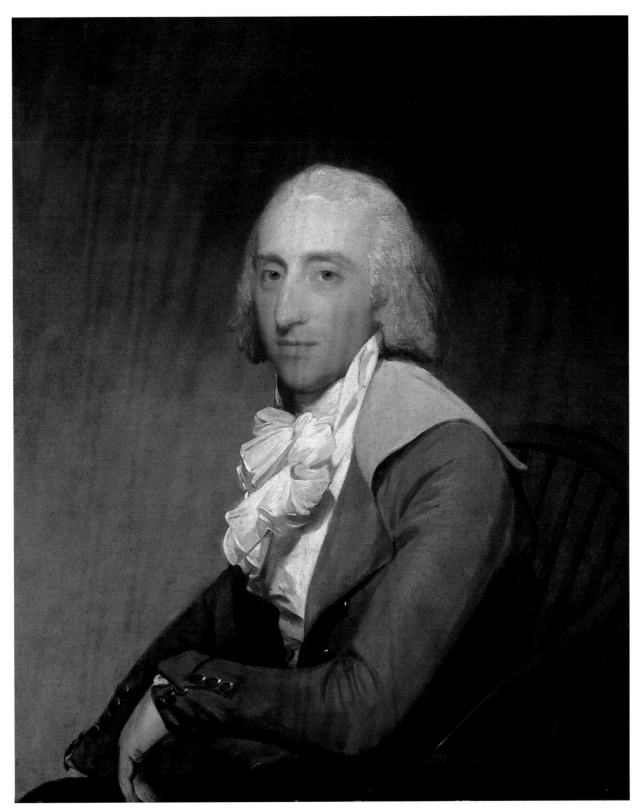

Gilbert Stuart, *Lawrence Reid Yates*, 1940.1.5

Thomas B. Clarke. It was acquired for Henry E. Huntington by the Duveen Brothers at the 7 January 1919 auction of Clarke's collection.[5]

The portrait was also copied by Walter Robertson (1750–1802) in miniature.

CJM

Notes

1. Warwick, Pitz, and Wyckoff 1965, 2:pl. 87c.
2. Lawrence Yates is described as Richard Yates' younger brother in Mason 1879, 282, as well as in a letter from Charles Henry Hart to Thomas B. Clarke, 6 June 1918 (NGA), in the catalogue for the sale of *Clarke* 1919, no. 38, and in Park 1926, 834. He is listed as Lawrence Yates or Lawrence R. Yates in contemporary documents; his full middle name of Reid appears only in Mason (1879) and in later references. His birth date is not known.
3. Letter from John E. McMillin, almoner, St. George's Society, New York City, 30 August 1974 (NGA). The society's membership qualifications included being English or of English descent. Mason 1879, 282, refers to Lawrence Yates as an "English merchant." Also see Park 1926, 834.
4. The couple was married on 2 February 1795, according to the "Register of Marriage" (1:154) of Trinity Church, New York (letter from Frederic S. Fleming, rector, 23 May 1940; NGA). The baptism of Caroline Yates took place on 1 March 1796, according to a letter dated 19 April 1974 from Helen Rose Cline, parish recorder, Parish of Trinity Church, New York City (NGA). A transcript of Lawrence R. Yates' will, dated 24 September 1796 and proved 7 November 1796, is at the New-York Historical Society (photocopy, NGA).
5. Tuckerman 1867, 109, 628, and Mason 1879, 282, as in the collection of Ward Hunt, Utica, New York; Park 1926, 836; *Huntington* 1986, 162, repro. 163. This is probably one of the two family portraits inherited by Van Rensselaer's sister Caroline Van Rensselaer Hillhouse from Mrs. Hunt, whose will and estate inventory are filed with the Surrogate's Court, Oneida County, New York (photocopy, NGA).

References

1834 Dunlap: 1:196.
1926 Park: 834–835, no. 940, repro.
1964 Mount: 170, 377.

1942.8.29 (582)

Richard Yates

1793/1794
Oil on canvas, 75.5 × 62.9 (29 ³/₄ × 24 ³/₈)
Andrew W. Mellon Collection

Technical Notes: The painting is on a medium-weight, plain-weave fabric. The canvas is very similar to that used for the portraits of Mrs. Richard Yates [1940.1.4] and Lawrence Reid Yates [1940.1.5]. The ground does not appear to be the same color throughout. An off-white ground lies underneath the background while a pale cool gray is beneath the figure. As in the portrait *Mrs. Richard Yates* [1940.1.4], the gray is incorporated into the tones of the flesh and the hair and into the whites in general. A pink layer can be detected beneath the papers under a gray layer. The paint is applied in a fresh, direct technique, with smoothly blended areas in the flesh tones. Richly fluid highlights are reduced in height somewhat, probably as a result of a past lining, but the use of impasto never appears as great as in *Mrs. Richard Yates*. The only compositional changes noted are minor adjustments to the length of one of the fingers on the sitter's right hand and to the outline of his left sleeve. In one area about half way up on the right, pink brush strokes are visible underneath a thinly applied area of beige-gray, which enlivens the background.

The painting is fairly badly abraded. A small old hole in the background, about halfway up the right side, has been patched on top of the lining fabric. Small, scattered losses are found throughout. In some areas the tops of the canvas threads are visible. The inpainting—concentrated in the background and coat, in the white areas, in the background just above the papers on the right, and in the flesh—is somewhat discolored. The varnish was removed and the painting lined in 1959. The present damar varnish is discolored to a slight degree.

Provenance: Same as 1940.1.4

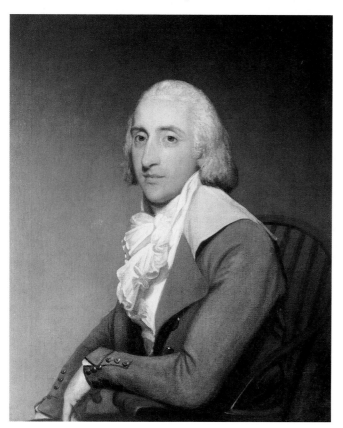

Fig. 1. Gilbert Stuart, *Lawrence Reid Yates*, oil on canvas, c. 1793–1794, San Marino, California, Henry E. Huntington Library and Art Gallery, The Virginia Steele Scott Collection

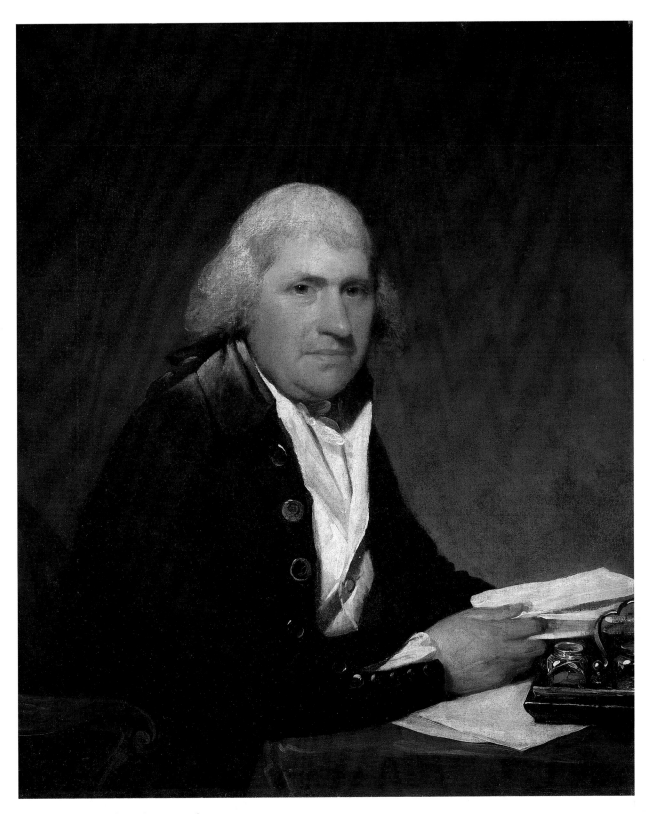

Gilbert Stuart, *Richard Yates*, 1942.8.29

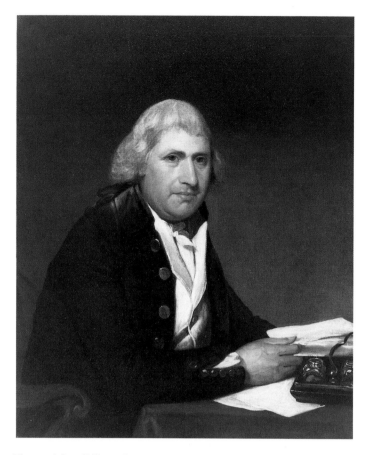

Fig. 1. After Gilbert Stuart, *Richard Yates*, oil on canvas, c. 1793/1794, The Fine Arts Museums of San Francisco, Gift of Mr. and Mrs. John D. Rockefeller 3rd

Exhibited: Union League Club, February 1922, no. 21. Philadelphia 1928, unnumbered. Richmond 1944–1945, no. 7. Hagerstown 1955, no cat. *National Gallery Loan Exhibition*, Mint Museum of Art, Charlotte, North Carolina, 1967, no. 1.[1] Kentucky 1970, unnumbered.

THIS PORTRAIT of New York merchant Richard Yates (1732–1808) is an apt companion for Stuart's painting of the sitter's wife [1940.1.4]. Yates, a bulky man with a ruddy face and large, rounded features, is seated in a Windsor armchair in front of a table covered with a green cloth. Wearing a blue coat, Yates is seen with his hair tied in a queue at the back. Hair powder has fallen on his right shoulder. The merchant holds some papers in his right hand, while others lie on the table under a silver tray with glass jars for ink and sealing wax. Strokes of white highlight the jars, the metal tray handle, and the figure's white waistcoat.

Richard Yates was born in England and moved to New York by 1757, when he married Catherine Brass.[2] A merchant, he became a member of the Chamber of Commerce in 1768.[3] At the beginning of the Revolutionary War he was elected to the Committee of One Hundred, which planned to take charge of New York City during "the present alarming Exigency." He also served as a deputy to New York's provincial congress.[4] Apparently Yates was no revolutionary firebrand and ultimately sided with the British.[5] After the Revolution, he continued his import-export business, with Lawrence Yates [1940.1.5] as his junior partner from 1792. After Lawrence Yates' death in 1796, Richard Yates was joined in the firm by his son-in-law George Pollock [1942.8.18].

Yates' company, which imported goods from Britain and the West Indies, owned a number of ships that took flour, bread, crackers, and other staples to Jamaica and returned with cargoes of sugar, rum, coffee, and ginger.[6] The business suffered severe losses in the late 1790s when French privateers seized a number of ships in which the firm had an interest (see entry for the portrait of George Pollock, 1942.8.18). The company apparently had ceased to exist by the turn of the century; it was last listed in New York City directories in 1799 as "Yates (R.) & G. Pollock's Counting-House, 97 Front St." Yates died in his mid-seventies in 1808.[7]

This portrait was later owned by descendants of Yates' daughter Catherine Pollock [1942.8.19]. A second version, which appears to be an early copy by an unidentified artist (Figure 1), was owned until the 1920s by descendants of Yates' second daughter Sophia, including Clarence Terry (1841–1886), who also owned the copy of *Mrs. Richard Yates* (MFA), which he later gave to his sister Emma Terry Lull. Thomas B. Clarke at one time owned both versions, exhibiting the Terry version in 1928 at the Century Association.[8] A smaller copy (60.6 by 48.6 [23⅞ by 19⅛ inches]) on a scored mahogany panel (Collection of Clifford A. Kaye, Brookline, Massachusetts, 1965) shows less of the figure. A copy of Stuart's portrait of Dr. William Hartigan (?) (see 1942.8.16) was in the same collection.

cjm / egm

Notes

1. Mint *Quarterly* 1967, cover repro.
2. Kerr 1927, 226. Yates was a member in 1789 of the St. George's Society, a group whose membership qualifications included being English or of English descent. See letter from John E. McMillan, almoner, St. George's Society of New York, 25 June 1974 (NGA).
3. Chamber of Commerce records are cited in a letter dated 29 October 1918 from Charles T. Gwynne, secretary, Chamber of Commerce of the State of New York, to Thomas B. Clarke (NGA).

4. Stokes 1915, 4:848–849 (broadside); Lamb 1877, 2:31.

5. Letter of 29 October 1918 from Charles T. Gwynne to Thomas B. Clarke, citing Chamber of Commerce records (NGA).

6. Petition, "Lucy Franklin Read McDonnell v. the United States," 3 December 1886, French Spoilation Case no. 2429; and Statement of Rule, Case no. 3107; U.S. Court of Claims, National Archives, Record Group 123.

7. He was buried in the churchyard of St. Paul's Chapel, Trinity Church, New York; letter from Helen Rose Cline, parish recorder, Parish of Trinity Church in the City of New York, 19 April 1947 (NGA).

8. Century Association 1928, no. 2. According to the Frick Art Reference Library, Clarke bought the portrait from Charles E. Terry in 1926. It was sold at Parke-Bernet on 2 December 1938 (*Hack* 1938, lot no. 32). It later appeared at Ferargil Galleries, New York, in 1942 and at Kennedy Galleries, New York, in 1976.

References
1834 Dunlap: 1:196.
1867 Tuckerman: 109.
1922 Sherman: 144.
1926 Park: 836, no. 942, repro.
1928 Barker: repro. 282.
1964 Mount: 377.
1980 Wilmerding: 52, repro.
1986 McLanathan: 79, repro.
1988 Wilmerding: 60, repro.

1940.1.4 (490)

Catherine Brass Yates (Mrs. Richard Yates)

1793/1794
Oil on canvas, 76.2 × 63.5 (30 × 25)
Andrew W. Mellon Collection

Technical Notes: The painting is on a medium-weight, plain-weave fabric that is very similar to the fabric used for the portraits of Richard Yates [1942.8.29] and Lawrence Reid Yates [1940.1.5], also by Stuart. There is cusping at the top and bottom edges.

The thin gray ground varies in thickness and in tone under different color areas. It often appears as a luminescent pearly shadow in the warm pinks of the flesh tones or is incorporated as a middle tone into areas such as the drapery. The paint is applied in a fresh, direct technique, with an economy of strokes ranging from fluid impasto highlights to thin dry outlines delineating some forms. There are small pentimenti in the position of some fingertips of both hands and in the drapery to the left of the sitter's left hand.

Two old tears were repaired in the background: a curved horizontal one 12 cm long at the upper left, and a 9 cm vertical tear at the lower left. There are a few scattered losses, and scattered moderate abrasion in the right side of the face and cap. The varnish was removed in 1956. The present varnish is quite discolored.

Provenance: The sitter's daughter Catherine Yates Pollock [c. 1760–1805] and her husband George Pollock [1762–1820], New York and New Orleans; their son Carlile Pollock [1791–1845], New Orleans; his daughter Marie Louise Pollock Chiapella [1828–1902]; possibly to her son Henry Chiapella [1849–c.1908]; his daughter Louise Chiapella Formento, New Orleans; sold to Isaac Monroe Cline [1861–1955], New Orleans, in 1911;[1] purchased 16 January 1918 by Thomas B. Clarke [1848–1931], New York;[2] his estate; sold as part of the Clarke collection on 29 January 1936, through (M. Knoedler & Co., New York), to The A.W. Mellon Educational and Charitable Trust, Pittsburgh.

Exhibited: Union League Club, February 1922, no. 2. Philadelphia 1928, unnumbered. *Trois Siècles d'Art aux Etats-Unis*, Musée de Jeu de Paume, Paris, 1938, no. 165. *Life in America*, MMA, 1939, no. 53. *Art of the United Nations*, Art Institute of Chicago, 1944–1945, 46. *Old and New England*, RISD, 1945, no. 60. *American Painting from the Eighteenth Century to the Present Day*, Tate Gallery, London, 1946, no. 207. *40 Masterpieces: A Loan Exhibition of Paintings from American Museums*, City Art Museum of St. Louis, 1947, no. 36. *Fifty Paintings by Old Masters*, Art Gallery of Toronto, Ontario, 1950, no. 44. *Diamond Jubilee Exhibition: Masterpieces of Painting*, Philadelphia Museum of Art, 1950–1951, no. 59. *Landmarks in American Art, 1670–1950*, Wildenstein and Co., Inc., New York, 1953, no. 7. *Painters' Painters*, Buffalo Fine Arts Academy, Albright Art Gallery, Buffalo, New York, 1954, no. 19. *Face of America, The History of Portraiture in the United States*, The Brooklyn Museum, New York, 1957–1958, no. 25. *Treasures in America*, Virginia Museum of Fine Arts, Richmond, 1961, no. 94. *Carolina Charter Tercentenary Exhibition*, North Carolina Museum of Art, Raleigh, 1963, no. 32. *200 Years of American Painting*, City Art Museum of St. Louis, 1964, 6. *Gilbert Stuart*, NGA; RISD, 1967, no. 19. *American Art: 1750–1800 Towards Independence*, YUAG; The Victoria and Albert Museum, London, 1976, no. 46. *La Pintura de Los Estados Unidos de Museos de la Ciudad de Washington*, Museo del Palacio de Bellas Artes, Mexico City, Mexico, 1980–1981, no. 5.

THIS INCISIVE STUDY of a merchant's wife is one of Stuart's best-known portraits. It has been prized for many years as an American masterpiece for its freshness of vision and its interpretation of a forceful personality. It has been hailed for its sophisticated technique, comparable to the achievements of major European artists, and for its "American" attributes. After its first public exhibition at the Union League Club in 1922, critic Royal Cortissoz compared the painting to the work of Velázquez. Four years later John Hill Morgan rhapsodized on the painting in his introduction to Lawrence Park's

catalogue raisonné of Stuart's work, calling its "harmony in grays" almost "Whistlerian." Frederic Fairchild Sherman said it showed "how powerfully the native influence in art moved [Stuart] at times."[3]

Catherine Brass Yates (1736?–1797?) was the second of nine children born to shoemaker Adolph Brass and his wife Maria Carstang. Her father, a property owner in New York, served as a fireman, constable, and tax collector and assessor. Members of her mother's family, possibly of Huguenot origin, were ropemakers. In 1757 Catherine Brass married Richard Yates [1942.8.29], a merchant who imported goods from Europe and the West Indies.[4] Their two daughters married brothers: Catherine Yates [1942.8.19] married George Pollock [1942.8.18], who became her father's business partner, and Sophia Yates married Carlile Pollock, an insurer and businessman. The three families had adjoining country houses on the banks of the Hudson River, where Grant's Tomb is now located.[5]

In his New York paintings, Stuart staked his claim to an artistic primacy in American portraiture. *Mrs. Richard Yates* is unusual, even among this group of paintings, because of its insightful analysis of character and its use of significant gesture. Stuart depicts Mrs. Yates as an elegantly dressed matron in her mid-fifties. Her silk dress, with long, narrow sleeves and a fichu, or scarf, over the bodice, is a glimmering combination of whites and silver grays, with slight dashes of red on the silk near her left elbow that capture the reflections of the red chair. Her dark hair is covered by a gauze mobcap decorated with a large bow, a style of at-home dress that became fashionable in the 1780s.[6] A gold wedding band serves as her only jewelry. Mrs. Yates' high cap emphasizes her features—large eyes and raised eyebrows, a sharply pointed nose and chin. She momentarily pauses in her sewing to face the viewer with a cool, assessing gaze. In her lap her left hand holds a piece of fabric that she is stitching. The forefingers and thumb of her raised right hand hold a needle, its sharp tip pointed upward, as her little finger tenses the thread that leads from the fabric.

Mrs. Yates' portrait has been cited as an example of American industriousness, yet English portraits by Stuart's contemporaries also show women sewing or doing needlework. Sir Joshua Reynolds' *Anne, Countess of Albemarle* (1757-1759, National Gallery of Art, London) and *Lady Caroline Fox* (1757–1758, private collection) both show sitters occupied with handwork.[7] An Anglo-American example is John Singleton Copley's *Mrs. Seymour Fort* (Wadsworth Atheneum, Hartford), which was painted in England and may have been exhibited at the Royal Academy of Arts in 1778, when Stuart was in London. Copley's painting does not convey the same tension as that of Mrs. Yates, with which it is often compared.[8] Stuart himself had used the theme of sewing in his double portrait *Miss Dick and Her Cousin, Miss Forster* (1787–1792, Collection Mr. and Mrs. R. Philip Hanes, Jr.), which was painted in Ireland. Miss Dick draws a design on a piece of silk in preparation for needlework.[9] She looks up at the viewer in the same way as Mrs. Yates, but without the older woman's sharpness.[10]

An early copy of this portrait by an unidentified artist (Figure 1) once belonged to the sitter's great-granddaughter Mrs. Emma G. Lull of Washington,[11] who also owned the second version of Stuart's portrait of Richard Yates (The Fine Arts Museums of San Francisco, Gift of Mr. and Mrs. John D. Rockefeller 3rd).

CJM

Fig. 1. After Gilbert Stuart, *Mrs. Richard Yates (Catherine Brass)*, oil on canvas, c. 1793/1794, Boston, Museum of Fine Arts, Henry Lillie Pierce Residuary Fund [photo: Courtesy, Museum of Fine Arts, Boston]

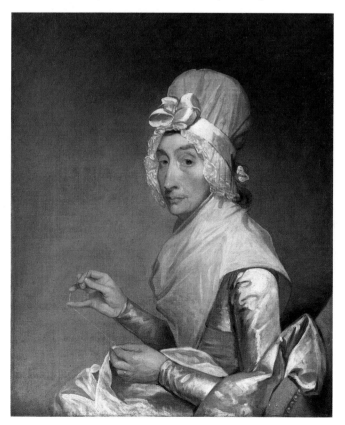

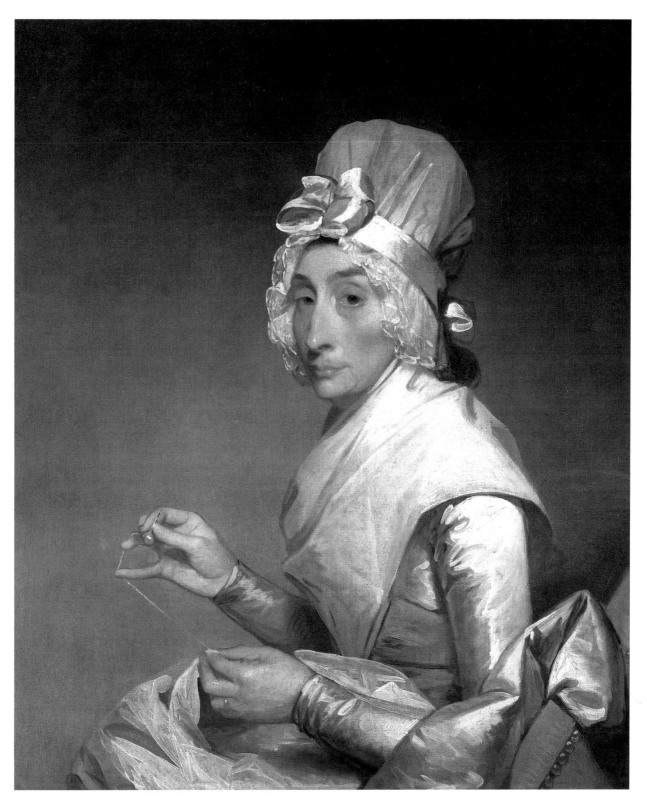

Gilbert Stuart, *Catherine Brass Yates (Mrs. Richard Yates)*, 1940.1.4 (see also color frontispiece)

Notes

1. Cline wrote Thomas B. Clarke in New York on 11 February 1918 that he had purchased the portraits of Mrs. Yates, her husband Richard Yates [1942.8.29], and Lawrence Reid Yates [1940.1.5] in 1911 and had later bought portraits of their daughter Catherine Yates Pollock [1942.8.19] and her husband George Pollock [1942.8.18] (NGA). Cline told David E. Finley that he had purchased all five Stuart portraits from Formento; letter of 1 March 1948 (NGA). For Cline's dates see *New Orleans Artists* 1987, 81. For the Pollock family see Hayden 1883, 48; letters from Bureau of Archives, St. Louis Cathedral, New Orleans, 3 April 1919 and 23 July 1918; "Last Will and Testament of George Pollock," signed 2 September 1819, New Orleans, and will of Carlile Pollock, signed 16 April 1845, New Orleans (copies, NGA).

2. The name of the seller and the date of purchase are recorded in an annotated copy of *Clarke* 1928 in the NGA library. Clarke sent Clarence J. Dearden of Art House, Inc., to New Orleans to negotiate the purchase of the five portraits; Dearden confirmed the purchase in a telegram to Clarke on 16 January 1918 (NGA).

3. Cortissoz 1924, 111; Morgan, in Park 1926, 78; Sherman 1932, 28. It has frequently been published as one of the treasures of American art.

4. Mrs. Yates was baptized on 25 January 1736 at the Dutch Reformed Church in New York; she died sometime after March 1797. See Kerr 1927, 221, 224–225.

5. "A Child's Monument," *Evening Post*, New York, 26 April 1897, 12.

6. Warwick, Pitz, and Wyckoff 1965, 2:pl. 76b.

7. Lady Albemarle is shown making a decorative linen braid with the aid of a small shuttle, an activity called "knotting"; Penny 1986, 190–191, 194–195. Ribeiro, *Dress in Europe*, 1984, 113, notes that knotting was an acceptable pastime at court, where it gave ladies "a chance to show off the graceful attitudes of the hands."

8. Prown 1966, 2:267. Numerous authors have contrasted the portraits of Mrs. Fort (the identification is uncertain) and Mrs. Yates, using the comparison to discuss individual artists' styles as well as to generalize about English and American painting and their characteristics.

9. *Stuart* 1967, cat. no. 14.

10. Donald D. Keyes, in *Stuart* 1967, 64, suggested that Mrs. Yates was cross-eyed and that Stuart attempted to disguise this condition. This notion was apparently based on a comparison of the portrait with a miniature by an unidentified artist that is also said to represent Mrs. Yates (NMAA). The sitter's identity in the miniature is uncertain, however, and her cross-eyed appearance may have resulted from the artist's ineptitude. Two ophthalmologists consulted on this issue, Dr. Marshall M. Parks of Washington and Dr. Charles Letocha of York, Pennsylvania, said that the Stuart painting of Mrs. Yates does not suggest a vision defect, although the miniature left them with some uncertainty.

11. MFA 1969, 1:261–262.

References

1834 Dunlap: 1:196.
1867 Tuckerman: 109.
1922 Sherman: 141 repro., 144.
1924 Cortissoz: 110–111, repro.
1926 Park: 78, 80, 837, no. 943, repro.
1928 Barker: 284, repro. 272.
1932 Sherman: 28, 49, 82, pl. 31.
1950 Barker: 246, pl. 32.
1953 Goodrich: 109, cover repro.
1956 Richardson: 98.
1964 Mount: 169–170, 177, 184–185, 377.
1969 Novak: 35–36, repro. 34.
1980 Wilmerding: 52, color repro. 53.
1981 Dinnerstein: 113, 115, fig. 3.
1981 Williams: color repro. 51, 65, 66 (detail).
1984 Walker: 380, color pl. 538.
1986 McLanathan: 79, color repro. 80.
1988 Wilmerding: 60–61, no. 7 (color repro.).

1942.8.20 (573)

Stephen Van Rensselaer

1793/1795
Oil on canvas, 91.7 × 71.3 (36 1/8 × 28 1/8)
Andrew W. Mellon Collection

Technical Notes: The support is a plain-weave linen with cusping along the top, bottom, and left sides. The tonality of the moderately thick gray ground appears to vary slightly from the background to the area of the figure. It was applied with a knife or scraper. The paint is thin, fluid, and smoothly applied with some texture in the highlights. Features are laid in economically with thin, feathered strokes. Flesh tones are applied in layers, and highlights on the forehead and cravat are put in with rich white paint in a thin opaque layer. A thin transparent glaze of red is added over the background at the perimeter of the sitter's head.

The enhancement of the fabric weave may be due to a past lining. There is a small area of retouching to the right, above the sitter's head, and minor retouches to the left of the sitter's shirt. Severely discolored residues of an older varnish lie beneath the present varnish.

Provenance: The sitter's son William Patterson Van Rensselaer [1805–1872], New York; his son Kiliaen Van Rensselaer [1845–1905]; his son Kiliaen Van Rensselaer [1879–1949], New York;[1] sold 13 February 1919 to Thomas B. Clarke [1848–1931], New York;[2] his estate; sold as part of the Clarke collection on 29 January 1936, through (M. Knoedler & Co., New York), to The A.W. Mellon Educational and Charitable Trust, Pittsburgh.

Exhibited: American Academy of the Fine Arts, New York, 1819, no. 48.[3] *Loan Exhibition of Colonial Relics*, MMA, 1907, no cat.[4] Union League Club, February 1922, no. 19. Philadelphia 1928, unnumbered. Richmond 1944–1945, no 11. Hagerstown 1955, no cat. NPG, on long-term loan, 1967–1990.

STEPHEN VAN RENSSELAER (1764–1839), the eighth patroon of the Van Rensselaer family, was

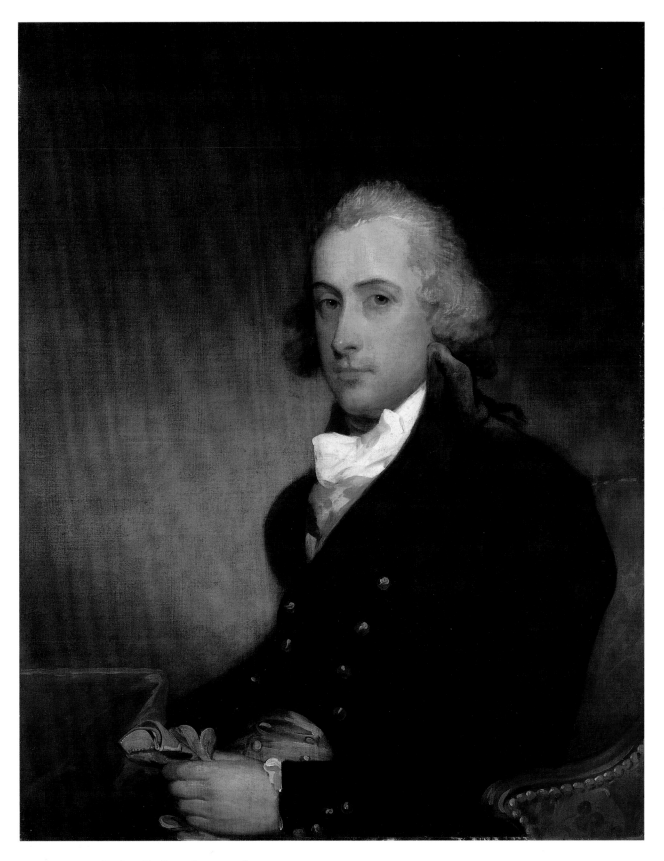

Gilbert Stuart, *Stephen Van Rensselaer*, 1942.8.20

one of the wealthiest men in New York state. He graduated from Harvard College in 1782 and was elected as a Federalist to the New York Assembly in 1789 and 1790. He served in the state Senate from 1791 to 1795, the period when this carefully orchestrated composition of browns and yellow ochres was painted. Van Rensselaer served as a United States congressman from 1823 to 1829, casting the tie-breaking vote in favor of John Quincy Adams in the presidential election of 1824. Also in that year he founded the school in Troy, New York, that became the Rensselaer Polytechnic Institute.[5]

Van Rensselaer wears a brown coat, a yellow-ochre waistcoat, and a white shirt and cravat, with his hair powdered and tied in a queue. He holds a pair of yellow-ochre gloves in his hand. He is seated in a red damask armchair next to a table covered with a red cloth, which is set against a warm brown background. The portrait, done with an economy of brush strokes, was probably painted in New York City rather than at the Van Rensselaer's manor house in Albany, as descendants of the sitter believed. When it was exhibited in 1819 at the American Academy of the Fine Arts, the catalogue dated the portrait to 1795.[6] Since this implies that Stuart returned to New York from Philadelphia, where he had gone in 1794, the date is probably incorrect.

Of the two other versions of this portrait attributed to Stuart, one represents only the head (Diplomatic Reception Rooms, U.S. Department of State, Washington) and is a copy by an unidentified artist.[7] The second, recently acquired by the Albany Institute of History and Art, New York,[8] has been described as a gift to John Jay from Van Rensselaer in return for a portrait of Jay at The Brook Club, New York.[9] Van Rensselaer was lieutenant-governor of New York from 1795 until 1801 during John Jay's term as governor.

EGM

Notes

1. Brief notices of Van Rensselaer's descendants are in Cutter 1913, 1:11–12; for Kiliaen Van Rensselaer's date of death see his obituary in the *New York Times*, 24 August 1949, 25.
2. The name of the seller and the date of purchase are recorded in an annotated copy of *Clarke* 1928 in the NGA library.
3. "Portrait of the Honourable Stephen Van Rensselaer, painted in the year 1795" by Stuart; no lender is listed. Cowdrey 1953, 2:341.
4. Letter from Eleanor Van Rensselaer Fairfax to Thomas B. Clarke, 10 March 1919 (NGA); the exhibition was organized by the Colonial Dames of the State of New York as a preview to the Jamestown Tercentennial Exposition held in Norfolk, Virginia, in the summer of 1919. The exhibition is briefly discussed in *BMMA* 1907, 71.
5. On Van Rensselaer see Cutter 1913, 1:6–11; *DAB* 10 (part 1):211–212; and Van Doren 1974, 1072.
6. Cowdrey 1953, 2:341.
7. Park 1926, 777, no. 867, measuring 77.5 by 59.7 cm (30 ½ by 23 ½ inches) on canvas, repro.; Conger and Rollins 1991, 399, no. 255 repro. Its early history is unknown.
8. It measures 91.4 by 71.1 cm (36 by 28 inches), on bedticking; Mason 1879, 273–274; Park 1926, 776–777, no. 866, not illustrated; sold from the collection of Jay's descendants, Christie, Manson & Woods, New York, on 25 January 1986, lot 237 (*Jay Family* 1986, 18–19, color repro.).
9. Park 1926, 438, no. 439, measuring 128.3 by 105.4 cm (50 ½ by 41 ½ inches); a version of the portrait is owned by the Diplomatic Reception Rooms, U.S. Department of State, Washington.

References

1888 Van Rensselaer: 17–21, repro.
1907 Pelletreau: 2: repro. facing title page.
1926 Park: 775–776, no. 865, repro.
1964 Mount: 376.
1984 McClave: frontispiece.

1942.8.11 (564)

Captain Joseph Anthony

1794
Oil on canvas, 91.5 × 71 (36 × 28)
Andrew W. Mellon Collection

Technical Notes: The original medium-weight, plain-weave fabric has two lining fabrics. During treatment in 1943–1944, the older lining fabric was left sandwiched between the original fabric and the newer lining. Cusping is found only along the left edge of the original fabric.

The ground is a thin white layer. A gray layer, used as a shadow tone, may replace the white ground under the flesh tones. The paint is applied in a thin, fluid manner, with the most detail and blending in the face. A more sketchy application of paint is seen in the jacket and hand, and a summary outlining of shapes is found in the chair and paper. The artist changed the outer contours of the sitter's blue coat, which has been widened on the right side by as much as 3.8 cm. At the same time, the corresponding inner edge of the coat was moved to the right, broadening the area of the vest. The upper left edge of the jacket also may have been widened. The cream-colored waistcoat has been painted in part over the blue of the jacket.

An old tear, 22 cm long, is located just above the quill pen. Enhancement of the fabric texture may be due to a past lining. Small, scattered dots of discolored retouch-

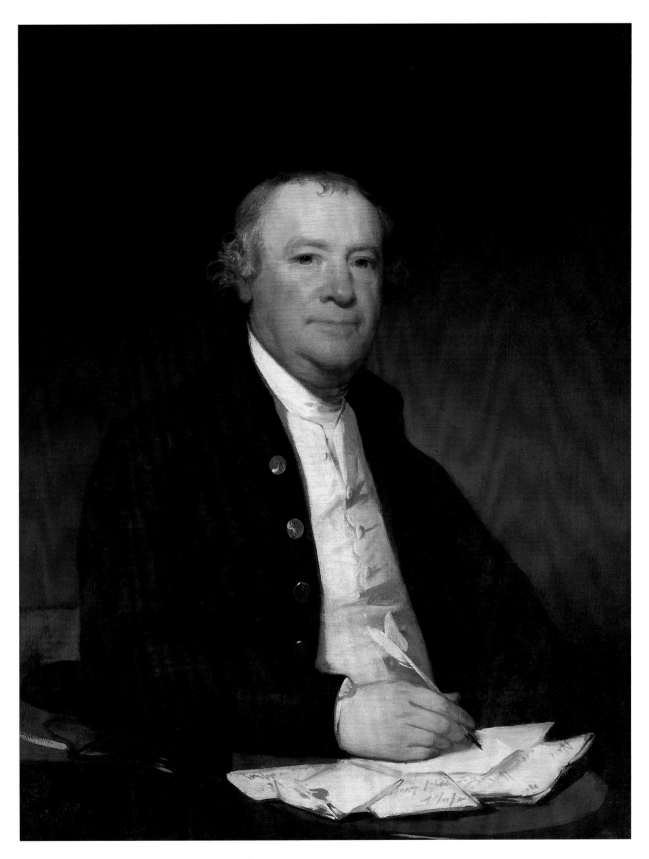

Gilbert Stuart, *Captain Joseph Anthony*, 1942.8.11

ing and some abrasion can also be observed. The varnish was removed when the painting was relined in 1943–1944. The present varnish is dull and streaky.

Provenance: The sitter's great-grandson Thomas Duncan Smith [1812–1880], Philadelphia;[1] his widow Mrs. Thomas Duncan Smith, Philadelphia;[2] their son William Rudolph Smith [d. 1922], Philadelphia;[3] sold by the trustees of his estate on 30 January 1923 to Thomas B. Clarke [1848–1931], New York;[4] his estate; sold as part of the Clarke collection 29 January 1936, through (M. Knoedler & Co., New York), to The A.W. Mellon Educational and Charitable Trust, Pittsburgh.

Exhibited: *Loan Exhibition of Historical Portraits*, PAFA, 1887–1888, no. 10. Union League Club, March 1924, no. 17. Philadelphia 1928, unnumbered. Richmond 1944–1945, no. 15.

JOSEPH ANTHONY (1738–1798), Gilbert Stuart's uncle and benefactor, lent encouragement and vital assistance to the artist on several occasions during his career. The son of Albro and Susan Anthony of Middletown, Rhode Island, Joseph Anthony was a merchant captain in Newport in his early years. His sister Elizabeth was Gilbert Stuart's mother. In the 1770s he traveled frequently to Philadelphia, where he settled by 1782 and ran a shipping firm in partnership with his son, trading with the West Indies, New York, and Boston.[5]

Anthony "was struck with admiration" by Stuart's earliest paintings. He was said to be particularly affected by a portrait that the young man, not yet twenty years old, had made from memory of Anthony's mother.[6] The captain commissioned him to make portraits (now lost) of his family, according to Benjamin Waterhouse, a childhood friend of Stuart, who wrote that "he was proud of patronizing his ingenious nephew."[7] In London, Anthony's name paved the way for Stuart's meeting with Benjamin West. According to one account, Stuart arrived unannounced when West was dining with several Americans, including "Mr. Wharton" from Philadelphia. Wharton was sent to determine the identity of the visitor. After learning that Stuart carried no letters of introduction, Wharton asked who he knew in Philadelphia. "Joseph Anthony," Stuart replied, and Wharton, recognizing the name, declared, "That's enough—come in."[8]

On his return to the United States in 1793, Stuart resumed his close association with his uncle. He had already begun painting this portrait of Anthony when he wrote from New York on 2 November 1794 that he was planning to visit Philadelphia.

"The object of my journey is only to secure a picture of the President, & finish yours."[9] The painting is similar to Stuart's depiction of New York merchant George Pollock [1942.8.18]. Its manner exhibits all the hallmarks of his New York portraits: strong highlights, varied brushwork, and a tightly structured composition. It shows Anthony in his mid-fifties, with thinning and graying brown hair and a pleasant expression on his ruddy face. He wears a blue coat with gold-colored buttons, a pale yellow waistcoat, and plain white stock. He sits in a Windsor writing chair, holding a quill pen that is poised over an array of documents. A few quick strokes of light-colored paint define the forward edge of the broad arm of the chair, which is covered with green cloth to provide a writing surface. The writing on the papers in front of Anthony is illegible; a red wax seal is seen on one letter.

Stuart painted two other portraits of his uncle. One, a bust portrait similar to this painting but without hands, shows Anthony wearing a blue brocade coat (1795, PAFA).[10] The other, a bust version that combines elements of both paintings, is unlocated.[11] Stuart also painted Anthony's son Joseph Anthony, Jr., a silversmith, and daughter-in-law Henrietta Hillegas Anthony (MMA).

CJM

Notes

1. This portrait is first recorded in MFA 1880, 29, no. 20, as being owned by Thomas D. Smith. Park 1926, 105–106, proposed that the provenance was from Joseph Anthony, Jr. (1762–1814), Philadelphia, the son of the sitter, to his daughter Eliza Anthony Smith (Mrs. William Rudolph Smith, 1789–1821), and after her husband's death in 1868, to their son Thomas D. Smith.
2. PAFA 1887, as lent by "Mrs. Thomas D. Smith."
3. "J. Rudolph Smith" is listed as the owner in "Stuart" 1906, 39; Fielding 1914, 315, lists "William R. Smith" as the owner.
4. A letter from Gordon Howard of Frank Partridge, Inc., New York, dated 23 January 1923, to Thomas B. Clarke, discusses the condition and price of the painting after it was offered for sale at Maclees' Gallery in Philadelphia (NGA). The name of the seller and the date of purchase are recorded in an annotated copy of *Clarke* 1928 in the NGA library.
5. Gillingham 1929, 208–209; Gillingham 1924, 240, 241, 245. In his will, dated 13 June 1794, Anthony described himself as "late of Newport, now of the City of Philadelphia" (copy, Historical Society of Pennsylvania, Philadelphia).
6. Dunlap 1834, 1:167.
7. Dunlap 1834, 1:167, quoting from Waterhouse's memoir of Stuart.
8. Wharton described this incident to painter Thomas

Sully, according to Dunlap 1834, 1:174. A similar story is told by the artist's daughter in Stuart 1877, 642.

9. Photostat, Massachusetts Historical Society, Boston. The unlocated original was once owned by Thomas B. Clarke; Park 1926, 105–106.

10. The portrait was bequeathed by Oliver Wolcott Gibbs of Cambridge, Massachusetts, to the Academy in 1909; Gibbs obtained the painting by descent from his grandfather George Gibbs of Boston, who was an early partner of Captain Anthony; curatorial file, PAFA; see also Park 1926, 106, no. 24, and Stuart 1967, 4, no. 1.

11. Park 1926, 106–107, no. 25, repro.; according to the Catalog of American Portraits, NPG, it was in the collection of Felix Kuntz in New Orleans in the 1970s.

References
1880	MFA: 29, no. 20.
1906	"Stuart": 38–39, pl. 6.
1914	Fielding: 315.
1924	Cortissoz: 110.
1926	Park: 105–106, no. 23, repro.
1929	Gillingham: 209.
1964	Mount: 168, 183, 191, 348, 363–364.
1986	McLanathan: repro. 79.

1942.8.27 (580)

George Washington (Vaughan portrait)

1795
Oil on canvas, 73.0 × 60.5 (28 3/4 × 23 3/4)
Andrew W. Mellon Collection

Inscriptions: Inscribed on the reverse of the original canvas, in a contemporary or slightly later hand: "General Washington By Mr Stuart. 1795"[1]

Technical Notes: The support is a medium-weight twill fabric with some uneven threads. The white ground is smoothly applied but contains some rather large inclusions that are visible on the paint surface. The paint was applied thinly and quickly. This is evident in the black of the coat, where the diagonal twill weave is emphasized by the brushwork. Color areas slightly overlap. There is impasto only in the shirt ruffle. The transparent brick red tone was added around the area of the head and does not extend under it; one can identify only a white ground layer beneath the paint in a loss in the flesh area. Instead, the brick red tone overlaps the edges of the white hair and the flesh tones and was painted after the face and hair were partially completed. Adjustments to the hair are painted over the dark tone of the background.

An L-shaped tear in the lower right quadrant extends into Washington's left jacket lapel. The varnish was removed and the painting lined in 1961. The present varnish has some scratches and abrasion.

Provenance: Purchased by John Vaughan, Philadelphia, for his father Samuel Vaughan [1720–1802], London; his son William Vaughan [1752–1850], London;[2] purchased around 1851 by Joseph Harrison, Jr. [1810–1874], Philadelphia;[3] his widow Sarah Poulterer Harrison [1817–1906]; sold (M. Thomas and Sons, Philadelphia, 12 March 1912, no. 30), to Thomas B. Clarke [1848–1931], New York;[4] his estate; sold as part of the Clarke collection on 29 January 1936, through (M. Knoedler & Co., New York), to The A.W. Mellon Educational and Charitable Trust, Pittsburgh.

Exhibited: Boston 1880, no. 262. *Loan Exhibition of Historical Portraits*, PAFA, 1887–1888, no. 448. Metropolitan Opera House, 1889, no. 30.[5] Philadelphia 1928, unnumbered. *Exhibition of Historical Portraits, 1585–1830*, Virginia Historical Society, Richmond, 1929, unnumbered.[6] *George Washington Bicentennial Historical Loan Exhibition of Portraits of George Washington and his Associates*, CGA, 1932, no. 12. *Masterpieces of Art*, World's Fair, New York, 1940, no. 181. Richmond 1944–1945, no. 12. *American Painting from the Eighteenth Century to the Present Day*, Tate Gallery, London, 1946, no. 203. Chattanooga 1952, unnumbered. *Gilbert Stuart*, NGA; RISD; PAFA, 1967, no. 27. *Presidential Portraits*, NPG, 1968, unnumbered. *Harry D.M. Grier Memorial Loan Exhibition*, The Frick Collection, New York 1972, no. 11.

STUART's "Vaughan" portrait of George Washington, named for its first owner, Samuel Vaughan, has been regarded since the 1840s as the painting that Stuart made from life in 1795. It now appears instead to be an early replica. Stuart wrote in 1823 of the unlocated original that he had "rubbed it out." How this misidentification occurred is part of the complex history of Stuart's portraits of Washington.

Gilbert Stuart went to Philadelphia in the late autumn of 1794 expressly to paint Washington's portrait. The sitting or sittings took place that winter or, according to Jane Stuart, "towards the Spring of 1795."[7] On 20 April 1795 Stuart compiled "A list of gentlemen who are to have copies of the Portrait of the President of the United States." The thirty-two names on the list included Philadelphia merchant John Vaughan: "J. Vaughan 200 2." The entry indicates that he paid $200 for two, and the inclusion of the price suggests that he paid Stuart when placing his request. Others who ordered portraits included the Marquis of Lansdowne, Benjamin West, Aaron Burr, John Jay, and the firm of Messrs. Pollock, New York.[8] Vaughan sent one of his portraits to London to his father Samuel Vaughan, an English merchant who was an admirer of Washington and had lived in Philadelphia from 1783 to 1790.[9] The portrait arrived sometime before 2 November 1796, the publication date on the engraving of the portrait made by Thomas

Holloway for the third volume of the English edition of John Caspar Lavater's *Essays on Physiognomy* (1789–1798). The engraving is inscribed "from a Picture painted by Mr. Stuart in 1795, in the possession of Samuel Vaughan Esqr." The analysis of Washington's physiognomy in the accompanying text complained that the technique of the portrait should have been "broader and more vigorous" but added, "Every thing in this face announces the good man, a man upright, of simple manners, sincere, firm, reflecting and generous."[10]

Stuart's success at painting Washington led to commissions for new portraits from Martha Washington and Mrs. William Bingham. The artist preferred the portrait that he painted for Mrs. Washington, known today as the "Athenaeum" portrait, and kept it in his studio, abandoning the earlier image on which Vaughan's portrait was based after he made about a dozen replicas. He explained the fate of the first life portrait in 1823 in an inscription he added to a letter from George Washington, which he had saved. The letter, dated 11 April 1796, discussed arrangements for a sitting for the Lansdowne full-length. "Sir: I am under promise to Mrs. Bingham, to set for you tomorrow at nine oclock, and wishing to know if it be convenient to you that I should do so, and whether it shall be at your own house (as she talked of the State House) I send this note to you, to ask information." In an explanatory inscription added on 9 March 1823, Stuart noted that the portrait in question was then owned by Samuel Williams of London. "I have thought it proper it [the letter] should be his, especially as he owns the only original painting I ever made of Washington except one I own myself [the Athenaeum portrait]. I painted a third, but rubbed it out. I now present this to his Brother, Timo. Williams, for said Samuel." T. Williams added a note: "N.B. Mr. Stuart painted in the *winter season* his first portrait of Washington, but destroyed it. The next portrait was ye one now owned by S. Williams; the third Mr. S. now has — two only remain as above stated."[11] Thus, the original was "rubbed out," and the Vaughan was an early replica.

Who, then, is the source of the idea that the Vaughan portrait was the original life portrait? The claim, according to John Hill Morgan and Mantle Fielding, "rests largely on letters and statements of the artist Rembrandt Peale" and was promoted vigorously by Thomas B. Clarke after he acquired the painting at auction in 1912.[12] Peale in the 1830s and 1840s was eager to document his own sittings

with Washington, which occurred in the fall of 1795. On 27 December 1834 he wrote William Dunlap that "when Washington had given me one sitting his second was delayed by an engagement to sit to Stuart."[13] On 16 March 1846 he sent the same information to C. Edwards Lester, adding that Stuart made only five copies before selling the original to "Winstanley the Landscape Painter, who took it to England."[14] Peale first saw the painting after Joseph Harrison purchased it and brought it to the United States from London. Peale borrowed it to make a copy for his lectures on portraits of Washington, and he wrote Harrison on 16 February 1859, when he returned it, that it was the "*first Original* Portrait painted by Stuart in September 1795, at the same time that Washington sat to me. After making five Copies of it, Mr. Stuart sold it to Winstanley, the Landscape Painter, who took it to England, and doubtless sold it to Wm. Vaughan, from whose Nephew you bought it."[15] Rembrandt Peale repeated this information in his lecture, using his painted copy of the portrait (New York Public Library) as an illustration.[16]

Peale's memory was accurate only in the details. First, Stuart had completed his first portrait of Washington by the fall of 1795. Second, although Winstanley did own a version of the Vaughan portrait, which he believed was the original, he acquired it after Vaughan had received his portrait, and like Vaughan's it was a replica. On 23 December 1799, very soon after Washington's death, Winstanley wrote Tobias Lear, Washington's private secretary, that he was planning to paint a full-length of the late president and wanted to borrow one of Washington's velvet suits. "To deliniate his likeness as correctly as possible, I have lately purchased the original head painted from life by Stuart, and have paid a very liberal price for it."[17] He soon took the painting to Washington, D.C. Anna Maria Thornton, wife of William Thornton, noted in her diary on 5 July 1800, "Mr. Winstanley's boxes came. They contain an original likeness of Genl Washington by Stewart — A small full length copied by Mr. W. from one of Stewart's — & several copies of the Bust, by Mr. W. . . . Stewarts original is very like but not an agreeable likeness." Next, according to Mrs. Thornton, miniaturist Robert Field borrowed "of Mr Winstanley Genl Washington's picture by Stewart to copy in Miniature." He completed the copy by 3 December: "Mr. Field brought the miniature of Genl Washington which he is painting from Stewart's Original, lent him by

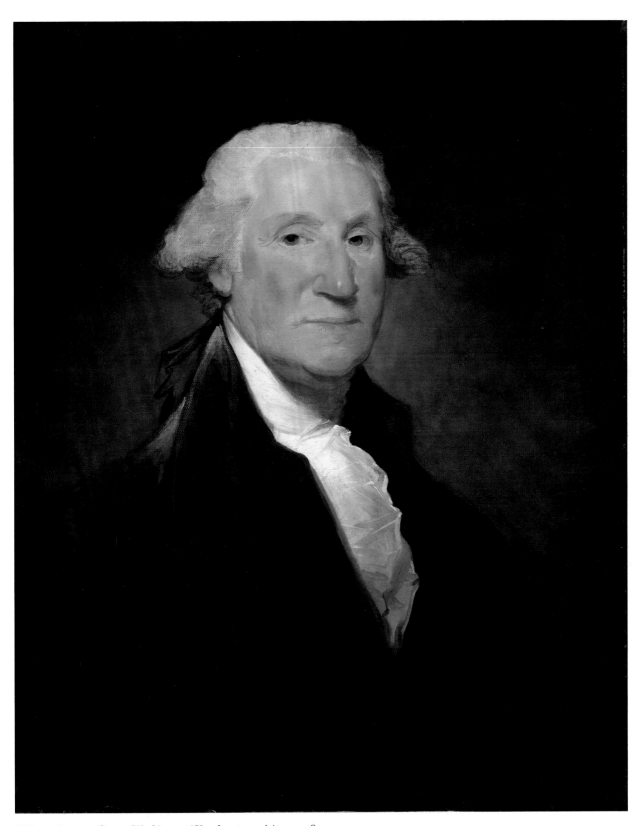

Gilbert Stuart, *George Washington (Vaughan portrait)*, 1942.8.27

Fig. 1. X-radiograph of detail of 1942.8.27

and the others that had been owned by George Gibbs of New York (MMA) and William Bingham of Philadelphia (The Henry Francis du Pont Winterthur Museum, Delaware) were still in private collections.[20]

Stuart's "Vaughan" portrait of Washington possesses the liveliness characteristic of his paintings of the 1790s. The face is carefully painted, with thin, dark lines added below the mouth and around the eyes. The twill weave of the canvas is visible through the thinly painted hair. Much of the detailed brushwork is revealed by x-radiography (Figure 1), which shows that Stuart heavily outlined the face and the features. When x-radiographs are compared with those of the Vaughan-Sinclair version [1940.1.6], it is clear that, although the second example is less precisely painted, the two portraits share the same type of highlighting, and the same technique of outlining the eyes and of using thinly painted canvas for shadowed areas. Close comparison of the x-radiograph with that of Stuart's "Athenaeum" portrait, his second life portrait of Washington (Figure 2) reveals that in the second painting Stuart more frequently

Fig. 2. X-radiograph of Gilbert Stuart, *George Washington* (detail), oil on canvas, 1796, jointly owned by Boston, Museum of Fine Arts, and Washington, The National Portrait Gallery, Smithsonian Institution [photo: Courtesy, Museum of Fine Arts, Boston]

Mr Winstanley — It is a beautiful picture."[18] Field's copy shows that Winstanley's portrait was indeed a version of the Vaughan type. As William Thornton's letter of 6 January 1800 to Winstanley makes clear, however, Stuart was known to use the term "original" very freely.

I have never seen Mr. Stewart's Paintings of the late illustrious Washington & shall with peculiar pleasure view the Painting with which you mean to honor our new City. I am sorry to be obliged to observe that the late Genl. & his Lady thought themselves extremely ill used by Mr. Stewart, who promised <u>repeatedly</u> the original Painting to them . . . but never sent it, though frequently solicited. He after took Mrs. Washington's portrait but keeps it unfinished. . . . Make me a promise you will not take the original out of this Country. . . . Promise my good Friend to deposit that original here, if it be the original of Originals, for Stewart you know has sold many originals.[19]

Rembrandt Peale apparently remembered this story, and in the 1850s, when he saw the portrait that the Vaughans had owned, he recognized the type, believing this example to be the original. By that time the Athenaeum portrait had become Stuart's best-known image of Washington, while examples of the first type were inaccessible and unknown. One early replica [1940.1.6] was in the British Isles,

used thinly applied paint layers, most notably in the cheeks and jaw, around the eyes, and on the temples and forehead.

Recently, Dorinda Evans interpreted the area of brushwork around the "Vaughan" head as seen in the x-radiographs as evidence of the "rubbed out" life image under the finished painting.[21] She suggested that Stuart did this because he was dissatisfied with his attempts at expressing Washington's character when he was in the presence of the president, and revised the image after the life sittings.[22] Gallery conservator Ann Hoenigswald interprets this same roughened area as the brushwork that marks the addition of the red background around Washington's head. This toning was added after the head was completed—touches of red lie on top of Washington's hair—and was later partly altered by the overlaying of a darker background tone. She also notes that in comparing x-radiographs of other portraits by Stuart in the Gallery's collection, most notably the Vaughan-Sinclair portrait of Washington, "the face is much denser, the sockets of the eyes are not as clearly defined, and there is significantly less distinction in form." She thinks, however, that this is not a result of a "rubbing out," since the brush strokes of the face and of the area to the right of the head are very distinct and clear. She adds that there are more alterations on the surface of this painting than in the Vaughan-Sinclair version.[23] Thus the physical evidence does not support the suggestion that under this image is the "rubbed out" life portrait. Instead, the Vaughan portrait appears to be a very early replica with brushwork that indicates Stuart's continued experimentation on the background. Thus Stuart's "rubbed out" image may not survive at all, or it may lurk beneath a different portrait of Washington. Whichever is true, the Vaughan portrait seems to be an early replica of this now-lost original.

EGM

Notes

1. This inscription, now covered by the lining canvas, is recorded in a photograph in the NGA conservation file. It was on the canvas by 1870 when it was noted in Harrison 1870, 6.
2. Sherman 1922, 44; Morgan and Fielding 1931, 250. On Vaughan see *Vaughan* 1839.
3. The painting was "purchased from the late Wm. Vaughan, Esq., London," according to Harrison 1870, 6. According to *Clarke* 1928 (unpaginated), Harrison bought the portrait in 1851 from the Vaughan family. On Harrison see Wainwright 1972, 661, who says that Harrison bought Joseph Wright's portrait of Benjamin

Franklin, now at PAFA, from the same source, which he does not identify. A search of Harrison's letterbooks at the Historical Society of Pennsylvania did not yield further documentation of the purchase.

4. *Harrison* 1912, 31; the auction was scheduled for 26 February 1912 but was postponed to 12 March. The paid invoice dated 12 March 1912 is in the NGA archives (copy, NGA). The name of the seller, date of purchase, and price are recorded in an annotated copy of *Clarke* 1928 in the NGA library and in *Art Annual* 1913, 65, where the portrait is reproduced opp. 19.
5. Bowen 1892, 144.
6. Weddell 1930, 215.
7. Stuart 1876, 369.
8. The memorandum was first quoted in Stuart 1876, 373; see also Morgan and Fielding 1931, 227, and most other sources on Stuart.
9. Morgan and Fielding 1931, 250; both men had been patrons of English painter Robert Edge Pine in the 1780s; see Stewart 1979, 19–20, 90.
10. Lavater 1798, 3:435.
11. Eisen 1932, 1:59, pl. V; Morgan and Fielding 1931, 358–359; National Register of Archives, by kind permission of the Rt Hon The Earl of Rosebery.
12. Morgan and Fielding 1931, 229.
13. Quoted in Morgan and Fielding 1931, 229, 348, from an unidentified 1845 newspaper, possibly the (New York) *Evening Star*, Wednesday, 31 December (photocopy with no year indicated, NGA).
14. Charles Henry Hart Collection, AAA, reproduced in Miller 1980, fiche VIA/10 B14–C2.
15. Peale's letter to Harrison, NGA archives (copy, NGA), quoted in Morgan and Fielding 1931.
16. Peale 1858, 21.
17. Decatur 1939, 71; the author owned the original letter.
18. Anna Maria Thornton Papers, Manuscript Division, LC; "Thornton Diary," 163–164, 214, 217–218. On Field's copies see Piers 1927, 157–166.
19. Thornton Papers, LC, transcript courtesy of Margaret Christman, NPG, whose research files on Stuart have provided important information for this entry. Verheyen 1989, 127–139, discusses the early nineteenth-century concepts of original and copy in reference to portraits of Washington by Stuart and Rembrandt Peale. That author assumes erroneously that the Vaughan type was the most admired portrait by Stuart in 1826; it was the Athenaeum type. He reproduces the Vaughan-Sinclair portrait [1940.1.6] in error for the Vaughan portrait.
20. For examples of replicas of the Vaughan portrait see Sherman 1922, 44–45; Morgan and Fielding 1931, 228; and Mount 1964, 378. On the Gibbs-Channing portrait see Morgan and Fielding 1931, 236, 251, 352–353, and Gardner and Feld 1965, 85–87, repro. On the Bingham portrait see Richardson 1986, 92–94, repro. The Metropolitan Museum of Art owns a second example of the Vaughan type, and another is owned by the Colonial Williamsburg Foundation, Virginia.
21. Evans 1984, 85–88.
22. Evans 1993, 130, 133.
23. "Examination summary," 20 November 1989; NGA Painting Conservation Department files; an addi-

tional examination of the painting and a comparison of x-radiographs by the author, with Ann Hoenigswald and Elizabeth Walmsley, occurred on 20 October 1993.

References

1798 Lavater: 3: repro. between 434 and 435, 435.
1834 Dunlap: 1:196–206.
1846 Lester: 129–130.
1855 Tuckerman: 345–347.
1858 Peale: (Miller 1980 fiche VIB/19F11–20B14: 16, 20–21). The lecture is reprinted in Eisen 1932, 1:297–323.
1860 Custis: 520–523, 628.
1867 Tuckerman: 115–120, 630.
1870 *Harrison*: 6–7, no. 22.
1876 Stuart: 369, 373–374.
1879 Mason: 87–91.
1879 Hart: 220–221.
1880 MFA: 25 (no cat. no.).
1882 Johnston: 91–93.
1889 Hart: 865.
1892 Bowen: repro. opp. 12, 544–545.
1904 Hart: 126, no. 259.
1922 Sherman, "Stuart": frontispiece, 43–45.
1923 Eisen: 386–394, repro.
1923 Fielding: 83, 85–87, 114, no. 1, repro. frontispiece and opp. 114.
1926 Park: 845, no. 1, repro.
1930 Sherman: 261–270, repro.
1930 Morgan: 215–216, repro. between 16 and 17, and opp. 216.
1931 Morgan and Fielding: 223, 225–232, 236, 250, 347–352, repro. opp. 224 and opp. 250.
1932 Eisen: 1: pl. III, 7–11, 21, 35–37, 39.
1932 Whitley: 93–95.
1939 Decatur: 70–72, repro.
1964 Mount: 186–195, 378.
1967 Richardson: 25–30.
1972 Wainwright: 660–668, repro. (color, pl. I).
1981 Williams: repro. 55, 66–67.
1984 Evans: 85–88, repro.
1984 Walker: 383, no. 542 color repro.
1989 Verheyen: 127–139.
1993 Evans: 130, 132 repro., 133.

1940.1.6 (492)

George Washington (Vaughan-Sinclair portrait)

1795
Oil on canvas, 73.8 × 61.1 (29 1/8 × 24 1/8)
Andrew W. Mellon Collection

Technical Notes: The support is a medium-weight, primed twill-weave fabric. A ground layer is present but the color cannot be determined. It lies beneath an opaque gray-green imprimatura that is visible below the hair and a warm brown tone under the face. In other places the artist has worked gray-green tones on top of the main flesh colors. Dry brush strokes are used throughout to emphasize textures, notably in the sitter's skin and in the background, where the red paint is rubbed down and then covered with a tan shade. The right shoulder was reworked at a slightly lower position.

A slight flattening of fabric and paint texture may be due to a past lining. Vertical indentations are found in the surface. There is retouching in the forehead and shirt ruffle, along with wear in the collar and possibly throughout the coat. The varnish was removed in 1941 and the painting was relined in 1945. The present varnish is thick and discolored.

Provenance: William Sinclair, Fort William, County Antrim, Ireland; his daughter Elizabeth Sinclair May [Mrs. Edward May], Belfast; her son George Augustus Chichester May [1815–1892], Belfast;[1] his son Sir Edward Sinclair May [1856–1936], Rockbeare Court, Exeter, Devon;[2] (Colnaghi and Obach, London) 1919; (M. Knoedler & Co., New York); sold November 1919 to Andrew W. Mellon, Pittsburgh;[3] deeded 28 December 1934 to The A.W. Mellon, Educational and Charitable Trust, Pittsburgh.

Exhibited: *Loan Exhibition of Old Masters for the Benefit of the Bellevue Hospital Convalescent Relief Committee*, M. Knoedler & Co., New York, 1920, no. 16. *George Washington Bicentennial Historical Loan Exhibition of Portraits of George Washington and his Associates*, CGA, 1932, no. 27. *Famous American Paintings*, Dallas Museum of Fine Arts, Texas, 1948, unnumbered. Columbia 1950, no. 15. *From Plymouth Rock to the Armory*, The Society of the Four Arts, Palm Beach, Florida, 1950, no. 17. NGA 1950, no. 1. *Amerikanische Malerei: Werden und Gegenwart*, Rathaus Schöneberg, Berlin, 1951, no. 3. Chattanooga 1952, unnumbered. Mint Museum of Art, Charlotte, North Carolina, 1952, no cat. *Works of Art Lent by Southern Museums*, Birmingham Museum of Art, Alabama, 1959, no. 29.[4] Reynolda House, Winston-Salem, North Carolina, 1965–1966, no cat. Paul Holden Fine Arts Building, University of Wisconsin at Superior, 1973, no cat. *The American Solution: The Origins of the United States Constitution*, LC, 1987, unnumbered.

THIS REPLICA of Stuart's first life portrait of Washington is more summary than the version once owned by Samuel Vaughan. Both are replicas of the first life portrait that Stuart painted of Washington in 1795 (see discussion under 1942.8.27). The only information about the early history of the painting comes from a label attached to the back in the nineteenth century: "Portrait of General Washington painted by an Irish Artist named Stewart for a public building in New York & sent by an American Gentleman as a present to William Sinclair of Belfast." Among the people who ordered replicas of the first life portrait in April 1795 (see 1942.8.27) are several with an English or Irish connection who

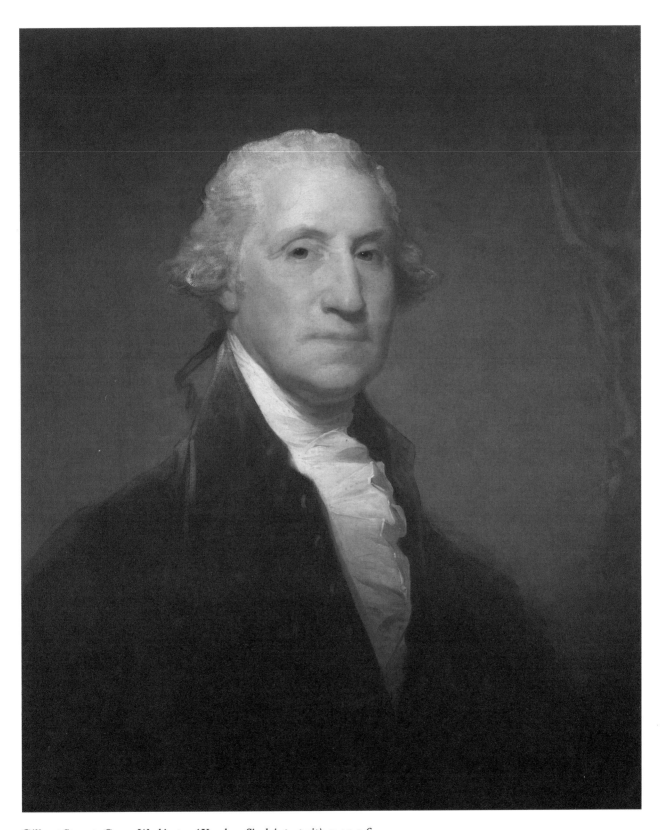

Gilbert Stuart, *George Washington (Vaughan-Sinclair portrait)*, 1940.1.6

could have been the unnamed "American Gentleman." Eisen, whose speculations were often wide of the mark, suggested that the painting was the second replica ordered by John Vaughan (the first was sent to his father in London).[5] Gallery curator William P. Campbell theorized that it might have been one of the two portraits ordered by the Pollocks, Irish merchants who had an import firm in New York and patronized Stuart both in Ireland and in the United States (see the Yates and Pollock portraits). Since not all the people on the 1795 list of subscribers bought examples of the Vaughan type, it would be difficult to determine the original owner who gave this example to Sinclair.

Two stamps on the reverse of the canvas provide important information about Stuart's painting materials. One is the stamp of the firm that prepared the canvas; the other is a tax stamp.[6] The partially legible maker's stamp appears to read "J POOLE HIGH HOLBORN LINNEN," denoting the London firm of James Poole, which was in business from 1780 until 1800. In the tax stamp some of the numbers are the same as those in the stamp on the reverse of Stuart's portrait of Robert Liston, painted in Philadelphia in 1800 [1957.10.1]. Both stamps have an "I 7" in the third section of the stamp and a "75" in the last section. Historians and conservators have not determined the meaning of these numbers.[7]

EGM

Notes

1. Information on the early ownership of the painting was provided by a label attached to the stretcher (see text). Sir Edward Sinclair May identified the writing as that of his grandmother Elizabeth Sinclair May in his letter of 28 May 1919 to an unidentified correspondent (copy, NGA). In a different writing on the label is the comment that the portrait was "Mentioned in Edmonds' 'Life of Washington,'" but Edmonds 1835 does not discuss the Vaughan image of Washington or this painting in particular. On Sinclair and May see the entry on May in *DNB* 13:140.

2. May's letter of 28 May 1919 to an unidentified correspondent inquires about the possible sale of the portrait (copy, NGA); on May see Burke 1952, 1746–1747.

3. Information on the ownership by Colnaghi and Obach and M. Knoedler & Co., and the sale to Andrew Mellon, was provided by Melissa De Medeiros, librarian, M. Knoedler & Co., in a letter dated 12 August 1992 (NGA).

4. Birmingham *Bulletin* 1959, unpaginated.

5. Eisen 1932, 39.

6. This information was copied before the canvas was lined in 1945 (drawing dated 23 May 1945, NGA).

7. For a discussion of canvas stamps see the entry on *Robert Liston* by Stuart [1957.10.1].

References

1923 Fielding: 122, no. 8.
1926 Park: 849–850, no. 8, repro.
1931 Morgan and Fielding: 254–255, no. 8, repro. opp. 256.
1932 Eisen: 1:39–40.
1964 Mount: 378.

1942.14.1 (701)

John Bill Ricketts

1795/1799
Oil on canvas, 74.6 × 61.5 (29 3/8 × 24 3/16)
Gift of Mrs. Robert B. Noyes in memory of Elisha Riggs

Inscriptions

Inscribed in a later hand, lower left, in pencil: Portrait of / Mr. Rickarts / Horse Equestraine / Friend of the Artist / Gilbert Stuart
Inscribed in a later hand, lower right, in pencil: Portrait of Rickarts / Horse Equestrian / An Intimate Friend of / Gilbert Stuarts

Technical Notes: The painting is on a two-by-two twill-weave fabric. There is cusping along the lower edge. The surface consists largely of unpainted, exposed ground that was probably once white but now is a light beige. The fluid paint was applied directly to the canvas with no underdrawing. Next to the fully realized head of the sitter are two horse heads that are sketched in a rich brown paint. One, to the left, is in outline, and the other was created from the dark circular area of paint around the sitter's head. In the lower corners on rectangular patches of gray-brown paint are inscriptions in pencil. They appear to be of a significantly later date than the portrait itself; the material of the inscriptions is lodged in the cracks in the paint.

Several horizontal cracks may be the result of rolling the painting. A few holes, to the right and above the sitter's head and in the lower left near the sitter's wrist, have been repaired. There is slight abrasion in the dark brown paint and a small area of retouching in the sitter's hair. Two varnish layers are found. A partial lower layer is covered by an upper layer, which is matte and slightly discolored.

Provenance: The sitter's brother Francis Ricketts.[1] Purchased at auction around 1853 by Peter Grain, Philadelphia.[2] (Barlow, Washington); sold before 1867 to George W. Riggs [1813–1881], Washington;[3] his daughters Alice Lawrason Riggs [1841–1927] and Jane Agnes Riggs [1853–1930], Washington; bequeathed by Jane Agnes Riggs to her friend Mary F. McMullan; purchased by Pauline Riggs Noyes [Mrs. Robert B. Noyes, d. 1942], Pomfret, Connecticut, and New York.

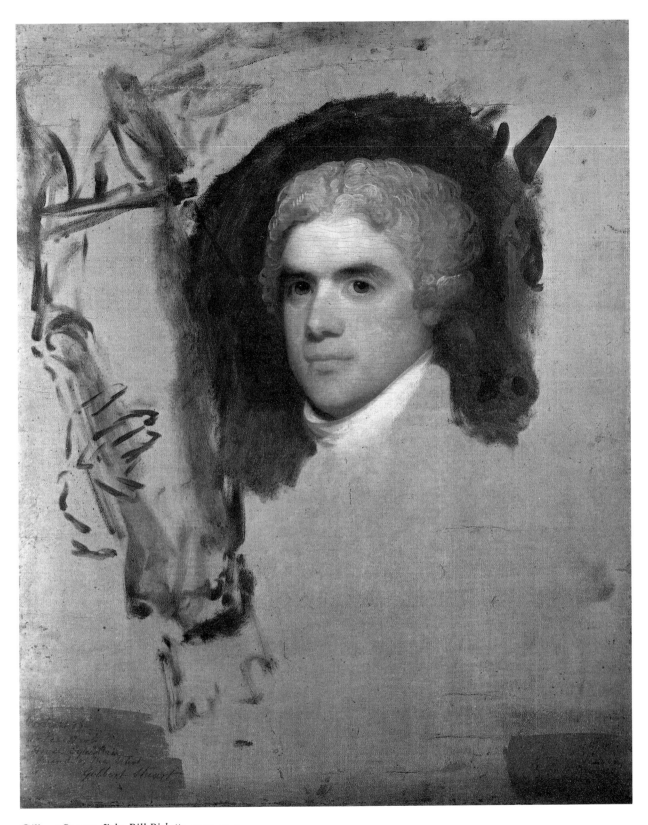

Gilbert Stuart, *John Bill Ricketts*, 1942.14.1

Exhibited: *Early American Paintings, Miniatures and Silver,* NGA, 1925–1926, no. 59, as *Circus Rider.* Richmond 1944–1945, no. 19, as *William Rickhart.* Columbia 1950, no. 14. Atlanta 1951, no. 14. Chattanooga 1952, unnumbered. Mint Museum of Art, Charlotte, North Carolina, 1952, no cat. Randolph-Macon Woman's College, Lynchburg, Virginia, 1952–1953, no cat. *Gilbert Stuart,* NGA; RISD; PAFA, 1967, no. 20. *Abroad in America: Visitors to the New Nation 1776–1914,* NPG, 1976, no. 18. Oklahoma Museum of Art, Oklahoma City, on long-term loan, 1984–1987.

JOHN BILL RICKETTS, who was described by contemporary American actor John Durang as "the renowned equestrian," came to the United States from Britain in 1792 and settled in Philadelphia, where he built an outdoor riding ring for public entertainment.[4] Its success led him to open a circus in 1793, the first described by that term in America. Performances included his own daring rides in which he juggled four oranges while standing in the saddle and rode horseback while standing on one leg, with another rider standing one-legged on his shoulders. An unidentified Philadelphia writer described Ricketts in 1794 as "perhaps the most graceful, neat, and expert public performer on horseback, that ever appeared in any part of the world."[5] The circus also featured a tightrope dancer and an equestrian clown.

Ricketts soon opened circuses in New York, Boston, and other cities, returning to Philadelphia in 1795 to build an "Art Pantheon and Amphitheatre" at the corner of Sixth and Chestnut. The round wooden, tentlike structure, ninety-seven feet in diameter, was topped by a conical roof. It seated six or seven hundred visitors and was illuminated at night by a chandelier. The troupe now included Matthew Sully, brother of painter Thomas Sully. Ricketts' performances often featured his favorite horse Cornplanter, named after the renowned Seneca leader.[6] George Washington visited the circus several times, and a birthday celebration was held for him in the amphitheater on 22 February 1797. Another popular attraction was Jack, a white horse that Ricketts bought from President Washington.[7] Ricketts went on the road again with his circus, performing throughout New York state, Vermont, and Canada. When his Philadelphia rotunda building burned in 1799, Ricketts took his circus to the middle Atlantic states before leaving for the West Indies. After several failures there, he sailed for England around 1803, and died when his ship was lost at sea.

Stuart undoubtedly painted Ricketts' portrait in Philadelphia, where the circus was based. The portrait remained there, unfinished, after Ricketts left for the West Indies. The artist intended to include the head of one of Ricketts' horses, probably Cornplanter, and the sitter's right hand rests gently on the horse's muzzle. Using his brush Stuart sketched the composition directly onto the primed canvas. Following a practice used by many eighteenth-century portraitists, he painted a dark circular area around Ricketts' head that enabled him to model the highlights and shadows of the sitter's face and hair by contrasting them with the darker background. Similar aureoles can be seen in other unfinished Stuart works, including the "Athenaeum" portraits of George and Martha Washington (NPG and MFA). Perhaps as a joke Stuart added a horse's ears, eyes, and nostrils to the aureole. Left unfinished, the portrait was later owned by Ricketts' brother Francis.

Two portraits of "Mr. Ricketts" are listed in Thomas Sully's register of paintings for 1807 and are unlocated today. Sully began the first, a work measuring 30.5 by 25.4 cm (12 by 10 inches) which was "copied from a painting," on 9 May and finished it on 27 May. He began the second, a bust-size portrait, on 11 November and finished it four days later.[8] The first could be a copy of Stuart's painting and the second, a portrait of Francis. According to mid-century writer Henry Tuckerman, Stuart's portrait became one of the "unfinished heads much prized by art-students as indicative of his method of painting."[9] It is still valued for that reason, as well as for its sympathetic depiction of the close relationship between horse and rider.

EGM

Notes

1. Brown 1861, 320. Francis Ricketts, also a circus performer, was last recorded in the United States in 1810, when he was with the Boston circus; see Culhane 1990, 4, and Hoh and Rough 1990, 55.

2. Brown 1861, 320. Peter Grain, a painter, was born in France around 1786 and came to the United States sometime before 1815. After living in various American cities, including New York and Charleston, he settled in Philadelphia around 1850 with his family, including his son Peter Grain, Jr.; Groce and Wallace 1957, 270, and Karel 1992, 360.

3. Park 1926, 634–635, whose information came from Riggs' daughters. Tuckerman 1867, 110, 633, lists the painting, sitter unidentified, as in Riggs' collection. "Barlow" is probably the picture framer and dealer Henry N. Barlow, who worked in Washington at 237 Pennsylvania Avenue, N.W., in the mid-1860s, according to

Boyd's Washington and Georgetown Directory of 1865–1867.

4. *Durang* 1966, 35. Information on Ricketts' circus is from Dunlap 1832, 1:138–139; Greenwood 1909, 77–90; Vail 1933, 173–175; Chindahl 1959, 7–10; *Durang* 1966, 42–104; Speaight 1980, 112–115; Culhane 1990, 6–10; and Hoh and Rough 1990, 7, 51–55.

5. Quoted in Greenwood 1909, 79.

6. American artist Edward Savage later exhibited a painting (now unlocated) called *An Extraordinary Feat Performed by Mr. Rickets* at his Columbian Gallery in New York in 1802; see Yarnall and Gerdts 1986, 3121. Savage's gallery was at the Pantheon, which was built in 1797 as Ricketts' Amphitheatre, with a riding stable and theater; see Rebora 1990, 1:10.

7. Fitzpatrick 1925, 4:249, 252.

8. Biddle and Fielding 1921, 259, no. 1471, 1472.

9. Tuckerman 1867, 110. The identity of the sitter was uncertain until the painting was acquired by the Gallery and extensive research was done by curators Mrs. Thornton Burnet and William Campbell. Campbell suggested that the inscriptions were added when the painting was lined, perhaps from information on the reverse of the original canvas. Since the two inscriptions do not fully agree, it can be suggested that one was an attempt to read the other after the varnish had darkened.

References

1861 Brown: 320.
1867 Tuckerman: 110, 633.
1879 Mason: 151, as *Breschard, the Circus-Rider*.
1880 MFA: 32, no. 90, as *Breschard, the Circus Rider*.
1926 Park: 634–635, no. 691, as *Mr. Rechart, or Rickart*, repro.
1981 Williams: 64, 66 repro.
1984 Walker: 378, no. 537 color repro.

1954.7.1 (1347)

John Adams

c. 1800/1815
Oil on canvas, 73.7 × 61 (29 × 24)
Gift of Mrs. Robert Homans

Technical Notes: The painting is on a medium-weight, twill-weave fabric lined to a pre-primed, plain-weave fabric and attached to a stretcher that appears to be the original. The off-white ground is relatively thin and smooth. The paint layer is applied quickly and sketchily, with thicker areas of paint in the highlights. The flesh tones are built up in blocks of color, from thin to thick and cool to warm. The shadows, apparently applied last, are transparent in many places.

Minute retouched areas are locted in the face and in the background to the left of the head. The varnish is discolored, and there are discolored varnish residues in the interstices of the canvas weave.

Provenance: John Quincy Adams [1767–1848], Quincy, Massachusetts; his son Charles Francis Adams [1807–1886], Boston; his son Brooks Adams [1848–1927], Boston; his niece Abigail Adams Homans [Mrs. Robert Homans, 1879–1974].[1]

Exhibited: Boston 1880, no. 304. Metropolitan Opera House 1889, no. 56.[2] MFA, on loan, 1931, 1932, and 1935.[3] *Stratford, The Lees of Virginia and Their Contemporaries*, M. Knoedler & Co., New York, 1946, no. 23. NGA 1950, no. 7. *They Gave Us Freedom*, Colonial Williamsburg and The College of William and Mary, Williamsburg, Virginia, 1951, no. 3. *A Nineteenth-Century Gallery of Distinguished Americans*, NPG, 1969, 12.

STUART'S IMAGES of John Adams (1735–1826), second president of the United States, and his wife Abigail Adams (1744–1818) [1954.7.2] are classics of American portraiture. In 1798, during Adams' presidency, the Massachusetts House of Representatives requested that he sit for his portrait, which would hang in the State House in Boston.[4] The undocumented sittings undoubtedly took place in Philadelphia, then the capital of the United States, at about the same time that Mrs. Adams sat for her portrait, that is, in early 1800 (see 1954.7.2). Stuart delayed completion and delivery of the portraits for fifteen years.

Family letters tell the saga of continuing attempts to coax Stuart to finish the portraits. In May 1801 the sitters' son Thomas Boylston Adams heard that to meet unpaid debts, a creditors' sale would be held of the contents of Stuart's studio in Germantown, Pennsylvania. He wrote his mother Abigail on 31 May that he went to the studio and found

my father's picture had not been seized or levied upon, but that your's had, and upon my assurance, that the picture was already paid for, the Sheriff consented to withdraw your representation, from the fangs of the law. I left the portrait in Stuart's hands, but I have no idea it will ever be finished, unless you should stimulate his attention by a letter. There is no appearance of any thing more having been done towards finishing the painting, than when I saw it twelvemonth, or more, ago. . . . It so happened, that your picture was the only one seized, as it was in his house and not in . . . his painting room.[5]

His mother commented to him in her letter of 12 June, "I know not what to do with that strange man Stewart. The likeness is said to be so good, both of your Father and of me, that I shall regret very much if he cannot be prevaild upon to finish them as our Children may like to look upon our Likeness when the originals are no more seen."[6]

In December 1804 Mrs. Adams urged her son John Quincy Adams to get Stuart to complete her portrait while he was in Washington. Adams wrote

his mother on 19 December, "It is so excellent a likeness, that being the only one extant of you, I am very anxious to have it in our own power; to whomsoever of us it may rightfully belong." In reply on 30 December she commented that

I wish he could be prevaild upon to execute the one of your Father, which was designed for the State House in Boston. Genius is always eccentrick, I think. Superior talents give no security for propriety of conduct; there is no knowing how to take hold of this Man, nor by what means to prevail upon him to fulfill his engagements.

The portraits still had not been completed by 13 May 1811, when John Quincy Adams wrote his brother Thomas Boylston Adams.

I never think of this subject without feeling against Stuart an indignation, which I wish I could change into contempt. If there was another portrait painter in America, I could forgive him. I beg of you to try to get the portrait he has of my mother, and to buy of him that of my father for me. If he will finish it, I will gladly give him his full price for pictures of that sort for it, taking care to withhold the payment until the work is finished.[7]

Stuart finally completed the portraits in 1815. Abigail's letter to John Quincy Adams of 8 June 1815 indicates that, while Adams sat again for Stuart, she did not sit again for hers.

Your father is gone, to comply with a request made by you through your Brother, to sit to Stuart for his portrait. If he gets a good likeness, as I think it promises, you will value it more than if it had been taken, in youth or middle Age. He has promised to finish that which twenty years ago he took for me, but now, no more like me than that of any other person. I am sure my Grand children will never know it and therefore I cared not whether he ever finished it. It has however a strong resemblance of you.[8]

Stuart was paid $100 for the portrait of Adams in December, and the finished paintings were delivered to John Quincy Adams in 1816.[9] The painting has evidence of its later completion in Stuart's looser technique, notably in the coat, shirt, and cravat, where gray pigment is applied over white to suggest the lace. In addition, Adams' features appear to be drawn with slight lines, while dots of blue enliven the inner eye and heavy impasto marks the forehead, all hallmarks of Stuart's technique in this period.

In 1821 Stuart made replicas of Adams' portrait for two series of paintings of the first five presidents. One is the version painted for Colonel George Gibbs (see 1979.4.1). The second, painted for John Doggett, was destroyed with those of Washington and Jefferson in a fire at the United States Capitol in 1851. Adams' portrait was very popular with copyists and engravers. Joseph Delaplaine in 1816 described it as "a likeness lately taken . . . which is so strong that a child not two years old knew it. Age has given a softness and mellowness to the countenance which Stuart has happily caught without losing the characteristic vigor of former years."[10] There are oil copies by Gilbert Stuart Newton (Boston Athenaeum) and Bass Otis (NYHS), as well as numerous engravings and lithographs. The portrait was also engraved (after Otis' copy) for James Herring and James Barton Longacre's *The National Portrait Gallery of Distinguished Americans* (vol. 4, 1839), by Longacre,[11] and was copied many years later by Jane Stuart (Adams National Historic Site, Quincy, Massachusetts).[12]

EGM

Notes

1. For Mrs. Homans' dates see *NYT Bio Service* 5:222.
2. Bowen 1892, 144.
3. Loan labels from the Adams Memorial Society are attached to the frame; the loan numbers indicate the years of the loans.
4. Oliver 1967, 132, 134, 135.
5. Oliver 1967, 133.
6. Oliver 1967, 133.
7. The three letters are quoted in Oliver 1967, 134–135.
8. Oliver 1967, 137, 140.
9. The invoice, dated 9 December 1815, is signed by Stuart; Oliver 1967, 135 n. 13.
10. Letter to Adams, 17 February 1816, quoted in Oliver 1967, 140, 149; although Delaplaine pretended that he was quoting an anonymous letter, these words are believed to be his own.
11. Stewart 1969, 12.
12. Oliver 1967, 257, nos. 162, 163.

References

1879 Mason: 125–126, 142.
1880 MFA: 28, no. 1.
1892 Bowen: repro. opp. 17, 144, 423–424.
1926 Park: 89, no. 1, repro.
1967 Oliver: 132–178, repro. fig. 64; 251, no. 106.
1981 Williams: 67, repro. 70.
1984 Walker: 383, no. 544, color repro.
1986 McLanathan: 113, color repro.

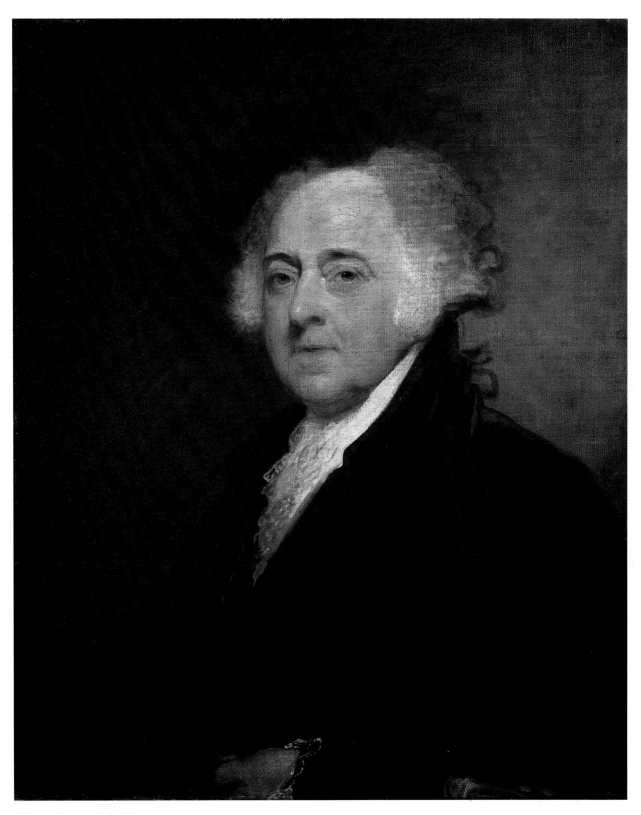

Gilbert Stuart, *John Adams*, 1954.7.1

1954.7.2 (1348)

Abigail Smith Adams (Mrs. John Adams)

1800/1815
Oil on canvas, 73.4 × 59.7 (28 7/8 × 23 1/2)
Gift of Mrs. Robert Homans

Technical Notes: The medium-weight, tightly woven twill-weave fabric has occasional thicker horizontal threads. It is lined to a plain-weave, pre-primed fabric. The four-member, butt-joined, mortise-and-tenon stretcher appears to be the original; Stuart's *Robert Liston* [1957.10.1] is attached to a very similar stretcher. Broad cusping in the upper third of the painting, with no signs of cusping at the other edges, suggests that this canvas was part of a much larger, pre-primed fabric (see also the canvases for *John Adams* [1954.7.1], *Robert Liston* [1957.10.1], and *Henrietta Marchant Liston (Mrs. Robert Liston)* [1960.12.1]).

The ground is thin and white. The paint is applied in a fluid, sketchy technique, with forms built up in thin, often transparent planes of color, and strokes over them marking highlights and shadows. A thicker, more paste-like application distinguishes the decoration of the transparent shawl and the highlights of the bonnet and chair. Pink flesh tones blend into soft grays at the edges of the forms, and quick brown or gray strokes provide a final demarcation of shadow.

A broad area of dark overpaint in the upper right corner covers paint loss or abrasion. There are other minor losses. Weave enhancement and flattening of the impasto may be the result of a past lining. The surface coating is moderately discolored.

Provenance: Same as 1954.7.1.

Exhibited: Boston 1880, no. 305. Metropolitan Opera House 1889, no. 57.[1] MFA, on loan, 1914, 1921, 1923, and 1931.[2] *Stratford, The Lees of Virginia and Their Contemporaries*, M. Knoedler & Co., New York, 1946, no. 24. NGA 1950, no. 6. *They Gave Us Freedom*, Colonial Williamsburg and The College of William and Mary, Williamsburg, Virginia, 1951, no. 65. *Gilbert Stuart*, NGA; RISD; PAFA, 1967, no. 42. *A Nineteenth-Century Gallery of Distinguished Americans*, NPG, 1969, 12. *Remember the Ladies: Women in America 1750–1815*, The Pilgrim Society, Plymouth, Massachusetts, traveling exhibition, 1976–1977, no. 249.[3] *Woman*, Terra Museum of American Art, Evanston, Illinois, 1984, no. 6.

THIS PORTRAIT of Abigail Adams, the best-known image of this strong-willed "first lady," was painted at the same time as that of her husband John Adams [1954.7.1]. She paid $100 for the portrait in 1800; the receipt reads: "Philadelphia May 20th 1800. Received of Mrs. Adams one hundred dollars in Payment for a Portrait painted by me. G. Stuart."[4] According to her nephew William Smith Shaw, who wrote her on 25 May, "Your likeness has attracted much company to Stewarts and has as many admirers as spectators. Stewart says, he wishes to god, he could have taken Mrs. Adams when she was young, he believes he should have a perfect Venus."[5]

The portrait, like that of John Adams, was not completed for fifteen years. Although the style of her dress is of the period of the sittings, the late completion of the portrait is evident in the style of the cap and the embroidered net shawl, which were fashionable in 1815.[6] Stuart's technique of this later period is apparent in the quick, short strokes that describe details of the cap and shawl and in the broad areas of color that delineate the ribbon on the cap. The portrait's appearance in its unfinished state between 1800 and 1815 is recorded in a painting that appears to be a copy (Massachusetts Historical Society, Boston), which Andrew Oliver believed to be the life study. He suggested that a painting then owned by John F. Seymour (NPG) was the companion life portrait of John Adams, and he surmised that the Gallery's portraits could have been painted entirely in 1815 from these works, a practice that Stuart followed for other portraits of notable sitters.[7] X-radiographs of the two portraits reveal, however, that they do not possess Stuart's characteristic handling of paint, which is clearly seen in the x-radiographs of the Gallery's canvases. In addition, the fabrics of the Gallery's paintings are identical in thread and cusping pattern to the fabrics that Stuart used for his portraits of Mr. and Mrs. Liston, which were also painted in Philadelphia in 1800 [1957.10.1 and 1960.12.1]. The fabric for Mrs. Adams' portrait also has pronounced cusping along the top edge, an indication that it was cut from a larger piece of commercially prepared canvas. The stretcher on each portrait is of the same type as that used for the portrait of Mr. Liston, and all appear to be original. This, in connection with documentation in family letters, provides sound evidence that Stuart began the portraits of John and Abigail Adams in 1800 in Philadelphia and finished them in 1815 in Boston.

Abigail Adams' portrait was engraved for James Herring and James Barton Longacre's *The National Portrait Gallery of Distinguished Americans* (vol. 4, 1839) by G. F. Storm,[8] and was copied many years later by Jane Stuart (Adams National Historic Site, Quincy, Massachusetts).[9]

EGM

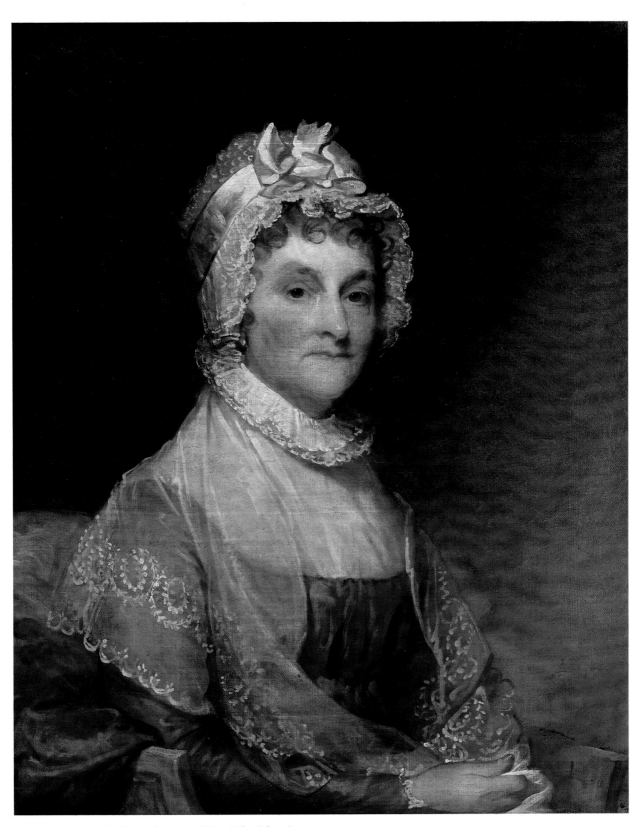

Gilbert Stuart, *Abigail Smith Adams (Mrs. John Adams)*, 1954.7.2

Notes

1. Bowen 1892, 144.
2. This information is from Park 1926, 93, and from loan labels from the Adams Memorial Society, Boston, attached to the frame; the loan numbers indicate the years of the loans.
3. The portrait was not shown at Pilgrim Hall, Plymouth, but was included at the five other exhibition sites: The High Museum of Art, Atlanta; The Corcoran Gallery of Art, Washington; The Chicago Historical Society; The Lyndon Baines Johnson Memorial Library, Austin; and The New-York Historical Society. See de Pauw and Hunt 1976, 147, color repro., 168.
4. Oliver 1967, 132.
5. Quoted in Oliver 1967, 137.
6. Nathalie Rothstein, curator emeritus, Textile Furnishings and Dress, The Victoria and Albert Museum, London, "What Silk Shall I Wear?: Fashion and Choice in Some 18th and Early 19th Century Paintings in the National Gallery of Art," lecture, NGA, 16 September 1990.
7. On these portraits see Oliver 1967, 137–138, fig. 65, 140–144, fig. 67, 251, nos. 103–104.
8. Stewart 1969, 12.
9. Oliver 1967, 257, nos. 162, 163.

References

1879 Mason: 125–126.
1880 MFA: 28, no. 4.
1892 Bowen: 144, repro. opp. 260, 426.
1926 Park: 93, no. 7, repro.
1967 Oliver: 132–140, fig. 66; 251, no. 105.
1975 Van Devanter: 116 color repro., 120.
1981 Williams: 67, repro. 70.
1984 Walker: 383, no. 543, color repro.
1986 McLanathan: 112, color repro.

1942.8.14 (567)

Counsellor John Dunn

c. 1798
Oil on canvas, 74 × 61.5 (29 ¼ × 24 ¼)
Andrew W. Mellon Collection

Technical Notes: The painting is on a twill-weave fabric. The ground is creamy white. Partially visible strokes of brown paint under the chin, in the hair, and below the white lace of the shirt ruffle or cravat suggest that the image was sketched directly onto the ground. The artist used the canvas weave to create an interplay of textures. The flesh is enlivened with strokes not fully blended together, while the roughness of the red cloth is described by using the accidental capture of pools of paint within the canvas weave.

Flattening of the impasto may be the result of a past lining. A little wear is noticeable in the fur. There are small dabs of retouching throughout. The varnish was removed and the painting was lined in 1960. The present varnish has bloomed.

Provenance: Unidentified descendants of the sitter, Norfolk, England; sold 1909 to (James Connell and Sons, London); (Louis Ralston, New York), 1909.[1] Sold in March 1923 by James W. Ellsworth [1849–1925], New York, to (M. Knoedler & Co., New York);[2] sold 26 March 1923 to Thomas B. Clarke [1848–1931], New York;[3] his estate; sold as part of the Clarke collection on 29 January 1936, through (M. Knoedler & Co., New York), to The A.W. Mellon Educational and Charitable Trust, Pittsburgh.

Exhibited: Union League Club, February 1924, no. 17, as Counselor David Dunn. Philadelphia 1928, unnumbered. Richmond 1944–1945, no. 13. Hagerstown 1955, no cat. Duke University Art Museum, Durham, North Carolina, 1969.

THIS PORTRAIT is one of three that Stuart painted of Irishman John Dunn. The unfinished study, which shows Dunn's head against a reddish brown background, was much admired in the nineteenth century. It was owned after Stuart's death by his daughter Jane and may be the painting now in a private collection. In 1867 American art critic Henry Tuckerman wrote that the study was one of the artist's "several unfinished heads much prized by art-students as indicative of his method of painting."[4] George C. Mason noted in 1879 that Stuart "would never part with" the study. "Stuart said of his portrait of Dunn, that he was willing to stake his reputation as an artist upon its merits."[5] When Jane Stuart sold the study in 1880 to J. Montgomery Sears, she described Dunn as

an Irish Barrister who was an intimate personal friend of my Father, Gilbert Stuart. This gentleman was noted for his wit and humor, and was a constant visitor of my Father's studio. My Father painted the picture about the year 1794, and as he considered it one of his best, he made frequent use of it in giving instruction of his pupils.[6]

Dunn, the son of the Reverend William Dunn of Dublin, studied law at Middle Temple, London, and was admitted as a barrister to the King's Inns, Dublin, in 1778.[7] He represented Randalstown, County Antrim, in the Irish House of Commons from 1790 to 1797 and perhaps earlier.[8] He may be the John Dunn who was nominated a corresponding member of the Massachusetts Historical Society in 1797.[9] Dunn came to the United States around that time, but he returned to Ireland by 1802. On 16 March 1802 he was elected to the Royal Irish Academy, and he delivered a paper there on 12 May.[10] A barrister in Dublin, he was appointed a King's Counsel by 1815, and probably died in 1827.[11]

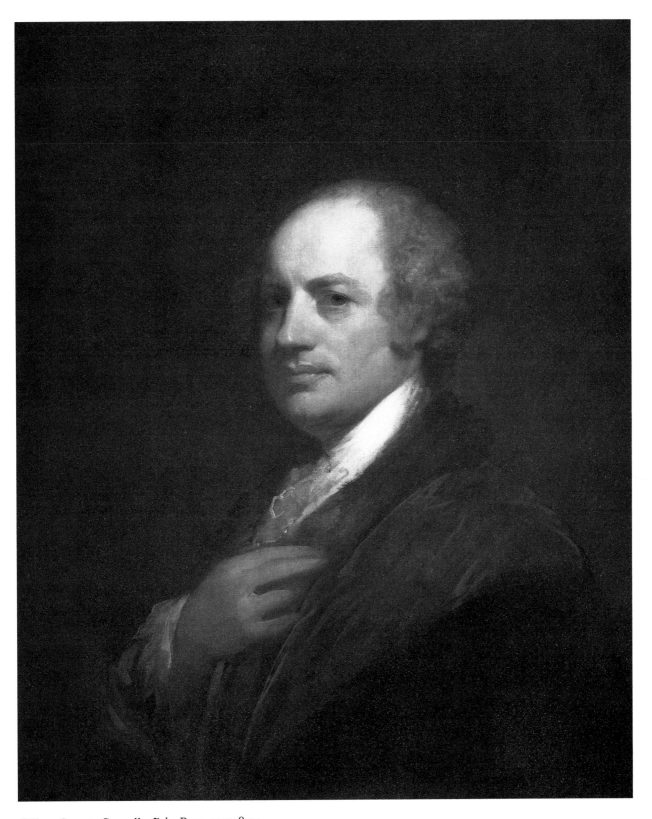

Gilbert Stuart, *Counsellor John Dunn*, 1942.8.14

A ruddy complexion, blue eyes, and light brown curly hair distinguish Dunn's features. Two finished versions of this portrait show Dunn in a white shirt with a lace ruffle or cravat and a red robe with brown fur trim. In the Gallery's version, Dunn touches the fur collar with his fingers pointing upward, a gesture that seems oratorical. The white cuff of his shirt has a jagged, lacy character, reminiscent of early seventeenth-century cuffs seen in portraits by Sir Anthony Van Dyck and his contemporaries. The image is unevenly finished, the hand sketchily painted. A notable contrast exists between the lightly painted curls of the hair and the thickly applied paint of the face. X-radiography reveals Stuart's characteristic brushwork in the head and upper body, but the remainder of the painting seems very flat. The second fully painted version (MFA) is more evenly finished. It once belonged to Sarah Apthorp Morton (1759–1846), the Boston poet, who sold it in 1828 to George Watson Brimmer.[12] In this version Dunn's hand is posed horizontally as he fingers the fur of the collar. Based on a receipt for this version, the portrait is dated around 1798, a more likely date than Jane Stuart's earlier date of around 1794.[13]

Dunn's friendship with Sarah Morton is documented only through Stuart's portraits. He owned one of Stuart's three paintings of her (The Henry Francis du Pont Winterthur Museum, Delaware),[14] and they apparently shared an interest in native Americans. In 1790 Mrs. Morton published her poem *Ouâbi: or the Virtues of Nature. An Indian Tale. In Four Cantos.* Twelve years later, in 1802, Dunn delivered a paper at the Royal Irish Academy entitled "Notices relative to some of the Native Tribes of North America," which recounted tales told to him by Miami chief Michikinikwa (Little Turtle). (Stuart painted his portrait when Michikinikwa visited Philadelphia after signing the 1795 Treaty of Greenville; the portrait was later destroyed by fire.)[15] Dunn also was said to have owned a version of Stuart's portrait of Washington.[16]

EGM

Notes

1. The early provenance of the portrait is documented only by a letter from Tom Connell of James Connell and Sons, London, dated 25 September 1909, to Louis Ralston (NGA). Clarke may have been given this letter in 1923. He apparently had asked Louis Ralston about the provenance of the portrait, for Ralston wrote on 1 June 1923 that he would "take up the matter" with Mr. Connell in London "and advise you of the result."

2. Melissa De Medeiros, librarian, M. Knoedler & Co., confirmed the purchase by Knoedler in a letter dated 7 March 1992 (NGA). Ellsworth, a financier and art collector, also sold his collection of books and manuscripts in 1923 for $450,000; *NCAB* 26:176 and *Who's Who* 1914, 727.

3. The name of the seller and the date of purchase are recorded in an annotated copy of *Clarke* 1928 in the NGA library.

4. Tuckerman 1867, 110.

5. Mason 1879, 176.

6. Her letter to Sears, unlocated today, was still with the portrait when it was sold at Parke-Bernet Galleries, New York, on 20 November 1947 (lot 32) from the collection of Helen Sears Bradley (Mrs. J.D. Cameron Bradley), Southboro, Massachusetts; see *American Portraits* 1947, 24, repro., Mason 1879, 176, and Park 1926, 294, no. 256; the portrait was painted on a wood panel measuring 60.3 by 58.4 cm (23 3/4 by 23 inches). Jane Stuart made a copy of the portrait that she exhibited at the Boston Athenaeum in 1847; Perkins and Gavin 1980, 137, no. 171, "*Counsellor Dunn. After Stuart.* For sale." This could be the unattributed oval copy of the portrait that was on the art market in the 1960s.

7. *King's Inns* 1982, 147. The most complete biography of Dunn is in Harris 1964, 215–218.

8. *Royal Kalendar* 1791, 257; *Royal Kalendar* 1797, 269; O'Hart 1892, 2:833; Park 1926, 294; Harris 1964, 215–218.

9. Harris 1964, 216; Virginia H. Smith, reference librarian of the society, confirmed this nomination in a letter dated 6 April 1992 (NGA). Dunn was nominated by James Freeman and is described as of Killaly, a village in County Cork.

10. Dunn's election is recorded in the minutes of the Academy, 1:177, according to Siobhán O'Rafferty, acting librarian, in a letter dated 19 May 1992 (NGA). The paper is published in *Royal Irish Academy* 1803, 9:101–137.

11. According to Thérèse Broy, assistant librarian, King's Inn Library, Dublin (letter of 28 April 1992), Dunn was listed in Dublin directories until 1814 as a barrister, and from 1815 as King's Counsel; see for example *Royal Kalendar* 1815, 384, and *Treble Almanack* 1823, 3:151. His name disappeared from the directories in 1828.

12. Mason 1879, 176; Park 1926, 295, no. 257; MFA 1969, 1:245, no. 909.

13. The date is included on the receipt that was in the papers of George Brimmer Inches, a descendant of George Watson Brimmer, who bought the portrait in 1828; see Park 1926, 295. It reads: "Mr. Geo. W. Brimmer Bo't [bought] of Perez Morton. The Portrait of Consellor John Dunn Member of the Irish Parliament painted by Gilbert Stuart about 1798. $150. Dorchester 4 August 1828 Rec'd Payment for P.M. Sarah Wentworth Morton. I acknowledge the above receipt to be good — being appropriated to her use — Perez Morton."

14. Mason 1879, 225–226; Harris 1964, 198–204. Mason recorded that Dunn's family sent this portrait to Mrs. Morton after his death.

15. On Little Turtle see *DAB* 6 (part 1):300, and Hodge 1907, 1:771, repro. (engraving, which dates the painting to 1797).

16. According to Tom Connell's letter of 25 Septem-

ber 1909 to Louis Ralston, the firm had acquired Dunn's portrait of Washington with that of Dunn and had sent both to New York (letter, NGA). Clarke apparently had purchased the portrait of Washington, since he asked Charles Henry Hart for his opinion of the painting. Hart described it as a "very fair" example of Stuart's portraits of Washington (letter of 28 May 1910; NGA). Clarke apparently later sold that portrait; it is not among the portraits of Washington by Stuart now owned by the Gallery.

References

1870 Tuckerman: 110.
1926 Park: 296, no. 258
1964 Harris: 198–220.
1964 Mount: 367.
1969 Watson: 40–41, 43, 48 repro.

1944.3.1 (765)

Horace Binney

1800
Oil on wood panel, 73.5 × 60.5 (29 × 23 ¾)
Gift of Horace Binney

Technical Notes: The support is a 0.7 cm thick, vertical-grain American mahogany (*Swientenia* sp.) panel scored on the diagonal, from top right to bottom left, with regular, parallel grooves to imitate the texture of twill fabric. The ground is a moderately thick, smooth gray layer. The oil paint is thinly applied with a free brush stroke and is worked wet-in-wet in most areas. Low impasto is in the whites and on the brass buttons. The background is very thinly painted, allowing the ground color to show through. Minor contour adjustments are evident in the sitter's left collar and shoulder, which were narrowed slightly, and in the placement of the figure's hand on the book, which appears to have been slightly lowered.

A vertical split begins at the top edge just right of the center and extends through the sitter's face to his white shirt collar. Apart from a few isolated sections of the coat, the paint layer is free of abrasion. Extensive retouching is present throughout the background, as well as along the vertical split. There is some strengthening in the sitter's hair. The varnish is moderately discolored.

Provenance: Commissioned by the sitter for his sister Susan [Mrs. John Bradford Wallace, 1778–1849], Philadelphia; her son John William Wallace [1815–1884], Philadelphia, who returned the painting to the sitter, his uncle; his daughter Susan Binney [1822–1887], Philadelphia; her nephew the Reverend John Binney [1844–1913], Middletown, Connecticut; his son Dr. Horace Binney [1874–1956], Milton, Massachusetts.[1]

Exhibited: *Gilbert Stuart Memorial Exhibition*, MFA, 1928, no. 9. *American Jurists*, Columbia Museum of Art, South Carolina, 1964, no cat.[2]

HORACE BINNEY (1780–1875) was born in Philadelphia and graduated from Harvard College in 1797 with high honors. He then studied law in Philadelphia, where he was admitted to the bar in March 1800, a few months before Stuart painted his portrait.[3] Binney served briefly in the Pennsylvania legislature (1806) before going on to pre-eminence in the legal profession. A strong Federalist, he was a member of the United States Congress from 1833 to 1835.

In 1852 Binney's nephew Horace Binney Wallace recorded Binney's recollections of his sittings to Stuart.

Wednesday, June 31st [*sic*], 1852: I called to-day upon Mr. Binney, before leaving town for the summer. The conversation turned upon Stuart's portrait of him, which hangs in our back parlor. He said that it was painted in the autumn of 1800, when he was not twenty-one years old. Some one had brought out from Canton some Chinese copies of Stuart's Washington, and Stuart prosecuted an injunction in the Circuit Court of the United States against the sale of them. "I was sedulous," said Mr. Binney, "in my attendance on the courts and here I became acquainted with Stuart. He came frequently to my office," continued Mr. Binney, "which was in Front street. I was always entertained by his conversation. I endeavored to enter into his peculiar vein, and show him that I relished his wit and character. So he took snuff, jested, punned and satirized to the full freedom of his bent. 'Binney,' he said to one of my friends, 'has the length of my foot better than any one I know of,' meaning, I suppose, that I knew how to humor him, and give him play.

"When your mother requested me to give her the portrait that is in your house, I made an appointment with Stuart, and called to give my first sitting. He had his panel ready (for the picture is painted on a board), and I said: 'Now, how do you wish me to sit? Must I be grave? Must I look at you?' 'No,' said Stuart; 'sit just as you like, look whichever way you choose; talk, laugh, move about, walk around the room, if you please.' So, without more thought of the picture on my part, Stuart led off in one of his merriest veins, and the time passed pleasantly in jocose and amusing talk. At the end of an hour I rose to go, and looking at the portrait, I saw that the head was as perfectly done as it is at this moment, with the exception of the eyes, which were blank. I gave one more sitting of an hour, and in the course of it Stuart said: 'Now, look at me one moment.' I did so. Stuart put in the eyes by a couple of touches of the pencil, and the head was perfect. I gave no more sittings.

"When the picture was sent home," continued Mr. Binney, "it was much admired; but Mr. T— M— observed that the painter had put the buttons of the coat on the wrong side. Sometime after this, Stuart sent for the picture, to do some little matter of finish which had been left, and, to put an end to a foolish cavil, I determined to

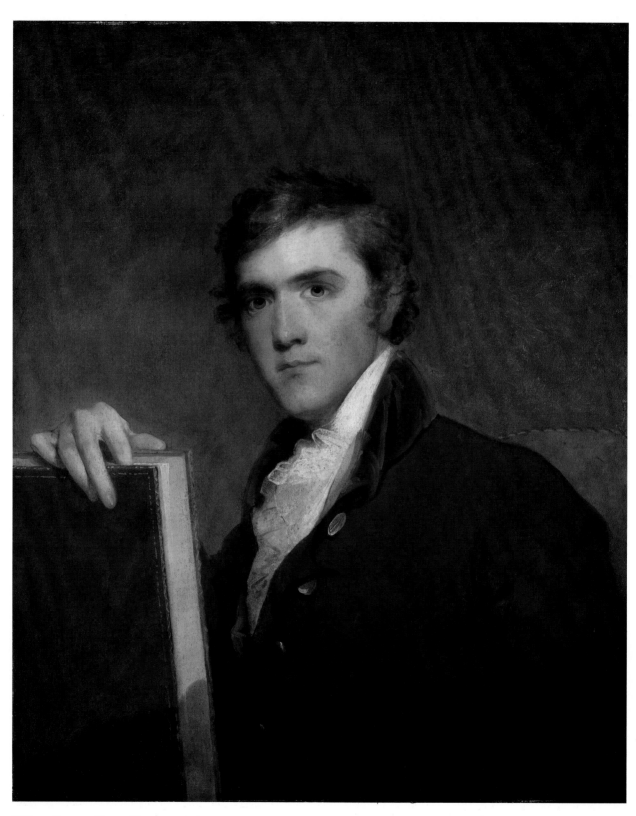

Gilbert Stuart, *Horace Binney*, 1944.3.1

tell him of M.'s criticism; but how to do it without offending him was the question. The conversation took a turn upon the excessive attention which some minds pay to the *minutiae* of costume, etc. This gave the opportunity desired. 'By the way,' said I, 'do you know that somebody has remarked that you have put the buttons on the wrong side of that coat?' 'Have I?' said Stuart. 'Well, thank God, I am no tailor.' He immediately took his pencil and with a stroke drew the *lapelle* to the collar of the coat, which is seen there at present. 'Now,' said Stuart, 'it is a double-breasted coat, and all is right, only the buttons on the other side not being seen.' 'Ha!' said I, 'you are the prince of tailors, worthy to be master of the merchant tailors' guild.'

"Stuart," said Mr. Binney, "had all forms in his mind, and he painted hands, and other details, from an image in his thoughts, not requiring an original model before him. There was no sitting for that big law-book that, in the picture, I am holding. The coat was entirely Stuart's device. I never wore one of that color. He thought it would suit the complexion.

"On the day when I was sitting to him the second time," said Mr. Binney, "I said to Stuart, 'What do you consider the most characteristic feature of the face? You have already shown me that the eyes are not; and we know from sculpture, in which the eyes are wanting, the same thing.' Stuart just pressed the end of his pencil against the tip of his nose, distorting it oddly. 'Ah, I see, I see,' cried Mr. Binney."[4]

Stuart depicted this youthful lawyer as somber and serious. Dressed in a white ruffled shirt and an ox blood-toned coat with gold buttons and a deep collar that appears to be velvet, Binney sits upright in an upholstered rose-pink chair in front of a greenish gray background. Partly covered in shadow, his blue eyes look directly at the viewer. His right hand props up a large brown book, his index finger between the pages. Stuart's rapid manner is easily visible, as is his talent for subtle combinations of color. The quick brushwork that the artist used to indicate a double-breasted coat is clearly visible, as are the buttons on the wrong, or sitter's left, side of the coat. The portrait is Stuart's earliest documented use of a wood panel. Its date negates the theory that Stuart began to use wood panels when he could not obtain imported canvas after the Embargo Act of 1807 curtailed trade with Great Britain.[5]

PB

Notes

1. For the provenance from Susan Binney to Dr. Binney see Dr. Binney's letter of 14 November 1947 (NGA), which provides dates for Susan Binney and Rev. John Binney. Other dates are found in Binney 1886, 66–67, 106–109, 188–189. Dr. Binney's death is recorded by the Harvard University Archives, Cambridge, Massachusetts.

2. The exhibition was announced in *Columbia* 1964, 2; the loan of the portrait is confirmed in the files of the registrar's office, NGA.

3. *DAB* 1 (part 2):280–282.

4. Mason 1879, 139–141; the original has not been located. The entry recounts additional anecdotes about Stuart and comments on other portraits.

5. Mount 1964, 284; DeLorme 1976, 128.

References

1867	Tuckerman: 109.
1877	Stuart: 646.
1879	Mason: 139–142, pl. 51.
1880	MFA: 31, no. 68.
1905	Binney: 42–44.
1926	Park: 156, no. 86.

1957.10.1 (1487)

Robert Liston

1800
Oil on canvas, 73.8 × 61 (29 × 24)
Chester Dale Collection

Inscriptions

Inscribed on the reverse, in black, in a later hand: Sir Robert Liston — Died 1837 / G C B / Her Britannic Majesty's / Ambassador to / the Sublime Porte / Painted by Raeburn

Technical Notes: The twill-weave fabric retains its original tacking edges and what appear to be the original dome-headed, square-shanked tacks. It is on its original four-member, yellow poplar stretcher with mortise-and-tenon joints. The strainer has been modified by the addition of keys in each corner. The painting has never been lined. The canvas has strong cusping at the top, mild cusping at the bottom, and none at the sides.

The ground is white, moderately thick, and smoothly applied. The entire fabric, including the tacking margins, is covered with ground. A stamp on the fabric verso is evidence that the fabric was commercially prepared (Figure 1). The paint is worked in fluid pastes, with impasto present primarily in the whites. The face was worked up first, followed by the rest of the figure, and then the background. Infrared reflectography reveals the use of a dark area of paint around the head. The uppermost part of the sky and throughout the curtain were underpainted with a beige color. The painting was completed before it was attached to the stretcher, as shown by the dark red paint on the right side, which continues under the tacks, and by the paint along the bottom edge, which ends just short of the tacking edge turnover.

The paint is lightly abraded, with paint missing in tiny areas in the tops of the weave texture. Retouching is lim-

Fig. 1. Infrared reflectogram of the tax stamp on the reverse of the fabric, 1957.10.1

ited to the sitter's chin. The toned varnish is very slightly discolored.

Provenance: The sitter's grand-niece and heir Henrietta Ramage Liston Foulis [d. 1850], Millburn Tower, County Edinburgh, Scotland;[1] her son Sir James Liston Foulis, 9th baronet [1847–1895], Woodhall and Millburn Tower, County Edinburgh; his son Sir William Liston Foulis, 10th baronet [1869–1918], Woodhall and Millburn Tower, County Edinburgh; (P. & D. Colnaghi and Obach, London, on joint account with M. Knoedler & Co., New York), 16 December 1919; sold April 1920 to Elbert H. Gary [1846–1927], New York;[2] sale of his estate (American Art Association, New York, 8 December 1934, no. 386);[3] bought by Helena Woolworth McCann [Mrs. Charles E. F. McCann, d. 1938], New York;[4] her children, Constance Woolworth Betts, Helena Woolworth Guest, and Frasier Winfield McCann;[5] (Parke-Bernet Galleries, New York, 21 February 1945, no. 48).[6] Booth Tarkington [1869–1946], Indianapolis; his widow Susannah Robinson Tarkington [d. 1966];[7] consigned by (Daniel H. Farr) to (M. Knoedler & Co.), November 1947; sold that month to Chester Dale, New York [1883–1962].

Exhibited: *Scottish National Portraits*, Edinburgh, 1884, no. 280, as by Sir Henry Raeburn.[8] Dallas Museum of Fine Arts, on long-term loan, 1942–1944, from the Winfield Foundation, New York.[9]

ROBERT LISTON (1742–1836) was born in Overtoun, Scotland, and attended the University of Edinburgh. He served as minister plenipotentiary in Madrid, as envoy in Stockholm, and ambassador in Constantinople (Istanbul) before he was appointed ambassador to the United States in February 1796. Liston served in this post until 1801, during which time he became a close friend of George Washington.[10] In the portrait he wears a black suit and stands with his arms crossed in front of him, looking

at the viewer. Behind him hangs a red curtain, with blue sky to the left. The composition is identical to that of Stuart's portrait of Colonel John Chesnut (1800, Denver Art Museum).[11] Stuart had used successful variants of this crossed-arms pose earlier in England and Ireland. Having developed it for his full-length of *The Skater (Portrait of William Grant)* (1782, [1950.18.1]), he employed it for the head and shoulder portraits of English actor John Philip Kemble (c. 1785–1787, National Portrait Gallery, London; see Figure 1 in the entry on *Luke White*) and of Dubliner *Luke White* (c. 1787, [1942.8.28]). According to Mrs. Liston's letters to her uncle in Glasgow, Stuart painted the Listons between May and October 1800 (see 1960.10.1). Many years later, in 1824, the portraits were on display in the Listons' home, Millburn Tower, near Edinburgh, when painter Sir David Wilkie wrote his sister on 15 September, "I go on Saturday morning . . . to visit Sir Robert Liston. I want Newton [Stuart's nephew Gilbert Stuart Newton] to go with me to see the portraits there by his uncle in America."[12]

The portrait's fabric support is on its original stretcher and has never been trimmed or lined. A rectangular tax stamp on the reverse of the fabric (Figure 1) indicates that the canvas was commercially prepared. It is similar to the tax stamps that appear on canvases prepared by James Poole of 163 High Holborn, London, a supplier of artists' materials who was in business from 1780 to 1800, and those of his successor Thomas Brown, whose business was at the same location until the 1850s.[13] A similar tax stamp, together with the stamp of Poole's firm, appears on the canvas of *Mother and Child in White* [1980.62.39] by an unidentified American artist, painted around 1790.[14] There is also a tax stamp, accompanied by a stamp with Poole's name and address, on the reverse of one of Gilbert Stuart's early portraits of George Washington [1940.1.6], which was painted in Philadelphia in 1795. Similar stamps have been found on other English canvases of the late eighteenth and early nineteenth century. They indicate the payment of the taxes that were levied after 1712 on all fabrics painted, printed, stained, or dyed in Britain. The tax continued until 1831 and included commercially prepared artists' canvases after about 1785. The numbers seem to indicate the firm that sold the canvas, the amount of duty paid, and perhaps the year it was paid, although the markings have not been fully decoded. Excise officers often marked the materials or canvases while they were on stretching

Gilbert Stuart, *Robert Liston*, 1957.10.1

frames, prior to being printed or primed.[15] The pronounced cusping along one edge of the fabric support appears to be additional evidence that this canvas was commercially prepared. It indicates that this piece of fabric was part of a larger piece when it was stretched and primed. Similar cusping along one side is found on the portraits of Mrs. Liston [1960.2.1] and of John and Abigail Adams [1954.7.1 and 1954.7.2].

<div align="right">EGM</div>

Notes

1. After Miss Liston married Sir William Foulis, 8th Baronet (1812–1858) in 1843, he assumed the name Liston. On the baronetcy see Cokayne 1900, 2:401–403, and Burke 1970, 1043–1044.

2. Melissa De Medeiros, librarian, M. Knoedler & Co., provided information about Knoedler's ownership and subsequent sales in a letter dated 5 June 1992 (NGA).

3. *Gary* 1934, 80, repro.; see "Absolute Stuarts" 1934, 8, and "Gary Estate" 1934, 3; on Gary see *DAB* 7:175–176.

4. Although Knoedler is listed as the purchaser in Comstock 1935, 99–100, which was confirmed by A. Rugo of Parke-Bernet Galleries in a letter dated 18 September 1964 (NGA), Knoedler was acting as the bidder on behalf of Mrs. McCann, according to Knoedler librarian Melissa De Medeiros.

5. Letter of 8 October 1964 from her son Frasier Winfield McCann, president of the Winfield Foundation, to whom the painting was lent by her estate (NGA); her death date and her children's names are found in the biography of her husband Charles Edward Francis McCann in *NCAB* 31:100–101.

6. *McCann* 1945, 44, repro.

7. On Booth Tarkington see *DLB* 9 (part 3):90–96, and *DAB*, *Supplement Four, 1946–1950*, 815–817; his wife's obituary is in the *New York Times* for 13 January 1966, 25.

8. *Scottish Portraits* 1884, unpaginated.

9. Letter from John Lunsford, associate curator, Dallas Museum of Fine Arts, 15 June 1964 (NGA).

10. *DNB* 33:356–357; Liston later served as ambassador at The Hague and again at Constantinople. He was made a Knight of the Grand Cross of the Bath in 1816.

11. Park 1926, 210–211, no. 151, illus.

12. Quoted in Cunningham 1843, 119, and in Whitley 1932, 117.

13. Katlan 1992, 456–458, 461–462, 480.

14. Chotner 1992, 550–552; the stamp is reproduced in Figure 1.

15. Cundall 1932, 397–398; Leach 1973, 2–4; Butlin 1981, 43–45; Katlan 1987, 7–8; letter of 15 November 1989 from Norman E. Muller, conservator, Princeton University Art Museum (NGA).

References

1843 Cunningham: 2:119.
1879 Mason: 215.
1880 MFA: 46, no. 369.
1901 Armstrong: 106.
1904 Pinnington: 238.
1911 Greig: 51.
1926 Park: 478–479, no. 493, repro.
1932 Whitley: 117.
1934 "Absolute Stuarts": 8.
1935 Comstock: 99–100, repro.
1954 Perkins: 592–632, repro.
1961 Wright: 118–127, repro.
1964 Mount: 224, 370.
1965 *Dale Collection*: 29, no. 1487, repro.
1984 Walker: 378, no. 533, color repro.
1986 McLanathan: 99–100, color repro.

1960.12.1 (1599)

Henrietta Marchant Liston (Mrs. Robert Liston)

1800
Oil on canvas, 74 × 61.3 (29 1/8 × 24 1/8)
Chester Dale Collection

Inscriptions

Inscribed on the reverse, in black, in a later hand:[1] Lady Liston / Wife of the Right Hon. Sir Robert Liston GCB / Her Brittanic Majesty's / Ambassador to the / Sublime Porte / Painter Raeburn

Technical Notes: The medium-weight, twill-weave fabric has been loosely lined with a medium-weight, plain-weave fabric. The original tacking margins are present. The creamy white, moderately thin ground enables the texture of the canvas to show through the paint layer. Evidence that the canvas was commercially prepared includes the presence of exaggerated cusping along only the top edge and the fact that the ground covers the tacking margins.

After an outline of the face and figure was sketched with a dark color, the face and the arms were painted with finely blended brush strokes. A thin, opaque, medium brown imprimatura was applied to the background around the figure before the clothing was painted. Additional layers of brown were added to the background, and a layer of blue was applied in the lower background area. The bonnet was then painted, and a darker brown continued around the edges of the bonnet and left side of the sitter to create definition. Last, highlights and detail were added. X-radiography also shows that the size of the bonnet was increased.

A damaged area along the left side, located 50 cm (19 3/4 inches) from the upper edge, has resulted in loss of ground and paint. A horizontal crackle pattern has developed in the thick areas of paint in the face, body, clothes, and blue of the background. There are minor areas of retouching and the varnish is discolored.

Provenance: The sitter's grand-niece and heir Henrietta Ramage Liston Foulis [d. 1850], Millburn Tower,

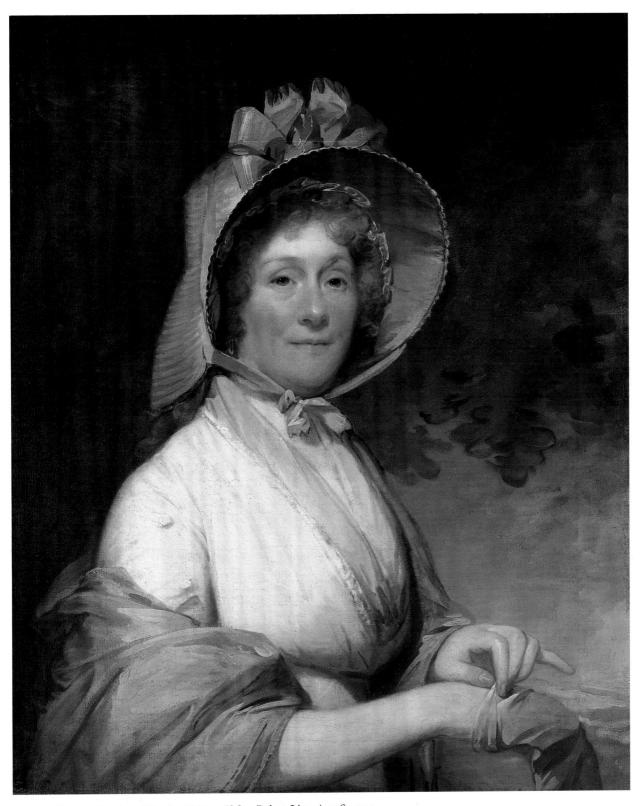

Gilbert Stuart, *Henrietta Marchant Liston (Mrs. Robert Liston)*, 1960.12.1

County Edinburgh, Scotland;[2] her son Sir James Liston Foulis, 9th baronet [1847–1895], Woodhall and Millburn Tower, County Edinburgh; his son Sir William Liston Foulis, 10th baronet [1869–1918], Woodhall and Millburn Tower, County Edinburgh; (P. & D. Colnaghi and Obach, London, on joint account with M. Knoedler & Co., New York), 16 December 1919; sold April 1920 to Elbert H. Gary [1846–1927], New York;[3] sale of his estate (American Art Association, New York, 8 December 1934, no. 385);[4] bought by Chester Dale [1883–1962], New York.[5]

Exhibited: *Scottish National Portraits*, Edinburgh, 1884, no. 264, as by Sir Henry Raeburn.[6] *An Exhibition of American Paintings from the Chester Dale Collection*, Union League Club, New York, 1937, no. 6.[7]

HENRIETTA MARCHANT (d. 1828), daughter of Nathaniel Marchant of Jamaica and ward of her uncle James Jackson of Glasgow, married Robert Liston, the newly appointed ambassador to the United States, on 27 February 1796. Stuart painted their portraits in the spring of 1800, toward the end of their four-year residence in Philadelphia and just prior to their return to England (for Stuart's portrait of Robert Liston see 1957.10.1). Mrs. Liston wrote her uncle in Glasgow about the portraits on 26 May 1800.

Mr. Liston & I, busy as we are at the moment, have consented to everybody's advice, and are sitting for our Pictures to Mr. Stewart an artist of great fame, but remarkable for being dilatory, I am endeavouring to persuade him to finish them soon & let us send them by one of Mr. Buchanans vessels to Greenock if I prevail I shall direct them to Mr. Dunlop's care to forward you, & I allow you to keep them till you see the originals.[8]

On 29 May she wrote, "Mr. Liston & I are now sitting for our Portraits to Stewart, an Artist of eminence — he is very dilatory but as soon as we can get them out of his hands they shall be sent to you to keep till you see the originals." On 8 October she wrote her uncle from New York, as they were returning to Philadelphia after a visit to Canada.

The pictures, (for they are really pictures as well as portraits,) are nearly finished, but paint drys so slowly in this climate that the Artist sais they must not be sent home immediately. We, therefore, propose taking them along with us in a box formed as frames, to be opened occasionally for air, & they shall be your Visitors for some time after our arrival, if not before we reach Glasgow.[9]

The Listons sailed for England that December.

The color harmonies and composition of the portrait are very successful. Mrs. Liston wears a white dress with blue edging, a peach-colored shawl trimmed with blue, peach gloves, and a peach-colored straw hat decorated with a large blue bow, its brim lined with blue fabric. The hat is tied under her chin with a taut blue ribbon. Behind the figure a leafy green tree stretches its boughs; the blue sky is filled with pink clouds. The use of a hat to frame her face and the gesture of pulling on a glove are unusual in Stuart's American portraits. They are reminiscent of John Singleton Copley's portrait of Mrs. Daniel Denison Rogers of about 1784 (Fogg Art Museum, Cambridge, Massachusetts), which Stuart might have seen in England. The composition— a fine example of Stuart's rapid, direct technique— was sketched on the canvas with great confidence. X-radiography reveals that the artist reserved a space for the ribbon on the hat brim as he planned the composition. He used a looser brushwork in the clothing than in the face. Before painting the tree and sky he toned the background area with a brown imprimatura. Later he reworked the image by adding the shawl over Mrs. Liston's arm and sleeve, enlarging the bonnet slightly, and making changes in the waistband of the dress. The final impression lends the charming sitter a sprightly personality.

EGM

Notes

1. This inscription, now covered by the lining canvas, was recorded in three versions with the same information but different spellings: by M. Knoedler & Co. in 1919–1920 (provided by Elizabeth Clare of Knoedler, 27 February 1961); in Park 1926, 480; and by George A. Smith of the F.J. Newcomb Company, framers, New York, for Chester Dale, 14 December 1934. Smith's version is recorded here, since it is the only one that indicates line breaks.

2. After Miss Liston married Sir William Foulis, 8th Baronet (1812–1858) in 1843, he assumed the name Liston. On the baronetcy see Cokayne 1900, 2 (1902):401–403, and Burke 1970, 1043–1044.

3. Melissa De Medeiros, librarian, M. Knoedler & Co., provided information about Knoedler's ownership and subsequent sales in a letter of 5 June 1992 (NGA).

4. *Gary* 1934, 78, repro.; see "Absolute Stuarts" 1934, 8, and "Gary Estate" 1934, 3; on Gary see *DAB* 4:175–176.

5. Comstock 1935, 99–100.

6. *Scottish Portraits* 1884, unpaginated, no. 264.

7. Frankfurter 1937, 14.

8. The letters are in the Sir Robert Liston Papers, Trustees of the National Library of Scotland, Edinburgh (microfilm, Manuscript Division, LC, reel 6), and are partially quoted in Perkins 1954, 630.

9. Liston Papers, quoted in Perkins 1954, 630, n. 48, and in Mount 1964, 231. She sent two copies of this letter to be sure that one reached her uncle, since delivery of mail was uncertain. She labeled this one the duplicate.

The first version is slightly different: ". . . the Artist sais they must not be sent yet — we therefore propose taking them along with us in a box formed as frames to open occasionally, & they shall be your visitors for some time after our arrival."

References

1843 Cunningham: 2:119.
1901 Armstrong: 106.
1904 Pinnington: 238.
1911 Greig: 51.
1920 Fielding: 89.
1926 Park: 480, no. 494, repro.
1932 Whitley: 117.
1934 "Absolute Stuarts": 8.
1935 Comstock: 99–100, repro.
1954 Perkins: 592–632, repro.
1961 Wright: 118–127, repro.
1964 Mount: 231, 371.
1965 *Dale Collection*: 28, no. 1599, repro.
1981 Williams: 67 repro.
1984 Walker: 378, no. 532, color repro.
1986 McLanathan: 99–100, color repro.

1942.8.23 (576)

Edward Stow

c. 1803
Oil on panel, 74 × 60 (29 ⅛ × 23 ⅝)
Andrew W. Mellon Collection

Technical Notes: The painting is on a single piece of vertical-grain mahogany. The panel has been thinned down and cradled. The ground is a smooth, white layer. A thin, red-brown wash lies underneath the sitter's coat and the sky. The paint is rich in medium and was applied wet-in-wet in the face, which is smoothly and tightly painted. The modeling in the drapery has been worked with thinly painted middle tones and more thickly painted highlights and shadows. Infrared reflectography reveals a design change in the hair. It corresponds to an area of paint around the sitter's head that is more built-up and has a crackle pattern not visible elsewhere in the painting.

There is a very fine vertical check at the top center. The paint layer is moderately abraded in the background at the top center. The background, the coat on the sitter's right side, and his fingers have been retouched. An area of paint loss measuring 1.25 by 5 cm at the left edge has been inpainted but not filled. There is slight abrasion around the eyes and a thin line of retouching beneath the chin. The varnish is unevenly glossy and has gone matte over the area of retouching in the coat.

Provenance: Gift of the sitter to his daughter Louisa Matilda Stow in 1838;[1] her sister Caroline Adelaide Stow Hyatt [Mrs. George Hyatt, 1807–1893], Ithaca, New York; her nephew John Phillips [d. 1905], Brooklyn, New York; bequeathed to his three sisters Edith, Norah, and Ann Broadhurst Phillips, Boston; gift of Ann Broadhurst Phillips and her cousin Ann Brattle Bascom, Cambridge, Massachusetts, to MFA in 1913;[2] sold (American Art Association, New York, 17 January 1922, no. 27)[3] to Thomas B. Clarke [1848–1931], New York;[4] his estate; sold as part of the Clarke collection 29 January 1936, through (M. Knoedler & Co., New York), to The A.W. Mellon Educational and Charitable Trust, Pittsburgh.

Exhibited: *Exhibition of Portraits painted by the late Gilbert Stuart, Esq.*, Boston Athenaeum, 1828, no. 123. Union League Club, February 1922, no. 15. Philadelphia 1928, unnumbered.

EDWARD STOW (c. 1768–1845) married Ann Brewer Peck in Boston in 1793. They soon moved to Philadelphia, where from 1798 to 1802 Stow was principal clerk for one of the commissions established by the treaty with Britain known as the "Jay Treaty."[5] The Stows moved back to Boston by 1806, when he is first listed in city directories as a merchant. From 1813 until shortly before his death, he was an officer of the New England Mississippi Land Company.

Fig. 1. Gilbert Stuart, *Mrs. Ann Stow*, oil on wood panel, 1802–1803, New York, Jordan-Volpe Gallery

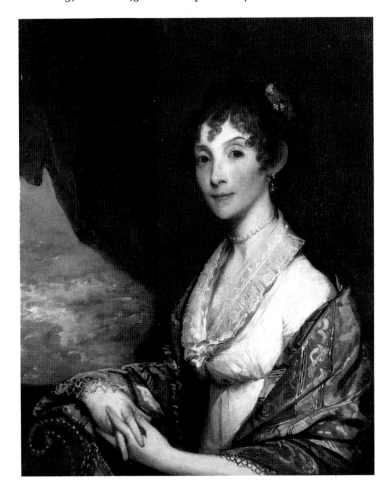

For this well finished, somewhat thickly painted portrait, Stuart employed a color scheme of brown, black, white, and red. Curly-headed Stow, wearing a black coat and a white waistcoat, is seated in a wooden armchair with red upholstery. Beyond the column and red curtain in the background is a cloudy sky. Stow is depicted in the act of writing at a desk that has an ink well and a second quill pen in a reference to his position as treaty commission clerk. The whites of Stow's waistcoat, frilled shirt, and cravat are applied in a pastose manner, with shaded areas denoted by short brush strokes of gray added on top of the white. Stow appears chubby and genial, in contrast to his thin, elegant wife, painted by Stuart in a white empire-style gown and colorful shawl (Figure 1).[6] Stow's appearance is similar to that in the miniature of him by Benjamin Trott (Figure 2).

Stow served as Stuart's business representative in Philadelphia after the painter went to Washington in 1803. The artist's wife and children, living in

Fig. 2. Benjamin Trott, *Edward Stow*, watercolor on ivory, 1795–1800, New Haven, Yale University Art Gallery, Lelia A. and John Hill Morgan Collection

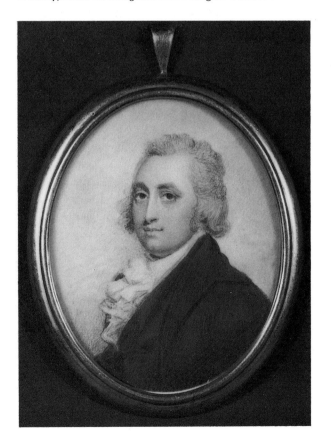

Bordentown, New Jersey, were perennially short of cash, as the artist's teenage son Charles Gilbert Stuart indicated when he wrote Stow on 22 December 1803. "Send me the Gun as soon as you can as Vacation has commenced which is only one week & the greatest service you can now do me would be to send me some powder & shot be it ever so little as mama's circumstances are such at present as to be unable to let me have any money."[7] The following spring Stuart wrote Stow twice from Washington. In a long, undated letter, the artist asked his friend to repay some of his Philadelphia debts with the money he enclosed. He also apologized for a misunderstanding: Stuart had intended to send money to his wife, and when it did not arrive, she blamed Stow.[8] In a short letter dated 15 May, Stuart wrote that he had received Stow's letter of 1 May. "Allow me now however to express my warmest thanks for the prompt & kind manner with which you performed my request. I beg permission to subscribe myself with unshaken esteem & affection your most obliged Friend Gilbert Stuart."[9]

Lawrence Park stated that Stuart painted the portraits of the Stows in Bordentown before his departure for Washington. There is, however, no evidence to place the Stows in Bordentown, and the portraits could as easily have been painted in Philadelphia. They are both on wood panels and could thus date anytime in or after 1800, the year Stuart first used wood panels (see *Horace Binney* [1944.3.1]). The compositions resemble those of other portraits by Stuart painted between 1800 and 1805 in Philadelphia, Washington, and Bordentown, including those of Sally McKean Martinez d'Yrujo (c. 1799, Duke of Sotomayor, Spain), Mr. and Mrs. William Thornton of 1804 [1948.8.25 and 1948.8.26], Dolley Madison (1804, PAFA), and Anne Pennington (1805, Philadelphia Society for the Preservation of Landmarks, Powel House). Although Mrs. Stow's dress is similar to that of Mrs. Jonathan Mason (1805, unlocated), which suggests a later date, Stow's clothing lacks the *M*-notch in the lapel, a style that was introduced in 1803 and became increasingly popular after that year.[10]

PB / EGM

Notes
1. Park 1926, 715, citing a memorandum from Stow dated 22 February 1838, which is unlocated; Stow also gave his daughter Louisa a miniature of himself by "Peale." At the same time he gave Stuart's portrait of his wife to his daughter Caroline, along with the portrait of

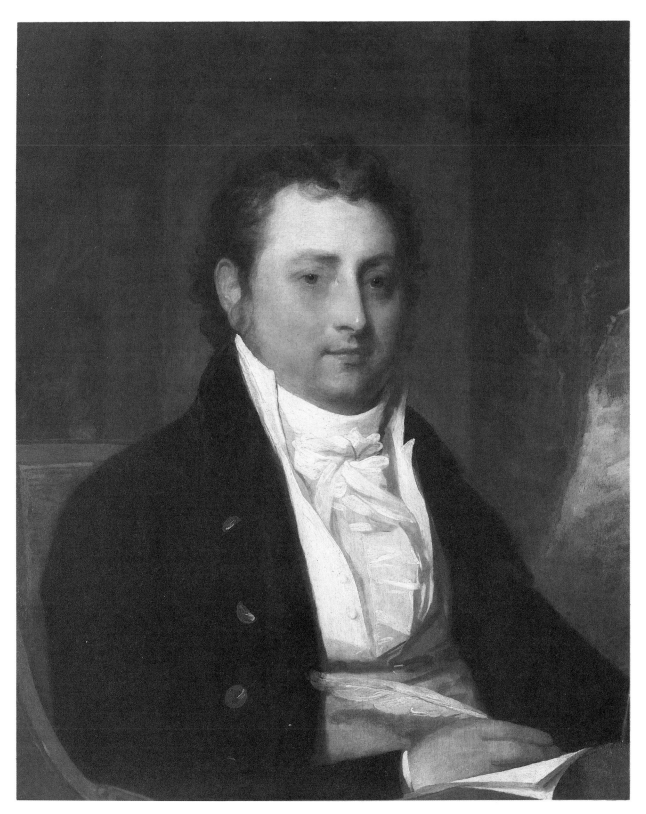

Gilbert Stuart, *Edward Stow*, 1942.8.23

her uncle John Peck by John Johnston [1947.17.65] and a miniature of himself by Benjamin Trott.

2. Fielding 1920, 90. John, Ann, Edith, and Norah Phillips were the children of George Phillips and his wife Ann Maria, sister of Caroline and Louisa Stow; see Phillips 1885, 184. According to Park 1926, 715, Ann Phillips and her cousin Ann Brattle Bascom of Cambridge, Massachusetts, each acquired half-interest in the portraits at the death of Ann's sisters Edith and Norah Phillips.

3. *Notable Paintings* 1922, unpaginated, lot 27, repro.; Stuart's portrait of Mrs. Stow was sold as no. 26. The MFA and Ann Phillips' descendants were forced to sell the painting because Ann Phillips only had title to a half share. The heirs of her sister Norah Phillips owned the other half share (memo from Harriett Pemstein, MFA, 18 April 1991; NGA).

4. The name of the seller and the date of purchase are recorded in an annotated copy of *Clarke* 1928 in the NGA library.

5. On Stow see Park 1926, 714; Holbrook Research, fiche 147, "Boston Marriages 1761–1807," and fiche 530, "Deaths Index, 1801–1845" (Stow died at the age of seventy-seven); letter of recommendation from Griffith Evans, 20 June 1802 (Massachusetts Historical Society); and Philadelphia and Boston city directories of the period. On Jay's treaty see *DAH* 3:493.

6. Park 1926, 716, no. 794; *Huntington* 1986, 162. The portrait, on a panel measuring 74 by 59.7 cm (29 1/8 by 23 1/2 inches), signed with initials, and dated 1802–1803, was owned until 1993 by the Huntington Library, Art Collections, and Botanical Gardens, San Marino, California.

7. Quoted in Morgan 1939, 47; the letter is unlocated.

8. This letter, now unlocated, was once in Thomas B. Clarke's collection and was sold by Stan Henkels from Albert Rosenthal's collection (*Rosenthal* 1920, 25–26, no. 116A); see Whitley 1969, 115–116, who erroneously dates it 15 May, and Mount 1964, 253–254, who wrongly stated that it was owned by the Massachusetts Historical Society.

9. This unlocated letter is quoted in Mount 1964, 254, from a photostat at the Massachusetts Historical Society, which provided a copy for this research (NGA).

10. For illustrations of the portraits of Sally Martinez d'Yrujo, Dolley Madison, and Anne Pennington, see McLanathan 1986, 104, 119, and 121. Jonathan Mason, also painted by Stuart, was a senator from Massachusetts from 1800 to 1803. His portrait and that of his wife are on wood panels the same size as those of the Stows; see Park 1926, 512–513, nos. 532 and 533, repro. Park dates them to 1805 in Washington but gives no evidence. They could have been painted earlier.

References

1920 Fielding: 90.
1926 Park: 714–715, no. 793, repro.
1932 Whitley: 115–116.
1964 Mount: 245, 253–254, 375.

1954.9.3 (1353)

Ann Barry

1803/1805
Oil on canvas, 74.3 × 61 (29 1/4 × 24)
Gift of Jean McGinley Draper

Technical Notes: The support is a twill-weave fabric. Cusping is evident at the top and sides. The thin, white, opaque ground does not mask the weave texture. Paint with a pastelike consistency is used in opaque mixtures to lay in the basic forms. The flesh tones of the face are worked wet-in-wet in the underlayers. Feathery dry strokes are added to give final definition to the features. The curtain is rapidly painted with a mixture of red lake, black, and white, with loose, almost calligraphic handling of the highlights and shading. The sky is rapidly executed with a drier paint mixture. The white dress and arms are painted with a full-bodied paint that retains brushmarks. Stuart first used a thinned brown mixture to sketch the shawl and then dragged precisely positioned scumbles of color to create the pattern of the fabric and the highlights. Impasto is used in the highlights on the fabric and on the upholstery tacks.

There are numerous small inpainted losses in the background curtain, and a long line of craquelure that extends through the left side of the neck has been inpainted. Some flattening of the impasto may be due to a past lining. The previous varnish was removed in 1961; the present varnish is clear.

Provenance: Bequeathed by the sitter's mother Joanna Barry [d. 1811], Washington, to her nephew James David Barry [1774–1849], Washington;[1] by descent to George Worthen Whistler [b. 1851], Baltimore;[2] sold by G.D. Whistler at (Christie, Manson & Woods, London, 4 February 1927, no. 62), bought by (Arthur Tooth, London).[3] Sold by (Daniel H. Farr Co., New York and Philadelphia) to Edward Small Moore [1881–1948], New York, 1927;[4] his wife Jean McGinley Moore Draper [Mrs. Charles Dana Draper, 1884 / 1885–1954], New York.[5]

Exhibited: Baltimore, 1879.[6] *Loan Exhibition of 18th Century English, American and French Paintings,* Daniel H. Farr Co., Philadelphia, 1927, no. 25.[7] *Loan Exhibition of Portraits for the Benefit of the Post Graduate Hospital,* Daniel H. Farr Co., New York, 1935, no. 12.

WHILE STUART was in Washington from 1803 to 1805, he painted portraits of Captain James Barry (The Art Museum, Princeton University), his wife Joanna (unlocated), and their two daughters Ann and Mary [1954.9.4]. James Barry (d. 1808), an Irishman from Lisbon, settled in Baltimore in 1793 as a merchant and served as the Portuguese consul general. In his correspondence with Thomas Law of Washington in the 1790s, Barry frequently mentioned his wife and "two little girls."[8] In 1800 Bar-

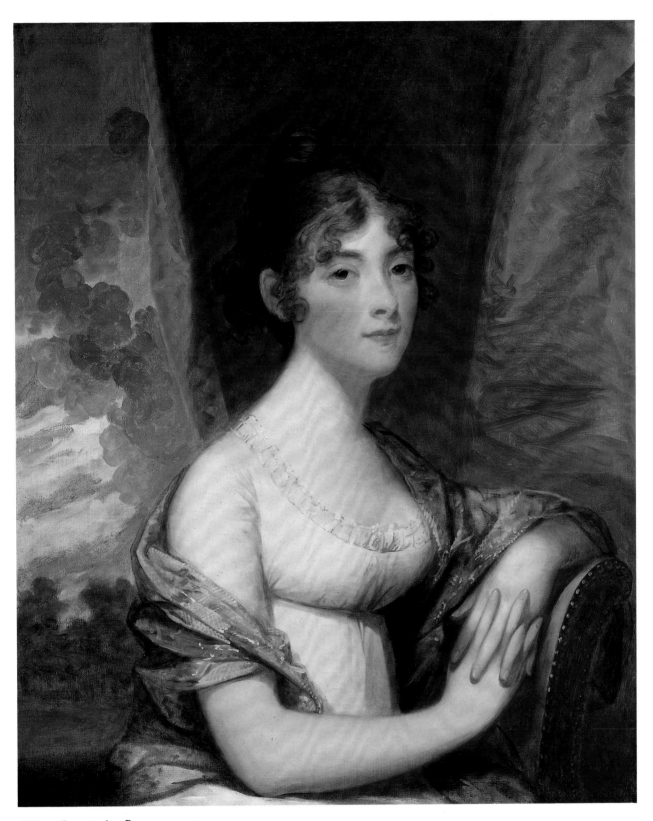

Gilbert Stuart, *Ann Barry*, 1954.9.3

ry moved his family to the federal capital to join Thomas Law in business.

Ann, the elder daughter, shared an interest in music and literature with Anna Maria Thornton, wife of Dr. William Thornton (see 1942.8.26); her diaries record social visits with the Barrys between 1800 and 1804.[9] It may have been Ann who in 1804 caught the eye of Englishman Augustus John Foster, secretary to the British legation. He wrote Lady Elizabeth Foster on 30 December, "I made a visit yesterday to the only pleasant family in the place, who live five miles off—a Mrs. Barry, an Irish woman, who has got a pretty daughter (that I mean to carry with me as wife to England)." He commented on her again in his letter of the following 8 February. "But really there is in this demi-city demi-wilderness a damsel of parti-coloured extraction—Irish and Portuguese—that I won't quite be sure of not melting a little; if so I shall be destined to be allways falling in love with Roman Catholics—She is the most determined devotee in existence, almost starves herself on fast days; but certainly beautiful."[10] Frail in health, Ann died in 1808, a few years after her portrait was painted.[11] Months before she died her poor health was the subject of letters between two family friends, John Carroll, Archbishop of Baltimore, and Elizabeth Seton. Mrs. Seton, a recent convert to Catholicism who would establish the American Sisters of Charity the following year, apparently had suggested to Carroll that Ann's "disorder was in the mind, more than in her bodily frame."[12]

In this portrait Stuart masterfully captured Ann's beauty and delicacy. Pictured in a white dress and a gray diaphanous shawl with gold threads, she is seated in a rose-pink upholstered chair with her body turned to her left, as she rests her left arm on the back of the chair. Her head, with its heavy-lidded brown eyes, gently turns to gaze out at the viewer. Soft curls of chestnut brown hair fall around her face and rest lightly against her rosy cheeks. This pink tone, repeated in her lips and in the chair, is complemented by the mauve curtain in the background. The portrait's soft coloring is combined with a fluidity of line that exaggerates some features. Her elongated right arm, for example, reaches gracefully across her lap without much sense of bone structure, and intertwining fingers of her clasped hands are elegantly boneless. Green trees and a blue sky with white and gray clouds complete the background.

The painting shares many compositional ele-

ments with Stuart's portrait of Mrs. Edward Stow (1802/1803, see 1942.8.23). The darker circle of paint in the area of the curtain adjacent to the sitter's head was painted during the initial stages of the portrait to provide background color as Stuart worked on the face and hair. Similar aureoles are found in other portraits by Stuart, notably in the unfinished "Athenaeum" paintings of George and Martha Washington (1796, NPG and MFA), and in his portrait of John Bill Ricketts [1942.14.1].

P B

Notes

1. Mrs. Barry died in Washington on 18 October 1811; *Federal Gazette and Baltimore Daily Advertiser*, 21 October 1811 (obituary). Her will (Office of Public Records, Washington) bequeathes "also to the same James D. Barry his uncles, my own and two dear childrens likenesses done by Steward. . . ." For James David Barry's dates see his obituary in the (Washington) *Daily National Intelligencer*, 16 August 1849.

2. Mason 1879, 134; Park 1926, 133. George Worthen Whistler was the great-grandson of Robert Barry, brother of James David Barry. Robert Barry's daughter Joanna married Julius Timolean Ducatel in 1824. Their daughter Mary married George William Whistler, older step-brother of painter James McNeill Whistler, in 1848. Their son George Worthen Whistler was born in 1851 (letter from Dr. Nigel Thorp, Glasgow University Library, Scotland, 19 March 1991; NGA). According to the 1880 Baltimore census, George Worthen Whistler lived at 56 Bolton Street with his wife Esther A. and daughter Esther M. The census notes that he was "not w any business." Mrs. G.W. Whistler is listed as the owner in MFA 1880, 30, no. 46.

3. Memo from Jeremy Rex-Parkes, archivist, Christie, Manson & Woods, London, 15 March 1991 (NGA). Daniel Farr wrote William Campbell on 24 July 1961 (NGA) that the paintings were sold at Christie's by an owner from Lucerne, Switzerland. The buyer's name is found in an annotated copy of Christie's catalogue (copy, NGA) and in *Art Prices* 1927, 6:128.

4. Sales receipt dated 15 December 1927 (NGA); for Moore's dates see the *New York Times*, 28 September 1948 (obituary).

5. The paintings (see also 1954.9.4) were first documented in the collection of Jean McGinley Moore Draper in March 1937 when they were stored at M. Knoedler & Co. in New York; letter from Melissa De Medeiros, librarian, M. Knoedler & Co., 18 January 1991 (NGA). For Mrs. Draper's dates see the *New York Times*, 27 September 1954 (obituary).

6. According to a publication titled *Two Portraits by Gilbert Stuart in the Collection of Edward S. Moore, Esq.* (NGA; no place or date noted), this portrait was included in an art exhibition in Baltimore in 1879. No documentation has surfaced to verify this information. The portrait of Mary Barry was also exhibited in Baltimore in 1879 (see 1954.9.4).

7. This exhibition is recorded on the picture mount

for this portrait at the Frick Art Reference Library, New York; no catalogue of the exhibition has been located.

8. Thomas Law Papers, Manuscript Division, LC.

9. The diaries of Anna Maria Thornton, which cover the years 1793–1863, are in the Manuscript Division, LC; see for example the entries of 28 August, 29 October, and 31 October 1800; "Thornton Diary," 184, 207.

10. Augustus John Foster (1780–1848) was a secretary in the British embassy in Washington from 1804 to 1808, and he returned in 1811 as British ambassador. His letters are quoted in Clark 1942, 6.

11. Obituary, *Federal Gazette and Baltimore Daily Advertiser*, 21 October 1808; she died on 17 July in Madeira, where she and her mother had gone in the hope that Ann would recover her health.

12. Bishop Carroll to Mrs. Seton, 28 March 1808, in *Carroll Papers* 1976, 3:51–52.

References

1879 Mason: 133–134.
1880 MFA: 30, no. 46.
1926 Park: 133, no. 57.
1942 Clark: 12–13, repro. opp. 12.
1973 Mount: 124.

1954.9.4 (1354)

Mary Barry

1803/1805
Oil on canvas, 74.3 × 61.6 (29 ¼ × 24 ¼)
Gift of Jean McGinley Draper

Technical Notes: The support is a finely woven twill fabric with cusping along all four edges. The smooth, white ground does not mask the weave texture of the support. The primarily wet-in-wet paint application ranges from thin, semi-translucent layers, applied in the background with broad, brushy strokes, to thicker, more opaque layers used for the flesh tones of the figure and in the drapery. The light, underlying ground influences the tonality of the thinly applied paint of the foliage and sky. Details of the face are brushed on with fluid strokes that are applied on top of the underlying paint layer.

The drapery is painted in broad strokes with low lying impasto depicting the highlights on the more prominent folds. Strokes of gray paint are blended wet-in-wet to represent shadows. The contours of the arms and hands are suggested with semi-transparent strokes of reddish brown paint. Part of the dog was painted over the underlying arm.

The paint has been moderately abraded. A tear at the bottom edge right corner has been repaired. The varnish was removed and the painting relined in 1961.

Provenance: Shares provenance with 1954.9.4 except that it was sold as lot 63 at (Christie, Manson & Woods, London, 4 February 1927) and was purchased by "Barry."[1] Sold with portrait of Ann Barry in December 1927 by (Daniel H. Farr Co.) to Edward Small Moore.

Exhibited: Charity Art Exhibition, Baltimore, 1879.[2] *Loan Exhibition of 18th Century English, American and French Paintings*, Daniel H. Farr Co., Philadelphia, 1927, no. 26.[3] *Loan Exhibition of Portraits for the Benefit of the Post Graduate Hospital*, Daniel H. Farr Co., New York, 1935, no. 13.

STUART PAINTED Mary Barry at the same time that he painted her older sister Ann [1954.9.3]. Details of Mary's brief life come from letters written to her parents by their friend John Carroll, Archbishop of Baltimore. In 1800, when the Barry family moved to Washington, Mary stayed at school in Baltimore, where Carroll and his family kept a protective eye on her.[4] Carroll's letters express concern for her, both then and after she rejoined her family in Washington in 1802. Her frail health was a troubling subject in February 1805 when he inquired about "her cough."[5] Hoping that a change of climate would offset "her weak and feverish state," the family traveled north that fall.[6] Mary died in New York on 17 November 1805.[7]

Mary's portrait, painted in strongly contrasted light and dark colors, is strikingly different from that of her sister. Stuart painted Mary in a landscape setting, holding a small dog. The portrait is reminiscent of his portrait of James Ward (1779, The Minneapolis Institute of Arts), painted in London and inspired by portraits by his English contemporaries. Mary's pale skin, white dress, and dog contrast with the dark brown tree trunk directly behind her. She is encircled by dark green leaves. The blue of her slightly averted eyes is echoed in the blue sky. As in the portrait of Ann, a painted aureole encircles her head, part of the early stages of the portrait's execution. The hastily executed landscape and extremely awkward placement of her left arm suggest that Stuart completed Mary's portrait rather hurriedly.

PB

Notes

1. "Barry" was either a pseudonym or the name of an agent for A.L. Nicholls; see memo from Jeremy Rex-Parkes, archivist, Christie, Manson & Woods, London, 15 March 1991 (NGA), an annotated copy of Christie's catalogue (photocopy, NGA), and *Art Prices* 1927, 6:128.

2. A label on the back of the painting reads: "Charity Art Exhibition / No. — / Owner Geo. W. Whistler / Subject Miss Mary Barry / Artist Gilbert Stuart / Insured Value $_____."

3. This exhibition is recorded on the picture mount for this portrait at the Frick Art Reference Library, New York; no catalogue of the exhibition has been located.

4. Bishop Carroll to James Barry, 23 January 1801, in *Carroll Papers* 1976, 2:344–345.

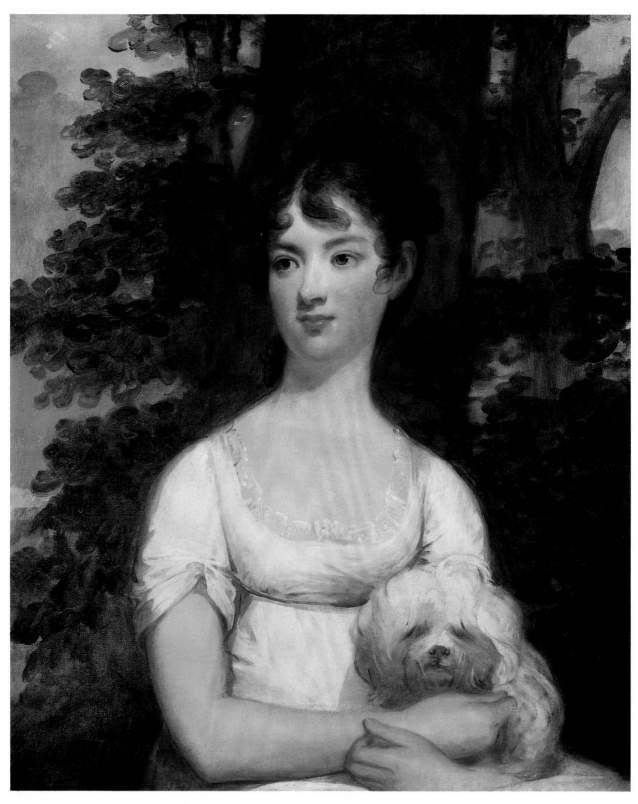

Gilbert Stuart, *Mary Barry*, 1954.9.4

5. Carroll to James Barry, 5 February 1805, in Hanley 1976, 2:471.

6. The family was in Pennsylvania in September and consulted with Carroll about continuing their journey to New York; Carroll to Joanna Barry, 15 September 1805, in Hanley 1976, 2:487–488.

7. Carroll to Joanna Barry, 22 November 1805, in Hanley 1976, 2:498–499 and n. 1.

References

1879	Mason: 133–134.
1880	MFA: 30, no. 47.
1926	Park: 135, no. 60.
1942	Clark: 12–13, repro. opp. 5.
1973	Mount: 97, 111, 124, repro. 97.

1954.9.2 (1352)

George Washington

c. 1803/1805
Oil on canvas, 73.6 × 61.4 (29 × 24 $^{3}/_{16}$)
Gift of Jean McGinley Draper

Inscriptions

Inscribed in a later hand on the reverse of the lining canvas, in paint: Stuart's Washington / painted for Genl McDonald / of Maryland, & from his walls / brought to Boston, & given to / Rob. C. Winthrop / by his wife & daughter.

Technical Notes: The support is a fine-weight, twill-weave fabric with slightly irregular threads, the pattern running from upper left to lower right. The five-member stretcher may be the original. The pebbled texture of the white ground is prominent. The paint is applied in opaque layers that vary from thin in the background and jacket to a thicker, fluid paste for the stock and cravat. The face is painted wet-in-wet, with details of the eyes, lips, and nose applied in semi-transparent strokes of brown paint, wet-over-dry. The rose of the cheeks is applied over flesh tones. The hair is applied in thin, fairly dry layers. The shadows of the hair are done with a brown glaze over the white ground. The black of the jacket was painted on top of a thin, semi-transparent sketch, and after the white of the stock and cravat.

The most thinly painted shadows of the face are slightly abraded. There is a small damage in the sitter's left shoulder. The previous varnish was removed in 1959. The present varnish is semi-opaque and dull.

Provenance: William C. McDonald [1757 / 1758–1845], Baltimore;[1] probably his grandson Samuel McDonald [1849–1877], Baltimore County, Maryland;[2] bought by Cornelia Adelaide Granger (Thayer) Winthrop [Mrs. Robert Charles Winthrop, 1819–1892] and her daughter Adele Thayer for Robert Charles Winthrop [1809–1894], Boston;[3] bequeathed to Adele Thayer and to his grandson Robert M. Winthrop [1873–1938], Boston;[4] (Frank W. Bayley & Son, Boston), consigned 5 December 1924 to (M. Knoedler & Co., New York);[5] sold 24 December 1924 to Edward Small Moore [1881–1948], New York;[6] his wife Jean McGinley Moore Draper [Mrs. Charles Dana Draper, 1884 /1885–1954], New York.[7]

Exhibited: Boston 1880, no. 291. *Mr. President,* Dallas Museum of Fine Arts, 1956, no. 7. *French, American, and Italian Review,* Oklahoma Art Center, Oklahoma City, 1963, no. 48.

THIS PORTRAIT is a version of Stuart's Athenaeum portrait of Washington (NPG and MFA), which he painted in Philadelphia in 1795–1796.[8] It is believed to derive from the replica that Stuart took to the city of Washington in 1803 and later sold to John Tayloe of "Mount Airy," Richmond County, Virginia (CGA).[9] The painting differs from the original life portrait in the careful drawing of the features with thin strokes of brown paint and the generalization of forms, especially in the shadows. The detailed lace and folds of the cravat and the use of a bow instead of a ribbon on the queue distinguish it from the later replica in the Gibbs-Coolidge set of presidential portraits [1979.5.1].

William McDonald (1757–1854), a Baltimore merchant and the painting's first owner, had a personal connection with George Washington. A member of the Maryland militia during the American Revolution and the War of 1812, McDonald commanded a regiment as a lieutenant colonel at the battle of Baltimore in 1814. He was later promoted to the rank of general. His obituary noted, "Our citizen soldiery will doubtless attend his funeral in token of respect to the memory of one of the few remnants of those who stood firmly by the side of Washington."[10] The circumstances of his acquisition of the portrait are unknown.

The association of the portrait's later owner Robert C. Winthrop (1809–1894) with George Washington is well documented. Winthrop, a prominent Bostonian, served as both a United States congressman and a senator. He was speaker of the House of Representatives in the thirtieth congress (1847–1849). An avid amateur historian, he was president of the Massachusetts Historical Society for thirty years. His talent for oratory and his interest in American history made him a popular speaker. He spoke at the laying of the cornerstone of the Washington Monument in the nation's capital on 4 July 1848, and he spoke again on 21 February 1885, at the completion of the monument almost forty years later.[11]

EGM

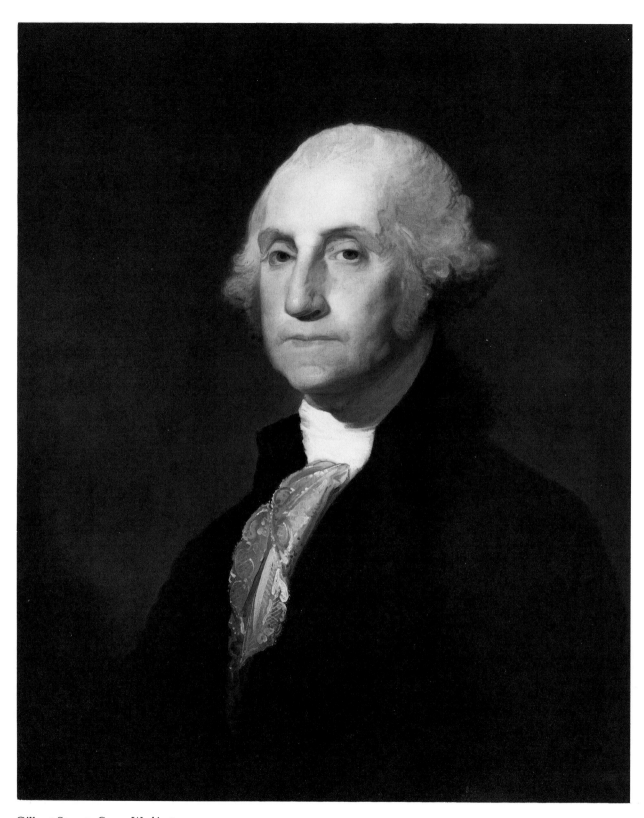

Gilbert Stuart, *George Washington*, 1954.9.2

Notes

1. See McDonald's obituary in the *Baltimore Sun*, 19 August 1845, 2; McDonald died "in his 87th year," which would mean that he was born either in 1757 or 1758.

2. Johnston 1882, 99–100, says that the portrait was offered for sale in Boston by the last McDonald male heir, who was Samuel McDonald. He inherited his father William McDonald's estate of a half-million dollars in 1870. He lived in Baltimore County, Maryland, and owned a hunting lodge in Terre Haute, Indiana. On his death at an early age see "Fortune Wasted" 1877, 3.

3. Adele Thayer, widow of John Eliot Thayer, married Robert C. Winthrop in 1865; see Granger 1893, 305, and Mayo 1948, 339. Mason 1879, 107, wrote that Winthrop had recently acquired the portrait; Fielding 1923, 194, noted that he placed it on deposit at the Massachusetts Historical Society.

4. Morgan and Fielding 1931, 295–296, say that Winthrop left it to his grandson, whom they call Robert C. Winthrop, the name of his son, who died in 1905; for the names and dates of both see see Mayo 1948, 343–344, 405.

5. Letter dated 18 August 1992 from Melissa De Medeiros, librarian, M. Knoedler & Co., New York (NGA).

6. Information from Melissa De Medeiros, librarian, M. Knoedler & Co., New York (letter, 18 August 1992) and from the memorandum of the sale, dated 24 December 1924 (NGA); for Moore's dates see the *New York Times*, 28 September 1948 (obituary).

7. For Mrs. Draper's dates see the *New York Times*, 27 September 1954 (obituary).

8. On the Athenaeum portrait see Morgan and Fielding 1931 for the most complete presentation of the documentation and the differences in the various replicas. Recent summaries with some illustrations include Richardson 1967, 25–30, and McLanathan 1986, 73–96.

9. Morgan and Fielding 1931, 246, 280–281, no. 46, repro. opp. 280.

10. Obituary, *Baltimore Sun*, 19 August 1845, 2; "Fortune Wasted" 1877, 3; Scharf 1879, 105, 124, 136.

11. Many of his speeches have been published; see Kennon 1986, 106–110.

References

1879	Mason: 107.
1880	MFA: 26, no cat. no.
1882	Johnston: 99–100.
1923	Fielding: 194, no. 73.
1926	Park: 881, no. 73, repro.
1931	Morgan and Fielding: 295–296, no. 73.
1932	Eisen: 1:162–163.

1974.108.1 (2677)

Eleanor Parke Custis Lewis (Mrs. Lawrence Lewis)

1804
Oil on canvas, 73.7 × 61.6 (29 × 24 1/4)
Gift of H. H. Walker Lewis in memory of his parents,
 Mr. and Mrs. Edwin A.S. Lewis

Technical Notes: The painting is executed on a fairly loosely woven, medium-weight twill fabric. The stretcher is probably the original. The ground is a thin, off-white layer, which is smoothly applied and fills the weave pattern of the fabric without completely hiding it. The ground layer covers all four tacking margins, which have been slightly trimmed. Broad cusping is visible along the edges of the fabric. Although some of the cusping is related to the present location of the tacks, other areas of cusping indicate the location of tacks when the ground was applied.

The paint is brushed out in thin, fluid, opaque strokes that appear to have been worked up quickly. The application is in a wet-in-wet technique. Slightly pastose paint was loosely applied with zig-zagging strokes to create a lively surface. The contour outlines of the flesh tones and details of the face are constructed with a semi-transparent brown-red glaze. The shadows of the face are applied on the surface and blended wet-in-wet with the adjacent flesh tones. The background is a thin scumble of gray green.

There is only minor retouching of small damages and abrasion at the edges. The varnish was removed and the painting relined in 1975. The present varnish is slightly toned.

Provenance: Given by the sitter to her son Lorenzo Lewis [1803–1847], Audley, Clarke County, Virginia;[1] his widow Esther Maria Coxe Lewis [1804–1885], Clarke County, Virginia; their son Edward Parke Custis Lewis [1837–1892], Hoboken, New Jersey;[2] his son Edwin Augustus Stevens Lewis [1870–1906], Hoboken, New Jersey; his widow Alice Stuart Walker Lewis [1877–1973], Hoboken, New Jersey; their son H.H. Walker Lewis [b. 1904], Baltimore.[3]

Exhibited: Metropolitan Opera House 1889, no. 142.[4] *Gilbert Stuart*, NGA; RISD; PAFA, 1967, no. 33.

DEEP FEELINGS of melancholy are reflected in this portrait of Eleanor Parke Custis Lewis (1779–1852) during her period of mourning after the recent deaths of several family members. Nelly Custis, as she was known, was the daughter of John Parke Custis and his wife Eleanor Calvert Custis. She became the ward of her grandparents George and Martha Washington shortly after the death of her father in 1781, and she spent most of her childhood

at Mount Vernon in Virginia. She lived with her grandparents in New York and Philadelphia during Washington's presidential years and returned to Mount Vernon with them on his retirement. On 22 February 1799, her grandfather's birthday, Nelly married Washington's nephew Lawrence Lewis. After Washington's death that December, the Lewises inherited property near Mount Vernon, where they built their new home, Woodlawn. The house was designed by William Thornton (see 1942.8.25), a family friend; the Lewises were living in a completed wing by early 1802.[5]

That year, however, Nelly suffered poor health and great sorrow. Perhaps most traumatic was the death of Martha Washington in May. Within a month Nelly's one-year-old daughter died of the measles, a disease that Nelly also contracted. Several months later her first son died shortly after birth. These losses affected Nelly deeply. She described this period in letters written to her close friend Elizabeth Bordley, who lived in Philadelphia. On 4 December 1804 she wrote,

We have both experienced the most severe distress in being deprived of affectionate Parents, whose loss can never be repair'd. In addition to this, I have lost two children, one of them the most lovely & engaging little Girl I ever saw. I have had very bad health since my marriage until the two last years, I have now recover'd my health, and have two charming children.[6]

On 11 January 1805 she wrote again.

For my part the Death of my Grandmother, to whom my obligations were unbounded, the experience of every hour teaches me that the loss is irreparable. I constantly call to mind her tenderness and unceasing care of me, & the reverse is so dreadful, that I shall never know happiness again. life has no charms for me unless when employ'd in the care of my children, & in that respect I suffer so much anxiety that I have more sorrow than joy in them.[7]

On 23 March 1806 she summed up her feelings. "Ah my Beloved friend, how sadly times are changed to us all, but to *me* more than anyone, deprived of those Beloved Parents whom I loved with so much devotion.... I look back with sorrow, & to the future without hope."[8]

This portrait can be dated to 1804 by Nelly's reference to it in her letter to Elizabeth Bordley, written on 4 August 1851, many years later. Elizabeth had thanked Nelly for a copy of the portrait, and Nelly wrote in return,

Accept my most sincere acknowledgements for the kind & cordial reception of my "keepsake," & all your affec-

tionate expressions of approbation. You are mistaken in your recollections of *Nelly Custis*, she was only *17*, The original of the Portrait was *25* & had been the Mother of four children—& *8* yrs in such circumstances, had certainly produced a considerable change in figure &c.[9]

Elizabeth had mistakenly thought that the copy of Nelly's portrait was based on an image of her when she was seventeen, perhaps thinking of James Sharples' portrait (National Trust for Historic Preservation, Woodlawn Collection, Alexandria, Virginia). Nelly pointed out that she was twenty-five, which would have been in 1804. Also she had her fifth child by the summer of the next year. It is likely, therefore, that she sat for Stuart in the spring or early summer of 1804. She visited her older sister Martha Custis Peter in Washington between 6 and 14 April[10] and by 12 May was staying with her aunt Rosalie Stier Calvert at Riversdale. She remained there into July, her visit coinciding with that of her step-sister Ann Calvert Stuart (Robinson). Both her aunt and her step-sister were also painted by Gilbert Stuart at about this time (see *Ann Calvert Stuart Robinson [Mrs. William Robinson]*, 1942.8.22).

Stuart depicts Nelly seated, wearing a white "day" dress. The color of the dress is characteristic of clothing worn during the second year of mourning.[11] She leans back in her chair, her left arm bent, her left hand resting gently against her chin. Her right arm lies along her right thigh. Around her waist and right arm twists a gold and silver sash. Her large brown eyes, engulfed in shadow, are averted from the viewer as she gazes out of the picture. The painted wood armchair and greenish gray wall create a somber setting quite unlike the upholstered crimson chairs, billowing mauve curtains, or lush landscapes that characterize other portraits of women that Stuart painted in Washington. The only definition of space is a curved decorative frieze at the upper edge of the painting. It suggests an oval or round interior, unidentifiable today as a specific setting.

Stuart's portrait successfully captures Nelly's emotional state. With her head held against her hand and her heavily shadowed eyes averted from the viewer, she embodies contemporary artistic conventions used to depict mourning. Her pose is similar to late eighteenth-century images of mourners seen on English tombs and in English portraits, as well as in American images made in tribute to Washington after his death in 1799.[12] Although Stuart's image is less dramatic, his use of muted colors and a simple environment underscore a somber,

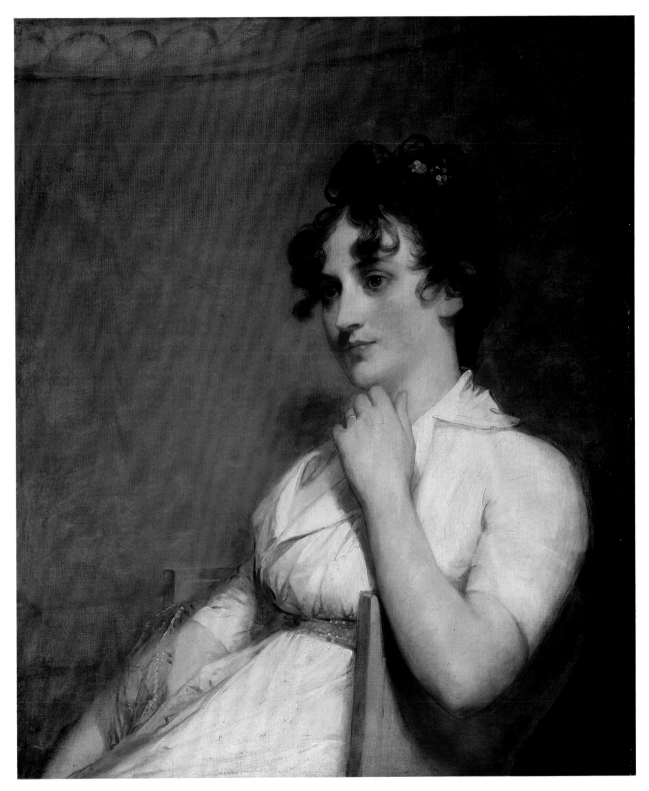

Gilbert Stuart, *Eleanor Parke Custis Lewis (Mrs. Lawrence Lewis)*, 1974.108.1

reflective mood. To reinforce the weight of her emotion, he placed her leaning back against the chair, in a position he later cautioned a younger artist to avoid because it "constrains the attitude and gen[era]l air" of the sitter.[13] Stuart's particular sensitivity may reflect his own ties to Nelly and her family. When he painted President and Mrs. Washington in Philadelphia in the 1790s, Nelly accompanied her grandparents to his Germantown studio for their sittings.[14] The contrast between the vibrant girl whom Stuart had known in Philadelphia and the melancholy young woman he saw in Washington seems to have made an impact on the observant artist.

<div align="right">P B</div>

Notes
1. An inscription in ink on the stretcher reads: "L. Lewis." A second reads: "For Lorenzo Lewis given by his Mother 1836." His dates and those of his wife and their descendants are found in Burke 1981, 21–22.
2. H.H. Walker Lewis to William P. Campbell, 29 November 1974, with a memo dated 28 November 1974 (NGA). "Lorenzo left his household furnishings . . . for the use of his widow for life, thereafter to be divided among his six sons in equal shares. Esther Maria died in 1885, and in the autumn of 1888 the portraits were divided by drawing lots . . . we know of the disposition of the Nelly Custis portrait from a letter written to his wife by Edward Parke Custis Lewis, who was then Minister to Portugal: 'Dear Mary . . . American mail just in & a letter from Dainger in which he tells me that I have drawn the Nellie Custis picture by Stuart. . . . Yr. affect husband E.P.C.L.'"
3. On Mrs. Lewis' death, 22 November 1973, the painting went to her son H.H. Walker Lewis as "remainderman" under his father's will; memo of 28 November 1974 from Lewis to Campbell.
4. Bowen 1892, 145.
5. For a brief biography of Nelly see the introduction to Brady 1991, 1–16; for the date of their move see Eleanor Lewis to Mrs. C.C. Pinckney, January 1802, quoted in Sorley 1979, 208.
6. Brady 1991, 65; the letters are in the collection of the Mount Vernon Ladies Association, Mount Vernon, Virginia. Nelly had five more children; of the eight, only four survived past childhood, and she outlived all but one. She died in 1852 at Audley, the home of her son Lorenzo, in Clarke County, Virginia.
7. Patricia Brady kindly supplied a transcript of this letter, which is owned by the Mount Vernon Ladies Association of the Union, Mount Vernon, Virginia, and is not included in Brady 1991.
8. Brady 1991, 67–68.
9. Brady 1991, 260–261, with thanks to Patricia Brady for bringing this letter to the author's attention. There are two copies of the portrait: at Woodlawn Plantation in Alexandria, Virginia, and at the Custis-Lee Mansion in Arlington, Virginia. Elizabeth Bordley, who was also

painted by Stuart (PAFA), may have sent Nelly a copy of her portrait in return; there is also a copy of her portrait at Woodlawn.
10. Her visits were noted by Anna Maria Thornton in her diary entries for 6, 9, 13, and 14 April 1804 (Thornton Papers, Manuscript Division, LC).
11. Cunnington and Lucas 1972, 146–147, 245–247, 263.
12. For similar poses of mourners in mid-eighteenth-century English tomb sculpture see Richard Hayward's *Monument to William Strode*, Westminster Abbey, London, c. 1786, and Thomas Banks' *Monument to the 2d Earle of Hardwicke*, Flitton, Bedfordshire, c. 1790, illustrated in Penny 1977, 7 and 67, respectively. Other examples of mourners are Joshua Reynolds' portrait *The Honorable Mrs. Edward Bouverie and Mrs. Crew* (1769, private collection) and Angelica Kauffmann's *Lady Louisa MacDonald* (n.d., Collection of the Duke of Sutherland, Dunrobin Castle). Anita Schorsch links the development of American needlework images of mourning to the death of Washington; see Schorsch 1979, 41–71.
13. Jouett 1816, in Morgan, *Stuart*, 1939, 86.
14. "About the time that the Washingtons were sitting for their portraits, my father's painting room was the resort of many of the most distinguished and interesting persons of the day. Nelly Custis, Mrs. Law, Miss Harriet Shaw (afterward Mrs. Carroll), generally accompanied Mrs. Washington"; Stuart 1876, 371.

References
1876 Stuart: 371–373.
1879 Mason: 27, 214.
1880 MFA: 46, no. 367.
1892 Bowen: 145, no. 142, repro. opp. 256, 441.
1926 Park: 294, 476–477, no. 491, 901.
1964 Mount: 255, 370.
1973 Mount: 106.
1981 Williams: 67, repro. 68.
1984 Walker: 378, no. 536, color repro.
1991 Brady: 260–261.

1942.8.25 (578)

William Thornton

1804
Oil on canvas, 73.2 × 61.9 (28 13/16 × 24 3/8)
Andrew W. Mellon Collection

Technical Notes: The primary support is a twill-weave fabric. The ground is a moderately thick white layer. The paint has a fluid consistency throughout, except in the whites used in the shirt and tie and in the highlights on the upholstery tacks. The modeling of the eyes is accomplished with a granular, thin paint used nearly dry. The cheeks have thin opaque scumbles of red over the body color, while the features are applied in fuller bodied opaque paints. The modeling of the coat and draperies is done with thinned layers of paint over the body color.

Tiny inpainted losses are observed at the upper limit of the hair, in the lower left background, and along the top right edge. The varnish was removed and the painting lined in 1962. The present varnish is thick and discolored.

Provenance: Bequeathed by the sitter's wife Anna Maria Brodeau Thornton [d. 1865], Washington, to her step-niece Adelaide Thomason Talbot [Mrs. Isham Talbot, 1799 / 1800–1873], Washington;[1] her daughter Mary Louisa Talbot, Kentucky.[2] Virginia Collins Miller [Mrs. Thomas Miller, 1809–1892], Washington;[3] her daughter Anna Thornton Miller Murray [Mrs. Sterling Murray, 1836–1917], Leesburg, Virginia.[4] Sold 4 January 1922 on behalf of an unidentified descendant by (Mary H. Sully, Brooklyn, New York) to (Art House, Inc., New York);[5] Thomas B. Clarke [1848–1931], New York; his estate; sold as part of the Clarke collection on 29 January 1936, through (M. Knoedler & Co., New York), to The A.W. Mellon Educational and Charitable Trust, Pittsburgh.

Exhibited: Union League Club, February 1922, no. 9. Philadelphia 1928, unnumbered. *Thomas Jefferson Bicentennial Exhibition, 1743–1943*, NGA, 1943, no. 33. Richmond 1944–1945, no. 16. *From Colony to Nation*, The Art Institute of Chicago, 1949, no. 110. NGA 1950, no. 130. Woodlawn Plantation, Alexandria, Virginia, 1952, no cat. Hagerstown 1955, unnumbered. *American Painters of the South*, CGA, 1960, no. 31. The Octagon House, Washington, on long-term loan, 1971–1983, 1984–1992. *The Capital Image: Painters in Washington, 1800–1915*, NMAA, 1983–1984, no. 2.

WILLIAM THORNTON (1759–1828) was born on Tortola in the West Indies in 1759 and went as a boy to live in England. He attended the University of Edinburgh from 1781 to 1784 and three years later came to the United States. Although he was trained as a physician, Thornton never fully pursued this career. After his marriage and a brief return to his birthplace, Thornton settled in Philadelphia where, according to his wife Anna Maria (see 1942.8.26), "he intended and indeed commenced the practice of physic, but it was so disagreeable to him, and he thought the fees so small. . . ."[6] Instead, Thornton busied himself with many projects, including steam travel—he asserted until his death that he and John Fitch invented the steamboat before Robert Fulton—the education of deaf people, breeding and racing horses, painting, and writing novels. He is best remembered for his designs for a number of public buildings, including the Library Company of Philadelphia (1789), the United States Capitol (1793), and Pavillion VII at the University of Virginia (1817). He also designed the Octagon, John Tayloe's winter residence in Washington (1798–1800), and Tudor Place, Thomas Peter's home in the

Georgetown area of Washington (c. 1805), as well as Woodlawn Plantation, the Lawrence Lewis home (1800), in Alexandria, Virginia. His involvement with the plans for the Capitol brought the Thorntons to Washington, where he held several public offices, including City Commissioner for Washington (1794–1801) and Superintendent of Patents in the Department of State (1802–1828).[7]

Mrs. Thornton kept a detailed record of the sittings for this portrait, as well as for her own, in her diary for 1804. In entries made between 11 March and 21 August 1804 she mentions Stuart frequently.[8] Some entries document specific sittings, while others refer to social occasions. Dr. Thornton sat five times for his portrait: "Dr. T sat to Mr. Stuart—he dined with us to Day" (11 March); "I went with Dr. T. to Stuart, he sat about 1½ hours" (23 March); "Dr. T and I sat to Mr. Stuart" (25 May); "Dr. T sat to Mr. Stuart. Mama and I went to the Hill & to Stuart's" (9 June); and "Dr. T & I went to Stuart's he worked at Dr. T.'s picture" (16 June). On 28 May, "Stuart called to ask us not to come till Thursday," and on 14 June they did not sit as planned because "he was grinding colors." Other entries may refer to social visits: "Dr. T. walked to Stuart's" (1 April); "Dr. T spent the afternoon and Evening with Mr. Stuart" (25 April); "Dr. T. went to Stuart's very early" (3 May). Stuart's studio was clearly a popular center for socially prominent Washingtonians. "Mama and I went with Mr. Peter to Mr. Stuart's" (27 March); "Went to Mr. Stuart's—Mrs. Law came there. —Col. Lyles staid all night" (31 May); and "Walked with Mr. & Mrs. F. & Mr. & Mrs. M. to Mr. Stuart's" (26 June). Dr. Thornton's last recorded sitting was on 16 June, while Mrs. Thornton "Sat for the last time to Mr. Stuart" on 24 June. Dolley Madison mentioned the completion of the portraits in a letter to her sister, probably written sometime in June 1804: "Dr. and Mrs. Thornton sat yesterday for the last time to Stuart."[9] On 21 August the Thorntons dined with Stuart and paid him for the portraits. "We rode to Mr. Stuart's — He dined with us. Dr. T. paid him the balance (64) in all 200$ for our portraits."

Thornton's portrait, typical of Stuart's work in Washington, is painted with an economy of effort and with little sense of volume. The composition, an undramatic waist-length pose, shows Thornton in a reddish brown coat with flat gold buttons. Behind him is a billowing mauve curtain, with a suggestion of sky and landscape. Stuart painted the portrait during the same period as that of James Madison

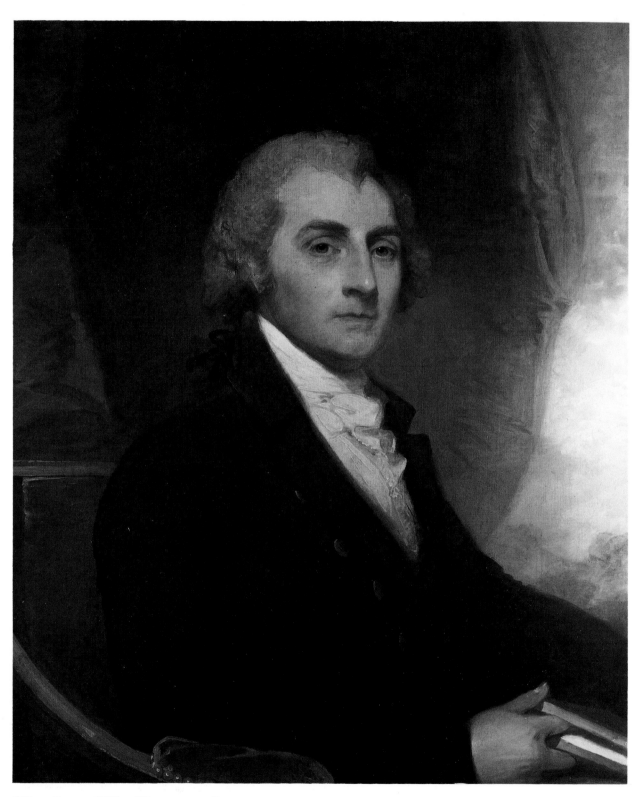

Gilbert Stuart, *William Thornton*, 1942.8.25

(1804, Colonial Williamsburg Foundation),[10] and the two men appear in similar poses wearing similar clothing. Thornton's expression, however, suggests his mental strength and energy, and the book he holds in his right hand, his fingers between the pages, perhaps alludes to his intellectual interests.

Mrs. Thornton, an amateur artist, may have tried to make drawings of the portraits, as she did with Stuart's portraits of James and Dolley Madison. In her diary on 26 July 1804 she noted, "Drawing—began yesterday to try to copy Mr & Mrs M's pictures by Stuart." The next day she wrote, "Drawing, but have not got a correct out line by Squares," and the following day she "traced the pictures & Dr. T reduced them with a pantograph." Three days later, on 31 July, she noted, "Got tracings of our pictures reduced by Mr St. Memin." French emigré profilist Charles Balthazar Julien Févret de Saint-Mémin (1770–1852), then at work in Washington, had made a portrait of William Thornton (Octagon House) that spring and had reduced the large drawing with a pantograph in preparation for making a small engraving. A watercolor copy of Thornton's portrait, attributed to Thornton, was owned in 1906 by J. Henley Smith of Washington, as was one of Mrs. Thornton, with the dress altered and a turban added.[11]

PB

Notes

1. Mrs. Thornton's will, dated June 1855 (Office of Public Records, Washington) lists the "Portraits by Stuart to Mrs. Talbot" (copy, NGA). Adelaide Talbot was the daughter of James B. Thomason, William Thornton's step-brother, and became the third wife of Isham Talbot, United States senator from Kentucky (1815–1819 and 1820–1825); Anna Maria Brodeau Thornton, "History and Life of Dr. William Thornton," unpublished manuscript, 1828, unpaginated, Thornton Papers, Manuscript Division, LC.

2. Mason 1879, 269; MFA 1880, 58, no. 614; letter of 4 June 1914 from Anna T. Murray to Charles Henry Hart (NGA).

3. Anna T. Murray to Charles Henry Hart, 4 June 1914; Virginia Miller was the wife of Dr. Thomas Miller, owner of the Thornton home on F Street, N.W., at the time of Mrs. Thornton's death (obituary of Anna M. Thornton, Daily National Intelligencer, 18 August 1865). How and when Mrs. Miller acquired the portraits is unknown. For Mrs. Miller's dates see her obituary in the (Washington) Evening Star, 6 June 1892.

4. Letter of 4 June 1914 from Murray to Hart; Mrs. Murray, who was named after Mrs. Thornton, left her belongings to her two sisters, Virginia Miller and Sally Fendall, "asking them to dispose of them in a proper manner, after my debts are paid, making gifts of remem-

brance to the special friends whom I love" (will, filed 28 November 1917; Circuit Court of Loudoun County, Leesburg, Virginia; copy, NGA).

5. Receipt dated 4 January 1922, signed by Mary H. Sully (NGA). Art House, Inc., was founded by Thomas B. Clarke in 1891; from 1919 to 1931 Thomas B. Clarke, Jr., Charles X. Harris, Alice T. Bay, and Clarence J. Dearden owned the firm. Mary Sully and her colleague A.E. Rueff provided Clarke with the provenance of the portraits.

6. Thornton, "History," 1828, unpaginated.

7. DAB 9 (part 2):504–507; Stearns and Yerkes 1976; Ridout 1989, 50–69.

8. Anna Maria Brodeau Thornton, diary, 1804, unpaginated, Thornton Papers, Manuscript Division, LC.

9. Dolley Madison to her sister Mrs. Anna Cutts (June 1804); Clark 1914, 73. Clark dates the letter to around 5 June 1804 because of an entry in Mrs. Thornton's diary: "Dr. T. at the president's with the Baron Humboldt." This reference to Humboldt, however, would not necessarily date Mrs. Madison's letter to 5 June.

10. Mount 1973, 91.

11. Hunt 1906, 616 repro.

References

1879 Mason: 269.
1880 MFA: 58, no. 614.
1914 Clark: 73, 472–473, repro. opp. 152.
1915 Clark: 144–208, repro. opp. 144.
1926 Park: 752–753, no. 839, repro.
1971 Nicholson: color repro. 75.
1973 Mount: 91, 127, repro. 92.
1976 Stearns and Yerkes: repro. 39.
1981 Williams: 67, repro. 68.

1942.8.26 (579)

Anna Maria Brodeau Thornton (Mrs. William Thornton)

1804
Oil on canvas, 73.2 × 61.3 (28 13/16 × 24 1/8)
Andrew W. Mellon Collection

Technical Notes: The support is a moderately fine-weight, twill-weave fabric. The ground is an opaque white layer of moderate thickness. The rich, fluid oil paint is smoothly worked to give a flat surface, except in the white of the dress and in the highlights on the sitter's nose and upholstery tacks, which project slightly above the surface plane. The modeling of the cheeks is accomplished with very thin, opaque scumbles, while the features are applied in fuller bodied opaque paints. Thin scumbles of blue are used in the shadows of the flesh tones. The modeling of the draperies and the dress is accomplished with layers of diluted and thinned paint over the body color. The dense aureole surrounding the sitter's head is probably the area of background paint

against which the head was modeled during the laying-in process. The back of the skirt is painted over the completed red chair.

There are small losses near the sitter's right arm and in the upper right background. Extensive reglazing of the left side of the sitter's chest and parts of the dress masks surface accretions. The varnish was removed and the painting lined in 1962.

Provenance: Same as 1942.8.25.

Exhibited: Union League Club, February 1922, no. 7. Philadelphia 1928, unnumbered. Richmond 1944–1945, no. 17. Woodlawn Plantation, Alexandria, Virginia, 1952, no cat. *American Painters of the South*, CGA, 1960, no. 32. The Octagon House, Washington, on long-term loan, 1976–1992.

LITTLE IS KNOWN about Anna Maria Brodeau's life before her marriage to William Thornton in 1790. She came to Philadelphia with her mother, Ann Brodeau, in 1777.[1] She met Thornton at a "musical tea" conveniently arranged by her mother, who was by then the proprietress of a local boarding school for young women.[2] After their marriage, the Thorntons moved to his family's plantation on Tortola, but they soon returned to Philadelphia. In 1794 they moved with her mother to Washington.

The Thorntons were part of the inner circle of Washington society, as Mrs. Thornton's highly descriptive diary entries attest.[3] They were frequent guests in the homes of the city's most influential families, and the Thorntons often entertained at their own home and on their farm in Montgomery County, Maryland. "Their residence became the centre of the literary, fashionable, and even political society of the Metropolis."[4] Mrs. Thornton's diaries frequently mention Gilbert Stuart, who was often in their company. He spent Christmas day of 1803 with them soon after his arrival in the city, and he regularly visited with them over the next eight months. Some diary entries refer to social occasions, while others note specific sittings. Mrs. Thornton sat five times for her portrait in 1804: on 22 May, "Dr. T. went very early to Stuart's. we[?] went at 12. I sat 1st time"; on 25 May, "Dr. T. and I sat to Mr. Stuart"; on 27 May, "Sat to Mr. Stuart—Dr. T. with me but did not sit"; on 10 June, "Sat for the Dress to Stuart"; and on 24 June, "Sat for the last time to Mr. Stuart. I began to draw a plant." Thornton paid the artist the balance of $64 for the portraits on 21 August; the total price for the two paintings was $200 (see 1942.8.25).[5]

Stuart painted this image with a completely as-sured manner, using a minimal series of brush strokes. He has shown Mrs. Thornton in a white dress with a low-cut bodice, seated in a wooden armchair that is upholstered in a deep red fabric. Her curly chestnut hair is tied up in a thin gold braid. Behind her billows a mauve curtain. The essential elements of the composition are very similar to those in Stuart's portrait of Dolley Madison (1804, PAFA), painted in Washington at about this time. Unlike Mrs. Madison's portrait, however, an emotional coolness marks Stuart's image of Mrs. Thornton. In comparison to other Stuart portraits of women painted in Washington, many of whom wear dresses cut in a similar Federal style, Mrs. Thornton's image seems somewhat somber. Her large brown eyes stare out at the viewer and her lips are unsmiling.

Stuart's association of Mrs. Thornton with music is the unusual feature of this portrait. She holds several sheets of musical notations, one with an illegible title beginning with a *C*. Brass-colored organ pipes, set in an oval frame, fill the left background. Women were often associated with music in late eighteenth- and early nineteenth-century portraits. They could be depicted holding a lute or guitar, or playing the harp or piano. Among such works are Robert Edge Pine's *Sophia Gough Carroll* (c. 1787, unlocated), a portrait of Mary Hopkinson attributed to Benjamin West (c. 1764, NMAA), and Charles Bird King's *Mrs. John Quincy Adams* (c. 1824, NMAA). In Stuart's portrait the association is puzzling, his inclusion of organ pipes intriguing. Stuart later recommended to his pupil Matthew Harris Jouett that "back grounds should contain whatever is necessary to illustrate the character of the person."[6] However, although Mrs. Thornton noted in her diaries that she played the piano in social settings, her leisure time was usually spent reading, playing chess, or painting. The organ pipes could refer instead to an invention of Dr. Thornton's that his wife described in her "History and Life of Dr. William Thornton," written at the time of his death in 1828.

He invented a musical instrument on which he spent much time and money, and no doubt if he could have accomplished his plan, it would have been a grand and novel instrument and he . . . would have been much gratified in surprizing his Wife with its fine tones — but alas! that also is left unfinished — He thought that an Instrument might be made to speak . . . and once when a Clergyman (Dr. Ralph) applied to him to subscribe to a Church in Maryland he told him he would if he would

Gilbert Stuart, *Anna Maria Brodeau Thornton (Mrs. William Thornton)*, 1942.8.26

subscribe to his Organ, which was to be a <u>speaking organ</u>.... [7]

It may indeed be this "surprising" instrument that Stuart has included in the portrait.

PB

Notes

1. The place and date of her birth and her father's identity are unknown, and there is even disagreement about her year of birth. Her obituary in the (Washington) *Daily National Intelligencer*, 18 August 1865, noted that she died at age 100, but most modern scholars state that she was fifteen at the time of her marriage in 1790, which would make her date of birth around 1775. Her obituary states that her father was the "unfortunate Dr. Dodd, of London, who was executed for forgery in the year 1777." In a letter published four days after her obituary, however, her friends were "much pained" by the reference to Dr. Dodd. "Her most intimate friends have never given credit to that suggestion. The rumor probably arose from the fact that Mrs. Brodeau ... never, in any manner, alluded to her life previous to her coming to America...." See "The Late Mrs. Anna T. Thornton," *Daily National Intelligencer*, 22 August 1865.
2. Clark 1914, 150.
3. Anna Maria Brodeau Thornton, diaries, 1793–1863, Thornton Papers, Manuscript Division, LC. The diaries are discussed in Carson 1990, 76–82. The diary for the year 1800 was published in 1907; see "Thornton Diary," 88–226.
4. (Washington) *Daily National Intelligencer*, 22 August 1865 (obituary).
5. Anna Maria Brodeau Thornton, diary, 1804, unpaginated, Thornton Papers, Manuscript Division, LC.
6. Jouett 1816, in Morgan, *Stuart*, 1939, 84–85.
7. Anna Maria Brodeau Thornton, "History and Life of Dr. William Thornton," unpublished manuscript, 1828, unpaginated, Thornton Papers, Manuscript Division, LC.

References

1879 Mason: 269.
1880 MFA: 58, no. 615.
1907 "Thornton Diary": 88–226.
1915 Clark: repro. opp. 150.
1926 Park: 754, no. 840.
1973 Mount: 89, 127, repro. 91.
1981 Williams: 67, repro. 68.
1990 Carson: repro. 77.

1942.8.22 (575)

Ann Calvert Stuart Robinson (Mrs. William Robinson)

c. 1804
Oil on wood panel, 71.8 × 57.5 (29 1/4 × 22 5/8)
Andrew W. Mellon Collection

Technical Notes: The painting is on a 0.5 cm thick panel of American mahogany (*Swientenia* sp.), scored on the front in both diagonal directions, top right to lower left and top left to lower right. There are also a few vertical and horizontal score lines. A thin white ground is present. The paint, applied with a fluid consistency, is moderately thin, except in the dress, where thicker paint is used on the sleeve, right breast, white highlights, and lace. The definition of features is accomplished with thin, sketchy, reddish brown lines.

Scattered inpainting in the flesh of the neck and chest and on the upper arm masks residues of discolored varnish. The dark red folds of the shawl and the browns of the hair have traction crackle. The varnish is only slightly discolored.

Provenance: Gift of the sitter's sister Eleanor Custis Stuart [b. 1796], Alexandria, Virginia, to her great-niece Rebecca Lynn Webster [b. 1861], Rochester, New York;[1] (Jonce I. McGurk, New York); sold 5 August 1919 to (M. Knoedler & Co., New York);[2] purchased 3 March 1923 by Thomas B. Clarke [1848–1931], New York;[3] his estate; sold as part of the Clarke collection on 29 January 1936, through (M. Knoedler & Co., New York), to The A.W. Mellon Educational and Charitable Trust, Pittsburgh.

Exhibited: Unidentified exhibition, 1879.[4] *Early American Portraits*, M. Knoedler & Co., New York, 1921, no. 6.[5] Union League Club, February 1924, no. 13. Philadelphia 1928, unnumbered.

ANN STUART (1784–1823?) was the eldest child of Eleanor Calvert Stuart and her second husband Dr. David Stuart of Fairfax County, Virginia.[6] Her mother's first husband was John Parke Custis, George Washington's step-son. Thus she was the half-sister of Elizabeth Parke Custis (Mrs. Thomas Law), Martha Parke Custis (Mrs. Thomas Peter), Eleanor Parke Custis (Mrs. Lawrence Lewis), and George Washington Parke Custis, the grandchildren of George and Martha Washington.[7] Stuart probably painted her portrait in Washington in 1804, two years before she married William Robinson of Westmoreland County, Virginia.[8] He painted a number of her relatives at that time, including her half-sister Eleanor Custis Lewis [1974.108.1] and her aunt and uncle Rosalie and George Calvert (private collection).

Gilbert Stuart, *Ann Calvert Stuart Robinson (Mrs. William Robinson)*, 1942.8.22

Writing in November 1803, Rosalie Stier Calvert described her niece as "the most delightful person I've met, extremely sweet, pleasant and well-bred."[9] When Mrs. Stuart purchased a house near Alexandria, Virginia, Rosalie wrote in December,

Her object in wanting to come and live in that neighborhood is to educate her children and give her daughters more opportunity to go out in society and get married. I'm afraid they won't find husbands easily since they are very difficult to please, and there isn't a good choice nowadays. The eldest is a delightful person, extremely sweet and amiable, and as soon as her mother is recovered from her confinement, she is coming with her sister to spend a few days with me.[10]

Ann's visit to Riverdale, the Calverts' home near Bladensburg, Maryland, the following spring and summer probably provided the opportunity for the sittings. Ann and her sister Sally visited her aunt at the same time as her half-sisters Eleanor Lewis and Eliza Law, as her aunt explained on 30 July 1804. "For the last two months I had the Misses Stuart here, and Mrs. Peter and Mrs. Lewis for a few days."[11]

Rosalie Calvert was also painted by Stuart that summer. She first mentioned Gilbert Stuart in a letter written in March 1804. "The painter Stuart — whose paintings Charles [her brother] admired so much — is in Washington, and I think he has improved. That is to say, he has changed his manner, which was very rude, and has settled down somewhat. He finishes quickly and has lots of work."[12] In May she took her daughter Caroline to visit Stuart, who later included the little girl in Mrs. Calvert's portrait. "I took her the other day to the home of the painter Stuart, who has a fine collection of portraits. He could not tire of looking at her and said she was exactly like a Mrs. Sheridan of England, a woman famous for her beauty and her lovely voice."[13] Mrs. Calvert wrote to her father about the painting a year later, on 19 May 1805. "I have enjoyed perfect health since Louise's birth and am much fatter. We had our portraits painted by Stuart this past summer, but my good health has so improved my looks that though when painted the portrait was as exact a resemblance as possible, everyone now tells me it doesn't do me justice."[14] In their portraits Ann Stuart and Rosalie Calvert are similarly posed and dressed. They both sit with their bodies turned to the left, their heads turned toward the viewer. They wear low-cut dark gowns, and soft curls frame their faces. Ann's bright red shawl adds a lively contrast to her black dress. Their portraits provide a notable contrast to that of Ann's half-sister, Nelly Custis Lewis. She appears more subdued and downcast, her pose somber and reflective.

Rosalie Calvert continued to worry that Ann and her sisters would never find husbands because "their mother paid scant heed to their education and brought them up as if they were to marry English lords, and I don't believe they accept the offers made to them."[15] After Ann married William Robinson of "Bunker Hill," Westmoreland County, Virginia, on 30 October 1806, her aunt described the marriage as one "to a wealthy Virginian of good reputation, but not renowned for his intelligence. She is an exceptional person and I am upset that she will be living so far from us."[16] Little is known of Ann after her marriage. She wrote to her friend Elizabeth Lee in the spring of 1807 that she was a different person. "You would be surprised to see what a change has taken place in my taste, instead of reading or writing all day and being out of humor when interrupted I am quite active about the Farm and garden and very solicitous to do something in that way to entitle me to become a member of the agricultural society."[17] Rosalie Calvert wrote her sister on 10 December 1807,

The eldest of the Stuart girls is a very nice girl, but she now lives quite far away in Virginia. Her father, whom I am sure you remember as an extremely austere and tedious man — completely respectable, but more knowledgeable about the customs of the Greeks and Romans than of today — forced her against her will to marry a man who does not have enough intelligence to make a woman such as she happy. Although she writes me that she is perfectly [content], I do not believe it.[18]

She commented again on the mismatch when discussing Rousseau's theories of education with her brother Charles Stier in her letter of 5 May 1808.

Believe me, these private educations which have been followed out with so much care and method often miss their purpose. Even here there are several examples of it, among others, my charming niece Miss Stuart in whom are united all the most loveable traits with the most solid virtues, fitted to adorn the highest position. And because her father had no fortune to give her, she has married a Virginia bonhomme who loves her á sa façon, and that is all. Her sisters, who are really her opposites, will perhaps be happier.[19]

The Robinsons had two sons, Edwin Wilberforce and Claudius Buchanan, who both died young.[20] Mrs. Robinson was still living in 1814, when her father left several bequests to her.[21] Almost a decade

later, in May 1823, her half-sister Nelly Lewis planned to visit her. "We are going tomorrow for a few days to visit my half sister Mrs. Robinson, who is, I fear, in a deep decline."[22] She may have died soon after this.[23]

EGM

Notes

1. Letter from Rebecca Webster, 15 August 1919, to Jonce I. McGurk, New York (typed copy, NGA). For their relationship and dates of birth (dates of death are undetermined), see Johnson 1905, 30, 41. According to Stuart 1876, 373, the portrait was owned by Mrs. George Goldsborough, granddaughter of Mrs. Robinson's half-sister Mrs. Thomas Law. Park 1926, 650, states, however, that the painting was only on loan to Mrs. Goldsborough, who lived in Talbot County, Maryland.

2. The dated receipt for McGurk's sale to Knoedler is in the NGA curatorial file.

3. The Knoedler invoice dated 28 February 1923 is in the NGA curatorial file; the name of the seller and the date of purchase are recorded in an annotated copy of *Clarke* 1928 in the NGA library.

4. The painting was said to have been exhibited in 1879; the Knoedler invoice of 1923 and Park 1926, 650, cite a label, now unlocated, that was once attached to the back of the painting. The exhibition, which has not been identified, may have been the one in Baltimore that included Stuart's portraits of Ann and Mary Barry [1954.9.3 and 1954.9.4].

5. The loan is recorded in the exhibition catalogue and in Merrick 1921, 32, repro.

6. Johnson 1905, 30; Torbert 1950, 48.

7. Johnson 1905, 29–30; genealogical table, Torbert 1950, opp. 1.

8. Park 1926, 649–650, erroneously dated the portrait to around 1812 and believed it was painted in Boston. NPG volunteer Leslie E. Cook helped to document this sitter's life and thus place the portrait in Stuart's years in Washington.

9. Callcott 1991, 63, to her mother Mme. H.J. Stier in Belgium.

10. Callcott 1991, 70, 29 December 1803, to her mother.

11. Callcott 1991, 92, 30 July 1804, to her mother. The visit apparently began by 12 May; see her letter of that date to her mother in Callcott 1991, 82.

12. Callcott 1991, 80, March 1804 to her mother.

13. Callcott 1991, 83, letter of 12 May 1804 to her mother; Callcott identifies Mrs. Sheridan as Caroline Henrietta Sheridan (1779–1851), a much acclaimed English beauty and daughter-in-law of Richard Brinsley Sheridan.

14. Callcott 1991, 119. Her portrait and that of her husband are reproduced in Callcott 1991, 21 and as the frontispiece.

15. Callcott 1991, 111–112, letter dated 18 February 1805 to Isabelle von Havre, her sister.

16. Callcott 1991, 169, letter of 6 May 1807 to her sister. Rosalie Calvert described the wedding as taking place "the other day," while the more precise date of 30

October 1806 is given in Torbert 1950, 119. Robinson was a landowner in Westmoreland County; Withington 1914, 24.

17. Torbert 1950, 121–122.

18. Callcott 1991, 176.

19. Callcott 1991, 186–187.

20. Withington 1914, 24. According to the research notes of J. Hall Pleasants of Baltimore, cited on the photo mount for this painting at the Frick Art Reference Library, Edwin died at the age of twenty-one after his graduation from the military academy at West Point, and Claudius died in infancy.

21. Will of David Stuart, Fairfax County Circuit Court Archives, Fairfax, Virginia, filed 17 October 1814 (copy, NGA); the will also provided for his four unmarried daughters and two sons, and included the bequest to his son-in-law William Robinson of the dressing table left to him by George Washington, should Robinson and "his present Wife" have a son.

22. Nelly Custis Lewis to Elizabeth Bordley Gibson, 7 May 1823, in Brady 1991, 136.

23. William Robinson, described in November 1823 as "of Fairfax County," had remarried by April 1834, when he and his wife Frances of "George Town," District of Columbia, are mentioned in connection with a Westmoreland County deed; see "Westmoreland County Deeds and Wills," 26:76 and 28:340–341 (courtesy of Jeanne Calhoun, research scholar, Robert E. Lee Memorial Association, Inc., Stratford Hall Plantation, Stratford, Virginia), and Withington 1914, 24.

References

1876 Stuart: 373.
1879 Mason: 250.
1880 MFA: 53, no. 516.
1926 Park: 649–650, no. 711, repro.
1964 Mount: 374.

1940.1.9 (495)

John Randolph

1804/1805
Oil on canvas, 73.6 × 61 (29 × 24)
Andrew W. Mellon Collection

Technical Notes: The painting is on a medium-weight, plain-weave fabric. There is broad cusping along the right and left edges. The ground is a thin, off-white layer that does not mask the texture of the canvas. The paint is applied in a wet-in-wet technique that ranges from thin, opaque paste layers in the flesh tones and shirt to thin, semi-transparent glazes in the background, drape, clothing, hair, and details of the facial features. The flesh tones are subtly textured with low-lying, lively brushwork, while the white shirt is built up using more highly textured paint. A light-colored imprimatura layer that extends slightly beyond the hair and left profile contour of the face may have been used to block in the face. A

semi-transparent, red-brown paint outlines and reinforces details such as the nostrils and the buttons on the waistcoat. There are no major discrete losses, although the edges have been damaged and are overpainted along the left, right, and top. The painting was lined in 1944 and again in 1965.

Provenance: The sitter; his estate until 1845;[1] his half-brother Nathaniel Beverley Tucker[1784–1851], Williamsburg, Virginia;[2] his daughter Cynthia Beverley Tucker Coleman [Mrs. Charles Washington Coleman, 1832–1908], Williamsburg, Virginia;[3] her son Charles Washington Coleman, Jr. [1862–1932], Williamsburg, Virginia;[4] his brother George Preston Coleman [1870–1948], Williamsburg, Virginia;[5] sold 21 January 1937 through (M. Knoedler & Co., New York), to The A.W. Mellon Educational and Charitable Trust, Pittsburgh.[6]

Exhibited: The Corcoran Gallery of Art, Washington, on long-term loan, 1900–1936. *Exhibition of Early American Paintings, Miniatures and Silver Assembled by the Washington Loan Exhibition Committee*, National Collection of Fine Arts, Smithsonian Institution, Washington, 1925–1926, no. 65. *Contemporary Portraits of Personages Associated with the Colony and Commonwealth of Virginia, 1585–1830*, Virginia Historical Society, Richmond, 1929, no. 53. *Masterpieces of American Historical Portraiture*, M. Knoedler & Co., New York, 1936, no. 4. Richmond 1944–1945, no. 18. *An Exhibition of American Painting from Colonial Times Until Today*, The Saginaw Museum, Michigan, 1948, no. 54. Colonial Williamsburg Inc., Virginia, on loan, 1951. *Gilbert Stuart*, NGA; RISD; PAFA, 1967, no. 39. *Classical Taste in America, 1800–1840*, The Baltimore Museum of Art; Mint Museum of Art, Charlotte, North Carolina; The Museum of Fine Arts, Houston, 1993–1994, no. 32.

STUART PAINTED John Randolph "of Roanoke" (1773–1833) in Washington when Randolph, a Virginia aristocrat and a great public speaker, was a member of the United States Congress. Elected to the House in 1799 as a supporter of Thomas Jefferson, Randolph was soon at odds with the Jeffersonians and later with subsequent administrations, as he repeatedly served in Congress until the election of Andrew Jackson in 1829. Stuart painted the congressman's portrait in the spring of 1804 or 1805; Randolph's only reference to the painting is confusing on this question of date. Included with information ranging from personal reminiscences to boot-blacking recipes that Randolph compiled into a notebook the year before he died, he wrote: "8th Congress—1803/4. At Miss Dashiel's in the Swamp (Penna. Avenue).... Peale (father and son from Philadelphia) picture of Gallatin piques Gilbert Stuart.... Went to Rose Hill with Bryan and Rodney. Delia accompanies us from Baltimore. Stuart takes my picture, on my return (March)."[7]

The entry combines events of 1804 and 1805. Randolph stayed at Miss Dashiell's boardinghouse during both sessions of the Eighth Congress (17 October 1803–27 March 1804 and 5 November 1804–3 March 1805). His trip to Rose Hill, the home of General David Forman near Chestertown, Maryland, with fellow congressmen Joseph Bryan and Caesar Rodney probably occurred near the end of the first session, sometime between 13 and 22 March 1804, when Bryan was courting General Forman's daughter Delia. There is a gap for these dates in Randolph's remarks to the House of Representatives; until then he had made almost daily reports or comments. Randolph remained in Washington until the first session recessed on 27 March and was in Richmond by 3 April 1804.[8] On the other hand, Charles Willson Peale and his son Rembrandt were in Washington at the same time only during the first months of 1805. Charles Willson Peale's journal for 11 January 1805 states that "this evening went to our new Lodging at Miss Deshields, where a number of members of Congress also boarded—." Peale was in Washington between 8 January and 3 February 1805, while his son Rembrandt stayed on a week or so longer and was back in Philadelphia by 15 February.[9] Years later Tucker's niece recalled, "I have often heard my father say that he [John Randolph] was 32 at the time he sat to Stuart for this portrait,"[10] which would date the sittings to 1805.

The date of 1804, however, does seem more likely. Randolph was in the Washington area that year until at least the end of March, whereas the following year he left the city on 3 March, shortly after the end of the second session of Congress.[11] He had managed the case against Supreme Court justice Samuel Chase in the justice's impeachment trial, and he was humiliated by the judge's acquittal. His involvement in Chase's trial had been personally draining, and during his closing remarks as prosecutor in late February, Randolph was apparently sick and confused. Henry Adams later wrote that for Randolph's closing address on 27 February 1805, "he was ill and unprepared ... he astonished the Senate by the desultory and erratic style of his address. Soon he broke down." Adams then quoted Randolph's address: "I am physically as well as morally incompetent.... My weakness and want of ability prevent me from urging my cause as I could wish, but it is the last day of my sufferings and of yours."[12]

This is hardly the figure that Stuart depicted. He presented Randolph as a serenely confident gentle-

Gilbert Stuart, *John Randolph*, 1940.1.9

man, one who would say, "I am an aristocrat. I love liberty; I hate equality."[13] Randolph leans back in a painted wood chair, gazing out at the viewer. He wears a dark green, almost black jacket with a black velvet rolled collar. A pink-toned buff waistcoat with touches of pale blue and golden brown emerge from under the jacket. His white shirt and the waistcoat are slightly disheveled, and his light brown hair is pulled back loosely in a queue with a black ribbon, which adds to his relaxed and comfortable demeanor. He is seated in a klismos chair, an example of sophisticated neoclassical furniture that imitated a classical Greek form. Wendy Cooper has recently suggested that Stuart's limited use of this style of chair in two portraits that he painted in Washington—this one and that of Eleanor Parks Custis Lewis [1974.108.1]—may indicate that the sitters owned such chairs and requested that they be portrayed in them.[14] However, while Stuart's choice of furnishings in his portraits does appear at times to express the tastes and personalities of his sitters, in general the furniture does not seem to be the sitters' personal property. Since his portraits were usually made in Stuart's painting room or studio, and not in his sitters' homes, Stuart had few opportunities to record his sitters' personal possessions.

The most striking feature of Stuart's portrait is the sitter's youthful appearance. Some writers have mistaken Randolph's age in the painting for twelve, rather than about thirty.[15] Randolph apparently suffered from a serious, but mysterious illness that left him boyish and delicate in appearance.[16] William Plummer, a congressman from New Hampshire, wrote in 1803, "Mr. Randolph goes to the House booted and spurred, with his whip in his hand. . . . He is a very slight man but of the common stature. At a distance, he does not appear older than you are; but, upon a nearer approach, you perceive his wrinkles and grey hairs. He is, I believe, about thirty."[17] Stuart ignored the "wrinkles and grey hairs" and exaggerated Randolph's boyish qualities. The wrinkles on the left side of his face are obscured in soft shadow, and those on the right side are obliterated by strong, direct lighting. The brushwork in his face emphasizes his skin's taut, beardless state. His hair is depicted with short, choppy strokes in a thin brown color, which gives it a soft, wispy effect. A comparison with John Wesley Jarvis' portrait of Randolph painted in 1811 (NPG) underscores the youthfulness of Stuart's image. Randolph was apparently pleased with Stuart's

portrait; it hung over his bed at his home in Roanoke.[18]

P B

Notes

1. John Randolph's estate was in litigation until 1845, when a judge ruled in favor of the 1821 version of Randolph's will; Bruce 1922, 2:57–58; the will, which is reproduced in Bouldin 1878, 203–210, does not mention the painting specifically. Records concerning the final disposition of Randolph's estate were destroyed in a fire in Richmond during the Civil War.

2. Writer-artist David Hunter Strother, known as "Porte Crayon," saw the portrait in the home of Judge Nathaniel Beverley Tucker in November 1849. "Some family portraits in the quaint costumes of past generations adorned the walls, among which was a more modern picture of John Randolph of Roanoke by Stewart" (Eby 1959, 444). For Tucker's dates see *Notable Americans* 1904, unpaginated.

3. Mrs. Coleman was quoted in 1892 as saying, "I have it by inheritance from my father, who was John Randolph's half-brother"; Bowen 1892, 522. For her life dates see Patricia A. Gibbs' letter of 4 August 1971 (NGA).

4. Charles Washington Coleman, Jr., to Charles Henry Hart, 13 June 1896 (NGA): "The portrait by Stuart, to which you refer, is mine by inheritance, John Randolph having been the brother of my grandfather." For C.W. Coleman's dates see Patricia A. Gibbs' letter dated 4 August 1971 (NGA).

5. Weddell 1930, opp. 332; for George P. Coleman's dates see Patricia A. Gibbs' 1971 letter (NGA).

6. Memorandum, The Corcoran Gallery of Art, 29 December 1936, noting release of the painting to Knoedler for sale by George Preston Coleman (copy, NGA).

7. John Randolph, notebook, c. 1832, unpaginated, Tucker-Coleman Collection, Earl Gregg Swen Library, College of William and Mary, Williamsburg, Virginia. The information is arranged alphabetically in the notebook; this entry is under *C*.

8. Stokes and Berkeley 1950, 39. Several letters that Randolph wrote during the summer of 1804 refer to Delia Forman, including that to Joseph H. Nicholson dated 1 July 1804, Joseph H. Nicholson Papers, Manuscript Division, LC.

9. Miller 1983, 2:785–786, n. 13, 798, 809.

10. Cynthia Beverley Tucker Coleman, quoted in Bowen 1892, 522; Randolph's birthday was 2 June.

11. He was in Fredericksburg by 6 March and at his family home by 8 March; Stokes and Berkeley 1950, 42.

12. Adams 1882, 103–104.

13. Quoted in Dawidoff 1979, 32.

14. Cooper 1993, 55–56.

15. Howe 1845, 223.

16. Randolph wrote in 1813 that he had contracted scarlet fever when he was nineteen; see Dawidoff 1979, 98–99. Others suggest he had syphilis; see William Stokes' unpublished thesis quoted in Kirk 1964, 3. The effects of this illness are also debated. Many believe that

the illness left him not only boyish in form and voice but also impotent.

17. See Plumer's letter to his son written in February 1803, quoted in Bruce 1922, 1:176. Mrs. Tucker, a descendant, later commented on the painting, "The face, which is of wonderful beauty and amiability, represents him a boy of 16, but the figure is that of a tall man.... I have also heard my father say that, as a likeness, the picture was excellent—the artist making the mistake, however, of omitting the wrinkles that had already begun to furrow his face. John Randolph had no beard. These facts will account for the very youthful appearance of his portrait" (Bowen 1892, 522).

18. Captain Harrison Robertson of Danville visited Randolph's home in 1839 with several other students from Hampden-Sydney College in Virginia. "Entering the log house we found every article of furniture remaining exactly (John [Randolph's slave] assured us) as it had been left by Mr. Randolph at the time of his departure for Philadelphia on his last journey.... In the bed room we found ... on the wall above the bed, hung a portrait of Mr. Randolph (in oil). I have forgotten the name of the artist, but the painting was well done. I distinctly recollect the beardless boyish appearance of the face" (quoted in Bouldin 1878, 263–264).

References

1845	Howe: 223.
1878	Bouldin: 62–64, 264.
1882	Adams: 110.
1892	Bowen: 522, repro. opp. 160.
1906	"Stuart": 37–38, pl. 4.
1914	Fielding: 330, no. 110.
1922	Bruce: 1:frontispiece; 2:66, 95.
1926	Park: 2:632–633, no. 689, repro.
1930	Weddell: 335, repro. opp. 332.
1959	Eby: 444.
1973	Mount: 101 repro., 126.
1981	Williams: 67, repro. 69.
1984	Walker: 383, no. 541 color repro.
1993	Cooper: 55–56, repro.

1980.11.2 (2775)

Samuel Alleyne Otis

1811/1813
Oil on wood panel, 71.6 × 57.8 (28 3/16 × 22 3/4)
Gift of the Honorable and Mrs. Robert H. Thayer

Technical Notes: The painting is executed on a single member, yellow poplar panel with a thickness of 0.7 cm. The front is heavily scored with a regular series of lines running from upper right to lower left, in imitation of twill fabric. The reverse is coated with gray paint. A gray ground does not completely fill the score marks on the panel and may have a slightly nubbled texture of its own. The paint is more thickly applied in the face, with the contours softly modeled in a wet-in-wet technique. The pink blush of the cheeks is applied as a thin opaque layer, and impasto is used for the highlights on the sitter's forehead and on the white of the shirt ruffle. Thin, opaque, and semi-translucent paint layers are used in the background.

A prominent split in the panel begins along the top edge to the right of center and travels toward the sitter's left ear. One small loss in the sitter's right cheek has been retouched. The paint suffers only from slight abrasion.

Provenance: The sitter's son Harrison Gray Otis [1765–1848], Boston;[1] his son James William Otis [1800–1869], New York;[2] his widow Martha Church Otis [d. 1888], New York; their grandson Harrison Gray Otis [1856–1915], Needham, Massachusetts;[3] his son William Alleyne Otis [b. 1895], Boston;[4] purchased by Virginia Pratt Thayer [Mrs. Robert Helyer Thayer, d. 1979], Washington.[5]

Exhibited: *Second Exhibition of Paintings*, Boston Athenaeum, 1828, no. 214.[6] *Exhibition of Portraits Painted by the Late Gilbert Stuart, Esq.*, Boston Athenaeum, 1828, no. 36. New York 1853, no. 10.[7] Old State-House, Boston, 1892.[8] MFA, on long-term loan, 1914–1949.[9] *Gilbert Stuart Memorial Exhibition*, MFA, 1928, no. 49. *A Necessary Fence: The Senate's First Century*, United States Senate, Washington, 1989, no. 19.

SAMUEL ALLEYNE OTIS (1740–1814) was the brother of Massachusetts political activist and pamphleteer James Otis and author Mercy Otis Warren. After he graduated from Harvard College, Otis became a merchant, selling supplies and clothing to American troops during the Revolution. He also served in the Massachusetts state House of Representatives. Bankrupted in the post-war depression, he continued his political career by serving as a delegate to Congress in 1787–1788. When the first federal congress convened in 1789, the United States Senate elected him secretary, a position he held for the rest of his life.[10]

Otis sat to Stuart in 1811, but the portrait may not have been completed until 1813. He noted in his journal on 3 October 1811: "Sat at Steuarts." Below this, on the next line, he noted, "Frothingham 7," perhaps a reference to Stuart's pupil James Frothingham. On 20 August 1813, almost two years later, he jotted down "1 Steuart."[11] The result is a portrait in black and white, with slight color accents. Otis, his white hair tied in a queue with a black ribbon, wears a black coat and a white shirt with a ruffle. A slight hint of red, perhaps a waistcoat or lining, appears along both sides of the shirt ruffle. Behind him to the left is a red curtain, to the right a

Fig. 1. X-radiograph showing white paint in the diagonal incisions made in the panel of 1980.11.2

gray wall. Stuart's technique is highly accomplished, the effects gained with the minimum of brush strokes needed to capture the likeness. He used the ridges made by the scoring in the wood panel (Figure 1) to catch the paint that describes the sitter's wispy hair, applied as a scumble. The face is modeled in multiple layers, wet-in-wet, and impasto is used for the highlights on Otis' forehead and shirt. In 1926 Lawrence Park assigned the date of 1809 to Otis' portrait, probably because Stuart painted his son Harrison Gray Otis (Society for the Preservation of New England Antiquities, Boston) and daughter-in-law Sally Foster Otis (Reynolda House, Winston-Salem, North Carolina) that year.[12]

EGM

Notes

1. For his dates see Otis 1924, 141. This portrait shares its provenance with John Singleton Copley's portraits of the sitter's wife Elizabeth Gray Otis [1980.11.1] and father-in-law Harrison Gray [1976.25.1].

2. For his dates see Otis 1924, 202.

3. Bowen 1892, 517; for his dates see Otis 1924, 495. Records in the registrar's office, MFA, give the painting's owners from 1917 to 1926 as Robert H. Gardiner, Robert H. Gardiner, Jr., and William Tudor Gardiner (letter from Jennifer Abel, 26 October 1990; NGA). Perhaps they were acting as trustees or executors of the estate of Harrison Gray Otis.

4. Park 1926, 565–566; for his birth date see Otis 1924, 608.

5. Robert Helyer Thayer [1901–1984] was William Otis' cousin; see Otis 1924, 496; Robert Thayer's mother Violet Otis Thayer was Harrison Gray Otis' sister. Mrs. Thayer's Last Will and Testament, dated 1 April 1976, states that she held ownership of the portrait; the purchase is documented in Robert Thayer's letter of 13 May 1976 to J. Carter Brown (NGA General Counsel files). The painting was delivered to the Thayers on 22 June 1949 by the Museum of Fine Arts, Boston, on the authority of William A. Otis. Mrs. Thayer's date of death is recorded in the NGA curatorial file. Thayer is listed in *Who's Who* 1974, 3056, and *NYT Bio Service* 1984, 143. Adrian Lamb painted a copy of this portrait in 1976 for the Thayers.

6. *Athenaeum Gallery* 1828, 6, lent by H.G. Otis; Swan 1940, 37; Perkins and Gavin 1980, 133.

7. *Washington Exhibition*, New York 1853, 8, lent by J.W. Otis. The exhibition is misdated 1 May 1854 by Yarnall and Gerdts 1986, 5:3418. For confirmation of the 1853 date see Cowdrey 1953, 1:283.

8. Bowen 1892, 517, wrote that this and other Otis family portraits were on deposit in the rooms of the Bostonian Society, Old-State House, Boston.

9. Records of the registrar, MFA; letter from Jennifer Abel, 26 October 1990 (NGA).

10. *NCAB* 2:500; *Appleton's* 1898, 4:607; Shipton 1968, 471–480; some sources spell his middle name "Allyne."

11. Diary of Samuel Alleyne Otis, 1809–1814, Massachusetts Historical Society, Boston; I am grateful to Virginia H. Smith, reference librarian, Massachusetts Historical Society, for locating these references.

12. For the portraits of Sally Foster Otis and Harrison Gray Otis see Lassiter 1971, 14–15, 53, repro., and *American Originals* 1990, 30–32, repro.

References

1879 Mason: 235.
1880 MFA: 50, no. 449.
1892 Bowen: repro. opp. 45, 517.
1924 Otis: 106, repro. opp. 106.
1926 Park: 565–566, no. 601, repro.
1968 Shipton: 471–480, repro. between 328 and 329.
1969 Morison: 4–6, 22, repro. 25, 39–40, 53.

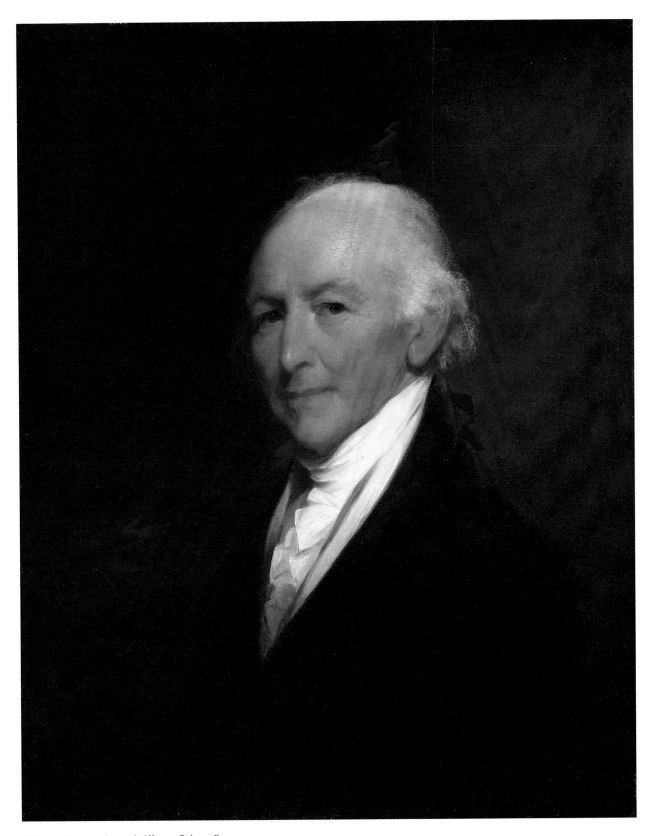

Gilbert Stuart, *Samuel Alleyne Otis*, 1980.11.2

1970.34.2 (2540)

Benjamin Tappan

1814
Oil on wood panel, 72.5 × 58.7 (28 9/16 × 23 1/8)
Gift of Lady Vereker

Technical Notes: The painting is executed on a single piece of American mahogany (*Swientenia* sp.) with a vertically oriented grain, 0.6 cm in thickness. The front and reverse have been textured on both diagonals with a comblike tool to resemble twill canvas. The paint is applied thinly over an off-white ground, with fluid strokes that retain the brush marks. The facial features and areas of the head are painted with smooth transitions of color, often wet-in-wet.

The reverse of the panel has been cradled without a veneer interleaf. The panel has not been thinned. The varnish was removed and the painting revarnished in 1972.

Provenance: The sitter's son Lewis Tappan [1788–1873], Brooklyn, New York;[1] his daughter Julianna Aspinwall Tappan [b. 1816], Brooklyn, New York;[2] bequeathed to her sister Ellen A.A. Hulett [d. 1906], Newburgh, New York; bequeathed to her daughter Margaret Hulett [d. 1947], Newburgh, New York, and Washington;[3] sold to John F. Braun, Merion, Pennsylvania.[4] Purchased in 1933 by Clarence Winthrop Bowen [1852–1935], New York, New York, and Woodstock, Connecticut;[5] his daughter Roxana Wentworth Bowen, Lady Gordon Vereker [1895–1968], Valbonne, France.[6]

Exhibited: *Exhibition of Portraits Painted by the Late Gilbert Stuart, Esq.*, Boston Athenaeum, 1828, no. 62.

AFTER SERVING as an apprentice to Boston goldsmith William Homes (1717–1783), Benjamin Tappan (1747–1831) settled in Northampton, Massachusetts, and worked for twenty years as a gold- and silversmith before becoming a dry goods merchant.[7] His son Lewis Tappan commissioned this portrait and that of Mrs. Tappan [1970.34.3] in September 1814, while his parents were visiting him in Boston. Lewis Tappan's older brother Benjamin (1773–1857) had studied painting with the artist in New York in the 1790s.[8] Tappan recorded the dates of the sittings and his payment for the portraits. The first visit was on 22 September: "At Stuart's — father's portrait first begun." Others were on 3 October: "At Stewart's — last sitting of father;" 10 October: "at Stuart's — mother sat;" 18 October: "rode to Roxbury & call at Stuart's;" and 27 October: "rode on horseback with S. to Stuart's to see portraits." He "paid G. Stuart esqr. $200 for father

& mother's portrait" on 4 November, visited Stuart again on 21 November, and on 3 December noted, "Portraits of father & mother brought home."[9] The portrait, an understated study of a man in his late sixties, shows Tappan, with gray hair and gray-blue eyes, wearing a black coat and a white shirt with a ruffle. The background is reddish brown on the left, gray on the right. Stuart's quick, unlabored brushwork is especially apparent in Tappan's face, where shadows and highlights were added over local color. The wispy curls of Tappan's gray hair and the impasto handling of the shirt ruffle introduce movement to the restrained image.

In a later reminiscence Lewis Tappan described his father's first sitting in greater detail.

In the year 1814, my parents being in Boston on a visit I persuaded them, after much entreaty to have their portraits painted by the celebrated Gilbert Stuart, who then had his studio in Roxbury. Having made my arrangements with the artist I invited my father to take a ride into the country. As we were returning I spoke to him of Stuart's paintings, and said he has the original heads of Washington & his wife painted by himself; would you not like to see them? He took out his watch, and said shall we have time? We stopt at Stuart's, who at once knew my errand and began to mix the paints on his pallet. My father, after a cursory look at the pictures, took out his watch again, "I am afraid we shall be too late." I then told my desire to have his portrait painted. He hung back, made many excuses, and at length gave a reluctant consent. Stuart did his best to entertain him by relating the circumstances attending his visit to Philadelphia to paint Washington, &c. And to beguile the time I stood at the painter's side to see that the conversation did not flag, and when impatience was manifested on the part of my father to say something to chase it away.

He also described the rest of the sittings.

There were 3 or 4 sittings at which I was present all the time. Stuart's slovenly apparel, his strong marks of intemperance, his filthy mode of taking snuff, and the stories he told of his intimacy with distinguished men now and then repeated during the sittings were almost too much for the patience of my father, and I had to force a laugh occasionally to keep up my father's spirits. When told that he need not come again he was much gratified; and he left without scarcely looking at the picture. As we came out he said, "Do you believe that General Washington was so intimate with Stuart?" How the artist could contrive, under such circumstances to take a likeness that expresses so much good nature I cannot imagine.[10]

Lewis Tappan recorded a further comment in his reminiscences. "Several years after, Washington Allston saw the original or a copy in company with my brother Charles, and said to him, 'That is a re-

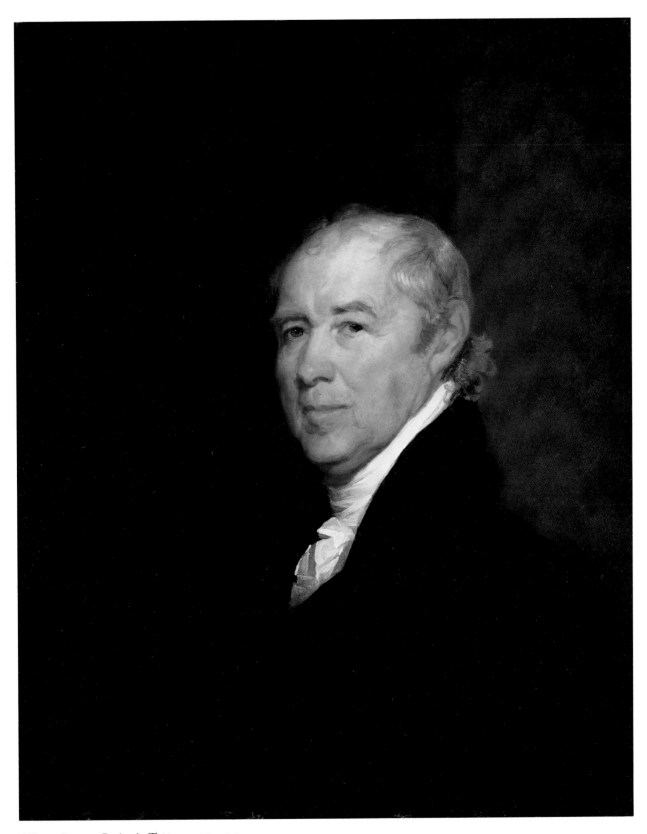

Gilbert Stuart, *Benjamin Tappan*, 1970.34.2

markable painting, and the head much resembles the head of Rubens.'"[11] Tappan may be referring to the replica of the portrait, which is on a similarly sized wood panel. It was owned until recently with a replica of the pendant of Mrs. Tappan by descendants of his brother William; both are now at the Montgomery Museum of Fine Arts in Alabama.[12]

For a number of years Clarence Bowen tried to acquire the portraits but, according to his diary entry for 1 February 1928, "There was a slip up and the Benj Tappan portrait was sold to a collector in Philadelphia."[13] When he finally acquired this portrait in 1933, he wrote in his diary on 4 August, "Got the portrait of my great grandfather Benjamin Tappan painted by Gilbert Stuart — the companion portrait to Mrs. Benj Tappan (niece of Benj Franklin) also by Stuart which hangs in the N.Y. house. I have tried for years to get these two portraits."[14]

<div align="right">EGM</div>

Notes

1. For his dates see Tappan 1915, 25, 40.
2. Her birth date is in *Tappan* 1834, 131; she is listed as "Julia" in Tappan 1915, 40.
3. The provenance to Margaret Hulett (sometimes spelled Hewlett or Hulette) is recounted in a memorandum from her sister Anna Hulett (NGA). A label attached to the reverse records that the painting was owned by both sisters and that on 27 June 1924, H.K. Bush-Brown of 1729 G Street, Washington, lent it to the National Gallery of Art, Smithsonian Institution (now NMAA). The Gallery's records indicate that the portrait, which was for sale, was returned to Bush-Brown on 17 September 1924 (copies, NGA). Margaret Hulett died in Washington on 4 January 1947; her will and a related document are filed with the probate court, District Court of the United States for the District of Columbia (copy, NGA).
4. The Frick Art Reference Library, New York, recorded the new owner's name when the painting was photographed in 1928. The phrase "Philadelphia collector owner 1926" was added in pencil to the entry on this portrait in a copy of Park 1926 (library, NMAA and NPG). The writer is unidentified.
5. Bowen was a cousin of the Huletts; their aunt Lucy Maria Hulett, who married Henry Chandler Bowen, was his mother; see Tappan 1915, 40–41. He recorded the acquisition of the portrait in his diary for 4 August 1933 (Clarence Winthrop Bowen, diary, 1924–1934, 277, AAS, courtesy of Thomas Knoles, curator of manuscripts). His niece Constance Holt told the Frick Art Reference Library in October 1933 that he had purchased the portrait.
6. Lady Vereker was uncertain whether the portrait was a gift during her father's lifetime or a bequest in his will (notes made by William Campbell, NGA). His will, dated 1 August 1935 (copy, NGA), bequeathed to her "all

pictures except those herein specified as bequeathed to others." Lady Vereker's birth date is in Tappan 1915, 41; her death date is recorded in the NGA curatorial file.
7. Tappan 1915, 25.
8. Benjamin Tappan worked briefly as a painter before becoming a lawyer. He moved to Ohio and later represented that state in the United States Senate; see *DAB* 9:300–301.
9. Lewis Tappan, pocket notebook, 1814, Manuscript Division, LC.
10. Lewis Tappan, journal (undated), 26–27, Manuscript Division, LC. Lewis Tappan's granddaughter Anna Hulett made a typescript of this entry titled "Stuart Portraits of Benjamin & Sarah Tappan" (NGA); some of Tappan's comments are also quoted in Park 1926, 737–738.
11. Lewis Tappan, journal (undated), 26–27, LC.
12. Sold at *American 18th Century, 19th Century and Western Paintings, Drawings, Watercolors, and Sculpture*, Sotheby Parke Bernet, New York, 17 October 1980, lot 104, with the pendant of Mrs. Tappan, purchased by Winton M. Blount.
13. Clarence Winthrop Bowen, diary 1924–1934, 107–108, AAS.
14. Clarence Winthrop Bowen, diary 1924–1934, 277, AAS.

References

1834 *Tappan*: 4–5.
1870 Tappan: 412–413.
1915 Tappan: 24–25, 40–41.
1926 Park: 737–738, no. 820, repro.
1964 Mount: 300, 376.
1984 Walker: 382, no. 540, color repro.

1970.34.3 (2541)

Sarah Homes Tappan (Mrs. Benjamin Tappan)

1814
Oil on wood panel, 72.8 × 58.6 (28 $^{11}/_{16}$ × 23 $^{1}/_{16}$)
Gift of Lady Vereker

Technical Notes: The painting is executed on a single piece of American mahogany (*Swientenia* sp.) that is 0.7 cm thick and has a vertically oriented grain. The panel, which has not been cradled or thinned, was scored with diagonal lines in two directions to resemble twill canvas. The back of the panel is coated with a thin, transparent greenish white paint. The thin ground is off-white. The paint is applied thinly with fluid strokes. The facial features and planar changes of the sitter's head are done with smooth transitions of color, often wet-in-wet. The blue chair is painted over a pink underlayer in the area of the figure's shadow. The background is painted in a transparent manner. The painting has fairly extensive superficial retouching.

Gilbert Stuart, *Sarah Homes Tappan (Mrs. Benjamin Tappan)*, 1970.34.3

Provenance: The sitter's son Lewis Tappan [1788–1873], Brooklyn, New York;[1] his daughter Julianna Aspinwall Tappan [b. 1816],[2] Brooklyn, New York; bequeathed to her sister Ellen A.A. Hulett [d. 1906], Newburgh, New York; bequeathed to her daughter Anna Hulett [d. 1961], Newburgh, New York, and Washington;[3] purchased 26 January 1928 through (Ehrich Galleries, New York) by her cousin Clarence Winthrop Bowen [1852–1935], New York, and Woodstock, Connecticut;[4] his daughter Roxana Wentworth Bowen, Lady Gordon Vereker [1895–1968], Valbonne, France.[5]

Exhibited: *Exhibition of Portraits Painted by the Late Gilbert Stuart, Esq.*, Boston Athenaeum, 1828, no. 63. *Portraits by Gilbert Stuart (1755–1828)*, Ehrich Galleries, New York, 1928, no. 9.

SARAH HOMES (1748–1826), daughter of Boston goldsmith William Homes (1717–1783), married Benjamin Tappan, her father's apprentice, in 1770. She and her husband had eleven children. In the portrait, Mrs. Tappan wears a brown dress with a white kerchief and collar. A white cap covers her hair, which looks reddish brown despite her sixty-six years. She sits in a gilded wood armchair that is upholstered in blue fabric. Her son Lewis commissioned the portrait and that of his father in September 1814, when they were visiting him in Boston (see 1970.34.2). Lewis recorded only one sitting for this portrait, on 10 October: "at Stuart's — mother sat."[6] The portrait shows signs of being quickly painted. Stuart's sure, rapid technique included placing darker colors on top of light colors as he articulated the shadows in the right side of the kerchief and in the bow on her cap. Lewis Tappan paid $200 for the portraits on 4 November 1814.

According to her contemporary, the Reverend Mark Tucker,

Mrs. Tappan, whether considered as to her intellect or to the energy of her moral character, was no ordinary woman. Though unobtrusive and modest she was exemplary and firm. She was eminently a woman of principle — her views of doctrine and duty were enlarged and remarkably correct — she read good books extensively, but the Bible most of all. . . . Her piety was deep and active — she was not one of those fitful Christians, whose religion blazes forth for a season and then dies away.

Reverend Tucker was at her side when she died. "As her life was an exemplification of the holiness of the gospel, her death was a confirmation of the preciousness of its hopes. I saw her die. It was the triumph of faith — the cloudless setting of an evening sun. Her confidence in God was unshaken."[7] After her death her son Lewis published his *Memoir of Mrs.*

Sarah Tappan (1834), illustrated with an engraving of Stuart's portrait, by New Haven banknote engraver Simeon Smith Jocelyn, as the frontispiece.[8] Her religious beliefs had considerable impact on her children, three of whom—Arthur, Benjamin, and Lewis—became leaders in the abolitionist movement.

Mrs. Tappan's great-grandson, the publisher and antiquarian Clarence Winthrop Bowen, acquired the portrait in 1928, noting in his diary on 1 February,

From Washington came today Gilbert Stuart's portrait of my greatgrandmother Mrs. Benjamin Tappan (Sarah Homes) grand niece of Benjamin Franklin which I bought Jan 26 through the Ehrich Galleries of my Cousins Anna and Margaret Hulett. A few years ago I bought this portrait or I supposed as well as its Companion my greatgrandfather Benjamin Tappan but there was a slip up and the Benj Tappan portrait was sold to a collector in Philadelphia. I used to see as a child these two Stuart portraits at Grandfather Tappan's home in Brooklyn. Copies of them I have had for years.[9]

Replicas of the two portraits, on similarly sized wood panels, were owned until recently by descendants of Lewis Tappan's brother William (Montgomery Museum of Fine Arts, Alabama).[10]

EGM

Notes

1. Tappan 1915, 25, 40.
2. Her birth date is in *Tappan* 1834, 131; she is listed as "Julia" in Tappan 1915, 40.
3. The provenance to Anna Hulett is recounted in her typed memorandum (NGA). A label attached to the reverse records that the painting was owned by Anna and her sister Margaret and that on 27 June 1924, H.K. Bush-Brown of 1729 G Street, Washington, lent it to the National Gallery of Art, Smithsonian Institution (now NMAA). The Gallery's records indicate that the portrait, which was for sale, was withdrawn 17 September 1924 (copies, NGA). Anna Hulett died in Washington on 16 May 1961 (probate court records, District Court of the United States for the District of Columbia; copy, NGA).
4. Bowen was the son of Ellen Hulett's aunt Lucy Maria and Henry Chandler Bowen; Tappan 1915, 40–41. His diary entry of 1 February 1928 (see essay) and the article "Acquires Portrait" 1928, 12, document the acquisition, which is confirmed by the phrase "C.W. Bowen — owner 1928" that was added in pencil to the entry on this portrait in a copy of Park 1926 (library, NMAA and NPG). The writer is unidentified.
5. Bowen's will, dated 1 August 1935 (copy, NGA), states that he gave this portrait to his daughter during his lifetime. Her birth date is in Tappan 1915, 41; her death date is recorded in the NGA curatorial file.
6. Lewis Tappan, pocket notebook, 1814, Manuscript Division, LC.

7. Quoted in *Tappan* 1834, 41–42.

8. Fielding 1917, 151, no. 748; *Tappan* 1834, 4, states that lithographic reproductions of both portraits are prefixed, but the book contains only the engraving of the portrait of Mrs. Tappan. No engraving of the portrait of Mr. Tappan has been located.

9. Clarence Winthrop Bowen, diary 1924–1934, 107–108, AAS.

10. Sold at *American 18th Century, 19th Century and Western Paintings, Drawings, Watercolors, and Sculpture*, Sotheby Parke Bernet, New York, 17 October 1980, lot 104, with the pendant of Mr. Tappan.

References

1828 "Memoir": 121–125.
1834 *Tappan*: repro. frontispiece (engraving by S.S. Osgood), 4.
1915 Tappan: 24–25, 40–41.
1917 Fielding: 151, no. 748.
1926 Park: 739, no. 821, repro.
1928 "Acquires Portrait": 12.

1942.8.17 (570)

Commodore Thomas Macdonough

c. 1815/1818
Oil on wood, 72.5 × 57.1 (28 ½ × 22 ½)
Andrew W. Mellon Collection

Technical Notes: The painting is on a vertically grained, 0.6 cm mahogany panel that has been thinned and cradled. Wax has been applied between the cradle members. The ground is a relatively thick off-white layer. The panel is scored on the diagonal to give the surface the texture of twill fabric. The paint is applied in a thin layer in the background, which allows the tone of the ground to show through. In the sitter's face, shirt, and jacket, the paint was worked with smaller brushes. In the decorative gold braid on his jacket, wet paint was quickly pulled across, allowing lower layers of paint to show through. Many strokes give the appearance of quick application. The build-up in the jacket and face suggests, however, a slower, more methodical application.

Three checks in the panel are filled, inpainted, and noticeably discolored. There are a few other scattered areas of inpainting; there is very little abrasion. The varnish has yellowed somewhat.

Provenance: The sitter's son James Edward Fisher Macdonough [1825–1849], Montclair, New Jersey; his brother Charles Shaler Macdonough [1818–1871], Middletown, Connecticut; his brother Augustus Rodney Macdonough [1820–1907], Middletown, Connecticut;[1] his nephew Rodney Macdonough [1863–1935], Brookline, Massachusetts; his son Charles Vance Macdonough [b. 1907], Wellesley, Massachusetts;[2] (M. Knoedler & Co., New York); sold 21 January 1937 to The A.W. Mellon Educational and Charitable Trust, Pittsburgh.

Exhibited: New York 1853, no. 160.[3] Century Club, New York, on long-term loan, 1879–1907.[4] *Masterpieces of American Historical Portraiture*, M. Knoedler & Co., New York, 1936, no. 13. *Loan Exhibition: Naval Personages and Traditions*, Naval Academy Museum, United States Naval Academy, Annapolis, Maryland, 1940, no. 44.

BORN IN DELAWARE, Thomas Macdonough (1783–1825) joined the United States Navy as a midshipman at the age of sixteen. He had a distinguished naval career, serving on some of the Navy's most noted ships, including the *Constellation*, the *Philadelphia*, the *Enterprise*, and the *Constitution*.[5] Macdonough is best known for his victory against British naval forces on Lake Champlain during the War of 1812. Then a lieutenant, he was commander of the American flotilla of fourteen battle ships. On 11 September 1814 his fleet defeated the British squadron in a closely contested battle near Plattsburg, New York, one of the most bitter naval engagements of the war. As victor, Macdonough was presented with a congressional gold medal. The states of New York and Vermont and the cities of New York and Albany gave him property, including a piece of land overlooking the battle site. And he was promoted to captain, the Navy's highest rank at that time.

Stuart probably made the portrait when Macdonough was in command of the Navy Yard in Portsmouth, New Hampshire, from 1815 to 1818, prior to his departure on the *Guerrière* on 22 July 1818 for the Mediterranean. He painted Macdonough in his blue captain's uniform with gold epaulettes and gold buttons.[6] His deep blue eyes look directly out to the viewer, and his ruddy complexion suggests the many hours he spent at sea. Light auburn hair and sideburns frame his face, and a hazy swirl of soft pink surrounds his head and deepens to mauve behind his body. Light blue and gray brush strokes in the background enhance the blue of his eyes and uniform. The composition is similar to five other portraits that Stuart painted of naval heroes of the War of 1812, which also depict uniformed sitters in waist-length poses, turned slightly to one side. Four of the portraits were completed by 1813, when they were engraved by David Edwin: William Bainbridge (Collection of Mrs. John Hay Whitney), Stephen Decatur (Independence National Historical Park, Philadelphia), Isaac Hull (unlocated), and James Lawrence (United States Naval Academy, Annapolis). The fifth, of Oliver Hazard Perry, was painted in 1818 (Toledo

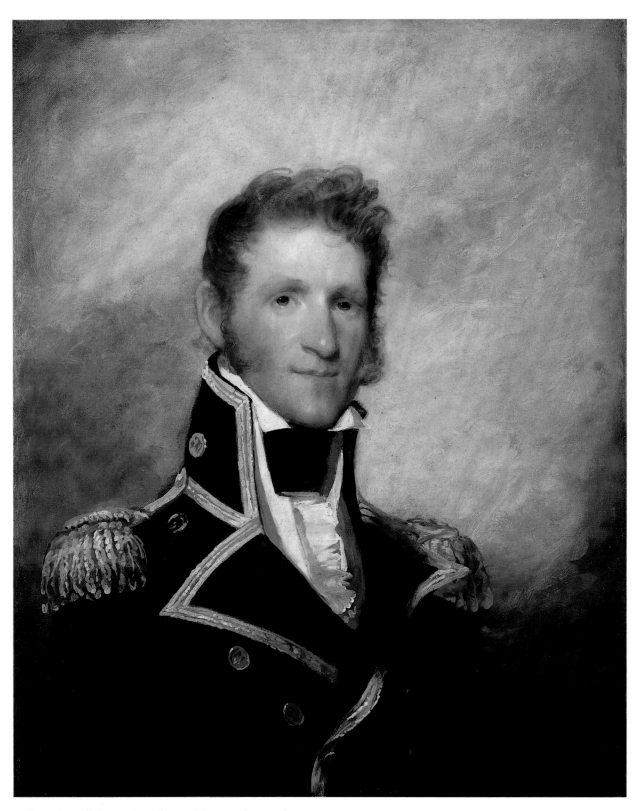

Gilbert Stuart, *Commodore Thomas Macdonough*, 1942.8.17

Museum of Art, Ohio). The backgrounds of those of Lawrence and Perry, like that of Macdonough, suggest the smoke of battle.[7]

PB

Notes

1. Lucy Macdonough Reade, Rodney Macdonough's sister, provided this provenance to Elizabeth Clare, M. Knoedler & Co., March 1948 (transcription, NGA); her information was from Macdonough 1909. Augustus Rodney Macdonough owned the portrait by 1853, when he lent it to the *Washington Exhibition* in New York.
2. Charles Vance Macdonough said that the painting became his property in 1935; letter to Elizabeth Clare, 22 April 1948 (NGA).
3. The exhibition is misdated 1 May 1854 by Yarnall and Gerdts 1986, 3416. For confirmation of the 1853 date see Cowdrey 1953, 1:283.
4. Mason 1879, 218; Armstrong 1920, 321; A. Rodney Macdonough was secretary of the Century Club.
5. *DAB* 6 (part 2):19–21.
6. Marko Zlatich, a historian of military uniforms in Washington, and Henry Vadnais of the Naval Historical Center, Washington Navy Yard, have identified Macdonough's uniform and rank.
7. On these portraits see Fielding 1921, 122–137, repros.; Park 1926: (Bainbridge) 122–123, no. 43, repro.; (Decatur) 273–274, no. 229, repro.; (Hull) 418–419, no. 419, repro., owned in 1926 by Mrs. Isaac Hull Platt; (Lawrence) 466–467, no. 476, repro.; and (Perry), 589–590, no. 630, repro.; and Stauffer 1907, 121, 127, 132, 135. McLanathan 1986, 130–131, illustrates the portraits of Bainbridge and Lawrence.

References

1879 Mason: 217–218.
1880 MFA: 46, no. 382.
1909 Macdonough: repro. frontispiece.
1984 Walker: 378, no. 535, color repro.
1986 McLanathan: 147, repro.

1940.1.3 (489)

Joseph Coolidge

1820
Oil on panel, 71.3 × 57.5 (28 1/16 × 22 5/8)
Andrew W. Mellon Collection

Technical Notes: The painting is on a panel of American mahogany (*Swientenia* sp.) that is 1.4 cm thick with a vertically oriented grain. The panel is scored with a series of diagonal lines to imitate the texture of twill fabric. The reverse is painted gray-green. The white ground is applied in broad horizontal strokes. The paint is primarily applied in a wet-in-wet technique, the details of the features and the hair added wet-over-dry. The white shirt ruffle is applied in broad, loose strokes. The coat is applied in thin, opaque black paint, perhaps over a base of brown-gray. The background is a fairly thin reddish brown layer.

Wooden strips have been added to the left and right edges, increasing the width by 1.1 to 58.6 cm. The edges of the original panel are slightly chipped, and the paint rubbed and abraded. There are a few small retouches in the eyebrows and in the background, over the sitter's right shoulder. The varnish is considerably discolored.

Provenance: The sitter's second wife Catherine Boyer Coolidge [1755–1820], Boston; her granddaughter Catherine Boyer Coolidge Pomeroy [Mrs. Samuel Wyllys Pomeroy, 1808–1861], Pomeroy, Ohio; deposited with her sister Hetty Bacon Coolidge Haight [Mrs. Benjamin Isaacs Haight, 1812–1879], New York, for her daughter Clarissa Alsop Pomeroy [b. 1846].[1] Sold by Greta Pomeroy Clark in January 1918 to (M. Knoedler & Co., New York);[2] sold 31 January 1918 to Thomas B. Clarke [1848–1931], New York;[3] his estate; sold as part of the Clarke collection on 29 January 1936, through (M. Knoedler & Co., New York), to The A.W. Mellon Educational and Charitable Trust, Pittsburgh.

Exhibited: Western Art Union, Cincinnati, Ohio, 1849, no. 77.[4] Union League Club, February 1922, no. 3. Philadelphia 1928, unnumbered.

JOSEPH COOLIDGE (1747–1821) was a merchant who sold English and American gold- and silversmiths' work, including jewelry, in Boston before the American Revolution.[5] His stamp appears on a few examples of pre-Revolutionary War silver, although he was not a silversmith.[6] He continued to be a successful importer after the war. Stuart painted two portraits of him, in 1813 and 1820. The first was for his eldest son Joseph Coolidge (Harvard University Portrait Collection, Cambridge, Massachusetts).[7] This, the second, was painted for his second wife Catherine Boyer Coolidge. Stuart portrayed the merchant in a black coat and a white shirt with a ruffle, his gray hair tied in a queue, against a reddish brown background. The painting is a good example of Stuart's late style, loosely painted with rapid, sure brushwork. As he often did, Stuart painted the white areas of his sitter's face and shirt front before superimposing gray strokes to denote the shaded areas. George C. Mason wrote in 1879 that "there was a warm intimacy between Stuart and Mr. Coolidge, and the artist is said to have looked upon this portrait as one of his most sucessful efforts."[8] Coolidge's great-grandson Thomas Jefferson Coolidge later owned Stuart's portraits of the first five presidents, the Gibbs-Coolidge series (see 1979.4.1).

EGM

Gilbert Stuart, *Joseph Coolidge*, 1940.1.3

Notes

1. On the Coolidge-Pomeroy family see Pomeroy 1912, 513, and Coolidge 1930, 335, 354, 355.

2. Letter from Melissa De Medeiros, librarian, M. Knoedler & Co, 7 July 1992 (NGA); her relationship to the previous owners has not been determined.

3. The name of the seller and the date of purchase are recorded in an annotated copy of *Clarke* 1928 in the NGA library.

4. Yarnall and Gerdts 1986, 3428, lent by S.W. Pomeroy.

5. According to Bridgman 1856, 190, Coolidge died on 6 October 1821 at age seventy-four, as recorded by the inscription on a monument in Kings Chapel cemetery; Park 1926, 237–238, also states that Coolidge died in 1821, while Coolidge 1930, 335, gives his death date as 6 October 1820. Confirmation of the 1821 date is found in the record of his estate, Suffolk County (Massachusetts) Probate Records, vol. 118, part 2, 37; for this reference and the Bridgman citation, I am grateful to Patricia Kane, curator of decorative arts, Yale University Art Gallery, who is compiling a biographical dictionary of colonial New England silversmiths.

6. For Coolidge's stamp see Kovel and Kovel 1961, 69, and Flynt and Fales 1968, 189.

7. Mason 1879, 163; Park 1926, 237, no. 186.

8. Mason 1879, 163.

References

1879 Mason: 162.
1880 MFA: 35, no. 145.
1926 Park: 237–238, no. 187, repro.
1929 Salisbury: 47 repro.
1964 Mount: 366.

The Gibbs-Coolidge Set of Presidential Portraits: George Washington, John Adams, Thomas Jefferson, James Madison, and *James Monroe*

1817/1821

Technical Notes: Each of these five portraits is on a single member, vertical grain panel of yellow poplar (*Liriodendron tulipifera*) approximately 66 by 55 cm in size and a thickness between 0.5 and 1 cm. The front of each panel is scored with parallel lines in at least one diagonal direction to imitate twill fabric. The thin, off-white ground does not mask this texturing. The paint was applied mainly in a wet-in-wet technique in varying degrees of thickness, with some details added after the paint had dried. There is generally little impasto. The varnish on the paintings was removed in 1988–1989. The present varnish is a synthetic resin.

Provenance: Colonel George Gibbs [1776–1833], "Sunswick Farm," Astoria, New York;[1] his widow Laura Wolcott Gibbs [1794–1870], New York;[2] sold through (Jacob Hart Lazarus [1822–1891], New York) in 1872 to Thomas Jefferson Coolidge [1831–1920], Boston;[3] his grandson Thomas Jefferson Coolidge III [1893–1959], Boston;[4] his son Thomas Jefferson Coolidge IV, Boston.

Exhibited (as a group): American Academy of the Fine Arts, New York, 1832, no. 10 (Washington), 13 (Jefferson), 188 (Monroe), 193 (Adams), 196 (Madison).[5] *Exhibition of Select Paintings, by Modern Artists, principally American, and living, under the Direction of a Committee of Amateurs,* Stuyvesant Institute, New York, 1838, no. 195 (Washington), 196 (Adams), 197 (Jefferson), 198 (Madison), 199 (Monroe).[6] Banquet held at City Hall, New York, on the occasion of the fiftieth anniversary of Washington's inauguration, 1839.[7] New York 1853, no. 47 (Washington), 55 (Monroe), 80 (Adams), 88 (Jefferson), 136 (Madison), lent by Mrs. Gibbs.[8] *First Annual Exhibition of the Washington Art Association,* Washington, 1857, no. 98 (Washington), 99 (Adams), 100 (Jefferson), 101 (Madison), 102 (Monroe), lent by Mrs. Col. Gibbs.[9] *Third Annual Exhibition at the Gallery of the Fine Art Institute,* Artists' Fund Society, New York, 1862, no. 176 (Madison), 177 (Jefferson), 178 (Washington), 179 (Adams), 180 (Monroe), lent by Mrs. Gibbs.[10] *Revolutionary Relics Exhibited at No. 56, Beacon Street,* Ladies' Centennial Commission, Boston, 1875, no. 109 (Washington), 110 (Jefferson), 111 (Madison), 112 (Adams), lent by T.J. Coolidge.[11] Boston 1880, no. 204 (Washington), 205 (Adams), 206 (Jefferson), 207 (Madison), 208 (Monroe), lent by T. Jefferson Coolidge. *Loan Exhibit of Early American Portraits,* The Boston Art Club, 1911, no. 42 (Washington), 43 (Adams), 44 (Jefferson), 45 (Madison), 46 (Monroe), lent by T. Jefferson Coolidge. MFA, on long-term loan, 1921, 1926–1931, 1936–1943, 1946–1959.[12] *Loan Exhibition of Early American Furniture and the Decorative Crafts for the Benefit of Free Hospital for Women,* Brookline, Mass., Park Square Building, Boston, 1925, no. 341 (Washington), 342 (Adams), 343 (Jefferson), 344 (Madison), 345 (Monroe), lent by T. Jefferson Coolidge. *Gilbert Stuart Memorial Exhibition,* MFA, 1928, no. 1 (Adams), 39 (Jefferson), 43 (Madison), 46 (Monroe), 77 (Washington), lent by Thomas Jefferson Coolidge. *George Washington Bicentennial Historical Loan Exhibition of Portraits of George Washington and his Associates,* CGA, 1932, no. 29 (Washington), 79 (Adams), 80 (Madison), 82 (Jefferson), 83 (Monroe), lent by T. Jefferson Coolidge. *The Thomas Jefferson Bicentennial Exhibition: 1743–1943,* NGA, 1943, no. 10 (Jefferson), 15 (Adams), 27 (Madison), 30 (Monroe), 34 (Washington), lent by T. Jefferson Coolidge. *Gilbert Stuart: Painter of Presidents,* Everson Museum of Art, Syracuse, New York, 1975–1976, no cat. *Zeichen der Freiheit: Das Bild der Republik in der Kunst des 16. bis 20 Jahrhunderts,* Bernisches Historisches Museum und Kunstmuseum, Bern, Switzerland, 1991, no. 324 a (Washington), b (Adams), c (Jefferson), d (Madison), e (Monroe).

STUART PAINTED two sets of portraits of the first five presidents of the United States. This is the only set that survives. It was painted for George Gibbs (1776–1833), known to contemporaries as "Colonel

George Gibbs of Rhode Island" to distinguish him from his father, George Gibbs, Sr. (1735–1803). The Gibbs family was from Newport, where the elder Gibbs was at one time a business partner of Stuart's uncle Joseph Anthony.[13] Gibbs worked in his father's mercantile business and inherited his considerable wealth. In 1810 he married Laura Wolcott, daughter of Oliver Wolcott, former secretary of the U.S. Department of the Treasury. Four years later they moved to "Sunswick Farm," an estate in Astoria, New York, across the East River from Manhattan. An amateur scientist, Gibbs owned the largest and most valuable mineral collection in the United States, which he acquired in Europe in 1805. In 1818, with his friend Benjamin Silliman, professor of chemistry and natural history at Yale College, Gibbs initiated the *American Journal of Science*, which soon became the leading scientific journal in the United States. He sold the mineral collection to Yale in 1824.

This set of portraits apparently was painted to reflect the political affiliations and ambitions of Gibbs and his father-in-law Oliver Wolcott. The portrait of James Monroe was painted in 1817 (see the entry for that portrait [1979.4.3]), but the idea of the set did not develop until four years later. On 19 May 1821, Stuart in Boston wrote to Gibbs in New York to arrange to borrow the painting for John Doggett (1780–1857), a Boston and Roxbury picture dealer and framer. "Dear Sir: Permit me to remind you of the obliging promise you were so good as to make me when I last had the pleasure of seeing you of the Head of Mr. Munroe. Mr. Doggett is now in New York & would take charge of it which would be the most safe and convenient mode of convayance that could be advised. Accept my thanks for your many kindnesses and believe me sincerely Yours Gt. Stuart."[14] It is very likely that the idea for making both sets arose at the same time, perhaps during the conversation between Gibbs and Stuart to which the artist referred in his letter. Stuart began the set of presidential portraits for Doggett sometime that year and completed it by 20 June 1822, when the *Boston Daily Advertiser* announced its exhibition.[15] The paintings were sent to France to be lithographed and were back in Boston by 16 November 1825, when the sale of the lithographs was announced.[16] Only the portraits of Madison (Figure 1) and Monroe (Figure 2) survive from this set, whose compositions are larger and more elaborate than those in Gibbs' series. The appearance of the other three paintings, which were

destroyed in a fire at the Library of Congress in 1851, is known from the lithographs, published in 1828 after a three-year delay (Figures 3–5).

In the past the Gibbs set has been given the date of 1810 to 1815 because of a statement by the artist's daughter Jane Stuart, who testified in 1854 that she had examined "the pictures of the first five Presidents painted by my Father for his friend Col Gibbs of Rhode Island, & now in possession of his Widow. They were painted between the years 1810 & 1815 during our residence in Boston."[17] Other authors have generally followed this dating, recognizing that the portrait of Monroe must have been added to the series after his election in 1816.[18] However, Jane Stuart, who was born in 1812, made the statement many years after her father's death, and there is no other evidence that the set was made during those years.

The painting of both sets depended on the availability of Stuart's own portraits from which he could make copies. Those of Washington and Adams presented no difficulties. Stuart already owned the original portrait of Washington, and he copied his earlier portrait of Adams, who gave the artist new sittings in September 1821 (see that entry [1979.4.1]). He undoubtedly copied Jefferson's "Edgehill" portrait before sending the original to the sitter in May 1821, and, as noted, borrowed Gibbs' replica in order to paint the portrait of Monroe. Only the portrait of Madison posed a problem. Since the only easily accessible painting of Madison was in Maine, at Bowdoin College, Stuart made a trip to copy it there. It has been assumed that the copy that resulted from this trip was for Doggett. However, Mrs. Isaac P. Davis, wife of the artist's longtime friend, wrote Mrs. Gibbs on 9 December 1853 that her husband recalled the portraits and said that "Col. Gibbs was so desirous of having his set complete that he employed Stuart at considerable expense to visit Bowdoin College & make a copy of President Monroe from the set he had painted for that Institution."[19] (She meant President Madison; there was no portrait of Monroe at Bowdoin College.) Perhaps both replicas, whose faces are extraordinarily similar, were painted directly from the portrait at Bowdoin College.

The size of each portrait in the Gibbs set was dictated by the size of Monroe's portrait, the first to be painted. Stuart had used wood panels of these dimensions—roughly 66 by 54.6 cm (26 by 21½ inches)—for many years. The "Edgehill" portrait of Jefferson, painted in Washington in 1805, is on a

Gilbert Stuart, *James Monroe*, 1979.4.3

Fig. 1. Gilbert Stuart, *James Madison*, oil on canvas, c. 1821, Amherst, Massachusetts, Mead Art Museum, Amherst College, Bequest of Herbert L. Pratt, Class of 1895

Fig. 2. Gilbert Stuart, *James Monroe*, oil on canvas, c. 1821, New York, The Metropolitan Museum of Art, Bequest of Seth Low, 1929

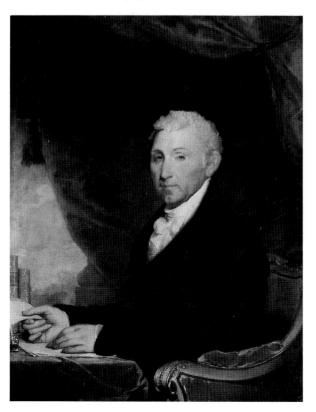

panel approximately this size, as are the portraits of Mr. and Mrs. John Amory, painted in Boston in 1806.[20] Around 1825 Gibbs had his own portrait painted by Stuart on the same size panel.[21] The technique of the four portraits of Washington, Adams, Jefferson, and Madison, done in Stuart's very loose manner, support a late date. His approach at that time was to combine broad tonal areas with carefully drawn details and strong highlighting. The artist began with the face, working up to an almost finished appearance, and then continued with the clothing and background, both thinly applied except for the cravat. Over the blocked-in face he added pale white, pale pink, and rosy flesh tones, with creamy highlights on the forehead and nose, and thinly painted shadows in warm, deep pink on the cheeks and chin. He used short, thin touches of brown to locate the folds of flesh around the eyes, and touches of blue (in the portraits of Adams and Jefferson, particularly) in the inner corners of the eyes and the area above the mouth. Over the general indications of hair he painted details with wisps of white, gray, and brown. By contrast, the sitters' coats are smoothly painted. The backgrounds were painted last, the brush strokes occasionally overlapping the paint of the face and hair.

Some differences exist between the portraits of the first three presidents and those of Madison and Monroe, whose backgrounds are lighter and more colorful. That of Madison [1979.4.2] has a green curtain similar to the one in the painting from which it was copied, and that of Monroe is enlivened by a blue sky with clouds or wisps of smoke, perhaps emblematic of his recent election (see that entry [1979.4.3]). By contrast, those of the first three presidents are colored a flat brown, reproducing the lack of a detailed background in the paintings from which they were copied. Also the original, deeply set gilded frames, which can be attributed to John Doggett and are identical in overall design, are slightly different in some details from the portraits of Madison and Monroe. All the frames share the same deep cove molding, decorated in the corners with laurel leaves and flowers.[22] Those for the portraits of Madison and Monroe, however, have an inner beaded molding between two concave moldings, while those for the portraits of Washington, Adams, and Jefferson have one narrow inner molding of a leafy design, next to one concave molding. The difference in the frames is slight and is not evidence that the portraits were painted or framed at different times.

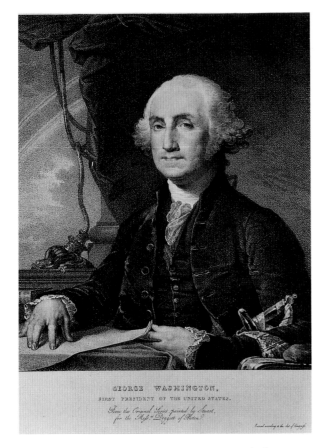

Fig. 3. Attributed to Antoine Maurin or Nicholas Eustache Maurin, after Gilbert Stuart, *George Washington*, lithograph, 1828, Washington, The National Portrait Gallery, Smithsonian Institution

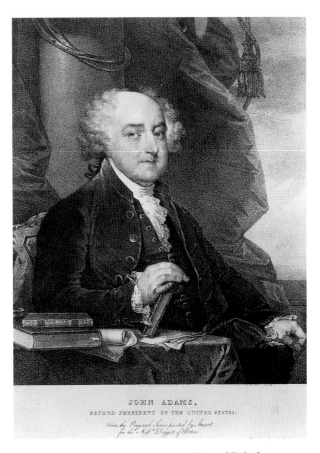

Fig. 4. Attributed to Antoine Maurin or Nicholas Eustache Maurin, after Gilbert Stuart, *John Adams*, lithograph, 1828, Washington, The National Portrait Gallery, Smithsonian Institution

The portraits were not well known during Gibbs' lifetime. When Doggett's set was exhibited at the Boston Athenaeum in the memorial exhibition of Stuart's work in 1828, it was erroneously described as "the only uniform series of the Presidents in existence."[23] Gibbs exhibited his set only once, at the American Academy of the Fine Arts, New York, in 1832. After his death Mrs. Gibbs tried to sell the portraits, but apparently there was some question of whether they were entirely Stuart's work. Isaac P. Davis wrote Mrs. Gibbs on 12 February 1854 that he had known Stuart for twenty years and had "a perfect recollection of his painting the Presidents for his friend Col Geo Gibbs of New Port Rhode Island."[24] George Gibbs, Jr., and his mother continued to discuss the sale of the portraits through the

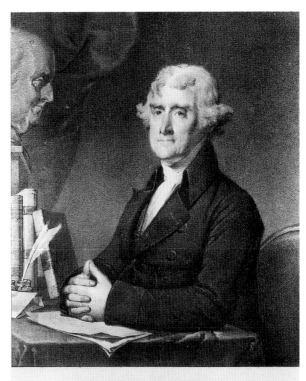

Fig. 5. Nicholas Eustache Maurin, after Gilbert Stuart, *Thomas Jefferson*, lithograph, 1828, Washington, The National Portrait Gallery, Smithsonian Institution

1860s, when they apparently offered them to the United States Congress.[25] After Thomas Jefferson Coolidge acquired the portraits following Mrs. Gibbs' death in 1870, the five paintings became known as the Gibbs-Coolidge set. Throughout their history they have remained much admired examples of Stuart's work.

EGM

Notes

1. On Gibbs see Gibbs 1933, 18–21, *DAB* 4 (part 1):244–245, and Beckham 1979, 28–47. Tom Michie's research on these portraits (NGA) has been very helpful in writing these entries.

2. For her dates see Gibbs 1933, 21–25.

3. Lazarus acted as the Gibbs' agent in the sale. After agreeing upon the price, he wrote Coolidge on 27 June 1872 that he was sending the portraits to Boston the next day with some documents concerning their history. These were his copies of letters written to Mrs. Gibbs in the 1850s certifying that the portraits were painted by Stuart for Colonel Gibbs (copies, NGA). On Coolidge see *DAB* 2 (part 2):395, and Coolidge 1930, 351.

4. Coolidge 1930, 353; his father Thomas Jefferson Coolidge II died in 1912.

5. *American Academy* 1832, 4, 12; for John Trumbull's letter of 26 April 1832 to George Gibbs requesting the loan see Rebora 1990, 2:401.

6. Yarnall and Gerdts 1986, 3421. A note in the exhibition catalogue (25) states, "The five Presidents by G.C. Stuart, are offered for sale at $2500."

7. Bowen 1892, 98, quoting Tuckerman 1889, 1:358: "The hall was decorated by Stuart's five portraits of the first five presidents, the property of Colonel George Gibbs."

8. Yarnall and Gerdts 1986, 3417–3418, where the exhibition is misdated 1 May 1854. For confirmation of the 1853 date see Cowdrey 1953, 1:283.

9. Yarnall and Gerdts 1986, 3417, 3418.

10. Yarnall and Gerdts 1986, 3423, 3424, 3430.

11. Yarnall and Gerdts 1986, 3417, 3418; the portrait of Monroe was not included.

12. Letter from Erica E. Hirshler, American Paintings Department, MFA, 8 June 1984 (NGA).

13. Stuart painted portraits of both men in Philadelphia in the 1790s. For Gibbs' portrait of about 1798 see Park 1926, 346–347, no. 326, repro. (76.2 by 63.5 cm [30 by 25 inches], oil on canvas), and Gibbs 1933, 145–149. Stuart painted Mary Channing Gibbs, his second wife, sometime after her husband died in 1803; see Park 1926, 348, no. 328. For one of Stuart's portraits of Anthony see 1942.8.11.

14. Oliver Wolcott Papers, Connecticut Historical Society, Hartford; microfilm, Manuscript Division, LC.

15. Sadik 1966, 160.

16. Swan 1931, 278–281, where the lithographs and the Gibbs replicas are reproduced.

17. Statement dated 27 October 1854 for Mrs. Gibbs, transcribed in 1872 by Jacob Hart Lazarus for Thomas Jefferson Coolidge (copy, NGA). These dates are repeated in Fielding 1923, 175, and by Park 1926, 874, as the date for the Gibbs portrait of Washington. Of the others, Park dated only the portrait of Adams to c. 1825.

18. Fielding 1923, 175.

19. Susan Davis (Mrs. Isaac P. Davis) to George Gibbs' widow, 9 December 1853, transcribed by Jacob Hart Lazarus in 1872 for Thomas Jefferson Coolidge (copy, NGA).

20. On the Amory portraits see Park 1926, 100–101, nos. 16 and 17.

21. Park 1926, 348–349, no. 329 (repro.), dates the portrait to 1825–1827, which is consistent with the style of his coat. When the series was complete, Gibbs gave his replica of Stuart's "Vaughan" portrait of Washington (MMA) to his sister Mrs. William Channing.

22. On this period of Doggett's life see Swan 1929, 196–200. Tom Michie checked Doggett's daybook (1802–1809) and a letter book for the 1820s (Joseph Downs Manuscript Collection, The Henry Francis du Pont Winterthur Museum, Delaware), but he found little about Doggett's activities as a frame-maker. The frames were regilded in 1872. In a note dated 12 June, A.J. [?] Bigelow wrote Thomas Jefferson Coolidge that he had offered Lazarus a price for "those pictures cleaned & put in order, frames regilt &c. all in the best manner — provided there was no question as to their Authenticity, Quality, Condition & Good looks in a parlor." Lazarus accepted the offer and in his letter dated 19 June 1872 commented, "If my frame maker does not disappoint me you shall have them by the 1st of July" (copies, NGA).

23. *Stuart* 1828, 2, nos. 27–31.

24. Copy by Lazarus for Coolidge, 1872 (copy, NGA).

25. George Gibbs to his mother, 13 November and 3 December 1866 (Gibbs Family Papers, State Historical Society of Wisconsin, Madison). Gibbs reminded his mother on 13 November that "you have once offered the Stuarts to Congress but without success."

References (for the set)

1879 Mason: 111–112.
1892 Bowen: 98, repro. opp. 150, 484.
1926 Park: 92, no. 5, repro. (Adams); 442, no. 445, repro. (Jefferson); 498–499, no. 518, repro. (Madison); 528, no. 554, repro. (Monroe); and 874, no. 55 (Washington).
1931 Swan: 278–281, repro.
1933 Gibbs: 148–149.
1940 Swan: 69.
1979 Gustafson: 976–978, repro. (color).
1980 Brown: 10–11.

1979.5.1 (2757)

George Washington

c. 1821
Oil on wood, 67 × 55 (26 3/8 × 21 5/8)
Gift of Thomas Jefferson Coolidge IV in memory of his great-grandfather, Thomas Jefferson Coolidge, his grandfather, Thomas Jefferson Coolidge II, and his father, Thomas Jefferson Coolidge III.

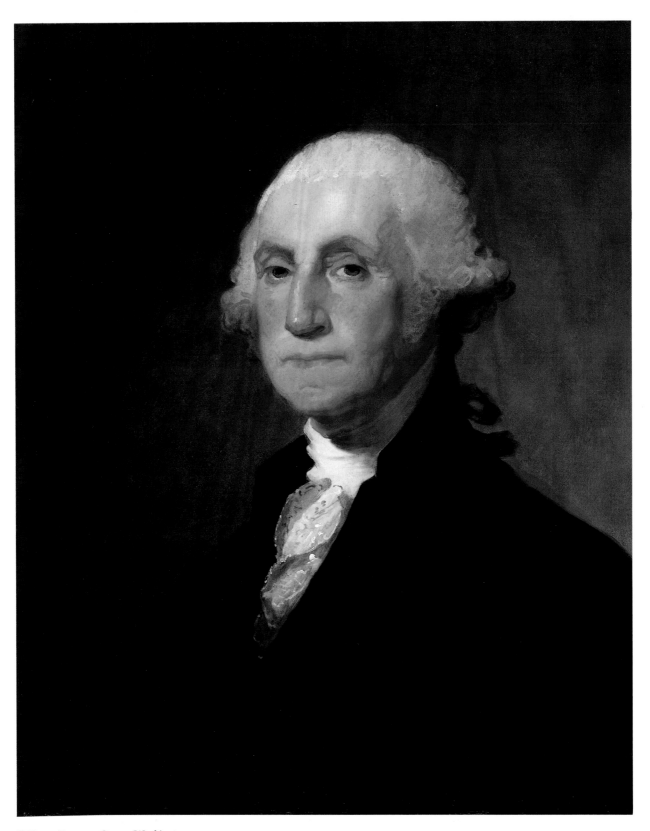

Gilbert Stuart, *George Washington*, 1979.5.1

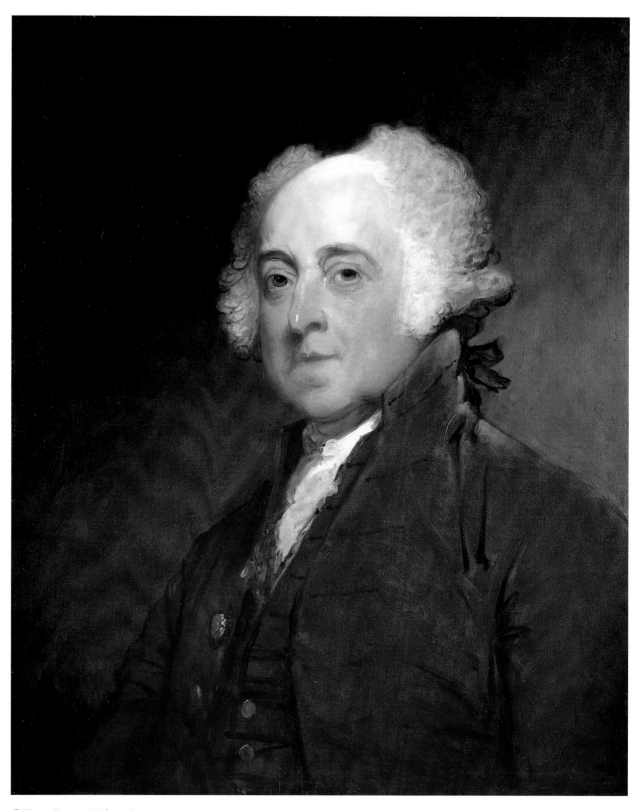

Gilbert Stuart, *John Adams*, 1979.4.1

Technical Notes: The poplar panel is 0.8 cm thick. The front of the panel has been scored on the diagonal. Two indented areas on the left side are either faults in the panel or the result of excessive force during scoring. The back of the panel has been painted gray-green. Three areas of change are noted: in the coat, which was completed over a blocked-in lower part of the cravat, in the outline of the chin, and in the sitter's left shoulder. The chin and shoulder areas were altered when the background was completed. There are scattered losses and abrasion around the edges.

Provenance: See general entry.

Exhibited: See general entry.

THIS IMAGE of George Washington (1732–1799), first president of the United States, is derived from the "Athenaeum" portrait, Stuart's second life portrait, painted in Philadelphia in 1796 (MFA and NPG). Stuart kept the painting in his studio throughout his life. The brushwork of this replica is noticeably looser and less precise than in the original, and by contrast is looser than the earlier replica in the Gallery's collection that was painted in 1803–1805 [1954.9.2]. There is less focus on details, and the shadows are very broad and thin.

<div align="right">EGM</div>

References

1879	Mason: 111–112.
1880	MFA: 26.
1892	Bowen: 98, repro. opp. 150, 542, no. 29.
1923	Fielding: 175, no. 54.
1926	Park: 874, no. 55, repro.
1931	Morgan and Fielding: 285, no. 54.
1932	Eisen: 171.

1979.4.1 (2758)

John Adams

c. 1821
Oil on wood, 66 × 54.5 (26 × 21 ½)
Ailsa Mellon Bruce Fund

Technical Notes: The 0.6 cm thick poplar panel has been scored on both diagonals. The panel has been cradled. A thin, reddish brown outline is visible around the head. A check in the panel runs from the bottom edge upward toward the head.

Provenance: See general entry.

Exhibited: See general entry.

THIS PORTRAIT is a version of the one that Stuart began of John Adams in 1798 and completed in 1815, which is also in the Gallery's collection [1954.7.1]. Adams (1735–1826) was second president of the United States. Stuart changed the color of the suit to a rich reddish brown, raised the collar, and omitted Adams' hand. Like the portrait of Jefferson [1986.71.1], it has touches of blue around the eyes, and blue tones are found elsewhere in the face. It may have been painted in September 1821 after Adams sat for Stuart to permit the artist to touch up the version that had been made for John Doggett.[1] John Quincy Adams noted this sitting of "two or three hours" in his diary on 27 September, adding that "Stuart paints this picture for a Mr. Doggett, as one of the five Presidents of the United States. He is to paint them all for him."[2]

<div align="right">EGM</div>

Notes

1. Lawrence Park and Andrew Oliver dated this replica to around 1825, but they did not offer any documentation and apparently confused it with a later portrait of Adams; Park 1926, 92; Oliver 1967, 167.

2. Oliver 1967, 161. The Doggett replica was destroyed in a fire at the Library of Congress in 1851.

References

1879	Mason: 111–112, 125.
1880	MFA: 28, no. 3.
1892	Bowen: 98, repro. opp. 150, 424.
1926	Park: 92, no. 5, repro.
1967	Oliver: 167, 253, no. 117, fig. 82.
1981	Williams: 67, repro. 70.

1986.71.1 (2759)

Thomas Jefferson

c. 1821
Oil on wood, 66 × 54.5 (26 × 21 7/16)
Gift of Thomas Jefferson Coolidge IV in memory of his great-grandfather, Thomas Jefferson Coolidge, his grandfather, Thomas Jefferson Coolidge II, and his father, Thomas Jefferson Coolidge III.

Technical Notes: The 0.7 cm thick poplar panel has been scored on both diagonals. The back of the panel is painted gray-green. The head has been outlined in thin, reddish brown paint. The panel has scattered losses and abrasion around the edges.

Provenance: See general entry.

Exhibited (in addition to its exhibition with the series):

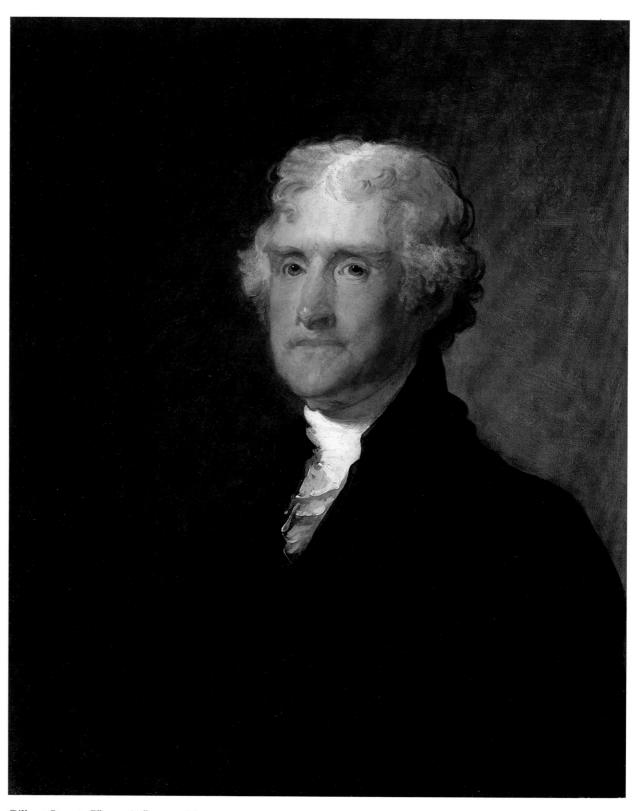

Gilbert Stuart, *Thomas Jefferson*, 1986.71.1

Fig. 6. Gilbert Stuart, *Thomas Jefferson*, oil on wood panel, 1805, jointly owned by Washington, The National Portrait Gallery, Smithsonian Institution, and Charlottesville, The Thomas Jefferson Memorial Foundation/Monticello, Gift of the Regents of the Smithsonian Institution, The Thomas Jefferson Memorial Foundation, and the Enid and Crosby Kemper Foundation

The Lost Portraits of Thomas Jefferson Painted by Gilbert Stuart, Mead Art Building, Amherst College, Massachusetts, 1959, unnumbered.

THIS IMAGE of Thomas Jefferson (1743–1826), third president of the United States, is taken from the similarly sized though slightly wider "Edgehill" portrait, which Stuart painted in Washington in the spring of 1805 (Figure 6). It does not closely resemble the slightly later portrait commissioned by James Bowdoin III (1805–1807, Bowdoin College Museum of Art, Brunswick, Maine), in which the sitter appears square-jawed.[1] Stuart must have painted the replica before 21 May 1821, when Henry A. S. Dearborn wrote Jefferson that he had finally obtained the original and had shipped it to Jefferson.[2] The "Edgehill" portrait had been in Stuart's studio since it was painted; Jefferson had tried for years to get Stuart to complete and send it. The

replica is very like the original, although looser and less precise in its brush strokes. Blue tones around the eyes of the replica are similar to the tonality of the original, which is painted on a blue-green ground.

EGM

Notes

1. Sadik 1966, 155–164; the second replica (Colonial Williamsburg Foundation, Virginia) was owned by James Madison.
2. Sadik 1966, 159; for a brief discussion of Stuart's portraits of Jefferson see Bush 1987, 57–59.

References

1879 Mason: 111–112, 207.
1880 MFA: 44, no. 334.
1892 Bowen: 98, repro. opp. 150, 484.
1926 Park: 442, no. 445, repro.
1944 Kimball: 517, fig. 15, 520–521.
1966 Sadik: 155–164.
1981 Meschutt: 3–16, repro. fig. 10.
1987 Bush: 57–59.

1979.4.2 (2760)

James Madison

c. 1821
Oil on wood, 65.3 × 54.3 (25 $^{11}/_{16}$ × 21 $^{3}/_{8}$)
Ailsa Mellon Bruce Fund

Technical Notes: The 0.7 cm thick panel has been scored diagonally, horizontally, and vertically. The paint is slightly abraded in the area of the coat and the cravat. There are also some old retouchings in the face and the cravat.

Provenance: See general entry.

Exhibited (in addition to its exhibition with the series): *Presidential Portraits,* NPG, 1968, 10, repro. 11.

STUART PAINTED a waist-length portrait of James Madison (1751–1836), fourth president of the United States, in Washington in 1804 (Colonial Williamsburg Foundation, Virginia). In that portrait Madison, who is turned slightly to the right, is seated in front of a curtain and bookshelves, and looks directly at the viewer. In 1805–1807 Stuart painted a larger, more elaborate version for James Bowdoin III that shows Madison seated at a table in front of a column and curtain, looking off to the viewer's right.[1] In 1821 Stuart journeyed to Maine to copy the painting, which had been given to Bow-

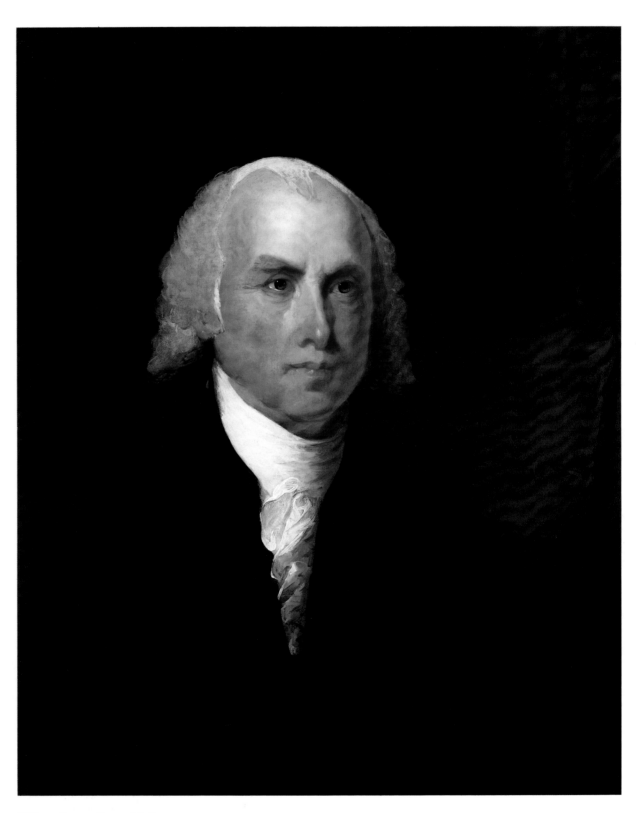

Gilbert Stuart, *James Madison*, 1979.4.2

Fig. 7. Gilbert Stuart, *James Madison*, oil on canvas, 1805–1807, Brunswick, Maine, Bowdoin College Museum of Art, Bequest of James Bowdoin III

Notes

1. Park 1926, 496–497, no. 515, 516; Bolton 1951, 41–42; Sadik 1966, 164–166, repro. Sadik discusses Bowdoin's commission under his entry for the pendant portrait of Thomas Jefferson (155–164).

2. Park 1926, 497–498, no. 517 repro.; Sadik 1966, 159–160; Shepard and Paley 1978, 196, color repro. 197.

References

1879 Mason: 111–112, 218–219.
1880 MFA: 46, no. 384.
1892 Bowen: repro. opp. 150, 505.
1926 Park: 498–499, no. 518, repro.
1951 Bolton: 30–31, 41–43.
1966 Sadik: 164–166.
1978 Shepard and Paley: 196.

1979.4.3 (2761)

James Monroe

c. 1817
Oil on wood, 64.8 × 55 (25 ½ × 21 ⅝)
Ailsa Mellon Bruce Fund

Technical Notes: The centimeter-thick poplar panel is slightly thicker than the others in the series. The front is scored on one diagonal. The back of the panel has been painted a gray-green, and the letters *BBS* are branded upside down in the upper left corner. Preceding them is a partial marking that appears to be a trace of the letter *G*. A space between *G* and *BBS* suggests that the entire brand read "G. GIBBS." The only detectable preparatory drawing is a thin red outline around the head. There are scattered minor losses in the forehead of the sitter and around the edges.

Provenance: See general entry.

Exhibited: See general entry.

SHORTLY AFTER James Monroe (1758–1831) was inaugurated fifth president of the United States in March 1817, he went on a tour of the northeastern United States. Stuart painted his portrait in Boston during the first days of July (Figure 8).[1] The *Essex Register* of Salem, Massachusetts, reported on 12 July, "Early the three last mornings, previous to his departure, the President has had sittings at Mr. Stewart's room. This eminent painter will execute a portrait of the President to be sent to Virginia. The President has also bespoke, from the same pencil, a superb portrait of President Washington."[2]

Monroe's New England supporters may have commissioned the portrait as a political gesture.

doin College (Figure 7). It has generally been believed that the result was the painting intended for Doggett, which is a similarly elaborate though not identical composition (Figure 1).[2] Mrs. Isaac P. Davis, however, wrote George Gibbs' widow in 1853 that Stuart went to Maine at Gibbs' expense (see general entry). If this is true, he might have painted Gibbs' portrait first and copied the face for Doggett's portrait after he returned to Boston. The two heads are so much alike that it is impossible to say which came first, or if, perhaps, both were copied from the Bowdoin painting on that trip.

Although the technique of the Gibbs replica is typical of Stuart's late style, the painting seems more focused and precise than those of Washington, Adams, and Jefferson. However, it shares with them an overall technique of using blocked-out areas of color, calligraphic details around the eyes, thinly painted hair, and thickly painted clothing. The dark green curtain in the background gives a cool but colorful tone to the painting.

EGM

Fig. 8. Gilbert Stuart, *James Monroe*, oil on wood panel, 1817, Philadelphia, The Pennsylvania Academy of the Fine Arts, Pennsylvania Academy Purchase [photo: Courtesy of The Pennsylvania Academy of the Fine Arts]

When Monroe was in New Haven, Connecticut, a few days earlier, he was greeted by Oliver Wolcott, the state's recently elected governor. Monroe had known Wolcott many years earlier, when Wolcott was secretary of the Treasury Department (1795–1800). Wolcott wrote his son-in-law George Gibbs on 30 June 1817, "The President was well recd. at N. Haven and I presume will leave this State, with very favourable impressions: — He is much altered since I saw him twenty-two years ago, & wholly for the better. I am satisfied entirely with the interview I had with him at N. Haven."[3] Perhaps Wolcott commissioned the original portrait as a gift for Monroe and arranged to have a replica of the same size painted for Gibbs before the original was sent to Washington. The name G. GIBBS is stamped on the reverse of the replica.

Monroe was apparently not very pleased with the portrait. When Samuel F.B. Morse was at the White House in December 1819 painting Monroe's portrait for the city of Charleston, he wrote his father,

I have succeeded to my satisfaction, and, what is better, to the satisfaction of himself and family; so much so that one of his daughters wishes me to copy the head for her. They all say that mine is the best that has been taken of him. The daughter told me (she said as a secret) that her father was delighted with it, and said it was the only one that in his opinion looked like him; and this, too, with Stuart's in the room.[4]

During the years after the portrait was painted Wolcott and Gibbs both petitioned Monroe for political favors. On a visit to Washington in January 1818, Gibbs sought a commission in the navy for his brother-in-law Oliver Stoughton Wolcott.[5] On 14 December 1818, Wolcott asked Monroe's assistance regarding claims made by the firm of Archibald Gracie and Sons of New York, of which his son-in-law William Gracie was a member.[6] And on 21 March 1820, Gibbs sought appointment as minister to Mexico, which he did not obtain.[7]

The Gibbs replica (see p. 267) seems looser and freer than the original, which is carefully painted and shows the figure against a dark background. There is more brushwork than in the other replicas, especially in the sitter's hair, frilled shirt, and cravat. Its background, unusual for the series, is a blue sky with wispy tones that suggest hazy clouds or smoke. Doggett's larger version (Figure 2)[8] also includes a blue sky. The sky and spirited clouds may symbolize heroism or political victory. Stuart used a similar sky in the background of his contemporary portrait of Commodore Thomas Macdonough [1942.8.17].

EGM

Notes

1. Park 1926, 527–528, no. 553, repro.; PAFA 1969, 57, on a wood panel measuring 67.3 by 54.6 cm (26 ½ by 21 ½ inches); Meschutt 1992, v–vi, 17–18, no. 11, repro., which lists the size as 82.6 by 58.4 cm (32 ½ by 23 inches) and lists the replica as owned by the National Portrait Gallery.

2. The *Essex Register* (Salem, Massachusetts), 12 July 1817, quoted in Park 1926, 527–538. The article is dated 10 July 1817.

3. Oliver Wolcott Papers, Manuscript Division, LC.

4. Morse to Jedidiah Morse, 17 December 1819, Samuel F.B. Morse Papers, LC, quoted in Kloss 1988, 60–61, and cited in Staiti 1989, 57.

5. Oliver Wolcott to his daughter Laura Wolcott Gibbs, 18 January 1818, Oliver Wolcott Papers, Manuscript Division, LC.

6. James Monroe Papers, Manuscript Division, LC.

7. Letter to Oliver Wolcott, 21 March 1820, Gibbs Family Papers, State Historical Society of Wisconsin, Madison.

8. Park 1926, 529, no. 555; Gardner and Feld 1965, 96–97 repro.

References
1879 Mason: 111–112, 229.
1880 MFA: 48, no. 423.

1892 Bowen: 98, repro. opp. 150, 510.
1926 Park: 528, no. 554, repro.
1992 Meschutt: 17–18, no. 11, repro.

Gilbert Stuart, completed by an unknown artist

1947.17.104 (1012)

Charlotte Morton Dexter (Mrs. Andrew Dexter)

1808/c. 1825
Oil on wood panel, 74.2 × 60. 2 (29 ³/₁₆ × 23 ¹¹/₁₆)
Andrew W. Mellon Collection

Technical Notes: The support is a 1.6 cm thick panel of American mahogany (*Swientenia* sp.) that has been scored on the diagonal from upper right to lower left. A smooth, grayish off-white ground has been applied to the surface. The paint is applied fluidly, built up from the middle tone to the light tone and from cool to warm in the flesh areas. The definition of features is accomplished with transparent reddish brown lines applied as finishing touches. The brightest highlights are added last with impasto.

A large oblong area through the neck of the sitter has been retouched. There is considerable glazed retouching around the left contour of the face and neck, and there are scattered smaller areas of retouching throughout. The varnish has discolored significantly.

Provenance: The sitter's daughter Charlotte Dexter [1812–1878], Montgomery, Alabama; her brother Andrew Alfred Dexter [1809–1853], Montgomery, Alabama, or his widow Sarah Williams Dexter [1815–1890], Palestine, Texas; their granddaughter Charlotte Morton Campbell Longino Howell [b. 1875], New Orleans, and Galveston, Texas; sold 1920 to (M. Knoedler & Co., New York);[1] sold 31 May 1921 to Thomas B. Clarke [1848–1931], New York;[2] his estate; sold as part of the Clarke collection on 29 January 1936, through (M. Knoedler & Co., New York), to The A.W. Mellon Educational and Charitable Trust, Pittsburgh.

Exhibited: Union League Club, February 1922, no. 20. Philadelphia 1928, unnumbered.

CHARLOTTE MORTON DEXTER (1787–1819) was the daughter of Perez and Sarah Apthorp Morton, prominent Bostonians. Stuart and Mrs. Morton had been friends since at least 1803, when the artist painted her portrait in Philadelphia. Mrs. Morton, a celebrated poetess, published some verses about Stuart in the 18 June 1803 issue of *Portfolio*, along with the painter's response.[3] Charlotte Morton married Andrew Dexter, a graduate of Brown University, in June 1808. In addition to being a law partner with his uncle Samuel Dexter in Boston, Dexter served as president of the Boston Bank. After he overextended credit to construct a large commercial building called the Boston Exchange, the bank failed. He and his wife left the city and settled in Athens, New York. After his father's death in 1816, Dexter moved to Alabama and was among the first residents of Montgomery. Mrs. Dexter joined him there in 1819. She died of a fever twelve days after her arrival.[4]

Stuart probably began Charlotte Morton's portrait in the spring of 1808, shortly before her wedding. On a surviving page of one of Stuart's appointment books is the listing for a sitting at eleven o'clock on 25 April: "Miss Charlotte Morton / Miss Caroline Knox [bracketed] Disappointed me."[5] Two days later, on Wednesday, Stuart noted on the same page that his visitors at the studio included "Mr. Dexter and Miss E. Morton" at eleven and the bride's mother Sarah Apthorp Morton. Perhaps "Miss E. Morton" is Charlotte Morton, making up the missed appointment. Only the entry for Mr. Dexter and Miss Morton specifies a time, and it is marked with an X to indicate, perhaps, that the appointment was kept. Mr. Dexter returned on Saturday, 30 April, with Mr. Morton.

Stuart left Charlotte Morton's portrait unfinished; he painted her face and shoulders and sketched in her auburn hair and low-cut white dress. He may have also indicated the blue shawl that she wears over her arms. The portrait remained uncompleted in Stuart's studio where, in 1825, her sister Sarah Morton Cunningham saw it while visiting her parents in Boston. Mrs. Cunningham wrote to her daughter Griselda at home in Nova Scotia that she and her mother went to Stuart's studio and, after a short visit,

Presently I requested him to show me the unfinished portrait, which he began of my dear sister Charlotte shortly after her marriage. He brought it from another room and placed it upon the easel. We all sat down before it, and it gave me a melancholy feeling, which would not suffer me to speak, for it is like her, though with a more pensive expression, and I think less beautiful than she was. "She was very unfortunate," said Mrs. Stuart [the artist's wife], after a pause.—"She was *not*" said Stuart—"Can you say it is unfortunate that an angel should be taken to the bosom of God; who does not daily sink under the troubles and vexations of this miserable world, and *she* is not unfortunate, who has passed through them so nobly, and was so soon called from them."

Mrs. Cunningham concluded, "What would I not give to have in my power to complete and to possess this interesting portrait!"[6]

The artist who completed the portrait painted with a heavier manner than Stuart, giving the dress a *V*-shaped bodice and puffed sleeves in the style of the 1820s. This unknown artist also finished the curls of her hair in an 1820s style and completed the background. The painter may have been Francis Alexander, a young Boston artist who is mentioned by Mrs. Cunningham in a letter, in which she comments that her sisters wanted her to have Alexander paint her portrait while she was in Boston. She thought his portraits were "striking likenesses," but his prices were too high.[7]

When the portrait appeared on the market in 1917, the owner was mysterious about its provenance, and at the same time she expressed interest in acquiring the portrait identified as of Mr. Dexter, which was also attributed to Stuart.[8] After Thomas Clarke acquired this portrait, researchers began to question the identity of the sitter because of the unclear provenance and the style of the sitter's clothing. The portrait of Mr. Dexter, with an equally uncertain provenance, was an unlikely pendant because of its different size. Also the sitter faced the same direction as Mrs. Dexter, which is not typical of paired portraits.[9] With the discovery of Charlotte

Morton's name in Stuart's appointment book, the reference to the portrait in Mrs. Cunningham's letter of 1825, and clarification of the provenance, the original identification is now confirmed.

EGM

Notes

1. This provenance was supplied by Mrs. Howell to Knoedler in a statement dated 7 May 1920 (NGA). Mrs. Howell's personal life was a source of confusion for later researchers, who did not realize that the sitter's namesake in each generation was the owner of the portrait. Mrs. Howell, the daughter of Charlotte Morton Dexter Campbell (Mrs. Joseph Campbell, 1848–1924) of Mobile, Alabama, first married Dr. Thomas Chandler Longino of Galveston (d. 1911). She then married Dr. Park Howell, but she divorced him shortly after she sold the portrait. (An unidentified label attached to the reverse of the painting incorrectly gives the owner as Dr. Park Howell.) Her third husband was John H. Means of San Antonio, Texas; letter of 12 November 1952 and other correspondence (NGA). Information on the family is found in Dexter 1904, 122–128, 184–185, 231–232.

2. The name of the seller and the date of purchase are recorded in an annotated copy of *Clarke* 1928 in the NGA library.

3. On Stuart's three portraits of Mrs. Morton (MFA; The Henry Francis du Pont Winterthur Museum, Delaware; and the Worcester Art Museum, Massachusetts) see Harris 1964, 198–220, where they are reproduced. See also the entry on Stuart's portrait of John Dunn [1942.8.14].

4. Dexter 1904, 122–128.

5. Swan 1938, 308; no other appointment books survive.

6. Whitehill 1971, 47; the letter is one of several written in the summer of 1825. They are owned by the Massachusetts Historical Society, Boston. Whitehill misquoted the letter.

7. Whitehill 1971, 46. Park 1926, 286, believed the artist's daughter Jane Stuart (1812–1888) completed the portrait, but there is no evidence for this. Other unfinished portraits, including one of Mrs. Morton (Worcester Art Museum), were left in the artist's studio when he died in 1828.

8. Park 1926, 285, no. 243, repro.; Mount 1964, 367, collection of Mrs. Stanley R. McCormick.

9. These reasons for questioning the attribution are in Rutledge and Lane 1952, 156–158, and the memorandum from William P. Campbell to John Walker, 20 January 1966 (NGA).

References

1879 Mason: 174.
1880 MFA: 37, no. 198.
1926 Bowen: 1:189, 191 repro.
1926 Park: 286, no. 244.
1928 Barker: 276–277.
1938 Swan: 308–309.
1964 Mount: 275–277, 367.
1971 Whitehill: 21–47.

Gilbert Stuart, completed by an unknown artist, *Charlotte Morton Dexter (Mrs. Andrew Dexter)*, 1947.17.104

Attributed to Gilbert Stuart

1942.8.12 (565)

John Ashe

c. 1793/1794
Oil on canvas, 91.4 × 70.8 (36 × 27 7/8)
Andrew W. Mellon Collection

Technical Notes: The picture is executed on a medium-weight, plain-weave fabric. Cusping is evident on all edges. An overall pale gray, almost white ground of moderate thickness covers but does not disguise the texture of the fabric. The sitter is depicted with careful strokes, while the background areas are more loosely brushed. The features are rendered with very fluid, fairly flat color areas on a flesh-tone base. Low impasto is in the highlights of the sitter's hair and cravat. An aureole of paint may have been used to define the shape of the head against the ground during the initial stages of painting. The painting is in poor condition, with minute losses throughout the surface. Larger areas of loss are located in the lower right portion of the sitter's jacket. The surface is abraded, with residues of a coarse, orange-red overpaint. The varnish, which has been toned with black pigment, lies over discolored residues of an older varnish. The painting was lined in 1943/1944.

Provenance: The sitter's daughter Mary Sidney Ashe Gadsden [Mrs. Christopher Gadsden, c. 1792–1855], Edisto River and Charleston, South Carolina; her granddaughter Jane Elizabeth Gadsden Doar [Mrs. Stephen Decatur Doar]; probably her sister Harriett Ann Gadsden Doar [Mrs. David Doar, 1845–1879]; her husband David Doar [1850–1928]; their son Thomas Screven Doar [1878–1951];[1] sold in 1922 by Charlotte Cordes Doar Shore [Mrs. George Shore, 1867–1948], Sumter, South Carolina, to (Frank W. Bayley, Copley Gallery, Boston);[2] by whom consigned to (M. Knoedler & Co., New York) in March 1923; from whom it was purchased 26 March 1923 by Thomas B. Clarke [1848–1931], New York;[3] his estate; sold as part of the Clarke collection on 29 January 1936, through (M. Knoedler & Co., New York), to The A.W. Mellon Educational and Charitable Trust, Pittsburgh.

Exhibited: Union League Club, February 1924, no. 15. Philadelphia 1928, unnumbered. Richmond 1944–1945, no. 14. *Early American Portraits on Loan From the National Gallery of Art, Washington, D.C.*, Pack Memorial Public Library, Asheville, North Carolina, 1949, no. 5.

THE IDENTITY OF THE SITTER in this portrait has been a subject of considerable confusion. Frank Bayley purchased the painting in 1922 as an image of John Ashe and consigned it to Knoedler under that name.[4] When the painting was first exhibited by Thomas B. Clarke two years later, the sitter had been re-identified as John Baptista Ashe (1748–1802), a North Carolina congressman who was elected governor of the state in 1802 but died before being inaugurated.[5] After the portrait was acquired by the National Gallery of Art, the title was changed to *Mr. Ashe* when descendants of John Baptista Ashe pointed out that the likeness did not agree with other portraits of Ashe.[6] The first identification was correct. The painting represents John Ashe (1760–1828) and was owned by his direct descendants.[7] Ashe was a wealthy South Carolina planter whose more than five thousand acres of land included city lots in Charleston as well as rice plantations. He married Catherine DeVeaux Lechmere, a widow, on 10 March 1785. They lived on a plantation called "The Point" and at 32 South Battery in Charleston.[8] Ashe, a trustee of Willtown Presbyterian Church, died on 14 August 1828 at age sixty-eight.[9]

The portrait can be dated to the early 1790s by Ashe's clothing, which is typical of those years. The patterned edge of his gold-colored waistcoat can be seen beneath his dark, double-breasted brown coat. Holding a pair of gray gloves, he sits in a red chair, with a red curtain pulled open behind him to reveal blue sky with gray and white clouds. Ashe would have been in his early thirties when Gilbert Stuart was working in New York in 1793–1794. Family ties with the Livingstons make it possible that Ashe visited New York and was painted at that time.[10]

It is also possible that the portrait was painted in Charleston by a different artist, James Earl (1761–1796), the younger brother of the Connecticut portraitist Ralph Earl (1751–1801). James Earl worked in Charleston as a portrait painter for almost two years prior to his death.[11] Any reattribution to Earl is made difficult by the abraded condition of the painting.[12] While x-radiography indicates that the technique in the face is similar to Stuart's handling of highlighting and shadow, it also reveals the use of larger areas of white pigment than is typical of Stuart's work at this time. Other stylistic features include the use of thick white paint in the sitter's cravat and shirt cuff, and touches of white in the

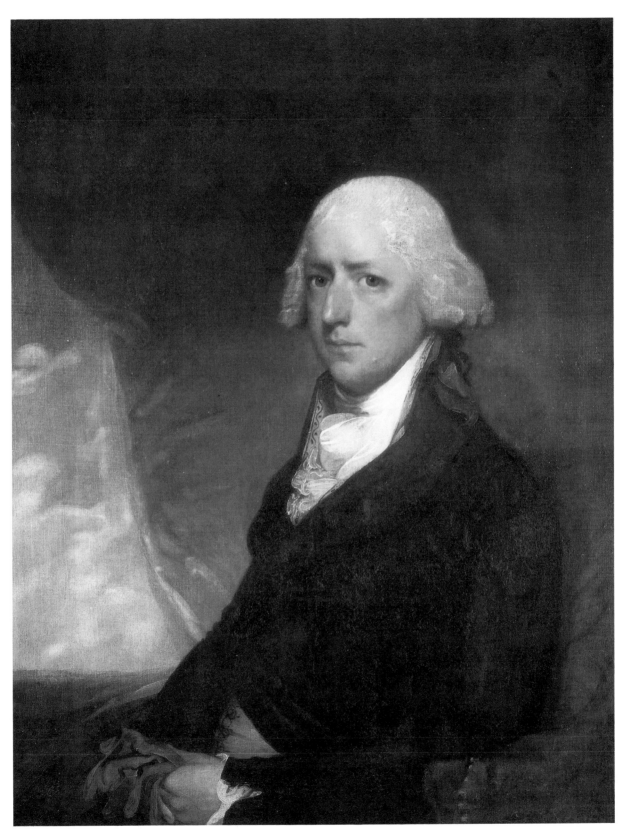

Attributed to Gilbert Stuart, *John Ashe*, 1942.8.12

powdered hair, the loosely painted gloves, and the vaguely defined landscape. In addition, the characterization seems slight, and both the arm of the red chair and the curtain seem poorly realized.

The portrait is very similar to Earl's known work. Ashe is posed to fill the corner of the painting's rectangular format. Comparable poses are found in the portraits of Lord Aubrey Beauclerk and Robert Carey Michell (both unlocated), which Earl painted in England around 1790.[13] The depiction of the gloves, the handling of the white pigment in the cravat and powdered hair, and the treatment of the background curtain are particularly similar to those areas in Michell's portrait. A portrait of an unidentified man by Earl (c. 1794, Bowdoin College Museum of Art, Brunswick, Maine) shares some of these compositional and stylistic features.[14] Also, Earl's habit of scribbling in the thick white pigment of the shirt and cravat with the wooden end of the paintbrush can be seen in these details of Ashe's portrait.[15] A firm attribution to James Earl, however, will require a more complete study of his American work.

CJM / EGM

Notes

1. Park 1926, 114. Thomas Screven Doar, Jr., of Sumter, South Carolina, recalled in a telephone interview on 19 May 1989 that his father owned the painting.

2. A letter from Frank Bayley, dated 31 August 1922, to Charlotte Shore, Sumter, South Carolina, discusses the sale (copy, Catalog of American Painting, NPG). George D. Shore, Jr., of Sumter, South Carolina, has suggested that his mother acted in the sale as a representative for her cousin Thomas Screven Doar (letter from George D. Shore, Jr., 21 April 1961; NGA).

3. The name of the seller and the date of purchase are recorded in an annotated copy of *Clarke* 1928 in the NGA library. Information was also provided by Melissa De Medeiros, librarian, M. Knoedler & Co., 29 April 1989 (letter, NGA).

4. Bayley to Charlotte Doar Shore, 31 August 1922, according to Melissa De Medeiros' letter of 29 April 1989 (NGA).

5. Union League Club, February 1924, no. 15.

6. The title was changed in 1964. A miniature of John Baptista Ashe by an unknown artist is illustrated in Bowen 1892, 427, repro. 125. For another image see Davis 1907, repro. 24.

7. Although Park 1926, 113–114, gave the wrong identity for the sitter, he provided a logical provenance for a painting of John Ashe. He wrote that the painting was given to the sitter's daughter, "Mrs. Gadsden, in 1802." According to genealogical records, John Baptista Ashe had only one child, Samuel Porter Ashe (d. 1848), who moved to Tennessee; letter from William Ash LaMotte King, Manhattan Beach, Florida, 15 August 1961 (NGA).

8. Will of John Ashe, Sr.; Ashe left the mansion to his sons, who had no heirs ("Ashe" and "South Battery" files, SCHS 30–4 and SCHS 30–1 32, South Carolina Historical Society, Charleston). For biographical information see "Laurens" 1902, 149, n. 10; and Barnwell and Webber 1922, 12.

9. Simmons 1961, 175. Ashe's name is sometimes spelled "Ash" in contemporary references, but the final *e* appears on his will and tombstone; see Webber 1928, 61.

10. The widow of ancestor Cato Ash had married a Henry Livingston; "Ash" 1921, 54. John Ashe's son, John Sidney Algernon Ashe, went to grammar school and college in New York state from 1806 to 1814; Bailey 1986, 1:82. Ashe's daughter Eliza Barnwell (b. 1792) married Philip P. Livingston, a descendant of Robert Livingston, in 1818; Van Rensselaer 1949, 158, no. 663.

11. The only recent study of Earl's work, Stewart 1988, 34–58, concentrates on his English painting. An earlier and much briefer study is Sherman 1935, 143–153. Earl's work was included in a 1972 exhibition at the William Benton Museum of Art, University of Connecticut, Storrs, with that of his brother and his nephew Ralph Eleazer Whiteside Earl (1785?–1838); see *American Earls* 1972.

12. Family tradition held that the portrait was saved when one of Ashe's plantation houses was set aflame by Northern troops during the Civil War. Frank Bayley commented on its poor condition when he notified Mrs. Shore on 31 August 1922 that he would buy it. "No one would consider the portrait in its present condition except someone who felt sure it could be restored. As it would take probably two months to restore the portrait and not until then would it be advisable to show it to a customer I have decided to buy it myself."

13. See Stewart 1988, 46, fig. 11, and 53, fig. 19.

14. Stewart 1988, 55, fig. 22.

15. This habit is described in Stewart 1988, 38.

References
1926 Park: 113–114, no. 34, repro.
1964 MacMillan: 6, repro.
1964 Mount: 364.
1970 NGA: 102, repro. 103.

After Gilbert Stuart

1947.17.106 (1014)

William Seton

after 1793/1794
Oil on canvas, 43.2 × 35.5 (17 × 14)
Andrew W. Mellon Collection

Technical Notes: The support is a medium-weight, plain-weave fabric. The original tacking margins are present, with a selvage at the lower edge. The stretcher is possibly original. The thick ground is white. The oil paint is thickly applied in the lower layers, with a thinner application for the fine details and planes of the forms. The texture of the thicker brushstrokes is visible through the thinner upper layers.

The original oval format was later extended with the application of thick paint to fill the rectangular surface of the fabric. Three large losses are along the upper right edge; two other small losses are along the right edge. There is scattered surface abrasion. The retouches and varnish have badly discolored.

Provenance: (Rose M. de Forest [Mrs. Augustus de Forest], New York); purchased 6 December 1921 by Thomas B. Clarke [1848–1931], New York;[1] his estate; sold as part of the Clarke collection on 29 January 1936, through (M. Knoedler & Co., New York), to The A.W. Mellon Educational and Charitable Trust, Pittsburgh.

Exhibited: Union League Club, February 1922, no. 10, as *Cyrus Griffin*. Century Association 1928, no. 18, as *Cyrus Griffin*. Philadelphia 1928, unnumbered, as *Cyrus Griffin*. *Exhibition of Historical Portraits, 1585–1830*, Virginia Historical Society, Richmond, 1929, unnumbered, as *Cyrus Griffin*.[2]

THOMAS CLARKE acquired this painting as a portrait of Cyrus Griffin by Gilbert Stuart. When its identification, attribution, and provenance became suspect, William Sawitzky used it as an example of "the danger a collector incurs by accepting credulously as definite evidence what in reality amounts to nothing else than tradition based on a misconstruction of facts."[3] The portrait is now recognized as a reduced copy, about a quarter of the size of the original, of Stuart's portrait of William Seton (1746–1798), a New York financier. The original, painted during Stuart's short stay in New York in 1793–1794, was owned by New York descendants of Seton about fifty years ago and is unlocated today.[4] In the Gallery's copy, Seton wears a green coat with a black velvet collar and a green patterned waistcoat. Behind him is a green wall to the right, a gray panel to the left. Details of the sitter's thickly painted face were added in the final, thinner application. Unlike the original, the copy was painted in an oval format. The red chair arm in the lower right corner and much of the inkstand and table in the left corner were added later. Two large copies—one with a background similar to the original (private collection)[5] and one with a curtain on the left[6]—are also known. In the large copies the sitter's coat is described as black or gray, the waistcoat a striped gray.

EGM

Notes

1. The name of the seller and the date of purchase are recorded in an annotated copy of *Clarke* 1928 in the NGA library. Park 1926, 372–373, published the portrait as of Cyrus Griffin, with the false provenance provided by Rose de Forest, who claimed that the portrait was handed down from Cyrus Griffin's daughter Mary to her daughter Eliza Waller and her son Matthew Page Waller. The typed copy of a letter to "Mr. de Forest," dated 16 April 1926 and purporting to be from Louisa Cosnahan, Dr. Waller's niece, stated that the portrait hung in Waller's home for many years (NGA; the original letter was not provided). This letter, provenance, and sitter identification were proven false by William Sawitzky and by Rutledge and Lane 1952; see Sawitzky 1933, 92–93, and lecture notes for his class at New York University, c. 1940, Rutledge and Lane 1952, 1–2, and William P. Campbell's memo of 11 January 1966 to John Walker (NGA).
2. Weddell 1930, 260.
3. Sawitzky 1933, 92.
4. Sawitzky 1933, 83–84, repro. 87.
5. *Reuling* 1925, 52, no. 150, repro. 53, attributed to Mather Brown; Park 1926, 675, as a copy.
6. Park 1926, 675, no. 746; *Rouss and Stein* 1930, 52, no. 91, 53 repro.

References

1922 Sherman: 144, as Cyrus Griffin.
1926 Park: 372–373, no. 361, repro., as Cyrus Griffin.
1930 Weddell: 258–260, repro., as Cyrus Griffin.
1933 Sawitzky: 83–84, 91, 92–93.

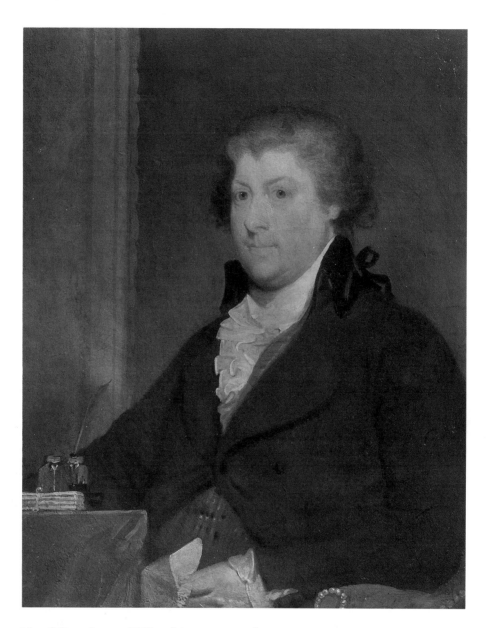

After Gilbert Stuart, *William Seton*, 1947.17.106

1954.1.9 (1193)

William Constable

After 1796
Oil on canvas, 73.8 × 61.2 (29 ¹/₁₆ × 24 ¹/₁₆)
Andrew W. Mellon Collection

Technical Notes: The support is a fine-weight, plain-weave fabric. Cusping is present on all four edges. The ground is off-white. The paint is applied in smooth, thick, and fairly opaque layers in the figure and lower part of the background, but it is thinner and more translucent in the upper background. The contours and folds of the coat are loosely applied over the surface with fluid strokes. The face is modeled in broad strokes, while details are brushed in over the top with tiny, exacting strokes in transparent paint. Details in the more thickly painted passages are worked in a fluid wet-in-wet technique.

There is little retouching other than thin lines in the background to the left and right of the sitter. An earlier varnish was removed in 1968. The present varnish is moderately discolored.

Provenance: The sitter's granddaughter Maria T. Moore [1816–1906], New York and Stamford, Connecticut; her nephew the Reverend Francis Van Rensselaer Moore [1872–1949], Vineland, New Jersey.[1] (André E. Rueff and Mary H. Sully, New York); sold 31 March 1921 to Thomas B. Clarke [1848–1931], New York;[2] his estate; sold as part of the Clarke collection on 29 January 1936, through (M. Knoedler & Co., New York), to The A.W. Mellon Educational and Charitable Trust, Pittsburgh.

Exhibited: Union League Club, February 1922, no. 5. Philadelphia 1928, unnumbered.

WILLIAM KERIN CONSTABLE (1752–1803) was a wealthy merchant, ship owner, banker, and land speculator in New York. He was born in Ireland, and his father, a surgeon in the British army, moved his family to Montreal in 1762 and then to Schenectady, New York. During the American Revolution, Constable was an aide-de-camp to the Marquis de Lafayette. His financial activities were "regarded with suspicion by most patriots and his name became anathema to ardent revolutionists when, with Benedict Arnold, he became involved in several devious dealings."[3] Constable's business acumen and contacts made him one of the leaders of New York's merchant community after the war. He accumulated large profits in the China trade, engaging naval hero Thomas Truxtun to command his ships. Such worldwide mercantile interests led to a business association with Gouverneur Morris and Robert Mor-

ris. He also joined in partnership with Alexander Macomb and Daniel McCormick in the celebrated purchase of nearly four million acres of land in upstate New York in 1791–1792, and he owned tracts of land in Ohio, Kentucky, Virginia, Georgia, and Maine. Constable married Anna White of Philadelphia, a renowned beauty who was a schoolmate and close friend of Martha Custis Washington.[4]

This portrait of Constable is a copy by an unknown artist of Stuart's original, which was painted in Philadelphia in 1796 (Figure 1). When he painted Constable's portrait, Stuart was at work on his full-length "Lansdowne" portrait of George Washington (on loan from the Earl of Rosebery to NPG), and Constable commissioned a replica (The Brooklyn Museum, New York).[5] Like the original of Constable, the Gallery's copy shows a pleasant-looking man in his mid-forties wearing a fashionable double-breasted coat.[6] The brush strokes of the copy are heavier and more labored than in Stuart's original, particularly in the rendering of the sitter's cravat, which lacks the lacy edges of the original, and in the highlights and powder on the collar of

Fig. 1. Gilbert Stuart, *William Kerin Constable*, oil on canvas, 1796, New York, The Metropolitan Museum of Art, Bequest of Richard de Wolfe Brixey, 1943

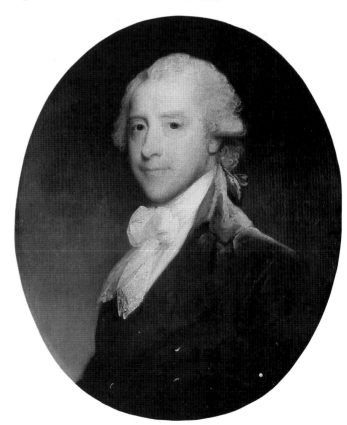

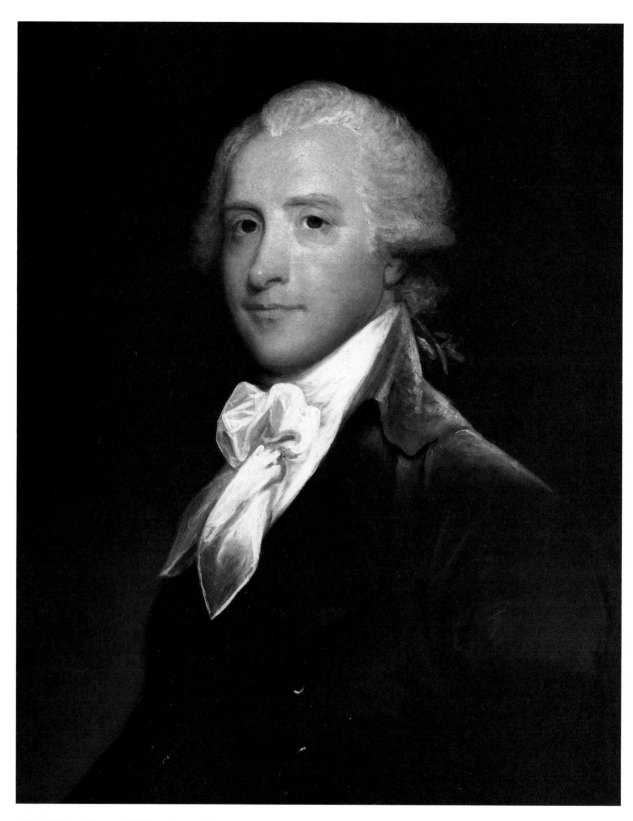

After Gilbert Stuart, *William Constable*, 1954.1.9

Constable's blue coat. In copying the face, the painter tried to imitate Stuart's technique of painting highlights over body color but did not succeed. The blue cast evident in the white tones of the sitter's face and wig is uncharacteristic of Stuart's work.

<div align="right">CJM / EGM</div>

Notes
1. Miss Moore's will (copy, Clarke files, NGA) directed that her nephews draw lots for the portrait. The lottery was won by the Reverend Moore. He stated in an affidavit dated 8 April 1921, at the time of the portrait's sale to Clarke (NGA), that it had been given by Constable to his daughter Emily (Mrs. Samuel Moore, 1795/1796–1844), and by her to her daughter, Miss Moore, but this has not been confirmed.

2. The name of the seller and the date of purchase are recorded in an annotated copy of *Clarke* 1928 in the NGA library. André Rueff sold several other American portraits to Clarke, including Joseph Blackburn's *Military Officer* [1947.17.25], John Johnston's *John Peck* [1947.17.65], and *James Lloyd*, a copy after Stuart [1947.17.107]. Mary Sully, who worked with Rueff on some of these sales, arranged Clarke's purchase of Stuart's portraits of the Thorntons [1942.8.25 and 1942.8.26].

3. David 1955, v–vi.

4. On Constable see David 1955; Hough 1860, 238–243; Moore 1903, 118; Burnham 1913, 183–187; and Pilcher 1985.

5. Constable also ordered a half-length portrait of Washington as a gift for Alexander Hamilton. He paid Stuart $850 for the three pictures: $100 for the portrait of himself, $500 for the full-length of Washington, and $250 for the portrait of Washington. Burnham 1913, 183–187; Mason 1879, 97–100; and Gardner and Feld 1965, 88–89, repro.

6. Warwick, Pitz, and Wyckoff 1965, 213, pl. 90b (the portrait owned by MMA).

References
1922 Sherman: 144.
1926 Park: 232–233, no. 180.
1933 Sawitzky: 84, 90–91.
1964 Mount: 216, 358.

1947.17.107 (1015)

James Lloyd

After 1808
Oil on canvas, 76.5 × 64.0 (30 1/8 × 25 1/8)
Andrew W. Mellon Collection

Technical Notes: The painting is on a medium-weight, plain-weave fabric. It was reduced in size by scoring the paint and ground layers and by folding the fabric over a smaller stretcher. Part of the red drape, the arm of the chair, and the sitter's left hand are visible along the bottom tacking edge. Original paint is also evident on the top and right tacking margins. A transparent brown layer is over the thin white ground in the area corresponding to the face. Thick glazes are in the deepest shadows of the curtain, thinner glazes in the coat and face, and very thin glazes in the hair. The shirt as well as the highlights on the drapery and face are applied in thick, textured brush strokes.

There is considerable retouching, especially in the lower part of the coat, the shadow of the face, and the red drape on the left of the painting. The jacket has been reinforced. The varnish is slightly discolored.

Provenance: The sitter's granddaughter Augusta Elizabeth Borland Greene [Mrs. William Parkinson Greene, 1795–1861], Norwich, Connecticut; her husband William Parkinson Greene [1795–1864], Norwich, Connecticut; their son Gardiner Greene [1822–1895], Norwich, Connecticut; his son Gardiner Greene [1851–1925], Norwich, Connecticut;[1] sold to (André E. Rueff, New York) by 2 May 1921, when it was purchased by Thomas B. Clarke [1848–1931], New York;[2] his estate; sold as part of the Clarke collection on 29 January 1936, through (M. Knoedler & Co., New York), to The A.W. Mellon Educational and Charitable Trust, Pittsburgh.

Exhibited: Union League Club, February 1922, no. 8. Philadelphia 1928, unnumbered. NPG, on long-term loan, 1967–1980.

BORN ON LONG ISLAND, James Lloyd (1728–1810) studied medicine in Boston and London before settling in Boston in 1752, where he became one of the first American physicians to specialize in obstetrics.[3] Sympathetic with both sides in the American Revolution, he chose to remain in the United States. He or his son James Lloyd later owned John Singleton Copley's *Colonel William Fitch and his Sisters Sarah and Ann Fitch* [1960.4.1], which depicts Lloyd's Loyalist nephew and nieces who moved to England at the beginning of the Revolution.

Dr. Lloyd was painted by Gilbert Stuart in 1808 (private collection).[4] Rembrandt Peale lithographed the portrait for James Thacher's *American Medical Biography* (1828), where it is described as "an almost speaking likeness of him, from the pencil of the most eminent portrait painter of his time."[5] This weak copy, like the original, shows Lloyd in a black coat and gray vest, seated in a red upholstered armchair before a red curtain. Painted the same size as the original (approximately 84 by 65 cm [33 by 25 1/2 inches]), it was restretched to the present dimensions while in Thomas B. Clarke's collection.[6] This copy could be by Boston artist James Frothingham (1788–1864), who studied with Stu-

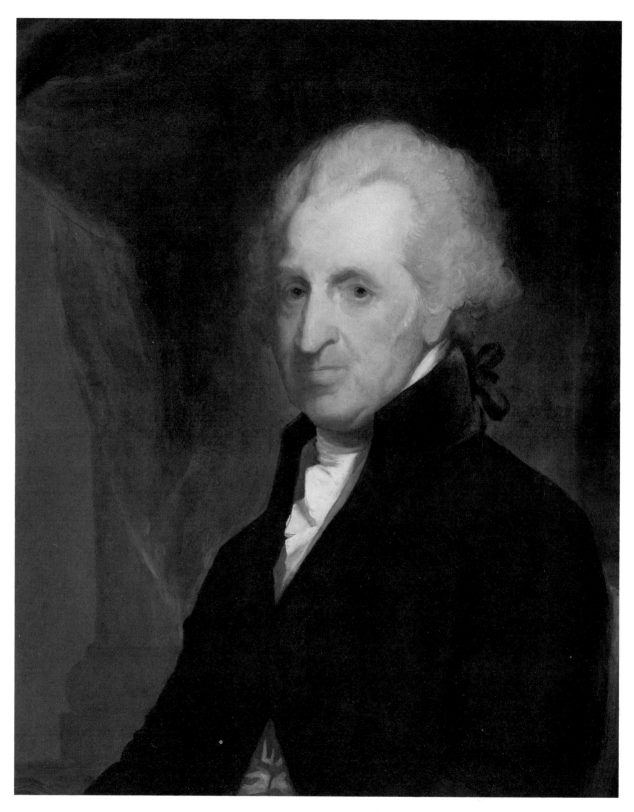

After Gilbert Stuart, *James Lloyd*, 1947.17.107

art. Frothingam painted a posthumous portrait of Lloyd for Joseph Delaplaine's National Gallery of Portraits; the copy was exhibited at The Pennsylvania Academy of the Fine Arts in 1818.[7] Acquired shortly afterward by Rembrandt Peale for his New York Museum and Gallery of the Fine Arts,[8] it is unlocated today.

EGM

Notes

1. Greene provided this provenance to André E. Rueff, letter of 1 May 1921 (NGA). On the Lloyds and the Greenes see Barck 1927, 2:895–896, 900; Greene 1903, 429–430, 578, 687; and the *New York Times*, 11 February 1925, 21 (obituary for Gardiner Greene).

2. The name of the seller and the date of purchase are recorded in an annotated copy of *Clarke* 1928 in the NGA library. The receipt signed by A.E. Rueff is dated 3 May 1921 (NGA).
3. *DAB* 6 (part 1):333.
4. Park 1926, 485, no. 500; like the copy, the original descended in the Borland family, Dr. Lloyd's heirs.
5. Thacher 1828, 1:376.
6. Rutledge and Lane 1952, 161; memo from William P. Campbell to John Walker, 12 January 1966 (NGA).
7. Rutledge 1955, 77, no. 38.
8. Yarnall and Gerdts 1986, 1352.

References

1879 Mason: 216.
1880 MFA: 46, no. 373.
1926 Park: 485, note.
1928 Barker: 276–277.

Jeremiah Theus

1716 – 1774

BORN IN CHUR, Switzerland, Jeremiah Theus emigrated to South Carolina in 1735 with other Swiss Protestants who were attracted by vivid descriptions of the colony as a land of opportunity. His training as a painter is unknown. He settled in Charleston by 1740, the date of his first newspaper advertisement. Like other American colonial painters, he was willing to undertake a variety of commissions.

Notice is hereby given, that Jeremiah Theus Limner is remov'd into the Market Square near Mr. John Laurans Sadler, where all Gentlemen and Ladies may have their Pictures drawn, likewise Landskips of all sizes, crests and Coats of Arms for Coaches or Chaises. Likewise for the Conveniency of those who live in the Country, he is willing to wait on them at their respective Plantations.[1]

In 1744 he advertised the opening of an evening drawing school for "young Gentlemen and Ladies."

Theus was South Carolina's resident portrait painter for more than three decades. His earliest works are small. Among his first patrons was plantation owner Barnard Elliott, for whom he painted a series of family portraits, each measuring about 51 by 41 cm (20 by 16 inches). Other early sitters included Colonel John Gibbes and his wife Mary Woodward Gibbes (Carolina Art Association, Gibbes Museum of Art, Charleston). By the mid-1750s he began to use a larger 76.2 by 63.5 cm (30 by 25 inch) format, the size of most of his work. His 127 by 101.6 cm (50 by 40 inch) portrait of Mrs. Peter Manigault (The Charleston Museum) is unusually large, the pendant to the portrait of her husband by English artist Allan Ramsay. For some portraits, especially those of women, he imitated the clothing and poses seen in imported English mezzotint engravings. This use of prints is particularly characteristic of the period when he was beginning to paint larger portraits.[2]

Theus' charm as a painter rested on his ability to depict cheerful, well-dressed sitters. Men in his portraits wear blue, rose, cream, gray, or dark green coats and vests, often decorated with embroidery; women are attired in blue, yellow, white, or light brown dresses trimmed with bows, lace, and pearls. Technical examinations of the Gallery's three portraits show that the colors of the clothing were enhanced by the use of an imprimatura layer of paint underneath the surface, a feature of his work that has not been previously recognized. In his technique of smooth surfaces and precise handling of detail, brush strokes are

carefully blended. Closely observed reflections and shadows enliven the images. He was less gifted as a draftsman; his postures and proportions are often awkward.

Theus painted more than 150 portraits. His only competition came from English painter John Wollaston (active 1742–1775), who worked in Charleston in 1765–1767. After Theus' death his estate, including "pictures, prints, paints, books, and personal belongings," was sold to produce cash legacies for his family. Among the items were "a great many PORTRAITS of Men, Women, and Children," soon advertised for sale by Edward Oats.[3]

<div align="right">EGM</div>

Notes

1. *South Carolina Gazette*, 6 September 1740, quoted in Middleton 1953, 33.

2. Severens 1985, 57.

3. *South Carolina and American General Gazette*, 9 September 1774, Archives, Museum of Early Southern Decorative Arts, Winston-Salem, North Carolina.

Bibliography

Middleton 1953.
Dresser 1958: 43–44.
Severens 1985: 56–70.
Saunders and Miles 1987: 183–186.

1947.17.12 (920)

Mr. Motte

c. 1760
Oil on canvas, 76.2 × 63.5 (30 × 25)
Andrew W. Mellon Collection

Technical Notes: The primary support is a plain-weave linen. The picture is lined to a pre-primed fabric. There is only mild cusping. A thin, off-white ground covers the entire surface of the fabric. There is an opaque light gray imprimatura under the sitter's face and hands and under the blue vest. It may extend under the entire figure.

The paint is applied thinly in fluid, opaque pastes. Much of the blending is accomplished wet-in-wet, with details added after the base layers dried. With the exception of the highlight along the top edge of the button on the sitter's cuff, there is no impasto. There are losses in the background to the right of the sitter, at the right side near the bottom, and in the jacket between the second and third buttons. The paint surface is generally abraded, with fine inpainting in thinned areas. The moderately thick layer of natural resin varnish is slightly uneven.

Provenance: Charles Henry Hart [1847–1918], New York; his widow Mrs. Charles Henry Hart; sold 29 May 1920 to Thomas B. Clarke [1848–1931], New York;[1] his estate; sold as part of the Clarke collection on 29 January 1936, through (M. Knoedler & Co., New York), to The A.W. Mellon Educational and Charitable Trust, Pittsburgh.

Exhibited: Union League Club, January 1923, no. 6. Philadelphia 1928, unnumbered. Chattanooga 1952, unnumbered. Mint Museum of Art, Charlotte, North Carolina, 1952, no cat. *Carolina Charter Tercentenary Exhibition*, North Carolina Museum of Art, Raleigh, 1963, no. 34. *National Gallery Loan Exhibition*, Mint Museum of Art, Charlotte, North Carolina, 1967, no. 3.[2] Georgia Museum of Art, University of Georgia, Athens, on long-term loan, 1972–1974.

THIS PORTRAIT was once identified as a representation of South Carolinian Isaac Motte (1738–1795), an officer during the American Revolution and a member of his state's constitutional convention. When questions were raised by the lack of similarity between the painting and another portrait also thought to be of Motte, the identification was changed to the present one. (The other portrait is now identified as an image of Charles Motte, who died in 1779.)[3] Further attempts to give "Mr. Motte" a full identity, or to trace the provenance of the portrait, have been unsuccessful.

The painting is typical of Theus' work. Motte, in a black wig, brown coat, and vivid blue silk waistcoat, is shown against a green background. The portrait can be dated to around 1760 by the style of the clothing.[4] Greater contrasts of light and dark are found in the modeling of the face than in the rest of the portrait; small triangles of light and shade adjacent to the features are used to convey a sense of volume. The surface of the painting is very smooth, with the only impasto highlighting the button on his sleeve cuff. An opaque, light gray imprimatura lies under the face, hands, and vest, which lightens the tone in these areas. A similar imprimatura is present in Theus' portraits of Mr. and Mrs. Cuthbert [1965.15.6 and 1965.15.7]. The use of such underpainting, not previously noted in Theus' work, is rare in colonial American portraits. It suggests that Theus had some training as a painter in his native Switzerland before coming to the colonies.

<div align="right">EGM</div>

Notes

1. The name of the seller and the date of purchase are recorded in an annotated copy of *Clarke* 1928 in the NGA

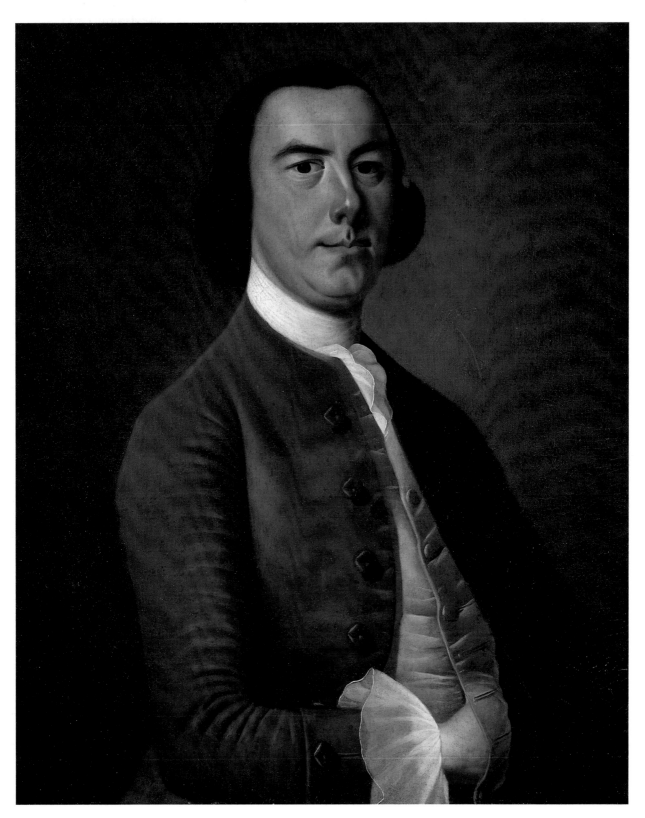

Jeremiah Theus, *Mr. Motte*, 1947.17.12

library. Mrs. Hart provided the information that her husband had owned the painting. Hart, a lawyer, was a writer, dealer, and collector of American art; *DAB* 4:355–356.

2. Mint *Quarterly* 1967, repro., unpaginated.

3. Stewart 1971, 61–62, no. 66, repro. The portrait has a provenance in the Motte family.

4. The portrait is illustrated and dated in Warwick, Pitz, and Wyckoff 1965, pl. 49c.

References

1951 Middleton: 104 repro.
1953 Middleton: 151–152.

1965.15.6 (1955)

James Cuthbert (?)

c. 1765
Oil on canvas, 75.3 × 62.3 (29 5/8 × 24 9/16)
Gift of Edgar William and Bernice Chrysler Garbisch

Technical Notes: The support is a medium-weight, plain-weave fabric. The painting has been marouflaged to a masonite panel with a honeycomb core. Fragments of the original tacking margins are present. The fabric was prepared with a thin, white-colored ground, over which a thin, opaque reddish brown imprimatura was applied in the area of the figure, and a gray imprimatura was applied in the area of the face. The paint was then applied in smooth, fluid layers and blended in a wet-in-wet technique without impasto. The paint of the coat is thin enough to allow the reddish brown imprimatura to show through. The face and the highlights in the hair are applied more thickly.

The background has been abraded, but the face has suffered very little. In addition there are discrete damages, primarily along the edges, in the upper and lower left corners, and to the right of the sitter's chin. There is a large tear to the right of the sitter's head.[1] The entire surface is disfigured by flyspecks on the original paint surface, which may indicate that the painting was not varnished. The painting was lined in 1955 and again in 1966. The varnish was removed in 1970. The present varnish is a thick, glossy layer.

Provenance: Sophie Cuthbert Aspinwall [Mrs. Woolsey Aspinwall], Washington;[2] her son John Cuthbert Aspinwall, Norfolk, Virginia; sold to (Eunice Chambers, Hartsville, South Carolina);[3] purchased January 1955 by Edgar William and Bernice Chrysler Garbisch.

Exhibited: Georgia Museum of Art, University of Georgia, Athens, on long-term loan, 1972–1974.

IN THIS waist-length composition the sitter, turned to the viewer's right, wears a blue coat and waistcoat and a white wig, and is placed in front of a blue-green background. Like Mr. Motte [1947.17.12], he has one hand tucked into his waistcoat, a pose often found in eighteenth-century Anglo-American portraits. It derives from stances discussed in contemporary etiquette books such as *The Rudiments of Genteel Behavior* (1737), which recommended that a gentleman stand gracefully with his arms positioned at his sides, so that "the Bend of the Elbow . . . will permit the right hand to place itself in the Waistcoat easy and genteel."[4]

The portrait can be dated to the 1760s by the style of the clothing, particularly the collarless coat and waistcoat and the small white collar folded at the neck.[5] The sitter's clothes are of a plain fabric and lack embroidery; the shirt has a plain ruffle and no cuffs. Such a lack of expensive clothing makes this one of Theus' plainer images and indicates the role of the sitter's taste in determining the look of a portrait. Theus' fondness for curved lines is seen in the shape of the coat, the upswept curls of the wig, the oval eyes, and the turned-up corners and dimples of his mouth and double chin.

In 1928 descendants identified the sitter as a member of the Cuthbert family of Beaufort and Charleston, South Carolina. Eunice Chambers added later that the sitter was also from Georgia, telling Colonel Garbisch that "the last descendant" identified him as Lucius Cuthbert.[6] This is not possible, since Lucius Cuthbert was born in 1798.[7] If the sitter's last name was Cuthbert, he was probably Dr. James Cuthbert (1716–1770), the only man with that name in Beaufort or Charleston at this time. Cuthbert, the Scottish-born grandson of William Hay, the Bishop of Moray, emigrated to South Carolina in 1737. In 1758 he married Mary Hazzard Wigg, a widow. He died in Georgia twelve years later.[8] A portrait by Theus of Jane Hay Cuthbert, his eldest child and only daughter (private collection),[9] supports this identification, since it was not uncommon for a portraitist to paint several members of the same family.

Technical examination reveals an opaque imprimatura under the figure. The use of such a preparation is rare in American colonial portraits. Here, the imprimatura's color differs according to the part of the figure it underlies: gray underneath the face, and reddish brown underneath the blue coat and waistcoat. Its tonality adds to the color of the pigment, imparting a rich blue tone to the coat and

a cool, silvery tone to the face. This technique probably explains the richness of Theus' colors, a noted feature of his work.

EGM

Notes
 1. A pre-restoration photograph at the Frick Art Reference Library shows the tear.
 2. Mrs. Aspinwall told the Frick Art Reference Library in 1928 that the portrait and the pendant of Mrs. Cuthbert [1965.15.7] had always been owned by members of the Cuthbert family of Beaufort and Charleston, South Carolina. The correct names and relationships of members of the Cuthbert and Aspinwall families were provided by their cousin Middleton Train of Washington, who confirmed the spelling of Mrs. Aspinwall's first name as "Sophie"; telephone conversation, 29 December 1989. (Middleton 1953, 195, listed her incorrectly as Mrs. Clarence A. Aspinwall.)
 3. Letter from the Frick Art Reference Library, 19 December 1989.
 4. Nivelon 1737, in Saunders and Miles 1987, 159, no. 37, repro.
 5. Cunnington and Cunnington 1972, 183–195.
 6. Mrs. Aspinwall to the Frick Art Reference Library, 1928; Mrs. Chambers to Colonel Garbisch, 24 April 1954 (NGA). The portrait was published in Middleton 1953 as a *Gentleman of the Cuthbert Family*.
 7. This identification suggests that the portrait and its pendant came down in the family through Lucius Cuthbert's descendants. On Lucius Cuthbert see Barnwell 1969, 178.
 8. "Hayne" 1909, 159; Barnwell and Webber 1922, 51; Barnwell 1969, 51; Whyte 1972, 89, where he is listed as "possibly a physician." His brother George, who emigrated to Georgia, died in 1768.
 9. Middleton 1953, 125.

References
 1953 Middleton: 126.

1965.15.7 (1956)

Mary Cuthbert (Mrs. James Cuthbert) (?)

c. 1765
Oil on canvas, 75.5 × 62.6 (29 $^{11}/_{16}$ × 24 $^{5}/_{8}$)
Gift of Edgar William and Bernice Chrysler Garbisch

Technical Notes: The painting is on a medium-weight, plain-weave fabric. Fragments of the original tacking margins are present. The painting has been marouflaged to a masonite panel with a honeycomb core. The fabric is covered with a thin white ground layer. A thin, opaque, gray imprimatura lies under the entire figure, including the face. The paint is applied in fluid, semi-opaque layers, blended in a wet-in-wet technique. There is no im-

pasto. The reddish shadows of the face are applied on top of the gray imprimatura.

There are losses along the right edge, where the painting appears to have been folded, and along the bottom edge. Tears are on the left side of the sitter's face and to the right of her head. There is a scratch along her chin and neck. The original paint surface is disfigured by flyspecks, which may indicate that the painting was left unvarnished by the artist. The varnish is gray and dull in appearance.

Provenance: Same as 1965.15.6.

Exhibited: *101 Masterpieces of American Primitive Painting from the Collection of Edgar William and Bernice Chrysler Garbisch*, American Federation of Arts, New York, traveling exhibition, 1961–1964, no. 13, as *Devout Lady*, attributed to Theus. Kentucky 1970, unnumbered.

LIKE THAT of Mr. Cuthbert [1965.15.6], this painting bears the hallmarks of a Theus portrait. The sitter's stiff pose and fixed smile, her blue dress and luminous pearl necklace, the dark rose-colored wall, and the blue sky with its pink clouds are all characteristic of this painter's work. Her dress and bonnet are of a style worn from the 1740s through

Fig. 1. X-radiograph showing changes in the placement of the book and the sitter's left hand, 1965.15.7

Jeremiah Theus, *James Cuthbert (?)*, 1965.15.6

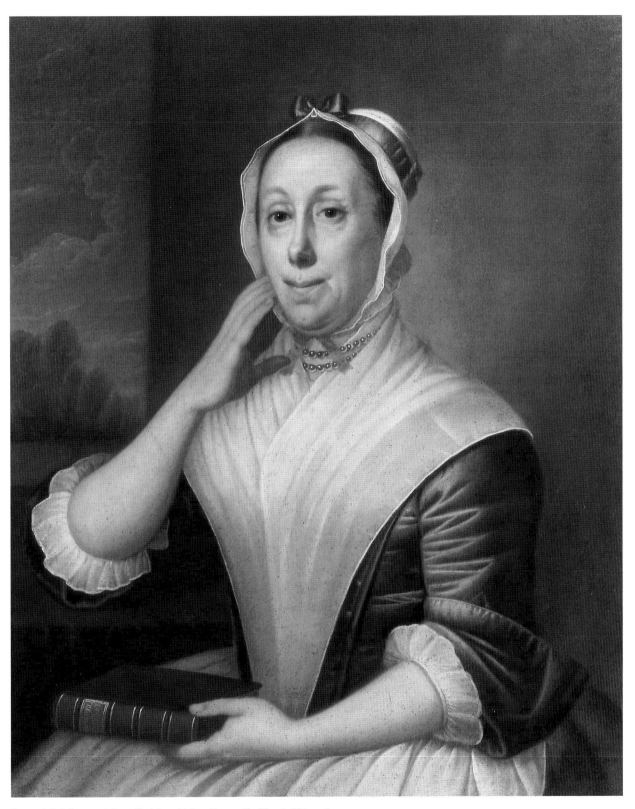

Jeremiah Theus, *Mary Cuthbert (Mrs. James Cuthbert) (?)*, 1965.15.7

the 1760s, making it difficult to date the portrait precisely. Since similar clothing was worn by several Boston matrons painted by John Singleton Copley in the 1760s, a date in the mid-1760s seems reasonable.[1]

According to descendants, the sitter was a member of the Cuthbert family of Charleston and Beaufort, South Carolina.[2] Seated, she rests her right elbow on a table and rests the fingers of her right hand against her cheek. In her lap she holds a book with the title *GOSPEL SONNET*. The x-radiograph (Figure 1) reveals that the book was previously in a vertical position with her hand along its top edge, perhaps to emphasize its title. The publication appears to be a popular collection of "theology in verse" by Scottish secessionist preacher Ralph Erskine, called *Gospel sonnets, or, spiritual songs*.[3] First published in London in 1720, *Gospel Sonnets* went through twenty-five editions by the end of the century. The first American edition was printed in Philadelphia in 1740.

The sitter was once incorrectly identified as Charlotte Fuller Cuthbert, who was born in 1802, long after Theus' death.[4] The piety of the sitter suggests that she may be Mary Cuthbert (1718–1787) of Beaufort, South Carolina. The widow of Edward Wigg, she married Dr. James Cuthbert in 1758 (see 1965.15.6).[5] She was a follower of English evangelist George Whitefield, who, during his third visit to America from 1744 to 1748, baptised her son William Hazzard Wigg (born 1746). Wigg was later educated at the orphanage and school established by Whitefield in Savannah.[6] After Dr. Cuthbert's death, she married William Elliott of Beaufort.[7] A second portrait has been identified as of this sitter, but it shows a different woman, one with a smaller chin and mouth. Like this woman, she is conservatively dressed and holds a book. The painting is attributed to Henry Benbridge (Bayou Bend Collection, The Museum of Fine Arts, Houston).[8]

An opaque, gray imprimatura under the face and body of the sitter imparts a light tone to the surface colors. This imprimatura differs from that in the portrait of Mr. Cuthbert by being one continuous color. Flyspecks on the paint surface beneath the varnish may indicate that the painting was not originally varnished.

EGM

Notes

1. For examples see his portraits of Mrs. Samuel Phillips Savage, Mrs. John Powell, Mrs. Thomas Boylston, and others, reproduced in Prown 1966, 1:pls. 142, 143, 146–148, 178–181.
2. Sophie Cuthbert Aspinwall to the Frick Art Reference Library, 1928 (see 1965.15.6); Middleton 1953, 126, called her a *Lady of the Cuthbert Family*.
3. *DNB* 6:851–852; Roberts 1988, 293.
4. Letter from Eunice Chambers to Colonel Garbisch, 24 April 1954 (NGA). On Charlotte Fuller Cuthbert see Barnwell 1969, 133.
5. Lewis 1973, 90; Barnwell and Webber 1922, 51; Barnwell 1969, 30, 51.
6. Lewis 1973, 90.
7. "Hayne" 1909, 159: "Deaths. 1770: James Cuthbert Dd in Georgia Oct: 15." When she married Elliott in 1775 she was described as "Mary Cuthbert W. [widow] Georgia"; see "Hayne" 1910, 105.
8. Stewart 1971, 32, no. 14, repro.; Warren 1975, 140, no. 262, repro. The portrait has the same provenance from the Cuthbert family to dealer Eunice Chambers; it was acquired by Ima Hogg in 1961.

References

1953 Middleton: 126.
1962 *Garbisch Collection*: color pl. 13.
1984 Walker: 375, no. 529, color repro.

John Trumbull

1756 – 1843

JOHN TRUMBULL is well known for his portraits and history paintings of the leaders and events of the American Revolution. His best work is lively, sensitive, and precise, formed by his artistic ability and his political sympathy for the revolutionary cause. Born in Lebanon, Connecticut, Trumbull graduated from Harvard College (1773) and served with the Connecticut First Regiment in the early months of the Revolution. He began his painting career in 1777 and went to England in 1780, where he studied briefly with Benjamin West. He returned to England four years later for

a longer period, from 1784 to 1789, which became the critical era of his life as a painter. In March 1785 he wrote to his father, Jonathan Trumbull, Sr., that "the great object of my wishes . . . is to take up the History of Our Country, and paint the principal Events particularly of the late War."[1] Influenced by the work of Benjamin West and John Singleton Copley, he completed his first history painting, *The Death of General Warren at the Battle of Bunker's Hill* (YUAG), in March 1786. He began the composition of *The Declaration of Independence* (YUAG) while visiting Thomas Jefferson in Paris that July. There he also saw private collections of paintings and met Jacques-Louis David and Jean-Antoine Houdon.

Trumbull returned to the United States in the fall of 1789. For the next four years he traveled along the East Coast, taking the likenesses he needed for his history paintings. His work during this period—small oil portraits, oil sketches for the history paintings, and life-size portraits, especially full-lengths—possesses a clarity and crispness that shows the influence of West and French painting.

In 1794, after the death of his cousin Harriet Wadsworth (1769–1793), whom he wished to marry, Trumbull accepted an offer from John Jay to serve as secretary with the Jay Treaty Commission in London. There he resumed his painting career and in 1800 married Sarah Hope Harvey. They returned to the United States in 1804, planning to settle in Boston. When Trumbull learned, however, that Gilbert Stuart intended to move there from Washington, he went instead to New York, thinking that "Boston . . . did by no means offer an adequate field of success for two rival artists."[2] His portraits from this period influenced the work of younger American artists. He was elected to the board of directors of the New York Academy of the Fine Arts (later the American Academy of the Fine Arts). The economic consequences of the Embargo Act of 1807, which restricted foreign trade, cut short his success, and he left the following year for Connecticut, and then for a sketching trip through New York state and eastern Canada. Blind in one eye since a childhood accident, Trumbull returned to England with his wife in 1809 for treatment of his failing eyesight. Some observers, including his contemporaries, attribute Trumbull's particular success with small-scale paintings to this lack of full eyesight.

Trumbull and his wife sailed back to America in 1815. In 1817 he received a commission for four large history paintings for the rotunda of the United States Capitol in Washington. That same year he was elected president of the American Academy of the Fine Arts, which under his strict guidance came in the 1820s to represent the older generation of artists. Trumbull completed the Capitol pictures in 1824 but failed to receive further federal commissions, and he turned again to portraiture. In difficult financial straits, he offered his painting collection to Yale College in return for an annuity. The offer was accepted in 1831, and the Trumbull Gallery opened the following year. After he retired from the presidency of the academy in 1836, he wrote his autobiography, in which he recalled his long career. Trumbull died in New York at the age of eighty-seven.

EGM

Notes
1. Connecticut Historical Society, Hartford, quoted in Cooper 1982, 7.
2. Autobiography 1841, quoted in Cooper 1982, 13.

Bibliography
Sizer 1967.
Jaffe 1975.
Cooper 1982: 2–19.
Prown 1982: 22–41.
Rodriguez Roque 1982: 94–105.

1964.15.1 (1926)

Patrick Tracy

1784/1786
Oil on canvas, 232.5 × 133.7 (91 ½ × 52 ⅝)
Gift of Patrick T. Jackson

Technical Notes: The painting is on a medium-weight, plain-weave fabric lined to a pre-primed fabric. The ground is fairly thin and off-white. The paint is applied in fairly free strokes, primarily in a wet-in-wet technique, with low impasto highlights on the ruffles, buttons, and buckles, and minor changes made after the painting had dried.

There is a pronounced crackle pattern in the sitter's face and in the sky. Flattening of impasto may be the result of a past lining. Retouching over the craquelure has whitened, especially in the sky. There is an area of abrasion in the sky to the right of the sitter's left shoulder. The previous varnish was removed in 1961. The present varnish is somewhat discolored.

Provenance: Probably bequeathed by the sitter to his daughter Hannah Tracy Jackson [Mrs. Jonathan Jackson, 1755–1797], Newburyport, Massachusetts;[1] her son Patrick Tracy Jackson [1780–1847], Boston;[2] Patrick Tracy Jackson, Jr. [1813–1891], Boston and Pride's Crossing, Massachusetts; Patrick Tracy Jackson III [1844–1918], Cambridge and Pride's Crossing, Massachusetts; Patrick Tracy Jackson IV [1871–1959], Boston and Boothbay, Maine; Patrick Tracy Jackson V [b. 1906], Boothbay Harbor, Maine.[3]

Exhibited: *Second Exhibition of Paintings in the Athenaeum Gallery*, Boston Athenaeum, 1828, no. 4, as by John Singleton Copley.[4] MFA, on long-term loan, 1880–1886, attributed to Copley.[5] MFA, on long-term loan, 1910–1911, as by an unknown artist.[6] NGA, on long-term loan, 1952–1964. *La Pintura de Los Estados Unidos de Museos de la Ciudad de Washington*, Museo del Palacio de Bellas Artes, Mexico City, 1980–1981, no. 4. *John Trumbull: The Hand and Spirit of a Painter*, YUAG, 1982–1983, no. 39.

PATRICK TRACY (c. 1711–1789) was a Massachusetts mariner and merchant who had acquired considerable wealth by the mid-1780s when this portrait was made. As a young man he had worked his way from his native Ireland to America on a merchant ship. He settled in Newburyport, Massachusetts, where he established himself as a merchant and shipowner, and built a wharf and several large warehouses. He sided with the Americans in the Revolution. When he died at age seventy-eight, his estate was valued at more than 3,700 pounds.[7]

The portrait depicts Tracy as an elderly merchant who, as a seafaring man, had weathered a long life in navigation, commerce, and politics. Tracy, in his seventies, is shown as a robust, meticulously dressed gentleman in an olive-green coat, waistcoat, and breeches, and a white shirt and white stockings. His face is weathered and ruddy. Despite the windy setting, his powdered wig is in place and his clothing is not ruffled. Yellow highlights indicate the metallic sheen of his shoe buckles and brass buttons.

The portrait is in Trumbull's "List of Pictures done in London 1784." as No. 15: "Whole length of Mr. P. Tracy (father of Nat) leaning on an Anchor — head copied — recd 20 Guineas."[8] Since Patrick Tracy was not in England at this time, it is believed that the painting was commissioned by his son Nathaniel. Trumbull's shorthand description of Patrick Tracy as the "father of Nat" suggests that he knew the sitter through his son. And his reference to "head Copied" indicates that the head was taken from another painting, drawing, or miniature, now

unlocated.[9] The portrait was probably painted in the winter or spring of 1785. Nathaniel Tracy, a merchant like his father, sailed to Europe in July 1784 on the *Ceres*, one of his own ships. Deeply in debt due to shipping losses during the war, Tracy went to Europe in an unsuccessful attempt to recoup his financial situation. He went first to Portugal and then to France and was in London by the end of the year. He returned to the United States in May 1785.

When Trumbull painted Tracy's portrait, one of his earliest life-size full-lengths, he also painted Nathaniel Tracy in a "small whole length" (unlocated) at the price of 10 guineas.[10] Nathaniel Tracy also had his portrait painted by Mather Brown, who, like Trumbull, was an American student of Benjamin West in London.[11] Why Tracy chose Trumbull and Brown for these commissions is unknown, but his friendship with Thomas Jefferson and John Adams probably played a role. Jefferson and Tracy met in July 1784 when Jefferson sailed to Europe as a passenger on the *Ceres*.[12] Tracy dined with Jefferson and the Adamses in September in Paris.[13] He could have heard about Mather Brown from the Adamses, whose daughter Abigail sat for a portrait by Brown in London at about that time,[14] and he could have met both artists when he went to London in December.[15] Tracy's brother-in-law Jonathan Jackson, also in London, would probably have recommended John Singleton Copley, who painted Jackson's portrait that spring.[16]

The full-length of Patrick Tracy belongs to the tradition of British paintings of seamen and naval heroes shown on isolated shores with roiling seas and stormy skies behind them. These include two portraits by Sir Joshua Reynolds, *Commodore Augustus Keppel* of 1753 (National Maritime Museum, Greenwich, England)[17] and *Edward Boscawen* (engraving by James McArdell, 1758, National Portrait Gallery, London). The inclusion of an anchor in such portraits was popularized by Thomas Gainsborough's 1768 painting of Augustus John Hervey, 3rd Earl of Bristol (National Trust, Ickworth, Sussex, England), which was engraved in 1773.[18] Only two years before Trumbull painted the portrait of Tracy, Copley depicted midshipman Augustus Brine on a rocky shore with a large anchor to his left (1782, MMA). And about the same time Ralph Earl, another American in London, painted the portrait of Admiral Richard Kempenfelt (National Portrait Gallery, London), in which the naval hero leans one elbow on the fluke of an anchor.[19]

The Tracy portrait is more static and less heroic

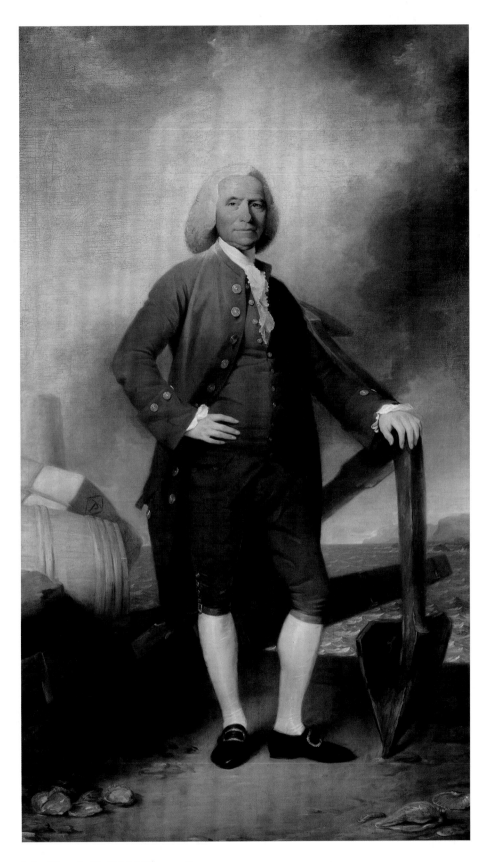

John Trumbull, *Patrick Tracy*, 1964.15.1

than these, perhaps due to Trumbull's necessity to invent a composition around a copied portrait head or due to his adaptation of a military format to a mercantile one. The rigid pose may also be a result of his inexperience with pictures on such a grand scale. In the portrait, the craggy rocks seen in the portraits of naval heroes have been replaced by symbols of Tracy's trade, including a large barrel and a bale with his monogram inside a diamond and the notation "N.° 7." Rather than referring to a particular incident, the anchor and other elements of the composition appear to symbolize Tracy's success in the shipping trade. The iron anchor, enlivened with orange-red brushwork to denote corrosion from the sea, is of a design that was the forerunner to the curved-crown Admiralty anchor. It consists of a long metal shaft with two sharply pointed flukes at one end and a large wooden stock at the other end. On the ground behind Tracy's feet is an iron ring for attaching the mooring cable to the anchor. Several types of sea shells, including oyster shells, are carefully depicted in the foreground.[20] Behind Tracy, a rocky coast with a solitary, towerlike building is silhouetted in blue across the choppy green sea. The water is stirred up as if a storm were passing. A band of dark clouds rises diagonally across the sky, which is blue with white clouds at the upper left and pink just above the horizon at the right.

The complexity of the composition indicates Trumbull's ambitions. He wrote to his brother early in 1785 that "the difficulties & labour of my profession begin to wear off as I acquire more practise & knowledge,— but portraits continue to be insupportable to me.—I wish to rise above the necessity of painting them." He had a new direction in mind and commented to his brother, "If I do succeed it makes me master of my time. & disengages me from all the trumpery & caprice & nonsense of mere copying faces — & places me the servant not of Vanity but Virtue."[21] A reference to the portrait with the date 1786 has been taken as the date the portrait was completed.[22] By that time Trumbull's work had indeed taken a new direction with his paintings of the events of the American Revolution.

CJM / EGM

Notes

1. The portrait is not listed by name in Tracy's will or in the inventory of his estate. He left his daughter most of his "Plate and Household Furniture," including "3 Family Pictures," valued at thirty pounds (will, proved 6 April 1789, and inventory of the estate, Essex County Court House, Salem, Massachusetts; copy, NGA).

2. The earliest documentation of ownership is the checklist for the exhibition at the Athenaeum Gallery, Boston, 1828, no. 4, which listed P. T. Jackson as the owner of the portrait, then attributed to John Singleton Copley; Swan 1940, 35.

3. The provenance is in a letter dated 19 December 1951 from Patrick Tracy Jackson IV of Cambridge, Massachusetts (NGA). Information on the successive generations of Patrick Tracy Jacksons was provided by the Harvard University Archives and by Helen E. Jackson (Mrs. Patrick Tracy Jackson V).

4. Swan 1940, 35; Perkins and Gavin 1980, 39.

5. MFA 1880 II, 22, no. 266; MFA 1881, 24, as by Copley; MFA 1886, 37, no. 404, as by Copley. Theodore Sizer wrote William P. Campbell on 5 April 1965, "For years the portrait hung in the Museum of Fine Arts, Boston, as a Copley and then as a questioned Copley" (NGA).

6. According to a letter dated 14 December 1989 from Jill Kennedy-Kernohan, MFA registrar's office, the portrait was on loan from 3 June 1910 to 7 December 1911 (NGA).

7. For biographies of Tracy see Currier 1896, 545–550; Putnam 1906, 68–69; Putnam and Putnam 1907, 25; Lee 1916, 193–194; and Lee 1921, 57–60.

8. The "List of Pictures" is in the "Account of Paintings by Jno: Trumbull. Copied from an Early Book which Was Ruined by Damp." The manuscript, in the John Trumbull Papers, Yale University Library, was first published in 1948; see Sizer 1948, 121. The Frick Art Reference Library records that, according to Lawrence Park, cataloguer of the work of Gilbert Stuart, a miniature copy of the head in this painting, signed "A.G.," was in the collection of John T. Morse, Jr., Boston.

9. The only other known life portrait of Tracy is a waist-length oil painted around 1750; see Porter 1937, 1:ix, repro. opp. 274. Although it clearly represents the same man as in Trumbull's portrait, it is not the source of the painting. It is attributed to Joseph Blackburn, but it is probably the work of John Greenwood, to whom the pendant portrait of Tracy's second wife Hannah Gookin, whom he married in 1749, is attributed; see Porter 1937, 1:ix, repro. opp. 260.

10. "List of Pictures done in London 1784," no. 16; Sizer 1948, 121.

11. Evans 1982, 44–45, 231.

12. Boyd 1953, 7:357–358, 362–364, 382.

13. Abigail Adams noted Tracy's presence at Auteuil (France) in September 1784; see *Letters of Mrs. Adams* 1848, 194.

14. Evans 1982, 42, 195; unlocated. The following spring, when the Adamses returned to London, they sat to Brown for more portraits; see Evans 1982, 42–46, 195.

15. Abigail Adams referred to Tracy at Auteuil in December; see *Letters of Mrs. Adams* 1848, 205, 211, 216. Mrs. Adams wrote on 12 December 1784 that Tracy was planning to return to London.

16. Prown 1966, 2:423 and fig. 474 (private collection). Copley had painted Jackson earlier in Boston; see Prown 1966, 1:220–221 and figs. 228 and 251 (private collections). Perhaps because of these portraits, Trumbull's full-length was attributed to Copley in the nineteenth

century; see Tuckerman 1867, 73; and Perkins 1878, 391, where it is also attributed to Joseph Blackburn.

17. Penny 1986, 181–182 and 87, color pl. 19.

18. Waterhouse 1958, 56 and fig. 105; for the suggestion of the connection between Gainsborough's portrait and that by Trumbull see Cooper 1982, 116.

19. Kornhauser 1991, 118–120, no. 12, repro.

20. According to Dr. Joseph Rosewater, curator of mollusks at the National Museum of Natural History, Smithsonian Institution, Trumbull depicted the oysters accurately but took artistic liberties in his rendering of the other shells; notes of a conversation with Rebecca Zurier, August 1982 (NGA).

21. Trumbull to Jonathan Trumbull, Jr., 18 January 1785; Yale University Library, John Trumbull Papers, quoted by Rodriguez Roque 1982, 98.

22. Helen E. Jackson found the notation "Patrick Tracy, painted by John Trumbull. 20 gns. 1786." in a notebook kept by her father-in-law Patrick Tracy Jackson IV (letter of 18 December 1964; NGA). It has been assumed that this notation was copied from the papers of Patrick Tracy, but this has not been verified.

References

1867 Tuckerman: 73.
1878 Perkins: 391.
1896 Currier: 547, repro. 546.
1906 Putnam: x, repro. opp. 68.
1921 Lee: 58.
1948 Sizer: 121, no. 15.
1949 Sizer: 27, fig. 5 opp. 29.
1950 Sizer: 54, fig. 12.
1956 Sizer: 116.
1967 Sizer: 71.
1982 Cooper: 99, 100 (fig. 53, color), 116.

1952.1.1 (1081)

Alexander Hamilton

c. 1792
Oil on canvas, 76.2 × 60.5 (30 × 23 7/8)
Gift of the Avalon Foundation

Technical Notes: The portrait is on a coarse, twill-weave canvas. The light-colored ground appears very dense in x-radiographs. The paint is applied in thin, blended layers, except in the moderately raised highlights and the white cravat of the sitter. No traditional underdrawing is revealed in infrared reflectography, but a black outline for the iris can be seen, which is not visible on the surface. The figure was broadly blocked in, followed by the coat, shirt, and background.

There is moderate abrasion in the lower part of the jacket and in the hair, but little inpainting. The varnish was removed in 1963 and again in 1966, at which time the painting was lined.

Provenance: Oliver Wolcott [1760–1833], Litchfield, Connecticut, and New York;[1] his son John Stoughton Wolcott [1802–1843], New York;[2] sold 1844 by his estate to William Jay [1789–1858], Katonah, New York;[3] his son John Jay II [1817–1894], New York and Katonah, New York;[4] his son William Jay II [1841–1915], New York and Katonah, New York;[5] his daughter Eleanor Jay Iselin [Mrs. Arthur Iselin, 1882–1953]; by gift to her son William Jay Iselin [1908–1951] by 1937;[6] from whose estate purchased 1952 by the Avalon Foundation for the National Gallery of Art.

Exhibited: Metropolitan Opera House 1889, no. 106.[7] *Loan Exhibition of Portraits for the Benefit of the Orthopaedic Dispensary and Hospital*, American Art Galleries, New York, 1903, no. 241.

FEDERALIST LEADER Alexander Hamilton (1755–1804), first secretary of the United States Treasury, was at the height of his public career in 1791 when a group of New York merchants commissioned John Trumbull to paint his full-length portrait. Hamilton had served as secretary and aide-de-camp to General Washington during the Revolutionary War and was one of New York's representatives to the Constitutional Convention of 1787. He was the author of many of the *Federalist Papers*. A trusted adviser to President Washington, he argued for a strong central government and the establishment of a national bank.

In asking him to pose for Trumbull, the merchants, a committee for the New York Chamber of Commerce, wrote Hamilton on 29 December 1791 that they sought to express "the sense they entertain of the important Services you have rendered your Country." The portrait would be placed "in one of our public Buildings." They asked that Hamilton "permit the representation to exhib[it] such part of your Political Life as may be most agreeable to yourself." Hamilton replied on 15 January 1792 from Philadelphia, then the capital of the United States, that he acknowledged the "mark of esteem" of his fellow citizens. "I shall chearfully obey their wish as far as respects the taking of my Portrait; but I ask that they will permit it to appear unconnected with any incident of my political life. The simple representation of their fellow Citizen and friend will best accord with my feelings."[8] Trumbull's life-size full-length (Figure 1) shows Hamilton standing in an interior by a desk, looking off to the left. His right hand rests on a piece of paper on the desk, his left arm is at his side. The portrait was completed by July 1792 and put on display at New York City Hall.[9]

Oliver Wolcott, Hamilton's successor as secretary of the Treasury and later governor of Connecticut (1817–1827), acquired this bust-length ver-

sion of the full-length portrait sometime before 1829, when he wrote his friend Dr. John R. Rhinelander on 12 March that he owned "portraits of Washington, Adams, Jay, Hamilton and Robert Morris, which I value as memorials of great and good men who were my friends."[10] Those of George Washington, John Adams, John Jay, first chief justice of the United States, and Hamilton were head and shoulder portraits by Trumbull. Wolcott and the artist had become friends in the 1790s, and Trumbull painted Wolcott's portrait in 1806. Wolcott could have acquired the portraits at any time. In 1832 Trumbull borrowed the portrait to make a copy for Yale College, describing it as "an original, painted at Washington in 1792, now in possession of Gov. Wolcott."[11] After Wolcott's death they were

Fig. 1. John Trumbull, *Alexander Hamilton*, oil on canvas, 1792, New York, Donaldson, Lufkin, and Jenrette Collection of Americana [photo: The National Portrait Gallery, Smithsonian Institution]

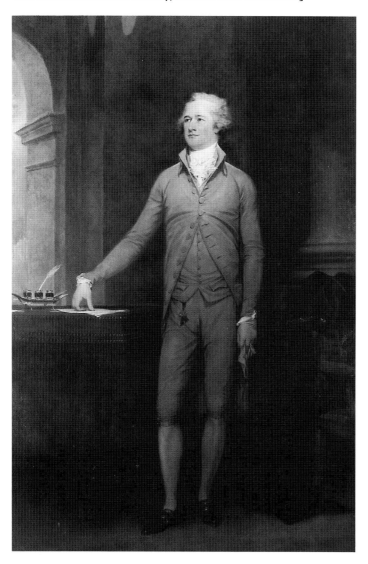

offered in 1844 to the Connecticut Historical Society.[12] "The four portraits are of the size of life as low as the chest. They are in gilded frames, somewhat tarnished by age. The canvas inside the frames is 24 by 30 inches. . . . The paintings are in a state of good preservation." The price was "$120, for the four Portraits."[13] When the society did not buy them, they were acquired by John Jay's son William Jay.

Without knowing the true story of the four paintings, Charles Henry Hart wrote in 1897 that the Gallery's painting of Hamilton, then owned by Jay's descendants, must have been the original from life because of its "character and animation . . . directness and freedom, qualities distinctly lacking in the whole-length picture."[14] Theodore Sizer agreed that it was the original and called it the "Jay Type" because he thought it had been owned by John Jay. He classified similar portraits in The Metropolitan Museum of Art, New York, the Essex Institute, Salem, Massachusetts, and the Yale University Art Gallery as replicas, and catalogued Wolcott's painting as unlocated.[15] Trumbull had called the painting "an original" in 1832. It does not appear, however, to be the study from life. A technical examination revealed none of the changes often found in life portraits, and the body imitates the pose of the full-length, with the right arm gesturing to the side, a compositional feature that is not typical of a bust-length life portrait. The dramatic lighting on the forehead, which Dorinda Evans describes as part of the artist's idealization of the sitter, "presented with the dignity and emotional restraint of the period," is also derived from the full-length.[16] The flowing brushwork and clear, bright colors are typical of Trumbull's work from the 1790s and suggest that it is an early replica.

CJM / EGM

Notes
1. Wolcott owned the portrait by 1829, when he commented on it in his letter of 12 March to Dr. John R. Rhinelander; Oliver Wolcott Papers, Connecticut Historical Society, Hartford. The letter is quoted in Wolcott 1881, 379 (information courtesy of Margaret Christman, NPG).
2. Oliver Wolcott bequeathed to his son John "who resides with me and is the protector of my declining age all my books papers manuscripts pictures and household furniture" in New York and at the farm in Litchfield, with all buildings and "appurtenances thereof including the pictures & furniture in the mansion house"; manuscript copy of his will, 14 July 1832, Gibbs Family Papers, State Historical Society of Wisconsin, Madison. On the Wolcotts see Rudd 1950, 113, and *DAB* 10 (part 2):443–445 (Oliver Wolcott).

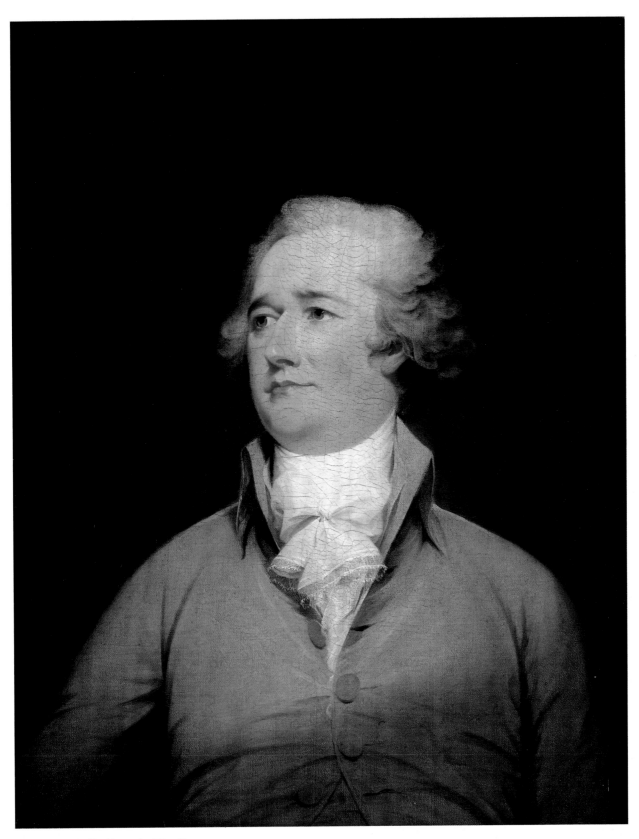

John Trumbull, *Alexander Hamilton*, 1952.1.1

3. After John Stoughton Wolcott's death, George C. Woodruff of Litchfield, Connecticut, offered the portrait to the Connecticut Historical Society. He wrote the secretary of the Society on 15 February 1844 that it and three other portraits "were the property of the late Govr. Wolcott & now belong to the estate of his son Doct. Wolcott decd.... They have been sent me by the Executor Geo. Gibbs Esq. of New York" (Connecticut Historical Society, Hartford; copy, NGA). The Society declined to buy them. William Jay's purchase of the portrait and the others of Washington, Adams, and Jay is recorded in his account book for 1844, according to Linda E. McLean, site manager, John Jay Homestead State Historic Site. Midway during the year he noted that he "acquired four Trumbulls" and listed the names.

4. Bowen 1892, 144.

5. "Col. William Jay" lent the painting to the exhibition at the American Art Galleries in New York in 1903.

6. A letter from Mrs. Iselin to the Atlantic Monthly Press, 29 March 1937, stated that her son owned the portrait (Frick Art Reference Library).

7. Bowen 1892, 144.

8. Gulian Verplanck, Roger Alden, Brockholst Livingston, Joshua Waddington, and Carlile Pollock to Hamilton, 29 December 1791; Hamilton's response, 15 January 1792; Alexander Hamilton Papers, LC, in Syrett 1961, 10 (1966): 482, 515.

9. (New York) *Daily Advertiser*, 4 July 1792, quoted in Cooper 1982, 122, where the full-length portrait is discussed.

10. See n. 1 above.

11. Trumbull 1832, 30, quoted in Cooper 1982, 122 n. 2.

12. See n. 3; Jaffe 1975, 310, under *John Jay*, noted this correspondence but thought the paintings were being offered on behalf of Trumbull's estate, not Wolcott's. She notes that the four portraits were "finally sold to an ancestor of the Iselin family."

13. George C. Woodruff, Litchfield, to Charles Hosmer, recording secretary, Connecticut Historical Society, 13 March 1844; Connecticut Historical Society, Hartford (copy, NGA). The four portraits, owned by Jay's descendants for many years, are now separated. Those of Washington and Adams were sold at auction in 1986; that of Adams is now owned by the White House Historical Association, Washington. That of Jay remained at the John Jay Homestead State Historic Site (New York State Office of Parks, Recreation, and Historic Preservation); see Sizer 1967, 18, 45, 83; Jaffe 1975, 308–310; and *Jay Family* 1986, lots 234 and 235.

14. Hart 1897, 510.

15. Sizer 1967, 36–37.

16. Evans 1993, 133.

References

1892 Bowen: 144, 469, repro. opp. 26.
1897 Hart: 507, 510, repro.
1931 Bolton and Binsse, "Trumbull": 54.
1948 Sizer II: 266.
1950 Sizer: 28.
1955 Bland and Northcutt: 191.
1956 Sizer: 115.
1966 Cairns and Walker: 1:390, color repro. 391.
1967 Sizer: 36 and fig. 22.
1975 Jaffe: 208, 309, fig. 146.
1982 Cooper: 122.

1947.17.13 (921)

William Rogers

1804/1808
Oil on canvas, 77.5 × 63.5 (30 ½ × 25)
Andrew W. Mellon Collection

Technical Notes: The support is a medium-weight, somewhat coarsely woven twill-weave fabric. The tacking edges have been partially trimmed, leaving a border that was then flattened. This border extends the picture's height by 1.3 cm to 77.5 cm and its width by a smaller amount.

A white ground layer of average thickness extends beyond the paint surface and covers the residual tacking edges. The paint is applied evenly in thin, semi-opaque layers with fluid strokes. Beyond slightly textured strokes in the details and highlights of the sitter's cravat and face, there is no impasto.

The painting is finely abraded overall. The twill-weave pattern is quite prominent and may have been emphasized by a past lining. The varnish was removed in 1970. The present varnish is considerably discolored.

Provenance: The sitter's adopted daughter Anne Béloste Taylor [Mrs. James Taylor, d. 1832], Albany, New York;[1] her daughter Maria Taylor Hunt [Mrs. Ward Hunt, d. 1912], Utica, New York;[2] her nephew Maunsell Van Rensselaer [1859–1952] and his wife Isabella Mason Van Rensselaer [1861–1955], Albany and Huntington, New York;[3] (D.B. Butler & Co., New York); sold 16 April 1921 to Thomas B. Clarke [1848–1931], New York;[4] his estate; sold as part of the Clarke collection on 29 January 1936, through (M. Knoedler & Co., New York), to The A.W. Mellon Educational and Charitable Trust, Pittsburgh.

Exhibited: Union League Club, February 1922, no. 14. *A Loan Exhibition of Paintings by Early American Portrait Painters*, Century Association, New York, 1926, no. 2. Philadelphia 1928, unnumbered. *Early American Portraits on Loan From the National Gallery of Art, Washington, D.C.*, Pack Memorial Public Library, Asheville, North Carolina, 1949, no. 7. Hagerstown 1955, no cat. *John Trumbull, Painter-Patriot*, Wadsworth Atheneum, Hartford, 1956, no. 91. *Faces of America*, El Paso Museum of Art, 1960–1961, no cat. *Inaugural Exhibition: American Portraits*, The Art Museum, Duke University, Durham, North Carolina, 1969, no cat. Kentucky 1970, unnumbered. National Society of the Colonial Dames of America at Dumbarton House, Washington, on long-term loan, 1974–1990.

ON HIS RETURN to New York City in 1804, Trumbull again took up portrait painting. His sitters in-

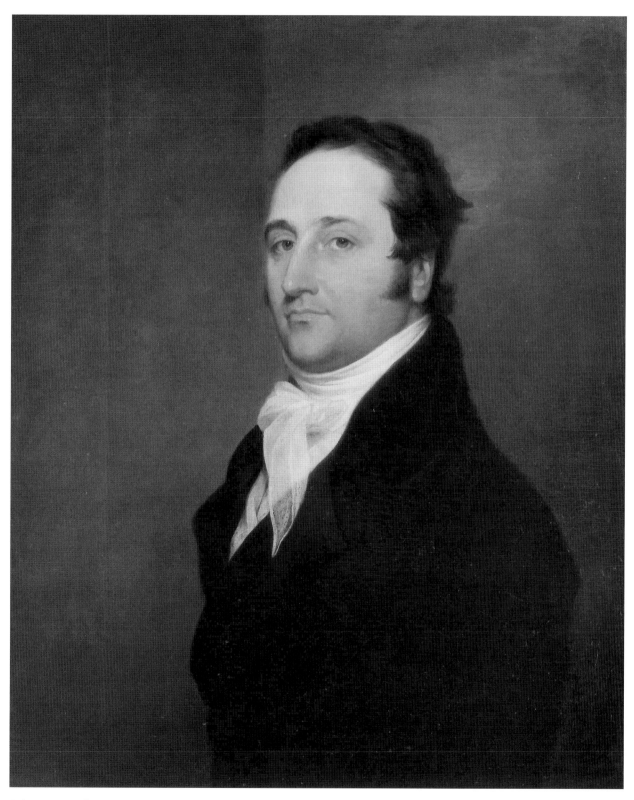

John Trumbull, *William Rogers*, 1947.17.13

cluded William Rogers (c. 1760–1817), a New York City merchant with family and business ties to the West Indies. Rogers married Anne Markoe Cruger, the widow of Nicholas Cruger, in 1801. In city directories for 1801 through 1811 he is listed on Wall Street and later on Broadway. In 1811 he purchased a country home north of the city, near the Hudson River. Rogers was one of the founders of the nearby St. Michael's Church, located at 99th Street and Amsterdam Avenue.[5]

Rogers' firm posture and slight smile convey an air of imperious reserve. Wearing a black coat with a velvet collar, and a white shirt, stock, and cravat, he is turned to the side so his right shoulder is not seen. His robust facial coloring, with red in his cheeks and on his lips, contrasts with his dark hair and dark coat. The brown of the background is varied slightly, with lighter tones above and to the right of his head. The portrait is typical of Trumbull's style at this time, especially in its use of black and in the general stiffness of the figure.[6]

CJM

Notes

1. Isabella Van Rensselaer, affidavit for D.B. Butler & Co., New York, 17 February 1921 (NGA), and letter, 3 June 1949 (NGA). The date of Mrs. Taylor's death is found in "Gravestone Records" 1928, 161.

2. Tuckerman (1867) and Weir (1901) list Ward Hunt, rather than his wife, as the owner of the portrait. This is not unusual; mid-nineteenth-century authors often listed the husbands as the owners of family portraits that undoubtedly came from their wives' families. Only two "family portraits" are listed in the inventory of Mrs. Hunt's estate that is appended to her will (Surrogate's Court, Oneida County, New York; copy, NGA). These were probably the portraits of Lawrence Yates and his wife Matilda Cruger; see 1942.8.13, *Matilda Caroline Cruger* by an unidentified painter. The painting of Rogers could be one of the "7 pictures with frames" in the same inventory.

3. Isabella Van Rensselaer, letter dated 3 June 1949 (NGA). The life dates of the Van Rensselaers were provided by the Albany Cemetery Association, Albany Rural Cemetery, Albany, New York, letter of 5 December 1989 (NGA).

4. The name of the seller and the date of purchase are recorded in an annotated copy of *Clarke* 1928 in the NGA library. The date of Mrs. Van Rensselaer's affidavit (see n. 1) suggests that she and her husband either consigned or sold the portrait to Butler immediately prior to its sale to Thomas B. Clarke.

5. For biographical details see the sitter's obituary in the (New York) *Commercial Advertiser*, 27 December 1817, unpaginated, which states that he died "in the 57th year of his age," and Sherman 1922, 259.

6. See Rodriquez Roque 1982, 103.

References

1867	Tuckerman: 94, 628.
1901	Weir: 79.
1922	Sherman, "Trumbull": 259, repro. 260.
1931	Bolton and Binsse, "Trumbull": 56.
1949	Sizer: 25.
1950	Sizer: 47.
1967	Sizer: 62.

1940.1.8 (494)

Alexander Hamilton

c. 1806
Oil on canvas, 77.0 × 61.0 (30 1/4 × 24 1/4)
Andrew W. Mellon Collection

Technical Notes: The coarse, heavy-weight, plain-weave fabric has been glued to a 0.6-cm thick plywood panel. There is cusping in the fabric along all four edges. X-radiography reveals a thin white ground that lacks density. Onto the ground a thin, transparent, reddish brown imprimatura was applied. There may be a darker imprimatura beneath the face. The paint is applied fluidly, ranging from thin in the shadows to moderate impasto in the highlights. The figure is broadly brushed, with more tightly controlled strokes in the tie. The face is well blended.

Two large tears are in the upper left and upper right. There is retouching in these areas and above the head, as well as to the left of the tip of the scarf.

Provenance: Probably from David Hosack [1769–1835], New York, to his son Nathaniel Pendleton Hosack [1806–1877], New York; his widow Sophia Church Hosack [d. 1891].[1] Her niece Mary Helen Church Gilpin;[2] by whom sold by (Stanislaus V. Henkels, Philadelphia, 15 May 1931, lot B, as by John Vanderlyn);[3] purchased by (M. Knoedler & Co., New York); sold 1 June 1931, to Andrew W. Mellon;[4] deeded 28 December 1934 to The A.W. Mellon Educational and Charitable Trust, Pittsburgh.

Exhibited: *George Washington Bicentennial Historical Loan Exhibition of Portraits of George Washington and his Associates*, CGA, 1932, no. 88. United States Constitution Sesquicentennial Commission, *Loan Exhibition of Portraits of the Signers and Deputies to the Convention of 1787 and Signers of the Declaration of Independence*, CGA, 1937–1938, no. 6. *Thomas Jefferson Bicentennial Exhibition, 1743–1943*, NGA, 1943, no. 22. Triennial Meeting of the Society of the Cincinnati, Washington, 1947, no cat. *American Heritage*, Denver Art Museum, 1948, no. 7. *From Colony to Nation: An Exhibition of American Painting, Silver and Architecture From 1650 to the War of 1812*, Art Institute of Chicago, 1949, no. 122. *From Plymouth Rock to the Armory*, The Society of the Four Arts, Palm Beach, Florida, 1950, no. 20. Columbia 1950, no. 20. NGA 1950, no. 4. *They Gave Us Freedom*, Colonial Williamsburg and the College of

William and Mary, Williamsburg, Virginia, 1951, no. 63. Atlanta 1951, no. 17. Chattanooga 1952, unnumbered. Mint Museum of Art, Charlotte, North Carolina, 1952, no cat. Randolph-Macon Woman's College, Lynchburg, Virginia, 1952-1953, no cat.[5] *Alexander Hamilton Bicentennial Exhibition*, United States Department of the Treasury, Washington, 1957, no cat.[6] *Paintings by American Masters*, Art Center, Kalamazoo Institute of Arts, Michigan, 1966, unnumbered. San Diego International Philatelic Exhibition, Fine Arts Gallery of San Diego, 1969, no cat.[7] *The Face of Liberty*, Amon Carter Museum, Fort Worth, 1975–1976, 142, pl. 38. *The American Solution: The Origins of the United States Constitution*, LC, 1987, no cat.[8]

ON 4 JULY 1804, a week before Alexander Hamilton's fatal duel with Aaron Burr, John Trumbull saw both men at a dinner of the Society of the Cincinnati in New York City. He wondered at their strange conduct, recalling many years later in his autobiography, "The singularity of their manner was observed by all, but few had any suspicion of the cause. Burr, contrary to his wont, was silent, gloomy, sour; while Hamilton entered with glee into all the gaiety of a convivial party, and even sung an old military song."[9] The death of Hamilton on 12 July of gunshot wounds received in the duel stunned his friends and admirers. On 29 November the New York City Council commissioned Trumbull to paint his full-length portrait for City Hall (Figure 1).

The portrait, which was finished in 1805, conveys a grandeur like the full-length of Hamilton that Trumbull painted from life in 1792 for the New York Chamber of Commerce (see 1952.1.1).[10] Trumbull based the likeness on Italian sculptor Giuseppe Ceracchi's bust of 1791 (Figure 2).[11] Trumbull converted Ceracchi's monochrome marble into a portrait with strong contrasts of light and dark. The National Gallery's painting is a replica of the head and shoulders, executed by the artist at about the same time. In the replica Hamilton wears a dark brown, almost black coat, a white stock, and a white cravat, with his powdered hair tied in a queue. The three-quarter view of the head, taken from slightly below, accentuates his deep-set eyes and long nose. To enliven the portrait, Trumbull added highlights of moisture to the eyes and used touches of reddish pink on the lips and in the shadows of the nostrils, ear lobes, and inner corners of the eyes. The treatment of the jacket is flat and summary, the brushwork broad and the paint layer thin. The sitter's right arm is held upward in a gesture that derives from the full-length.

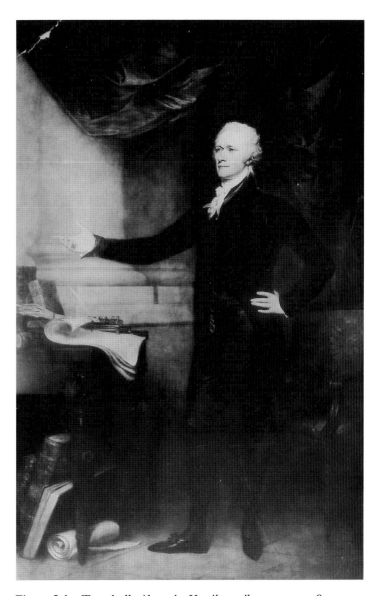

Fig. 1. John Trumbull, *Alexander Hamilton*, oil on canvas, 1805, City Hall, Governor's Room, New York, Collection of the City of New York

Trumbull made at least seven such replicas.[12] In 1806 he recorded payments for two of $100 each—his usual price for a "head alone"—from Bostonians Isaac P. Davis and S.S. Perkins.[13] Other replicas are less firmly documented, including the Gallery's example, whose provenance indicates that it was owned by Dr. David Hosack, the surgeon who attended Hamilton on the day of the duel and declared him dead the next day.[14] Although this version is similar to the 1806 replicas, there are subtle differences. The highlights and shadows of the face and wig are softer, and the contrasts less extreme. Hamilton's coat collar has almost no white powder along the hairline, and the tie on his queue

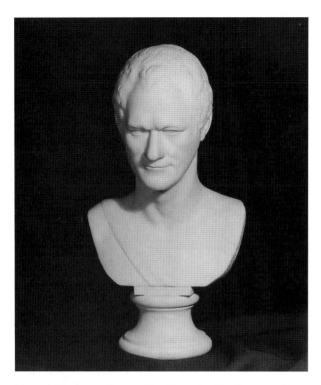

Fig. 2. Giuseppe Ceracchi, *Alexander Hamilton*, marble, c. 1794, Washington, The National Portrait Gallery, Smithsonian Institution

is in a lower position. In addition, there is no vertical line to designate a wall behind the figure to the right.

Since Trumbull had a long association with Hosack at the American Academy of the Fine Arts, of which Hosack was an incorporator, he could have painted a replica for him at any time.[15] Trumbull was elected to the academy's board of directors in July 1805. He painted Hosack's portrait in 1806 (Society of the New York Hospital), listing receipt of payment "from Dr. Hosack for a portrait $140" in his account book for 15 November.[16] By the 1830s Hosack owned a number of works by Trumbull, including landscapes, copies of old master paintings, and portraits.[17] After Hosack's death in 1835, Trumbull mourned him as "the oldest & best friend I had in the City [New York]."[18]

CJM / EGM

Notes

1. Sophia Hosack is the first recorded owner of the portrait (Durand 1881, 230, note). David Hosack died without a will; the inventory of his estate (misc. mss. Hosack, NYHS) included twenty-two "Oil Paintings in Gilt Frames" as well as "1 Marble Bust and stand (General Hamilton)." Family tradition stated that the portrait was painted for Hosack and was inherited by his son Nathaniel, who bequeathed it to his sister Mary Hosack Harvey (Mrs. Jacob Harvey, 1800–1872), who gave it to her sister-in-law; see Henkels 1931, 12, lot B, repro. Since Mrs. Harvey predeceased her brother, her ownership is uncertain. On the Hosack family descendants see Robbins 1964, 188–194, 198.

2. Henkels 1931, 12, stated that Sophia Hosack willed the portrait to her brother Richard Church, who in turn left it to his daughter. However, in her will (Surrogate's Court, New York, New York; copy, NGA) Mrs. Hosack bequeathed the articles that her husband received from his father to her sister-in-law Emily Hosack Rodgers and two nieces, Mary Harvey and Rebecca Harvey. Her brother is not mentioned. His daughters Mary Helen and Angelica were each bequeathed trust funds. The will mentions a memorandum distributing other property, which may have included the portrait. The will is discussed in Robbins 1964, 190, 192.

3. According to a letter from Stan Henkels to M. Knoedler & Co., 11 May 1931 (copy, NGA), research completed after the publication of the auction catalogue established that the painting was by Trumbull.

4. Letter from Melissa De Medeiros, librarian, M. Knoedler & Co., New York, 10 April 1990 (NGA).

5. Campbell 1953, 7.

6. The exhibition is described in *Final Report* 1958, 40–42.

7. A letter from Marvin E. Petersen, curator of Western art, Fine Arts Gallery of San Diego, 28 January 1971 (NGA), included the exhibition's press release and a checklist of loans.

8. The painting was not included in the publication issued in conjunction with the exhibition, but it is found in the checklist of the exhibition, filed with the Department of Exhibits, LC.

9. Sizer 1953, 237–238.

10. Jaffe 1975, 208, 210, fig. 147; *Minutes of the Common Council* 3, 636, quoted in Syrett 1961, 26 (1979): 317, n. 1. The bill, dated April 1805, was for $500.

11. Ceracchi modeled Hamilton's portrait from life in 1791 in terra cotta and presented him with a version in marble as a gift. He later demanded payment, and Hamilton wrote that he paid the sculptor $620 "through *delicacy* . . . for making my bust on his own opportunity" (Syrett 1961, 18 [1973]: 504, n. 6).

12. Sizer 1967, 37–38.

13. Davis' painting is unlocated today; Perkins' is in the MFA; see Sizer 1967, 37–38, and MFA 1969, 1:272. A third Massachusetts-owned replica (NPG) belonged to Senator George Cabot (1752–1823). An engraving of one of these portraits was published in Boston on 31 August 1806 by Robert Field (NPG). For Trumbull's prices see his letter to Joseph Elgar, 10 December 1828 (The Huntington Library, Art Collections, and Botanical Gardens, San Marino, California), quoted in Sizer 1967, 139.

14. Hosack described Hamilton's death to William Coleman in his letter of 17 August 1804; Syrett 1961–1987, 26 (1979): 344–347.

15. On Hosack see *NCAB* 1899, 9:354–355, and *DAB* 5:239–240; for his role at the Academy see Jaffe 1974,

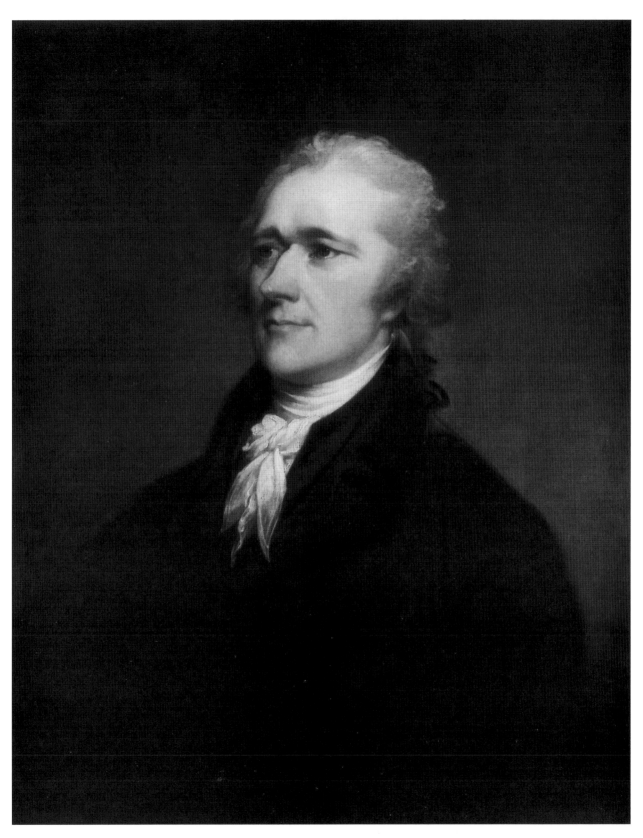

John Trumbull, *Alexander Hamilton*, 1940.1.8

207–208, 215, 264, 274, and Rebora 1990, 1:57–101.

16. Sizer 1967, 42; the account book is in the John Trumbull Papers, Yale University Library.

17. Dunlap 1834, 2:462.

18. Trumbull, New York, 26 December 1835, to Benjamin Silliman, John Trumbull Papers, Yale University Library.

References

1881 Durand: 230 note.
1901 Weir: 75.
1931 Bolton and Binsse, "Trumbull": 54, repro. 18.
1948 Sizer II: 266.
1950 Sizer: 29.
1967 Sizer: 37–38.

Adolph-Ulrich Wertmüller

1751 – 1811

BORN IN STOCKHOLM, Adolph-Ulrich Wertmüller studied painting there and in Paris. With the help of his cousin, portraitist Alexandre Roslin, he became a student of academic painter Joseph Marie Vien. In 1775 Wertmüller accompanied Vien to Rome when Vien became director of the French Academy there. After painting in Rome and in Lyon, he returned to Paris, where he worked as a portrait painter and copyist. He became a member of the Royal Academy of Arts in 1784; his portrait of French sculptor Jean-Jacques Caffieri (1784, MFA) was one of his reception pieces on election. Wertmüller also painted mythological subjects, including the tale of the nude Greek nymph *Danaë Receiving the Shower of Gold* (1787, National Museum, Stockholm). Unable to find portrait commissions in Paris, he worked in Bordeaux and, after the beginning of the French Revolution, in Madrid and Cadiz.

Wertmüller came to the United States in 1794 and settled in Philadelphia, where he painted a number of portraits, including several of George Washington. He returned to Europe in 1796 to settle his personal and financial affairs and sailed once more to the United States four years later, bringing his collection of his own work. He married Betsey Henderson, granddaughter of Swedish painter Gustavus Hesselius, and in 1802 he became an American citizen. Wertmüller gave up his painting career almost entirely and purchased a farm in Delaware, describing farming life in detail in his "Journal de la Terre situé à Naaman's Creek."[1] There he permitted visitors to see his paintings, especially the *Danaë*, for which he charged admission. Charles Willson Peale advised architect Benjamin Henry Latrobe to visit Wertmüller and see the painting. "Such subjects may be good to shew Artists talents, but in my opinion not very proper for public exhibition — I like no art which can raise a blush on a lady's cheek."[2] When the painting later went on public exhibition, it shocked many viewers.

Wertmüller's American work is rare. In addition to the portraits he made in Philadelphia, he painted in New York and Annapolis. Throughout his career he kept a careful account of his paintings in several manuscripts: "Notte de tous mes ouvrages ... pour les années 1780–1801";[3] "Liste de mes ouvrages que je me suis offert à peindre pour des amis et connaissances et desquels je n'ai accepté aucun payement" (1779–1788);[4] and "Livre de Caisse" (1801–1811).[5]

EGM

Notes

1. Royal Library of Stockholm; Scott 1963, 33–173.
2. Miller 1983, 3:834, letter dated 13 May 1805.
3. Royal Library of Stockholm; Benisovich 1956, 47–63.
4. Copy, PAFA; Benisovich 1963, 21–23.
5. PAFA; Benisovich 1963, 20–21.

Bibliography

Benisovich 1953: 20–39.
Benisovich 1956: 35–68.
Benisovich 1963: 7–30.
Scott 1963.

Attributed to Adolph-Ulrich Wertmüller

1954.1.4 (1188)

Portrait of a Quaker

1795
Oil on canvas, 71.2 × 56.1 (28 1/16 × 22 1/8)
Andrew W. Mellon Collection

Technical Notes: The painting is on a heavy-weight fabric, which exhibits cusping on all four edges. The colors are applied in a fluid manner with little use of impasto. X-radiography reveals slight changes in the sitter's hairline: a widow's peak in the center of the sitter's forehead has been smoothed out and the curve between the hair and face along the left brow and cheek has been accentuated. Another change occurs in the dark coat collar on the left, which has been painted over a white stock.

The flattened impasto may be the result of a past lining procedure. The thickly applied varnish is discolored, and hides slightly discolored minor retouches that are scattered throughout. The painting was lined in 1930. Glued to the stretcher crossbar is a photograph of an inscription that is said to be on the back of the original canvas, now hidden by the lining fabric. It reads: "General William Shepard / R. Earl Pinxt 1788."

Provenance: (Rose M. de Forest [Mrs. Augustus de Forest], New York); purchased 1930 by Thomas B. Clarke [1848–1931], New York;[1] his estate; sold as part of the Clarke collection on 29 January 1936, through (M. Knoedler & Co., New York), to The A.W. Mellon Educational and Charitable Trust, Pittsburgh.

THIS PAINTING was sold in 1930 to Thomas Clarke as a portrait of General William Shepard by Ralph Earl, painted in 1788. An inscription reading "General William Shepard / R. Earl Pinxt 1788" was said to be on the reverse of the original canvas, purportedly covered by the lining during the 1930 restoration by Beers Brothers, Inc., New York. A photograph of the inscription, given to the purchaser, is now attached to the stretcher. Information supplied at the sale included a biography of the supposed sitter, William Shepard (1737–1817), who was a general at the time of the American Revolution, and a provenance in the Wetmore family, beginning with the sitter's daughter Nancy Shepard Wetmore. After the portrait came to the National Gallery, research revealed that the provenance was false.[2] The attribution to Earl was rejected by many experts on American painting. The inscription became suspect, as did the identification of the sitter

and the assumption that the portrait was American. This led to a change in identification to *Portrait of a Man*, c. 1790, and an attribution to an anonymous eighteenth-century artist of unknown nationality.[3]

The portrait, with its precise manner and the rosy coloring in the face, can be attributed to Swedish painter Adolph-Ulrich Wertmüller, who lived in the United States from 1794 to 1796 and from 1800 until his death in 1811.[4] The treatment of highlights and soft shadows in the face, the careful outlining of eyes and mouth, and the slight backward tilt of the body are typical of his portraits. The composition and treatment is similar to his American portraits of George Washington, painted in 1795 for Théophile Cazenove (MMA; approximately 68.6 by 53.3 cm [27 by 21 inches])[5] and James Asheton Bayard (1807, private collection; 67.3 by 54 cm [26 1/2 by 21 1/4 inches]),[6] as well as his copy of a portrait of William Hamilton, who lived from 1676 to 1741 (1809, Historical Society of Pennsylvania; 72.4 by 58.4 cm [28 1/2 by 23 inches]).[7] Most of his American works, however, were small, oval portraits on wood, such as those of Robert Lea (1795, CGA; 25.4 by 21.3 cm [10 by 8 3/8 inches]) and Mrs. John Hesselius (1796, The Baltimore Museum of Art; 16.2 by 13.5 cm [6 3/8 by 5 5/16 inches]).[8]

This portrait seems to be the one described in the artist's "Notte de tous mes ouvrages" in an entry dated 24 January 1795: "Fini une copie d'un *Quaker* avec une main enfoncée dans la veste. Toile de 20, quaré" (finished a copy of a Quaker with one hand in his waistcoat, on a rectangular canvas size 20). He was paid for the portrait on 16 February, noting the amount in three currencies: "Reçu pour la copie d'un *Quaker*, p. 70, la somme de vingt cinq guinées font: 116.2/3 piastres 583 livres 6s 4d."[9] The canvas, "toile de 20, quaré," was a standard French size that measured 72.9 by 59.4 cm (about 28 by 22 inches).[10] Wertmüller used this size canvas in Bordeaux in 1788–1790, also for portraits "avec une main."[11] This copy is the only American painting for which he used this size canvas. This indicates that he chose canvases according to the amount of figure to be depicted. The next larger size would have been a "25," measuring 81 by 64.8 cm (32 by 25 1/2 inches). The smaller size was a "15," measuring 66.8 by 54 cm (26 1/4 by 21 1/4 inches). By con-

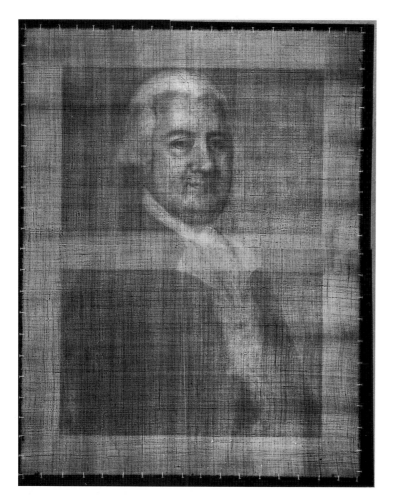

Fig. 1. X-radiograph of 1954.1.4

Fig. 2. Infrared reflectogram composite of coat and waistcoat, 1954.1.4 [1.2–2.0 microns (μm)]

trast, most artists working in the United States used canvases prepared in England, and their head and shoulder portraits measure 76.2 by 63.5 cm (30 by 25 inches). Since this canvas shows no signs of having been cut down, its present dimensions, about 71 by 56 cm (about 28 by 22 inches), can be assumed to be original.

The sitter wears a dark green or black coat with a standing collar and large round metal plate buttons, a pale yellow waistcoat with a standing collar, and a shirt with a pleated front and a starched white linen stock. The style of his clothing is somewhat conservative for the date of the painting, since the stock, pleated shirt ruffle, and large coat buttons are typical of men's clothing of the late 1780s to early 1790s. Wertmüller apparently changed the clothing from an earlier style. As revealed by x-radiography (Figure 1), the present coat and vest collars are

painted over a white stock that continues to the left around the sitter's neck. An infrared reflectogram (Figure 2) reveals that under the present coat and waistcoat are found a collarless coat and waistcoat with patterned buttons. The outlines of the top of the coat or waistcoat and two sizes of buttons are visible to the right of, and above, the present buttons, having been covered when the present vest and shirt were painted. The style of the earlier clothing dates to the 1760s or 1770s. The original from which the copy was made has not been identified.

EGM

Notes
1. The name of the seller is recorded in the back of an annotated copy of *Clarke* 1928 in the NGA library and in documents in the NGA curatorial file, which give the date of the purchase.

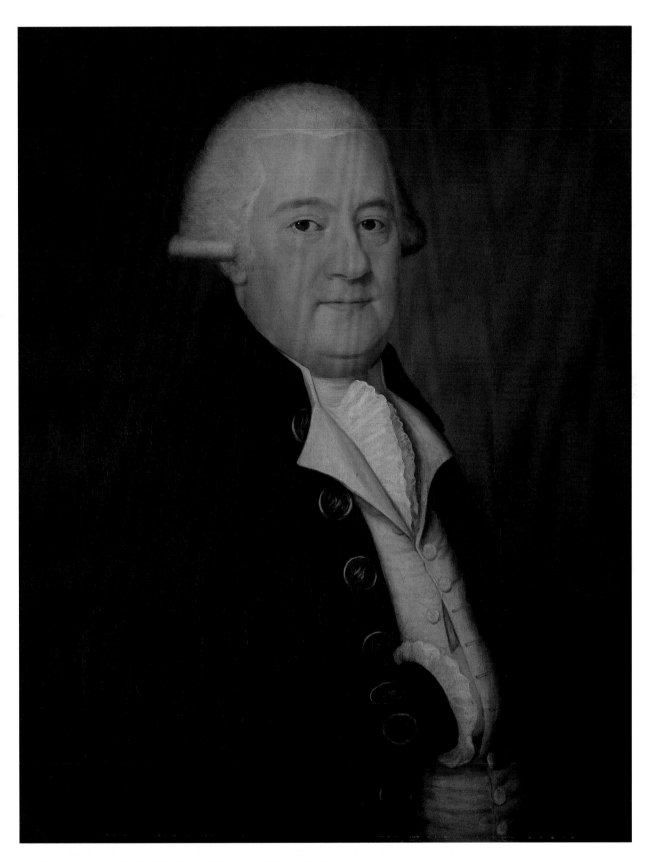

Attributed to Adolph-Ulrich Wertmüller, *Portrait of a Quaker*, 1954.1.4

2. The provenance from Mrs. Wetmore (d. 1802) to descendant William Boerum Wetmore (b. 1851) was shown to be false through research conducted by James W. Lane and others (NGA). A second painting said to represent General Shepard, attributed to Gilbert Stuart and with the same spurious provenance, was privately owned in 1950; its identity and attribution were also questioned (see NGA).

3. Minutes of the NGA Acquisitions Committee meeting, 6 May 1964.

4. The attribution was proposed by Marianne Uggla of the Royal Treasury, Stockholm, based on a black and white photograph and a description of the portrait's size, technique, and coloring (letter of 26 January 1990; NGA). The acknowledged expert on Wertmüller's work, she died the following year.

5. The painting was finished 18 March 1795; see Gardner and Feld 1965, 75–77, and Benisovich 1956, 59. Wertmüller described it as a "toile de 15 quaré."

6. *Delaware* 1951, 18, repro. 119; the portrait is listed in Wertmüller's "Livre de Caisse" (PAFA): "January 1808. Received from *Mr. Bayard* for his portrait finished in November. doll. 100" (Benisovich 1963, 21).

7. "Livre de Caisse," PAFA: 6 October 1809, "Re-ceived from *William Hamilton* for a bust portrait of his grandfather. doll. 100" (Benisovich 1963, 21).

8. Wertmüller described her portrait as "sur bois de 5 pouces sur 6, ovale"; the dimensions for Lea's are not listed; Benisovich 1956, 59–60.

9. Benisovich 1956, 59.

10. For standardized French canvas sizes see Bomford 1990, 44–45. The metric dimensions are those advertised in the nineteenth century. The number denoting the size "originally indicated the price of the canvas in *sous* in the pre-Revolutionary period." They "seem to date back at least to the mid-eighteenth century" and can be found in Pernety 1757, where they are given in feet and inches rather than centimeters; see "toile," 534–535.

11. Letter from Marianne Uggla, 23 May 1991 (NGA); some of these portraits are discussed in Lundberg 1970 and *Bordeaux* 1989, 335–352.

References

1956 Benisovich: 59.
1970 NGA: Washington: 162, repro. 163, as unknown artist, *Portrait of a Man*.
1980 NGA: Washington: 307, as unknown artist, *Portrait of a Man*.

Benjamin West

1738 – 1820

BORN in the American colonies, Benjamin West became one of the most prominent artists of late eighteenth-century London. President of the Royal Academy of Arts almost every year from 1792 until his death, he received many commissions from George III and other English patrons and at the same time served as teacher and advisor to three generations of American artists. West was born in Springfield, Pennsylvania, near Philadelphia. His earliest paintings were portraits of two children, Robert and Jane Morris (c. 1752, Chester County Historical Society, West Chester, Pennsylvania). His early work was influenced by that of John Wollaston, Robert Feke, John Valentine Haidt, and William Williams. His exceptional talent was quickly recognized, and he painted portraits in eastern Pennsylvania and briefly in New York City before going to Italy in 1760 to study painting. After three years, which he spent primarily in Rome, Florence, and Venice, he settled in London.

West was a painter of historical and religious subjects and, as patronage required, a portrait painter. The first works he exhibited in London, at the Society of Artists in 1764, were of subjects from Renaissance literature—*Cymon and Iphigenia* (1763, unlocated) and *Angelica and Medoro* (c. 1763–1764, University Art Gallery, State University of New York at Binghamton)—and a full-length portrait of General Robert Monckton (Trustees of Lady Galway's Chattels Settlement, England). Within the next few years he painted several classical subjects, including *Agrippina Landing at Brundisium with the Ashes of Germanicus* (1768, YUAG), which was commissioned by Robert Hay Drummond, Archbishop of York, and exhibited at the Society of Artists in 1768. George III then commissioned *The Departure of Regulus from Rome* (1769, Her Majesty Queen Elizabeth II), marking the beginning of royal patronage of West, who painted some sixty pictures for the king between then and 1801.

West is best known for his influential history

painting *The Death of General Wolfe* (1770, National Gallery of Canada, Ottawa), which he exhibited at the Royal Academy of Arts in 1771. The painting, a milestone in English and American art, was the first major depiction of a contemporary event whose figures were dressed in modern, rather than classical, clothing. Its subject was the heroic death of an English general in a major battle against the French in Canada. Two subsequent paintings with American subjects were *Penn's Treaty with the Indians* (1771–1772, PAFA) and the unfinished *Signing of the Preliminary Treaty of Peace in 1782* (1783–1784, The Henry Francis du Pont Winterthur Museum, Delaware).

In the 1770s West's subject matter began to include the religious themes that dominated his work of the late 1770s and 1780s. Most notable were his paintings of the Progress of Revealed Religion for the Royal Chapel and designs for stained glass for St. George's Chapel, both at Windsor Castle. Other commissions for Windsor included family portraits and eight English history paintings for the Audience Chamber. After George III withdrew his support of West in the 1790s, William Beckford, who commissioned religious paintings and portraits for his Gothic Revival country house, Fonthill Abbey, became an important patron.

During most of his career West painted complex multifigure compositions and employed sophisticated techniques that differed dramatically from the painting methods he had learned in Pennsylvania. The extraordinary stylistic and compositional differences between West's American and English work are largely due to his three years of study in Italy, when he absorbed the painting styles and compositions of Italian Renaissance and baroque painters, as well as those of his contemporaries. Later, as West became a pivotal figure in educating American-born artists in England, this knowledge in turn transformed the work of his pupils. Americans who studied with West before and during the Revolution included Matthew Pratt, Charles Willson Peale, and Gilbert Stuart. Among his students in the 1780s were Ralph Earl and John Trumbull. These and later Americans, including Washington Allston and Thomas Sully, brought West's ideas and techniques back to the United States, providing a foundation for the growth of the arts

in America in the Federal period and creating a late eighteenth- and early-nineteenth century American style of considerable sophistication.

EGM

Bibliography
Sawitzky 1938: 433–462.
Evans 1980.
Abrams 1982: 243–257.
Von Erffa and Staley 1986.
West 1989.

1964.23.7 (1939)

Dr. Samuel Boude

1755/1756
Oil on canvas, 90.4 × 76.5 (35 5/8 × 30 1/8)
Gift of Edgar William and Bernice Chrysler Garbisch

Technical Notes: The painting is on a medium-weight, plain-weave fabric. The original tacking margins are visible. Pronounced cusping is found along all four edges of the fabric. The thinly applied ground is light brown. The paint is thinly applied without impasto. X-radiography reveals old fold lines that suggest the painting was once on a smaller stretcher. X-radiography also reveals that the sitter's wig has been reduced in size.

Nearly the entire painting has been overpainted to mask the badly abraded paint layer.[1] The eyes have been punched in, and there are losses in the sitter's right shoulder. The varnish was removed in 1955; the present varnish is discolored.

Provenance: The sitter's descendant Elizabeth F.G. Heistand [Mrs. Henry S. Heistand, b. 1872], Marietta, Pennsylvania;[2] sold December 1947 to (M. Knoedler & Co., New York); bought that same month by Edgar William and Bernice Chrysler Garbisch.[3]

Exhibited: *Loan Exhibition of Historical and Contemporary Portraits Illustrating the Evolution of Portraiture in Lancaster County, Pennsylvania*, The Iris Club and the Historical Society of Lancaster County, Lancaster, Pennsylvania, 1912, no. 24. *American Paintings of the 18th & Early 19th Century in Our Current Collection*, M. Knoedler & Co., New York, 1948, no. 10a. *American Primitive Paintings from the Collection of Edgar William and Bernice Chrysler Garbisch*, NGA, 1957, 12. *American Primitive Painting*, Springfield Art Museum, Missouri, 1958, no cat. *John Singleton Copley 1738–1815, Gilbert Stuart 1755–1828, Benjamin West 1738–1820 in America & England*, MFA, 1976, no. 2.

BENJAMIN WEST painted portraits of Dr. Samuel Boude and his wife [1964.23.8] in Lancaster, Pennsylvania, on his first painting trip in 1755–1756,

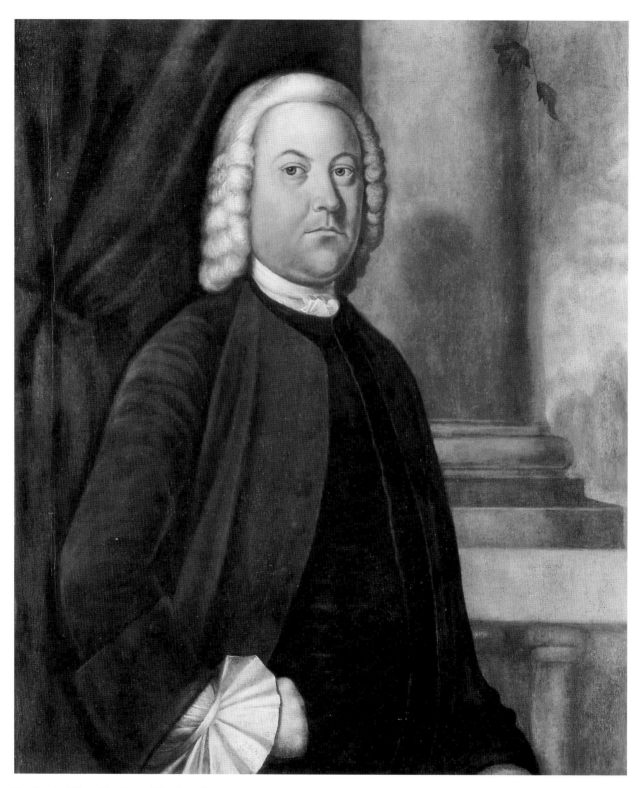

Benjamin West, *Dr. Samuel Boude*, 1964.23.7

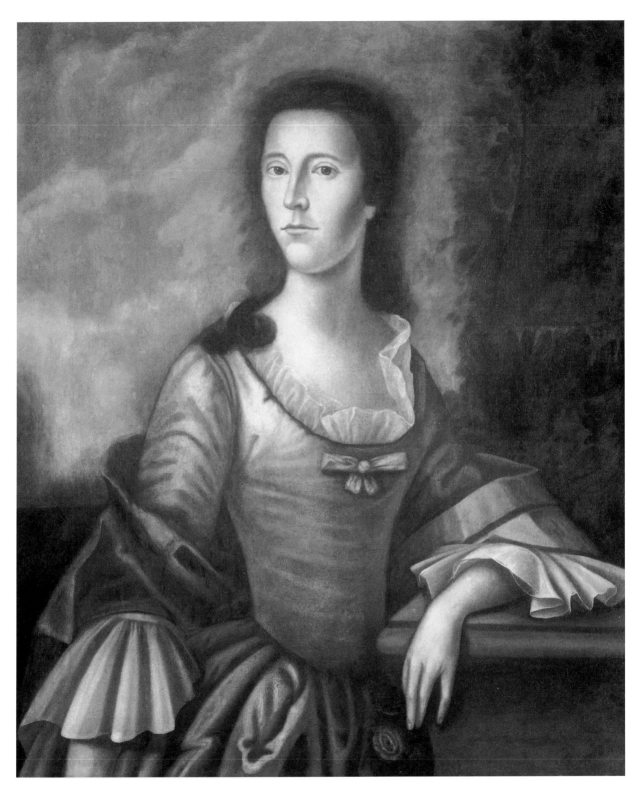

Benjamin West, *Mary Bethel Boude (Mrs. Samuel Boude)*, 1964.23.8

when he was seventeen.[4] Dr. Boude (c. 1723/ 1724–1781/1791) (his name is pronounced "Bowd," to rhyme with "cloud") was probably born in Philadelphia. After studying medicine he settled in Lancaster, where he worked as a physician and apothecary. He was chief burgess in 1757–1758 and 1761.[5] Boude may have provided the critical connection that brought West to Lancaster, since his younger sister Mary Boude had recently married West's friend Matthew Clarkson, a Philadelphia merchant. Clarkson's brother John Levenus Clarkson was married to West's sister Rachel.[6] West also painted portraits for Lancaster gunsmith William Henry and attorney George Ross, and at Henry's suggestion painted his first narrative subject, *The Death of Socrates* (private collection).[7]

The portrait is slightly wider than the standard kit-cat size (91.4 by 71.1 cm [36 by 28 inches]). Boude, in a brown coat, black vest, white shirt and wig, stands in front of a green curtain and a column with a few stray vine leaves. A balustrade and a landscape complete the background. West's composition repeats a traditional one in American and English eighteenth-century portraits of men, in which the subject stands with his body turned slightly, his arms at his sides, his nearer hand resting on his hip. The background also has features typical of these portraits, in particular the curtain and column. West could have copied the composition from an English engraving or from the work of a contemporary painter in the Philadelphia area, such as John Hesselius. He also could have seen the work of Robert Feke, who painted portraits in Philadelphia in 1746 and again in 1749–1750, and John Wollaston, who was there in the early 1750s.

The portrait is in poor condition. Past restoration has falsely strengthened the outlines of objects as well as the lines of the folds in the fabrics, obscuring any subtleties of modeling that may have been present and that are characteristic of West's other early portraits. One aspect of West's technique is revealed under x-radiography: the head of the sitter appears to be surrounded by a larger outline. Perhaps it relates to a change in the size of Boude's wig, or perhaps it indicates that, when painting the sitter's head, West also painted the area immediately around it, following the method used by studio-trained portrait painters to provide a tonal setting against which the artist would model the head in the portrait.

EGM

Notes

1. A photograph reproduced in Sawitzky 1938, no. 11, between pages 448 and 449, shows the painting before restoration, in its original black frame.

2. Lancaster 1912, 7; Sawitzky 1938, 451. According to Case 1929?, 19, this portrait and that of Mrs. Boude hung for many years at "Mt. Bethel," the Bethel family home in Columbia, Pennsylvania. Case recounts two family stories about the portraits: that they were recovered from a tavern, and that the damage to the eyes was caused by a bad-tempered child.

3. Letter from Melissa De Medeiros, librarian, M. Knoedler & Co., 30 October 1989 (NGA).

4. For a discussion of the uncertain date of this trip see Staley 1989, 27.

5. Dallett 1981, 92–94; the author explains that Boude's name should not have an accent on the last letter (Boudé), the form of his name that resulted from a modern error by a "respected art historian."

6. Flexner 1952, 17–18, 24; he erroneously identifies Clarkson's wife as Mrs. Boude's sister. According to Dallett 1981, 95, Clarkson and Mary Boude (1734/1735–1794) were married in 1753. Allen Staley kindly pointed out to the author the importance of the tie between Boude and West.

7. For these paintings see Von Erffa and Staley 1986, 518–519, nos. 637–638; 548–550, nos. 691–693; and 165, no. 4.

References

1929? Case: 18–20.
1938 Sawitzky: 437, 451, no. 11, repro. between 448 and 449.
1952 Flexner: 24–25.
1976 *Copley, Stuart, West*: 14 color repro., 20, no. 2.
1981 Dallett: 92–94, repro.
1986 Von Erffa and Staley: 494, no. 596, repro.

1964.23.8 (1940)

Mary Bethel Boude (Mrs. Samuel Boude)

1755/1756
Oil on canvas, 90.4 × 76.3 (35 9/16 × 30 1/16)
Gift of Edgar William and Bernice Chrysler Garbisch

Technical Notes: The portrait is on a medium-weight, plain-weave fabric, and the original tacking edges are intact. The thinly applied ground is light brown. There is a change in the center section of the edge of the left sleeve ruffle. The earlier, more rounded outline is now visible next to the straighter edge because of abrasion in the upper paint layer.

The painting is badly damaged and abraded. Losses are concentrated in the sitter's upper body, face (including holes punched in her eyes), the right background, and along the edges. Almost the whole painting has been overpainted, and this retouching has discolored. The

painting's earlier varnish was removed in 1955. The present varnish is slightly discolored.

Provenance: Same as 1964.23.7.

Exhibited: *Loan Exhibition of Historical and Contemporary Portraits Illustrating the Evolution of Portraiture in Lancaster County, Pennsylvania*, The Iris Club and the Historical Society of Lancaster County, Lancaster, Pennsylvania, 1912, no. 25. *American Paintings of the 18th & Early 19th Century in Our Current Collection*, M. Knoedler & Co., New York, 1948, no. 10b. *American Primitive Paintings from the Collection of Edgar William and Bernice Chrysler Garbisch*, NGA, 1957, 13. *John Singleton Copley 1738–1815, Gilbert Stuart 1755–1828, Benjamin West 1738–1820 in America & England*, MFA, 1976, no. 3.

MARY BETHEL was the daughter of Samuel and Sarah Blunston Bethel of Lancaster, Pennsylvania; her life dates are unknown. She married Samuel Boude in 1749.[1] In her portrait she wears a gold-colored dress with a pink bow. A pink drape is wrapped behind her and over her arms, and she holds a rose in her left hand. West used a similar pose for his portrait of Sarah Ursula Rose (c. 1756, MMA), also painted in Lancaster. The composition resembles English portraits of women that West could have seen in mezzotint engravings. West demonstrated his familiarity with these poses in the drawings he made in a sketchbook now owned by the Historical Society of Pennsylvania, Philadelphia, as well as in his slightly later portraits, such as that of Jane Galloway (Mrs. Joseph Shippen, c. 1757, Historical Society of Pennsylvania).[2] The painting, like that of Dr. Boude [1964.23.7], had deteriorated badly when William Sawitzky saw it in 1934.[3] It is no longer a good example of West's colonial American style of painting. The greater density of pigment around her head, however, as seen in x-radiography, may be an original feature of West's portrait-painting technique.

EGM

Notes

1. Dallett 1981, 92.

2. Von Erffa and Staley 1986, 548–549, no. 690 repro., and 508 no. 622 (7, color repro.). For West's notebook see Sawitzky 1938, 433–462; Saunders and Miles 1987, 199–203, nos. 61–65, repro.; and Weintraub and Ploog 1987, 17–18, nos. 1–2, repro., and 59–65.

3. Sawitzky 1934, no. 12, between 448 and 449. The photograph shows the painting in its original black frame.

References

1929? Case: 18–20.

1938 Sawitzky: 437, 451, no. 12, repro. between 448 and 449.
1952 Flexner: 24–25.
1981 Dallett: 92.
1981 Williams: 37, repro. 36
1986 Von Erffa and Staley: 494, no. 597, repro.

1940.1.10 (496)

Colonel Guy Johnson and Karonghyontye (Captain David Hill)

1776
Oil on canvas, 202 × 138 (79 1/2 × 54 3/8)
Andrew W. Mellon Collection

Technical Notes: The painting is on a plain-weave fabric with fine, loosely woven threads. There is strong cusping on the right edge of the support, and cusping to a lesser degree along the top. The granular quality of the off-white ground is especially noticeable where the paint layer is thin.

The paint was applied thinly, with dots of impasto in the Indian beadwork. Several alterations can be detected with x-radiography. Johnson once wore a large bow at his throat. His left leg was altered: x-radiography and pentimenti reveal that the artist first painted breeches and thigh-high leggings on both legs, and later painted the blanket over the left leg. At the upper left, the sky and clouds once extended farther, probably to the top of the canvas. The impasto of the underlying layers in these areas can be seen.

There are two tears, one in the hat and the other in the tail of the sash. There are few losses.

Provenance: Ethel Dixon-Brown [d. c. 1950], Henfield, Sussex;[1] (Sotheby's, London, 7 December 1927, no. 54, as a portrait of Sir Joseph Banks); bought by (Frank T. Sabin, London);[2] sold 27 November 1936 to (M. Knoedler & Co., New York);[3] sold 21 January 1937 to The A.W. Mellon Educational and Charitable Trust, Pittsburgh.

Exhibited: *Masterpieces of American Historical Portraiture*, M. Knoedler & Co., New York, 1936, not in catalogue.[4] *Portraits of American Indians from Pocahontas to Sitting Bull*, The University Museum, University of Pennsylvania, Philadelphia, 1938, uncatalogued, as *Joseph Brant and Colonel Guy Johnson*.[5] *The Painter and the New World / Le Peintre et le Nouveau Monde*, Montreal Museum of Fine Arts, 1967, no. 85, as *Colonel Guy Johnson and Chief Joseph Brant*. *The European Vision of America*, NGA; The Cleveland Museum of Art; Grand Palais, Paris, 1975–1977, no. 177, as *Colonel Guy Johnson*. *Georgian Canada: Conflict and Culture, 1745–1820*, Royal Ontario Museum, Toronto, 1984, no. 115, as *Portrait of Colonel Guy Johnson*.

WEST'S STRIKING full-length double portrait represents Colonel Guy Johnson (1740–1788), British superintendent of the Six Nations of the Iroquois from 1774 to 1782, and Karonghyontye (d. 1790), a prominent Mohawk chief also known as Captain David Hill. The Mohawks were one of the Six Nations of the Iroquois, which consisted also of the Senecas, Onondagas, Cayugas, Oneidas, and Tuscaroras, who lived in what is now northern New York state and Canada. While the figure of Johnson has been identified for many years, Karonghyontye was previously identified as Joseph Brant (1742–1807), the Mohawk leader whose given name was Thayendanegea.[6] Karonghyontye (Hill) was a close ally of Brant.[7]

These identifications are based on Karonghyontye's letter of 6 November 1784, written in the Mohawk language to Daniel Claus (1727–1787), who served from 1755 to 1775 in the Indian department of the British colonial government and later was appointed deputy agent for the Six Nations by governor Frederick Haldimand (1718–1791).[8] Writing from Quebec to Claus in London, Hill discussed the peace terms concluding the American Revolution

Fig. 1. X-radiograph detail of 1940.1.10

and ended the letter with an inquiry about several portraits, which reads in translation:

Brother-in-law, I want you to bring back with you the picture of my late brother, John Hill. The paper tells that Tha yen da ne gen [Joseph Brant] has already paid for it. The picture of Ga ragh wa dir on [Guy Johnson] and I, Governor Haldimand took it with him. We two really want to have one, Tha yen da ne gen [Joseph Brant] and I, if you could get another one made and bring along with you, we will be glad.

He signed the letter with his English and Mohawk names, David Hill and Karonghyontye.[9]

The full-length double portrait shows Johnson and Hill outdoors, in front of a rocky ledge. The predominant colors are brown, tan, red, and black. The broadly painted figures have no strong highlighting, while the details of clothing and Indian objects are closely observed and precisely delineated. Johnson, seated on an outcropping, wears a combination of Indian and British army clothing suitable to his position as superintendent of Indian Affairs, a quasi-military post.[10] Although his clothing is modeled on a British army uniform, it bears no braid or lace to indicate military rank, and several features show personal idiosyncracy in their modified military style. Over his red jacket and buff waistcoat and breeches he wears a large brown robe made of animal skins that is decorated on the skin side with a black and red geometric design. Beadwork adorns his red and blue powder horn strap and red garters. The magenta sash, also worn by military officers, is here beaded and tied with the knot at the front of his waist rather than at the side. Wearing brown leggings and brown moccasins decorated with red beadwork, Johnson holds a round black cap ornamented with multicolored beading and red feathers. X-radiography (Figure 1) reveals that West painted a full white bow at Johnson's neck but later painted the black stock over it. In his left hand he holds a type of musket called a fuzee. Karonghyontye (David Hill), who stands to the left and slightly behind Johnson, in the shadows, is bare chested and wears leggings and moccasins. A black cloak draped over one shoulder extends around his waist. Beading embellishes his headdress and the red straps across his chest. Black and white bracelets of wampum encircle his wrists, and a knife sheath hangs on a thong around his neck. The rims of his ears have been split and bound with silver wire. In his right hand he holds a quill-wrapped calumet, or peace pipe, whose coals glow red; a wisp of smoke rises from the mouth-

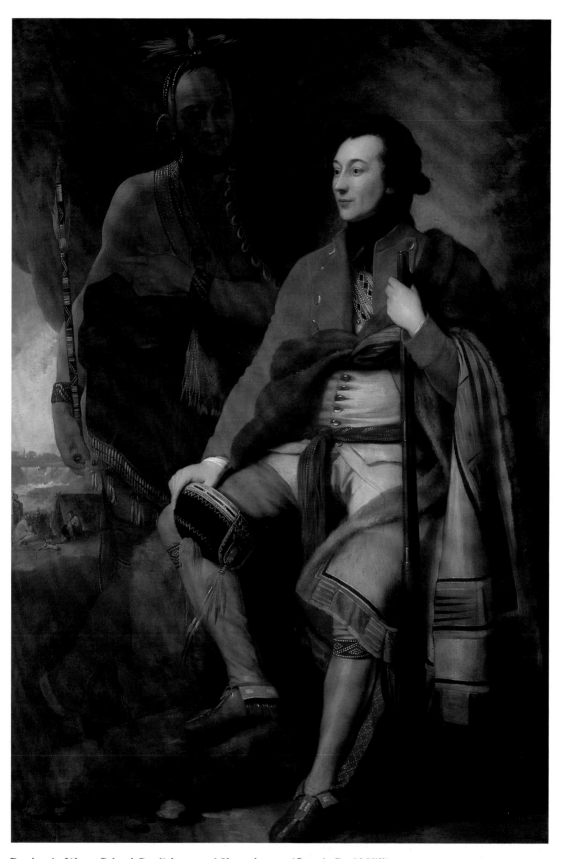

Benjamin West, *Colonel Guy Johnson and Karonghyontye (Captain David Hill)*, 1940.1.10

piece at the top.[11] With his left hand he points to the pipe. Beyond, in the distance, is a scene of Indians camped near a waterfall. The vignette is in West's characteristic technique for such figures; they are clearly demarcated but are not as detailed as objects in the foreground.

Guy Johnson was born in Ireland around 1740 and may have come to America as early as 1755.[12] During the French and Indian War he commanded a company of rangers under Jeffrey Amherst. He was later promoted to the rank of colonel and adjutant general in the New York militia. A relative of Sir William Johnson (c. 1715–1774), the British superintendent of northern American Indians, Johnson became a deputy agent in the department in 1762. He married Sir William Johnson's daughter Mary the following year and settled at Guy Park, near Amsterdam, New York. Undoubtedly he met Brant there: Brant's sister was Sir William Johnson's housekeeper and common-law wife. When Sir William died in July 1774, Johnson was provisionally made superintendent, pending confirmation by the Crown. The Six Nations accepted him as Sir William's successor. He was given his Iroquois name Uraghquadirha (also written Garaghwadiron) on 15 September 1774 at a meeting with the chiefs and warriors of the Six Nations. "According to an antient custom they had fixed a new name for Col. Johnson in consequence of the office he now discharged." The name has been translated as "Rays of the Sun Enlightening the Earth."[13]

The double portrait was painted in London at a time when revolutionary activity had increased in America, and the British sought to ensure the loyalty of the Iroquois. The Mohawks held a crucial position as the eastern-most tribe of the Iroquois confederacy. The Six Nation Confederacy ultimately split apart during the Revolution, with most of the Oneidas and Tuscaroras supporting the Americans. Although the majority of the Mohawks remained allied with the British, some division within the Indian nation did occur.[14] In the late spring of 1775 Johnson went to Canada from New York to meet the Iroquois at Oswego and Montreal.[15] His authority, however, was threatened by the appointment of John Campbell as agent of Indian Affairs for the province of Quebec, and he sailed to England in November on the *Adamant*. The ship was owned by London merchant Brook Watson (see 1963.6.1), who accompanied thirty-four American and Canadian prisoners of war to London, including Vermont colonel Ethan Allen, captured when

his forces attacked Montreal that fall.[16] Johnson was accompanied by several Indian department officials, including Daniel Claus and Joseph Chew, and by at least two Mohawks, Thayendanegea (Joseph Brant) and Oteroughyanento (John Hill, David Hill's brother), who planned to present grievances and to assess the advantages of a continued alliance. Ethan Allen's account of the trip described Johnson's party as "about thirty."[17]

Although only these two Mohawks are named in accounts of the visit, and David Hill is not mentioned,[18] this trip to London is the only documented trip that Guy Johnson made to England accompanied by Mohawks and thus the only occasion for the painting of the double portrait. The trip in 1775–1776 was important to Johnson, whose purpose during his term as superintendent was to "preserve the Indians dependance on, & their attachment to the Crown."[19] Johnson and the Mohawks had an audience on 29 February 1776 with George III and met with Lord George Sackville Germain, the new colonial secretary, two weeks later. Thayendanegea and Oteroughyanento presented grievances about encroachments on their land. They reminded Germain of past faithful service to the king and said that nonetheless they had

been very badly treated by his people in that country, the City of Albany laying an unjust claim to the lands on which our Lower Castle is built.... Indeed it is very hard when we have let the Kings subjects have so much of our lands for so little value, they should want to cheat us in this manner of the small spots we have left for our women and children to live on.... We are tired out in making complaints & getting no redress.[20]

As a result of this meeting, Johnson was officially appointed superintendent of the Six Nations, although his sphere of authority, reduced from that of Sir William Johnson, did not include Canada. Germain also promised the native Americans full support and a satisfactory settlement to their land claims after the war was successfully concluded.

Johnson undoubtedly commissioned the double portrait to mark his appointment as superintendent. He probably intended to hang it in Guy Park, his mansion on the Mohawk River in New York, where he was rebuilding the old house that had been destroyed by summer lightning in 1773.[21] The house was later described in the claims he listed for the Loyalist Claims Commission on 23 March 1784: "Called Guy Park on the Bank of the Mohock River about 15 Miles from Schenectady.... The Mansion House... a large well built new House of

wrought stone 2 stories high . . . with west chimney pieces Mahogany Stair Case & Complete Cellars under the whole."[22] Other portraits painted during this visit to London include one by George Romney of Joseph Brant, painted for the Earl of Warwick (National Gallery of Canada, Ottawa),[23] and Alice Richardson's "Portrait of Oteronganente, one of the American chiefs now in London; in crayons," which was part of the spring exhibition of the Royal Academy of Arts.[24] Hers may be the portrait of John Hill to which David Hill referred in his letter to Claus when he asked him to "bring back with you the picture of my late brother, John Hill. The paper tells that Tha yen da ne gen has already paid for it."[25] Johnson and most of his party returned to America in the summer of 1776, arriving in New York City at the end of July.[26] He presumably brought the portrait with him.

Johnson's choice of Benjamin West for the commission is not surprising. He may have had an introduction to West through his brother-in-law John Johnson, who, like West, had been a pupil of William Smith in Philadelphia.[27] John Johnson knew General Robert Monckton, whose portrait West painted around 1764 (Trustees of Lady Galway's Chattels Settlement, England).[28] And at about this time West depicted Sir William Johnson in *General Johnson Saving a Wounded French Officer from the Tomahawk of a North American Indian* (c. 1764–1768, Derby Museum and Art Gallery, England).[29] But the painting that may have caught Johnson's attention was West's *Death of General Wolfe* (1770, National Gallery of Canada, Ottawa), which includes Monckton as a prominent figure.[30] Guy Johnson's arrival in London coincided with the publication of William Woollett's engraving of West's *Death of Wolfe*, which gave the image enormous popularity. Johnson could also have seen the replica of *The Death of Wolfe* that was in West's studio at the time (William L. Clements Library, University of Michigan, Ann Arbor).[31]

West had demonstrated a keen interest in native Americans as early as about 1760 in his painting of *The Savage Warrior Taking Leave of His Family* (Royal College of Surgeons of England, London).[32] Many of the details of the Indian's appearance are similar to those in the portrait of Hill: the separated ears, the knife hanging from the neck, the loosely draped mantle, the protective leggings, plucked forehead, and the powder horn with beaded pouch. West showed a continued familiarity with the subject in *General Johnson Saving a French Officer* and in *William*

Fig. 2. Algonquian or Iroquoian moccasins, London, Department of Ethnography, British Museum [photo: Courtesy, The Trustees of the British Museum]

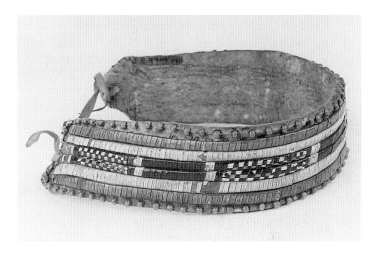

Fig. 3. Algonquian or Iroquoian beaded hat band, London, Department of Ethnography, British Museum [photo: Courtesy, The Trustees of the British Museum]

Penn's Treaty with the Indians (1771–1772, PAFA).[33] He owned a number of native American artifacts, which he incorporated into the paintings. Twelve such items, recently acquired from a descendant of West's by the Department of Ethnography, British Museum, London, include a pair of moccasins identical to those worn by Guy Johnson (Figure 2) and a beaded strap very similar to that on Johnson's hat (Figure 3).[34] The background scene probably represents Niagara Falls, a well-known American landmark that was associated with the Iroquois. In 1774 English landscapist Richard Wilson exhibited a painting of the falls at the Royal Academy of Arts. His *Falls of Niagara* (Central Art Gallery, Wolver-

hampton, England) was based on one of the earliest drawings of the falls, by Lieutenant William Pierie, a British officer. Wilson's view was engraved by William Byrne as *Cataract of Niagara* (1774, National Archives of Canada, Ottawa).[35] In the background scene West included two images of Indians that he repeated from his own work. The image of a kneeling Indian is taken from his *Death of Wolfe*, and the vignette of a seated Indian woman nursing a child that has been strapped to a board appears in the right foreground of *William Penn's Treaty with the Indians*. A similarly kneeling Indian is seen in Swiss artist Heinrich Füssli's etching *Vue du Cataract de Niagara, au Pais des Iroquois* (c. 1776, Royal Ontario Museum, Toronto), and here the title of the etching clearly identifies the falls as being in the homeland of the Iroquois.[36]

Johnson remained in New York City until he went to Montreal in the spring of 1779. That fall he helped provide for the Iroquois who had been displaced by the war. Turning his office over to his brother-in-law Sir John Johnson, he returned to London in 1783 to claim restitution for property lost in the war. He died there in 1788. David Hill, who led war parties in attacks on the American enemy during the Revolution, settled on the Grand River tract in Ontario that was granted to loyalist Mohawks in 1784.[37] That November he wrote Daniel Claus from Quebec about the portraits, referring to the double portrait as the picture Governor Haldimand took with him.[38] In 1789 Hill inducted a young Irishman, Lord Edward Fitzgerald, into the Bear clan at Detroit. A document of this event, written in Mohawk and English and dated 21 June 1789, gives Hill's Mohawk and English names, and states, "I, David Hill, chief of the Six Nations, give the name of *Eghnidal* to my friend Lord Edward Fitzgerald, for which I hope he will remember me as long as he lives. The name belongs to the Bear Tribe."[39] A description of Hill by Anne Powell at about this time seems very close to West's image. Powell was traveling from Montreal to Detroit in 1789 with her brother William Dummer Powell, later the chief justice of upper Canada, when she went with others to see an Indian council of over "two hundred chiefs . . . the delegates of the six nations" near Fort Erie.

I was very much struck with the figures of these Indians as they approached us. They are remarkably tall, and finely made, and walk with a degree of grace and dignity you can have no idea of. . . . One man called to my mind some of Homer's finest heroes. One of the gentlemen told me that he was a chief of great distinction and spoke English, and if I pleased he should be introduced to me. . . . The Prince of Wales does not bow with more grace than Captain David; he spoke English with propriety, and returned all the compliments that were paid him with ease and politeness. As he was not only the handsomest but the best drest man I saw, I will endeavor to describe him.

His person is tall and fine as it is possible to conceive, his features handsome and regular, with a countenance of much softness, his complexion was disagreeably dark, and I really believe he washes his face, for it appeared perfectly clean, without paint; his hair was all shaved off except a little on the top of his head to fasten his ornaments to; his head and ears painted a glowing red; round his head was fastened a fillet of highly polished silver; from the left temple hung two straps of black velvet covered with silver beads and brooches. On the top of his head was fixed a Foxtail feather, which bowed to the wind, as did a black one in each ear; a pair of immense earrings which hung below his shoulders completed his head-dress, which I assure you was not unbecoming, though I must confess somewhat fantastical.

His dress was a shirt of colored calico . . . his sleeves . . . fastened about the arm with a broad bracelet of highly polished silver, and engraved with the arms of England. Four smaller bracelets of the same kind about his wrists and arms; around his waist was a large scarf of a very dark colored stuff, lined with scarlet, which hung to his feet. One part he generally drew over his left arm which had a very graceful effect when he moved. His legs were covered with blue cloth made to fit neatly, with an ornamental garter bound below the knee. I know not what kind of a being your imagination will represent to you, but I sincerely declare to you, that altogether Captain David made the finest appearance I ever saw in my life.[40]

On 15 April 1790 David Hill and his son requested a deed for their lands on the Grand River.[41] David Hill died that autumn. Two years later English traveler Patrick Campbell met his son Aaron Hill and noted, "Mr Aaron Hill . . . is eldest son of the renowned chief, Captain David, whom every one that knew him allowed to be the handsomest and most agreeable Indian they had ever seen."[42]

No other portraits of Johnson or Hill exist to provide confirmation of the identification. A miniature of Johnson's brother-in-law Sir John Johnson has occasionally been published as a portrait of Guy Johnson, but this identification appears very unlikely.[43] Also no firm documentation places Hill in London with Johnson in 1776. Allen Staley suggested an alternative identification of the army officer as Sir William Johnson, observing that the painting is of the style of West's work in the late 1760s, rather than that of the mid-1770s.[44] William Johnson,

however, did not visit London after going to America in 1738. It is even less likely to be a portrait of his son John Johnson, who visited London in 1765–1767 when he was a young man, given the apparent age of the sitter and the lack of similarity with the miniature thought to be of John Johnson painted many years later. Instead it seems likely that David Hill's letter of 1784 provides the correct identifications, and that the portrait is a celebration of the Mohawk delegation's visit to London in 1776 and of Johnson's new position. Karonghyontye and Johnson seem to stand together in a complex alliance.

LKR

Notes

1. "Miss E. Dixon Brown, Martyn Lodge, Henfield, Sussex" is identified as the pre-sale owner in the records of the firm of Frank T. Sabin, compiled in 1927 (letter from Sidney F. Sabin, 6 June 1991, NGA). This is confirmed by a label on the back of the painting. The owner's name has been misread in the past as E. Dina Brown. She was the daughter of the Reverend Dixon Dixon Brown (1826–1901) and his wife Georgina Elizabeth Dixon Brown (d. 1914); see Burke 1952, 278–279. Her death date was provided by Irene Dixon-Brown, her nephew's wife (letter of 15 July 1991; NGA). The earlier history of the painting is unknown.

2. *Valuable Pictures* 1927, 14; annotated copy, Yale Center for British Art, New Haven.

3. The date of the sale is recorded in a stockbook owned by Sabin Galleries, Ltd., London (letter from Sidney F. Sabin, 6 June 1991; NGA). According to M. Knoedler & Co., the painting was consigned to them in October 1936; letter from Melissa De Medeiros, librarian, 28 May 1991 (NGA).

4. Annotated photograph supplied by M. Knoedler & Co., Frick Art Reference Library, New York.

5. "Indian Portraits" 1938, 18.

6. The painting was sold by Sotheby's as a portrait of Sir Joseph Banks by West and went to the Sabin Galleries collections with that identification. According to a letter dated 5 June 1940 from C.R. Henschel, M. Knoedler & Co., the identification to Johnson was changed on the advice of "the present holder of the Johnson title, who said he knew the picture very well"; he identified the Mohawk as Brant (NGA). The British sitter was recently identified as possibly Sir William Johnson; see Von Erffa and Staley 1986, 523.

7. There is no published biographical information on Hill for the period before 1780; for his activities during the period 1780–1790 see below. His death is recorded in a letter from Joseph Brant to Governor George Clinton, 5 November 1790: "My good Friend Capt. David, a few days gone, after a fit of sickness departed this life"; Pilkington 1980, 152 n. 63, from Hough 1861, 464.

8. Claus began his career as a translator and diplomat and knew the Mohawk language; see *DCB* 4:154–155. On Haldimand see *DCB* 4:793–794.

9. Claus Family Papers, MG 19, F1, 4:57–60, National Archives of Canada, Ottawa, translation provided by the archives, MG 24, F1, 24:57–59. This letter was called to the attention of George R. Hamell, senior museum exhibits planner in anthropology, New York State Museum, Albany, by Dr. David Faux of Haggersville, Ontario. Mr. Hamell verified the translation with Gunther Michelson of Montreal and generously shared his information and expertise with the Gallery; see his letters of 14 September and 8 November 1988 (NGA). Recently Timothy Dubé of the Manuscripts Division, National Archives of Canada, provided an enlarged copy of the manuscript for research purposes. Marianne Mithun, Department of Linguistics, University of California, Santa Barbara, agreed with the translation, in particular that the Mohawk refers to a single picture of Guy Johnson and David Hill (letter of 24 March 1991; NGA).

10. Marko Zlatich, an historian of military uniforms in Washington, has generously assisted with the identification of Johnson's clothing.

11. According to Smithsonian anthropologist William C. Sturtevant, who offered valuable assistance with this entry, Hill's Iroquois clothing is depicted with great accuracy.

12. On Johnson see *DCB* 4:393–394, and Gibb 1941, 27:595–613.

13. *Colonial Documents* 1857, 8:500–501, reference provided by Barbara Graymont (letter of 26 May 1991). According to Marianne Mithun, letter of 24 March 1991, it is a Mohawk name that is still used. Spellings of the name vary.

14. See "Mohawks" and "Six Nations Confederacy," *DCB* 4: LIV, LVII.

15. "Journal of Colonel Guy Johnson from May to November, 1775," *Colonial Documents* 1857, 8:658–662.

16. The names of the prisoners were provided with a letter from the Admiralty Commissioners to Commodore Sir Peter Parker dated 27 December 1775; *Naval Documents* 1968, 3:457–458.

17. Allen 1845, 44–45.

18. There is no definitive list of passengers on the ship. Kelsay 1984, 159, says the party included Daniel Claus, his wife and child, Guy Johnson's daughters (his wife had died), Walter Butler, Peter Johnson, Gilbert Tice, Joseph Chew, John Dease, Joseph Brant, John Hill, and possibly others.

19. Guy Johnson to Lord George Sackville Germain, 26 January 1776, in *Colonial Documents* 1857, 8:656.

20. "The Speech of Thayendenegeh a Chief, accompanied by Oteroughyanento a Warrior, both of the Six Nations, 14 March 1776"; *Colonial Documents* 1857, 8: 670-671. Later two Mohawks responded to Germain's reply: "The Answer of Thayendanagea a Sachem, and of Ohrante a warrior of the Mohocks to the Right Honble Lord George Germaine, 7 May 1776"; in *Colonial Documents* 1857, 8:678. It is unclear whether "Ohrante" is John Hill or a third Mohawk; "Ohrante" is recognizable as a Mohawk name, but it has been "distorted beyond recovery," according to Marianne Mithun (letter, 14 February 1994; NGA).

21. Guy Johnson to Mr. Blackburn, London, 25 April 1774, from Guy Park: "By an unforeseen calamity namely the destruction of my House by Lightening last June, I lost all my acco.ts and what I shall always feel much more

sensibly, several interesting family papers, with Manu-
scripts and Drawings of my own Collection that would
have one day been deemed Valuable, as they were not to
be met with elsewhere . . ." (British Library, Additional
Mss. 24323; transcript, Manuscript Division, LC). Sir
William Johnson wrote to Blackburn on 20 January 1774
that "Col. Johnson has been so occupied about his New
House, the former having been destroyed by Lightening
last Summer that he has not as yet sent you his power of
Attorney . . ." (British Library, Additional Mss. 24323;
transcript, Manuscript Division, LC).

22. According to the "Memorial of Guy Johnson
Esqr.," he also had "a Brick House 3 Stories high and a
large Lot of Ground situated in the Main or Albany
Street" in Schenectady, in addition to many tracts of
land. The personal property losses he listed included
"Household Furniture all new . . . An Elegant Phaeton
quite new . . . 19 Negroes, most of them young & some
valuable . . . 15 Horses. . . ." His total claim amounted to
twenty-two thousand pounds (London, Public Record
Office, AO 12/22 f. 22–46; microfilm copies, Manuscript
Division, LC).

23. The sittings with Romney took place on 29 March
and 4 April at Romney's studio; see Thompson 1969,
49–53.

24. Graves 1905, 6:283, "Alice Richardson, Crayon
Painter. 4, College Street, Westminster." She also exhib-
ited crayons at the Society of Artists, but otherwise she is
unknown; Waterhouse 1981, 310.

25. According to Kelsay 1984, 169, the British gov-
ernment paid £4/4 for this portrait.

26. Colonel Guy Johnson to Lord George Germain,
9 August 1776, in Colonial Documents 1857, 8:681–682.

27. Von Erffa and Staley 1986, 524, and n. 6, citing
Hamilton 1961, 123.

28. Von Erffa and Staley 1986, 25 (color repro.),
534–535, no. 665, who note that Monckton met West
through West's brother Samuel, who served in the Penn-
sylvania militia.

29. Von Erffa and Staley 1986, 210–211, no. 92, repro.

30. Von Erffa and Staley 1986, 58, 211–214, no. 93.

31. Von Erffa and Staley 1986, 214, no. 95.

32. Von Erffa and Staley 1986, 420–421, no. 452.

33. Von Erffa and Staley 1986, 68–69 (color),
206–208, no. 85.

34. King 1991, 36 fig. 2 (color), 38, 39 fig. 7 (color), 40.
At least some of the artifacts could have come to West
from Sir William Johnson.

35. Adamson 1985, 22, 76 n. 49; Byrne's engraving see
22, fig. 8 and 134, no. 39.

36. Adamson 1985, 85 fig. 76, 140, no. 88. Füssli
(1755–1829) was a cousin of the Anglo-Swiss painter
Henry Fuseli.

37. Hill is mentioned occasionally in British records
after 1780; see Graymont 1972, 225, 245 for references in
1780 and 1781, and Kelsay 1984, 329, 340, 350, 380, 399,
417, 422, 427, and 431 for references during the years
1782–1789. He was one of the signers of a "Deed from the
Six Nations Inhabiting the Grand River" on 26 Febru-
ary 1787; Johnston 1964, 70–72.

38. Governor Haldimand wrote from Quebec in No-
vember 1784 that "Capt Brant and David, and a Cayuiga

Chief will follow immediately, the former will remain the
Winter at Cataraqui, the other will proceed to Niagara,
thence to the New Settlement at the Grand River . . .";
Johnston 1964, 51–52.

39. Fitzgerald (1763–1798), eldest son of the 1st Duke
of Leinster, traveled with Joseph Brant from Fort Erie to
Detroit in June 1789 and then went to New Orleans. He
wrote his mother from Detroit on 20 June that "I have
been adopted by one of the Nations, and am now a thor-
ough Indian." He returned to Ireland in the 1790s and
became a leader in the Irish cause for independence from
Britain. The document was transcribed by Fitzgerald's
early biographer Thomas Moore in 1831, who said it was
found in Fitzgerald's papers at his death; it is quoted in
Severance 1911, 221–222, and referred to by other biogra-
phers.

40. Her journal was first published in *Magazine of
American History* 5 (1880): 34–47; the text is also repro-
duced in Riddell 1924, 60–72, and in part in Severance
1911, 223–234. George Hamell generously provided these
references to her description.

41. Johnston 1964, 55.

42. Campbell 1791, 162–180, quoted in Johnston 1964,
61. Campbell noted that Hill died about two years earli-
er and that his son "was the best scholar at the universi-
ty of Cambridge, in New England, when he was there.
He writes a remarkably fine hand, both in the Roman
characters and German text, a specimen of which he
gave me, and I now have in my custody."

43. Pound and Day 1930, opp. 232; Martha Marleau,
archivist in the department of Art Acquisition and Re-
search at the National Archives of Canada, Ottawa,
notes that the miniature, which was engraved by
Francesco Bartolozzi, has been published many times
since the late eighteenth century as a portrait of Sir John
Johnson; letter, 23 April 1993 (NGA).

44. Von Erffa and Staley 1986, 524.

References

1958 Hamilton: 122–123.
1959 Evans: 46, 119 n. 53, pl. 33.
1967 Hamilton: 39 (repro.).
1974 Parry: 31, 33 (repro.), 34.
1977 Dillenberger: 23–24, pl. 13.
1980 Wilmerding: 40–41, no. 1, color repro.
1981 Williams: 40, 48 color repro.
1984 Walker: 370, no. 523, color repro.
1986 Von Erffa and Staley: 59 (color repro.),
523–525, no. 647.
1988 Wilmerding: 9, 16, 48, 49 color repro.
1991 King: 34–47, repro. 34, fig. 1 (color).

1959.8.1 (1535)

The Battle of La Hogue

c. 1778
Oil on canvas, 152.7 × 214 (60 ⅛ × 84 ¼)
Andrew W. Mellon Fund

Technical Notes: The support is a medium-weight, twill-weave fabric. There are regularly spaced tack holes across the front of the painting on all edges. The ground is a warm gray. The paint is applied with broad brush strokes, with finer handling in the details. Glazes and scumbles are used, with impasto in many highlights.

Drying cracks in the dark colors have been inpainted; some of the inpainting has discolored. There is a large area of abrasion in the dark clouds in the upper left quadrant, and scattered losses throughout. The heavily applied varnish is slightly discolored.

Provenance: Richard Grosvenor, 1st Earl Grosvenor [1731–1802]; his son Robert Grosvenor, 1st Marquess of Westminster [1767–1845]; his son Richard Grosvenor, 2nd Marquess of Westminster [1795–1869]; his son Hugh Grosvenor, 1st Duke of Westminster [1825–1899]; his grandson Hugh Richard Arthur Grosvenor, 2nd Duke of Westminster [1879–1953];[1] his estate; (sale, Sotheby's, London, 15 July 1959, no. 125); to (John Nicholson Gallery, London and New York); by whom sold 11 December 1959 to the National Gallery of Art.

Exhibited: Royal Academy of Arts, London, 1780, no. 73, as *The Destruction of the French fleet at La Hogue, 1692*. British Institution, London, 1851, no. 117.[2] *Art Treasures of the United Kingdom*, Manchester, 1857, no. 109.[3] *Royal Naval Exhibition*, Chelsea, London, 1891, no. 296, as *Destruction of the French Ships in the Bay of La Hogue, after the Battle of Barfleur, 23rd May 1692. Four Centuries of American Art*, Minneapolis Institute of Arts, 1963–1964, unnumbered. *Benjamin West: American Painter at the English Court*, The Baltimore Museum of Art, 1989, no. 21.

The Battle of La Hogue is one of four subjects from seventeenth-century English history that West painted for Richard, Lord Grosvenor after the Earl acquired West's masterpiece, *The Death of General Wolfe* (1770, National Gallery of Canada, Ottawa). In addition to this painting, they are *The Battle of the Boyne* (1778, His Grace the Duke of Westminster), *Oliver Cromwell Dissolving the Long Parliament* (1782, Montclair Art Museum, New Jersey), and *General Monk Receiving Charles II on the Beach at Dover* (1782, Milwaukee Art Center, Layton Art Gallery Collection).[4] West initially had proposed that he paint the discovery of the bones of General Edward Braddock, killed in Pennsylvania in 1755, as an American subject to form a pair with *The Death of General Wolfe*, but the topic was rejected as obscure.[5] The subjects instead were probably based on David Hume's *History of England* published from 1754 to 1762.[6] *The Battle of La Hogue* has been regarded since its exhibition at the Royal Academy in 1780 as one of West's masterpieces.

The painting represents the English victory at the battle of La Hogue on 19–24 May 1692, when the English and Dutch fleets fought the French in the English Channel. During the battle the French navy retreated into the Bay of La Hogue near Cherbourg, under the protective guns of two French fortresses. English Admiral George Rooke and his sailors entered the bay in small boats, burned the French warships, and also destroyed the ships that were intended to carry a combined French and Irish army to England. Thus he ended Louis XIV's plans to invade England and restore James II to the throne.

The painting conveys the swirl of action and the clamor and smoke of battle at the moment of victory. The action moves from left to right as the English pursue the French enemy. As the battle cry is sounded by a trumpeter on the left, Admiral Rooke, standing in the boat on the left, raises his sword. The English charge forward, and the faces of the sailors express emotions ranging from fear and anguish, to sorrow, apprehension, and militant attention. A small boat sinks in the foreground, and its drowning occupants are pulled from the water, including a youth whose pallor suggests that he is near death. Among other images of the defeated and dying are two men fighting in the water in the right foreground as a hat with a red feather floats nearby. A Frenchman fleeing on the far right is elegantly dressed in a blue silk suit but has lost his wig. Behind, to the left, a French warship burns, smoke filling the sky. In the center background other large French navy ships are surrounded by the small boats of the English. James II stands in the distance, on a cliff, looking out over the smoke and destruction.

West depicted the myriad of foreground details with short brush strokes, from the scattered blue tones on hats, coats, and shirts to shirtless rowers, flags with red, white, and blue patterns, and a translucent green-brown sea. The background details are less closely depicted, but the events are clear. The unsigned painting may have been completed by 1778, the date inscribed on *The Battle of the Boyne*, exhibited with *La Hogue* at the Royal Acade-

Fig. 1. Benjamin West, *Study for The Battle of La Hogue*,
pen and ink on paper, c. 1778, Washington,
National Gallery of Art, Avalon Fund, 1991.90.1.a

Fig. 2. Benjamin West, *Sailing Vessels and Longboats*,
black chalk on cream-colored paper, c. 1778, New York,
The Pierpont Morgan Library, Purchased as the Gift
of Mrs. Robert H. Charles, 1970.11:121

Fig. 3. Benjamin West, *A Naval Battle*,
black chalk on paper, c. 1778, New York,
The Pierpont Morgan Library, Purchased as the Gift
of Mrs. Robert H. Charles, 1970.11:64

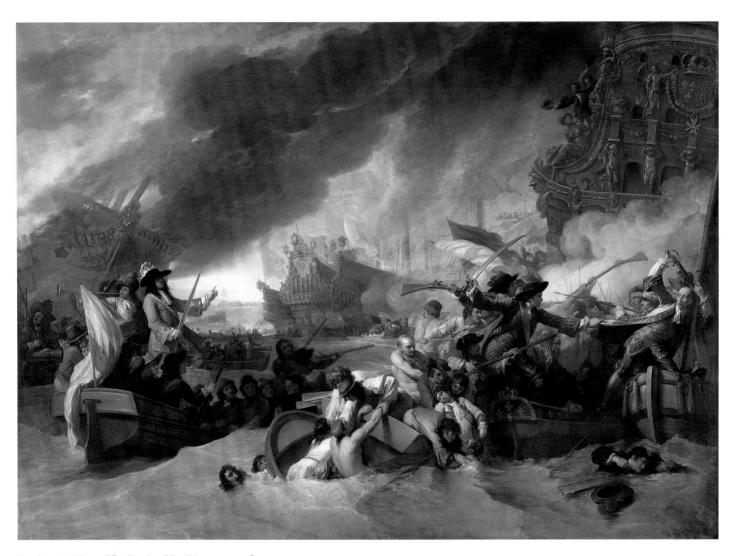

Benjamin West, *The Battle of La Hogue*, 1959.8.1

my of Arts in 1780. William Woollett's engraving, published in 1781 with a key that identifies the foes, Rooke and James II, bears that date,[7] as does the replica painted for West by John Trumbull under West's direction in 1785 (MMA). The replica, which West "retouched and harmonized," was painted to hang in West's gallery at 14 Newman Street.[8] West later touched it up and inscribed it with the additional date of 1806, the year that he cleaned the Gallery's version and had the two paintings in his studio for the first time in twenty years.[9]

An early pen and ink design for the painting (Figure 1) represents the theme of the English in small boats attacking the large, landlocked warships, with a slightly different arrangement of the groupings of ships and men. The English admiral is not present, nor is James II. Nevertheless, the swirl of smoke, the details of a man jumping from one boat to another, and figures in the water reaching for rescue are already present.[10] Another drawing, *Sailing Vessels and Longboats* (Figure 2), may be related, although it appears to represent a contemporary rather than a historical scene. William Dunlap wrote in 1832 that when West was painting this picture, "An admiral took him to Spithead, and to give him a lesson on the effect of smoke in a naval engagement, ordered several ships of the fleet to manoeuvre as in action, and fire broadsides, while the painter made notes."[11] A third drawing, of a naval battle (Figure 3), may also be a preliminary sketch.[12] Two friends served as models for figures. One was West's first painting teacher in America, William Williams, who had returned to England at the beginning of the American Revolution. West later wrote that he had "introduced a likeness of Williams in one of the Boats, next in the rear of Sir George Rook."[13] This suggests that Williams is the man in the hat with the feather on the far left, which is borne out by comparison with his late self-portrait of about 1788–1790 (The Henry Francis du Pont Winterthur Museum, Delaware).[14] Two other suggestions made in the past have been that Williams could also be the man blowing the trumpet, who at closer view does not look like the same person,[15] and that he is the rowing sailor in the center of the composition, a location that does not agree with West's description.[16] Joseph Wharton, Jr., also from Philadelphia, modeled for an unidentified figure in the painting.[17]

Reviews of the Royal Academy exhibition in 1780 declared that the *Battle of La Hogue* was one of West's best paintings. "West has some great

Pieces . . . No. 73, *The Destruction of the French Fleet off la Hogue*, exceeds all that ever came from Mr. West's Pencil."[18] "The Battle of the Boyne, and the Defeat of the French Fleet at La Hogue, two excellent historical Pictures by Mr. West, especially the latter, which seems to be one of the best Pictures he has ever painted."[19] "Candid," a writer to the *Morning Chronicle, and London Advertiser* for 20 May wrote that the painting was in West's "best stile, which is bold, chaste, and animated, though somewhat severe." In the *London Courant, and Westminster Chronicle* for 6 May, the commentary focused on the figure of the admiral. "The Admiral Sir George Rooke is a principal figure: he stands on the prow of his ship with his sword drawn, and seems eagerly panting for a nearer approach, that he may board the enemy." The reviewer added that this painting and that of the *Battle of the Boyne* "are both superb and correct compositions, and do infinite honour to the artist." One reviewer went further: "No. 73, the *Destruction of the French Fleet at La Hogue*, is a fine painted picture, and from the animation that pervades the whole, it is evident that Mr. West excels in great and spirited subjects; the several figures are naturally grouped, and the effects of the various passions in general characteristically discriminated."[20] The review continued with some criticism of the wigless Frenchman leaping for his safety and the sailor battling with a drowning man, details that viewers immediately notice today. "We object however to the disgraceful attitude of the French officer in the boat, and the sailor aiming a blow with his fist at a drowning man, in order to disengage himself from his grasp, as circumstances too ludicrous for the sublimity of such a composition."

An unidentified artist published *A Candid Review of the Exhibition*, in which he discussed the painting at great length, again in conjunction with its companion piece. "These pictures are now engraving and nearly finished by *Woollet* and *Hall*; and are intended as parts of a design to form a series of *English* history." The writer praised West's *Destruction of the French fleet at La Hogue*.

Here the Artist has excelled even himself: The moment chosen for the relation of the story is so exceedingly happy, the groups are so well contrived, and at the same time their forms so just, that they produce a most powerful effect. The smallness of the boats contrasted by the large ships, gives an idea of the danger which enhances the glory of the day. *Sir George Rook* is seen with that anxious, enterprizing look, mixed with a confidence of success, which tells the spectator the event of the action. There are several beautiful passages in the foreground. In one

place, while we see the *English* Sailors bearing down every thing before them, in others we see them nobly employed in endeavouring to save those whom they had overpowered. We cannot avoid remarking the beauty of the struggle in the water between an *English* and *French* Sailor. *Charles II* is seen on the coast of *France*, viewing the catastrophe. The clouds of smoak arising from the burning of one of the ships, contrasted by the clearness of the elements, give a striking effect of light and shade.

A correspondent to the *Gazetteer and New Daily Advertiser* for 15 May, signing himself "Another Artist," wrote a lengthy response that included a comment on this picture.

In the Great Room, I shall not follow you in your witticisms, but content myself with shewing your ignorance in point of history; for, to what else can we ascribe your having made Charles the Second present at the battle of La Hogue, which happened in the reign of King William and Queen Mary. You certainly meant his spirit hovering over the clouds of smoke, and enjoying the sight of his once loyal subjects fighting for the glory of their country.

For those who did not see the painting on exhibition, *The Battle of La Hogue* became widely known through William Woollett's engraving, which was later praised by English sculptor Joseph Nollekens as one of his best.[21] When Julius Ibbetson, an impoverished young artist, "laid out a solitary half guinea to subscribe to a print to be engraved of the Battle of La Hogue" in 1780, West told him that he could have an impression without paying the balance.[22] American author Joel Barlow mentioned the painting in the eighth book of "The Columbiad," his epic poem on America, in a discussion of West's works as an example of the progress of American art. "West with his own great soul the canvass warms. / Creates, inspires, impassions human forms, / Spurns critic rules, and seizing safe the heart, / Breaks down the former frightful bounds of Art; ... / Lahogue, Boyne, Cressy, Nevilcross demand / And gain fresh lustre from his copious hand."[23] Copies made from the engraving include one by Dutch painter Dirk Langendijk (1748–1805), who changed the subject to the destruction of the English fleet by the Dutch at Chatham in 1667. English painter George Chambers (1803–1840) painted a copy in 1836 (National Maritime Museum, Greenwich, England), and copies by unidentified painters are at Swarthmore College and in private collections. Nineteenth-century writers continued to praise the painting as one of West's best works. German artist John David Passavant wrote in 1836 that the painting was "a Sea piece, in

excellent grouping, the colouring also good; full of animation and expression in the figures."[24] The painting is included in the background of *The Fine Arts Commissioners of 1846* (National Portrait Gallery, London) by John Partridge as among a number of paintings chosen to represent the established masters of the English school.[25]

EGM

Notes

1. Von Erffa and Staley 1986, 209; for the owners' dates see Cokayne 1910, 12 (1959): 537–542.
2. British Institution 1851, 12.
3. *Art Treasures* 1857, 104, "Paintings by Modern Masters, English School, Saloon D." A label on the reverse also documents this loan.
4. For *La Hogue* see Von Erffa and Staley 1986, 209–210, no. 90. For a discussion of the paintings as a group see *Oliver Cromwell Dissolving the Long Parliament*, Von Erffa and Staley 1986, 204, 206, no. 83. For discussions and reproductions of the other three paintings, including *The Death of Wolfe*, see Von Erffa and Staley 1986, 206, 208–209, and 211–213, nos. 84, 88, and 93.
5. Von Erffa and Staley 1986, 68.
6. Von Erffa and Staley 1986, 75.
7. Fagan 1885, 52–53; the date first appears on the second state.
8. Gardner and Feld 1965, 29–32; Jaffe 1975, 70 fig. 44, 316; Cooper 1982, 26 fig. 8, 27; Von Erffa and Staley 1986, 210, no. 91.
9. Joseph Farington noted on 2 July 1806 that "West cleaned the two pictures belonging to His Lordship, the death of Wolfe & battle of La Hogue. He washed them and then passed oil over them part of which was absorbed in the night & the next [day] he rubbed off what was on the surface, the pictures appeared like *a diamond*." He saw both "*original* pictures" in West's studio on 8 July 1806; *Farington* 1982, 8:2803, 2806.
10. The gallery purchased the drawing from the sale of the collection of Maurice Bloch in 1990. It could be the drawing for the painting that is listed in Galt 1820, 233, and other early lists of West's work; see Dillenberger 1977, 183, no. 456.
11. Dunlap 1834, 1:65.
12. The two drawings at the Morgan Library are discussed in Kraemer 1975, 13–14, nos. 17 and 18, pl. 9. She also attributes to West an "elaborate compositional drawing" for the painting (British Museum, 1860.6.9.1), which Von Erffa and Staley 1986, 210, do not believe is by West.
13. West to Thomas Eagles, 10 October 1810; Dickason, "Letter," 1970, 132.
14. Dickason, *Williams*, 1970, 233 n. 60; Von Erffa and Staley 1986, 209 repro. (detail).
15. Dickason, *Williams*, 1970, 233 n. 60.
16. Flexner 1952, 41, from Eagles' description of Williams; Edgar P. Richardson also published this as the image of Williams, in Richardson 1972, 8 fig. 1, 9.
17. Alberts 1978, 127, cites Wharton's letter to West dated 20 December 1809 (Historical Society of Pennsylvania).

18. "Royal Academy," *Morning Chronicle, and London Advertiser*, 2 May 1780, 3; the same comment appeared in "Royal Academy," *London Chronicle*, 2–4 May 1780, 428.

19. "Exhibition 1780," *Public Advertiser*, 2 May 1780, 2.

20. "The Painter's Mirror," *Morning Post, and Daily Advertiser*, 4 May 1780, 3.

21. Smith 1829, 302.

22. The story was recorded by Joseph Farington in his diary on 24 January 1805 after West showed him Ibbetson's letter describing his attempts to become a painter; *Farington* 1982, 7:2503.

23. Barlow 1807, 310, lines 587–590, 597–598.

24. Passavant 1836, 1:158.

25. Staley 1986, 157 n. 90, in Von Erffa and Staley 1986; see Ormond 1967, 397–401, where the study of the deteriorated painting is reproduced.

References

1780 "An Artist." *A Candid Review of the Exhibition (being the twelfth) of the Royal Academy, MDCCLXXX. Dedicated to His Majesty.* 2d ed. London: 18.

1780 [Notice of the Opening of the Academy]. *London Evening-Post.* 29 April–2 May: 4.

1780 "Royal Academy." *Morning Chronicle, and London Advertiser.* 2 May: 3.

1780 "Exhibition 1780." *Public Advertiser.* 2 May: 2.

1780 "Royal Academy." *London Chronicle.* 2–4 May: 428.

1780 "The Painter's Mirror." *Morning Post, and Daily Advertiser.* 4 May: 3.

1780 "Exhibition of the Royal Academy." *London Courant, and Westminster Chronicle.* 6 May: 4.

1780 "Another Artist." "To the Author of *A Candid Review of the Exhibition (being the twelfth) of the Royal Academy, 1780.*" *Gazetteer, and New Daily Advertiser.* 15 May: 1.

1780 "Candid." "To the Printer of the Morning Chronicle." *Morning Chronicle, and London Advertiser.* 20 May: 2.

1796 Pasquin: 75–76.
1805 *Public Characters*: 561.
1805 *Universal Magazine*: 528.
1807 Barlow: 310, 432 n. 45.
1808 *Bell's Court*: 14, 19, 54.
1820 Galt: 2:220, 225, 233.
1821 Young: 7, no. 18, and pl. 7.
1829 Smith: 2:302.
1832 Hamilton: 4:280.
1834 Dunlap: 1:65, 88–91, 93, 125.
1836 Passavant: 1:158; 2:55, 221.
1838 Waagen: 2:173, 317, 318.
1844 Jameson: 284, no. 156.
1854 Waagen: 2:173.
1867 Tuckerman: 100–101.
1952 Flexner: 41.
1970 Dickason, "Letter": 132.
1970 Dickason, *Williams*: 41, 233 n. 60.
1975 Kraemer: 13–14, no. 17–18, and pl. 9.
1977 Dillenberger: 152, no. 141.
1978 Alberts: 127, 132, 145, 153, 165, 182, 326, 390, 397.
1981 Williams: color detail 2–3, 25, repro. 38–39, 40, 57.
1982 *Farington*: 7:2503, 2757; 8:2803, 2806.

1984 Walker: 372, no. 524, color repro.
1986 Von Erffa and Staley: 63, 68, 71 (color), 72–73 (detail, color), 75, 102, 157 n. 90, 190, 206, 209–210, 222.
1988 Wilmerding: 16, 50, 51 color repro.

1989.12.1

The Expulsion of Adam and Eve from Paradise

1791
Oil on canvas, 186.8 × 278.1 (73 ⁹⁄₁₆ × 109 ½)
Avalon Fund and Patrons' Permanent Fund

Inscriptions
Signed lower left: B. West / 1791

Technical Notes: The painting is on a heavy-weight, highly textured, twill-weave fabric. Most of all four original tacking margins remain, flattened down on the same plane as the painted area of the canvas. The fabric was prepared with a thick, off-white ground. The paint layer is applied rapidly, wet-in-wet, thinly in the background and in the animals at the lower right, where a good deal of the ground shows through, and more thickly in the figures of Adam, Eve, and the archangel. Low impastos are in the brightest highlights.

There are scattered paint losses, areas of abrasion along the right side, and craquelure in the figures. Areas of old overpaint are in the white clouds above and to the right of Adam's head, in two areas in the patch of blue sky below these clouds, in two areas in the dark clouds on the horizon to the right, in an area of the angel's wing, in two areas of the upper part of the angel's right sleeve, as well as a large area in the dark clouds beneath the angel's feet. Residues of discolored varnish over the entire painting have been retouched.

Provenance: Painted for George III of England but never delivered;[1] ownership rights returned in 1828 by George IV to the artist's sons Raphael Lamar West [1766–1850] and Benjamin West, Jr. [1772–1848]; sold (George Robins, London, 25 May 1829, no. 154); bought by Smith, apparently for Raphael West;[2] sold (George Robins, London, 16 July 1831, no. 40).[3] Private collection, Yorkshire, England; sold (Phillips, Son & Neale, London, 13 December 1988, no. 35);[4] bought by (Thomas Agnew and Sons, London); from whom purchased by the National Gallery of Art.

Exhibited: Royal Academy of Arts, 1791, no. 147, as *The Expulsion of Adam and Eve from Paradise, for his Majesty's chapel, Windsor-castle.* West's Gallery, Newman Street, London, 1821, no. 47; 1822–1828, no. 98.

BENJAMIN WEST's recently rediscovered painting of the expulsion of Adam and Eve from the garden

of Eden was part of the ambitious cycle of paintings that he designed for King George III for a royal chapel at Windsor Castle. In 1779 the king asked West to decorate the private chapel with "a pictorial illustration of the history of revealed religion,"[5] which would represent the stages in which, according to conservative Anglican theology, God's purpose was revealed to man through biblical prophecies. The artist spent more than twenty years working on the project before it was abandoned when he fell out of royal favor. In that time West completed at least eighteen paintings, left one unfinished, and exhibited sketches for a number of others for the chapel project, which was the largest commission given to any individual in England at this time.[6]

Elements of the overall program of the chapel and the number of paintings changed over the years. The final design appears to have called for more than thirty scenes from the four stages or "Dispensations" of revealed religion. Publications of West's works after 1801 divide these stages into the Antediluvian and Patriarchal, the Mosaical, the Gospel, and Revelations. *The Expulsion of Adam and Eve from Paradise* was the earliest in the biblical narrative sequence, although it was not the first painting completed for the chapel.[7] Many Anglican theologians held that the expulsion was the occasion for God's first prophecy of man's future,[8] making West's expulsion scene an appropriate starting point for the chapel's theme. Its intended location within the chapel is uncertain. It may be the picture planned for the space labeled "Adam," one of three subjects on an end wall beneath a large crucifixion, as shown in a diagram of the chapel made around 1801 (Friends Historical Library, Swarthmore College, Pennsylvania).[9] Of the three, the space on the left is unlabeled, that in the middle is titled "Supper" (the Last Supper), and that on the right is marked "Adam."

The emotionally charged painting shows an angel in white, a coral red drape swirling around him as he ejects Adam and Eve from Eden. Overhead is a spear of bright light. Eve, dressed in a white animal skin robe, looks up at the angel, while Adam, draped in a brown animal skin, covers his eyes. The three figures are brightly lit, while dark clouds fill the left side of the composition. The sky to the right, over a large body of water, is also darkened, but breaks in the clouds reveal a blue sky. In the air to the right an eagle attacks a heron, while on land, a lion pursues two horses, one dark and one light. In the fore-ground are a large snake and various plants, including a thistle. West's preparatory oil study, which he painted in 1791 and retouched in 1803 (Figure 1), agrees generally with the final composition of the painting, although there is no spear of light and Eve's animal skin robe covers only her hips.[10]

The subject of the painting is found in the biblical book of Genesis, chapter 3, verses 21–24. After Adam and Eve have eaten the prohibited fruit,

the Lord God made for Adam and for his wife garments of skins, and clothed them. Then the Lord God said, "Behold, the man has become like one of us, knowing good and evil; and now, lest he put forth his hand and take also of the tree of life, and eat, and live for ever" — therefore the Lord God sent him forth from the garden of Eden, to till the ground from which he was taken. He drove out the man; and at the east of the garden of Eden he placed the cherubim, and a flaming sword which turned every way, to guard the way to the tree of life.

West has represented some elements of the biblical account literally. Adam and Eve wear animal skins in accordance with Genesis, and the flaming sword is included as a spear of light. The thistle is present because after God cursed the serpent for tempting Eve, he told Adam, "Cursed is the ground because of you; in toil you shall eat of it all the days of thy life; thorns and thistles it shall bring forth to you" (Genesis 3:17–18).

The painting also represents the expulsion as described by John Milton in Book XI of *Paradise Lost*. In Milton's version, God sent the archangel Michael to escort Adam and Eve from the garden (lines 99–111), seeing that they were "soft'nd and with tears bewailing thir excess." God asked Michael to place a four-faced cherubim to guard the way to the tree of life with a sword of flame. Eve assumed that they would be able to remain in the garden, but Adam recognized the eagle and the lion in pursuit of prey as omens of change.

> Nature first gave Signs, imprest
> On Bird, Beast, Aire, Aire suddenly eclips'd
> After short blush of Morn; nigh in her sight
> The bird of *Jove*, stoopt from his airie tour
> Two Birds of gayest plume before him drove:
> Down from a Hill the Beast that reigns in Woods,
> First Hunter then, pursu'd a gentle brace,
> Goodliest of all the Forrest, Hart and Hinde;
> Direct to th' Eastern Gate was bent their flight.
> (XI, lines 182–190)[11]

Adam addressed Eve:

> O Eve, some furder change awaits us nigh,
> Which Heav'n by these mute signs in Nature shews

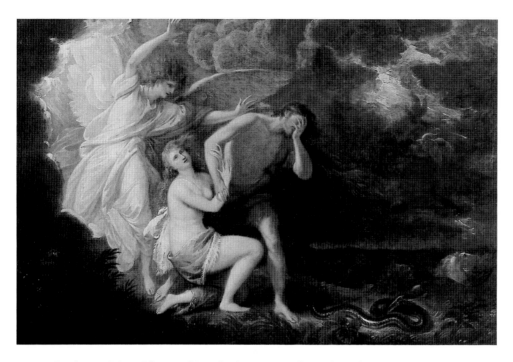

Fig. 1. Benjamin West, *The Expulsion of Adam and Eve from Eden*, oil on canvas, 1791,
The Art Institute of Chicago, George F. Harding Collection [photo: copyright 1993,
The Art Institute of Chicago, All Rights Reserved]

Forerunners of his purpose....
Why else this double object in our sight
Of flight pursu'd in th' Air and oer the ground
One way the self-same hour? why in the East
Darkness ere Daye's mid-course, and Morning light
More orient in yon Western Cloud that draws
O'er the blew Firmament a radiant white,
And slow descends, with some thing heav'nly fraught.
<div align="right">(XI, 193–195, 201–207)</div>

Before they left Paradise, Michael foretold the future of humanity, including redemption and the Last Judgment. As they left the garden,

High in Front advanc't
The brandisht Sword of God before them blaz'd
Fierce as a Comet.
. .
Som natural tears they drop'd, but wip'd them soon;
The world was all before them, where to choose
Thir place of rest, and Providence thir guide:
They hand in hand with wandring steps and slow
Through Eden took their solitarie way.
<div align="right">(XII, 632–634, 645–649)</div>

The painting thus represents Adam and Eve at the moment of the expulsion.

West developed his composition from traditional interpretations of the scene in Western art, including perhaps the first illustrated editions of *Par-*

adise Lost. He emulated the Italian Renaissance tradition that showed an anguished Adam holding his head in his hand and a solemn Eve turning her eyes upward. These gestures are found in Masaccio's Brancacci Chapel fresco of about 1425 as well as in the fresco in the Vatican Loggia that was completed by Raphael's workshop around 1518, both well-known images that were frequently engraved in later centuries. West also may have been familiar with a drawing owned by George III that was believed to be a preparatory sketch by Raphael for the Loggia expulsion scene.[12] He may have consulted illustrated editions of *Paradise Lost* that continued these visual traditions in the poses of the figures of Adam and Eve, showing them walking out of the garden, Adam covering his eyes in shame, Eve looking back at the angel. Among these are the illustrations that John Baptist Medina composed for the first illustrated English edition of *Paradise Lost*, published by Jacob Tonson in 1688, Louis Cheron's illustration for the edition of *The Poetical Works* of Milton published by Tonson in 1720, and Francis Hayman's image for the edition of *Paradise Lost* that Bishop Thomas Newton, an early patron of West, published in 1749.[13] West, however, departed from the Renaissance pictorial tradition and followed Mil-

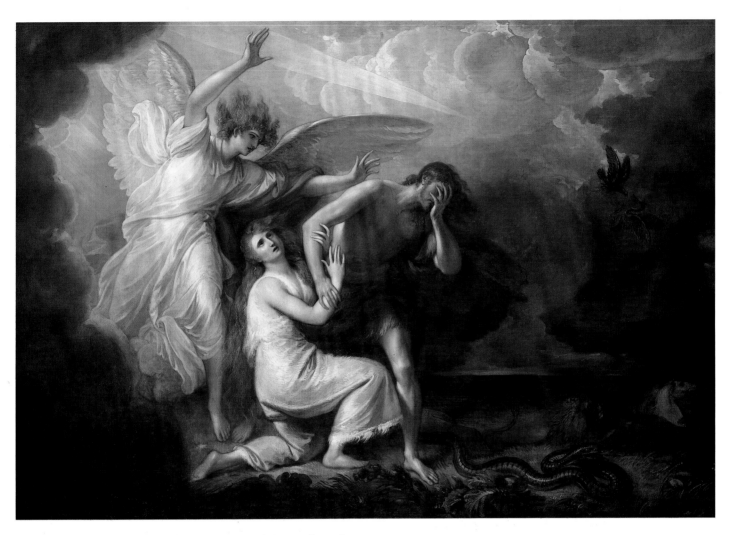

Benjamin West, *The Expulsion of Adam and Eve from Paradise*, 1989.12.1

Fig. 2. Benjamin West, *The Expulsion of Adam and Eve*, black chalk on paper, c. 1791, New York, The Pierpont Morgan Library, Purchased as the Gift of Mrs. Robert H. Charles, 1970.11:65

ton's words by showing Adam and Eve holding each other by the arms. He also depicted Eve kneeling, an unusual image. A drawing that could be an early study for the composition shows Adam and Eve standing, with Adam's right arm around Eve (Figure 2).[14]

West's setting and animal imagery resemble some of the images in these early illustrated editions of Milton's epic. Medina's illustration *Michael Comes to the Garden* and Hayman's *Michael Foretells the Future* both show similarly dramatic landscape settings and similar birds in flight.[15] West, however, developed his image of the eagle attacking the heron in a preparatory drawing of 1783 for a different theme, *Death on a Pale Horse* (Royal Academy of Arts, London), where it is seen in the upper left. He omitted the image from his oil study of 1796 of the same subject (The Detroit Institute of Arts) but reintroduced it in the background of the final work of 1817 (PAFA).[16] The illustrations disagree with each other and with West about the appearance and identity of the angel. Milton described the archangel

Michael as present at the expulsion, leading Adam and Eve from the garden.

> In either hand the hastning Angel caught
> Our lingring Parents, and to th' Eastern Gate
> Led them direct, and down the Cliff as fast
> To the subjected Plaine; then disappeer'd.
> They looking back, all th' Eastern side beheld
> Of Paradise, so late thir happie seat,
> Wav'd over by that flaming Brand, the Gate
> With dreadful Faces throng'd and fierie Armes:
> (XII, 637–644)

When *The Expulsion* was exhibited at the Royal Academy of Arts, reviewers identified the angel as Michael. If West intended the figure to be Michael, however, he deviated from Milton's description of the archangel wearing "a militarie Vest of purple" and a "starrie Helme" (helmet) (XI, 240–248). One illustrator, Francis Hayman, showed Michael dressed in this military fashion, accompanying Adam and Eve at the expulsion. In the scenes of the expulsion by Medina and Cheron, however, Adam and Eve are accompanied by a winged, draped angel similar to that by West. This was not Michael, who in their other illustrations wears military clothing.

When West exhibited *The Expulsion of Adam and Eve from Paradise* at the Royal Academy in 1791 with his *Abating of the Waters after the Deluge* (unlocated), the *Whitehall Evening Post* wrote that West's two works were "such as will be approved by the admirers of this master" and noted that few historical pictures were in the exhibition.[17] Some reviewers quoted lines from *Paradise Lost*, including the *Morning Chronicle* for 5 May, which began its description of the picture with the poem's final lines, describing the sinners' departure from Paradise. In the *Morning Post, and Daily Advertiser* for 31 May, the critic wrote,

Mr. West's general tone of colouring and style of drawing we have not taste enough to admire, but his pictures are invariably well studied, and his figures judiciously grouped. The figure of Eve is highly interesting. Adam is well drawn, and covers his face to hide his affliction. The Archangels appear,
> "Not in his shape celestial, but as man
> Clad to meet man."
And in the air:
> "The bird of Jove, stopp'd from his airy tour,
> Two birds of gayest plume before him drives."[18]

Some reviewers focused on the "pathetic" nature of the scene, a concept associated with the religious sublime and distinguished by both "heroically elevating and tender subjects" that induce strong sen-

timental reactions.[19] The critic of the *Public Advertiser* praised the painting as "finely expressive and pathetic," while he described the *Deluge* as "awful, grand, and striking" and *Satan after the Fall*, a scene from *Paradise Lost* by West's son Raphael, as "terribly grand, and sublime!"[20] The *London Chronicle* of 30 April–3 May described the paintings as possessing all of West's "usual accuracy and merit" and called the *Deluge* "a grand picture for sublimity and effect."[21] The *Oracle* declared the *Expulsion* "a very fine picture, and, in our idea, infinitely preferable to the retiring Deluge."[22]

There was also considerable criticism. The *Evening Mail* on 2–4 May described the two paintings as "not the works of a great master."[23] There was considerable debate about Eve's animal skin clothing, which apparently led West to retouch the small oil sketch (Figure 1). The writer in the *St. James's Chronicle* on 30 April declared about the *Expulsion*, "The whole tolerably grouped. The Adam expressive and characteristick; but the Eve too artificially clothed; and the colouring too monotonous."[24] The writer in the *Times* on 5 May complained that West had attempted to give the often illustrated biblical scene some originality "by cloathing the universal mother of mankind in a fringed petticoat. The group of figures is very well imagined, and the accessory parts naturally introduced." Apparently unaware of the biblical basis for West's decision, the reviewer continued, "But what part of the Talmud, or from what Rabbinical information Mr. West feels himself to be justified in such a breach of the *costume*, is beyond the reach of our conjecture: — as we, who have no knowledge of the event here described, but from our Bible, have been in the habit of believing, that the whole paraphernalia of Eve, consisted in an apron of fig leaves."[25] The *Morning Chronicle* for 5 May continued this theme.

By a happy union of engaging tenderness, enchanting delicacy, and feminine sensibility, the Figure of Eve is rendered peculiarly interesting and attractive; but the skin in which she is wrapped, being turned inside out, gave us at first sight the idea of a straw coloured silk; and we were on the point of inquiring at whose loom it was weaved. The Arch-Angel's garment leads to the same enquiry; but we may suppose it is of an angelic texture, and a paradisaical manufactory. Adam is a manly and characteristic figure, and Michael has that sort of countenance and character which we have seen in the Angels of *Raffaelle Divino*. Considered as a whole, the drawing, composition, above all the colouring of this picture, are superior to almost any we have seen from the pencil of his Majesty's Historical Painter.[26]

West, in his chapel paintings, gradually moved toward an emotionally charged manner. Unlike his earlier history paintings, including *The Battle of La Hogue* [1959.8.1], with their clarity of form and carefully applied local color, the *Expulsion* and other large paintings for the chapel are more broadly painted. While the figures are closely depicted, the darker areas are more generalized. West undoubtedly planned for the scale of the completed project, in which each painting would be seen at a distance, set in a large architectural framework that would give the works their impact. Contemporaries, however, began to prefer the small oil sketches exhibited at the Royal Academy. Allen Staley summarized the difficulty, noting that West's "lively handling disappeared when the sketches were worked up into large finished pictures," leading to fewer commissions for West's very large works.[27]

When *The Expulsion of Adam and Eve from Paradise* was sold in 1829, the auction catalogue described the subject: "Expelled from Paradise by the Angel, overwhelmed with mental agony, these beings, so recently innocent and happy, have suddenly opened before them a wide world, the first step into which is terror, gloom and sadness. Never was painted story more emphatically told. It is a masterpiece of the pathetic of the graphic art."[28] Two years later the sales catalogue grouped it with *The Deluge* (lot 41) and *The Crucifixion* (lot 39) by West as suitable for the altar of the private chapel of "any great personage." It concluded, "Such a series so placed, could not but tend to awaken even the most torpid mind, to a certain sense of serious mediation."[29]

CJM

Notes

1. The painting is listed in West's manuscript account for 1797 of works painted for George III, with the price of £525 (Historical Society of Pennsylvania), and in his 1801 account, printed as the first appendix to Galt 1820, 209, "The Account of Pictures painted by Benjamin West for His Majesty, by his Gracious Commands, from 1768 to 1780. A True Copy from Mr. West's Account Books, with their several Charges and Dates"; see Von Erffa and Staley 1986, 286, and for a discussion of these accounts, 159–160, 579.

2. *Historical Pictures* 1829, 46; Von Erffa and Staley 1986, 286.

3. *Raphael West* 1831, 7.

4. *British Paintings* 1988, 46.

5. Galt 1820, part 2, 53. For modern scholarship on the chapel see Pressly 1983, 15–25; Meyer, "Religious Paintings," 1975, 114–159; Meyer, "Chapel," 1975, 247–265; Dillenberger 1977, 44–93; and Von Erffa and Staley 1986, 577–581.

6. George IV retained only *The Last Supper*, now in the

Tate Gallery, London. The other pictures were dispersed at sales by West's sons. Seven are now owned by Bob Jones University, Greenville, South Carolina.

7. A list of West's "finished pictures" in Barlow 1807, 431, includes an *Adam and Eve Created* for the royal chapel, but there is no other mention of that painting's existence, and it is missing from West's account of 4 December 1804 of works he painted for the king; see *Academic Annals* 1805, 63–69. Von Erffa and Staley 1986, 286, conclude, "It seems certain that it was never painted."

8. For example see Bayly 1751; Newton 1754; and Hurd 1772.

9. See Von Erffa and Staley 1986, 580, repro.

10. See Von Erffa and Staley, 286, no. 233, 49.5 by 72.5 cm (19 ½ by 28 ½ inches). In a recent examination the signature "B. West. 1791. Retouched 1803." was observed and x-radiography revealed that Eve's clothing agreed initially with the NGA painting. The sketch was exhibited at the Royal Academy in 1805 with the text from Genesis 3:21–23; Graves 1905, 218, no. 86.

11. With the exception of the lines that appeared in newspaper reviews and are quoted below, the citations from *Paradise Lost* are from *Milton* 1947, 333–363, books XI and XII.

12. Gere 1987, 163–166, no. 43, repro.

13. On these illustrations see Pointon 1970, 1–57, especially 26 fig. 24, 30 fig. 29, and 56 fig. 52. For a discussion of expulsion scenes in relation to the imagery in *Paradise Lost* see Frye 1978, especially 308–325.

14. Kraemer 1975, 32, no. 50, repro. pl. 29.

15. Pointon 1970, 9, fig. 10 and 50, fig. 43.

16. Von Erffa and Staley 1986, 388–392, nos. 401–403, repros. The author is grateful to Allen Staley for pointing out West's transfer of imagery from one work to another.

17. "Royal Academy. The Twenty-third Exhibition," *Whitehall Evening Post*, 30 April–3 May 1791, 4. An abbreviated version of this review appeared in "Royal Academy," *Morning Post, and Daily Advertiser*, 3 May 1791, 2. Clare Lloyd-Jacob of the Paul Mellon Centre for Studies in British Art, London, kindly provided copies of many of these reviews. On West's *Deluge* see Von Erffa and Staley 1986, 286–287, no. 234, and the study, 287, no. 235. Since the study is signed "B. West 1790 / Retouched 1803," it apparently preceded the *Expulsion* in conception; Allen Staley kindly pointed this out to the author.

18. "The Royal Exhibition," *Morning Post, and Daily Advertiser*, 31 May 1791, 3.

19. Evans 1959, 83–86.

20. "Royal Academy, Somerset-Place," *Public Advertiser*, 3 May 1791, 2.

21. "Royal Academy Dinner and Exhibition," *London Chronicle*, 30 April–3 May 1791, 423; a version of this review appeared in the *Morning Chronicle*, 2 May 1791, 3.

22. "Royal Academy," *Oracle*, 3 May 1791, 2.

23. "Royal Academy, No. I," *Evening Mail*, 2–4 May 1791, 3; the article was reprinted in the *Times*, 4 May 1791, 2.

24. "The Exhibition of the Royal Academy for 1791," *St. James's Chronicle; or, British Evening Post*, 30 April–3 May 1791, 4.

25. "Royal Academy. No. II. Mr. West, Historical Painter to His Majesty," *Times*, 5 May 1791, 3. The writer

in the *Times* for 9 May commented again about the "fringed petticoat"; "Royal Academy IV," 2.

26. "The Royal Academy. (Continuation.)," *Morning Chronicle*, 5 May 1791, 2.

27. Von Erffa and Staley 1986, 102.

28. *Historical Pictures* 1829, 46.

29. *Raphael West* 1831, 7.

References

1791 "The Exhibition of the Royal Academy for 1791." *St. James's Chronicle; or, British Evening Post*. 30 April–3 May: 4.

1791 "Royal Academy Dinner and Exhibition." *London Chronicle*. 30 April–3 May: 423.

1791 "Royal Academy. The Twenty-third Exhibition." *Whitehall Evening Post*. 30 April–3 May: 4.

1791 "Royal Academy Dinner and Exhibition." *Morning Chronicle*. 2 May: 3.

1791 "Royal Academy. No. I." *Evening Mail*. 2–4 May: 3.

1791 "Royal Academy." *Morning Post, and Daily Advertiser*. 3 May: 2.

1791 "Royal Academy." *Oracle*. 3 May: 2.

1791 "Royal Academy, Somerset-Place." *Public Advertiser*. 3 May: 2.

1791 "Royal Academy. No. I." *Times*. 4 May: 2.

1791 "The Royal Academy. (Continuation)." *Morning Chronicle*. 5 May: 2.

1791 "Royal Academy. No. II. Mr. West, Historical Painter to His Majesty." *Times*. 5 May: 3.

1791 "Royal Academy IV." *Times*. 9 May: 2.

1791 "The Royal Exhibition." *Morning Post, and Daily Advertiser*. 31 May: 3.

1797 Benjamin West. Manuscript account of paintings for George III. 20 June. Historical Society of Pennsylvania, Philadelphia.

1805 *Public Characters*: 560.

1805 *Universal Magazine*: 527.

1805 *Academic Annals*: 66.

1807 Barlow, "Note 45 [list of works by Benjamin West]": 431.

1808 *Bell's Court*: 14.

1820 Galt: 209, 218.

1821 *West*: 18, no. 47.

1828 *West*: 27, no. 98.

1975 Kraemer: 32, no. 50, repro. pl. 29.

1975 Meyer, "Religious Paintings": 284.

1975 Meyer, "Chapel": 247–265.

1977 Dillenberger: 58–63, 133, 143, 193, 208, 233.

1983 Pressly: 15–25.

1986 Von Erffa and Staley: 286, no. 232; 577–581.

1947.17.101 (1009)

Elizabeth, Countess of Effingham

c. 1797
Oil on canvas, 146.3 × 115.6 (57 ⅝ × 45 ½)
Andrew W. Mellon Collection

Inscriptions
Signed, lower right: B. West
Inscribed on the back of the canvas in a later hand: Elisabeth Countess of Effingham / Daughter of Peter Beckford Esq:ʳ

Technical Notes: The canvas is a medium-weight, plain-weave, somewhat loosely woven fabric on its original stretcher, which has been modified into a strainer. The painting has never been lined, and the original tacks hold the fabric in position. Wooden shims (1.5 cm wide) are nailed to all four edges. Paint continues over the shims, indicating that they are original. The nine-member stretcher has a central horizontal crossbar, diagonal corner braces, and butt-joined, mortise-and-tenon corners.

The red ground, probably applied by the artist, provides warm shadows in some flesh tones, as well as a middle tone in the drapery. The paint is applied in a fluid manner that ranges from thin washes and sketchy strokes, especially in the lower left, to a thicker, more carefully worked application in the central part of the figure and in the face. Prominent brush stroke texture is present in all colors with little final blending except in the flesh tones and furs. The impasto of the highlights is fluid and thick. The red curtain originally extended from the right across the top of the painting, behind the figure, to within 5 cm of the upper left edge. West later repainted the area with clouds and sky. There is a small puncture above the sitter's head, and two small repaired losses at the lower right. The thick varnish has discolored.

Provenance: William Beckford [1760–1844], Fonthill Abbey, Wiltshire, and Bath, England; his daughter Susan Euphemia Beckford, 10th Duchess of Hamilton [1786–1859], Hamilton Palace, County Lanark, Scotland; by descent to William Alexander Louis Stephen Douglas-Hamilton, 12th Duke of Hamilton [1845–1895]; his estate sale, (Christie, Manson and Woods, London, 6 November 1919, no. 77); bought by (Tooth Brothers, London);[1] sold 4 February 1920 to Thomas B. Clarke [1848–1931], New York;[2] his estate; sold as part of the Clarke collection on 29 January 1936, through (M. Knoedler & Co., New York), to The A.W. Mellon Educational and Charitable Trust, Pittsburgh.

Exhibited: Union League Club, November 1921, no. 18. Philadelphia 1928, unnumbered.

WEST'S PORTRAIT of Elizabeth, Countess of Effingham is one of four family portraits that he painted for William Beckford of Fonthill Abbey in

the late 1790s.[3] Beckford, the son of Maria Hamilton and William Beckford of Jamaica, inherited the family sugar cane fortune when his father died in 1770.[4] Although he was a member of Parliament from Wells (1784–1790) and Hindon (1790–1794, 1806–1820), he spent much of his life on the continent or in virtual isolation at his family estate Fonthill, in Wiltshire. He devoted himself to his art collection and to the construction of Fonthill Abbey, the extravagant Gothic Revival monument that replaced Fonthill Splendens, the earlier Palladian-style house. Beckford began plans to build Fonthill Abbey by 1796. The Abbey was part of his self-conscious creation of an aristocratic heritage. One of its most imposing wings, the King Edward Gallery, was emblazoned with coats of arms of the Knights of the Garter and displayed portraits of the kings from whom Beckford claimed descent. In addition to the portraits, West created paintings or stained glass images of scenes from the book of Revelations for the Abbey.[5]

The group of four family portraits that West painted were part of Beckford's desire to secure his noble ancestry. The sitter in this portrait is Beckford's aunt Elizabeth (1725–1791), daughter of Peter Beckford, speaker of the House of Assembly in Jamaica. She married Thomas Howard, 2nd Earl of Effingham (1714–1763), and, after his death, Sir George Howard (d. 1796). One of the most socially prominent members of the family, she was Lady of the Bedchamber to Queen Charlotte from 1761 to 1769. The other three portraits in the group represent Beckford's mother Mrs. William Beckford [1947.17.23] and his ancestors Peter Beckford and his wife Mrs. Peter Beckford (1797, MMA).[6] These four portraits were done on canvases that were unusually large for paintings then termed "half-lengths," which were normally painted on a canvas 127 by 101.6 cm (50 by 40 inches) in size.[7] They are all posthumous and are purposefully historical in composition and technique. That of Peter Beckford imitates portraits by early seventeenth-century English painter Sir Anthony Van Dyck, and that of Mrs. Peter Beckford appears from its clothing to imitate early eighteenth-century English portraits. The portrait of Beckford's mother depicts her as she would have appeared in the 1760s, while *Elizabeth, Countess of Effingham* is reminiscent of portraits of the aristocracy by mid-eighteenth-century painters Thomas Hudson and Allan Ramsay and their contemporaries.

Characterized by bold colors and broad brush-

Fig. 1. X-radiograph, upper left section of 1947.17.101

with his mother. I well remember both of them petting me."[10]

The portraits were intended as decorative additions to Fonthill's public spaces. When the four paintings hung at Splendens, John Britton described them in his *Beauties of Wiltshire* (1801) as above the four doors of the saloon or drawing room.

Over the four doors are as many three-quarter portraits, copied by West, from originals in a gallery on the chamber floor. They represent the late Mrs. Beckford, who was daughter, and one of the co-heirs, of the Honourable George Hamilton; Elizabeth Countess of Effingham, sister to the Lord Mayor [Beckford's father], his mother, daughter and heir of Colonel Julines Herring, and his father, Peter Beckford, Esq.[11]

Despite his remarks that they were "copied by West," it is unclear whether West's portraits were based on existing images. Portraits of the countess and Mrs. William Beckford by Andrea Casali (c. 1700–1784) were at Fonthill in the 1760s with other family portraits, but they are now unlocated.

Fig. 2. Benjamin West, *Countess of Effingham*, black and white chalk on blue paper, c. 1797, London, British Museum [photo: Courtesy, The Trustees of the British Museum]

work, this portrait can be dated to about 1797 on the basis of its similarity in technique to the portraits of Mr. and Mrs. Peter Beckford, which are signed and dated 1797. Elizabeth wears the robes of a peeress, her coronet resting on the draped plinth to her right. Such formal dress was worn at state occasions and suggests the countess' presence at the coronation of George III in 1760. The portrait once included a drapery like those of Mr. and Mrs. Peter Beckford, but West reworked the area with clouds and sky. X-radiographs show the fringe and tassel of the drapery in the upper left section of the painting (Figure 1). West's careful study for the costume (Figure 2) also includes this curtain, as well as a wall behind the figure.[8] Beckford may have included his aunt in the series because she provided a connection with the royal family. As Lady of the Bedchamber, she was a member of the court and had an apartment at St. James's Palace.[9] Beckford later reminisced about King George II that "I was not a year old when he died, but the King saw me when I was an infant in arms in my Aunt Effingham's apartment in St. James's Palace. She was a great favorite with the young King George III and

Benjamin West, *Elizabeth, Countess of Effingham*, 1947.17.101

They are described in a letter from William Beckford's tutor Robert Drysdale to his friend Robert Nairne, written sometime between 13 October 1768 and 19 December 1769. The letter quotes Elizabeth Marsh, Mrs. Beckford's daughter from her first marriage: "My Papa & Mama's portraits by Casali, are on each side of it [a white marble fountain], and opposite to these are my Papa's Mother's & Lady Effingham his sister's."[12] Beckford referred to West's portraits in 1822 as "West's great dauberies" and later moved this portrait to his mansion in Bath, where a visitor, H.V. Lansdown, saw it in 1838 in the room that Beckford called the "Duchess Drawing Room."[13]

LKR / EGM

Notes

1. *Hamilton* 1919; annotated copy, Frick Art Reference Library, New York (copy, NGA).

2. The name of the seller and the date of purchase are recorded in an annotated copy of *Clarke* 1928 in the NGA library.

3. Gardner 1954, 41–49; Hamilton-Phillips 1980, 157–174; Von Erffa and Staley 1986, 490–493, nos. 592–594 and 504–505, no. 615. The four portraits were grouped together in early lists of West's works as four half-lengths painted for William Beckford.

4. On Beckford see Fothergill 1979; Alexander 1957; and *DNB* 2:82–85. Beckford, who married Lady Margaret Gordon in 1783, was socially ostracized the following year when, after an involvement with William ("Kitty") Courtenay of Powderham Castle, he was accused of pederasty, a crime punishable at the time by death. He also was romantically entangled with Louisa Beckford, his cousin by marriage, a scandal that cost him a hoped-for peerage.

5. Von Erffa and Staley 1986, 102–103.

6. Gardner and Feld 1965, 34–35; Von Erffa and Staley 1986, 490–492, nos. 592–593, repro. These two paintings represent either William Beckford's grandparents or his great-grandparents.

7. William P. Campbell noted that the frames of the four paintings are identical (NGA).

8. Hamilton-Phillips 1980, 164–165, fig. 10.

9. Letter from David Rankin-Hunt, assistant to the surveyors, The Royal Collection, St. James's Palace, 23 May 1991 (NGA). Her husband the Earl of Effingham was Deputy Earl Marshal.

10. Redding 1859, 1:299.

11. Britton 1801, 230, who clearly believed that the two portraits at The Metropolitan Museum of Art were of William Beckford's grandparents.

12. Von Erffa and Staley 1986, 492, refer to these portraits. Nairne's (unlocated) letter was copied by John W. Oliver, William Beckford's biographer, and in turn by Boyd Alexander, who provided the information to Helmut von Erffa in a letter dated 7 July 1959; the information is quoted here courtesy of Allen Staley.

13. Letter to the Abbé Macquin, 7 August 1822, in

Alexander 1957, 336 (original in French, translated by Alexander). Describing the numerous public visitors to Fonthill Abbey that summer, Beckford poked fun at their discomfort at not being able to use the water closets hidden behind the wainscotting of the room where the portraits were hung. Lansdown 1893, 9, described it as "a portrait of the Countess of Effingham, Mr. Beckford's aunt."

References

1801	Britton: 1:230.
1805	*Public Characters*: 561.
1805	*Universal Magazine*: 528.
1808	*Bell's Court*: 14.
1820	Galt: 220
1859	Redding: 2:369–370.
1893	Lansdown: 9.
1954	Gardner: 41–49.
1957	Alexander: 336.
1977	Dillenberger: 151, no. 135.
1980	Hamilton-Phillips: 157–174, repro.
1986	Von Erffa and Staley: 107, 504–505, no. 615, repro.

1947.17.23 (931)

Maria Hamilton Beckford (Mrs. William Beckford)

1799
Oil on canvas, 146.0 × 115 (57 1/2 × 45 1/4)
Andrew W. Mellon Collection

Technical Notes: The painting is on a medium-weight, plain-weave canvas with many thread irregularities. The nine-member mortise-and-key stretcher, with a central crossbar and four diagonal corner members, is original. The canvas has never been removed from the stretcher or lined, and the tacks have rusted in place in the original tack holes. The fabric is covered with a moderately thick red ground that shows through the paint layer and provides a middle tone to the painting. The ground was not applied on the tacking margins. Infrared reflectography reveals underdrawing outlining her upper left arm and the ruffles of the sleeve of her dress, and painted washes indicating the shadows in her skirt. There may be underdrawing in a dry medium in the laying out of the architecture to the right of the sitter. The paint layer ranges in application from thin and fluid in the sky to heavy and paste-like in the figure. There are both wet-in-wet and wet-over-dry brush strokes; the handling is broad and free.

The sitter originally wore a veil over her head and shoulders, which can be seen in an x-radiograph (Figure 1). Also the top of the musical instrument was a trefoil shape. There are pentimenti of completed areas of foliage underneath some of the architectural images. There are small scattered losses. The heavily applied varnish has yellowed.

Provenance: William Beckford [1760–1844], Fonthill Abbey, Wiltshire, and Bath, England; his daughter Susan Euphemia Beckford, 10th Duchess of Hamilton [1786–1859], Hamilton Palace, County Lanark, Scotland; by family descent to William Alexander Louis Stephen Douglas-Hamilton, 12th Duke of Hamilton [1845–1895]; his estate sale, (Christie, Manson and Woods, London, 6 November 1919, no. 74, as *Lady Elizabeth Gordon, mother of William Beckford, Esq.*); bought by (Tooth Brothers, London);[1] sold 4 February 1920 to Thomas B. Clarke [1848–1931], New York;[2] his estate; sold as part of the Clarke collection on 29 January 1936, through (M. Knoedler & Co., New York), to The A.W. Mellon Educational and Charitable Trust, Pittsburgh.

Exhibited: Union League Club, November 1921, no. 5, as Elizabeth Gordon, Countess of Sutherland. *Exhibition of Paintings and Drawings by Benjamin West and of Engravings Representing His Work*, The Brooklyn Museum, New York, 1922, no. 24, as Elizabeth Gordon, Countess of Sutherland. Philadelphia 1928, unnumbered, as Elizabeth Gordon, Countess of Sutherland. Kentucky 1970, unnumbered. *The Grand Tour: The Tradition of Patronage in Southern Art Museums*, Montgomery, Alabama, 1988–1989, unnumbered.

THIS PORTRAIT of William Beckford's mother Maria Hamilton Beckford is one of four family portraits that Beckford commissioned from West in the late 1790s (see 1947.17.101).[3] It is dated to 1799 by an invoice for eighty-four pounds, for "painting the Portrait of Mr. Beckford's Mother," sent by West to Nicholas Williams, Beckford's agent, on 30 September of that year.[4] Maria Hamilton (c. 1724–1798) was the daughter of George Hamilton, the second son of James, 6th Earl of Abercorn. Widowed after her first marriage, in 1756 she married William Beckford, senior (1709–1770), a London alderman who was twice elected Lord Mayor. West depicted Mrs. Beckford as she might have appeared in the 1760s, seated in front of Fonthill Splendens, the Palladian-style mansion built by her husband between 1756 and 1765. The house was torn down by her son in 1807 but is known today from eighteenth-century engravings.[5] She is shown with all the signs of wealth and refinement. Her dark blue dress, edged at the sleeves and neck with a fine, transparent lace, is in the style fashionable at that time.[6] She turns the pages of a large book bound with a warm yellow cover, and an English guitar rests at her side.[7] The pages of the book and the neck of the guitar echo the falling curve of her extended arm; the spray of multicolored flowers and the shawl, striped in gold, black, white, and blue, reiterate the compositional diagonal from upper left to

Fig. 1. X-radiograph of the sitter's head and shoulders, 1947.17.23

lower right. A wooded landscape rises behind Splendens, and peacocks wander on the grass.

Mrs. Beckford differs in technique from the other three portraits in the series. Here West worked the paint more carefully, which lends Mrs. Beckford's portrait a certain softness and precision. Perhaps West consciously chose a technique that was typical of his own mid-century portraits. While he was deliberately creating a new visual ancestry for his patron, West at the same time may have relied on existing portraits for the likeness. John Britton commented in 1801 that the four portraits were "copied by West, from originals in a gallery on the chamber floor" (see 1947.17.101).[8] However, two preparatory sketches for this painting, on two sides of the same sheet of paper (Figures 2 and 3) suggest that if West used an earlier portrait as a source, it would have been for the likeness and not for the composition.[9] In one sketch West, experimenting with poses, changed the position of Mrs. Beckford's arms several times and shows the flowers to the right of the figure. In the other he worked out the final pose, adding the musical instrument and sketching in an outline of Fonthill Splendens in the background.[10]

Beckford in 1822 remembered the spirit in which the portraits were created, calling them "West's great dauberies."[11] H.V. Lansdown, a visitor to Beckford's mansion in Bath in 1838, saw the painting in the room that Beckford called the "Duchess Drawing Room." He described it to his daughter as "a portrait of Beckford's mother painted by West, with a view of Fonthill in the background," and criticized West's manner in comparison to Joshua Reynolds' *Mrs. Peter Beckford, later Lady Rivers* (Lady Lever Art Gallery, Port Sunlight), then in the same collection. "Never was there a greater contrast in this and the last picture; West certainly knew nothing of portrait painting. The *tout ensemble* of the portrait in question is as dry and hard as if painted by a Chinese novice."[12]

LKR / EGM

Notes

1. *Hamilton* 1919, 21; annotated copy, Frick Art Reference Library, New York (copy, NGA).

2. The name of the seller and the date of purchase are recorded in an annotated copy of *Clarke* 1928 in the NGA library.

3. Gardner 1954, 41–49; Hamilton-Phillips 1980, 157–174; and Von Erffa and Staley 1986, 490–493, nos. 592–594, and 504–505, no. 615. The four portraits were grouped together in early lists of West's works as four half-lengths painted for William Beckford; citations of those early catalogues are from Von Erffa and Staley 1986, 490, 492.

4. The invoice is on page 69 of a scrapbook titled "Galt's Benjamin West" that accompanies the copy of Galt 1820 owned by the Historical Society of Pennsylvania, Philadelphia.

5. See, for example, the engraving by James Storer after John Britton in Britton 1801, opp. 208. Part of Fonthill Splendens was demolished in 1801; it was torn down completely in 1807.

6. Cunnington and Cunnington 1972, 266–280. Hamilton-Phillips 1980, 166 n. 32, dates the pearl necklace to the 1760s by comparison to George Romney's portrait of Nelly O'Brien of 1763 (Wallace Collection, London).

7. Hamilton-Phillips 1980, 166; *Grove's Dictionary of Music* 3:848–849: "About 1756–58 there was introduced from the Continent the Italian form of *cetra* referred to as the English guitar. . . . In spite of its feeble quality, the

Fig. 2. Benjamin West, *Sketch for a seated woman with a musical instrument*, black chalk on gray paper, c. 1799, New York, The Pierpont Morgan Library, Purchased as the Gift of Mrs. Robert H. Charles, 1970.11:188 verso

Fig. 3. Benjamin West, *Sketch for a seated woman with a musical instrument*, black chalk on gray paper, c. 1799, New York, The Pierpont Morgan Library, Purchased as the Gift of Mrs. Robert H. Charles, 1970.11:188 recto

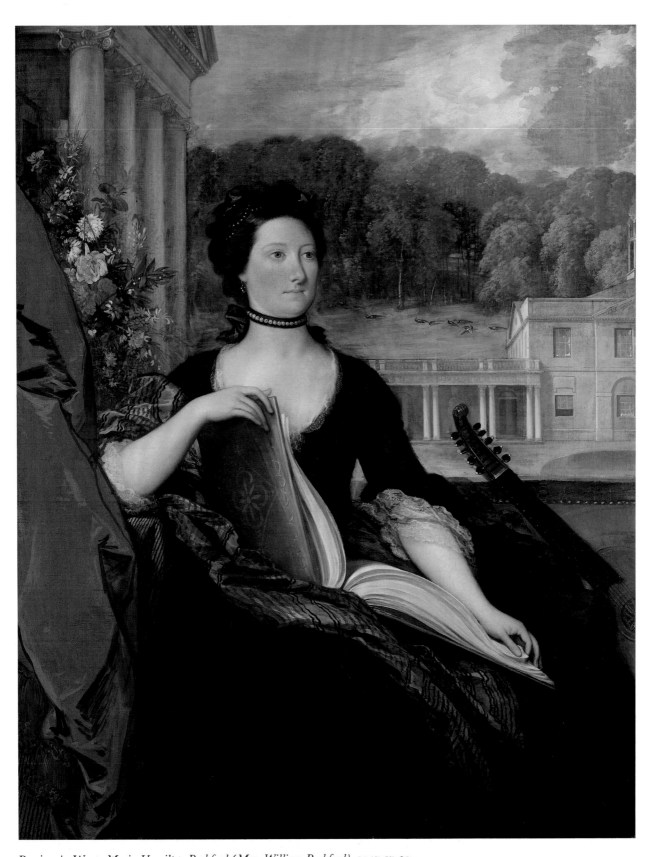

Benjamin West, *Maria Hamilton Beckford (Mrs. William Beckford)*, 1947.17.23

English wire-strung guitar had considerable popularity, being the feminine substitute for the German flute, then in such favour with the male amateur."

8. Britton 1801, 1:230.

9. Kraemer 1975, 71–72, no. 158, black chalk heightened with white, on gray paper; some outlines are reinforced with black ink.

10. According to Hamilton-Phillips 1980, 166, West painted the English guitar over a cello or gamba. X-radiographs indicate only that there once was a floral shape at the top of the instrument.

11. Letter to the Abbé Macquin, 7 August 1822, in Alexander 1957, 336 (original in French, translated by Alexander).

12. Lansdown 1893, 9.

References
1801 Britton: 1:230.
1805 *Public Characters*: 561.
1805 *Universal Magazine*: 528.
1808 *Bell's Court*: 14.
1820 Galt: 220.
1859 Redding: 2:369–370.
1893 Lansdown: 9.
1937 Chapman: 9, repro. opp. 40, 244.
1954 Gardner: 41–49.
1975 Kraemer: 71–72, no. 158, pls. 86, 87.
1977 Dillenberger: 151, no. 135.
1980 Hamilton-Phillips: 157–174, repro.
1981 Williams: 57, repro. 59.
1986 Von Erffa and Staley: 107, 493, no. 594, repro.

After Benjamin West

1942.8.39 (592)

Benjamin West

c. 1776
Oil on canvas, 75.8 × 63 (29 $^{13}/_{16}$ × 24 $^{13}/_{16}$)
Andrew W. Mellon Collection

Technical Notes: The painting is on a medium-weight, plain-weave fabric with many irregularities. X-radiography reveals cusping on all sides and suggests that the ground, which is not visible beneath the opaque paint layers, is based on a non-dense material. The paint is applied over a brown imprimatura. The face is delicately handled, while the body is more broadly worked. The body color is opaque and thicker than the thin washes and glazes used in the shadows and background. Originally there was a curtain on the right and the composition was in an oval format with painted spandrels. Both the curtain and the spandrels have been covered with overpaint, extending the composition to the edges of the canvas.

There is a large three-corner tear in the upper right background. There are small areas of damage in the sleeve and along the top edge. The thick varnish is extremely discolored.

Provenance: (Tooth Brothers, London, 1919), sold 15 May 1919 to Thomas B. Clarke [1848–1931], New York;[1] his estate; sold as part of the Clarke collection on 29 January 1936, through (M. Knoedler & Co., New York), to The A.W. Mellon Educational and Charitable Trust, Pittsburgh.

Exhibited: *Exhibition of Paintings and Drawings by Benjamin West and of Engravings Representing His Work*, The Brooklyn Museum, New York, 1922, no. 25.[2] Union League Club, March 1924, no. 9. Philadelphia 1928, unnumbered. *John Trumbull and His Contemporaries*, Lyman Allyn Museum, New London, Connecticut, 1944, no. 139. *Early American Portraits and Silver*, J.B. Speed Memorial Museum, Louisville, Kentucky, 1947, no cat.[3] Columbia 1950, no. 21. *Benjamin West: His Times and His Influence*, Mead Art Museum, Amherst College, Massachusetts, 1950, no. 4.[4] *From Plymouth Rock to the Armory*, The Society of the Four Arts, Palm Beach, Florida, 1950, no. 23. Atlanta 1951, no. 6. Chattanooga 1952, unnumbered. Mint Museum of Art, Charlotte, North Carolina, 1952, no cat. Hagerstown 1955, no cat. *Faces of America*, El Paso Museum of Art, Texas, 1960–1961, no cat. *Inaugural Exhibition*, Museum of Fine Arts, St. Petersburg, Florida, 1965, no. 5. *The Age of Queen Charlotte, 1744–1818*, Mint Museum of Art, Charlotte, North Carolina, 1968, no. 33. *Drawings by Benjamin West and His Son Raphael Lamar West*, The Pierpont Morgan Library, New York, 1975.[5] *Benjamin West and His American Students*, NPG; PAFA, 1980–1981, no. 52.

THIS PORTRAIT, a contemporary copy of Benjamin West's self-portrait of about 1776 (Figure 1), was accepted for many years as by West himself.[6] After the two paintings were compared in the conservation department of the National Gallery of Art in 1983, the Baltimore painting was considered by all viewers to be the original.[7] The brushwork in the copy is less free than in the original, and the detail less precise. The fabric weaves of the two paintings, however, are similar, the application of the ground

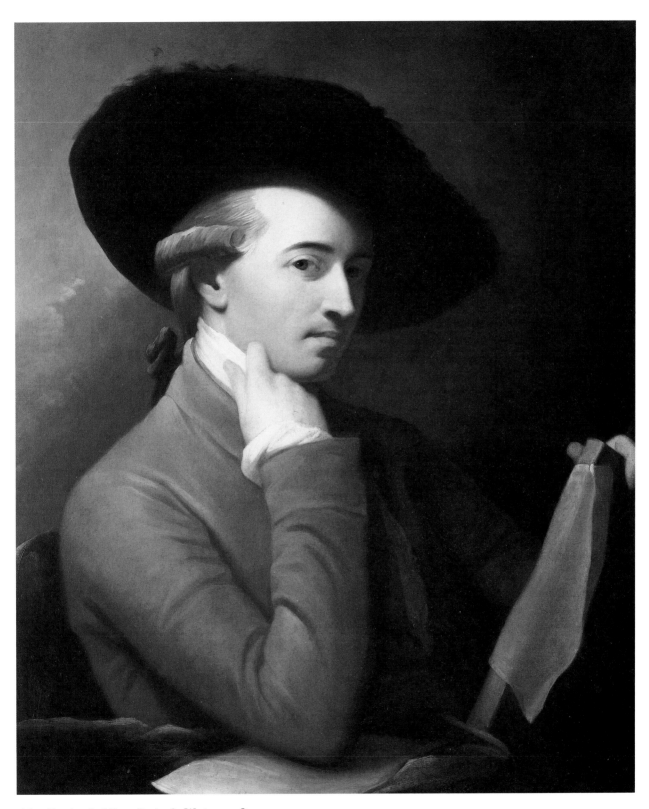

After Benjamin West, *Benjamin West*, 1942.8.39

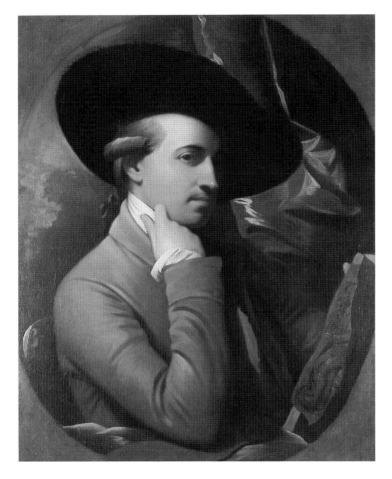

Fig. 1. Benjamin West, *Self-Portrait*, oil on canvas, c. 1776, The Baltimore Museum of Art, Gift of Dr. Morton K. Blaustein, Barbara B. Hirschhorn, and Elizabeth B. Roswell, in Memory of Jacob and Hilda K. Blaustein, BMA 1981.73

the background, as revealed in the x-radiograph (Figure 2).

The Baltimore portrait is dated around 1776 by the artist's style and by the inclusion of a drawing of two figures from *The Death of General Wolfe* (1770, National Gallery of Canada, Ottawa), the painting for which West is best known today.[8] Its fame was increased dramatically after the publication of William Woollett's engraving in January 1776. The large, round hat and the angle of the image "suggest his [West's] conscious emulation of the well-known self-portrait by Rubens in the English Royal Collection, which by 1776 he certainly would have known first-hand."[9] Another American artist in London, Gilbert Stuart, imitated the Rubens self-portrait in his own self-portrait of 1778 (Redwood Library and Athenaeum, Newport, Rhode Island),[10] and he has been suggested as the possible author of this copy. However, there is no obvious stylistic similarity with his other early work, and no documentation indicates that he copied West's portrait.

In addition to this eighteenth-century copy are modern copies of varying quality, including one in the Alexander Smith Cochran collection of historic portraits at Philipse Manor Hall State Historic Site, Yonkers (New York State Office of Parks, Recreation and Historic Preservation), which has been identified as an overpainted chromolithograph. Like Thomas Clarke, the first American owner of the National Gallery's painting, Cochran formed his collection of historical portraits in the early decades of the twentieth century.[11]

EGM

identical, and the handling of the paint, as seen in x-radiographs, very similar, suggesting that it is a contemporary copy.

In both paintings West wears a blue coat and a black hat, and his hair is powdered to appear gray. The copy differs from the original primarily in the lack of any detail on the drawing that West holds, and in some aspects of the coloring. In the Baltimore painting the paper West holds is blue, and he leans on a blue surface that could be paper or a piece of drapery. In the copy he sits in a red chair, and a large area of red appears along the lower part of the painting, perhaps intended as drapery. The paper he holds is white, and he leans his elbow on a second sheet of white paper. Other differences in the appearances of the paintings are the result of modern overpainting. The copy originally repeated the oval format of the original and included drapery in

Notes

1. The name of the seller and the date of purchase are recorded in an annotated copy of *Clarke* 1928 in the NGA library. Correspondence about the sale was with G. Stanley Sedgwick, who seems to have had a business arrangement with the Tooth Brothers and with Clarke. His letters of 14 and 24 April and 5 May 1919 precede the shipping notice from Hensel, Bruckmann & Lorbacher dated 13 May 1919, announcing the arrival of the painting in New York (NGA). Additional correspondence indicates that Sedgwick hoped to locate other works by Gilbert Stuart for Clarke's collection and was searching for *The Skater* [1950.18.1] and portraits of the Hartigans [1942.8.16], Luke White [1942.8.28], and the Pollocks [1942.8.18 and 1942.8.19] (NGA Clarke collection files).

2. The painting was lent anonymously. The loan is confirmed in *Brooklyn Quarterly* 1922, 138, and the painting is illustrated in Rosenthal 1922, 134. The original portrait from which this was copied was also in the exhibition, as no. 2; see below, n. 6.

3. *Speed Bulletin* 1947, unpaginated.

4. The paintings in the exhibition are discussed in Morgan and Toole 1950, 203–278.

5. The portrait is not included in Kraemer 1975, which served as the exhibition catalogue as well as a catalogue of the collection of West drawings owned by the Morgan Library.

6. The Baltimore painting is discussed in Johnston 1983, 179–180, no. 158, repro., and Von Erffa and Staley 1986, 451–452, no. 526, repro. (color), vi.

7. Memo from Charlotte Hale, NGA conservation intern, 6 October 1983; NGA conservation department files.

8. Von Erffa and Staley 1986, 58 (color repro.), 211–213, no. 94.

9. Von Erffa and Staley 1986, 451.

10. Evans 1980, 52; the relationship of the three images is also discussed in *Copley, Stuart, West* 1976 by Jonathan Fairbanks in the introduction, 12, and by Lucretia Giese in the catalogue entry, 32, no. 21 (West's self-portrait) at The Baltimore Museum of Art.

11. Saunders 1993, 144, repro. 145, fig. 48.

References

1922	Rosenthal: 134 repro.
1922	*Brooklyn Quarterly*: 138.
1928	Lee: repro. 298.
1950	Morgan and Toole: 209.
1973	Van Devanter: 765–766.
1977	Dillenberger: 6, repro.
1980	Wilmerding: 12, repro.
1980	Evans: 52, 56 fig. 35.
1981	Williams: 40, color repro. 43.
1983	Johnston: 179 (repro.), 180.
1984	Walker: 375, no. 528, color repro.
1986	Von Erffa and Staley: 452.

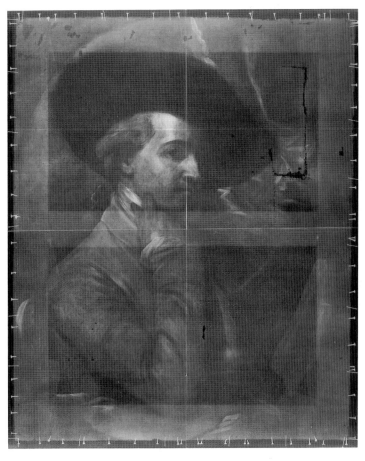

Fig. 2. X-radiograph of 1942.8.39 showing painted oval and drapery

John Wollaston

active 1742 – 1775

JOHN WOLLASTON was the son of London portrait painter John Wollaston (c. 1672–1749). His life dates are unknown. His first firmly documented portrait is of evangelist George Whitefield (1742, National Portrait Gallery, London). Part of his training took place with "a noted drapery painter in London," according to Charles Willson Peale.[1] This undoubtedly was Joseph van Aken (c. 1699–1749), who completed the draperies for portraits by several London portrait painters, including Thomas Hudson and Allan Ramsay. Not surprisingly, Wollaston's work often resembles theirs.

In 1749 Wollaston immigrated to New York City, where he introduced London's fashionable styles in portraiture to American patrons. His portraits featured rich fabrics, graceful poses, and smiling faces with upturned lips and oval eyes. In the next three years he painted portraits of almost fifty New York merchants and landowners and their families. In 1752 Wollaston went south, visiting Philadelphia briefly before arriving in Annapolis by the spring of 1753. In the next year or two he painted about sixty portraits of Maryland sitters. He then moved on to Virginia, where be-

tween 1755 and 1757 he painted about as many portraits, continuing to use compositions that he had learned in London, which by the mid-1750s were less fashionable but still impressive.

Wollaston returned to Philadelphia by the fall of 1758 and was last recorded there in May 1759. Next he may have gone to the West Indies. He arrived in Charleston in September 1765 and painted at least seventeen portraits there before returning to London in May 1767. These late American works represent figures on a smaller scale than the monumental sizes—127 by 101.6 cm (50 by 40 inches)—that were preferred by sitters in Maryland and Virginia. Except for a chance encounter in England in 1775 with an acquaintance from the Leeward Islands, nothing is known of Wollaston after 1767.

Wollaston was a competent but not very inventive painter who produced more than two hundred portraits in the colonies, almost as many as John Singleton Copley in the same number of years. He traveled more widely in the colonies than any other painter, satisfying the growing demand for formal portraiture for the new homes of the members of the merchant and land-owning classes. His work was praised in poetry published in the *Maryland Gazette* in 1753 and in the *American Magazine and Monthly Chronicle for the British Colonies* in 1758, where Francis Hopkinson's verses to "Mr. Wollaston, An eminent face-painter" advised the young Benjamin West, "Let his just precepts all your works refine, Copy each grace, and learn like him to shine."[2] Wollaston's impact on younger artists was felt especially in Philadelphia, where Robert Feke, West, and John Hesselius imitated his technique and compositions in their own work.

EGM

Notes

1. Letter to Rembrandt Peale, 28 October 1812, Miller 1983, 3:173.

2. *American Magazine and Monthly Chronicle for the British Colonies* (Philadelphia) 1, no. 12 (September 1758), 607–608.

Bibliography

Bolton and Binsse, "Wollaston," 1931: 30–33, 50, 52.
Groce 1952: 132–149.
Craven 1975: 19–31.
Weekley 1976.
Saunders and Miles 1987: 176–182.

1947.17.105 (1013)

Unidentified British Navy Officer

c. 1745
Oil on canvas, 127.3 × 101.9 (50 ¹⁄₈ × 40 ¹⁄₈)
Andrew W. Mellon Collection

Technical Notes: The support is a tightly woven, plain-weave fabric. Shallow cusping is found along all four edges. The white ground is moderately thick and fills the interstices of the fabric. An opaque, gray imprimatura lies under the figure. The thin, fluid paint is smoothly laid in. The only impasto is in the ornament of the gold braid and the white highlights. The blue coat is worked up with a monochrome underpainting followed by a blue glaze. Elsewhere the paint is opaque. The dark background paint is brought up to the coat but does not overlap, and the hair was laid in after the background and the face.

Extensive repaint in the chin and white cravat has discolored. The lines defining the sitter's right eyelid and the upper and lower lids of the sitter's left eye have been strengthened, as has a portion of each pupil. Another line of retouching extends from the top left edge through the sitter's right elbow. The surface is slightly abraded. A flattening of the impasto may be due to a past lining. The varnish was removed in 1970. Older, discolored varnish residues can be seen in the impasted paint beneath the present thick, clear varnish.

Provenance: (Rose M. de Forest [Mrs. Augustus de Forest], New York);[1] purchased 2 March 1927 by Thomas B. Clarke [1848–1931], New York;[2] his estate; sold as part of the Clarke collection on 29 January 1936, through (M. Knoedler & Co., New York), to The A.W. Mellon Educational and Charitable Trust, Pittsburgh.

Exhibited: *Exhibition of Paintings by Early American Portrait Painters*, Century Club, New York, 1928, no. 15. Philadelphia 1928, unnumbered. Kentucky 1970, unnumbered. Georgia Museum of Art, University of Georgia, Athens, on long-term loan, 1972–1974.

THE SITTER wears a teal blue coat and a white waistcoat trimmed with gold braid, holds a telescope, and stands next to a cannon. His clothing, which is cut in the style of the early to mid-1740s, suggests, in combination with the ships in the background, that he is an officer in the royal navy. Flags flying on the larger of the two ships associate it with the red squadron, one of three divisions of the British navy. The mast pennant is red, and the flag at the stern, with a pinkish white field and a white corner in the upper left with a pattern of radiating blue lines, can be identified as the red navy ensign.[3] The sitter's blue coat does not conform to the 1748 regulations that were the first to govern the color

John Wollaston, *Unidentified British Navy Officer*, 1947.17.105

and cut of navy uniforms.[4] It lacks the white lapels, white cuffs, and gold buttons of a uniform of the post-1748 period, as seen, for example, in Joshua Reynolds' portrait of First Lieutenant Paul Henry Ourry (c. 1755, Morely Collection, The National Trust, Saltram, Plymouth).[5] Therefore, the portrait was probably painted before that date, at a time when naval officers had considerable freedom of choice in their clothing, including even its color.[6]

The identification of the sitter is elusive. Thomas B. Clarke acquired the painting as a portrait of Archibald Kennedy (1718–1794), the son of Archibald Kennedy, receiver-general for the province of New York and collector of customs.[7] The younger Kennedy was born in New York and entered the British navy on 16 December 1744 as a lieutenant on the *Otter*, a sloop. He was made a commander in 1756, and captain of the *Vestal* in 1757. He served in the navy in the Mediterranean and the eastern Atlantic until the mid-1760s, when he returned to New York. In 1792, when his cousin David Kennedy died, he inherited the title

Fig. 1. Unknown artist, *Archibald Kennedy, Earl of Cassillis*, oil on canvas, c. 1792, Culzean Castle, National Trust for Scotland, Ayrshire [photo: copyright National Trust for Scotland]

of the Earl of Cassillis in the English peerage and settled on the family estate in Scotland. The identification of the sitter as Kennedy seems unlikely. While the undocumented early provenance of the painting provides no evidence for or against the identification, comparison with a later portrait, done after Kennedy became the Earl of Cassillis (Figure 1), suggests that the sitter is not Kennedy, since the features of the two men differ significantly.[8]

The attribution to Wollaston is sound; the portrait resembles other examples of his work in both style and composition. The shaping of the eyes and mouth into ovals, the zig-zag highlighting on the sleeves, the angular depiction of the cravat, and the curvilinear treatment of the hands, especially the fingers, are familiar from other portraits. Similarly sized American images include those of William Walton (New-York Historical Society) and Nathaniel Marston (Museum of the City of New York), which, though not identical in pose, use the same type of gestures and exhibit the same pattern of highlighting and shadow.[9] It is possible that Wollaston painted this portrait in England before he came to New York in 1749, and that it was offered for sale in the 1920s with an American identification to satisfy the market for American colonial portraits. Comparison with Wollaston's other portraits of navy officers in uniform does not provide a solution, since at least two—those of Admiral Augustus Keppel (Bayou Bend Collection, Museum of Fine Arts, Houston) and Sir Charles Hardy (The Brooklyn Museum, New York), which may also be incorrectly identified—show men in uniforms of the mid-1750s.[10]

EGM

Notes

1. The provenance provided for this portrait by Mrs. de Forest was from the sitter's second wife Anne Watts Kennedy to her cousin Stephen de Lancey, North Salem, New York, to his wife Hannah Sackett de Lancey (1751–1836) and her descendants, to Julia Baldwin Titus (b. 1825), Geneva and Albany, New York. This provenance was given for thirteen portraits sold to Clarke by de Forest. No evidence has been found to support such a history for this group of paintings; see Rutledge and Lane 1952, 64.

2. The name of the seller and the date of purchase are recorded in an annotated copy of *Clarke* 1928 in the NGA library. The receipt for payment is also dated 2 March 1927 (NGA).

3. Letter from Roger Quarm, Curator of Pictures, National Maritime Museum, Greenwich, London, 13 May 1992 (NGA).

4. Jarrett 1960, 30–33.

5. Penny 1986, 76 (color repro.), 173–174, no. 11.

6. Jarrett 1960, 26.

7. Rutledge and Lane 1952, 64, questioned both the identification and the attribution. The painting was most recently catalogued as *Lieutenant Archibald Kennedy (?)*, c. 1750; see NGA 1992, 384.

8. On Kennedy see Charnock 1798, 252–255; *Royal Navy* 1954, 2:511 (copy with annotations by Commander C.G. Pitcairn Jones, courtesy of Roger Quarm, Curator of Pictures, National Maritime Museum); and Cokayne 1910, 3:80. Further research would be required to determine whether the ship in the background could be the *Otter* and whether the sloop was part of the red squadron of the British navy.

9. See *New-York Historical Society* 1974, 2:852, no. 2161 repro.; Groce 1952, 155, fig. 6. Ellis K. Waterhouse commented on 29 April 1975 that the painting was "very close to Wollaston, if not by him" (NGA).

10. Brooklyn Museum 1979, 126 repro.; Warren 1975, 130, no. 244 repro.

References

1931 Bolton and Binsse, "Wollaston": 50.
1952 Rutledge and Lane: 64.
1981 Williams: 16–17, color repro. 41.

1942.8.41 (594)

A Gentleman of the Morris Family

1749/1752
Oil on canvas, 76.4 × 63.4 (30 1/16 × 25)
Andrew W. Mellon Collection

Technical Notes: The painting is on a plain-weave, medium-weight fabric that exhibits cusping at the top and bottom but not at the sides. The thin ground is white. The paint is flat, smooth, and evenly applied. The darker colors are fluid and rich, though not transparent. The painting of the features is very sure, with single brush strokes marking their placement. The face and hair adjoin exactly with little overlap. After the face and clothing were painted, the hair appears to have been brushed loosely over the completed background and figure. The background color was in place before the overall concept of the figure was completed, but the contours were adjusted later. The hat and spandrels were painted last.

There is an old tear in the upper right and a second tear below the final waistcoat button. A minor paint loss is found in the hair to the left of the face. The surface has general abrasion, compensated with tiny strokes of retouch, and there are large, sweeping retouches around the hair, along the neckline, in the left shoulder of the sitter's coat, and in the lower left spandrel. The varnish is markedly discolored.

Provenance: Henry Manigault Morris [1817–1892], New York;[1] his widow Georgia Edwards Morris [d. 1894], New York; her brother-in-law Charles Manigault Morris [1820–1895], Baltimore; his widow Clementina Morris, Baltimore; their son Lewis Morris [b. 1867], Neponsit, New York;[2] sold 26 May 1922 to (William Macbeth, New York);[3] sold 4 December 1923 to (Art House, Inc., New York);[4] Thomas B. Clarke [1848–1931], New York;[5] his estate; sold as part of the Clarke collection on 29 January 1936, through (M. Knoedler & Co., New York), to The A.W. Mellon Educational and Charitable Trust, Pittsburgh.

Exhibited: Union League Club, March 1924, no. 20. Philadelphia 1928, unnumbered. United States Constitution Sesquicentennial Commission, *Loan Exhibition of Portraits of the Signers and Deputies to the Convention of 1787 and Signers of the Declaration of Independence*, CGA, 1937–1938, no. 184. *The World of Franklin and Jefferson*, The American Revolution Bicentennial Administration, traveling exhibition, 1975–1977, not in cat. M.H. de Young Memorial Museum, San Francisco, on long-term loan, 1977–1979.

THIS SITTER wears a light brown coat, a white vest, and a white shirt; he holds a black hat under his left arm. Painted spandrels fill the corners of the canvas. The features, coat, and waistcoat are all painted in Wollaston's familiar style, with abbreviated strokes. The subject of the portrait was identified by at least 1881 as Lewis Morris (1726–1798), a graduate of Yale College in 1746 and owner of "Morrisania," the family manor in present-day Westchester County, New York. Chairman of the delegation from Westchester to the New York provincial convention in 1775, he became a member of the second Continental Congress that same year. A brigadier general in the Westchester militia, Morris signed the Declaration of Independence for New York and after the Revolution served in the state legislature.[6]

The subject's identification, however, has been questioned since 1922. Boston dealer Frank Bayley succinctly summarized the dilemma when he telegraphed Macbeth Galleries in 26 January 1923 about the painting: "Send all informations about Morris must prove it a portrait of Lewis Morris."[7] A second Wollaston portrait has also been identified as Lewis Morris (Figure 1).[8] The identification is documented by an engraving of the painting that is inscribed "Painted by Wollaston Engraved by Burr LEWIS MORRIS Published by Andrew Maverick 1818 21 Liberty Street New York" (Figure 2).[9] Comparison with the only other portrait of Morris, by John Trumbull in his *Declaration of Independence* (YUAG), supports the identification of the National Portrait Gallery's painting as Morris, since the sitter has a round face similar to the double-chinned

man seen in profile in the background of Trumbull's painting on the far left.[10]

The confusion of the two portraits probably occurred when both were owned by descendant Henry M. Morris of New York, along with other family portraits. In his collection by 1881 were the Gallery's portraits, described as "General Lewis Morris, signer of the Declaration of Independence and Brigadier-General in the Continental army, dressed in [an] olive-green coat; [and] Mary Walton, wife of the signer, dressed in a light blue silk dress." The National Portrait Gallery's painting was apparently the one misidentified as "Isaac Gouverneur, dressed in a blue coat and a red waistcoat."[11]

<div align="right">EGM</div>

Notes

1. According to Bolton 1881, 484, this portrait and that of the sitter's wife Mary Walton Morris [1942.8.40] were inherited with other family portraits at "Morrisania," the Morris manor house in Westchester County, New York. Previous owners were identified as Lewis Morris [1752–1824] and his son Lewis Morris [1785–1863],

Fig. 1. John Wollaston, *Lewis Morris*, oil on canvas, c. 1750, Washington, The National Portrait Gallery, Smithsonian Institution

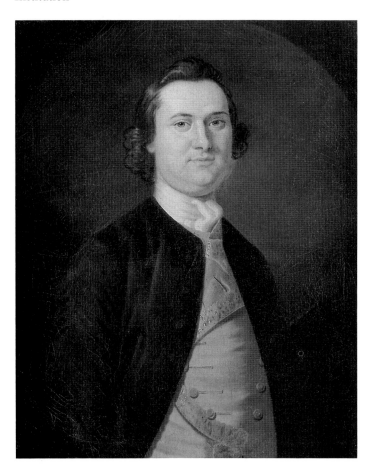

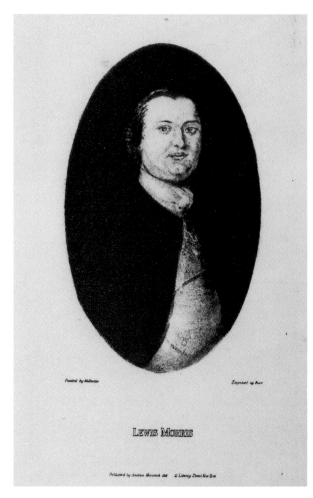

Fig. 2. Burr after John Wollaston, *Lewis Morris*, engraving, undated (photostat), Washington, The National Portrait Gallery, Smithsonian Institution

father of Henry Manigault Morris. For the genealogy of this family see Spooner 1906, 136–142, 321–323, 427–428.

2. Lewis Morris provided the names of past owners to dealer William Macbeth in 1922 in letters and in a handwritten document; see the Correspondence Files, Macbeth Gallery Papers, AAA. A family tree with owners' names and dates was prepared by the Macbeth Gallery to clarify the provenance.

3. The sale is documented by a receipt signed for Lewis Morris by his agent Margaret Stiles, 26 May 1922; Correspondence Files, Macbeth Gallery Papers, AAA.

4. Stock disposition card, Macbeth Gallery Papers, AAA. Art House, Inc., was the dealership that Thomas B. Clarke established.

5. The name of the seller and the date of purchase, 4 December 1923, are recorded in an annotated copy of *Clarke* 1928 in the NGA library. The date is the same as the purchase of the painting from Macbeth by Art House, Inc., showing the close connection between the firm's holdings and Clarke's personal collection.

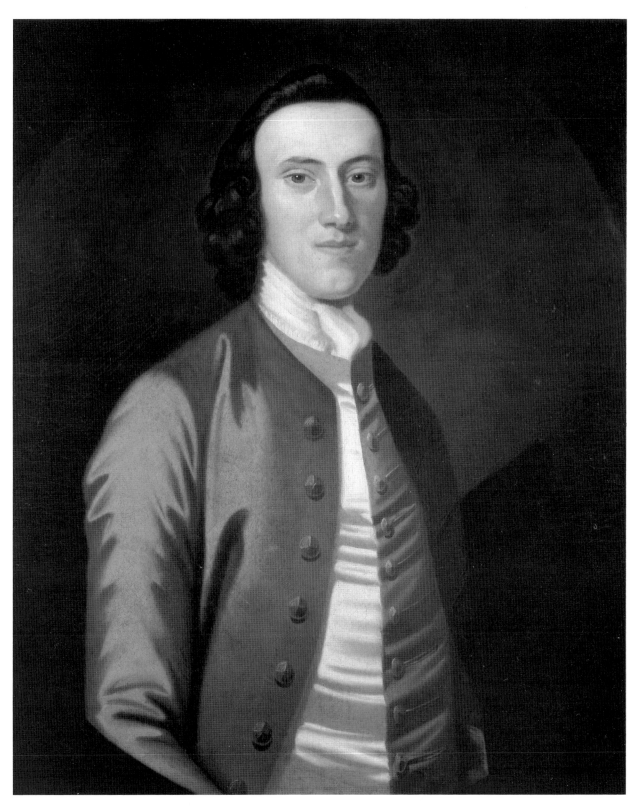

John Wollaston, *A Gentleman of the Morris Family*, 1942.8.41

6. Spooner 1906, 136–142; *DAB* 7 (part 1):214–215.

7. Correspondence Files, Macbeth Gallery Papers, AAA.

8. The painting, acquired in 1978 from dealer Victor Spark, was previously owned by Mrs. John L. Baber of Arlington, Virginia, whose mother Dora Alderson Curtis bought it from Lewis Morris, former owner of the NGA portrait.

9. The photostat, which is the only record of the engraving, was given to the National Portrait Gallery by Victor Spark when the Gallery acquired its portrait of Morris. The original from which the photostat was made was inscribed "Rough Trial Proof 3 / 19 / 47 [?] Please return." No engraver named Burr has been identified. The publisher, a member of the Maverick family of engravers, had his shop at 21 Liberty Street, New York, from 1816 until his death ten years later; Stephens 1950, 182.

10. Sizer 1967, 55, repro. fig. 158 and key, fig. 159. An engraving of this portrait by H.B. Hall is reproduced as the frontispiece of part 3 of Spooner 1906.

11. Bolton 1881, 484.

References

1881 Bolton: 2:484.
1923 Sherman, "Wollaston": 333–334.
1931 Bolton and Binsse, "Wollaston": 52.
1932 Sherman: 37.

1942.8.40 (593)

Mary Walton Morris

1749/1752
Oil on canvas, 76.3 × 63.5 (30 × 25)
Andrew W. Mellon Collection

Technical Notes: The support is a plain-weave fabric with distinct cusping along the two sides and top. A moderately thick, yellowish white ground covers the fabric. A thinner, whiter layer is clearly visible under the figure and probably covers the entire surface. The paint is worked in a flat manner, with the exception of the whites, which retain some body and brushwork. The modeling of the dress is done wet-in-wet, while the flowers are painted with glazes over the stomacher. There is little hesitation, overlap, or reworking in the modeling of the features. The stomacher was painted after the face, followed by the dress. Painted spandrels in the four corners were later overpainted with an extension of the background or with the extension of the sitter's arms.

The paint is abraded overall. The upper right portion of the blue dress on the right shoulder is repainted, and the flowers have been strengthened. The varnish is slightly discolored and lies over residues of a very discolored, older varnish.

Provenance: Same as 1942.8.41 to Lewis Morris [b. 1867], Neponsit, New York; (William Macbeth, New York); sold 27 May 1922 to (Art House, Inc., New York);[1] Thomas B. Clarke [1848–1931], New York;[2] his estate; sold as part of the Clarke collection on 29 January 1936, through (M. Knoedler & Co., New York), to The A.W. Mellon Educational and Charitable Trust, Pittsburgh.

Exhibited: Union League Club, January 1923, no. 21. *A Loan Exhibition of Paintings by Early American Portrait Painters*, Century Association, New York, 1926, no. 13. Philadelphia 1928, unnumbered. United States Constitution Sesquicentennial Commission, *Loan Exhibition of Portraits of the Signers and Deputies to the Convention of 1787 and Signers of the Declaration of Independence*, CGA, 1937–1938, no. 187. *Historical American Paintings*, Department of Fine Arts, Golden Gate International Exposition, San Francisco, 1939, no. 26. *Early American Portraits and Silver*, J.B. Speed Memorial Museum, Louisville, 1947, no cat.[3] Columbia 1950, no. 22. Atlanta 1951, no. 9. Chattanooga 1952, unnumbered. Mint Museum of Art, Charlotte, North Carolina, 1952, no cat. Randolph-Macon Woman's College, Lynchburg, Virginia, 1952–1953, no cat.[4] *The World of Franklin and Jefferson*, The American Revolution Bicentennial Administration, traveling exhibition, 1975–1977, not in cat. M.H. de Young Memorial Museum, San Francisco, on long-term loan, 1977–1979.

MARY WALTON (1727–1794), eldest daughter of Jacob and Maria Beekman Walton of New York, married Lewis Morris in 1749.[5] Her blue satin dress trimmed with its white lace and the white stomacher decorated with pink, white, and yellow artificial flowers are typical of fashionable upper-class, Anglo-American clothing in the late 1740s.[6] She wears a black ribbon tied in a bow at her neck and a cap with white lace on top of her brown hair. Wollaston also painted her sister Catherine Walton Thompson (Bayou Bend Collection, Museum of Fine Arts, Houston)[7] and her brother and sister-in-law William and Cornelia Beekman Walton (NYHS).[8] The three women appear in similar dresses.

Mrs. Morris' face is painted with the sureness of a trained portraitist. The brushwork depicts the features with carefully placed strokes. The decorative touches of the flowers and the twists of the lace at the edge of the cap and on her bodice are hallmarks of Wollaston's London training. The four corners of the canvas were originally filled with painted spandrels. Modern overpaint covered those at the top to blend with the background and extended the sleeves of her dress in the lower corners. The heavily painted lace of her right sleeve is not original.[9]

EGM

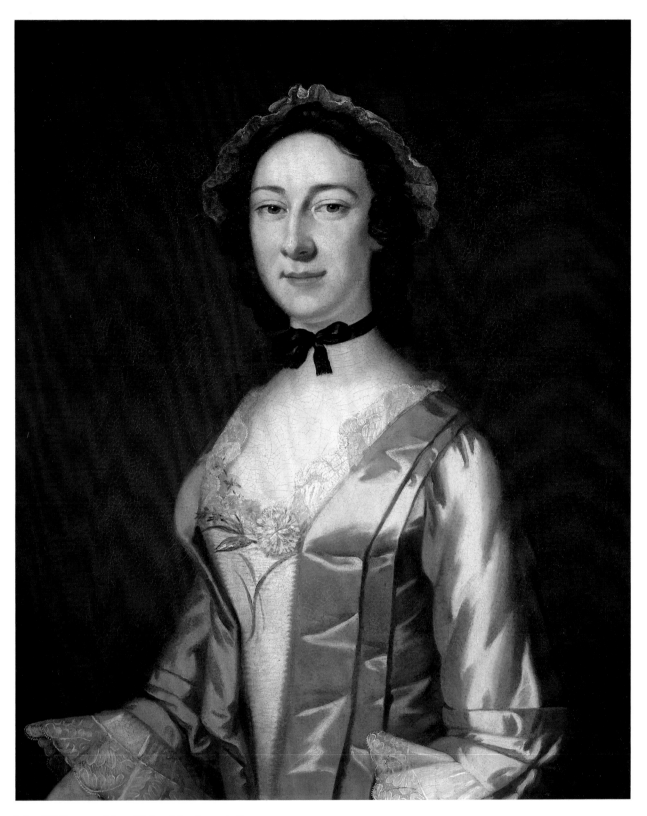

John Wollaston, *Mary Walton Morris*, 1942.8.40

Notes

1. Stock disposition card, Macbeth Gallery Papers, AAA. Clarence Dearden, a partner in Art House, Inc., was the purchaser (letter from Macbeth Gallery to Clarke, 29 May 1922; Correspondence Files, Macbeth Gallery Papers, AAA).

2. The name of the seller and the date of purchase, 27 May 1922, are recorded in an annotated copy of *Clarke* 1928 in the NGA library. The date is the same as the purchase of the painting by Art House, Inc., showing that paintings acquired by the dealership often went immediately into Clarke's own collection.

3. *Speed Bulletin* 1947, unpaginated.

4. Campbell 1953, 7–8.

5. Spooner 1906, 141–142; *DAB* 7 (part 1):214, under "Lewis Morris."

6. Nathalie Rothstein, curator emeritus, Textile Furnishings and Dress, Victoria and Albert Museum, London, "What Silk Shall I Wear?: Fashion and Choice in Some 18th and Early 19th Century Paintings in the National Gallery of Art," lecture, NGA, 16 September 1990.

7. Warren 1975, 129–130, repro.

8. *New-York Historical Society* 1974, 2:852–853, no. 2161 and 2162, repro.

9. A pre-restoration photograph in the file labeled "Photographs of Paintings," Macbeth Gallery Papers, AAA, shows the original spandrels. This suggests that the overpainting was done after the portrait was acquired by Art House, Inc.; see *Provenance*.

References

1881 Bolton: 2:484.
1906 Spooner: repro. opp. 136.
1923 Sherman, "Wollaston": 331 repro., 333–334.
1931 Bolton and Binsse, "Wollaston": 52.
1932 Sherman: 37.

1947.17.103 (1011)

John Stevens (?)

c. 1749–1752
Oil on canvas, 76.5 × 63.6 (30 ⅛ × 25 1/16)
Andrew W. Mellon Collection

Technical Notes: The support is a loosely woven, plain-weave fabric. The moderately thick ground is light gray. The paint is used in consistencies varying from thin washes to pastes. The face is painted with fuller bodied paint, and the placement of the features is sure, with no reworking visible. The coat and vest are blocked in with thin opaque paints, and impasto was used to render buttons and highlights. The dark spandrels in the corners are not original.

The lining process has flattened the impasto. The paint and ground have cupped craquelure, with innumerable tiny losses. Abrasion of the paint layer is general but not severe. The previous varnish was removed in 1964. The present varnish lies over discolored residues of old varnish.

Provenance: (C.K. Johnson, Greenwich, Connecticut); sold 15 October 1925 to Thomas B. Clarke [1848–1931], New York;[1] his estate; sold as part of the Clarke collection on 29 January 1936, through (M. Knoedler & Co., New York), to The A.W. Mellon Educational and Charitable Trust, Pittsburgh.

Exhibited: *A Loan Exhibition of the Earliest Known Portraits of Americans Painted in This Country by Painters of the Seventeenth and Eighteenth Centuries*, Century Association, New York, 7–29 November 1925, no. 15. Philadelphia 1928, unnumbered.

THIS LIKENESS is typical of the small portraits that Wollaston painted in New York from 1749 to 1752. The sitter wears a blue coat and a yellow vest trimmed with silver ribbon. His wig is brown; his hat is tucked under his left arm. Other examples of the pose include his portraits of Joseph Reade and Cadwalader Colden (MMA) and *A Gentleman of the Philipse Family* (NYHS).[2]

The portrait was acquired by Thomas Clarke in 1925 as an image of John Stevens (1716–1792), a merchant in Perth Amboy, New Jersey, who owned extensive tracts of land in the colony and served as a member of the general assembly. He married Elizabeth Alexander in 1748 and was the father of John Stevens, the engineer and inventor, and of Mary Stevens, wife of Robert Livingston. Stevens served as a member of the Continental Congress in 1784 and as president of the New Jersey state convention that ratified the United States Constitution in 1787.[3]

There is no evidence that this is Stevens in the numerous family documents that survive, and the lack of a provenance before 1925 is suspicious.[4] Wollaston might have had the opportunity to paint Stevens when he made portraits of his wife's parents James and Mary Alexander (Museum of the City of New York) and her brother William Alexander and sister-in-law Sarah Livingston Alexander (NYHS). In that case, however, one would expect to find a pendant portrait of Mrs. Stevens, whereas the only known portrait of her was painted many years later, after her husband's death, by Gilbert Stuart (c. 1793–1794, NYHS).[5]

EGM

Notes

1. The name of the seller and the date of purchase are recorded in an annotated copy of *Clarke* 1928 in the NGA library. Two letters from C.K. Johnson to Clarke, 5 October 1925 and 12 October 1925, offer the portrait without an attribution to Wollaston (NGA).

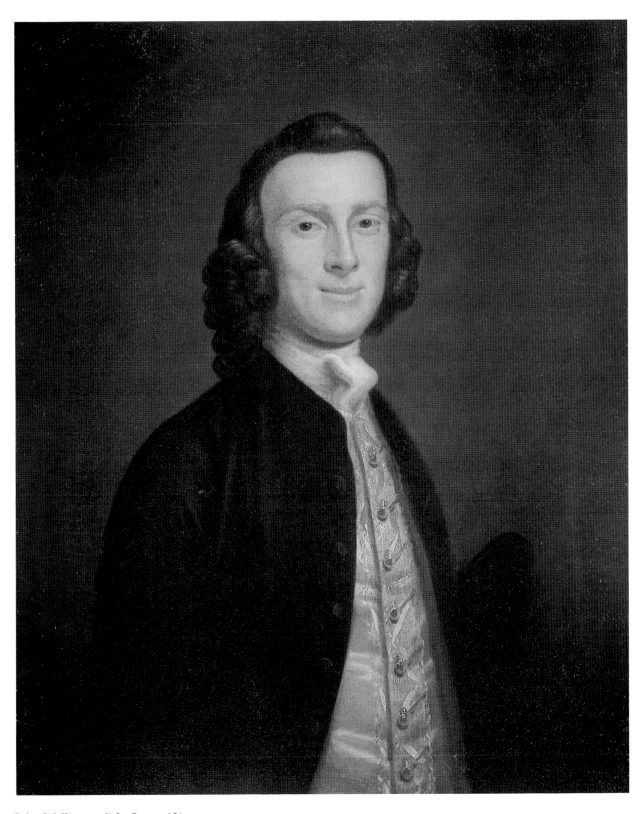

John Wollaston, *John Stevens (?)*, 1947.17.103

2. Gardner and Feld 1965, 10–11, repro.; *New-York Historical Society* 1974, 2:620, no. 1600 repro.

3. Rutherfurd 1894, 72–80 and genealogical chart opp. 24; Turnbull 1928, 22–113; *DAB* 9 (part 1):614, under the entry for his son John Stevens (1749–1838); *Congress* 1989, 1872.

4. Papers of the Stevens family, including information about family portraits, are at the Samuel C. Williams Library, Stevens Institute of Technology, Castle Point, Hoboken, New Jersey. They do not include a photograph or record of this painting, according to Associate Curator Mrs. Jane G. Hartye (letter, NGA, 23 March 1993). Turnbull 1928, 25, who comments that Stevens was a "prolific letter writer," does not mention a portrait of Stevens.

5. The portraits of James and Mary Alexander are reproduced in Rutherfurd 1894, 79, as the frontispiece and opp. 8; those of William and Sarah Alexander and Elizabeth Alexander Stevens are catalogued in *New-York Historical Society* 1974, 1:11–12, nos. 23–24, repro., and 2:759–760, no. 1951, repro.

References

1928 Barker: repro. 276.
1931 Bolton and Binsse, "Wollaston": 52.
1932 Sherman: 37.

Unknown American Artists

1943.1.3 (704)

Elisha Doane

c. 1783
Oil on fabric, 101.7 × 84.2 (40 1/16 × 33 1/8)
Chester Dale Collection

Technical Notes: The support is a coarse, loosely woven, plain-weave fabric. The ground is a medium brown-biege color applied in a moderate thickness that does not hide the interstices of the fabric. Striations in the paint film may be related to the texture of the ground layer.

The paint is applied in moderately smooth, thick paste, opaque layers, with broad, low-textured brush strokes in some of the highlights and details of the clothing. Semi-transparent glazes are also used here and in the background. Underlying brush strokes in the sitter's right hand and right lapel may indicate a shift in the design. A layer of blue-green paint beneath the white vest carries over into the shadows of the sleeves. It is the same blue as the flowers on the vest.

There is abrasion as well as small losses throughout, and a damaged area above the sitter's right knee. Traction crackle appears in the background and in the shadows of the clothing, where the paint may contain bitumen. A layer of thick brown paint appears to have been applied to the surface of the background and over the hair and the shadows of the face, and then rubbed off or removed; the residue is disfiguring. Many of the glazes have been abraded. The folded papers on the desk retain little of the original inscription, and these remaining traces are not legible. The rest of the inscription is a later addition. The toned varnish is severely discolored.[1]

Provenance: The sitter's son James Cutler Doane [1788–1878], Cohasset, Massachusetts;[2] his granddaughter Harriet Doane [b. 1866], Southboro, Massachusetts; sold around 1920 to (Dwight Prouty, Boston);[3] (Brooks Reed);[4] (Israel Sack, New York);[5] (James P. Labey, New York).[6] Sold 16 February 1929 by (James P. Silo, New York) to Chester Dale, New York.[7]

Exhibited: *An Exhibition of American Paintings from the Chester Dale Collection*, Union League Club, New York, 1937, no. 5, as by Samuel King. *American Paintings from the Collection of the National Gallery of Art*, NGA, 1947, no cat., as by Samuel King.[8]

ELISHA DOANE (1762–1832), the son of Elisha and Hope Doane of Wellfleet, Massachusetts, graduated from Harvard College in 1781 and received an A. M. degree in 1784. He married Jane Cutler [1943.1.4] on 24 June 1783 and settled in Cohasset.[9] Doane inherited a substantial fortune when his father, a wealthy merchant, died in 1783. Doane became a shipper in coastal and foreign markets, and also owned a grist and flour mill, a ropewalk, and salt works in Cohasset.[10]

Doane's wealth is reflected by the large size of the painting and by his stylish clothing. He wears a dark green double-breasted coat, a white vest with floral decoration, a white shirt with lace at the neck and cuffs, dark breeches, and white stockings. The white vest buttons have a red circle around the edge and a red dot in the center. His clothing can be dated to the early 1780s by its cut and its similarity to clothing worn by some of Ralph Earl's sitters, including Dr. Joseph Trumbull, painted in 1784 (Historic Deerfield, Massachusetts).[11] Doane is seated on a mahogany Chippendale-style ladderback chair.[12] A dark curtain hangs to the right in

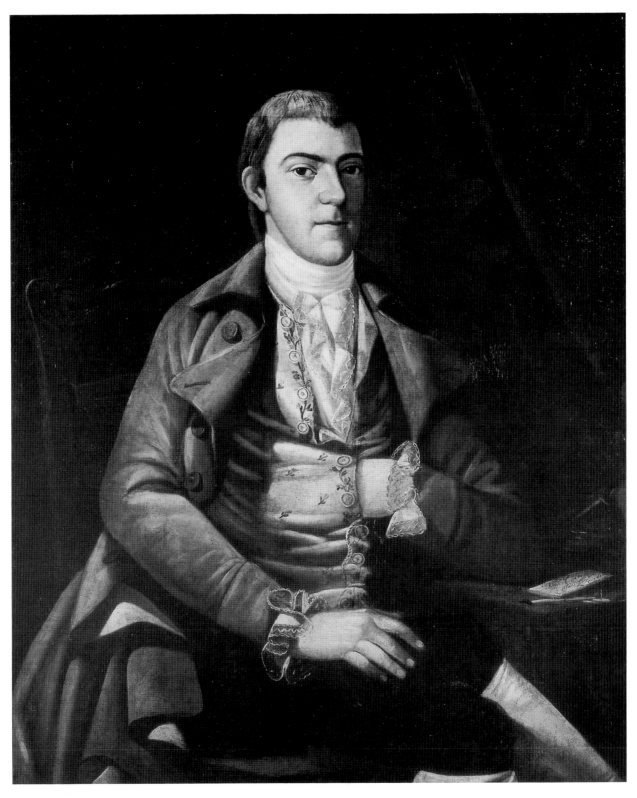

Unknown American Artist, *Elisha Doane*, 1943.1.3

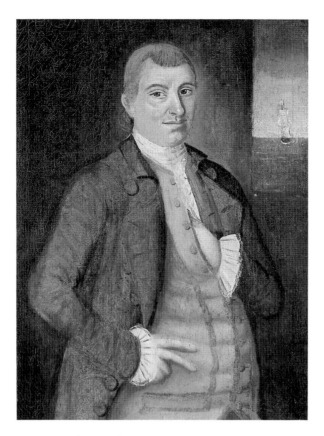

Fig. 1. Benjamin Blyth, *Benjamin Moses,*
oil on canvas, 1781, Salem, Massachusetts,
Peabody and Essex Museum

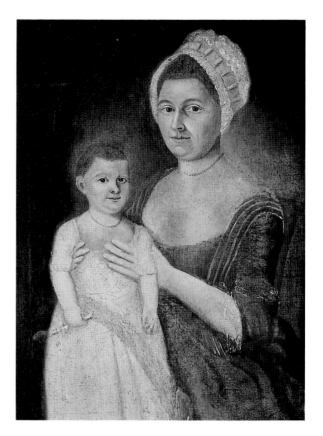

Fig. 2. Benjamin Blyth, *Sarah Carrol Moses holding
daughter Betsey,* Salem, Massachusetts, Peabody and
Essex Museum

the background. An inscription on the document on the table is not legible.

The painting came to the Gallery with an attribution to Samuel King, an artist in Newport, Rhode Island. This was rejected in 1968 because the portrait and that of Doane's wife did not appear similar to other work by King, notably his pair of portraits of Ezra Stiles and his wife (YUAG).[13] A new attribution can be proposed. The portraits exhibit stylistic features similar to the work of Salem artist Benjamin Blyth (1746–after 1786). The representation of Doane's face closely follows the technique used by Blyth in the approximately thirty pastel portraits that he made between the mid-1760s and the early 1780s.[14] Notable are the outlining of the eyes, the careful shading of the mouth, and the formulaic shaping of the nose and chin. Some physical characteristics of the materials used by the artist–especially the unusual size of the canvas in comparison to standardized commercial canvases, and the use of a loosely woven fabric–suggest an

artist untrained in working in oil paint on canvas. Only three oils by Blyth are known: a pair of portraits of Mr. and Mrs. Benjamin Moses, signed and dated 1781 (Figures 1 and 2),[15] and a portrait of evangelist George Whitefield, copied from a mezzotint of an earlier portrait by English painter Nathaniel Hone.[16] The paintings of the Doanes are remarkably similar to the Moses portraits in the combination of compositional sophistication with naive manner and style, seen especially in the pudgy fingers and the rendering of the hair. If these are by Blyth, the portraits would have been made at the time of or soon after the couple's wedding. Blyth was in Virginia by 12 February 1785, when he married Mary Dougle in Norfolk County. He was still in Virginia in the summer of 1786, when he advertised "the performance of Limning in Oil, Crayons, and miniature" in the *Virginia Gazette* (Richmond), the last record of his activity.[17]

EGM

Notes

1. A photograph of the painting before cleaning, in the original carved rococo frame that descendants once attributed to Paul Revere, is at the Frick Art Reference Library.

2. For his dates see Doane 1902, 422–423.

3. Letter from Harriet Doane to James W. Lane, 6 September 1948 (NGA). John Howland described Prouty as a collector; letter, 18 September 1940, Frick Art Reference Library.

4. Letter from John Howland, dated 17 August 1947, to Chester Dale (NGA).

5. This information is found on an undated note possibly made when the painting was in the Chester Dale collection (NGA).

6. *Dale Collection* 1965, 26. Laby was described as a dealer in his obituary in the *New York Times*, 27 October 1946, 62.

7. Two labels on the stretcher give the address of Silo's auction house as 40 East 45th Street, New York, and the lot number as 2792–2.

8. "Two Interesting Portraits" 1947, 341–342, repro.; *American Collector* 16, no. 5 (June 1947), repro., front cover, attributed to Samuel King.

9. Doane 1902, 254; letter from Robin McElheny, Harvard University Archives, 26 October 1992 (NGA).

10. Doane 1902, 254–255; John Howland, "Memorandum. Elisha Doane (1762–1832); Jane Cutler Doane (1765–1823)," undated typescript (NGA), 1.

11. His clothing was dated by Linda Baumgarten, curator of textiles, Colonial Williamsburg, Inc. (telephone conversation, 10 November 1992) and Claudia Kidwell, curator, Division of Costume, National Museum of American History, SI (telephone conversation, 15 January 1993). The portrait of Dr. Trumbull is discussed and reproduced in Kornhauser 1991, 131, repro. 132.

12. Examples of this type of Massachusetts Chippendale chair, dating from c. 1775–1800, are illustrated in Kane 1975, 155–156, no. 133, and in Schwartz 1982, unpaginated, no. 71.

13. The attribution was changed to an unidentified artist in a memorandum from William Campbell to John Walker, 12 June 1968. For work by King, including the Stiles portraits, see Little 1976, 146–151, where the portrait of Mrs. Stiles is reproduced, 147.

14. Foote 1953, 64–107; Little 1972, 49–57.

15. Little 1976, 52–55, nos. 16, 17, repro.; see also Foote 1953, 97–98, and Little 1972, 53, repro. figs. 7–8. The portraits each measure 54 by 68.6 cm (37 by 27 inches). Mrs Moses is shown holding her daughter Betsey.

16. Foote 1953, 104–105; Little 1972, 53, fig. 9.

17. Little 1972, 52.

References

1947 "Two Interesting Portraits": 341–342, repro., attributed to Samuel King.

1965 *Dale Collection*: 26, no. 704, repro., attributed to Samuel King.

1943.1.4 (705)

Jane Cutler Doane

c. 1783
Oil on canvas, 102.2 × 83.5 (40 ¼ × 32 ⅞)
Chester Dale Collection

Technical Notes: The painting's support, ground, and manner of applying paint are identical to that in the pendant portrait *Elisha Doane* [1943.1.3].[1] A horizontal seam in the bottom quadrant suggests that the fabric consists of two joined pieces. The white dress appears to be painted over a white underlayer. Semi-transparent glaze layers are in the drapery and the blue sash of the dress, as well as over the base red of the chair.

Provenance: Same as 1943.1.3; sold 16 February 1929 by (James P. Silo, New York) to Chester Dale, New York.[2]

Exhibited: *An Exhibition of American Paintings from the Chester Dale Collection*, Union League Club, New York, 1937, no. 4, as by Samuel King. *American Paintings from the Collection of the National Gallery of Art*, NGA, 1947, no cat., as by Samuel King.[3] *Early American Portraits and Silver*, J.B. Speed Memorial Museum, Louisville, Kentucky, 1947, no cat., attributed to Samuel King.[4]

JANE CUTLER (1765–1823), daughter of John and Mary Cutler of Boston, married Elisha Doane in 1783.[5] In her portrait she wears a white dress with blue hexagonal buttons, a blue sash at the waist, and a lavender drape with a white lining that has a white slit (with buttons) along each arm. Her dress is not a contemporary fashion. Instead it is in the style of clothing worn by late seventeenth- and early eighteenth-century sitters in portraits by Sir Godfrey Kneller. They, like Mrs. Doane, are depicted with their hair in long curls, a style not typical of late eighteenth-century fashion. Mrs. Doane's dress and frontal, seated pose, with one arm at her side and the other held upward, may be derived from John Smith's 1689 mezzotint of Kneller's portrait of Madam d'Avenant (Figure 1).[6] Mrs. Doane sits in a dark wood armchair with a curved back and red brocade upholstery that could also be derived from an engraving, since no chairs of this type were made in New England until the late 1790s. Behind her on the left hangs a green curtain with a tassel. Like her husband's portrait, this painting can be attributed to Benjamin Blyth, who is primarily known for pastel likenesses (see 1943.1.3).

EGM

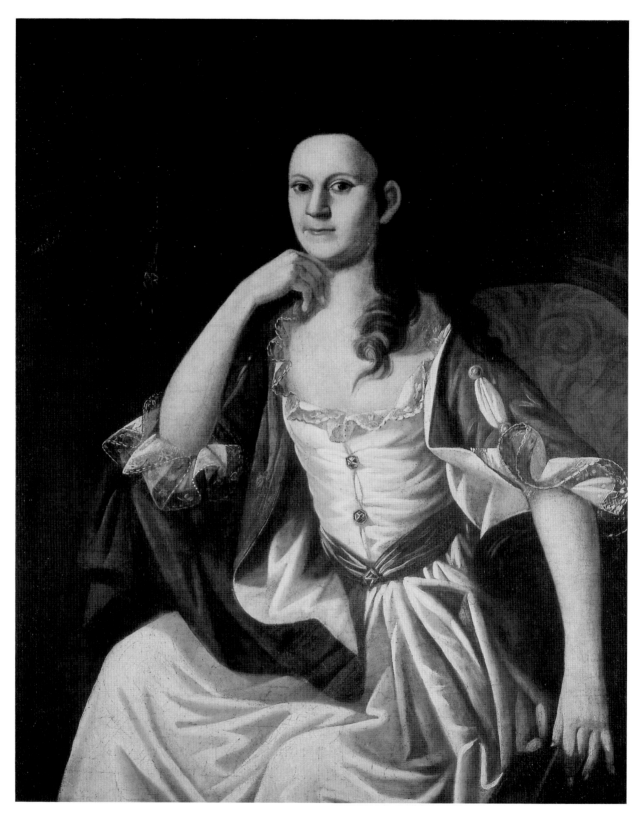

Unknown American Artist, *Jane Cutler Doane*, 1943.1.4

Fig. 1. John Smith after Sir Godfrey Kneller, *Madam d'Avenant*, mezzotint, 1689, Winterthur, Delaware, The Henry Francis du Pont Winterthur Museum [photo: Courtesy, Winterthur Museum]

Notes

1. A photograph of the painting before cleaning, in the original carved rococo frame that descendants once attributed to Paul Revere, is at the Frick Art Reference Library.

2. A label on the reverse gives the auctioneer's name; a second label has the lot number, 2792–1.

3. "Two Interesting Portraits" 1947, 341–342, repro.

4. *Speed Bulletin* 1947, unpaginated.

5. Doane 1902, 254.

6. The mezzotint, catalogued in Smith 1878, 3:1162, no. 76, is reproduced in Belknap 1959, pl. XXXV, no. 38. Kneller's portrait is unlocated; see Stewart 1983, 101, no. 209.

References

1947 "Two Interesting Portraits": 341–342, repro.
1965 *Dale Collection*: 27, no. 705, repro.

1942.8.13 (566)

Matilda Caroline Cruger

c. 1795
Oil on canvas, 91.7 × 71.6 (36 ⅛ × 28 ⅛)
Andrew W. Mellon Collection

Technical Notes: The medium-weight, plain-weave fabric has its original tacking margins. The unlined painting is on its original, four-member pine stretcher with mortice-and-tenon joints. The ground, which was applied before the fabric was stretched, is a thin gray layer, visible in large vertical patches on the reverse, where it extruded during application. The paint is thin and fluid, in application. The extremely rich colors are applied wet-in-wet, with final definition and detail added in fluid, linear strokes. There is very little textural relief or impasto. The gray ground is visible through the thin white paint and in the interstices of the fabric under the flesh tones. The door is painted over the green background paint, which is over a blue underlayer.

There are small losses in paint and ground on the left side. The thick varnish is slightly discolored, with residues of older varnish layers.

Provenance: Maria Taylor Hunt [Mrs. Ward Hunt, d. 1912], Utica, New York;[1] bequeathed to her niece Caroline Matilda Van Rensselaer Hillhouse [Mrs. Phineas P. Hillhouse], Cambridge, Massachusetts;[2] (Charles Henry Hart, New York, and Frank W. Bayley, Boston); sold in 1917 to Frank Bulkeley Smith [1864–1918], Worcester, Massachusetts;[3] his sale, (American Art Association, New York, 23 April 1920, no. 141); purchased by W.S. Burke for Thomas B. Clarke [1848–1931], New York;[4] his estate; sold as part of the Clarke collection on 29 January 1936, through (M. Knoedler & Co., New York), to The A.W. Mellon Educational and Charitable Trust, Pittsburgh.

Exhibited: Union League Club, February 1922, no. 17. Philadelphia 1928, unnumbered. Richmond 1944–1945, no. 6. *Early American Portraits on Loan From the National Gallery of Art, Washington, D.C.*, Pack Memorial Public Library, Asheville, North Carolina, 1949, no. 6. Columbia 1950, no. 16. Atlanta 1951, no. 15. Chattanooga 1952, unnumbered. Mint Museum of Art, Charlotte, North Carolina, 1952, no cat. Randolph-Macon Woman's College, Lynchburg, Virginia, 1952–1953, no cat.[5]

MATILDA CRUGER (1776–1812), one of six children born to New Yorker Henry Cruger (1739–1827) and his second wife Elizabeth Blair, married Lawrence Yates (1940.1.5) in 1795; they had one daughter, Caroline, before Yates' death the following year. Mrs. Yates later married Judge Henry Walton (1768–1844) of Saratoga Springs, New York.[6] This likeness was painted to be part of the portrait series of members of the Yates and Pollock

families of New York by Gilbert Stuart. The painting is especially similar to the portrait of Catherine Yates Pollock [1942.8.19]. The two portraits of the same size have similar compositions and the sitters' hair styles are similar, as is the color of their dresses (Matilda's is white with an aquamarine sash). Both are seated in red upholstered chairs with brass tacks, although Matilda's chair has a lower back. The backgrounds consist of a similar green wall and gray paneling.

The possibility that the portrait is not by Stuart was first proposed in 1933 and is now generally accepted.[7] The portrait was first recorded by Henry Tuckerman in 1867, when it belonged to descendants of the sitter, who also owned a version of Stuart's portrait of Lawrence Yates (Huntington Library, Art Collections, and Botanical Gardens, San Marino, California) (see entry for 1940.1.5); both were attributed to Stuart.[8] When the painting is examined closely, and especially when it is compared with the portrait of Mrs. Pollock, stylistic elements not typical of Stuart become very apparent. The figure of Matilda Cruger is larger in proportion to the canvas surface, and her head is placed higher in the composition. Her face is painted in more sharply defined areas of color, and the brush strokes are more uniform, a feature easily seen in the ruffle of the bodice. There is less variation in color, and the highlights lack impasto. The regularity of forms, such as the straight outline of Matilda's left arm and the triangular shapes separating her arms and torso, is not typical of Stuart's work. Heavy lines delineate the curls of her hair. And while the background color of the portrait of Mrs. Pollock is painted with a green glaze over the gray ground, the background of the Cruger portrait is an opaque green over a blue paint layer. X-radiography reveals that the Cruger painting lacks the great variations between highlights and shadow seen in x-radiographs of Stuart's portraits. Yet with so many compositional characteristics of Stuart's work, this portrait could be a copy of a lost painting. The artist had painted the sitter's father Henry Cruger, a prominent merchant and political figure in England who returned with his family to America in 1790 (City of Bristol Museum and Art Gallery, England).[9]

cjm/egm

Notes

1. Tuckerman 1867, 109, 628, and Mason 1879, 282, list the portrait as owned by her husband Ward Hunt. Mrs. Hunt is listed as the owner in MFA 1880, 61. Mrs. Hunt is the first documented owner of the portrait, which was assumed to have come to her from her stepmother Caroline Matilda Yates Taylor [Mrs. James Taylor, d. 1866], Albany, New York, the sitter's daughter.

2. Maria T. Hunt's will (Surrogate's Court, Oneida County, New York; copy, NGA) lists her sister Sarah A. Van Rensselaer and her niece Caroline Van Rensselaer Hillhouse as her primary heirs; the inventory of her estate lists "2 family portraits (oil) with gold frames, latter damaged." Because Mrs. Van Rensselaer was deceased, Mrs. Hillhouse inherited the portraits. This provenance is repeated in *Smith* 1920, unpaginated, lot 141, which states that the portrait went to Mrs. Hillhouse under the terms of Mrs. Taylor's will.

3. Park 1926, 244–245.

4. *Art Annual* 1920, 331. The name of the seller and the date of purchase are recorded in an annotated copy of *Clarke* 1928 in the NGA library.

5. Campbell 1953, 7.

6. Townsend 1945, 52.

7. Sawitzky 1933, 92. To rule out the possibility that the painting is a late nineteenth- or twentieth-century work, the National Gallery's Scientific Research Department was asked to examine it for the presence of modern pigments. Using energy dispersive x-ray flourescence (sampling of the pigment was not permitted), the department found that the tested pigments (white, blue, and green) were of the type used in the late eighteenth or early nineteenth century, and that "no elements suggesting anachronistic pigments were detected." See the report of analysis carried out by Lisha Glinsman, dated 4 November 1991 (NGA).

8. Tuckerman 1867, 109; Mason 1879, 282.

9. According to Van Schaack 1859, 41, Cruger sent a portrait of himself to his son in England. It may be Stuart's painting, which is not catalogued by Lawrence Park. On Cruger see Hasell 1897 (copy, NGA); Hamm 1902, 1:71 *DAB* 2 (part 2): 581–582.

References

1867	Tuckerman: 109, 628.
1879	Mason: 282.
1880	MFA: 61, no. 683.
1926	Park: 244–245, no. 196, repro.
1933	Sawitzky: 84, 91–92.
1964	Mount: 169, 366.

Unknown American Artist, *Matilda Caroline Cruger*, 1942.8.13

Bibliography

A

Abrams 1979 Abrams, Ann Uhry. "Politics, Prints and John Singleton Copley's *Watson and the Shark*." *Art Bulletin* 61, no. 2 (June 1979): 265–276.

Abrams 1982 Abrams, Ann Uhry. "A New Light on Benjamin West's Pennsylvania Instruction." *Winterthur Portfolio* 17, no. 4 (Winter 1982): 243–257.

"Absolute Stuarts" 1934 "When Genuine Raeburns Turn Out to Be Absolute Gilbert Stuarts." *Art Digest* 9, no. 5 (1 December 1934): 8.

Academic Annals **1805** "An Account, delivered at the Desire of the Council of the Royal Academy, of the Great Historical Works painted for His Majesty by Benjamin West, Esq. President." *Academic Annals, published by Authority of the Royal Academy of Arts, 1804–5.* London, 1805: 63–69.

"Acquires Portrait" 1928 "Acquires Portrait Sought 54 Years." (New York) *World* (18 February 1928): 12.

Adams 1874 Adams, Charles Francis, ed. *Memoirs of John Quincy Adams, comprising portions of his Diary from 1795 to 1848.* 12 vols. Philadelphia, 1874–1877. Reprint, Freeport, New York, 1969.

Adams 1882 Adams, Henry. *John Randolph.* New York, 1882. Reprint, 1961.

Adamson 1985 Adamson, Jeremy Elwell. *Niagara: Two Centuries of Changing Attitudes, 1697–1901.* [Exh. cat. CGA] Washington, 1985.

Addison 1910 Addison, Julia de Wolf. *The Boston Museum of Fine Arts.* Boston, 1910.

Addison 1924 Addison, Julia de Wolf. *The Boston Museum of Fine Arts.* 2nd ed. Boston, 1924.

Alberts 1978 Alberts, Robert C. *Benjamin West. A Biography.* Boston, 1978.

Alexander 1957 Alexander, Boyd, ed. *Life at Fonthill, 1807–1822, With Interludes in Paris and London, from the Correspondence of William Beckford.* London, 1957.

Allan 1937 Allan, George A.T. *Christ's Hospital.* London and Glasgow, 1937.

Allen 1838 *A Narrative of Colonel Ethan Allen's Captivity. Written by Himself.* 3rd ed. Burlington, Vermont, 1838.

Allen 1845 Allen, Ethan. *Allen's Captivity, Being a Narrative of Colonel Ethan Allen, Containing His Voyages, Travels, &c., Interspersed with Political Observations.* Boston, 1845.

American Academy **1832** *Catalogue of Paintings and Statuary exhibited by the American Academy of the Fine Arts, May, 1832.* New York, 1832.

American Earls **1972** *The American Earls: Ralph Earl, James Earl, R.E.W. Earl.* William Benton Museum of Art, University of Connecticut, Storrs. Storrs, Connecticut, 1972.

American Originals **1990** *American Originals: Selections from Reynolda House, Museum of American Art.* New York, 1990.

American Portraits **1947** Parke-Bernet Galleries. *American Portraits, Barbizon and Genre Paintings, American Portrait Sculptures and other Busts, from the Estate of the Late Percy A. Rockefeller . . . and from other Owners* [20 November 1947]. New York, 1947.

Amory 1882 Amory, Martha Babcock. *The Domestic Life of John Singleton Copley, R.A.* Boston, 1882.

Andrus 1977 Andrus, Lisa Fellows. *Measure and Design in American Painting 1760–1860.* New York and London, 1977.

Anthony 1956 Anthony of Padua, Brother. *The Tyng Family in America.* Poughkeepsie, New York, 1956.

Appleton's **1898** *Appleton's Cyclopaedia of American Biography.* Edited by James Grant Wilson and John Fiske. Rev. ed. 6 vols. New York, 1898–1899.

Armstrong 1901 Armstrong, Sir Walter. *Sir Henry Raeburn.* London, 1901.

Armstrong 1920 Armstrong, D. Maitland. *Day Before Yesterday.* New York, 1920.

Art Annual **1913** "Paintings Sold at Auction, October 1911–October 1912." *American Art Annual* 10 (1913): 23–74.

Art Annual **1920** "Paintings Sold at Auction, Season of 1919–1920." *American Art Annual* 17 (1920): 280–341.

Art Prices **1927** *Art Prices Current.* N.s. Vol. 6 (1926–1927). London, 1927.

"Ash" 1921 "The Excommunication of Joseph Ash." *South Carolina Historical and Genealogical Magazine* 22, no. 2 (April 1921): 53–59.

Athenaeum Gallery **1828** *Catalogue of the Second Exhibition of Paintings in the Athenaeum Gallery consisting of Specimens by American Artists and a selection from the works of the Old Masters.* 2nd ed. Boston, 1828.

Avery Galleries 1892 Avery Galleries. *Exhibition of the Important Oil Painting Washington and His Family by Edwin Savage, of Princeton, Mass.* New York, 1892.

B

Babcock 1903 Babcock, Stephen. *Babcock Genealogy.* New York, 1903.

Bailey 1986 Bailey, N. Louise, Mary L. Morgan, and Carolyn R. Taylor, eds. *Biographical Directory of the South Carolina Senate 1776–1985.* 3 vols. Columbia, South Carolina, 1986.

Baker 1945 Baker, C.H. Collins. "Notes on Joseph Blackburn and Nathaniel Dance." *Huntington Library Quarterly* 9, no. 1 (November 1945): 33–47.

Barck 1927 Barck, Dorothy C., ed. *Papers of the Lloyd Family of the Manor of Queen's Village, Lloyd's Neck, Long Island, New York, 1654–1826.* 2 vols. New York, 1927.

Barker 1928 Barker, Virgil. "Portraiture in America Before 1876." *The Arts* 13, no. 5 (May 1928): 275–288.

Barker 1942 Barker, Creighton. "The Origin of the

Connecticut State Medical Society." In *The Heritage of Connecticut Medicine*. Edited by Herbert Thoms. New Haven, 1942.

Barker 1950 Barker, Virgil. *American Painting, History and Interpretation*. New York, 1950.

Barker, "Copley," 1950 Barker, Virgil. "Copley's American Portraits." *Magazine of Art* 43, no. 3 (March 1950): 82–88.

Barlow 1807 Barlow, Joel. *The Columbiad. A Poem*. Philadelphia, 1807.

Barnhill 1993 Barnhill, Georgia Brady. "'Extracts from the Journals of Ethan A. Greenwood': Portrait Painter and Museum Proprietor." *Proceedings of the American Antiquarian Society* 103, part 1 (October 1993): 91–178.

Barnwell and Webber 1922 Barnwell, Joseph W., and Mabel L. Webber. "St. Helena's Parish Register." *South Carolina Historical and Genealogical Magazine* 23, no. 1 (January 1922): 8–25.

Barnwell 1969 Barnwell, Stephen B. *The Story of An American Family*. Marquette, Michigan, 1969.

Bayley 1910 Bayley, Frank W. *A Sketch of the Life and a List of Some of the Works of John Singleton Copley*. Boston, 1910.

Bayley 1915 Bayley, Frank W. *The Life and Works of John Singleton Copley*. Boston, 1915.

Bayley 1929 Bayley, Frank W. *Five Colonial Artists of New England*. Boston, 1929.

Bayly 1751 Bayly, Anselm. *The Antiquity, Evidence and Certainty of Christianity, canvased, on Dr. Middleton's Examination of the Lord Bishop of London's discourses on the Use and Intent of Prophecy*. London, 1751.

Beaver 1892 Beaver, Alfred. *Memorials of Old Chelsea: A New History of the Village of Palaces*. London, 1892.

Beckham 1979 Beckham, Stephen Dow. "Colonel George Gibbs." In *Benjamin Silliman and his Circle: Studies on The Influence of Benjamin Silliman on Science in America*. Edited by Leonard G. Wilson. New York, 1979.

Beechey 1855 Beechey, Henry William, ed. *The Literary Works of Sir Joshua Reynolds, First President of the Royal Academy*. Rev. ed. 2 vols. London, 1855.

Belknap 1959 Belknap, Waldron Phoenix, Jr. *American Colonial Painting; Materials for a History*. Cambridge, Massachusetts, 1959.

***Bell's Court* 1808** "A Correct Catalogue of the Works of Benjamin West, Esq." *La Belle Assemblée or Bell's Court and Fashionable Magazine* 4, supplement (February 1808): 13–20.

Benisovich 1953 Benisovich, Michel. "The Sale of the Studio of Adolph-Ulrich Wertmüller." *Art Quarterly* 16, no. 1 (Spring 1953): 20–39.

Benisovich 1956 Benisovich, Michel. "Wertmüller et son Livre de Raison intitulé La 'Notte.'" *Gazette des Beaux-Arts*. 6th ser. Vol. 48. (July-August 1956): 35–68.

Benisovich 1963 Benisovich, Michel. "Further Notes on A.U. Wertmüller in the United States and France." *Art Quarterly* 26, no. 1 (Spring 1963): 7–30.

Betham 1805 Betham, William. *The Baronetage of England; or the History of the English Baronets*. London, 1805.

Beverly 1705 Beverly, Robert. *History and Present State of Virginia*. 2 vols. London, 1705.

Biddle and Fielding 1921 Biddle, Edward, and Mantle Fielding. *The Life and Works of Thomas Sully*. Philadelphia, 1921.

Binney 1886 Binney, Charles J.F. *Genealogy of the Binney Family in the United States*. Albany, New York, 1886.

Binney 1905 Binney, Charles Chauncey. *The Life of Horace Binney, With Selections from his Letters*. Philadelphia and London, 1905.

Birmingham *Bulletin* 1959 "Works of Art Lent by Southern Museums." Birmingham Museum of Art (Alabama). *Bulletin* 7, no. 1 (May 1959), unpaginated.

Blake 1915 Blake, Francis Everett. *History of the Town of Princeton*. 2 vols. Princeton, Massachusetts, 1915.

Bland and Northcutt 1955 Bland, Harry MacNeill, and Virginia W. Northcutt. "The Life Portraits of Alexander Hamilton." *William and Mary Quarterly*. 3rd ser. Vol. 12, no. 2 (April 1955): 187–198.

BMMA 1907 "Loan Exhibition of Colonial Relics." *Bulletin of the Metropolitan Museum of Art* 2, no. 4 (April 1907): 71.

BMMA 1924 "The American Wing." *Bulletin of the Metropolitan Museum of Art* 19, no. 11 (November 1924): 251–265.

Boatner 1966 Boatner, Mark Mayo. *Encyclopedia of the American Revolution*. New York, 1966.

Bohlin 1979 Bohlin, Diane DeGrazia. *Prints and Related Drawings by the Carracci Family: A Catalogue Raisonné* Washington, 1979.

Boime 1989 Boime, Albert. "Blacks in Shark–Infested Waters: Visual Encodings of Racism in Copley and Homer." *Smithsonian Studies in American Art* 3, no. 1 (Winter 1989): 18–47.

Boime 1990 Boime, Albert. *The Art of Exclusion: Representing Blacks in the Nineteenth Century*. Washington, 1990.

Bolton 1881 Bolton, Robert. *A History of the Several Towns, Manors, and Patents of the County of Westchester from its first Settlement to the Present Time*. 2 vols. New York, 1881.

Bolton and Binsse, "Blackburn," 1930 Bolton, Theodore, and Harry Lorin Binsse. "An American Artist of Formula: Joseph Blackburn." *Antiquarian* 15, no. 5 (November 1930): 50–53, 88, 90, 92.

Bolton and Binsse, "Copley," 1930 Bolton, Theodore, and Harry Lorin Binsse. "John Singleton Copley." *Antiquarian* 15, no. 6 (December 1930): 76–83, 116, 118.

Bolton and Binsse, "Pratt," 1931 Bolton, Theodore, and Harry Lorin Binsse. "Pratt, Painter of Colonial Portraits and Signboards." *Antiquarian* 17, no. 3 (September 1931): 20–24.

Bolton and Binsse, "Trumbull," 1931 Bolton, Theodore, and Harry Lorin Binsse. "Trumbull, 'Historiographer' of the Revolution." *Antiquarian* 17, no. 1 (July 1931): 13–18.

Bolton and Binsse, "Wollaston," 1931 Bolton, Theodore, and Harry Lorin Binsse. "Wollaston, An Early American Portrait Manufacturer." *Antiquarian* 16, no. 6 (June 1931): 30–33, 50, 52.

Bolton 1942 Bolton, Theodore. "Charles Loring Elliott, An Account of his Life and Work." *Arts Quarterly* 5 (Winter 1942): 58–96.

Bolton 1951 Bolton, Theodore. "The Life Portraits of James Madison." *William and Mary Quarterly* 3rd ser. Vol. 8, no. 1 (January 1951): 25–47.

Bomford 1990 Bomford, David, et al. "Canvases and Primings for Impressionist Paintings." *Art in the Making: Impressionism.* [Exh. cat. National Gallery, London] London, 1990.

Bordeaux 1989 *Le port des Lumières, La peinture à Bordeaux, 1750–1800.* [Exh. cat. Musée des Beaux-Arts] Bordeaux, 1989.

Bordley 1801 Bordley, John Beale. *Essays and Notes on Husbandry and Rural Affairs.* 2nd ed. Philadelphia, 1801.

Boston Museum 1841 *Catalogue of the Paintings, Marble and Plaster Statuary and Engravings comprised in the Collection of the Boston Museum and Gallery of Fine Arts.* Boston, 1841.

Boston Museum 1842 *Catalogue of the Paintings, Marble and Plaster Statuary and Engravings comprised in the Collection of the Boston Museum and Gallery of Fine Arts.* Boston, 1842.

Boston Museum 1844 *Catalogue of the Paintings, Marble and Plaster Statuary and Engravings comprised in the Collection of the Boston Museum and Gallery of Fine Arts.* Boston, 1844.

Boston Museum 1847 *Catalogue of the Paintings, Portraits, Marble and Plaster Statuary, Engravings & Water Color Drawings, in the Collection of the Boston Museum.* Boston, 1847.

Bouldin 1878 Bouldin, Powhatan. *Home Reminiscences of John Randolph of Roanoke.* Danville and Richmond, Virginia, 1878.

Bowen 1892 Bowen, Clarence W., ed. *The History of the Centennial Celebration of the Inauguration of George Washington as the First President of the United States.* New York, 1892.

Bowie 1899 Bowie, Walter Worthington. *The Bowies and their Kindred.* Washington, 1899.

Bowler 1905 Bowler, Noadiah Potter. *Record of the Descendants of Charles Bowler.* Cleveland, 1905.

Boyd 1953 Boyd, Julian P., ed. *The Papers of Thomas Jefferson.* Vol. 7. Princeton, New Jersey, 1953.

Boydell 1779 Boydell, John. *To the Lord Mayor, Aldermen, and Common-Council-Men of the City of London.* London, 1779.

Bradley 1980 Bradley, Laurel. "Eighteenth-Century Paintings and Illustrations of Spenser's *Faerie Queene*: A Study in Taste." *Marsyas; Studies in the History of Art* 20 (1979–1980): 31–51.

Brady 1991 *George Washington's Beautiful Nelly: The Letters of Eleanor Parke Custis Lewis to Elizabeth Bordley Gibson, 1794–1851.* Edited by Patricia Brady. Columbia, South Carolina, 1991.

Brand 1965 Brand, C.P. *Torquato Tasso; A Study of the Poet and of his Contribution to English Literature.* Cambridge, England, 1965.

Bridenbaugh 1948 Bridenbaugh, Carl, ed. *Gentleman's Progress: The Itinerarium of Dr. Alexander Hamilton, 1744.* Chapel Hill, 1948.

Bridgman 1856 Bridgman, Thomas. *Pilgrims of Boston.* New York, 1856.

British Institution 1851 British Institution. *Catalogue of Pictures by Italian, Spanish, Flemish, Dutch, French and English Masters, with which the Proprietors have Favoured the Institution.* London, 1851.

British Paintings 1988 Phillips, Son & Neale. *Fine British Paintings* [13 December 1988]. London, 1988.

Britton 1801 Britton, John. *The Beauties of Wiltshire.* 10 vols. London, 1801.

Brooklyn Museum 1979 Brooklyn Museum. *American Paintings: A Complete Illustrated Listing of Works in the Museum's Collection.* Brooklyn, New York, 1979.

Brooklyn Quarterly 1922 "Summary of Press Notices on the Benjamin West Exhibition." *Brooklyn Museum Quarterly* 9, no. 3 (July 1922): 136–139.

Brown 1861 Brown, Thomas Allston. "A Complete History of the Amphitheatre and Circus, from its earliest date, with sketches of some of the principal performers." *New York Clipper* 8 (19 January 1861).

Brown 1980 Brown, J. Carter. "Five Gilbert Stuart Portraits At The National Gallery of Art Link Charlottesville To New England—The Coolidge Connection." (Charlottesville, Virginia) *Daily Progress* (23 September 1980).

Brown 1983 Brown, David Alan. *Raphael and America.* [Exh. cat. NGA] Washington, 1983.

Bruce 1922 Bruce, William Cabell. *John Randolph of Roanoke.* 2 vols. New York and London, 1922.

Bruntjen 1985 Bruntjen, Sven H.A. *John Boydell (1719–1804): A Study of Art Patronage and Publishing in Georgian London.* New York and London, 1985.

Buel and Buel 1984 Buel, Joy Day, and Richard Buel, Jr. *The Way of Duty; A Woman and her Family in Revolutionary America.* New York and London, 1984.

Burke 1934 *A Genealogical and Heraldic History of the Peerage and Baronetage, the Privy Council, and Knightage, by Sir Bernard Burke and Ashworth P. Burke.* 92nd ed. London, 1934.

Burke 1939 *Burke's Genealogical and Heraldic History of the Peerage, Baronetage and Knightage, Privy Council and Order of Precedence.* 97th ed. London, 1939.

Burke 1952 *Burke's Genealogical and Heraldic History of the Landed Gentry.* 17th ed. London, 1952.

Burke 1956 *Burke's Genealogical and Heraldic History of the Peerage, Baronetage and Knightage, Privy Council and Order of Precedence.* 101st ed. London, 1956.

Burke 1967 *Burke's Genealogical and Heraldic History of the Peerage, Baronetage and Knightage.* 104th ed. London, 1967.

Burke 1970 *Burke's Genealogical and Heraldic History of the Peerage, Baronetage and Knightage.* 105th ed. London, 1970.

Burke 1981 *Burke's Presidential Families of the United States of America.* 2nd ed. London, 1981.

Burnham 1913 Burnham, R. Moffat. *Pierrepont Genealogies.* New York, 1913.

Burroughs, "Copley," 1943 Burroughs, Alan. "Young Copley." *Art in America* 31, no. 4 (October 1943): 160–171.

Burroughs, *Greenwood*, 1943 Burroughs, Alan. *John Greenwood in America, 1745–1752.* Andover, Massachusetts, 1943.

Busch 1992 Busch, Werner. "Copley, West, and the Tradition of European High Art." *American Icons; Transatlantic Perspectives on Eighteenth- and Nineteenth-Century American Art.* Edited by Thomas W. Gaehtgens and Heinz Ickstadt. Santa Monica, California, 1992.

Bush 1987 Bush, Alfred L. *The Life Portraits of Thomas Jefferson.* 2nd ed. Charlottesville, Virginia, 1987.

Butlin 1981 Butlin, Martin. "Turner's Late Unfinished Oils: Some new evidence for their late date." *Turner Studies* 1, no. 2 (1981): 42–45.

Button 1973 Button, Dick. "The Art of Skating." *Antiques* 103, no. 2 (February 1973): 351–362.

C

Cairns and Walker 1966 Cairns, Huntington, and John Walker. *A Pageant of Painting from the National Gallery of Art.* 2 vols. New York and Washington, 1966.

Calder 1921 Calder, Charles M. *John Vassall and His Descendants.* Hertford, England, 1921.

Callcott 1991 *Mistress of Riversdale: The Plantation Letters of Rosalie Stier Calvert, 1795–1821.* Edited by Margaret Law Callcott. Baltimore and London, 1991.

Campbell 1937 Campbell, Patrick. *Travels in the Interior Inhabited Parts of North America in the Years 1791 and 1792.* Edited by Hugh H. Langton and William Francis Ganong. Toronto, 1937.

Campbell 1953 Campbell, T. Moody. "A Rare Exhibit of Portraits and Prints." *Alumnae Bulletin, Randolph-Macon Woman's College* 46, no. 2 (February 1953): 7–8.

Carroll Papers 1976 *The John Carroll Papers.* Edited by Thomas O'Brien Hanley, S.J. 3 vols. Notre Dame, Indiana, and London, 1976.

Carson 1990 Carson, Barbara G. *Ambitious Appetites: Dining, Behavior, and Patterns of Consumption in Federal Washington.* Washington, 1990.

Case 1929? Case, Sarah McCorkle. *Bellmont, 1726 – Mt. Bethel, 1929.* Columbia, Pennsylvania?, 1929?

Chapman 1937 Chapman, Guy. *Beckford.* New York, 1937.

Charnock 1798 Charnock, John. *Biographia Navalis; or, Impartial Memoirs of the Lives and Characters of Officers of the Navy of Great Britain From the Year 1660 to the Present Time.* London, 1798.

Chichester and Burges-Short 1900 Chichester, Henry Manners, and George Burges-Short. *The Records and Badges of Every Regiment and Corps in the British Army.* London, 1900.

Chiefly Modern Pictures 1865 Christie, Manson and Woods. *Catalogue of a valuable Assemblage of Chiefly Modern Pictures, and Drawings and Engravings and some capital copies from celebrated Italian Pictures: which will be sold by Auction . . . on Tuesday, May 23, 1865.* London, 1865.

Childe-Pemberton 1925 Childe-Pemberton, William S. *The Earl Bishop; The Life of Frederick Hervey, Bishop of Derry, Earl of Bristol.* 2 vols. London, 1925.

Chindahl 1959 Chindahl, George L. *A History of the Circus In America.* Caldwell, Idaho, 1959.

Chotner 1992 Chotner, Deborah, Julie Aronson, Sarah D. Cash, and Laurie Weitzenkorn. *American Naive Paintings.* Washington, 1992.

Christ's Hospital 1953 *The Christ's Hospital Book.* London, 1953.

Cikovsky 1988 Cikovsky, Nicolai, Jr. "Democratic Illusions." In *Raphaelle Peale Still Lifes.* Edited by Nicolai Cikovsky, Jr. [Exh. cat. NGA] Washington, 1988.

Clark 1914 Clark, Allen C. *Life and Letters of Dolly Madison.* Washington, 1914.

Clark 1915 Clark, Allen C. "Dr. and Mrs. William Thornton." *Records of the Columbia Historical Society of Washington, D.C.* 18 (1915): 144–208.

Clark 1930 Clark, Jane. "Metcalf Bowler as a British Spy." *Collections of the Rhode Island Historical Society* 23, no. 4 (October 1930): 101–117.

Clark 1942 Clark, Allen C. "Captain James Barry." *Records of the Columbia Historical Society of Washington, D.C.* 42–43 (1942): 1–16.

Clarke 1903 Clarke, Louise Brownell. *The Greenes of Rhode Island, with Historical Records of English Ancestry, 1534–1902.* New York, 1903.

Clarke 1919 American Art Association. *Early American Portraits collected by Mr. Thomas B. Clarke* [7 January 1919]. New York, 1919.

Clarke 1928 *Portraits by Early American Artists of the Seventeenth, Eighteenth and Nineteenth Centuries Collected by Thomas B. Clarke.* [Exh. cat. Philadelphia Museum of Art] Philadelphia, 1928.

"Clarke Collection Sold" 1936 "The Thomas Clarke American Portrait Collection Is Sold." *Art News* 34 (8 February 1936): 5–6.

Classical Spirit 1976 *The Classical Spirit in American Portraiture.* [Exh. cat. Bell Gallery, Brown University] Providence, Rhode Island, 1976.

Coburn 1932 Coburn, Frederick W. "The Johnstons of Boston. Part One." *Art in America* 21, no. 1 (December 1932): 27–36.

Coburn 1933 Coburn, Frederick W. "The Johnstons of Boston. Part Two." *Art in America* 21, no. 4 (October 1933): 132–139.

Cokayne 1900 Cokayne, George Edward. *Complete Baronetage.* 6 vols. Exeter, England, 1900–1909.

Cokayne 1910 Cokayne, George Edward. *The Complete Peerage of England, Scotland, Ireland, Great Britain and the United Kingdom, extant, extinct or dormant.* New ed. 13 vols. London, 1910–1959.

Colonial Documents 1857 *Documents Relative to the Colonial History of the State of New-York.* Vol. 8. Edited by Edmund Bailey O'Callaghan. Albany, New York, 1857.

Columbia 1964 *Columbia Museum of Art News* 15, no. 4 (April 1964), 2.

Compleat Drawing-Master 1766 *The Compleat Drawing-Master: containing many curious specimens . . . neatly Engraved on Copper-Plates, after the Designs of the greatest masters.* Printed for Henry Parker. London, 1766.

Comstock 1935 Comstock, Helen. "The Connoisseur in America: A Recapitulation of Portraits Recovered for Gilbert Stuart." *Connoisseur* 95, no. 402 (February 1935): 99–100.

Comstock 1937 Comstock, Helen. "The Connoisseur in America: An Unrecorded Stuart." *Connoisseur* 99, no. 428 (April 1937): 215.

Conger and Rollins 1991 Conger, Clement E., and Alexandra W. Rollins. *Treasures of State: Fine and Decorative Arts in the Diplomatic Reception Rooms of the U.S. Department of State.* New York, 1991.

Congress 1989 *Biographical Directory of the United States Congress, 1774–1989.* Washington, 1989.

Cook 1888 Cook, Clarence. *Art and Artists of Our Time.* 3 vols. New York, 1888.

Coolidge 1930 Coolidge, Emma Downing. *Descendants of John and Mary Coolidge of Watertown, Massachusetts.* Boston, 1930.

Cooper 1982 Cooper, Helen A., ed. *John Trumbull: The Hand and Spirit of a Painter.* [Exh. cat. YUAG] New Haven, 1982.

Cooper 1993 Cooper, Wendy A. *Classical Taste in America, 1809–1840.* [Exh. cat. The Baltimore Museum of Art] New York, London, and Paris, 1993.

Copley-Pelham Letters *Letters and Papers of John Singleton Copley and Henry Pelham, 1739-1776.* Boston, 1914. Reprint, New York, 1970.

Copley, Stuart, West 1976 *John Singleton Copley 1738–1815, Gilbert Stuart 1755–1828, Benjamin West 1738–1820 in America & England.* [Exh. cat. MFA] Boston, 1976.

Cormack 1985 Cormack, Malcolm. *A Concise Catalogue of Paintings in the Yale Center for British Art.* New Haven, 1985.

Cortissoz 1924 Cortissoz, Royal. "The Field of Art." *Scribner's Magazine* 76 (July 1924): 569–576. Reprinted as "Early American Portraiture" in *Personalities in Art.* New York and London, 1925.

Cowdrey 1953 Cowdrey, Mary Bartlett. *American Academy of the Fine Arts and American Art-Union.* 2 vols. New York, 1953.

Cox 1976 Cox, Richard J. "From Feudalism to Freedom: Maryland in the American Revolution." In *Maryland Heritage* 1976.

Cozzens 1868 Leavitt, Strebeigh & Co. *Catalogue of the Entire Collection of Paintings Belonging to the Late Mr. A.M. Cozzens . . . May 22, 1868.* New York, 1868.

Craven 1975 Craven, Wayne. "John Wollaston: His Career in England and New York City." *American Art Journal* 7, no. 2 (November 1975): 19–31.

Crayon 1856 "Sketchings. Our Private Collections. No. III." [Abraham M. Cozzens' collection]. *The Crayon* 3, no. 4 (April 1856): 123.

Crean 1990 Crean, Hugh R. "Gilbert Stuart and the Politics of Fine Arts Patronage in Ireland, 1787–1793: A Social and Cultural Study." Ph.D. diss., City University of New York, 1990.

Culhane 1990 Culhane, John. *The American Circus, An Illustrated History.* New York, 1990.

Cundall 1932 Cundall, H.M. "Duty Stamps on Old Oil Paintings." *Connoisseur* 89, no. 370 (June 1932): 397–398.

Cunningham 1832 Cunningham, Allan. *The Lives of the Most Eminent British Painters, Sculptors and Architects.* Vol. 5 (1832). 6 vols. London, 1829–1833.

Cunningham 1843 Cunningham, Allan. *The Life of Sir David Wilkie; with his Journals, Tours, and Critical Remarks on Works of Art; and a Selection from his Correspondence.* 3 vols. London, 1843.

Cunningham 1938 Cunningham, Charles C. "Introduction." *John Singleton Copley, 1738–1815; Loan Exhibition of Paintings, Pastels, Miniatures and Drawings.* [Exh. cat. MFA] Boston, 1938.

Cunnington and Cunnington 1972 Cunnington, Willett C., and Phillis Cunnington. *Handbook of English Costume in the Eighteenth Century.* Boston, 1972.

Cunnington and Lucas 1972 Cunnington, Phillis, and Catherine Lucas. *Costumes for Births, Marriages and Deaths.* London, 1972.

Currier 1896 Currier, John J. *Ould Newbury.* Boston, 1896.

Currier & Ives 1984 Gale Research Company. *Currier & Ives, A Catalogue Raisonné.* 2 vols. Detroit, 1984.

Curwen 1972 *The Journal of Samuel Curwen, Loyalist.* Edited by Andrew Oliver. 2 vols. Cambridge, Massachusetts, 1972.

Custis 1860 Custis, George Washington Parke. *Recollections and Private Memoirs of Washington.* Edited by Benson J. Lossing. New York, 1860.

Cutter 1913 Cutter, William Richard, ed. *Genealogical and Family History of Southern New York and the Hudson River Valley.* 3 vols. New York, 1913.

D

DAB *Dictionary of American Biography.* 20 vols. New York, 1928–1936. Reprinted in 10 vols. with 8 supplements. New York, 1944–1988.

DAH *Dictionary of American History.* Rev. ed. 7 vols. New York, 1976.

Dallett 1981 Dallett, Francis James. "The Inter-Colonial Grimstone Boude and his Family." *Genealogist* 2, no. 1 (Spring 1981): 74ff.

Dale Collection 1965 *Paintings other than French in the Chester Dale Collection.* Washington, 1965.

Daniell 1890 Daniell, Frederick B. *A Catalogue Raisonné*

of the Engraved Works of Richard Cosway, R.A. London, 1890.

David 1955 David, William Allen. "William Constable, New York Merchant and Land Speculator." Ph.D. diss., Harvard University, 1955.

Davies 1959 Davies, Martin. *The British School.* 2nd ed. London, 1959.

Davis 1907 Davis, Charles Lukens. *North Carolina Society of the Cincinnati.* Boston, 1907.

Dawidoff 1979 Dawidoff, Robert. *The Education of John Randolph.* New York, 1979.

DCB Dictionary of Canadian Biography. Vol. 4, *1771–1800.* Toronto, 1979. Vol. 5, *1801–1820.* Toronto, 1983.

De Beixedon 1921 de Beixedon, Edward Francis Frémaux, Jr. *The Ancestors and Descendants of Dr. David Rogers.* N.p., 1921.

Decatur 1939 Decatur, Stephen. "Stuart's First Life Portrait of Washington." *Antiques* 35, no. 2 (February 1939): 70–72.

Delaware **1951** National Society of the Colonial Dames of America in the State of Delaware. *Portraits in Delaware, 1700–1850.* Wilmington, Delaware, 1951.

DeLorme 1976 DeLorme, Eleanor Pearson. "Attribution and Laboratory Analysis in Portraiture, the Master and the Student." *American Art Review* 3, no. 2 (March–April 1976): 122–132.

DeLorme 1979 DeLorme, Eleanor Pearson. "Gilbert Stuart; Portrait of an Artist." *Winterthur Portfolio* 14, no. 4 (Winter 1979): 339–360.

de Loutherbourg **1973** *Philippe Jacques de Loutherbourg, R.A., 1740–1812.* [Exh. cat. Iveagh Bequest, Kenwood] London, 1973.

de Pauw and Hunt 1976 de Pauw, Linda Grant, and Conover Hunt. *Remember the Ladies: Women in America, 1750–1915.* New York, 1976.

Detroit **1991** *American Paintings in the Detroit Institute of Arts.* Vol. 1. New York, 1991.

Dexter 1904 Dexter, Orrando Perry. *Dexter Genealogy, 1642–1904.* New York, 1904.

Dexter 1907 Dexter, Franklin Bowditch. *Biographical Sketches of the Graduates of Yale College, with Annals of the College History.* Vol. 4. New York, 1907.

"Dick" 1804 [Obituary, Sir John Dick]. *Gentleman's Magazine and Historical Chronicle* 74, part 2 (1804): 1175.

Dickason, *Letter,* 1970 Dickason, David Howard. "Benjamin West on William Williams: A Previously Unpublished Letter." *Winterthur Portfolio* 6 (1970): 127–133.

Dickason, *Williams,* 1970 Dickason, David Howard. *William Williams — Novelist and Painter of Colonial America, 1727–1791.* Bloomington, Indiana, 1970.

Dickson 1949 Dickson, Harold E. *John Wesley Jarvis, American Painter: 1780–1840.* New York, 1949.

Dickson 1973 Dickson, Harold E. "Artists As Showmen." *American Art Journal* 5, no. 1 (May 1973): 4–17.

Dillenberger 1977 Dillenberger, John. *Benjamin West: The Context of His Life's Work.* San Antonio, 1977.

Dinnerstein 1981 Dinnerstein, Lois. "The Industrious Housewife: Some Images of Labor in American Art." *Arts* 55, no. 8 (April 1981): 109–119.

DLB Dictionary of Literary Biography. Vol. 9, part 3: *American Novelists, 1910–1945.* Detroit, 1981.

DNB Dictionary of National Biography. 66 vols. Oxford, England, 1890. Reprinted in 22 vols. Oxford, England, 1963–1964.

Doane 1902 Doane, Alfred Alder. *The Doane Family: Deacon John Doane, of Plymouth; Doctor John Done, of Maryland; and their Descendants.* Boston, 1902.

Dresser 1952 Dresser, Louisa. "Edward Savage, 1761–1817." *Art in America* 40, no. 4 (Autumn 1952): 157–212.

Dresser 1958 Dresser, Louisa. "Jeremiah Theus: Notes on the Date and Place of his Birth and Two Problem Portraits Signed by Him." *Worcester Art Museum Annual* 6 (1958): 43–44.

Dresser 1966 Dresser, Louisa. "The Background of American Colonial Portraiture: Some Pages from a European Notebook." *Proceedings of the American Antiquarian Society* 76, no. 2 (1966): 19–53.

Dunlap 1832 Dunlap, William. *A History of the American Theatre.* 2 vols. New York, 1832.

Dunlap 1834 Dunlap, William. *A History of the Rise and Progress of the Arts of Design in the United States.* 2 vols. New York, 1834.

Durand 1881 Durand, John. "John Trumbull." *American Art Review* 2, second division (1881): 181–191, 221–230.

Durang **1966** *The Memoir of John Durang, American Actor, 1785–1816.* Edited by Alan S. Downer. Pittsburgh, 1966.

Dussler 1971 Dussler, Luitpold. *Raphael, A Critical Catalogue of his Pictures, Wall-Paintings and Tapestries.* London and New York, 1971.

E

Earle 1888 Earle, Pliny. *The Earle Family: Ralph Earle and His Descendants.* Worcester, 1888.

Earle 1903 Earle, Alice Morse. *Two Centuries of Costume in America: 1620-1820.* 2 vols. New York and London, 1903. Reprint, Williamstown, Massachusetts, 1974.

Eby 1959 Eby, Cecil D., Jr., ed. "'Porte Crayon' in the Tidewater." *Virginia Magazine of History and Biography* 67, no. 4 (October 1959): 438–449.

Edmonds 1835 Edmonds, Cyrus. *Life and Times of General Washington.* 2 vols. London, 1835–1836.

Edwards 1808 Edwards, Edward. *Anecdotes of Painters Who Have Resided or been Born in England.* London, 1808.

Eisen 1923 Eisen, Gustavus A. "Stuart's Three Washingtons." *International Studio* 76, no. 309 (February 1923): 386–394.

Eisen 1932 Eisen, Gustavus A. *Portraits of Washington.* 3 vols. New York, 1932.

Emblems **1755** *Emblems for the Improvement and Entertainment of Youth.* London, 1755.

Enc. Amer. Encyclopaedia Americana. Edited by Francis Lieber. 13 vols. Philadelphia, 1829–1833.

Enc. Brit. *Encyclopaedia Britannica.* 11th ed. New York, 1910.

Evans 1959 Evans, Grose. *Benjamin West and the Taste of His Times.* Carbondale, Illinois, 1959.

Evans 1972 Evans, Dorinda. "Mather Brown (1761–1831): A Critical Study." Ph.D. diss., Courtauld Institute of Art, University of London, 1972.

Evans 1980 Evans, Dorinda. *Benjamin West and His American Students.* [Exh. cat. NPG] Washington, 1980.

Evans 1982 Evans, Dorinda. *Mather Brown: Early American Artist in England.* Middletown, Connecticut, 1982.

Evans 1984 Evans, Dorinda. "Gilbert Stuart: Two Recent Discoveries." *American Art Journal* 16, no. 3 (Summer 1984): 84–89.

Evans 1993 Evans, Dorinda. "Survival and Transformation: The Colonial Portrait in the Federal Era." In *The Portrait in Eighteenth-Century America.* Edited by Ellen G. Miles. Newark, London, and Toronto, 1993.

Everett 1841 Everett, Edward. "Curiosity Baffled." *The Boston Book.* Boston, 1841.

Ewan 1970 Ewan, Joseph Andorfer. *John Banister and His Natural History of Virginia, 1678–1692.* Urbana, Illinois, 1970.

Eye of Jefferson **1976** *The Eye of Thomas Jefferson.* [Exh. cat. NGA] Washington, 1976.

F

Faculty of Advocates **1944** *The Faculty of Advocates in Scotland 1532–1943.* Edinburgh, 1944.

Fagan 1885 Fagan, Louis Alexander. *A Catalogue Raisonné of the Engraved Works of William Woollett.* London, 1885.

Fairbrother 1981 Fairbrother, Trevor J. "John Singleton Copley's Use of British Mezzotints for his American Portraits: A Reappraisal Prompted by New Discoveries." *Arts Magazine* 55, no. 7 (March 1981): 122–130.

Farington **1982** *The Diary of Joseph Farington.* Vols. 7 and 8. Edited by Kathryn Cave. New Haven and London, 1982.

Faulkner 1810 Faulkner, Thomas. *An Historical and Topographical Description of Chelsea and Environs.* London, 1810.

Feld 1965 Feld, Stuart P. "Loan Collection, 1965." *The Metropolitan Museum of Art Bulletin.* N.s. Vol. 23, no. 8 (April 1965): 275–294.

Felton 1792 Felton, Samuel. *Testimonies to the Genius and Memory of Sir Joshua Reynolds.* London, 1792.

Fielding 1914 Fielding, Mantle. "Paintings by Gilbert Stuart Not Mentioned in Mason's Life of Stuart." *Pennsylvania Magazine of History and Biography* 38 (July 1914): 311–334.

Fielding 1917 Fielding, Mantle. *American Engravers Upon Copper and Steel.* Philadelphia, 1917.

Fielding 1920 Fielding, Mantle. "Addenda and Corrections to Paintings by Gilbert Stuart. Not Noted in Mason's Life of Stuart." *Pennsylvania Magazine of History and Biography* 44 (January 1920): 88–91.

Fielding 1921 Fielding, Mantle. "American Naval Portraits Engraved by David Edwin, after Gilbert Stuart, and others." *Print Connoisseur* 2, no. 2 (December 1921): 122–137.

Fielding 1923 Fielding, Mantle. *Gilbert Stuart's Portraits of George Washington.* Philadelphia, 1923.

Fielding 1924 Fielding, Mantle. "Edward Savage's Portraits of Washington." *Pennsylvania Magazine of History and Biography* 48, no. 3 (1924): 193–200.

Filipczak 1990 Filipczak, Zirka Zaremba. "Reflections on Motifs in Van Dyck's Portraits." In *Anthony Van Dyck.* [Exh. cat. NGA] Washington, 1990.

Final Report **1958** *Final Report of the Alexander Hamilton Bicentennial Commission.* Washington, 1958.

Fischer 1962 Fischer, David Hackett. "John Beale Bordley, Daniel Boorstin and the American Enlightenment." *Journal of Southern History* 28, no. 3 (August 1962): 327–342.

Fitzpatrick 1925 *The Diaries of George Washington, 1748–1799.* Edited by John C. Fitzpatrick. 4 vols. Boston and New York, 1925.

Fitzpatrick 1941 *The Writings of George Washington.* Edited by John C. Fitzpatrick. Vol. 36. Washington, 1941. Reprint, Westport, Connecticut, 1970.

Fleischer 1988 Fleischer, Roland E. "Emblems and Colonial American Painting." *American Art Journal* 20, no. 3 (1988): 2–35.

Flexner 1952 Flexner, James Thomas. "Benjamin West's American Neo-Classicism, with Documents on Benjamin West and William Williams." *New-York Historical Society Quarterly* 36 (January 1952): 5–41.

Flynt and Fales 1968 Flynt, Henry N., and Martha Gandy Fales. *The Heritage Foundation Collection of Silver, With Biographical Sketches of New England Silversmiths, 1625–1825.* Old Deerfield, Massachusetts, 1968.

Foote 1930 Foote, Henry Wilder. *Robert Feke, Colonial Portrait Painter.* Cambridge, Massachusetts, 1930.

Foote 1953 Foote, Henry Wilder. "Benjamin Blyth of Salem: Eighteenth Century Artist." *Proceedings of the Massachusetts Historical Society* 71 (October 1953–May 1957): 64–107.

Forbes 1897 Forbes, Mrs. Athol, ed. *Curiosities of a Scots Charta Chest.* Edinburgh, 1897.

Forbes 1927 Forbes, Harriette Merrifield. *Gravestones of Early New England.* Boston, 1927.

Ford 1921 Ford, James Lauren. *Forty-odd Years in the Literary Shop.* New York, 1921.

"Fortune Wasted" 1877 "Golden Opportunities Lost. A Fortune Wasted and a Life Thrown Away — Death of Samuel McDonald in Indiana." *New York Times* (24 August 1877): 3:

Forty-Seventh Exhibition **1871** *Catalogue of the Forty-Seventh Exhibition of Paintings at the Athenaeum Gallery.* 2nd ed. Boston, 1871

Foskett 1972 Foskett, Daphne. *A Dictionary of British Miniature Painters.* 2 vols. New York, 1972.

Fothergill 1979 Fothergill, Brian. *Beckford of Fonthill.* London, 1979.

Fowble 1969 Fowble, E. McSherry. "Rinaldo and Armida, An Example of Classical Nudity in Eighteenth-Century American Painting." *Winterthur Portfolio* 5 (1969): 49–58.

Fox-Davies 1904 Fox-Davies, Arthur. *The Art of Heraldry; An Encyclopedia of Armory*. London, 1904. Reprint, New York, 1976.

Frankfurter 1937 Frankfurter, Alfred M. "Some Unfamiliar American Paintings." *Art News* 35, no. 17 (January 1937): 14, 20.

Fredericksen Fredericksen, Burton B., ed. *The Index of Paintings Sold in the British Isles during the Nineteenth Century*. Vol. 1: *1801–1805* (1988). Vol. 2: *1806–1810* (1990). Santa Barbara, California, and Oxford, England.

Friedman 1976 Friedman, Winifred H. *Boydell's Shakespeare Gallery*. New York and London, 1976.

Frye 1978 Frye, Roland Mushat. *Milton's Imagery and the Visual Arts: Iconographic Tradition in the Epic Poems*. Princeton, 1978.

Fryer 1984 Fryer, Peter. *Staying Power; the History of Black People in Britain*. London and Sydney, 1984.

G

Galt 1816 Galt, John. *The Life and Studies of Benjamin West*. London, 1816.

Galt 1820 Galt, John. *The Life, Studies, and Works of Benjamin West, Esq., President of the Royal Academy*. 2 vols. London, 1820. Reproduced, two volumes in one, as *The Life of Benjamin West*. Introduction by Nathalia Wright. Gainesville, Florida, 1960.

Garbisch Collection 1962 *101 Masterpieces of American Primitive Painting from the Collection of Edgar William and Bernice Chrysler Garbisch*. 2nd ed. [Exh. cat. American Federation of Arts] New York, 1962.

Gardner 1954 Gardner, Albert TenEyck. "Beckford's Gothic Wests." *Metropolitan Museum of Art Bulletin* 13, no. 2 (October 1954): 41–49.

Gardner and Feld 1965 Gardner, Albert TenEyck, and Stuart P. Feld. *American Paintings: A Catalogue of the Collection of The Metropolitan Museum of Art*. Vol. 1. New York, 1965.

Garlick 1964 Garlick, Kenneth. "A Catalogue of the Paintings, Drawings and Pastels of Sir Thomas Lawrence." *The Thirty-Ninth Volume of the Walpole Society, 1962–1964*. Glasgow, 1964.

Garlick 1989 Garlick, Kenneth. *Sir Thomas Lawrence, A Complete Catalogue of the Oil Paintings*. New York, 1989.

Gary 1934 American Art Association. *Important Rugs, Paintings, Georgian Silver and English Furniture from the Estate of the Late Elbert H. Gary and from the Estate of the Late Emma T. Gary*. New York, 1934.

"Gary Estate" 1934 "Active Bidding Marks Auction of Gary Estate." *Art News* 33, no. 11 (15 December 1934): 3, 15.

Gerdts 1974 Gerdts, William H. *The Great American Nude*. New York, 1974.

Gerdts 1987 Gerdts, William H. *The Art of Henry Inman*. [Exh. cat. NPG] Washington, 1987.

Gere 1987 Gere, J.A. *Drawings by Raphael and His Circle From British and North American Collections*. [Exh. cat. Pierpont Morgan Library] New York, 1987.

Gibb 1941 Gibb, Harley L. "Colonel Guy Johnson, Superintendent General of Indian Affairs, 1774–82." In vol. 27 of *Papers of the Michigan Academy of Science, Arts and Letters*. Ann Arbor and London, 1941.

Gibbs 1933 Gibbs, George. *The Gibbs Family of Rhode Island and Some Related Families*. New York, 1933.

Gibson 1865 Gibson, Elizabeth Bordley. *Biographical Sketches of the Bordley Family of Maryland, For Their Descendants*. Philadelphia, 1865.

Gillingham 1924 Gillingham, Harrold E. "Dr. Solomon Drowne." *Pennsylvania Magazine of History and Biography* 48, no. 3 (1924): 227–250.

Gillingham 1929 Gillingham, Harrold E. "Old Business Cards of Philadelphia." *Pennsylvania Magazine of History and Biography* 53 (1929): 203–229.

Gillon 1967 Gillon, Edmund V., Jr. *Early New England Gravestone Rubbings*. New York, 1967.

Goldwaithe 1895 Goldthwaite, Charlotte. *Boardman Genealogy 1525–1895*. Hartford, 1895.

Goodrich 1946 Goodrich, Lloyd. "Ralph Earl." *Magazine of Art* 39, no. 1 (January 1946): 2–8.

Goodrich 1953 Goodrich, Lloyd. "Landmarks in American Art." *Magazine of Art* 46, no. 3 (March 1953): 108–111.

Goodrich 1967 Goodrich, Laurence B. *Ralph Earl, Recorder of an Era*. Albany, New York, 1967.

Gottesman 1954 Gottesman, Rita Susswein. *The Arts and Crafts in New York, 1777–1800*. New York, 1954.

Gottesman 1959 Gottesman, Rita Susswein. "New York's First Major Art Show." *New-York Historical Society Quarterly* 43, no. 3 (July 1959): 288–305.

Gottesman 1965 Gottesman, Rita Susswein. *The Arts and Crafts in New York, 1800–1804*. New York, 1965.

"Graham" 1837 "Obituary: Right Hon. Sir Robert Graham." *Gentleman's Magazine* 6 (1837): 653.

Granger 1893 Granger, James Nathaniel. *Launcelot Granger of Newbury, Mass.* Hartford, Connecticut, 1893.

Graves 1897 Graves, Algernon. "A New Light on Alderman Boydell and the Shakespeare Gallery." *Magazine of Art* 21 (May-October 1897): 143–148.

Graves 1905 Graves, Algernon. *The Royal Academy of Arts; A Complete Dictionary of Contributors and their Work from its Foundation in 1769 to 1904*. 8 vols. London, 1905–1906.

Graves 1907 Graves, Algernon. "An Account of the Society of Artists of Great Britain." *The Society of Artists of Great Britain, 1760–1791; The Free Society of Artists, 1761–1783; A Complete Dictionary of Contributors and their Work from the Foundation of the Societies to 1791*. London, 1907.

Graves 1913 Graves, Algernon. *A Century of Loan Exhibitions, 1813–1912*. 5 vols. London, 1913–1915.

Graves 1918 Graves, Algernon. *Art Sales From Early in the Eighteenth Century to Early in the Twentieth Century*. 3 vols. London, 1918–1921.

"**Gravestone Records**" 1928 "Gravestone Records from Old Burying Ground, Orange, Essex County" *Genealogical Magazine of New Jersey* 4, no. 1 (July 1928): 46ff.

Graydon 1822 Graydon, Alexander, Jr. *Memoirs of a Life, Chiefly Passed in Pennsylvania, Within the Last Sixty Years*. Edinburgh, 1822.

Graydon 1828 Graydon, Alexander, Jr. *Life of an Officer, Written by Himself During a Residence in Pennsylvania*. Edinburgh, 1828.

Graydon 1846 Graydon, Alexander, Jr. *Memoirs of His Own Time*. Philadelphia, 1846. Reprinted as *Alexander Graydon's Memoirs of His Own Time*. Edited by John Stockton Littell. New York, 1969.

Graymount 1972 Graymount, Barbara. *The Iroquois in the American Revolution*. Syracuse, 1972.

Greene 1903 Greene, George Sears. *The Greenes of Rhode Island*. New York, 1903.

Greene Family 1901 *The Greene Family in England and America with Pedigrees*. Boston, 1901.

Greenwood 1909 Greenwood, Isaac John. *The Circus, Its Origin and Growth prior to 1835, with a Sketch of Negro Minstrelsy*. 2nd ed. New York, 1909. Reprint, New York, 1970.

Greenwood 1934 Greenwood, Isaac John. *The Greenwood Family of Norwich, England, in America*. Concord, New Hampshire, 1934.

Grieg 1911 Greig, James. *Sir Henry Raeburn, R.A.* London, 1911.

Groce 1952 Groce, George C. "John Wollaston (FL. 1736–1767): A Cosmopolitan Painter in the British Colonies." *Art Quarterly* 15, no. 2 (Summer 1952): 132–149.

Groce and Wallace 1957 Groce, George C., and David H. Wallace. *The New-York Historical Society's Dictionary of Artists in America, 1564–1860*. New Haven and London, 1957.

Guillum 1724 Guillum, John. *A Display of Heraldry*. London, 1724.

Gustafson 1979 Gustafson, Eleanor H. "Museum accessions." *Antiques* 115, no. 5 (May 1979): 976–978.

Gustafson 1984 Gustafson, Eleanor H. "Museum accessions." *Antiques* 126, no. 5 (November 1984): 1052–1053, 1056, 1060.

H

Haarman 1980 Haarman, Albert W. "American Uniforms during the French and Indian War, 1754–1763." *Military Collector and Historian; Journal of the Company of Military Historians* 32, no. 2 (Summer 1980): 58–69.

Hack 1938 Parke-Bernet Galleries. *Valuable Paintings Property of the Estates of Harold W. Hack, Short Hills, N.J.* New York, 1938.

Hagen 1940 Hagen, Oskar. *The Birth of the American Tradition in Art*. New York, 1940.

Hallam 1982 Hallam, John S. "Charles Willson Peale and Hogarth's line of beauty." *Antiques* 122, no. 5 (November 1982): 1074–1079.

Halsey and Tower 1925 Halsey, R.T. Haines, and Elizabeth Tower. *The Homes of Our Ancestors as shown in the American Wing of the Metropolitan Museum of Art of New York*. New York, 1925.

Hamilton 1832 Hamilton, George. *The English School: A Series of the Most Approved Productions in Painting and Sculpture, Executed by British Artists from the Days of Hogarth to the Present Time*. Vol. 4. London, 1832.

Hamilton 1919 Christie, Manson and Woods. *Catalogue of Family Portraits: Works by Old Masters and Modern Pictures: The Property of The Trustees of His Grace the Late Duke of Hamilton* [6–7 November 1919]. London, 1919.

Hamilton 1958 Hamilton, Milton W. "Joseph Brant — The Most Painted Indian." *New York History* 39, no. 2 (April 1958): 119–132.

Hamilton 1961 Hamilton, Milton W. "An American Knight in Britain: Sir John Johnson's Tour 1765–1771." *New York History* 42 (1961): 119–144.

Hamilton 1967 Hamilton, Milton W. *Sir William Johnson and the Indians of New York*. Albany, New York, 1967.

Hamilton-Phillips 1980 Hamilton-Phillips, Martha. "Benjamin West and William Beckford: Some Projects for Fonthill." *Metropolitan Museum Journal* 15 (1980): 157–174.

Hamm 1902 Hamm, Margherita Arlina. *Famous Families of New York*. 2 vols. New York and London, 1902.

Hammelmann 1975 Hammelmann, Hanns. *Book Illustrators in Eighteenth-Century England*. Edited and completed by T.S.R. Boase. New Haven and London, 1975.

Hansen 1981 Hansen, James M. *An Exhibition of Paintings by Colin Campbell Cooper*. Santa Barbara, 1981.

Harris 1964 Harris, Paul S. "Gilbert Stuart and a Portrait of Mrs. Sarah Apthorp Morton." *Winterthur Portfolio* 1 (1964): 198–220.

Harris 1990 Harris, Eileen. "Robert Adam's Ornaments for Alderman Boydell's Picture Frames." *Furniture History. The Journal of the Furniture History Society* 26 (1990): 93–96.

Harrison 1870 *Catalogue of Pictures, Statuary, and Bronzes in the Gallery of Joseph Harrison, Jr., Rittenhouse Square, Philadelphia*. Philadelphia, 1870.

Harrison 1912 Philadelphia Art Galleries. *Paintings, Statuary, etc. The Remainder of the Collection of the Late Joseph Harrison, Jr.* Philadelphia, 1912.

Hart 1879 Hart, Charles Henry. "Mason's Life of Stuart." *American Art Review* 1, first division (1879/1880): 219–222.

Hart 1880 Hart, Charles Henry. "The Stuart Exhibition at the Museum of Fine Arts, Boston." *American Art Review* 1, second division (1880): 484–487.

Hart 1889 Hart, Charles Henry. "Original Portraits of Washington." *Century Magazine* 37, no. 6 (April 1889): 860–865.

Hart, "Hamilton," 1897 Hart, Charles Henry. "Life Portraits of Alexander Hamilton." *McClure's Magazine* 8 (April 1897): 507f.

Hart, "Washington," 1897 Hart, Charles Henry.

"Life Portraits of George Washington." *McClure's Magazine* 8, no. 4 (February 1897): 290–308.

Hart 1904 Hart, Charles Henry. *Catalogue of the Engraved Portraits of Washington.* New York, 1904.

Hart 1905 Hart, Charles Henry. *Edward Savage, Painter and Engraver, and his Unfinished Copper-plate of "The Congress Voting Independence."* Boston, 1905.

Hart 1917 Hart, Charles Henry. "Portrait of Thomas Dawson, Viscount Cremorne, Painted by Mather Brown." *Art in America* 5, no. 6 (October 1917): 309–314.

Hart 1985 Hart, Sidney. "A Graphic Case of Transatlantic Republicanism." *Pennsylvania Magazine of History and Biography* 109, no. 2 (April 1985): 203–213. Reprinted in Miller and Ward 1991.

Harvey 1942 Harvey, Samuel C. "Surgery of the Past in Connecticut." In *The Heritage of Connecticut Medicine.* Edited by Herbert Thoms. New Haven, 1942.

Hayden 1883 Hayden, Horace Edwin. *Pollock Genealogy.* Harrisburg, Pennsylvania, 1883.

Hayes 1975 Hayes, John. *Gainsborough.* New York, 1975.

Hayes 1990 Hayes, John. *The Art of Thomas Rowlandson.* [Exh. cat. Art Services International] Alexandria, Virginia, 1990.

Hayes 1992 Hayes, John. *British Paintings of the Sixteenth through Nineteenth Centuries.* Washington and Cambridge, England, 1992.

"Hayne" 1909 "Records kept by Colonel Isaac Hayne." *South Carolina Historical and Genealogical Magazine* 10 (1909): 145–170, 220–235.

"Hayne" 1910 "Records kept by Colonel Isaac Hayne." *South Carolina Historical and Genealogical Magazine* 11 (1910): 27–38, 64, 92–106, 160–170.

Hazard 1915 Hazard, Thomas Robinson. *The Jonny-Cake Papers of "Shepherd Tom," together with Reminiscences of Narragansett Schools of Former Days.* Boston, 1915.

Head 1916 Christie, Manson & Woods. *Catalogue of Family Portraits, Books, Autographs, Manuscripts, etc. Relating to William Penn and His Descendants and the Early History of Pennsylvania: The Property of J. Meyrick Head, Esq. Deceased; Late of Pennsylvania Castle, Portland.* London, 1916.

Herbert 1836 Herbert, John Dowling. *Irish Varieties.* London, 1836.

Henkels 1931 Henkels, Stanislaus V. *Historical Sale, Portraits and Autographs, Revolutionary and other Letters. The Alexander Hamilton Family Papers, Portrait of Hamilton from Life by Vanderlyn . . . May 15, 1931.* Philadelphia, 1931.

Hess 1916 Hess, Abram. "The Life and Services of John Philip de Haas." In Lebanon County Historical Society. *Historical Papers and Addresses* 7, no. 2 (February 1916): 71–123.

Heydenryk 1963 Heydenryk, Henry. *The Art and History of Frames.* New York, 1963.

Hirschl & Adler 1975 *American Portraits by John Singleton Copley.* [Exh. cat. Hirschl & Adler Galleries] New York, 1975.

Hirschl & Adler 1979 *Recent Acquisitions of American Art, 1769–1938.* [Exh. cat. Hirschl & Adler Galleries] New York, 1979.

Hirschl & Adler 1988 *Adventure and Inspiration: American Artists in Other Lands* [Exh. cat. Hirschl & Adler Galleries] New York, 1988.

Historical Pictures 1829 George Robins. *A Catalogue Raisonné of the Unequalled Collection of Historical Pictures, and Other Admired Compositions, the Works of the revered and highly-gifted Painter, the late Benjamin West, Esq.* [22–25 May 1829]. London, 1829.

Historical Records Survey 1939 Historical Records Survey. *American Portraits 1620–1825 Found in Massachusetts.* 2 vols. Boston, 1939.

Historical Records Survey 1942 Historical Records Survey. "Preliminary Checklist of American Portraits Found in New Hampshire." Boston, 1942.

Hodge 1907 *Handbook of American Indians North of Mexico.* Edited by Frederick Webb Hodge. 2 vols. Washington, 1907.

Hodges 1907 Hodges, George. *Holderness; An Account of the Beginnings of a New Hampshire Town.* Boston and New York, 1907.

Hoh and Rough 1990 Hoh, LaVahn G., and William H. Rough. *Step Right Up! The Adventures of CIRCUS in America.* White Hall, Virginia, 1990.

Holbrook Research Holbrook Research Institute. *Massachusetts Vital Records.* Oxford, Massachusetts, 1982–1991.

Honour 1989 Honour, Hugh. *The Image of the Black in Western Art.* Vol. 4. *From the American Revolution to World War I*, Part I: *Slaves and Liberators.* Cambridge, Massachusetts, 1989.

Hough 1860 Hough, Franklin B. *History of Lewis County in the State of New York.* Albany, New York, 1860.

Hough 1861 Hough, Franklin B. *Proceedings of the Commissioners of Indian Affairs.* Albany, New York, 1861.

Howe 1845 Howe, Henry. *Historical Collections of Virginia.* Charleston, 1845. Reprint, Baltimore, 1969.

Hume 1933 Hume, Major Edgar Erskine. "General George Washington's Eagle of the Society of the Cincinnati." *Numismatist* 46, no. 12 (December 1933): 749–759.

Hunt 1906 "Washington in Jackson's Time with Glimpses of Henry Clay from the Diaries and Family Letters of Mrs. Samuel Harrison Smith (Margaret Bayard)." Edited by Gaillard Hunt. *Scribner's Magazine* 40, no. 5 (November 1906): 608–626.

Huntington 1986 *The Huntington Art Collections: A Handbook.* The Huntington Library. San Marino, California, 1986.

Hurd 1772 Hurd, Richard. *An Introduction to the Study of the Prophecies concerning the Christian Church.* London, 1772.

I

Index of Obituaries 1968 *Index of Obituaries in Boston Newspapers, 1704–1785.* Compiled by Boston Athenaeum. Boston, 1968.

"Indian Portraits" 1938 "American Indian Portraits." *University Museum Bulletin* (University of Pennsylvania) 7, no. 2 (April 1938): 18–25.

Isham 1904 Isham, Samuel. "The Art of Copley." *Masters in Art: A Series of Illustrated Monographs.* Vol. 5, part 60. Boston, 1904.

Isham 1905 Isham, Samuel. *The History of American Painting.* New York, 1905.

J

Jackson and Twohig 1979 *The Diaries of George Washington.* Edited by Donald Jackson and Dorothy Twohig. 6 vols. Charlottesville, 1979.

Jacobus 1932 Jacobus, Donald Lines. *History and Genealogy of the Families of Old Fairfield.* 2 vols. Fairfield, Connecticut, 1932.

Jaffe 1975 Jaffe, Irma B. *John Trumbull: Patriot-Artist of the American Revolution.* Boston, 1975.

Jaffe 1977 Jaffe, Irma B. "John Singleton Copley's *Watson and the Shark.*" *American Art Journal* 9, no. 1 (May 1977): 15–25.

Jameson 1844 Jameson, Anna Brownell. *Companion to the most Celebrated Private Galleries of Art in London.* London, 1844.

Jarrett 1960 Jarrett, Dudley. *British Naval Dress.* London, 1960.

Jay Family 1986 Christie, Manson and Woods. *The Jay Family Collection of Historical American Portraits . . . January 25, 1986.* New York, 1986.

Johnson 1905 Johnson, Robert Winder. *The Ancestry of Rosalie Morris Johnson.* Philadelphia, 1905.

Johnston 1964 Johnston, Charles M., ed. *The Valley of the Six Nations; A Collection of Documents on the Indian Lands of the Grand River.* Toronto, 1964.

Johnston 1882 Johnston, Elizabeth Bryant. *Original Portraits of Washington, including Statues, Monuments and Medals.* Boston, 1882.

Johnston 1983 Johnston, Sona K. *American Paintings, 1750–1900, from the Collection of the Baltimore Museum of Art.* Baltimore, 1983.

Jones 1930 Jones, Edward Alfred. *The Loyalists of Massachusetts, their Memorials, Petitions and Claims.* London, 1930.

Jouett 1816 Jouett, Matthew Harris. "Notes Taken by M.H. Jouett while in Boston from Conversations on painting with Gilbert Stuart Esqr." Manuscript, published in Morgan, *Stuart,* 1939.

K

Kane 1975 Kane, Patricia E. *Three Hundred Years of American Seating Furniture: Chairs and Beds from the Mabel Brady Garvan and Other Collections at Yale University.* Boston, 1975.

Kaplan 1973 Kaplan, Sidney. *The Black Presence in the Era of the American Revolution, 1770–1800.* [Exh. cat. NPG] Washington, 1973.

Karel 1992 Karel, David. *Dictionnaire des Artistes de Langue Française en Amérique du Nord.* Quebec, 1992.

Katlan 1987 Katlan, Alexander W. *American Artists' Materials.* Vol. 1: *Suppliers Directory, Nineteenth Century: New York 1810–1899, Boston 1823–1887.* Park Ridge, New Jersey, 1987.

Katlan 1992 Katlan, Alexander W. *American Artists' Materials.* Vol. 2: *A Guide to Stretchers, Panels, Millboards, and Stencil Marks.* Madison, Connecticut, 1992.

Kauffmann 1968 *Angelika Kauffmann und ihre Zeitgenossen.* [Exh. cat. Vorarlberger Landesmuseum, Bregenz, and Österreichisches Museum für Angewandte Kunst, Vienna] Vienna, 1968–1969.

Kauffmann 1979 *Angelika Kauffmann und ihre Zeit; Graphik und Zeichnungen von 1760–1810.* Düsseldorf, 1979.

Kelsay 1984 Kelsay, Isabel Thompson. *Joseph Brant, 1743–1807: Man of Two Worlds.* Syracuse, New York, 1984.

Kemp 1980 Kemp, Martin. [Letter to the Editor]. *Art Bulletin* 62, no. 4 (December 1980): 647.

Kennon 1986 *The Speakers of the U.S. House of Representatives: A Bibliography, 1780–1984.* Edited by Donald R. Kennon. Baltimore, 1986.

Kerr 1927 Kerr, John Clapperton. "Gideon Carstang (168?–1759) and Some of his Descendants." *New York Genealogical and Biographical Record* 18, no. 3 (July 1927): 221ff.

Kimball 1944 Kimball, Fiske. *The Life Portraits of Jefferson and their Replicas.* Philadelphia, 1944.

Kindred Spirits 1992 Ars. Libri, Ltd. *Kindred Spirits: The E. Maurice Bloch Collection of Manuscripts, Letters and Sketchbooks of American Artists, Mostly of the Nineteenth Century, and of Books, Pamphlets, and Other Contemporary Publications Relating to Them. Part 1: Books and Printed Matter.* Boston, 1992.

King 1991 King, J.C.H. "Woodlands Artifacts From the studio of Benjamin West, 1738–1820." *American Indian Art Magazine* 17, no. 1 (Winter 1991): 34–47.

King's Inns 1982 *King's Inns Admission Papers, 1607–1867.* Edited by Edward Keane, P. Beryl Phair, and Thomas U. Sadleir. Dublin, 1982.

Kirk 1964 Kirk, Russell. *John Randolph of Roanoke: A Study in American Politics.* Chicago, 1964.

Kloss 1988 Kloss, William. *Samuel F.B. Morse.* New York, 1988.

Knapp 1829 Knapp, Samuel L. *Lectures on American Literature, with Remarks on some Passages of American History.* New York, 1829.

Kornhauser 1988 Kornhauser, Elizabeth Mankin. "Ralph Earl: Artist-Entrepreneur." Ph.D. diss., Boston University, 1988.

Kornhauser 1991 Kornhauser, Elizabeth Mankin. *Ralph Earl: The Face of the Young Republic* [Exh. cat. Wadsworth Atheneum, Hartford] New Haven and London, 1991.

Kovel and Kovel 1961 Kovel, Ralph M., and Terry H. Kovel. *A Directory of American Silver, Pewter and Silverplate.* New York, 1961.

Kraemer 1975 Kraemer, Ruth. *Drawings by Benjamin West and His Son Raphael Lamar West.* New York, 1975.

L

Lacy 1990 Lacy, Allen. *The Glory of Roses.* New York, 1990.

Lamb 1877 Lamb, Martha. *History of the City of New York.* 3 vols. New York and Chicago, 1877–1896.

Lancaster 1912 *Loan Exhibition of Historical and Contemporary Portraits Illustrating the Evolution of Portraiture in Lancaster County, Pennsylvania, under the auspices of The Iris Club and The Historical Society of Lancaster County...November 23, to December 13, 1912.* Lancaster, Pennsylvania, 1912.

Lane 1940 Lane, James W. "This Year the Carnegie National, Pittsburgh's Brilliant Survey of 160 Years of U.S. Painting." *Art News* 39, no. 4 (26 October 1940): 7–18.

Lansdown 1893 Lansdown, H.V. *Recollections of the Late William Beckford, of Fonthill, Wilts. and Lansdown, Bath.* Edited by Charlotte Lansdown. Privately printed, 1893.

Lassiter 1971 Lassiter, Barbara B. *Reynolda House: American Paintings.* Winston-Salem, North Carolina, 1971.

"Laurens" 1902 "Letters from Hon. Henry Laurens to his Son John, 1773–1776." *South Carolina Historical and Genealogical Magazine* 3, no. 3 (July 1902): 139–149.

Lavater 1789 Lavater, John Caspar. *Essays on Physiognomy, designed to promote the Knowledge and Love of Mankind.* Edited by Thomas Holloway. 3 vols. in 5. London, 1789–1798.

Lawrence 1979 *Sir Thomas Lawrence, 1769–1830.* [Exh. cat. National Portrait Gallery, London] London, 1979.

Lawson 1961 Lawson, Cecil C.P. *A History of the Uniforms of the British Army.* London, 1961.

Lawson 1992 Lawson, Karol Ann Peard. "Charles Willson Peale's *John Dickinson:* An American Landscape as Political Allegory." *Proceedings of the American Philosophical Society* 136, no. 4 (December 1992): 455–486.

Lea and Gang 1981 Lea, Kathleen M., and T.M. Gang. "Tasso's Reputation in England." In Lea and Gang, eds. *Godfrey of Bulloigne.* Oxford, England, 1981.

Leach 1965 Leach, F.W. "Rush Family of Pennsylvania." In Jason Adamson. *Rush Genealogy.* Turlock, California, 1965.

Leach 1973 Leach, Cathy. "19th Century Prepared Artists' Canvases." *Antique Collecting* 8, no. 3 (July 1973): 2–4.

Lee 1916 Lee, Thomas Amory. "Nathaniel Tracy, Harvard, 1769." *Harvard Graduates Magazine* 25, no. 98 (December 1916): 193–197.

Lee 1921 Lee, Thomas Amory. "The Tracy Family of Newburyport." *Essex Institute Historical Collections* 57 (January 1921): 57ff.

Lee 1928 Lee, Cuthbert. "The Thomas B. Clarke Collection of Early American Portraits." *American Magazine of Art* 19, no. 6 (June 1928): 293–305.

Lee 1929 Lee, Cuthbert. *Early American Portrait Painters.* New Haven, 1929.

Lee 1967 Lee, Rensselaer W. *Ut Pictura Poesis: The Humanistic Theory of Painting.* New York, 1967.

Leger Galleries 1975 Leger Galleries. *Exhibition of English Eighteenth Century Conversation Pieces, Portraits and Landscapes.* London, 1975.

Leslie and Taylor 1865 Leslie, Charles Robert, and Tom Taylor. *The Life and Times of Sir Joshua Reynolds, with Notices of some of his Contemporaries.* 2 vols. London, 1865.

Lester 1846 Lester, C. Edwards. *The Artists of America.* New York, 1846.

Letters of Mrs. Adams 1848 Abigail Adams. *Letters of Mrs. Adams, the Wife of John Adams.* 4th ed. Boston, 1848.

Lewis 1973 Lewis, Bessie M. "The Wiggs of South Carolina." *South Carolina Historical Magazine* 74, no. 2 (April 1973): 80–97.

Linzee 1917 Linzee, John William. *The Linzee Family of Great Britain and the United States of America.* 2 vols. Boston, 1917.

Little 1972 Little, Nina Fletcher. "The Blyths of Salem: Benjamin, Limner in Crayons and Oil, and Samuel, Painter and Cabinetmaker." *Essex Institute Historical Collections* 108, no. 1 (January 1972): 49–57.

Little 1976 Little, Nina Fletcher. *Paintings by New England Provincial Artists, 1775–1800.* [Exh. cat. MFA] Boston, 1976.

Lockwood 1954 Parke-Bernet Galleries. *XVII and XVIII Century American Furniture and Paintings, The Celebrated Collection Formed by the Late Mr. and Mrs. Luke Vincent Lockwood* [13–15 May 1954]. New York, 1954.

Lovell 1987 Lovell, Margaretta M. "Reading Eighteenth-Century American Family Portraits: Social Images and Self-Images." *Winterthur Portfolio* 22, no. 4 (Winter 1987): 243–264.

Lovell 1991 Lovell, Margaretta M. "To Be 'Conspecuous in the Croud': John Singleton Copley's *Sir William Pepperrell and His Family.*" *North Carolina Museum of Art Bulletin* 15 (1991): 29–42.

Lugt 1921 Lugt, Frits. *Les Marques de Collections de Dessins et d'Estampes.* Amsterdam, 1921. *Supplément.* The Hague, 1956.

Lundberg 1970 Lundberg, Gunnar W. *Wertmüller, Peintre suédois de Marie-Antoinette, son séjour à Bordeaux.* Bordeaux, 1970.

M

Macdonough 1909 Macdonough, Rodney. *Life of Commodore Thomas Macdonough, U.S. Navy.* Boston, 1909.

MacMillan 1964 MacMillan, Henry Jay. "Gilbert Stuart's Portrait of an Ashe." *Lower Cape Fear Historical Society Bulletin* 8 (October 1964): 6.

Makers of History 1950 *Makers of History in Washington 1800–1950.* [Exh. cat. NGA] Washington, 1950.

Manchester 1857 *Catalogue of the Art Treasures of the United Kingdom Collected at Manchester in 1857.* [Exh. cat.] London, 1857.

Maryland Heritage 1976 *Maryland Heritage: Five Baltimore Institutions Celebrate the American Bicentennial.* Edited by John B. Boles. Baltimore, 1976.

Mason 1879 Mason, George C. *The Life and Works of Gilbert Stuart.* New York, 1879.

Mather 1927 Mather, Frank Jewett, Jr. "Painting." In Frank Jewett Mather, Jr., Charles Rufus Morey, and William James Henderson. *The American Spirit in Art.* Vol. 12 of *The Pageant of America.* Edited by Ralph Henry Gabriel. New Haven, 1927.

Mayo 1948 Mayo, Lawrence Shaw. *The Winthrop Family in America.* Boston, 1948.

Mayor 1943 Mayor, A. Hyatt. "Early American Painters in England." *Proceedings of the American Philosophical Society* 87, no. 1 (July 1943).

McCann 1945 *Notable Paintings by Old Masters, Works by XIX Century Artists From the Collection of the Late Mr. & Mrs. Charles E.F. McCann. . . .* New York, 1945.

McClave 1984 McClave, Elizabeth W. *Stephen Van Rensselaer III: A Pictorial Reflection and Biographical Commentary.* Stephentown, New York, 1984.

McElroy 1990 McElroy, Guy C. *Facing History: The Black Image in American Art, 1710–1940.* [Exh. cat. CGA] Washington, 1990.

McLanathan 1986 McLanathan, Richard. *Gilbert Stuart.* New York, 1986.

Mead 1981 Mead, Katherine Harper, ed. *The Preston Morton Collection of American Art.* Santa Barbara, 1981.

"Memoir" 1828 "Memoir of the late Mrs. Sarah Tappan of Northampton, Massachusetts, the materials of which have been furnished by a surviving relative." *Home Missionary and American Pastor's Journal* 1, no. 7 (1 November 1828): 121–125.

Merrick 1921 Merrick, Lulu. "In the New York Art Galleries." *Spur* 28, no. 10 (15 November 1921): 32.

Meschutt 1981 Meschutt, David. "Gilbert Stuart's Portraits of Thomas Jefferson." *American Art Journal* 13, no. 1 (Winter 1981): 2–16.

Meschutt 1992 Meschutt, David. "Checklist of Portraits of James Monroe." *Images of a President: Portraits of James Monroe.* [Exh. cat. James Monroe Museum and Memorial Library] Fredericksburg, Virginia, 1992.

Metcalf 1938 Metcalf, Bryce. *Original Members and Other Officers eligible to the Society of the Cincinnati, 1783–1938.* Strasburg, Virginia, 1938.

Methodist Episcopal Church 1928 *Journal of the Eightieth Session of the New York East Annual Conference of the Methodist Episcopal Church.* Bridgeport, Connecticut, 1928.

Meyer, "Chapel," 1975 Meyer, Jerry D. "Benjamin West's Chapel of Revealed Religion. A Study in Eighteenth-Century Protestant Religious Art." *Art Bulletin* 57, no. 2 (June 1975): 247–265.

Meyer, "Religious Paintings," 1975 Meyer, Jerry D. "The Religious Paintings of Benjamin West: A Study in Late Eighteenth and Early Nineteenth Century Moral Sentiment." Ph.D. diss., New York University, 1975.

MFA 1880 Museum of Fine Arts. "Portraits Painted by Stuart . . . taken from Mason's *Life and Works of Gilbert Stuart.*" *Exhibition of Portraits Painted by Gilbert Stuart.* Boston, 1880.

MFA 1880 II Museum of Fine Arts. *Fifteenth Catalogue of the Collection of Ancient and Modern Works of Art given or lent to the Trustees.* Part II. Boston, 1880.

MFA 1881 Museum of Fine Arts. "Contributions to the Loan Exhibitions for the year 1880." *Annual Report.* Boston, 1881.

MFA 1886 Museum of Fine Arts. *Catalogue of Works of Art Exhibited on the Second Floor.* Boston, 1886.

MFA 1890 Museum of Fine Arts. "Contributions to the Loan Exhibitions for the Year 1889." *Annual Report.* Boston, 1890.

MFA 1892 Museum of Fine Arts. *Catalogue of Paintings and Drawings, with a Summary of Other Works of Art, Exhibited on the Second Floor, Third Edition, Winter 1891–1892.* Boston, 1892.

MFA 1895 Museum of Fine Arts. *Catalogue of Paintings and Drawings, with a Summary of Other Works of Art, Exhibited on the Second Floor. Winter 1895–1896.* Boston, 1895.

MFA 1932 Museum of Fine Arts. *Selected Oil and Tempera Paintings & Three Pastels.* Boston, 1932.

MFA 1969 Museum of Fine Arts. *American Paintings in the Museum of Fine Arts, Boston.* 2 vols. Boston, 1969.

MFA Bulletin 1903 "Guide to the Museum: Second Picture Gallery." (Boston) *Museum of Fine Arts Bulletin* 1, no. 3 (July 1903): 18.

MFA Handbook 1906 *Handbook of the Museum of Fine Arts, Boston.* Boston, 1906.

Middleton 1951 Middleton, Margaret Simons. "Jeremiah Theus of Charles Town." *Antiques* 60, no. 2 (August 1951): 102–104.

Middleton 1953 Middleton, Margaret Simons. *Jeremiah Theus: Colonial Artist of Charles Town.* Columbia, South Carolina, 1953.

Miles 1976 Miles, Ellen G. "Thomas Hudson (1701–1779): Portraitist to the British Establishment." 2 vols. Ph.D. diss., Yale University, 1976.

Miles and Simon 1979 Miles, Ellen G., and Jacob Simon. *Thomas Hudson (1701–1779): Portrait Painter and Collector; A Bicentenary Exhibition.* [Exh. cat. Iveagh Bequest, Kenwood] London, 1979.

Miles 1993 Miles, Ellen G. "Copley's *Watson and the Shark.*" *Antiques* 143, no. 1 (January 1993): 162–171.

Millar 1963 Millar, Oliver. *The Tudor, Stuart and Early Georgian Pictures in The Collection of Her Majesty the Queen.* 2 vols. London, 1963.

Millar 1967 Millar, Oliver. *Zoffany and his Tribuna.* London and New York, 1967.

Millar 1978 Millar, Oliver. *Sir Peter Lely, 1616–1680.* [Exh. cat. National Portrait Gallery, London] London, 1978.

Miller 1969 Miller, Hope Ridings. *Great Houses of Washington, D.C.* New York, 1969.

Miller 1980 Miller, Lillian B., ed. *The Collected Papers of Charles Willson Peale and His Family.* Microfiche edition. Millwood, New York, 1980.

Miller 1983 Miller, Lillian B., Sidney Hart, Toby A. Appel, and David C. Ward, eds. *The Selected Papers of Charles Willson Peale and His Family.* Vol. 1: *Charles Willson Peale: Artist in Revolutionary America, 1735–1791.* Vol. 2, parts 1 and 2: *Charles Willson Peale: The Artist as Museum Keeper, 1791–1810.* Vol. 3: *The Belfield Farm Years, 1810–1820.* New Haven and London, 1983–1991.

Miller, "Harmony and Purpose," 1983 Miller, Lillian B. "Charles Willson Peale: A Life of Harmony and Purpose." In Richardson, Hindle, and Miller 1983.

Miller and Ward 1991 Miller, Lillian B., and David C. Ward, eds. *New Perspectives on Charles Willson Peale.* Pittsburgh, 1991.

Milton **1947** *The Student's Milton.* Edited by Frank Allen Patterson. Rev. ed. New York, 1947.

Mint *Quarterly* **1967** Mint Museum of Art (Charlotte, North Carolina). *Quarterly* (Fall 1967).

Montclair **1989** *Three Hundred Years of American Painting: The Montclair Art Museum Collection.* New York, 1989.

Monthly Magazine **1804** "Monthly Retrospect of the Fine Arts." *Monthly Magazine; or British Register* 17 (1 July 1804): 595.

Moore 1903 Moore, James W. *Rev. John Moore of Newton, L.I., and Some of His Descendants.* Easton, Pennsylvania, 1903.

Mooz 1970 Mooz, Robert Peter. "The Art of Robert Feke." Ph.D. diss., University of Pennsylvania, 1970.

Mooz 1971 Mooz, R. Peter. "Robert Feke: The Philadelphia Story." In *American Painting to 1776: A Reappraisal.* Edited by Ian M.G. Quimby. Charlottesville, 1971.

Morgan 1930 Morgan, John Hill. "Portraiture of Washington." In Weddell 1930.

Morgan and Fielding 1931 Morgan, John Hill, and Mantle Fielding. *The Life Portraits of Washington and their Replicas.* Philadelphia, 1931.

Morgan 1937 Morgan, John Hill. "Some Notes on John Singleton Copley." *Antiques* 31, no. 3 (March 1937): 116–119.

Morgan and Foote 1937 Morgan, John Hill, and Henry Wilder Foote. *An Extension of Lawrence Park's Descriptive List of the Work of Joseph Blackburn.* Worcester, Massachusetts, 1937.

Morgan, *Copley,* **1939** Morgan, John Hill. *John Singleton Copley, 1737/8–1815.* Windham, Connecticut, 1939.

Morgan, *Stuart,* **1939** Morgan, John Hill. *Gilbert Stuart and his Pupils.* New York, 1939. Reprint, New York, 1969.

Morgan and Toole 1950 Morgan, Charles H., and Margaret C. Toole. "Benjamin West: His Times and His Influence." *Art in America* 38, no. 4 (December 1950): 205–278.

Morison 1969 Morison, Samuel Eliot. *Harrison Gray Otis, 1765–1848, The Urbane Federalist.* Boston, 1969.

Morris 1966 Morris, John N. *Versions of the Self; Studies in English Autobiography from John Bunyan to John Stuart Mill.* New York and London, 1966.

Mount 1959 Mount, Charles Merrill. "A Hidden Treasure in Britain." *Arts Quarterly* 22, no. 3 (Autumn 1959): 216–228.

Mount 1964 Mount, Charles Merrill. *Gilbert Stuart: A Biography.* New York, 1964.

Mount 1973 Mount, Charles Merrill. "Gilbert Stuart in Washington: with a Catalogue of His Portraits Painted between December 1803 and July 1805." *Records of the Columbia Historical Society of Washington, D.C.* 48 (1973): 81–127.

N

Naeve 1976 Naeve, Milo M. "'The best likeness' of George Washington by Edward Savage." *Bulletin of the Art Institute of Chicago* 70, no. 4 (July-August 1976): 13–16.

Namier and Brooke 1964 Namier, Sir Lewis, and John Brooke. *The History of Parliament: the House of Commons, 1754–1790.* 3 vols. New York, 1964.

Naval Documents *Naval Documents of The American Revolution.* 6 vols. Vol. 2 (1966), vol. 3 (1968). Edited by William Bell Clark. Washington, 1964–1972.

NCAB *The National Cyclopaedia of American Biography.* 63 vols. Clifton, New Jersey, 1893–1984.

Neal 1824 Neal, John. [Essay on American art.] *Blackwood's Edinburgh Magazine* 16 (August 1824). Reprinted in *Observations on American Art; Selections from the Writings of John Neal (1793–1876).* Edited by Harold E. Dickson. State College, Pennsylvania, 1943.

New England Register **1925** "Proceedings of the New England Historic Genealogical Society" [meeting of 1 April 1925]. *New England Historical and Genealogical Register* 74 (July 1925): 325.

New Orleans Artists **1987** Historic New Orleans Collection. *Encyclopedia of New Orleans Artists 1718–1918.* New Orleans, 1987.

Newton 1754 Newton, Thomas. *Dissertations on the Prophecies, which have remarkably been fulfilled and at this time are fulfilling in the World.* 3 vols. London, 1754–1758.

New-York Historical Society **1974** *Catalogue of American Portraits in the New-York Historical Society.* 2 vols. New Haven and London, 1974.

NGA 1970 National Gallery of Art. *American Paintings and Sculpture: An Illustrated Catalogue.* Washington, 1970.

NGA 1980 National Gallery of Art. *American Paintings: An Illustrated Catalogue.* Washington, 1980.

NGA 1992 National Gallery of Art. *American Paintings: An Illustrated Catalogue.* Washington, 1992.

Nicholson 1971 Nicholson, Arnold. "Dr. Thornton, who practiced everything but medicine." *Smithsonian Magazine* 2, no. 1 (April 1971): 66–75.

Nivelon 1737 Nivelon, F. *The Rudiments of Genteel Behavior.* London, 1737.

Notable Americans **1904** *The Twentieth Century Biographical Dictionary of Notable Americans.* 10 vols. Boston, 1904.

Novak 1969 Novak, Barbara. *American Painting of the Nineteenth Century.* New York, Washington and London, 1969.

Nylander 1972 Nylander, Richard C. "Joseph Badger, American Portrait Painter." Master's thesis, State University of New York at Oneonta, 1972.

NYT Bio Service *The New York Times Biographical Service*. 24 vols. (and continuing). New York, 1969–.

O

O'Donoghue 1906 O'Donoghue, Freeman. *Catalogue of Engraved British Portraits Preserved in the Department of Prints and Drawings in the British Museum*. 6 vols. London, 1906–1925.

O'Hart 1892 O'Hart, John. *Irish Pedigrees; or, the Origin and Stem of The Irish Nation*. 5th ed. 2 vols. Dublin, 1892. Reprint, Baltimore, 1976.

Oliver 1967 Oliver, Andrew. *Portraits of John and Abigail Adams*. Cambridge, Massachusetts, 1967.

Oliver 1970 Oliver, Andrew. *Portraits of John Quincy Adams and His Wife*. Cambridge, Massachusetts, 1970.

Ormond 1967 Ormond, Richard. "John Partridge and the Fine Arts Commissioners." *Burlington Magazine* 109 (July 1967): 397–403.

Oswald 1961 Oswald, Arthur. "Our Ancestors on the Ice." *Country Life* 129 (9 February 1961): 268–270.

Otis 1924 Otis, William A. *A Genealogical and Historical Memoir of the Otis Family in America*. Chicago, 1924.

P

PAFA 1887 *Loan Exhibition of Historical Portraits*. [Exh. cat. PAFA] Philadelphia, 1887.

PAFA 1969 The Pennsylvania Academy of the Fine Arts. *Checklist: Paintings, Sculptures, Miniatures from the Permanent Collection*. Philadelphia, 1969.

Papenfuse 1979 Papenfuse, Edward C. et al. *A Biographical Dictionary of the Maryland Legislature, 1635–1789*. 2 vols. Baltimore and London, 1979–1985.

Park 1918 Park, Lawrence. *Joseph Badger (1708–1765), And a Descriptive List of some of his Works*. Boston, 1918.

Park 1923 Park, Lawrence. *Joseph Blackburn: A Colonial Portrait Painter with a Descriptive List of his Works*. Worcester, Massachusetts, 1923.

Park 1926 Park, Lawrence. *Gilbert Stuart: An Illustrated Descriptive List of his Works, with an Account of his Life by John Hill Morgan and an Appreciation by Royal Cortissoz*. 4 vols. New York, 1926.

Parker and Wheeler 1938 Parker, Barbara Neville, and Anne Bolling Wheeler. *John Singleton Copley; American Portraits in Oil, Pastel, and Miniature with Biographical Sketches*. Boston, 1938.

Parnassus Gallery 1955 Parnassus Gallery advertisement. *Antiques* 67, no. 1 (January 1955): 24.

Parry 1974 Parry, Ellwood C., III. *The Image of the Indian and the Black Man in American Art, 1590–1900*. New York, 1974.

Parry 1988 Parry, Ellwood C., III. *The Art of Thomas Cole: Ambition and Imagination*. Newark, Delaware, 1988.

Pasquin 1796 Pasquin, Anthony [John Williams]. *Memoirs of the Royal Academicians and an Authentic History of the Artists of Ireland*. London, 1796.

Passavant 1836 Passavant, Johann David. *Tour of a German Artist in England*. 2 vols. London, 1836.

Paulson 1975 Paulson, Ronald. *Emblem and Expression: Meaning in English Art of the Eighteenth Century*. London, 1975.

Peabody Institute 1949 *List of Works of Art in the Collection of the Peabody Institute*. Baltimore, 1949.

Peale 1858 Peale, Rembrandt. "Washington and his Portraits." Unpublished lecture, Charles Roberts Autograph Letters Collection, Haverford College, Pennsylvania. In Miller 1980.

Pearson 1987 Pearson, Andrea G. "Gilbert Stuart's *The Skater (Portrait of William Grant)* and Henry Raeburn's *The Reverend Robert Walker, D.D., Skating on Duddingston Loch*: A Study of Sources." *Rutgers Art Review* 8 (1987): 55–70.

Pelletreau 1907 Pelletreau, William S. *Historic Homes and Institutions and Genealogical and Family History of New York*. 4 vols. New York and Chicago, 1907.

Pennsylvania Families 1982 *Genealogies of Pennsylvania Families. From the Pennsylvania Genealogical Magazine*. 3 vols. Baltimore, 1982.

Penny 1977 Penny, Nicholas. *Church Monuments in Romantic England*. New Haven and London, 1977.

Penny 1986 Penny, Nicholas, ed. *Reynolds*. [Exh. cat. Royal Academy of Arts] London, 1986.

Perkins 1873 Perkins, Augustus Thorndike. *A Sketch of the Life and a List of Some of the Works of John Singleton Copley*. Boston, 1873.

Perkins [after 1873] Perkins, Augustus Thorndike. *Supplementary List of Paintings by John Singleton Copley*. Boston, [after 1873].

Perkins 1878 Perkins, Augustus T. "Notes on Blackburn and Smibert." *Massachusetts Historical Society Proceedings* 16 (December 1878): 385ff.

Perkins 1954 Perkins, Bradford. "A Diplomat's Wife in Philadelphia: Letters of Henrietta Liston, 1796–1800." *William and Mary Quarterly* 11, no. 4 (October 1954): 592–632.

Perkins and Gavin 1980 Perkins, Robert F., and William J. Gavin III. *The Boston Athenaeum Art Exhibition Index, 1827–1874*. Boston, 1980.

Pernety 1757 Pernety, Antoine. *Dictionnaire portatif de peinture, sculpture et gravure*. Paris, 1757. Reprint, Geneva, 1972.

Phillips 1885 Phillips, Albert M. *Phillips Genealogies*. Auburn, Massachusetts, 1885.

Phipps 1930 Phipps, Pownoll Ramsay. "The Story of William Fitch and his Portrait." Typescript 1930. Revised by Sir Edmund Phipps. London, 1934.

Pierce 1899 Pierce, Frederick Clifton. *Foster Genealogy*. Chicago, 1899.

Piers 1927 Piers, Harry. *Robert Field*. New York, 1927.

Pilcher 1985 Pilcher, Edith. *Castorland: French Refugees in the Western Adirondacks 1793–1814*. Harrison, New York, 1985.

Pilkington 1980 Pilkington, Walter, ed. *The Journals of Samuel Kirkland.* Clinton, New York, 1980.

Pinckney 1895 Pinckney, Charles Cotesworth. *Life of General Thomas Pinckney.* Boston and New York, 1895.

Pinnington 1904 Pinnington, Edward. *Sir Henry Raeburn, R.A.* London, 1904.

Plumer 1857 Plumer, William, Jr. *The Life of William Plumer.* Boston, 1857.

Pointon 1970 Pointon, Marcia R. *Milton and English Art.* Toronto and Buffalo, 1970.

Pomeroy 1912 Pomeroy, Albert A. *History and Genealogy of the Pomeroy Family.* Toledo, Ohio, 1912.

Porter 1937 Porter, Kenneth Wiggins. *The Jacksons and the Lees.* 2 vols. Cambridge, Massachusetts, 1937.

"Portrait by Earl" 1917 "Landscape and Portrait by Ralph Earl." *Bulletin of the Worcester Art Museum* 7, no. 4 (January 1917): 7–10.

Portraits of Soldiers 1945 Duveen Galleries. *A Loan Exhibition of Portraits of Soldiers and Sailors in American Wars.* New York, 1945.

Posner 1971 Posner, Donald. *Annibale Carracci: A Study in the Reform of Italian Painting Around 1590.* 2 vols. New York, 1971.

Pound and Day 1930 Pound, Arthur, and Richard Day. *Johnson of the Mohawks.* New York, 1930.

Powell 1925 Powell, Henry Fletcher. *Tercentenary History of Maryland.* 4 vols. Chicago and Baltimore, 1925.

Praz 1958 Praz, Mario. "Tasso in England." In *The Flaming Heart; essays on Crashaw, Machiavelli, and other studies in the relations between Italian and English literature from Chaucer to T. S. Eliot.* New York, 1958.

Press Clippings *Press Clippings from English Newspapers on Matters of Artistic Interest, 1686–1835.* 3 vols. National Art Library. Victoria and Albert Museum, London.

Pressly 1983 Pressly, Nancy L. *Revealed Religion: Benjamin West's Commissions for Windsor Castle and Fonthill Abbey.* [Exh. cat. San Antonio Museum of Art] San Antonio, Texas, 1983.

Pressly 1986 Pressly, William L. "Gilbert Stuart's *The Skater*: An Essay in Romantic Melancholy." *American Art Journal* 18, no. 1 (1986): 42–51.

Prime 1929 Prime, Alfred Coxe. *The Arts and Crafts in Philadelphia, Maryland and South Carolina.* Vol. 2: *1786–1800.* Topsfield, Massachusetts, 1929.

Prown 1966 Prown, Jules David. *John Singleton Copley.* 2 vols. Cambridge, Massachusetts, 1966.

Prown, "Computer," 1967 Prown, Jules David. "The Art Historian and the Computer: An Analysis of Copley's Patronage 1753–1774." *Smithsonian Journal of History* 1, no. 4 (Winter 1967): 17–30.

Prown 1969 Prown, Jules David. *American Painting, From its Beginnings to the Armory Show.* Geneva, 1969.

Prown 1982 Prown, Jules David. "John Trumbull as History Painter." In Cooper 1982.

Prown 1986 Prown, Jules David. "Benjamin West's Family Picture: A Nativity in Hammersmith." *In Honor of Paul Mellon, Collector and Benefactor: Essays.* Edited by John Wilmerding. Washington, 1986.

Prown 1991 Prown, Jules David. "Charles Willson Peale in London." In Miller and Ward 1991.

Prussing 1927 Prussing, Eugene E. *The Estate of George Washington, Deceased.* Boston, 1927.

Public Characters 1805 "A Correct Catalogue of the Works of Mr. West." *Public Characters of 1805.* (London, 1805): 559–569.

Putnam 1906 Putnam, James Jackson. *A Memoir of Dr. James Jackson.* Boston and New York, 1906.

Putnam and Putnam 1907 Putnam, Elizabeth Cabot, and James Jackson Putnam, eds. *The Hon. Jonathan Jackson and Hannah (Tracy) Jackson, Their Ancestors and Descendants.* Boston, 1907.

Q

Quick 1981 Quick, Michael. "Princely Images in the Wilderness: 1720–1775." In *American Portraiture in the Grand Manner: 1720–1920.* [Exh. cat. Los Angeles County Museum of Art] Los Angeles, 1981.

Quincy 1883 Quincy, Josiah. *Figures of the Past from the Leaves of Old Journals.* 4th ed. Boston, 1883.

R

Raffael 1905 *Raffael, des Meisters Gemälde in 202 Abbildungen.* Stuttgart and Leipzig, 1905.

Raphael West 1831 George Robins. *A Catalogue of Nine Pictures, of the First Class; the genuine Property of Mr. Raphael West* [16 July 1831]. London, 1831.

Rather 1993 Rather, Susan. "Stuart and Reynolds: A Portrait of Challenge." *Eighteenth-Century Studies* 27, no. 1 (Fall 1993): 61–84.

Razzetti 1983 Razzetti, F. "Il 'Raffaello d'America' a Parma per il Correggio." *Gazzetta di Parma* (4 July 1983): 3.

Rebora 1990 Rebora, Carrie J. "The American Academy of the Fine Arts, New York, 1802–1842." 2 vols. Ph.D. diss., City University of New York, 1990.

Redding 1859 Redding, Cyrus, ed. *Memoirs of William Beckford of Fonthill, Author of "Vathek."* 2 vols. London, 1859.

Redford 1888 Redford, George. *Art Sales.* 2 vols. London, 1888.

Reuling 1925 Anderson Galleries. *Old Masters and Early American Portraits from the Estate of the late Dr. George R. Reuling . . . and Others* [4–5 November 1925]. New York, 1925.

"Reunion" 1942 "Reunion in Minneapolis." *Art Digest* 17, no. 2 (15 October 1942): 15.

"Reviews" 1947 "Reviews and Previews." *Art News* 46, no. 3 (May 1947): 3.

Rhode-Island Art Association 1854 *Catalogue of the First Exhibition of Paintings, Statuary, and other Works of Art, by the Rhode-Island Art Association, at Westminster Hall, Providence, September, 1854.* Providence, 1854.

Ribeiro 1984 Ribeiro, Aileen. *The Dress Worn at Masquerades in England, 1730 to 1790, and Its Relation to Fancy Dress in Portraiture.* New York and London, 1984.

Ribeiro, *Dress in Europe*, 1984 Ribeiro, Aileen. *Dress in Eighteenth-Century Europe, 1715–1789.* London, 1984.

Ricci 1930 Ricci, Corrado. *Corregio.* London and New York, 1930.

Richardson 1942 Richardson, Edgar P. "The Recent Acquisitions: The Red Cross Knight by Copley." *Art Quarterly* 5, no. 3 (Summer 1942): 264, 267–269.

Richardson 1947 Richardson, Edgar P. "Watson and the Shark by John Singleton Copley." *Art Quarterly* 10, no. 3 (Summer 1947): 213–218.

Richardson 1956 Richardson, Edgar P. *Painting in America*. New York, 1956.

Richardson 1967 Richardson, Edgar P. "Portraits of Washington, 1795–1796." In *Stuart 1967*.

Richardson 1968 Richardson, Edgar P. *From El Greco to Pollock: Early and Late Works by European and American Artists*. [Exh. cat. The Baltimore Museum of Art] Baltimore, 1968.

Richardson 1972 Richardson, Edgar P. "William Williams — A Dissenting Opinion." *American Art Journal* 4, no. 1 (Spring 1972): 5–23.

Richardson 1983 Richardson, Edgar P. "Charles Willson Peale and His World." In Richardson, Hindle, and Miller 1983.

Richardson 1986 Richardson, Edgar P. *American Paintings and Related Pictures in The Henry Francis du Pont Winterthur Museum*. Charlottesville, Virginia, 1986.

Richardson, Hindle, and Miller 1983 Richardson, Edgar P., Brooke Hindle, and Lillian B. Miller. *Charles Willson Peale and His World*. New York, 1983.

Rickword 1951 Rickword, G.O. "Colonel Fitch of the 83rd: Some Essex Associations with America." *Essex Review* 60, no. 239 (July 1951): 112–115.

Riddell 1924 Riddell, William Powell. *The Life of William Dummer Powell*. Lansing, Michigan, 1924.

Ridout 1989 Ridout, Orlando, V. *Building the Octagon*. Washington, 1989.

Robbins 1964 Robbins, Christine Chapman. *David Hosack, Citizen of New York*. Philadelphia, 1964.

Roberts 1953 Roberts, Kenneth. "Elizabeth Browne, Joseph Blackburn and 'Northwest Passage.'" *Art in America* 41, no. 1 (Winter 1953): 4–21.

Roberts 1988 Roberts, Richard Owen. *Whitefield in Print, A Bibliographic Record of Works by, For, and Against George Whitefield*. Wheaton, Illinois, 1988.

Rodriguez Roque 1982 Rodriguez Roque, Oswaldo. "Trumbull's Portraits." In Cooper 1982.

Rogers 1923 Rogers, Mary Cochrane. *Glimpses of an Old Social Capital (Portsmouth, New Hampshire) as illustrated by the Life of the Reverend Arthur Browne and His Circle*. Boston, 1923.

Rosand and Muraro 1976 Rosand, David, and Michelangelo Muraro. *Titian and the Venetian Woodcut*. [Exh. cat. International Exhibitions Foundation] Washington, 1976.

Rosenthal 1920 Stanislaus V. Henkels. *The most important collection of miniatures and small oil paintings . . . belonging to Albert Rosenthal*, catalogue no. 1269. Philadelphia, 1920.

Rosenthal 1922 Rosenthal, Albert. "The Benjamin West Exhibition." *Brooklyn Museum Quarterly* 9, no. 3 (July 1922): 135–136.

Rouss and Stein 1930 Anderson Galleries. *Oil Paintings of the XVIII and XIX Centuries from the Collections of Peter W. Rouss and Leonard L. Stein* [20 February 1930]. New York, 1930.

Royal Academy 1878 Royal Academy of Arts. *Exhibition of Works by the Old Masters, and by Deceased Masters of the British School*. London, 1878.

Royal Irish Academy 1803 *Transactions of the Royal Irish Academy*. Vol. 9. Dublin, 1803.

Royal Kalendar 1791 *The Royal Kalendar; or Complete and Correct Annual Register for England, Scotland, Ireland, and America, for the Year 1791*. London, 1791.

Royal Kalendar 1797 *The Royal Kalendar; or Complete and Correct Annual Register for England, Scotland, Ireland, and America, for the Year 1797*. London, 1797.

Royal Kalendar 1815 *The Royal Kalendar; or Court and City Register for England, Scotland, Ireland, and America, for the Year 1815*. London, 1815.

Royal Navy 1954 Admiralty, Great Britain. *The Commissioned Sea Officers of the Royal Navy, 1660–1815*. 3 vols. London, 1954.

Rudd 1950 Rudd, A. Böhmer. *Wolcott Genealogy: The Family of Henry Wolcott*. Washington, 1950.

Rutherfurd 1894 Rutherfurd, Livingston. *Family Records and Events compiled principally from the Original Manuscripts in the Rutherfurd Collection*. New York, 1894.

Rutledge 1955 Rutledge, Anna Wells. *Cumulative Record of Exhibition Catalogues: The Pennsylvania Academy of the Fine Arts, 1807–1870; the Society of Artists, 1800–1814; the Artists' Fund Society, 1835–1845*. Philadelphia, 1955.

Rutledge 1957 Rutledge, Anna Wells. "American Loyalists: A Drawing for a Noted Copley Group." *Art Quarterly* 20, no. 2 (Summer 1957): 195–203.

Rutledge and Lane 1952 Rutledge, Anna Wells, and James W. Lane. "110 Paintings in the Clarke Collection." Unpublished typescript. NGA, Department of Curatorial Records.

S

Sadik 1966 Sadik, Marvin S. *Colonial and Federal Portraits at Bowdoin College*. Brunswick, Maine, 1966.

Sadik 1976 Sadik, Marvin S. *Christian Gullager; Portrait Painter to Federal America*. [Exh. cat. NPG] Washington, 1976.

Safford 1922 Safford, William E. "Daturas of the Old World and New: An Account of Their Narcotic Properties and Their Use in Oracular and Initiatory Ceremonies." *Annual Report of the Board of Regents of the Smithsonian Institution for the year Ending June 30, 1920* (Washington, D.C., 1922): 537–567.

Sailors' Fair 1864 *Catalogue of Paintings and Statuary, exhibited for the Benefit of the National Sailors' Fair, at the Athenaeum Gallery, Beacon Street, Boston*. Boston, 1864.

Salisbury 1929 Salisbury, William. "The Clarke Collection of Paintings." *Antiquarian* 12, no. 5 (June 1929): 46–47.

Sanitary Fair 1863 *Catalogue of Pictures lent to the Sani-*

tary Fair for Exhibition. Together with Catalogue of Paintings and Statuary, of the Athenaeum Gallery, Beacon Street, Boston. Boston, 1863.

Sargent and Sargent 1924 Sargent, Emma Worcester, and Charles Sprague Sargent. *Epes Sargent of Gloucester and his Descendants.* Boston and New York, 1924.

Saunders 1979 Saunders, Richard H. "John Smibert (1688–1751), Anglo-American Portrait Painter." 2 vols. Ph.D. diss., Yale University, 1979.

Saunders 1993 Saunders, Richard H. "The Eighteenth-Century Portrait in American Culture of the Nineteenth and Twentieth Centuries." In *The Portrait in Eighteenth-Century America.* Edited by Ellen G. Miles. Newark, Delaware, 1993.

Saunders and Miles 1987 Saunders, Richard B., and Ellen G. Miles. *American Colonial Portraits, 1700–1776.* [Exh. cat. NPG] Washington, 1987.

"Savage Sold" 1941 "Savage Canvas Sold." *Art Digest* 15, no. 17 (1 June 1941):30.

Sawitzky 1933 Sawitzky, William. "Some Unrecorded Portraits by Gilbert Stuart, Part Three: Portraits Painted in America." *Art in America* 21, no. 3 (June 1933): 81–93.

Sawitzky 1938 Sawitzky, William. "The American Work of Benjamin West." *Pennsylvania Magazine of History and Biography* 62, no. 4 (October 1938): 433–462.

Sawitzky 1942 Sawitzky, William. *Matthew Pratt, A Study of his Work.* New York, 1942.

Sawitzky and Sawitzky 1960 Sawitzky, William, and Susan Sawitzky. "Two Letters from Ralph Earl, with Notes on his English Period." *Worcester Art Museum Annual* 8 (1960): 8–41.

Scharf 1879 Scharf, J. Thomas. *History of Maryland from the Earliest Period to the Present Day.* Baltimore, 1879. Reprint, Hatboro, Pennsylvania, 1967.

Schloss 1972 Schloss, Christine Skeeles. *The Beardsley Limner and Some Contemporaries; Postrevolutionary Portraiture in New England, 1785–1805.* [Exh. cat. Abby Aldrich Rockefeller Folk Art Center] Williamsburg, 1972.

Schorsch 1979 Schorsch, Anita. "A Key to the Kingdom: The Iconography of a Mourning Picture." *Winterthur Portfolio* 14, no. 1 (Spring 1979): 41–71.

Schroeder 1849 Schroeder, John Frederick. *Memoir of the Life and Character of Mrs. Mary Anna Boardman, with a Historical Account of Her Forefathers.* New Haven, 1849.

Schwartz 1982 Schwartz, Marvin D. *Chairs, Tables, Sofas and Beds.* New York, 1982.

Schwarz and Son 1982 Schwarz, Frank S., and Son. *Philadelphia Portraiture 1740–1910: Exhibition Celebrating Philadelphia's Tricentennial.* Philadelphia, 1982.

Scott 1963 Scott, Franklin D. *Wertmüller: Artist and Immigrant Farmer.* Chicago, 1963.

Scottish Portraits **1884** Board of Trustees for Manufactures in Scotland. *Scottish National Portraits; Catalogue of [the] Loan Exhibition.* Edinburgh, 1884.

Sellers 1952 Sellers, Charles Coleman. *Portraits and Miniatures by Charles Willson Peale.* Philadelphia, 1952.

Sellers 1962 Sellers, Charles Coleman. *Benjamin Franklin in Portraiture.* New Haven and London, 1962.

Sellers, "Jimson Weed," 1969 Sellers, Charles Coleman. "The Jimson Weed Warning: Charles Willson Peale and John Beale Bordley." *Pharos* 7, nos. 2 and 3 (Summer-Fall 1969): 20–25.

Sellers, *Peale,* 1969 Sellers, Charles Coleman. *Charles Willson Peale.* New York, 1969.

Sellers, *Patron and Populace,* 1969 Sellers, Charles Coleman. *Charles Willson Peale With Patron and Populace.* Philadelphia, 1969.

Semmes 1945 Semmes, Raphael, ed. *Proceedings and Acts of the General Assembly of Maryland, 1769–1770.* Vol. 62 of *Archives of Maryland.* Baltimore, 1945.

Severance 1911 Severance, Frank H. *Studies of the Niagara Frontier.* Vol. 15 of *Buffalo Historical Society Publications.* Buffalo, New York, 1911.

Severens 1985 Severens, Martha. "Jeremiah Theus of Charleston: Plagiarist or Pundit." *Southern Quarterly: A Journal of the Arts in the South* 24, nos. 1 and 2 (Fall-Winter 1985).

Shank 1984 Shank, J. William. "John Singleton Copley's Portraits: A Technical Study of Three Representative Examples." *Journal of the American Institute for Conservation* 23, no. 2 (Spring 1984): 130–152.

Shapley 1979 Shapley, Fern Rusk. *Catalogue of the Italian Paintings.* 2 vols. Washington, 1979.

Sharks **1986** Reader's Digest Services. *Sharks: Silent Hunters of the Deep.* Sydney and New York, 1986.

Sharpe 1909 Sharpe, Mary Ellen Graydon. *A Family Retrospect.* Indianapolis, 1909.

Shepard and Paley 1978 Shepard, Lewis A., and David Paley. *A Summary Catalogue of the Collection at the Mead Art Gallery.* Amherst, Massachusetts, 1978.

Sherman 1922 Sherman, Frederic Fairchild. "Current Comment: Exhibitions." *Art in America* 10, no. 3 (April 1922): 143–144.

Sherman, "Johnston," 1922 Sherman, Frederic Fairchild. "John Johnston's Portrait of John Peck." *Art in America* 10, no. 6 (October 1922): 259–260.

Sherman, "Stuart," 1922 Sherman, Frederic Fairchild. "Gilbert Stuart's First Portrait of Washington from Life: The Vaughan Picture Painted in 1795." *Art in America* 11, no. 1 (December 1922): 42–45.

Sherman, "Trumbull," 1922 Sherman, Frederic Fairchild. "John Trumbull's Portrait of William Rogers." *Art in America* 10, no. 6 (October 1922): 259.

Sherman, "Peale," 1923 Sherman, Frederic Fairchild. "Charles Willson Peale's Portrait of Major John Philip De Haas." *Art in America* 11, no. 6 (October 1923): 334–335.

Sherman, "Wollaston," 1923 Sherman, Frederic Fairchild. "John Wollaston's Portrait of Mary Walton Morris." *Art in America* 11, no. 6 (October 1923): 333–334.

Sherman 1928 Sherman, Frederic Fairchild. "Portraits and Miniatures by Copley, Dunlap, Eichholtz, and Robert Street." *Art in America* 16, no. 3 (April 1928): 122–129.

Sherman 1930 Sherman, Frederic Fairchild. "Gilbert

Stuart's Portraits of George Washington." *Art in America* 18, no. 6 (October 1930): 260–270.

Sherman 1932 Sherman, Frederic Fairchild. *Early American Painting*. New York and London, 1932.

Sherman 1934 Sherman, Frederic Fairchild. "Ralph Earl: An Eighteenth Century Connecticut Portrait Painter." *Art in America* 22, no. 3 (June 1934): 80–91.

Sherman 1935 Sherman, Frederic Fairchild. "James Earl, A Forgotten American Portrait Painter." *Art in America* 23, no. 4 (October 1935): 143–153.

Sherman 1939 Sherman, Frederic Fairchild. "The Painting of Ralph Earl With a List of His Portraits." *Art in America* 27, no. 4 (October 1939): 163–178.

Shipton 1937 Shipton, Clifford K., ed. *Biographical Sketches of Those who attended Harvard College in the Classes 1701–1712, with bibliographical and other Notes*. Vol. 5 of *Sibley's Harvard Graduates*. Boston, 1937.

Shipton 1965 Shipton, Clifford K., ed. *Biographical Sketches of Those who Attended Harvard College in the Classes 1751–1755, with bibliographical and other Notes*. Vol. 13 of *Sibley's Harvard Graduates*. Boston, 1965.

Shipton 1968 Shipton, Clifford K., ed. *Biographical Sketches of Those who Attended Harvard College in the Classes 1756–1760, with bibliographical and other Notes*. Vol. 14 of *Sibley's Harvard Graduates*. Boston, 1968.

Simmons 1961 Simmons, Slann L.C. "Records of the Willtown Presbyterian Church, 1738–1841." *South Carolina Historical and Genealogical Magazine* 62, no. 3 (July 1961): 172–181.

Simmons 1981 Simmons, Linda Crocker. *Charles Peale Polk 1767–1822: A Limner and His Likenesses*. [Exh. cat. CGA] Washington, 1981.

Sizer 1948 Sizer, Theodore. "An Early Check-List of the Paintings of John Trumbull." *Yale University Gazette* 22 (April 1948): 116–123.

Sizer 1948 II Sizer, Theodore. "A Tentative 'Short-Title' Check List of the Works of Col. John Trumbull." Part II. *Art Bulletin* 30, no. 4 (December 1948): 260–269.

Sizer 1949 Sizer, Theodore. "A Tentative 'Short-Title' Check-List of the Works of Col. John Trumbull." Part III. *Art Bulletin* 31, no. 1 (March 1949): 21–37.

Sizer 1950 Sizer, Theodore. *The Works of Colonel John Trumbull, Artist of the Revolution*. New Haven, 1950.

Sizer 1953 Sizer, Theodore, ed. *The Autobiography of Colonel John Trumbull, Patriot-Artist, 1756–1843*. New Haven, 1953.

Sizer 1956 Sizer, Theodore. "Colonel John Trumbull's Works: A Final Report." *Art Bulletin* 38, no. 2 (June 1956): 113–118.

Sizer 1967 Sizer, Theodore. *The Works of Colonel John Trumbull*. Rev. ed. New Haven and London, 1967.

Smart 1992 Smart, Alastair. *Allan Ramsay, 1713–1784*. [Exh. cat. Scottish National Portrait Gallery] Edinburgh, 1992.

Smith 1829 Smith, John Thomas. *Nollekens and His Times*. 2nd ed. 2 vols. London, 1829.

Smith **1876** F.W. Bennett & Co. *Catalogue of a large and valuable Private Collection . . . belonging to the Estate of Louis E. Smith* [3–5 May 1876]. Baltimore, 1876.

Smith 1883 Smith, John Chaloner. *British Mezzotinto Portraits*. 4 vols. London, 1883.

Smith 1898 Smith, Mrs. J. Stewart. *The Grange of St. Giles, and the other Baronial Homes of the Dick-Lauder Family*. Edinburgh, 1898.

Smith **1920** American Art Association. *Catalogue of the Frank Bulkeley Smith Collection Sale* [23 April 1920]. New York, 1920.

Smith and Selincourt 1912 Smith, J.C., and E. de Selincourt, eds. *Spenser, Poetical Works*. With an introduction by E. de Selincourt. London, New York, and Toronto, 1912.

"Smyth Family" 1915 "The Smyth Family of Berechurch Hall." *Essex Review* 24, no. 96 (October 1915): 178–190.

Soby and Miller 1943 Soby, James Thrall, and Dorothy C. Miller. *Romantic Painting in America*. [Exh. cat. Museum of Modern Art] New York, 1943.

Social Register 1911 Social Register Association. *Social Register, Boston, 1911*. New York, 1910.

Social Register 1932 Social Register Association. *Social Register, New York, 1932*. New York, 1931.

Social Register 1993 Social Register Association. *Social Register, 1993*. New York, 1992.

Sommer 1976 Sommer, Frank H. "The Metamorphoses of Britannia." In *American Art: 1750–1800 Towards Independence*. Edited by Charles F. Montgomery and Patricia E. Kane. [Exh. cat. YUAG] Boston, 1976.

Sorley 1979 Sorley, Merrow Egerton. *Lewis of Warner Hall: The History of a Family*. Baltimore, 1979.

Speaight 1980 Speaight, George. *A History of the Circus*. London, San Diego, and New York, 1980.

Spear 1982 Spear, Richard E. *Domenichino*. 2 vols. New Haven and London, 1982.

Speed Bulletin **1947** "Recent Exhibitions: Early American Art." *J.B. Speed Memorial Museum Bulletin* 8, no. 5 (May 1947): 1–2.

Spooner 1906 Spooner, W.W. "The Morris Family of Morrisania." *American Historical Magazine* 1, nos. 1–5 (1906): 134ff.

Staiti 1989 Staiti, Paul J. *Samuel F.B. Morse*. Cambridge, England, 1989.

Staley 1989 Staley, Allen. "Benjamin West." In *West 1989*.

Stauffer 1878 Stauffer, David McNeely. "General John Philip de Haas." *Pennsylvania Magazine of History and Biography* 2, no. 1 (1878): 345–347, 474.

Stauffer 1907 Stauffer, David McNeely. *American Engravers Upon Copper and Steel*. 2 vols. New York, 1907. Reprint, New York, 1964.

Stearns and Yerkes 1976 Stearns, Elinor, and David N. Yerkes. *William Thornton: A Renaissance Man in the Federal City*. Washington, 1976.

Stebbins, Troyen, and Fairbrother 1983 Stebbins, Theodore E., Jr., Carol Troyen, and Trevor J. Fairbrother. *A New World: Masterpieces of American Painting, 1760–1910*. [Exh. cat. MFA] Boston, 1983.

Stechow 1973 Stechow, Wolfgang. "Peter Paul Rubens' *Deborah Kip, Wife of Sir Balthasar Gerbier, and Her*

Children." *Studies in the History of Art* 5 (1973): 6–22.

Stein 1975 Stein, Roger B. *Seascape and the American Imagination.* New York, 1975.

Stein 1976 Stein, Roger B. "Copley's *Watson and the Shark* and Aesthetics in the 1770s." In Calvin Israel, ed., *Discoveries and Considerations. Essays on Early American Literature and Aesthetics, Presented to Harold Jantz.* Albany, New York, 1976.

Stephens 1950 Stephens, Stephen DeWitt. *The Mavericks, American Engravers.* New Brunswick, New Jersey, 1950.

Stevens 1967 Stevens, William B., Jr. "Joseph Blackburn and his Newport Sitters, 1754–1756." *Newport History* 40, part 3 (Summer 1967): 95–107.

Stewart 1969 Stewart, Robert Gordon. *A Nineteenth-Century Gallery of Distinguished Americans.* [Exh. cat. NPG] Washington, 1969.

Stewart 1971 Stewart, Robert Gordon. *Henry Benbridge (1743–1812), American Portrait Painter.* [Exh. cat. NPG] Washington, 1971.

Stewart 1979 Stewart, Robert Gordon. *Robert Edge Pine: A British Portrait Painter in America, 1784–1788.* [Exh. cat. NPG] Washington, 1979.

Stewart 1983 Stewart, J. Douglas. *Sir Godfrey Kneller and the English Baroque Portrait.* Oxford, England, 1983.

Stewart 1988 Stewart, Robert G. "James Earl: American Painter of Loyalists and His Career in England." *American Art Journal* 20, no. 4 (1988): 34–58.

Stokes 1915 Stokes, I.N. Phelps. *The Iconography of Manhattan Island.* 6 vols. New York, 1915–1928.

Stokes and Berkeley 1950 Stokes, William E., Jr., and Francis L. Berkeley, Jr. *The Papers of Randolph of Roanoke: A Preliminary Checklist of his Surviving Texts in Manuscript and in Print.* Charlottesville, Virginia, 1950.

Strickland 1913 Strickland, Walter G. *A Dictionary of Irish Artists.* 2 vols. Dublin and London, 1913.

Strickler 1979 Strickler, Susan. *American Paintings: Toledo Museum of Art.* Toledo, Ohio, 1979.

Stuart 1828 Boston Athenaeum. *Catalogue of an Exhibition of Portraits Painted by the Late Gilbert Stuart, Esq.* Boston, 1828.

Stuart 1876 Stuart, Jane. "The Stuart Portraits of Washington." *Scribner's Monthly* 12, no. 3 (July 1876): 367–374.

Stuart 1877 Stuart, Jane. "The Youth of Gilbert Stuart." *Scribner's Monthly* 13, no. 5 (March 1877): 640–646.

"Stuart" 1906 "Stuart." *Masters in Art: A Series of Illustrated Monographs.* Vol. 7, part 73. Boston, 1906.

Stuart 1963 *Portraits by Gilbert Stuart, 1755–1828.* [Exh. cat. PAFA] Philadelphia, 1963.

Stuart 1967 *Gilbert Stuart: Portraitist of the Young Republic, 1755–1828.* [Exh. cat. NGA] Washington, 1967.

S.W. 1934 S.W. [S. Winkworth]. "'A Youth Rescued from a Shark.' A Documentary Glass Transfer Picture." *Apollo* 19 (January 1934): 52.

Swan 1929 Swan, Mabel Munson. "The Man Who Made Simon Willard's Clock Cases. John Doggett of

Roxbury." *Antiques* 15, no. 3 (March 1929): 196–200.

Swan 1931 Swan, Mabel Munson. "The 'American Kings.'" *Antiques* 19, no. 4 (April 1931): 278–281.

Swan 1938 Swan, Mabel Munson. "Paging Gilbert Stuart in Boston." *Antiques* 34, no. 6 (December 1938): 308–309.

Swan 1940 Swan, Mable Munson. *The Athenaeum Gallery 1827–1873.* Boston, 1940.

Swan 1943 Swan, Mabel Munson. "The Johnstons and Reas-Japanners." *Antiques* 43, no. 5 (May 1943): 211–213.

Syrett 1961 Syrett, Harold C., ed. *The Papers of Alexander Hamilton.* 27 vols. New York, 1961–1987.

T

Tappan 1834 *Memoir of Mrs. Sarah Tappan.* New York, 1834.

Tappan 1870 Tappan, Lewis. *The Life of Arthur Tappan.* New York, 1870.

Tappan 1915 Tappan, Daniel Langdon. *Tappan-Toppan Genealogy: Ancestors and Descendants of Abraham Toppan of Newbury, Massachusetts, 1606–1672.* Arlington, Massachusetts, 1915.

Tashjian 1974 Tashjian, Dickran and Ann. *Memorials for Children of Change: The Art of Early New England Stone Carving.* Middletown, Connecticut, 1974.

Taylor 1931 Taylor, J. George. *Some New Light on the Later Life and Last Resting Place of Benedict Arnold and of his wife Margaret Shippen.* London, 1931.

Thacher 1828 Thacher, James. *American Medical Biography.* 2 vols. Boston, 1828.

Thompson 1969 Thompson, J.R. Fawcett. "Thayendanegea the Mohawk and his Several portraits." *Connoisseur* 170 (January 1969): 49–53.

Thorpe 1868 Thorpe, Thomas Bangs. *Reminiscences of Charles L. Elliott, artist.* New York, 1868.

"Thornton Diary" "Diary of Mrs. William Thornton 1800–1863." With prefatory note by Worthington C. Ford. *Records of the Columbia Historical Society, Washington, D.C.* 10 (1907): 88–226.

Tiffany 1901? Tiffany, Nelson Otis. *The Tiffanies of America: History and Genealogy.* Buffalo, New York, 1901?

Torbert 1950 Torbert, Alice Coyle. *Eleanor Calvert and her Circle.* New York, 1950.

Torquato Tasso 1985 *Torquato Tasso tra Litteratura Musica Teatro e Arti Figurative.* [Exh. cat. Castello Estense and Casa Romei, Ferrara] Bologna, 1985.

Townsend 1945 Townsend, Annette. *The Walton Family of New York, 1630–1940.* Philadelphia, 1945.

Treble Almanack 1823 *The Treble Almanack for the Year 1823.* Dublin, 1823.

Trollope 1834 Trollope, William. *A History of the Royal Foundation of Christ's Hospital.* London, 1834.

Troyen 1980 Troyen, Carol. *The Boston Tradition: American Paintings from the Museum of Fine Arts, Boston.* [Exh. cat. American Federation of Arts] New York, 1980.

Trumbull 1832 Trumbull, John. *Catalogue of Paintings by Colonel Trumbull . . . Now Exhibiting in the Gallery of Yale College*. New Haven, 1832.

***Truth to Nature* 1968** Leger Galleries. *Truth to Nature: An Exhibition of English Painting*. London, 1968.

Tuckerman 1847 Tuckerman, Henry T. *Artist-Life: or Sketches of American Painters*. New York and Philadelphia, 1847.

Tuckerman 1855 Tuckerman, Henry T. "Original Portraits of Washington." *Putnam's Monthly* 6, no. 34 (October 1855): 337–349.

Tuckerman 1867 Tuckerman, Henry T. *Book of the Artists: American Artist Life Comprising Biographical and Critical Sketches of American Artists*. New York, 1867. 5th printing, 1870. Reprint, New York, 1966.

Tuckerman 1889 Tuckerman, Bayard, ed. *The Diary of Philip Hone, 1828–1851*. 2 vols. New York, 1889.

Turnbull 1928 Turnbull, Archibald Douglas. *John Stevens; An American Records*. New York and London, 1928.

Turner 1987 Turner, Ronald, ed. *Thinkers of the Twentieth Century*. 2nd ed. Chicago and London, 1987.

"Two Interesting Portraits" 1947 "The Editor's Attic: Two Interesting Portraits." *Antiques* 51, no. 5 (May 1947): 341–342.

U

***Universal Magazine* 1805** "A Correct List of the Works of Mr. West." *Universal Magazine* 3, no. 19 (June 1805): 527–532.

Updike 1907 Updike, Wilkins. *A History of the Episcopal Church in Narragansett, Rhode Island*. 2nd ed. Boston, 1907.

V

Vail 1933 Vail, R.W.G. "Random Notes on the History of the Early American Circus." *Proceedings of the American Antiquarian Society*. N.s. 43, part 1 (April 1933): 173–175.

***Valuable Pictures* 1927** Sotheby and Co. *Catalogue of Valuable Pictures by Old Masters of the Italian School; Portraits of the Dutch and English Schools; Pictures and Drawings of the English and French Schools*. London, 1927.

Van Devanter 1973 Van Devanter, Ann C. "Benjamin West and his Self-Portraits." *Antiques* 103, no. 4 (April 1973): 764–773.

Van Devanter 1975 Van Devanter, Ann C. "The Signers' Ladies." *Antiques* 108, no. 1 (July 1975): 114–122.

Van Horn 1921 Van Horn, Henry. "Arts and Decoration." *Town and Country* 77, no. 3801 (20 February 1921): 22–30.

Van Doren 1974 *Webster's American Biographies*. Edited by Charles Van Doren. Springfield, Massachusetts, 1974.

Van Rensselaer 1888 Van Rensselaer, May King. *The Van Rensselaers of the Manor of Rensselaerswyck*. New York, 1888.

Van Rensselaer 1949 Van Rensselaer, Florence. *The Livingston Family in America*. New York, 1949.

Van Schaack 1859 Van Schaack, Henry C. *Henry Cruger: The Colleague of Edmund Burke in the British Parliament*. New York, 1859.

***Vaughan* 1839** *Memoir of William Vaughan, Esq. F.R.S.* London, 1839.

Verheyen 1989 Verheyen, Egon. "'The Most exact representation of the Original': Remarks on Portraits of George Washington by Gilbert Stuart and Rembrandt Peale." *Multiple Originals, Copies, and Reproductions*. Center for Advanced Studies in the Visual Arts Symposium Papers 7. Washington, 1989.

Von Erffa and Staley 1986 Von Erffa, Helmut and Allen Staley. *The Paintings of Benjamin West*. New Haven and London, 1986.

W

Waagen 1838 Waagen, Gustav Friedrich. *Works of Art and Artists in England*. 3 vols. London, 1838.

Waagen 1854 Waagen, Gustav Friedrich. *Treasures of Art in Great Britain*. 3 vols. London, 1854.

Wainwright 1972 Wainwright, Nicholas B. "Joseph Harrison Jr., a forgotten art collector." *Antiques* 102, no. 4 (October 1972): 660–668.

Wainwright 1963 Wainwright, Nicholas B. "The Penn Collection," *Pennsylvania Magazine of History and Biography* 87, no. 4 (October 1963): 393–419.

Walker and James 1943 Walker, John, and MacGill James. *Great American Paintings from Smibert to Bellows, 1729–1924*. London, New York, and Toronto, 1943.

Walker 1951 Walker, John. *Paintings from America*. Harmondsworth, England, 1951.

Walker 1984 Walker, John. *National Gallery of Art*. Rev. ed. New York, 1984.

Walker 1985 Walker, Richard. *Regency Portraits*. 2 vols. London, 1985.

Ward and Roberts 1904 Ward, Humphrey, and William Roberts. *Romney: A Biographical and Critical Essay with a Catalogue Raisonné of his Works*. 2 vols. London and New York, 1904.

Warren 1975 Warren, David B. *Bayou Bend: American Furniture, Paintings and Silver from the Bayou Bend Collection*. Houston, Texas, 1975.

Warren 1980 Warren, Phelps. "Badger Family Portraits." *Antiques* 118, no. 5 (November 1980): 1043–1047.

Warwick, Pitz, and Wyckoff 1965 Warwick, Edward, Henry C. Pitz, and Alexander Wyckoff. *Early American Dress; The Colonial and Revolutionary Periods*. New York, 1965.

Washburn 1860 Washburn, Emory. *Historical Sketches of the Town of Leicester*. Boston, 1860.

***Washington Exhibition* 1853** *The Washington Exhibition in aid of the New-York Gallery of the Fine Arts, at the American Art-Union Gallery*. [Exh. cat. American Art-Union] New York, 1853.

Waterhouse 1946 Waterhouse, Ellis K. "Tasso and

the Visual Arts." *Italian Studies* 3 (1946–1948): 146–162.

Waterhouse 1953 Waterhouse, Ellis. *Painting in Britain, 1530 to 1790*. Baltimore, 1953.

Waterhouse 1958 Waterhouse, Ellis K. *Gainsborough*. London, 1958.

Waterhouse 1973 Waterhouse, Ellis. *Reynolds*. London, 1973.

Waterhouse 1981 Waterhouse, Ellis K. *The Dictionary of British Eighteenth Century Painters in Oils and Crayons*. Woodbridge, Suffolk, England, 1981.

Waterson 1981 Waterson, Merlin. "Hissing Along the Polished Ice." *Country Life* 169 (2 April 1981): 872–874.

"Watson" 1807 "Obituary, Sir Brook Watson, Baronet." *Gentleman's Magazine, and Historical Chronicle* 77, part 2 (1807): 987–988.

Watson 1969 Watson, Ross. "Irish Portraits in American Collections." *Quarterly Bulletin of the Irish Georgian Society* 12, no. 2 (April-June 1969): 31ff.

Webber 1928 Webber, Mabel L. "Inscriptions from the Independent or Congregational (Circular) Churchyard, Charleston, S.C." *South Carolina Historical and Genealogical Magazine* 29 (1928): 55–66, 133–150, 238–257, 306–328.

Webster 1924 Webster, John Clarence. *Sir Brook Watson, Friend of the Loyalists*. Sackville, New Brunswick, 1924.

Webster 1936 Webster, John Clarence. *The Journal of Joshua Winslow*. Saint John, New Brunswick, 1936.

Webster 1939 Webster, John Clarence. *Catalogue of the John Clarence Webster Canadian Collection, New Brunswick Museum*. Saint John, New Brunswick 1939.

Weddell 1930 Weddell, Alexander Wilbourne, ed. *A Memorial Volume of Virginia Historical Portraiture, 1585–1830*. Richmond, 1930.

Weekley 1976 Weekley, Carolyn. "John Wollaston, Portrait Painter: His Career in Virginia, 1754-1758." M.A. thesis, University of Delaware, 1976.

Weintraub and Ploog 1987 Weintraub, Stanley, and Randy Ploog. *Benjamin West Drawings from The Historical Society of Pennsylvania*. [Exh. cat., Pennsylvania State University Museum of Art] University Park, Pennsylvania, 1987.

Weir 1901 Weir, John F. *John Trumbull, A Brief Sketch to Which Is Added a Catalogue of His Works*. New York, 1901.

Werlich 1974 Werlich, Robert. *Orders and Decorations of all Nations*. 2nd ed. Washington, 1974.

West **1821** *A Catalogue of Pictures painted by the late Benjamin West, Esq. . . . now exhibiting at No. 14, Newman Street*. London, 1821.

West **1828** *Catalogue of Pictures and Drawings by the late Benjamin West, Esq. . . . now exhibiting at No. 14, Newman Street*. London, 1828.

West **1989** *Benjamin West: American Painter at the English Court*. [Exh. cat. The Baltimore Museum of Art] Baltimore, 1989.

White **1878** Christie, Manson & Woods. *Catalogue of the Valuable Collection of Pictures of Thomas George Graham White, Esq., Deceased*. London, 1878.

Whitehill 1971 Whitehill, Walter Muir. "Perez Morton's Daughter Revisits Boston in 1825." *Proceedings of the Massachusetts Historical Society* 82 (1971): 21–47.

Whitfield 1973 Whitfield, Clovis. "Balthasar Gerbier, Rubens, and George Vertue." *Studies in the History of Art* 5 (1973): 23–31.

Whitley 1928 Whitley, William T. *Artists and Their Friends in England, 1700-1799*. 2 vols. London and Boston, 1928.

Whitley 1932 Whitley, William T. *Gilbert Stuart*. Cambridge, Massachusetts, 1932.

Whitney 1793 Whitney, Peter. *The History of the County of Worcester*. Worcester, 1793.

Who's Who **1914** *Who's Who in America*. Vol. 8. Chicago, 1914.

Who's Who **1948** *Who's Who in America*. Vol. 25. Chicago, 1948.

Who's Who **1974** *Who's Who in America*. 38th ed. Chicago, 1974.

Who Was Who/Authors **1976** *Who Was Who among American Authors, 1921–1939*. 2 vols. Detroit, 1976.

Who Was Who *Who Was Who in America*. Historical volume, 1607–1896; vol. 1, 1897–1942; vol. 2, 1943–1950; vol. 3, 1951–1960; vol. 4, 1961–1968; vol. 5, 1969–1973. Chicago, 1943–1973.

Whyte 1972 Whyte, Donald. *A Dictionary of Scottish Emigrants to the U.S.A.* Baltimore, 1972.

Williams 1981 Williams, William James. *A Heritage of American Paintings from the National Gallery of Art*. Maplewood, New Jersey, 1981.

Wilmerding 1976 Wilmerding, John. *American Art*. New York, 1976.

Wilmerding 1980 Wilmerding, John. *American Masterpieces from the National Gallery of Art*. New York, 1980.

Wilmerding 1987 Wilmerding, John. *American Marine Painting*. 2nd ed. New York, 1987.

Wilmerding 1988 Wilmerding, John. *American Masterpieces from the National Gallery of Art*. Rev. and enlg. ed. New York, 1988.

Wilmerding, Ayres, and Powell 1981 Wilmerding, John, Linda Ayres, and Earl A. Powell. *An American Perspective: Nineteenth-Century Art from the collection of Jo Ann & Julian Ganz, Jr.* [Exh. cat. NGA] Washington, 1981.

Wilson 1989 Wilson, R. Jackson. *Figures of Speech; American Writers and the Literary Marketplace, from Benjamin Franklin to Emily Dickinson*. New York, 1989.

Wind, "Charity," 1938 Wind, Edgar. "Charity; The Case History of a Pattern." *Journal of the Warburg Institute* 1 (April 1938): 322–330.

Wind, "History Painting," 1938 Wind, Edgar. "The Revolution in History Painting." *Journal of the Warburg Institute* 2 (October 1938): 116–127.

Withington 1914 Withington, Lothrop. "Virginia Gleanings in England." *Virginia Magazine of History and Biography* 22, no. 2 (1914): 22–24.

Wolcott 1881 Wolcott, Samuel. *Memorial of Henry Wolcott and Some of His Descendants*. New York, 1881.

Wright 1961 Wright, Esmond. "Robert Liston, Sec-

ond British Minister to the United States." *History To-day* 11, no. 2 (February 1961): 118–127.

Y

Yarnall and Gerdts 1986 Yarnall, James L., and William B. Gerdts. *The National Museum of American Art's Index to American Art Exhibition Catalogues From the* *Beginning through the 1876 Centennial Year.* 6 vols. Boston, 1986.

York Gallery 1990 Richard York Gallery. *An American Gallery.* Vol. 6, no. 1. New York, 1990.

Young 1821 Young, John. *A Catalogue of the Pictures at Grosvenor House, London; with Etchings from the Whole Collection.* London, 1821.

Abbreviations for Frequently Cited Exhibitions

Atlanta 1951
American Portraits from the National Gallery of Art, Atlanta Art Association, High Museum of Art, Atlanta, 1951.

Boston 1880
Exhibition of Portraits Painted by Gilbert Stuart, Museum of Fine Arts, Boston, 1880.

Century Association 1928
A Loan Exhibition of Paintings by Early American Portrait Painters, The Century Association, New York, 1928.

Chattanooga 1952
Opening Exhibition of the George Thomas Hunter Gallery of Art, Chattanooga Art Association, Chattanooga, Tennessee, 1952.

Columbia 1950
The Face of American History, Columbia Museum of Art, Columbia, South Carolina, 1950.

Copley, 1965–1966
John Singleton Copley, National Gallery of Art, Washington; Metropolitan Museum of Art, New York; Museum of Fine Arts, Boston, 1965–1966.

Gilbert Stuart
Gilbert Stuart: Portraitist of the Young Republic, 1755–1828, National Gallery of Art, Washington; Museum of Art, Rhode Island School of Design, Providence; The Pennsylvania Academy of the Fine Arts, Philadelphia, 1967.

Hagerstown 1955
Famous Americans, Washington County Museum of Fine Arts, Hagerstown, Maryland, 1955, no cat.

Kentucky 1970
Two Centuries of American Portraits, University of Kentucky Art Gallery, Lexington; Paducah Art Gallery; J.B. Speed Art Museum, Louisville, 1970.

Metropolitan Opera House 1889
Centennial Celebration of the Inauguration of George Washington: Loan Exhibition of Historical Portraits and Relics, Metropolitan Opera House, New York, 1889.

New York 1853
The Washington Exhibition in aid of the New-York Gallery of the Fine Arts, at the American Art-Union Gallery, New York, 1853.

NGA 1950
Makers of History in Washington 1800–1950, National Gallery of Art, Washington, 1950.

Philadelphia 1928
Portraits by Early American Artists of the Seventeenth, Eighteenth and Nineteenth Centuries Collected by Thomas B. Clarke, Philadelphia Museum of Art, 1928.

Richmond 1944–1945
Gilbert Stuart: Portraits Lent by the National Gallery of Art, Washington, D.C., Virginia Museum of Fine Arts, Richmond, 1944–1945.

Tate Gallery 1946
American Painting From the Eighteenth Century to the Present Day, The Tate Gallery, London, 1946.

Union League Club, November 1921
Exhibition of Paintings by Early American Portrait Painters, The Union League Club, New York, 1921. [10–24 November]

Union League Club, January 1922
Exhibition of Paintings: Portraits Painted in Europe by Early American Artists, The Union League Club, New York, 1922. [12–16 January]

Union League Club, February 1922
Exhibition of Paintings: Portraits Painted in the United States by Early American Artists, The Union League Club, New York, 1922. [9–13 February]

Union League Club, March 1922
Exhibition of Portraits by Early American Artists, The Union League Club, New York, 1922. [9–11 March]

Union League Club, January 1923
Exhibition of Portraits by Early American Portrait Painters, The Union League Club, New York, 1923. [11–13 January]

Union League Club, February 1924
Exhibition of Portraits by Early American Portrait Painters, The Union League Club, New York, 1924. [14, 15, 21, 22 February]

Union League Club, March 1924
Exhibition of the Earliest Known Portraits of Americans by Painters of the Seventeenth, Eighteenth and Nineteenth Centuries, The Union League Club, New York, 1924. [12–13 March]

Abbreviations of Frequently Cited Institutions

AAA	Archives of American Art, Smithsonian Institution, Washington
AAS	American Antiquarian Society, Worcester, Massachusetts
CGA	The Corcoran Gallery of Art, Washington
LC	Library of Congress, Washington
MFA	Museum of Fine Arts, Boston
MMA	The Metropolitan Museum of Art, New York
NGA	National Gallery of Art, Washington
NMAA	National Museum of American Art, Smithsonian Institution, Washington
NPG	The National Portrait Gallery, Smithsonian Institution, Washington
NYHS	The New-York Historical Society, New York
PAFA	The Pennsylvania Academy of the Fine Arts, Philadelphia
RISD	Museum of Art, Rhode Island School of Design, Providence
SI	Smithsonian Institution, Washington
YUAG	Yale University Art Gallery, New Haven

General Index

Page numbers in bold refer to an artist's biography.
Titles of paintings in bold refer to works in the
National Gallery of Art.
Also see Index of Previous Owners.

John Brown, Mr. and Mrs., portraits of (private collection), 10
Military Officer, A [1947.17.25], *ill. on 12,* 11–13
Portrait of a Young Girl Holding a Dublin Lottery Ticket (Dublin, National Gallery of Ireland), 11
Blyth, Benjamin, 364, 365
 works by
 Benjamin Moses (Salem, Massachusetts, Peabody and Essex Museum), 364, 364 (fig. 1)
 George Whitefield, portrait of (after Nathaniel Hone), 364
 Sarah Carrol Moses holding daughter Betsey (Salem, Massachusetts, Peabody and Essex Museum), 364, 364 (fig. 2)
 works attributed to
 Elisha Doane [1943.1.3], *ill. on 363,* 362–365
 Jane Cutler Doane [1943.1.4], *ill. on 366,* 365–367
Boardman, Daniel, as sitter, 96–98
Boardman family, portraits by Ralph Earl, 91, 96
Bordley, John Beale, 130
 as sitter, 113–117
Boston, activity of painters in, 3, 10, 21, 102, 104, 109, 161
Boston Athenaeum, 269
 Newton, Gilbert Stuart, copy of Stuart's *John Adams,* 212
Boude, Dr. Samuel, as sitter, 317–320
Boude, Mary Bethel, as sitter, 319–321
Bowdoin College Museum of Art, Brunswick, Maine
 Earl, James, portrait of unidentified man, 284
 Feke, Robert
 Mrs. James Bowdoin II, 106, 106 (fig. 2)
 Samuel Waldo, portrait of, 102
 Johnston, John, portrait of Judge David Sewall, 110
 Stuart, Gilbert
 James Madison, 277, 277 (fig. 7)
 Thomas Jefferson, 275
Bowdoin, James, III, as patron, 275
Bowdoin family, portraits by Robert Feke, 102
Bowen, Clarence Winthrop, 258, 260
Bowler, Anne Fairchild, as sitter, 28–30
Bowler, Metcalf, 28–30
Boydell, John, 67, 74–75, 172–173, 174
 portrait by Gilbert Stuart, 173
Boydell, Josiah, 176n.5
 portrait by Gilbert Stuart, 173
Brant, Joseph (Thayendanegea), 322
British Museum, London
 beaded hat band, Algonquian or Iroquoian, 325, 325 (fig. 3)
 Martini, P., engraving of J. H. Ramberg, *George III and the Royal Family,* 19 (fig. 1)
 moccasins, Algonquian or Iroquoian, 325, 325 (fig. 2)
 West, Benjamin
 Countess of Effingham, 342, 342 (fig. 2)
 Skateing, 163, 164 (fig. 1), 166
Britton, John
 Beauties of Wiltshire, quoted, 342, 345
Brocket Hall, England
 Collection of Lord Brocket
 Reynolds, Joshua, *George, Prince of Wales,* 84 (fig. 1)

Brooklyn Museum, New York
 Stuart, Gilbert, *George Washington,* 287
 Williams, William, *Deborah Hall,* 133–134
 Wollaston, John, portrait of Sir Charles Hardy, 354
Brown, Mather, 13–14, 300
 use of preparatory studies, 16, 17
 works by
 John and Abigail Adams, portraits of, 13, 14
 Lord Howe on the Deck of the "Queen Charlotte" (Greenwich, National Maritime Museum), 14
 Raleigh Destroying the Spanish Fleet off Cadiz, 14
 Thomas Dawson, Viscount Cremorne [1947.17.28], *ill. on 18,* 17–20
 William Vans Murray [1940.1.1], *ill. on 15,* 14–16
Brown, Mr. and Mrs. John, portraits by Joseph Blackburn, 10
Browne, Jane, as sitter, 22–24
Browne, John, portrait by Gilbert Stuart, 173
Browne family, portraits by John Singleton Copley, 24
Browne family, portraits by John Smibert, 27n.25
Burr
 Lewis Morris (engraving after Wollaston) (Washington, National Portrait Gallery), 355, 356 (fig. 2)
Byrne, William
 Cataract of Niagara (engraving after Richard Wilson) (Ottawa, National Archives of Canada), 326

C

Caffieri, Jean-Jacques, portrait by Adolph-Ulrich Wertmüller, 312
Callander, Adam
 works attributed to
 Brook Watson and the Cattle Incident at Chignecto (St. John, New Brunswick Museum), 66
Calvert, Rosalie Stier, 236, 246, 248
Campbell, Patrick, 326
Campbell, William P., ix, 140, 208
Canot, Peter
 View of the Entrance of the Harbour of the Havanna (engraving), 58
Carracci, Agostino, 124
Carracci, Annibale
 Rinaldo and Armida (Naples, Pinacoteca Nazionale), 124
Carroll, Mr. and Mrs. Charles, portraits by Charles Willson Peale, 116
Cary, Thomas, portrait by John Singleton Copley, 36
Casali, Andrea
 portraits of the Countess of Effingham and Mrs. William Beckford, 342
Central Art Gallery, Wolverhampton, England
 Wilson, Richard, *Falls of Niagara,* 325
Ceracchi, Giuseppe
 Alexander Hamilton (Washington, The National Portrait Gallery), 309, 310 (fig. 2)
Chambers, Eunice, 294
Chambers, George
 copy of Benjamin West's *Battle of La Hogue* (Greenwich, National Maritime Museum), 333

works after
Lord Churchill's Two Daughters, The (mezzotint by John Smith), 22, 22 (fig. 1)
Madam d'Avenant (mezzotint by John Smith), 365, 367 (fig. 1)

L

Lady Lever Art Gallery, Port Sunlight
 Reynolds, Sir Joshua, *Mrs. Peter Beckford*, 346
Lafayette, the Marquis de, portrait by Charles Willson Peale, 112
Laming, Benjamin, as sitter, 120–128
Laming, Eleanor Ridgley, as sitter, 120–128
Langendijk, Dirk, 333
Lansdown, H.V., 346
LaSalle University Art Museum
 Opie, John, portrait of Grant children, 163
Latrobe, Benjamin Henry, 312
Lavater, John Caspar, *Essays on Physiognomy*, 202
Lawrence, Thomas, 19
 Portrait of Thomas Dawson, 1st Viscount Cremorne (New York, Richard L. Feigen & Co.), 19 (fig. 2)
 portrait of William Fitch (Belfast, Royal Irish Rangers), 84
LeBrun, Charles, 61
 engravings after, from *The Compleat Drawing-Master*, 64 (figs. 9–13)
Lee, Mrs. Jeremiah, portrait by John Singleton Copley, 42
Lee, Rensselaer, 124, 125
L'Enfant, Pierre, 132n.7
Lewis, Eleanor Parke Custis, as sitter, 146–158, 237–240, 249
Lieber, Francis, 66–67
Liston, Henrietta Marchant, as sitter, 224–227
Liston, Robert, as sitter, 221–224
Lloyd, James, as sitter, 289–291
Longacre, James Barton, *National Portrait Gallery of Distinguished Americans*, 212, 214
Lyman Allen Museum, New London, Connecticut
 Johnston, John, portrait of Samuel Bass, 110

M

Macdonald, Flora, mezzotint after portrait by Thomas Hudson, 32, 32 (fig.1)
Macdonough, Commodore Thomas, as sitter, 261–263
MacKay, John
 portrait of Catherine Brower (Washington, National Gallery of Art), 133
Madison family
 portraits by Charles Peale Polk, 133
 portraits by Gilbert Stuart, 161
Madison, Dolley, 241, 243
Martini, P.
 engraving of J.H. Ramberg, *George III and the Royal Family* (London, British Museum), 17–19, 19 (fig. 1)
Maryland Historical Society, Baltimore
 Sharples, James, *William Vans Murray*, 16 (fig. 1)
Masaccio, frescoes, 336

Mason, George C., 216, 263
Massachusetts Historical Society, Boston
 unidentified artist, portrait of Abigail Adams, 214
Mather, Frank Jewett, 25
Mather family, 13. *See also* Brown, Mather
Maurin, Antoine
 works attributed to
 George Washington (after Gilbert Stuart) (Washington, The National Portrait Gallery), 266, 269 (fig. 3)
 John Adams (after Gilbert Stuart) (Washington, The National Portrait Gallery), 266, 269 (fig. 4)
Maurin, Nicholas Eustache
 works by
 Thomas Jefferson (after Gilbert Stuart) (Washington, The National Portrait Gallery), 266, 269 (fig. 5)
 works attributed to
 George Washington (after Gilbert Stuart) (Washington, The National Portrait Gallery), 266, 269 (fig. 3)
 John Adams (after Gilbert Stuart) (Washington, The National Portrait Gallery), 266, 269 (fig. 4)
McDonald, William, 235
Mead Art Museum, Amherst College, Amherst, Massachusetts, 99
 Blackburn, Joseph, portrait of Jeffrey Amherst, 10
 Stuart, Gilbert, *James Madison*, 266, 268 (fig. 1)
Medina, John Baptist
 illustrations for *Paradise Lost*, 336, 338
Metropolitan Museum of Art, New York, 304
 Copley, John Singleton
 portrait of Augustus Brine, 300
 preparatory drawing for *The Ascension*, 60
 Earl, Ralph, portrait of Elijah Boardman, 96
 Feke, Robert, portrait of Tench Francis, 102
 Pratt, Matthew
 The American School, 138
 Cadwalader Colden and Warren de Lancey, 138
 Stuart, Gilbert
 James Monroe, 266, 268 (fig. 2)
 Portrait of the Artist, 167, 167 (fig. 3)
 portrait of Henrietta Hillegas Anthony, 200
 William Kerin Constable, 287, 287 (fig. 1)
 Trumbull, John, replica of West's *Battle of La Hogue*, 332
 Wertmüller, Adolph-Ulrich, portrait of George Washington, 313
 West, Benjamin
 Hagar and Ishmael, 17
 portrait of Sarah Ursula Rose, 321
 portraits of Peter Beckford and Mrs. Peter Beckford, 341
 Wollaston, John
 portrait of Cadwalader Colden, 360
 portrait of Joseph Reade, 360
mezzotints. *See* portraits; portraiture, English
Miller, Dorothy, 67
Miller, William, portrait by Gilbert Stuart, 173
Milton, John
 Paradise Lost, quoted, 335–336, 338

Index of Previous Owners

Abbott, Gordon: 82
Abbott, Katharine Tiffany (Mrs. Gordon Abbott): 82
Adams, Brooks: 211, 214
Adams, Charles Francis: 211, 214
Adams, John Quincy: 211, 214
Agnew, Thomas, and Sons (London): 334
American Art Association (New York): 222, 226, 227, 367
Amory, Charles: 46, 76, 87,
Amory, Copley (1841–1879): 36
Amory, Copley (1866–1960): 36, 46
Amory, Copley, Jr. (1890–1964): 36, 46
Amory, Copley, Jr., Elizabeth Cole Amory, Henry Russell Amory, Katharine Amory Smith, and Walter Amory: 46
Amory, Edward Linzee: 46
Amory, Martha Babcock Greene (Mrs. Charles Amory): 46, 76, 87,
Amory, Mary Forbes Russell: 36
Amory, Walter: 36
Art House, Inc. (New York): 11, 22, 146, 241, 244, 355, 358
Aspinwall, John Cuthbert: 294, 295
Aspinwall, Sophie Cuthbert (Mrs. Woolsey Aspinwall): 294, 295
Avalon Foundation: 25, 36, 303
Avery, Samuel P., Jr. (New York): 146

Bacon, Virginia Murray (Mrs. Robert Low Bacon): 42
Barlow, (Henry N.?) (Washington): 208
Barra Foundation, Inc., The: 113
Barry, James David: 230, 233
Barry, Joanna: 230, 233
"Barry": 233
Bascom, Ann Brattle: 227
Batchelder, Katharine Abbott (Mrs. George L. Batchelder): 82
Bayley, Frank W.: 282, 367
Bayley, Frank W., & Son (Boston): 235
Bayley, Frank W. (Boston): 367
Beckford, Susan Euphemia, 10th Duchess of Hamilton: 341, 345
Beckford, William: 341, 345
Betts, Constance Woolworth, Helena Woolworth Guest, and Frasier Winfield McCann (children of Helena Woolworth McCann): 222
Binney, Horace (1780–1875): 219
Binney, Dr. Horace (1874–1956): 219
Binney, Rev. John: 219
Binney, Susan: 219
Blake, Edwin A.: 38, 42
Boardman, Rev. William S.: 96
Bordewich, Mrs. John Stuart (Georgiana Elizabeth May Pelham-Clinton): 163
Borland, John Nelson and M. Woolsey Borland: 82
Bowen, Clarence Winthrop: 256, 260
Bowen, Roxana Wentworth (Lady Gordon Vereker): 256, 260
Bowie, Elizabeth Stoddert (Mrs. Robert Bowie, Jr.): 129

Bowler, Susan Louisa Pendleton (Mrs. Robert Bonner Bowler): 28
Boydell, John: 172
Boydell, Josiah: 172
Braun, John F.: 256
Buckingham, Margaret Freeman: 136
Buffum, Mrs. David: 3, 4
Buffum, Dr. Thomas Bellows: 3, 4, 6, 9
Burke, W. S.: 367
Burnside, Harriet Pamela Foster: 158
Burnside, Sophia Dwight Foster (Mrs. Samuel MacGregor Burnside): 158
Butler, D. B. & Co. (New York): 306

Carrier, Anna Frances Peale (Mrs. Frederick Carrier): 118
Chambers, Eunice (Hartsville, South Carolina): 294, 295
Chandler, Melinda Earle Nye (Mrs. Marcus Chandler): 99
Chapman, Alice Greenwood: 38, 42
Chiapella, Henry: 183, 186, 188, 190, 193
Chiapella, Marie Louise Pollock: 183, 186, 188, 190, 193
Christ's Hospital, London: 55
Christie, Manson and Woods (London): 17, 46, 72, 76, 87, 230, 233, 341, 345
Clark, Greta Pomeroy: 263
"Clarke": 46, 76
Clarke, Thomas B.: 11, 14, 22, 99, 109, 118, 129, 146, 169, 172, 177, 180, 183, 186, 188, 190, 193, 196, 200, 201, 216, 227, 241, 244, 246, 263, 279, 282, 285, 287, 289, 292, 306, 313, 341, 345, 348, 352, 355, 358, 360, 367
Clements, Caroline Dixwell (Mrs. George Henry Clements): 25
Cline, Isaac Monroe: 183, 186, 188, 190, 193
Clinton Hall Art Galleries (New York): 180
Coffin, Edward Francis (Worcester, Massachusetts): 99
Coleman, Charles Washington, Jr.: 250
Coleman, Cynthia Beverley Tucker (Mrs. Charles Washington Coleman): 250
Coleman, George Preston: 250
Colnaghi, and Obach (London): 206, 222, 226
Connell, James, and Sons (London): 216
Conner, James A.: 129
Coolidge, Catherine Boyer (Mrs. Joseph Coolidge): 263
Coolidge, Thomas Jefferson (1831–1920): 265
Coolidge, Thomas Jefferson, III: 265
Coolidge, Thomas Jefferson, IV: 265
Cooper, Colin Campbell, Emily, Samuel M., or Ned: 133
Cooper, Emily Williams (Mrs. Colin Campbell Cooper): 133
Copley, John Singleton: 46, 76
Copley, John Singleton, Jr., Lord Lyndhurst: 46, 76
Copley Gallery (Boston): 282
Cozzens, Abraham M.: 180
Crane, Josephine Porter Boardman (Mrs. Winthrop Murray Crane): 96

Palmer, Mary Ridgely (Mrs. Henry Clay Palmer): 120
Parke-Bernet Galleries (New York): 120, 222
Peale, Louisa Harriet Hubley (Mrs. Edward Burd Peale): 118
Peale, Margaretta Angelica: 118
Peale, Mary Jane: 118
Peck, Mrs. Philip: 6, 9
Pelham-Clinton, Charles Stapleton: 162
Pelham-Clinton, Elizabeth: 163
Pelham-Clinton, Elizabeth Grant (Mrs. Charles): 162
Pelham-Clinton, Georgiana Elizabeth May (Mrs. John Stuart Bordewich): 163
Penn, Granville: 17
Phillips, Ann Broadhurst: 109, 227
Phillips, Edith, Norah, and Ann Broadhurst: 227
Phillips, John: 227
Phillips, Son & Neale (London): 334
Pollock, Carlile: 183, 186, 188, 190, 193
Pollock, Catherine Yates: 188, 190, 193
Pollock, George: 188, 190, 193
Pomeroy, Catherine Boyer Coolidge (Mrs. Samuel Wyllys Pomeroy): 263
Pomeroy, Clarissa Alsop: 263
Prouty, Dwight (Boston): 362, 365

Ralston, Louis (New York): 216
Randolph, John: 250
Reed, Brooks: 362, 365
Ricketts, Francis: 208
Riggs, Alice Lawrason: 208
Riggs, George W.: 208
Riggs, Jane Agnes: 208
Robins, George (London): 334
Robinson & Farr (Philadelphia): 17
Robinson, T. H. (London): 169, 172, 177
Rogers, Dr. David: 91
Rogers, Martha Tennent: 94
Rogers, Samuel Henry: 94
Rueff, André E. (Brooklyn, New York): 11, 109, 287, 289
Rush, Benjamin: 14
Rush, Richard: 14

Sabin, Frank T. (London): 321
Sack, Israel (New York): 362, 365
Savage, Edward: 146
Schapiro, Morris: 120
Schoepf, Harriet M. Chandler: 99
Shore, Charlotte Cordes Doar (Mrs. George Shore): 282
Silo, James P. (New York): 362, 365
Sinclair, William: 206
Sittig, Edgar H. (Shawnee-on-Delaware, Pennsylvania): 102
"Smith": 334
Smith, Frank Bulkeley: 367
Smith, Thomas Duncan: 200
Smith, Mrs. Thomas Duncan: 200
Smith, William Rudolph: 200
Smyth, Sir George Henry, 6th Baronet: 87
Sotheby's (London): 321, 329
Spark, Victor (New York): 105, 133
Stetson University, The: 113
Stoddert, John Truman: 129

Stoddert, William Truman: 129
Stow, Edward: 109, 227
Stow, Louisa Matilda: 227
Stuart, Eleanor Custis: 246
Sturges, Henry C.: 180
Sturges, Jonathan: 180
Sturges, Mary P.: 180
Sully, Mary H. (Brooklyn, New York): 241, 244, 287
Sweet, Joy Singleton Copley Greene (Mrs. Gordon Sweet): 43

Talbot, Adelaide Thomason (Mrs. Isham Talbot): 241, 244
Talbot, Mary Louisa: 241, 244
Tappan, Julianna Aspinwall: 256, 260
Tappan, Lewis: 256, 260
Tarkington, Booth: 222
Tarkington, Susannah Robinson: 222
Taylor, Anne Béloste (Mrs. James Taylor): 306
Thayer, Adele: 235
Thayer, Robert Helyer: 28, 34
Thayer, Virginia Pratt (Mrs. Robert Helyer Thayer): 28, 34, 253
Thomas, M., and Sons (Philadelphia): 201
Thornton, Anna Maria Brodeau: 241, 244
Thorpe, Russell W. (Flushing, New York): 158
Thomond, 3rd Marquis of and 7th Earl of Inchiquin (James O'Brien): 172
Thomond, 1st Marquis of and 5th Earl of Inchiquin (Murrough O'Brien): 172
Tiers, Clarence Van Dyke: 139
Tooth, Arthur (London): 230
Tooth Brothers (London): 341, 345, 348
Tracy, Patrick: 300
Tucker, Nathaniel Beverley: 250

Van Rensselaer, Isabella Mason: 306
Van Rensselaer, Kiliaen (1845-1905): 196
Van Rensselaer, Kiliaen (1879-1949): 196
Van Rensselaer, Maunsell: 306
Van Rensselaer, William Patterson: 196
Vaughan, John: 201
Vaughan, Samuel: 201
Vaughan, William: 201
Vereker, Lady Gordon (Roxana Wentworth Bowen): 256, 260

Wallace, John William: 219
Wallace, Susan Binney (Mrs. John Bradford Wallace): 219
Walton, Adelaide Phillips: 109
Watson, Brook: 55
Webster, Rebecca Lynn: 246
West, Addison Tinsley: 91, 94
West, Annie Munro: 91
West, Benjamin, Jr.: 334
West, Frank Bartow: 94
West, Raphael Lamar: 334
Westminster, Robert Grosvenor, 1st Marquess of: 329
Westminster, Richard Grosvenor, 2nd Marquess of: 329
Westminster, Hugh Grosvenor, 1st Duke of: 329
Westminster, Hugh Richard Arthur Grosvenor, 2nd Duke of: 329

Whistler, G. D.: 230, 233
Whistler, George Worthen: 230, 233
White, Thomas George Graham: 87
Williams, Annie Buffum (Mrs. Nathan W. Williams): 3, 4, 6, 9
Winthrop, Cornelia Adelaide Granger (Thayer) (Mrs. Robert Charles Winthrop): 235

Winthrop, Robert Charles: 235
Winthrop, Robert M.: 235
Wolcott, John Stoughton: 303
Wolcott, Oliver: 303
Worcester Art Museum: 99

York, Richard (New York): 43

Concordance of Old-New Titles

Titles changed since publication by the National Gallery of Art of *American Paintings: An Illustrated Catalogue* (Washington, 1992) and *European Paintings: An Illustrated Catalogue* (Washington, 1985).

Artist	Accession Number	Old Title	New Title
Joseph Badger	1957.11.2	Mrs. Isaac Foster	Eleanor Wyer Foster (Mrs. Isaac Foster)
John Singleton Copley	1942.4.1	Sir Robert Graham	Baron Graham
John Singleton Copley	1960.4.1	Colonel Fitch and His Sisters	Colonel William Fitch and His Sisters Sarah and Ann Fitch
John Singleton Copley	1968.1.1	Mrs. Metcalf Bowler	Anne Fairchild Bowler (Mrs. Metcalf Bowler)
John Singleton Copley	1980.11.1	Mrs. Samuel Alleyne Otis (Elizabeth Gray)	Elizabeth Gray Otis (Mrs. Samuel Alleyne Otis)
John Singleton Copley	1985.20.1	Mrs. Adam Babcock	Abigail Smith Babcock (Mrs. Adam Babcock)
Ralph Earl	1965.15.9	Martha Tennent Rogers and Daughter	Martha Tennent Rogers (Mrs. David Rogers) and Her Son, probably Samuel Henry Rogers
John Greenwood	1961.4.1	Mrs. Welshman	Elizabeth Fulford Welshman
Matthew Pratt	1942.13.2	The Duke of Portland	William Henry Cavendish Bentinck, 3rd Duke of Portland
Gilbert Stuart	1940.1.4	Mrs. Richard Yates	Catherine Brass Yates (Mrs. Richard Yates)
Attributed to Gilbert Stuart	1942.8.12	Mr. Ashe	John Ashe
Gilbert Stuart	1942.8.19	Mrs. George Pollock	Catherine Yates Pollock (Mrs. George Pollock)
Gilbert Stuart	1942.8.22	Mrs. William Robinson	Ann Calvert Stuart Robinson (Mrs. William Robinson)
Gilbert Stuart	1942.8.26	Mrs. William Thornton	Anna Maria Brodeau Thornton (Mrs. William Thornton)
Gilbert Stuart	1954.7.2	Mrs. John Adams	Abigail Smith Adams (Mrs. John Adams)
Gilbert Stuart	1960.12.1	Mrs. Robert Liston	Henrietta Marchant Liston (Mrs. Robert Liston)
Gilbert Stuart	1970.34.3	Mrs. Benjamin Tappan	Sarah Homes Tappan (Mrs. Benjamin Tappan)
Gilbert Stuart	1974.108.1	Mrs. Lawrence Lewis	Eleanor Parke Custis Lewis (Mrs. Lawrence Lewis)
Gilbert Stuart	1954.9.2	George Washington (Athenaeum portrait)	George Washington

Artist	Accession Number	Old Title	New Title
Gilbert Stuart, completed by an unidentified artist	1947.17.104	Mrs. Andrew Dexter (?)	Charlotte Morton Dexter (Mrs. Andrew Dexter)
Jeremiah Theus	1965.15.6	Mr. Cuthbert	James Cuthbert (?)
Jeremiah Theus	1965.15.7	Mrs. Cuthbert	Mary Cuthbert (Mrs. James Cuthbert) (?)
Attributed to Adolph-Ulrich Wertmüller	1954.1.4	Portrait of a Man	Portrait of a Quaker
Benjamin West	1940.1.10	Colonel Guy Johnson	Colonel Guy Johnson and Karonghyontye (Captain David Hill)
Benjamin West	1947.17.23	Mrs. William Beckford	Maria Hamilton Beckford (Mrs. William Beckford)
Benjamin West	1964.23.8	Mrs. Samuel Boude	Mary Bethel Boude (Mrs. Samuel Boude)
After Benjamin West	1942.8.39	Self-Portrait	Benjamin West
John Wollaston	1942.8.41	Lewis Morris (?)	A Gentleman of the Morris Family
John Wollaston	1947.17.105	Lieutenant Archibald Kennedy (?)	Unidentified British Navy Officer

Concordance of Old-New Attributions

Attributions changed since publication by the National Gallery of Art of *American Paintings: An Illustrated Catalogue* (Washington, 1992) and *European Paintings: An Illustrated Catalogue* (Washington, 1985).

Old Attribution	Accession Number	New Attribution
Gilbert Stuart	1942.8.12	Attributed to Gilbert Stuart
Gilbert Stuart (?) and Unknown Artist	1947.17.104	Gilbert Stuart, completed by an unknown artist
Unknown Nationality 18th Century	1954.1.4	Attributed to Adolph-Ulrich Wertmüller
Benjamin West	1942.8.39	After Benjamin West

1940.1.1	487	Mather Brown, *William Vans Murray*
1940.1.2	488	Edward Savage, *The Washington Family*
1940.1.3	489	Gilbert Stuart, *Joseph Coolidge*
1940.1.4	490	Gilbert Stuart, *Catherine Brass Yates (Mrs. Richard Yates)*
1940.1.5	491	Gilbert Stuart, *Lawrence Reid Yates*
1940.1.6	492	Gilbert Stuart, *George Washington (Vaughan-Sinclair portrait)*
1940.1.8	494	John Trumbull, *Alexander Hamilton*
1940.1.9	495	Gilbert Stuart, *John Randolph*
1940.1.10	496	Benjamin West, *Colonel Guy Johnson and Karonghyontye (Captain David Hill)*
1942.4.1	550	John Singleton Copley, *Baron Graham*
1942.4.2	551	John Singleton Copley, *The Red Cross Knight*
1942.8.2	555	John Singleton Copley, *Jane Browne*
1942.8.9	562	Charles Willson Peale, *John Philip de Haas*
1942.8.11	564	Gilbert Stuart, *Captain Joseph Anthony*
1942.8.12	565	Attributed to Gilbert Stuart, *John Ashe*
1942.8.13	566	Unknown American Artist, *Matilda Caroline Cruger*
1942.8.14	567	Gilbert Stuart, *Counsellor John Dunn*
1942.8.16	569	Gilbert Stuart, *Dr. William Hartigan (?)*
1942.8.17	570	Gilbert Stuart, *Commodore Thomas Macdonough*
1942.8.18	571	Gilbert Stuart, *George Pollock*
1942.8.19	572	Gilbert Stuart, *Catherine Yates Pollock (Mrs. George Pollock)*
1942.8.20	573	Gilbert Stuart, *Stephen Van Rensselaer*
1942.8.21	574	Gilbert Stuart, *Sir Joshua Reynolds*
1942.8.22	575	Gilbert Stuart, *Ann Calvert Stuart Robinson (Mrs. William Robinson)*
1942.8.23	576	Gilbert Stuart, *Edward Stow*
1942.8.25	578	Gilbert Stuart, *William Thornton*
1942.8.26	579	Gilbert Stuart, *Anna Maria Brodeau Thornton (Mrs. William Thornton)*
1942.8.27	580	Gilbert Stuart, *George Washington (Vaughan portrait)*
1942.8.28	581	Gilbert Stuart, *Luke White*
1942.8.29	582	Gilbert Stuart, *Richard Yates*
1942.8.39	592	After Benjamin West, *Benjamin West*
1942.8.40	593	John Wollaston, *Mary Walton Morris*
1942.8.41	594	John Wollaston, *A Gentleman of the Morris Family*
1942.13.2	697	Matthew Pratt, *William Henry Cavendish Bentinck, 3rd Duke of Portland*
1942.14.1	701	Gilbert Stuart, *John Bill Ricketts*
1943.1.3	704	Unknown American Artist, *Elisha Doane*
1943.1.4	705	Unknown American Artist, *Jane Cutler Doane*
1944.3.1	765	Gilbert Stuart, *Horace Binney*
1944.17.1	777	Matthew Pratt, *Madonna of Saint Jerome*
1947.13.1	1943	Charles Peale Polk, *General Washington at Princeton*
1947.15.1	907	John Singleton Copley, *The Death of the Earl of Chatham*
1947.17.12	920	Jeremiah Theus, *Mr. Motte*
1947.17.13	921	John Trumbull, *William Rogers*
1947.17.23	931	Benjamin West, *Maria Hamilton Beckford (Mrs. William Beckford)*
1947.17.25	933	Joseph Blackburn, *A Military Officer*
1947.17.28	936	Mather Brown, *Thomas Dawson, Viscount Cremorne*
1947.17.42	950	Ralph Earl, *Thomas Earle*
1947.17.65	973	John Johnston, *John Peck*
1947.17.89	997	Robert Edge Pine, *General William Smallwood*
1947.17.101	1009	Benjamin West, *Elizabeth, Countess of Effingham*
1947.17.103	1011	John Wollaston, *John Stevens (?)*
1947.17.104	1012	Gilbert Stuart, completed by an unknown artist, *Charlotte Morton Dexter (Mrs. Andrew Dexter)*
1947.17.105	1013	John Wollaston, *Unidentified British Navy Officer*
1947.17.106	1014	After Gilbert Stuart, *William Seton*
1947.17.107	1015	After Gilbert Stuart, *James Lloyd*
1948.8.1	1026	Ralph Earl, *Daniel Boardman*
1950.18.1	1051	Gilbert Stuart, *The Skater (Portrait of William Grant)*

1952.1.1	1081	John Trumbull, *Alexander Hamilton*
1953.5.32	1236	Charles Peale Polk, *Anna Maria Cumpston*
1954.1.4	1188	Attributed to Adolph-Ulrich Wertmüller, *Portrait of a Quaker*
1954.1.9	1193	After Gilbert Stuart, *William Constable*
1954.1.10	1194	Gilbert Stuart, *Sir John Dick*
1954.7.1	1347	Gilbert Stuart, *John Adams*
1954.7.2	1348	Gilbert Stuart, *Abigail Smith Adams (Mrs. John Adams)*
1954.9.2	1352	Gilbert Stuart, *George Washington*
1954.9.3	1353	Gilbert Stuart, *Ann Barry*
1954.9.4	1354	Gilbert Stuart, *Mary Barry*
1957.10.1	1487	Gilbert Stuart, *Robert Liston*
1957.11.1	1488	Joseph Badger, *Captain Isaac Foster*
1957.11.2	1489	Joseph Badger, *Eleanor Wyer Foster (Mrs. Isaac Foster)*
1957.11.3	1490	Joseph Badger, *Isaac Foster, Jr.*
1957.11.4	1491	Joseph Badger, *Dr. William Foster*
1959.4.1	1533	John Singleton Copley, *Epes Sargent*
1959.8.1	1535	Benjamin West, *The Battle of La Hogue*
1960.3.1	1552	Edward Savage, *George Washington*
1960.4.1	1550	John Singleton Copley, *Colonel William Fitch and His Sisters Sarah and Ann Fitch*
1960.12.1	1599	Gilbert Stuart, *Henrietta Marchant Liston (Mrs. Robert Liston)*
1961.4.1	1600	John Greenwood, *Elizabeth Fulford Welshman*
1961.7.1	1650	John Singleton Copley, *The Copley Family*
1963.6.1	1904	John Singleton Copley, *Watson and the Shark*
1964.15.1	1926	John Trumbull, *Patrick Tracy*
1964.23.7	1939	Benjamin West, *Dr. Samuel Boude*
1964.23.8	1940	Benjamin West, *Mary Bethel Boude (Mrs. Samuel Boude)*
1965.6.1	1944	John Singleton Copley, *Eleazer Tyng*
1965.15.6	1955	Jeremiah Theus, *James Cuthbert (?)*
1965.15.7	1956	Jeremiah Theus, *Mary Cuthbert (Mrs. James Cuthbert) (?)*
1965.15.8	1957	Ralph Earl, *Dr. David Rogers*
1965.15.9	1958	Ralph Earl, *Martha Tennent Rogers (Mrs. David Rogers) and Her Son, probably Samuel Henry Rogers*
1966.10.1	2313	Charles Willson Peale, *Benjamin and Eleanor Ridgely Laming*
1966.13.2	2318	Robert Feke, *Captain Alexander Graydon*
1968.1.1	2341	John Singleton Copley, *Anne Fairchild Bowler (Mrs. Metcalf Bowler)*
1970.34.2	2540	Gilbert Stuart, *Benjamin Tappan*
1970.34.3	2541	Gilbert Stuart, *Sarah Homes Tappan (Mrs. Benjamin Tappan)*
1974.108.1	2677	Gilbert Stuart, *Eleanor Parke Custis Lewis (Mrs. Lawrence Lewis)*
1976.25.1	2691	John Singleton Copley, *Harrison Gray*
1978.79.1	2756	John Singleton Copley, *Adam Babcock*
1979.4.1	2758	Gilbert Stuart, *John Adams*
1979.4.2	2760	Gilbert Stuart, *James Madison*
1979.4.3	2761	Gilbert Stuart, *James Monroe*
1979.5.1	2757	Gilbert Stuart, *George Washington*
1980.11.1	2774	John Singleton Copley, *Elizabeth Gray Otis (Mrs. Samuel Alleyne Otis)*
1980.11.2	2775	Gilbert Stuart, *Samuel Alleyne Otis*
1984.2.1		Charles Willson Peale, *John Beale Bordley*
1985.20.1	2679	John Singleton Copley, *Abigail Smith Babcock (Mrs. Adam Babcock)*
1986.71.1	2759	Gilbert Stuart, *Thomas Jefferson*
1989.12.1		Benjamin West, *The Expulsion of Adam and Eve from Paradise*
1991.141.1		John Singleton Copley, *Sketch for The Copley Family*

Editor-in-Chief, Frances P. Smyth
Production Manager, Chris Vogel
Senior Editor and Manager, Systematic Catalogue, Mary Yakush
Editor, Nancy Eickel
Designer, Klaus Gemming, New Haven, Connecticut
Typeset in Baskerville by Stamperia Valdonega S.R.L., Verona, Italy
Printed by Balding and Mansell, Peterborough, England,
on Zenith Silk 130 gsm. text.